PEOPs

stories and portraits of people
by FLY

soft Skull | Brooklyn, NY | 2K3

PEOPs

stories and portraits of people
by FLY

*Disclaimer: the words surrounding the
portraits are paraphrased & in some rare
instances may not accurately represent the
opinion of the subject.*

Book design and layout by
Fly and Don Goede
Cover design by Fly
www.bway.net/~fly
Cover layout assistance by
Kriss De Jong at Killer Banshees Studios,
Oakland, California
www.killerbanshee.com

*Printed and bound in
Hong Kong*

Distributed to the book trade by
Publishers Group West
www.pgw.com

This book published in 2003 by
Soft Skull SHORTWAVE
a division of Soft Skull Press, Inc.
71 Bond St.
Brooklyn, NY 11217
www.softskull.com

SOFTSKULL
SHORTWAVE

FLY ON THE WALL

by Trina Robbins

foreword

I can't remember where I first saw Fly's comix, although it was probably in the New York alternative comic book, World War 3 Illustrated. I liked her clean inking style, and I liked what she had to say. If I had to work a little harder to understand her quirky way of spelling—well, that was okay with me.

At some point—again, I can't remember when—we started communicating, thanks to the modern miracle of e-mail. I learned she was coming to my side of the country, San Francisco, for a comic convention. The night of the con, at a party thrown by the Cartoon Art Museum, I finally met her.

There sat Fly, surrounded by Californians, looking every bit like the resident of a New York squat, which she is, in black kickass boots, torn fishnets and one single stud in her lip.

Nowadays Fly spends a few months of every year on the Left Coast, but it hasn't changed her. She still looks like the resident of a New York squat, but she's added two studs: one for each dimple. We've become friends. Becoming Fly's friend is easy, because she likes her friends, appreciates them, and is proud of them—so proud that she's produced PEOPs, a record of just about everybody with whom Fly has come in contact. Fly becomes a Fly on the wall and just lets her subjects talk, until the face on her finished page is surrounded by words. The result is portraits that are unique because Fly feels that everyone is unique, and she manages to communicate that feeling to anyone who turns the pages of PEOPs. But most unique of all is Fly.

introduction

Who do you know? Who do you live with?

Who gives you a kind word when you feel down?

Who bums a quarter off you?

Who do you admire and who gets on your nerves?

IN THIS BOOK, FLY HAS ATTEMPTED TO DO ONE-PAGE PORTRAITS OF AS MANY OF THE PEOPLE IN HER LIFE AS POSSIBLE. GENERALLY THE CREATION OF ONE OF THESE PORTRAITS INVOLVES BOTH A LIVE SKETCH AND AN INFORMAL INTERVIEW WHILE SKETCHING. FLY LIKES PEOPLE AND TRIES TO FIND SOMETHING WORTHWHILE IN EVERYONE, BUT SHE ALSO HAS A CYNICAL WIT THAT FINDS HUMOR IN THE WORST SITUATIONS.

FLY, CARTOONIST, SQUATTER, ANARCHIST, MUSICIAN AND WORLD TRAVELER, HAS TOURED WITH THE BANDS GOD IS MY CO-PILOT AND ZERO CONTENT AS WELL AS TOURING HER OWN SPOKEN-WORD AND ART SHOWS. THIS BOOK EVOLVES FROM THE SKETCHBOOKS SHE FILLS ON THE ROAD. IT CAN BE READ AS A MAP OF THE CONTEMPORARY UNDERGROUND SCENE, COMPLETE WITH ARTISTS AND RIOTERS. BUT FLY SAYS THAT SHE WOULD BE HAPPY TO DO PORTRAITS OF BUSH AND CHENEY IF THEY WOULD SIT FOR HER (I AM IMAGINING THEM SITTING IN HER SQUAT RIGHT NOW). EUROPEAN AND AMERICAN CULTURE ARE DEEPLY HUMANISTIC AND INDIVIDUALISTIC, PLACING THE INDIVIDUAL, NOT GOD, NATURE, SOCIETY, OR THE GROUP, AT THE CENTER OF ALL ART AND LITERATURE. SO PORTRAITURE IS A VERY TRADITIONAL, EVEN CONSERVATIVE, IDIOM. BUT THERE IS ANOTHER EFFECT WHEN WE LOOK AT SO MANY PORTRAITS IN A ROW. THE FACES BECOME A LANDSCAPE THAT THE ARTIST IS WALKING THROUGH. A PICTURE OF THE WORLD. OR PERHAPS, AS IN VAN GOGH'S WHEAT FIELDS, A REFLECTION OF THE ARTIST'S INNER LIFE, A SELF-PORTRAIT TURNED INSIDE OUT. MAYBE WE ARE LOOKING AT AN EXPLODED VIEW OF FLY HERSELF, HEARING THE MANY VOICES IN HER HEAD.

PEOPS CONFIRMS FLY AS ONE OF THE TODAY'S MOST INNOVATIVE COMIC BOOK ARTISTS, ABLE TO SPEAK IN MANY VOICES AND DRAW IN MANY WAYS. IF YOU CARE ABOUT COMICS, POLITICS OR JUST PEOPLE, YOU SHOULD PICK UP PEOPS AND EVERYTHING ELSE BY FLY.

—Seth Tobocman

New York, 2003

This book is dedicated

To all my incredible present, past & future PEOPs
Thank you all for your patience & support -
this project would not exist without you!
& to anyone who thinks their life is insignificant
this book is especially dedicated to you

Much thanks & appreciation!!

To Kriss De Jong & Eliot Daughtry
(aka kbanshee & koyote)
at the Killer Banshee Studios in Oakland, CA

To Sander Hicks & Don Goede for believing in this
project & supporting its progress
& the whole soft skull crew,
especially Tom, David, Tennessee, Richard, & Sarah
for helping to make it happen

To my mom

To Chupa — Cover Girl extraordinaire

& to all my PEOPs who are named
on every page of this book

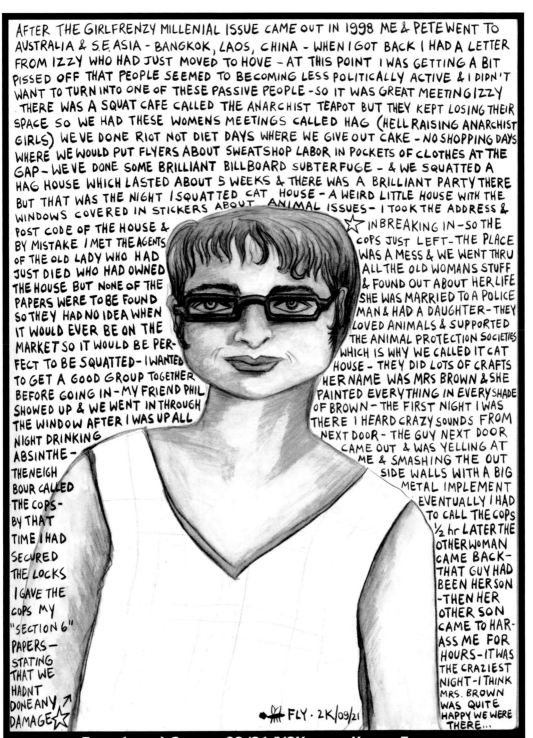

AFTER THE GIRLFRENZY MILLENIAL ISSUE CAME OUT IN 1998 ME & PETE WENT TO AUSTRALIA & S.E. ASIA - BANGKOK, LAOS, CHINA - WHEN I GOT BACK I HAD A LETTER FROM IZZY WHO HAD JUST MOVED TO HOVE - AT THIS POINT I WAS GETTING A BIT PISSED OFF THAT PEOPLE SEEMED TO BECOMING LESS POLITICALLY ACTIVE & I DIDN'T WANT TO TURN INTO ONE OF THESE PASSIVE PEOPLE - SO IT WAS GREAT MEETING IZZY THERE WAS A SQUAT CAFE CALLED THE ANARCHIST TEAPOT BUT THEY KEPT LOSING THEIR SPACE SO WE HAD THESE WOMENS MEETINGS CALLED HAG (HELL RAISING ANARCHIST GIRLS) WE'VE DONE RIOT NOT DIET DAYS WHERE WE GIVE OUT CAKE - NO SHOPPING DAYS WHERE WE WOULD PUT FLYERS ABOUT SWEATSHOP LABOR IN POCKETS OF CLOTHES AT THE GAP - WE'VE DONE SOME BRILLIANT BILLBOARD SUBTERFUGE - & WE SQUATTED A HAG HOUSE WHICH LASTED ABOUT 5 WEEKS & THERE WAS A BRILLIANT PARTY THERE BUT THAT WAS THE NIGHT I SQUATTED CAT HOUSE - A WEIRD LITTLE HOUSE WITH THE WINDOWS COVERED IN STICKERS ABOUT ANIMAL ISSUES - I TOOK THE ADDRESS &

POST CODE OF THE HOUSE & BY MISTAKE I MET THE AGENTS OF THE OLD LADY WHO HAD JUST DIED WHO HAD OWNED THE HOUSE BUT NONE OF THE PAPERS WERE TO BE FOUND SO THEY HAD NO IDEA WHEN IT WOULD EVER BE ON THE MARKET SO IT WOULD BE PERFECT TO BE SQUATTED - I WANTED TO GET A GOOD GROUP TOGETHER BEFORE GOING IN - MY FRIEND PHIL SHOWED UP & WE WENT IN THROUGH THE WINDOW AFTER I WAS UP ALL NIGHT DRINKING ABSINTHE - THE NEIGHBOUR CALLED THE COPS - BY THAT TIME I HAD SECURED THE LOCKS I GAVE THE COPS MY "SECTION 6" PAPERS - STATING THAT WE HADNT DONE ANY DAMAGE ☆

☆ IN BREAKING IN - SO THE COPS JUST LEFT - THE PLACE WAS A MESS & WE WENT THRU ALL THE OLD WOMANS STUFF & FOUND OUT ABOUT HER LIFE SHE WAS MARRIED TO A POLICE MAN & HAD A DAUGHTER - THEY LOVED ANIMALS & SUPPORTED THE ANIMAL PROTECTION SOCIETIES WHICH IS WHY WE CALLED IT CAT HOUSE - THEY DID LOTS OF CRAFTS HER NAME WAS MRS BROWN & SHE PAINTED EVERYTHING IN EVERY SHADE OF BROWN - THE FIRST NIGHT I WAS THERE I HEARD CRAZY SOUNDS FROM NEXT DOOR - THE GUY NEXT DOOR CAME OUT & WAS YELLING AT ME & SMASHING THE OUTSIDE WALLS WITH A BIG METAL IMPLEMENT EVENTUALLY I HAD TO CALL THE COPS ½ hr LATER THE OTHER WOMAN CAME BACK - THAT GUY HAD BEEN HER SON - THEN HER OTHER SON CAME TO HARASS ME FOR HOURS - IT WAS THE CRAZIEST NIGHT - I THINK MRS. BROWN WAS QUITE HAPPY WE WERE THERE...

✳ FLY · 2K/09/21

ERICA (WORD) SMITH – 09/21/Y2K – FRM HOVE – ENGLAND
I FIRST MET ERICA WHEN SHE WAS HANGIN OUT WITH PETER PAVEMENT IN HOVE UK – I HAD BEEN TOUR WITH GOD IS MY CO-PILOT & WAS ON MY WAY BACK TO NYC FROM AMSTERDAM – I ARRIVED IN LONDON IN THE PISSING RAIN AT 3AM & UNFORTUNATELY LONDON IS A CITY THAT SLEEPS SO I HAD TO WAIT FOR IT TO WAKE UP BEFORE I COULD GET TO BRIXTON TO FIND MY SQUATTER PAL MARK AT THE 121 CENTER – HE LET ME CALL PETER WHO SAID HE WAS LEAVING THE NEXT DAY FOR GERMANY BUT WE COULD HANG OUT TONIGHT SO I HAD TO GET MY ASS TO BRIGHTON WHERE I MET ERICA & SHE INTERVIEWED ME FOR THE MILLENNIAL ISSUE OF HER AWESOME MAG GIRL FRENZY – THEY LET ME TAKE A BATH & LEFT FOR THE NIGHT JUST TELLING ME TO LOCK THE DOOR BEHIND ME – WOW

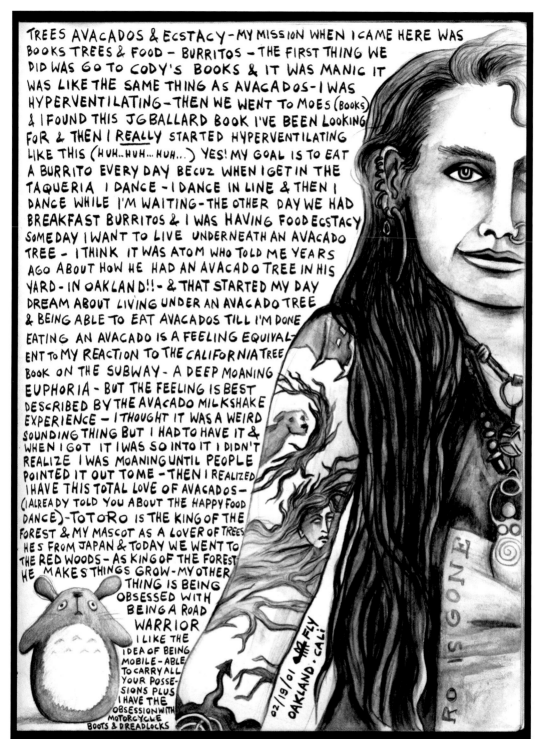

TREES AVACADOS & ECSTACY - MY MISSION WHEN I CAME HERE WAS BOOKS TREES & FOOD - BURRITOS - THE FIRST THING WE DID WAS GO TO CODY'S BOOKS & IT WAS MANIC IT WAS LIKE THE SAME THING AS AVACADOS - I WAS HYPERVENTILATING - THEN WE WENT TO MOES (BOOKS) & I FOUND THIS JG BALLARD BOOK I'VE BEEN LOOKING FOR & THEN I REALLY STARTED HYPERVENTILATING LIKE THIS (HUH...HUH...HUH...) YES! MY GOAL IS TO EAT A BURRITO EVERY DAY BECUZ WHEN I GET IN THE TAQUERIA I DANCE - I DANCE IN LINE & THEN I DANCE WHILE I'M WAITING - THE OTHER DAY WE HAD BREAKFAST BURRITOS & I WAS HAVING FOOD ECSTACY SOMEDAY I WANT TO LIVE UNDERNEATH AN AVACADO TREE - I THINK IT WAS ATOM WHO TOLD ME YEARS AGO ABOUT HOW HE HAD AN AVACADO TREE IN HIS YARD - IN OAKLAND!! - & THAT STARTED MY DAY DREAM ABOUT LIVING UNDER AN AVACADO TREE & BEING ABLE TO EAT AVACADOS TILL I'M DONE EATING AN AVACADO IS A FEELING EQUIVALENT TO MY REACTION TO THE CALIFORNIA TREE BOOK ON THE SUBWAY - A DEEP MOANING EUPHORIA - BUT THE FEELING IS BEST DESCRIBED BY THE AVACADO MILKSHAKE EXPERIENCE - I THOUGHT IT WAS A WEIRD SOUNDING THING BUT I HAD TO HAVE IT & WHEN I GOT IT I WAS SO INTO IT I DIDN'T REALIZE I WAS MOANING UNTIL PEOPLE POINTED IT OUT TO ME - THEN I REALIZED I HAVE THIS TOTAL LOVE OF AVACADOS - (I ALREADY TOLD YOU ABOUT THE HAPPY FOOD DANCE) - TOTORO IS THE KING OF THE FOREST & MY MASCOT AS A LOVER OF TREES HE'S FROM JAPAN & TODAY WE WENT TO THE RED WOODS - AS KING OF THE FOREST HE MAKES THINGS GROW - MY OTHER THING IS BEING OBSESSED WITH BEING A ROAD WARRIOR I LIKE THE IDEA OF BEING MOBILE - ABLE TO CARRY ALL YOUR POSSESIONS PLUS I HAVE THE OBSESSION WITH MOTORCYCLE BOOTS & DREADLOCKS

FLY
02/19/01 OAKLAND, CALI

RO IS GONE

CHRISTINE BOARTS-LARSON – 02/19/2K1 – OAKLAND
I DREW THIS IN OAKLAND ON MY BIRTHDAY – CHRIS WAS VISITING FROM VIRGINIA & STAYING WITH ROADIE-GIRL KAROLINE – WE HAD BEEN WALKING ALL DAY IN THE RAIN & TREES & WE HAD REALLY REALLY GOOD FOOD – CHRIS LOVES TREES MORE THAN ANYTHING & SHE GETS ALL ECSTATIC ABOUT THEM & ALL ECSTATIC ABOUT GOOD FOOD & THIS IS SOMETHING THAT HAPPENS TO ME TOO SO WE WERE TALKING ABOUT IT & WE WERE BOTH GETTING ALL GIDDY & DIZZY – OH – CHRIS DOES AN AWESOME PUNK ZINE CALLED SLUG & LETTUCE WHICH I DO A COMIC FOR CALLED ZERO CONTENT – YOU SHOULD SEND SOME $ & GET A COPY – CHRISTINE, PO BOX 26632, RICHMOND, VA 23261–6632 USA

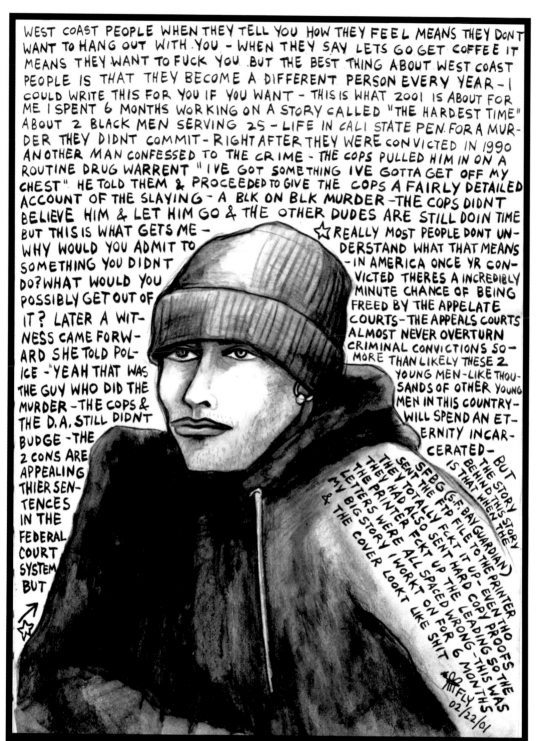

WEST COAST PEOPLE WHEN THEY TELL YOU HOW THEY FEEL MEANS THEY DONT WANT TO HANG OUT WITH YOU - WHEN THEY SAY LETS GO GET COFFEE IT MEANS THEY WANT TO FUCK YOU. BUT THE BEST THING ABOUT WEST COAST PEOPLE IS THAT THEY BECOME A DIFFERENT PERSON EVERY YEAR - I COULD WRITE THIS FOR YOU IF YOU WANT - THIS IS WHAT 2001 IS ABOUT FOR ME I SPENT 6 MONTHS WORKING ON A STORY CALLED "THE HARDEST TIME" ABOUT 2 BLACK MEN SERVING 25 - LIFE IN CALI STATE PEN. FOR A MURDER THEY DIDNT COMMIT - RIGHT AFTER THEY WERE CONVICTED IN 1990 ANOTHER MAN CONFESSED TO THE CRIME - THE COPS PULLED HIM IN ON A ROUTINE DRUG WARRENT "IVE GOT SOMETHING IVE GOTTA GET OFF MY CHEST" HE TOLD THEM & PROCEEDED TO GIVE THE COPS A FAIRLY DETAILED ACCOUNT OF THE SLAYING - A BLK ON BLK MURDER - THE COPS DIDNT BELIEVE HIM & LET HIM GO & THE OTHER DUDES ARE STILL DOIN TIME BUT THIS IS WHAT GETS ME - WHY WOULD YOU ADMIT TO SOMETHING YOU DIDNT DO? WHAT WOULD YOU POSSIBLY GET OUT OF IT? LATER A WITNESS CAME FORWARD SHE TOLD POLICE - "YEAH THAT WAS THE GUY WHO DID THE MURDER - THE COPS & THE D.A. STILL DIDNT BUDGE - THE 2 CONS ARE APPEALING THIER SENTENCES IN THE FEDERAL COURT SYSTEM BUT

☆ REALLY MOST PEOPLE DONT UNDERSTAND WHAT THAT MEANS - IN AMERICA ONCE YR CONVICTED THERES A INCREDIBLY MINUTE CHANCE OF BEING FREED BY THE APPELATE COURTS - THE APPEALS COURTS ALMOST NEVER OVERTURN CRIMINAL CONVICTIONS SO - MORE THAN LIKELY THESE 2 YOUNG MEN - LIKE THOUSANDS OF OTHER YOUNG MEN IN THIS COUNTRY - WILL SPEND AN ETERNITY INCARCERATED - BUT THE STORY BEHIND THIS STORY IS THAT WHEN THE SFBG (S.F. BAY GUARDIAN) SENT THE FTP FILE TO THE PRINTER THEY TOTALLY FCKT IT UP - EVEN THO THEY HAD ALSO SENT HARD COPY PROOFS SO THE PRINTER FCKT UP THE LEADING - THIS WAS THE LETTERS WERE ALL SPACED WRONG - MY BIG STORY I WORKT ON FOR 6 MONTHS & THE COVER LOOKT LIKE SHIT

FLY
02/22/01

A.C. THOMPSON - 02/22/2K1 - OAKLAND
ATOM IS A REALLY GREAT JOURNALIST - HE WRITES FOR THE SF BAY GUARDIAN & HE S PRETTY INVOLVED IN COVERING URBAN CULTURE & BUSTIN "THE MANS" ASS - FOR A WHILE HE WAS ALSO WORKING WITH YOUTH IN THE PRISON SYSTEM - OF COURSE THATS NOT ALL HE WRITES ABOUT - I FIRST MET ATOM ON THE STREET IN POITIER, FRANCE, WHEN HE WAS TOURING WITH AVAIL - LATER HE POSED FOR ONE OF MY MOST POPULAR DRAWINGS - (THE GUY WITH THE TV HEAD & THE CAPTION SAYS - IF YOU DONT HAVE A HOME YOU CAN ALWAYS LIVE IN YR MIND BUT DO YOU HAVE A MIND OF YR OWN?) - AC_THOMPSON@SFBG.COM

MY GRANDPARENTS CAME TO THE LOWER EAST SIDE IN 1910 APPROXIMATELY - ALL 4 OF THEM AROUND THAT TIME - MY GRANDMOTHER - WHO IS THE LAST LIVING GRAND PARENT & WHO IS ABOUT TO LEAVE HER BODY - SPENT ONE CHRISTMAS DAY ON THE BOTTOM OF A BOAT IN NEW YORK HARBOR BECUZ THERE WERE NO WORKERS AT ELLIS ISLAND TO STAMP HER IN - I STARTED SQUATTING BEFORE I KNEW WHAT SQUATTING WAS - SO NATURALLY ON ONE OF MY RETURNS TO NEW YORK MY FRIEND FLY THOUGHT I WOULD BE A NATURAL AT SQUATTING - I WAS GONNA GO BACK TO THE HILLBILLY LIFESTYLE I HAD DISCOVERED IN THE OZARK MOUNTAINS IN ARKANSAS BUT THEN I FOUND AN APARTMENT IN A SQUAT CALLED DOS BLOCOS SO BOOM I STAYED IN NEW YORK - NO ELECTRICITY - NO RUNNING WATER - IT WAS KIND OF RURAL - DOS BLOCOS WAS AN EXPERIMENT - A TRUE MICROCOSM OF THE FULL FLAVORED VARIETY OFFERED BY THE PLANET EARTH - DREGS & ANGELS - OH - DREGS - THAT REMINDS ME OF A STORY - BANG! BANG! BANG! BANG! "PASTRAMI WE NEED YOU!" - PRACTICALLY A DAILY OCCURRANCE AS SOMETHING ALWAYS SEEMED TO BE GOING WRONG IN DOS BLOCOS - "ITS UNCLE GUI - HE'S DEAD - ON THE 6th FLOOR LANDING & WE DONT KNOW WHAT TO DO!" SO I RUN UP TO THE 6th FLR & SURE ENOUGH HE'S NOT BREATHING & HE'S GOT NO PULSE - SO I PULLED A QUICK MANEUVER THAT I LEARNED WHEN TAKING THE NYC FIREMAN'S TEST & HOISTED HIS DEAD WEIGHT UP ONTO MY SHOULDER & CARRIED HIM DOWN THE 6 FLIGHTS OF STAIRS & THEN DOWN TO THE CORNER OF 9th & C - SOMEONE ELSE CALLED 911 & IN JUST A COUPLE OF MINUTES THE PARAMEDICS WERE THERE ALONG WITH THE USUAL 9th & C CROWD - THEY GAVE UNCLE GUI A SHOT OF SOMETHING - SOME KIND OF JOLT TO BRING OD'ed JUNKIES BACK FROM THE DEAD & SURE ENOUGH BY THE TIME THE AMBULANCE WAS PULLING AWAY DEAD UNCLE GUIERRMO WAS WAVING AT ME THRU THE BACK WINDOW OF THE AMBULANCE - TIME TO REMOVE THE OTHER JUNKIES SO WE DID - RIGHT THERE & THEN - IN THE PROCESS OF REMOVING THE PEOPLE & STARTING

07/19/2K1 ✸ FLY - PASTRAMI @ 209

TO PULL OUT THEIR TRASH I UNCOVERED A HEADLESS MOTHER PUPPY KILLED BY ITS PSYCHOTICALLY NEGLECTED MOTHER I WRAPT IT IN A SHEET & UNCLE GUI - I GOT DOWN ON ONE KNEE I HAD JUST TAKEN OUT THE TRASH PAIL - A FEW MONTHS LATER & PRAYED OVER THE TRASH PAIL - UP LOOKING SHEEPISH - UNCLE GUI SHOWED - YOU SAVED MY LIFE... HE SAID - "I HEAR THANKS."

PAH AKA PAHSTRAHMI AKA ANANDABAHAIRAVA AKA ALIBABANANAYAYAGAGA AKA MAHA PAH – 07/19/2K1 – LOISAIDA – NYC
PAH IS PROBABLY MY BEST FRIEND IN THE WORLD – HE HAS STUCK WITH ME THROUGH THE WORST OF MY INSANITY & ALWAYS MAKES ME LAUGH SO HARD I ALMOST PEE MY PANTS – HE HAS ALSO HELPED ME BUILD MY HOUSE – HE USED TO TAKE ME OVER TO P.S. 34 WHERE HE WOULD TUTOR KIDS & HE WOULD GET ME TO DO ART WITH THEM – ONE TIME WE DID THIS CRAZY MURAL PROJECT WITH A GRADE 5 CLASS – IT GOT TRULY OUT OF HAND & WAS AMAZING!! – WE ARE CURRENTLY WORKING ON A SITCOM & A BOOK

JACKIE ISNT HERE ANY MORE BUT SHE BROUGHT ME TO E 13th ST-THERE I MET ENGLISH STEVE & PAULA & DAVE & SCOTT & ELIZABETH & THEY WERE ALL WORKING ON THE HOUSE & I WAS PRETTY IMPRESSED - I WAS IN TRANSITION - COMIN FRM BROOKLYN LOOKIN FOR A PLACE TO BE - JACKIE THOUGHT I WOULD DO O.K. HELPING TO PUT THE SQUAT TOGETHER - THESE GUYS GAVE ME A BOOK CALLED "LIVING WITHOUT RENT" - IT WAS LIKE A SQUATTERS MANUAL & I REALIZED THAT THESE FOLKS WERE PRETTY ORGANIZED - I PUT IN ABOUT 6 WEEKS OF WORK DAYS & I EARNED MYSELF A PLACE - I TOOK A SPACE ON THE 2ND FLOOR - MOVED IN WITH MY GIRL & WHEN IT RAINED THE RAIN CAME DOWN PAST THE BED - I WAS IN 537 HOUSE - I STAYED THERE ALMOST 8 YRS - IT WAS A MAIN SPOT WITH A KITCHEN FOR FOOD NOT BOMBS - SQUATTER MEETINGS - MUSIC - THEATRE - ENDLESS SQUAT OR ROT PARTIES - IN THE LAST DAYS OF THOSE BUILDINGS ON 13th ST. I WAS ONE OF THE LONGEST STANDING RESIDENTS - IN THE LAST DAYS - WINTER OF '94 - 95 THE CITY HAD CUT OUR ELECTRICITY & OUR PIPES WERE FROZEN - THERE WAS A 24 HR GUARD HOUSE - POLICE ACROSS THE STREET - PROTECTED BY THE 2-FACED SQUAT - THE - WHAT CAN I SAY? - CALL THEM THE WUSSY SQUAT - AFTER A YEAR OF SURVEILLANCE & HARRASMENT THE RIOT COPS CAME EN FORCE IN THE MIDDLE OF THE NIGHT IN THE POURING RAIN - I WAS THE LAST ONE TO LEAVE THE BUILDING - I WAS POSITIVE THEY WOULD NEVER COME IN THE RAIN STORM I WAS ABLE TO THROW WHAT I HAD INTO THE BACK OF A VAN & START ALL OVER AGAIN BLOWN IN THE BREEZE TO 209 - I WAS WHAT YOU WOULD CALL COUCH SURF- ING HOMELESS - BUT LIKE ITS BEEN SAID ITS ALL GOOD - I FINALLY CAUGHT UP WITH MYSELF AT 209 WITH A NEW SPACE - ANOTHER SQUAT IN THE L.E.S. MY SON CAME BACK TO LIVE WITH ME TO FINISH HIS HIGH SCHOOL YRS - COMING FROM BROOKLYN - HE ROCKED THE PIRATE RADIO PRO- GRAM FOR A FEW MONTHS - I'M THROWIN OFF MY CREATIVE THINGS - CREATING THIS DJUKE MUSIC THING - THATS A NAME I'M CALLING THIS STYLE DONT EXPLAIN IT - & MY ONOCULII DESIGN- EYE GEAR - WORKING REALLY HARD AT TRY- ING TO KEEP THINGS PUSHED AHEAD - SOMETIMES I THINK ABOUT THINGS & I WONDER - HMMMMM - WELL IF I HAD AN ANSWER FOR THAT YOU'D BE THE FIRST TO KNOW ABOUT IT - LIKE I SAID ITS ALMOST A MIRACLE TO BE LOVED & UNDERSTOOD - & FOR ALL YOU FOLKS AT HOME - JUST REMEMBER ☆→

PIMPIN AINT EASY THAT - HOLD ON - I HOPE I BORROUT WELL - MIND IF I BORROUT HIS LINES - I DAM SURE MAKES A LOT OF SENSE - OK FLY - NOV. 2K1 ☀ MY NEIGHBOR - ON - THATS IT!

ON DAVIS – NOV. 2K1 – LOISAIDA – NYC
ON IS COOL – HE'S MY NEIGHBOR NOW BUT HE USED TO LIVE IN A SQUAT OVER ON E. 13th STREET – THOSE BUILDINGS GOT EVICTED BACK IN 1995 DURING A CRAZY NIGHT OF POUR- ING RAIN – IT WAS A REALLY SAD THING – LATER THOSE BUILDINGS WERE MOMENTARILY RETAKEN IN A SPECTACULAR 4TH OF JULY ACTION – I THINK THAT WAS THE LAST TIME I GOT CHASED DOWN AVE. A BY A GANG OF RIOT COPS – ON IS A GREAT NEIGHBOR – HE IS JUST CHILL ABOUT EVERYTHING – HE'S ALSO A GREAT MUSICIAN & HE MAKES VERY EXQUI- SITE DESIGNER EYE WEAR – I'M STILL TRYING TO GET MYSELF SOME OF THAT!

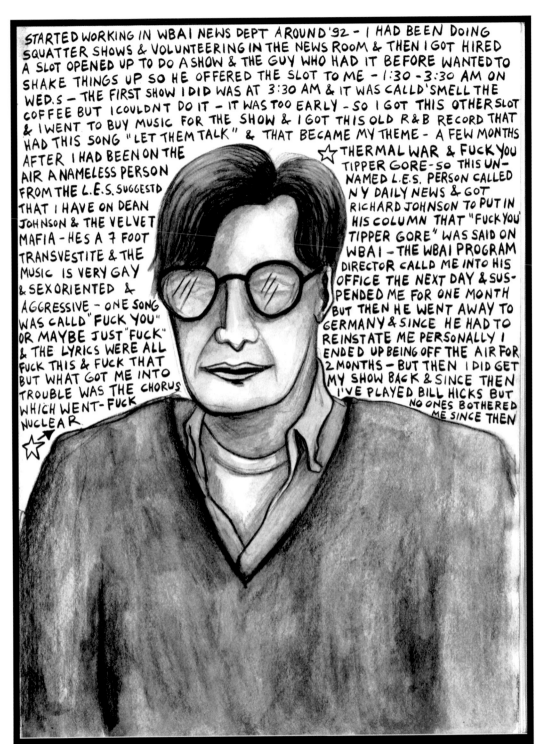

STARTED WORKING IN WBAI NEWS DEPT AROUND '92 - I HAD BEEN DOING SQUATTER SHOWS & VOLUNTEERING IN THE NEWS ROOM & THEN I GOT HIRED A SLOT OPENED UP TO DO A SHOW & THE GUY WHO HAD IT BEFORE WANTED TO SHAKE THINGS UP SO HE OFFERED THE SLOT TO ME - 1:30 - 3:30 AM ON WED.S - THE FIRST SHOW I DID WAS AT 3:30 AM & IT WAS CALLD 'SMELL THE COFFEE BUT I COULDNT DO IT - IT WAS TOO EARLY - SO I GOT THIS OTHER SLOT & I WENT TO BUY MUSIC FOR THE SHOW & I GOT THIS OLD R&B RECORD THAT HAD THIS SONG "LET THEM TALK" & THAT BECAME MY THEME - A FEW MONTHS AFTER I HAD BEEN ON THE AIR A NAMELESS PERSON FROM THE L.E.S. SUGGESTD THAT I HAVE ON DEAN JOHNSON & THE VELVET MAFIA - HES A 7 FOOT TRANSVESTITE & THE MUSIC IS VERY GAY & SEX ORIENTED & AGGRESSIVE - ONE SONG WAS CALLD "FUCK YOU" OR MAYBE JUST "FUCK" & THE LYRICS WERE ALL FUCK THIS & FUCK THAT BUT WHAT GOT ME INTO TROUBLE WAS THE CHORUS WHICH WENT - FUCK NUCLEAR

THERMAL WAR & FUCK YOU TIPPER GORE - SO THIS UN-NAMED L.E.S. PERSON CALLED NY DAILY NEWS & GOT RICHARD JOHNSON TO PUT IN HIS COLUMN THAT "FUCK YOU TIPPER GORE" WAS SAID ON WBAI - THE WBAI PROGRAM DIRECTOR CALLD ME INTO HIS OFFICE THE NEXT DAY & SUS-PENDED ME FOR ONE MONTH BUT THEN HE WENT AWAY TO GERMANY & SINCE HE HAD TO REINSTATE ME PERSONALLY I ENDED UP BEING OFF THE AIR FOR 2 MONTHS - BUT THEN I DID GET MY SHOW BACK & SINCE THEN I'VE PLAYED BILL HICKS BUT NO ONES BOTHERED ME SINCE THEN

PAUL DeRIENZO – NEW YEARS DAY 2K1 – NYC
I FIRST MET PAUL IN TOMPKINS SQUARE PARK I THINK IN 1992 OR 1993 & HE WAS STILL SUSPENDED FROM HIS SHOW AT WBAI BUT HE SAID AS SOON AS HE COULD GO BACK ON THE AIR THAT HE WANTED ME TO COME ON THE SHOW – FINALLY I MADE IT DOWN TO THE STATION WITH MY POET PAL TERRI PAIN FRM SF – WE GOT A STRONG RESPONSE FROM LISTENERS – ONE GUY CALLED IN & SAID HE WOULD MEET US OUTSIDE WITH A GUN – PAUL THOUGHT IT WENT SO WELL THAT HE ASKED ME TO BE HIS CO-HOST & I DID THAT FOR A COUPLE FUN YEARS – THANKS PAUL!!!! – PDR.AUTONO.NET – NWO.MEDIA.XS2.NET

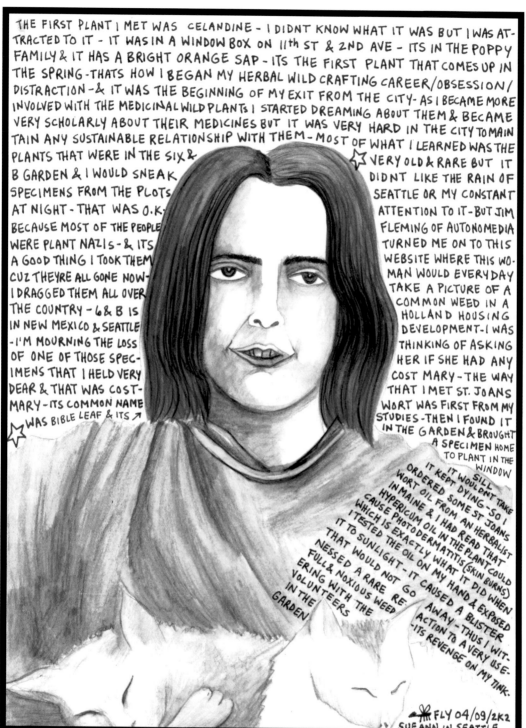

THE FIRST PLANT I MET WAS CELANDINE - I DIDNT KNOW WHAT IT WAS BUT I WAS ATTRACTED TO IT - IT WAS IN A WINDOW BOX ON 11th ST & 2ND AVE - ITS IN THE POPPY FAMILY & IT HAS A BRIGHT ORANGE SAP - ITS THE FIRST PLANT THAT COMES UP IN THE SPRING - THATS HOW I BEGAN MY HERBAL WILD CRAFTING CAREER/OBSESSION/DISTRACTION - & IT WAS THE BEGINNING OF MY EXIT FROM THE CITY - AS I BECAME MORE INVOLVED WITH THE MEDICINAL WILD PLANTS I STARTED DREAMING ABOUT THEM & BECAME VERY SCHOLARLY ABOUT THEIR MEDICINES BUT IT WAS VERY HARD IN THE CITY TO MAINTAIN ANY SUSTAINABLE RELATIONSHIP WITH THEM - MOST OF WHAT I LEARNED WAS THE PLANTS THAT WERE IN THE SIX &

B GARDEN & I WOULD SNEAK SPECIMENS FROM THE PLOTS AT NIGHT - THAT WAS O.K. BECAUSE MOST OF THE PEOPLE WERE PLANT NAZIS - & ITS A GOOD THING I TOOK THEM CUZ THEYRE ALL GONE NOW - I DRAGGED THEM ALL OVER THE COUNTRY - 6 & B IS IN NEW MEXICO & SEATTLE - I'M MOURNING THE LOSS OF ONE OF THOSE SPECIMENS THAT I HELD VERY DEAR & THAT WAS COSTMARY - ITS COMMON NAME WAS BIBLE LEAF & ITS →

VERY OLD & RARE BUT IT DIDNT LIKE THE RAIN OF SEATTLE OR MY CONSTANT ATTENTION TO IT - BUT JIM FLEMING OF AUTONOMEDIA TURNED ME ON TO THIS WEBSITE WHERE THIS WOMAN WOULD EVERY DAY TAKE A PICTURE OF A COMMON WEED IN A HOLLAND HOUSING DEVELOPMENT - I WAS THINKING OF ASKING HER IF SHE HAD ANY COSTMARY - THE WAY THAT I MET ST. JOANS WORT WAS FIRST FROM MY STUDIES - THEN I FOUND IT IN THE GARDEN & BROUGHT A SPECIMEN HOME TO PLANT IN THE WINDOW SILL IT WOULDNT TAKE

IT KEPT DYING - SO I ORDERED SOME ST JOANS WORT OIL FROM AN HERBALIST IN MAINE & I HAD READ THAT HYPERICUM OIL IN THE PLANT COULD CAUSE PHOTODERMATITIS (SKIN BURNS) WHICH IS EXACTLY WHAT IT DID WHEN I TESTED THE OIL ON MY HAND & EXPOSED IT TO SUNLIGHT - IT CAUSED A BLISTER THAT WOULD NOT GO AWAY - THUS I WITNESSED A RARE REACTION TO A VERY USEFULL & NOXIOUS WEED - ITS REVENGE ON MY TINKERING WITH THE VOLUNTEERS IN THE GARDEN

FLY 04/09/2K2 SUE ANN IN SEATTLE...

SUE ANN HARKEY - 04/09/2K2 - SEATTLE
I MET SUE ANN IN 1990 IN NYC - SHE WAS A GOOD FRIEND OF THE GARGOYLES (OF THE GARGOYLE MECHANIQUE LAB) - SHE WAS DOING COMPUTER GRAPHICS & DESIGN - SHE WAS ALSO MAKING BEAUTIFUL MUSIC & SOMETIMES DID SHOWS AT THE GARGOYLE - SHE LET ME STAY AT HER HOUSE ON E. 7TH ST. (RIGHT ACROSS FRM THE SQUAT I ENDED UP LIVING IN THE FOLLOWING YEAR & I M STILL HERE!) WITH HER CAT TIMMY TOM WHILE SHE WENT ON TOUR IN EUROPE - THEN SHE MOVED TO NEW MEXICO & THEN SEATTLE WHERE SHE BOUGHT A SWEET LITTLE HOUSE - I GOT TO STAY THERE WITH HER & HER CATS - WE WATCHED MOVIES & DRANK RED WINE - WWW.CACTUSBONES.COM

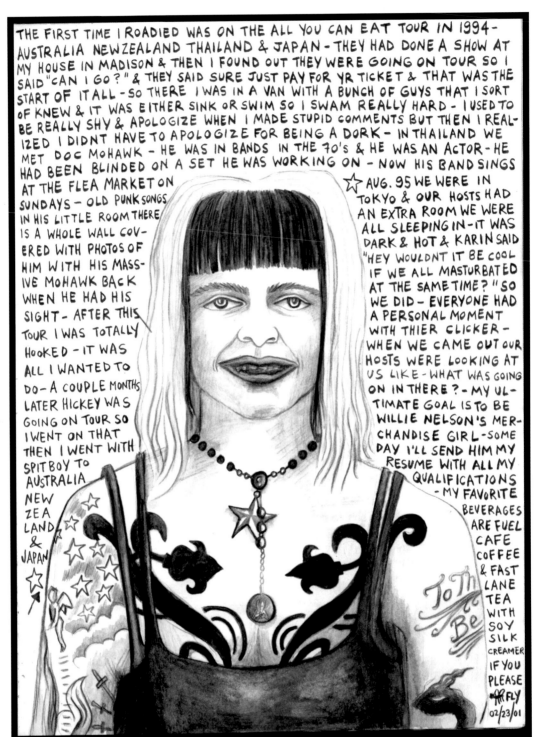

THE FIRST TIME I ROADIED WAS ON THE ALL YOU CAN EAT TOUR IN 1994 - AUSTRALIA NEWZEALAND THAILAND & JAPAN - THEY HAD DONE A SHOW AT MY HOUSE IN MADISON & THEN I FOUND OUT THEY WERE GOING ON TOUR SO I SAID "CAN I GO?" & THEY SAID SURE JUST PAY FOR YR TICKET & THAT WAS THE START OF IT ALL - SO THERE I WAS IN A VAN WITH A BUNCH OF GUYS THAT I SORT OF KNEW & IT WAS EITHER SINK OR SWIM SO I SWAM REALLY HARD - I USED TO BE REALLY SHY & APOLOGIZE WHEN I MADE STUPID COMMENTS BUT THEN I REAL- IZED I DIDNT HAVE TO APOLOGIZE FOR BEING A DORK - IN THAILAND WE MET DOC MOHAWK - HE WAS IN BANDS IN THE 70's & HE WAS AN ACTOR - HE HAD BEEN BLINDED ON A SET HE WAS WORKING ON - NOW HIS BAND SINGS

AT THE FLEA MARKET ON SUNDAYS - OLD PUNK SONGS IN HIS LITTLE ROOM THERE IS A WHOLE WALL COV- ERED WITH PHOTOS OF HIM WITH HIS MASS- IVE MOHAWK BACK WHEN HE HAD HIS SIGHT - AFTER THIS TOUR I WAS TOTALLY HOOKED - IT WAS ALL I WANTED TO DO - A COUPLE MONTHS LATER HICKEY WAS GOING ON TOUR SO I WENT ON THAT THEN I WENT WITH SPITBOY TO AUSTRALIA NEW ZEA LAND & JAPAN

☆ AUG. 95 WE WERE IN TOKYO & OUR HOSTS HAD AN EXTRA ROOM WE WERE ALL SLEEPING IN - IT WAS DARK & HOT & KARIN SAID "HEY WOULDNT IT BE COOL IF WE ALL MASTURBATED AT THE SAME TIME?" SO WE DID - EVERYONE HAD A PERSONAL MOMENT WITH THIER CLICKER - WHEN WE CAME OUT OUR HOSTS WERE LOOKING AT US LIKE - WHAT WAS GOING ON IN THERE? - MY UL- TIMATE GOAL IS TO BE WILLIE NELSON'S MER- CHANDISE GIRL - SOME DAY I'LL SEND HIM MY RESUME WITH ALL MY QUALIFICATIONS - MY FAVORITE BEVERAGES ARE FUEL CAFE COFFEE & FAST LANE TEA WITH SOY SILK CREAMER IF YOU PLEASE ☆FLY 02/23/01

To Th Be

KAROLINE COLLINS – 02/23/2K1 – OAKLAND
I FIRST MET KAROLINE WHEN SHE WAS ROADIEGIRLING FOR CITIZEN FISH – I WAS ALL CRUSTY & SQUATTER AT THAT POINT & LATER KAROLINE TOLD ME SHE HAD BEEN VERY IMPRESSED BY MY CRUSTY SHORTS THAT WERE DISINTEGRATING DUE TO HEAVY MASONRY & OTHER CONSTRUCTION WORK IN MY BUILDING & WERE SUBSEQUENTLY HELD TOGETHER BY PATCHES – KAROLINE IS AWESOME & EVERY TIME I SEE HER SHE SPOILS ME ROTTEN BY FEEDING ME YUMMY THINGS & LETTING ME WATCH JERRY SPRINGER ON HER TV
ROADIEGIRL@HOTMAIL.COM

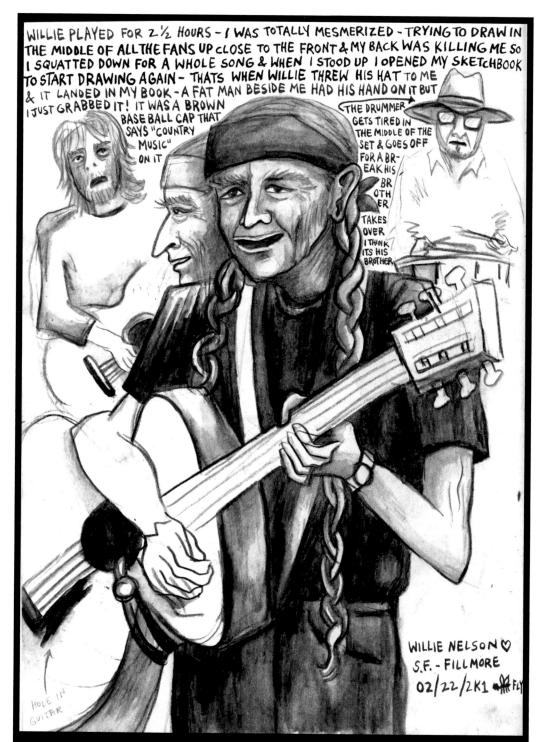

WILLIE PLAYED FOR 2½ HOURS - I WAS TOTALLY MESMERIZED - TRYING TO DRAW IN THE MIDDLE OF ALL THE FANS UP CLOSE TO THE FRONT & MY BACK WAS KILLING ME SO I SQUATTED DOWN FOR A WHOLE SONG & WHEN I STOOD UP I OPENED MY SKETCHBOOK TO START DRAWING AGAIN - THATS WHEN WILLIE THREW HIS HAT TO ME & IT LANDED IN MY BOOK - A FAT MAN BESIDE ME HAD HIS HAND ON IT BUT I JUST GRABBED IT! IT WAS A BROWN BASEBALL CAP THAT SAYS "COUNTRY MUSIC" ON IT

THE DRUMMER GETS TIRED IN THE MIDDLE OF THE SET & GOES OFF FOR A BR- EAK HIS BR OTH ER TAKES OVER I THINK ITS HIS BROTHER

WILLIE NELSON ♥ S.F. - FILLMORE 02/22/2K1

HOLE IN GUITAR

WILLIE NELSON – 02/22/2K1 – AT THE FILLMORE – SF
THIS WAS THE FIRST TIME I HAVE EVER SEEN WILLIE NELSON PERFORM & IT TOTALLY BLEW ME AWAY – HE WAS AMAZING! – HE SANG FOR LIKE 3 HOURS STRAIGHT WITHOUT A BREAK & BARELY EVEN TOOK A DRINK OF WATER – MEANWHILE THE REST OF THE BAND WERE TAKING SHIFTS – WILLIE KEPT THROWING STUFF OUT INTO THE AUDIENCE – I WAS PRETTY CLOSE TO THE FRONT BUT NOT RIGHT AT THE FRONT – I HAD MY NOSE DOWN IN MY SKETCHBOOK DRAWING & THE NEXT THING I KNOW THERE IS THIS HAT THAT LANDS IN MY SKETCHBOOK!!! THE BIG FAT GUY NEXT TO ME TRIED TO GRAB IT BUT I MANAGED TO HANG ON – A BASEBALL HAT FROM WILLY THAT SAID "COUNTRY MUSIC" ON IT!!

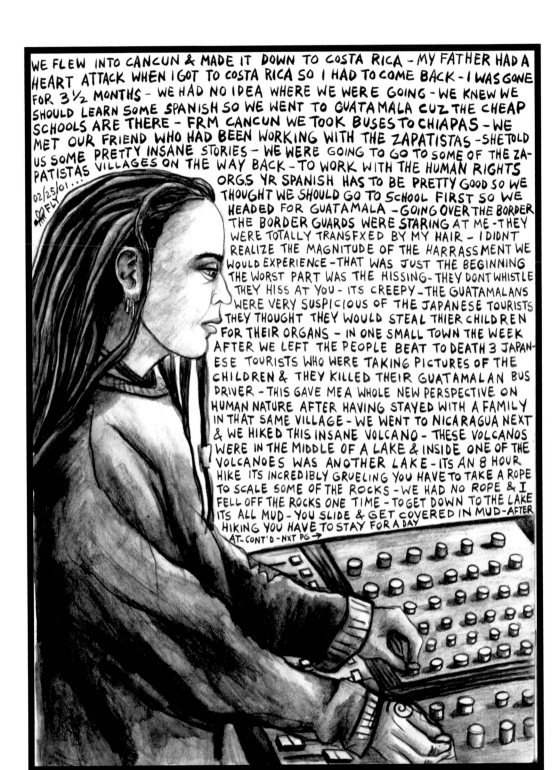

WE FLEW INTO CANCUN & MADE IT DOWN TO COSTA RICA - MY FATHER HAD A HEART ATTACK WHEN I GOT TO COSTA RICA SO I HAD TO COME BACK - I WAS GONE FOR 3½ MONTHS - WE HAD NO IDEA WHERE WE WERE GOING - WE KNEW WE SHOULD LEARN SOME SPANISH SO WE WENT TO GUATAMALA CUZ THE CHEAP SCHOOLS ARE THERE - FRM CANCUN WE TOOK BUSES TO CHIAPAS - WE MET OUR FRIEND WHO HAD BEEN WORKING WITH THE ZAPATISTAS - SHE TOLD US SOME PRETTY INSANE STORIES - WE WERE GOING TO GO TO SOME OF THE ZA-PATISTAS VILLAGES ON THE WAY BACK - TO WORK WITH THE HUMAN RIGHTS ORGS YR SPANISH HAS TO BE PRETTY GOOD SO WE THOUGHT WE SHOULD GO TO SCHOOL FIRST SO WE HEADED FOR GUATAMALA - GOING OVER THE BORDER THE BORDER GUARDS WERE STARING AT ME - THEY WERE TOTALLY TRANSFXED BY MY HAIR - I DIDNT REALIZE THE MAGNITUDE OF THE HARRASSMENT WE WOULD EXPERIENCE - THAT WAS JUST THE BEGINNING THE WORST PART WAS THE HISSING - THEY DONT WHISTLE THEY HISS AT YOU - ITS CREEPY - THE GUATAMALANS WERE VERY SUSPICIOUS OF THE JAPANESE TOURISTS THEY THOUGHT THEY WOULD STEAL THIER CHILDREN FOR THEIR ORGANS - IN ONE SMALL TOWN THE WEEK AFTER WE LEFT THE PEOPLE BEAT TO DEATH 3 JAPAN-ESE TOURISTS WHO WERE TAKING PICTURES OF THE CHILDREN & THEY KILLED THEIR GUATAMALAN BUS DRIVER - THIS GAVE ME A WHOLE NEW PERSPECTIVE ON HUMAN NATURE AFTER HAVING STAYED WITH A FAMILY IN THAT SAME VILLAGE - WE WENT TO NICARAGUA NEXT & WE HIKED THIS INSANE VOLCANO - THESE VOLCANOS WERE IN THE MIDDLE OF A LAKE & INSIDE ONE OF THE VOLCANOES WAS ANOTHER LAKE - ITS AN 8 HOUR HIKE ITS INCREDIBLY GRUELING YOU HAVE TO TAKE A ROPE TO SCALE SOME OF THE ROCKS - WE HAD NO ROPE & I FELL OFF THE ROCKS ONE TIME - TO GET DOWN TO THE LAKE ITS ALL MUD - YOU SLIDE & GET COVERED IN MUD - AFTER HIKING YOU HAVE TO STAY FOR A DAY
AT - CONT'D - NXT PG →

02/25/01...
FLY

PAIGE - 02/25/2K1 - AT THE COVERED WAGON SALOON - SF
I MET PAIGE WHILE I WAS TOURING WITH AUS ROTTEN ON THE PRIMATE FREEDOM TOUR & SHE WAS DOING SOUND - IT WAS SORT OF A ROUGH TOUR BUT WE HAD SUCH A BLAST - PAIGE IS ONE OF THOSE PEOPLE WHO CAN DO ANYTHING THEY WANT TO DO AFTER A LITTLE BIT OF FIGURING IT OUT - SHE CAN ALSO PLAY CLASSICAL FLUTE!! - WE STAYED AT HER HOUSE IN OAKLAND WHICH WAS THIS CRAZY HOUSE - I THINK IT WAS #666 - CANT REMEMBER THE STREET - THE NIGHT I DREW THIS I HADNT SEEN PAIGE IN A REALLY LONG TIME & THIS WAS THE ONLY NIGHT WE COULD GET TOGETHER - SHE WAS DOING SOUND FOR

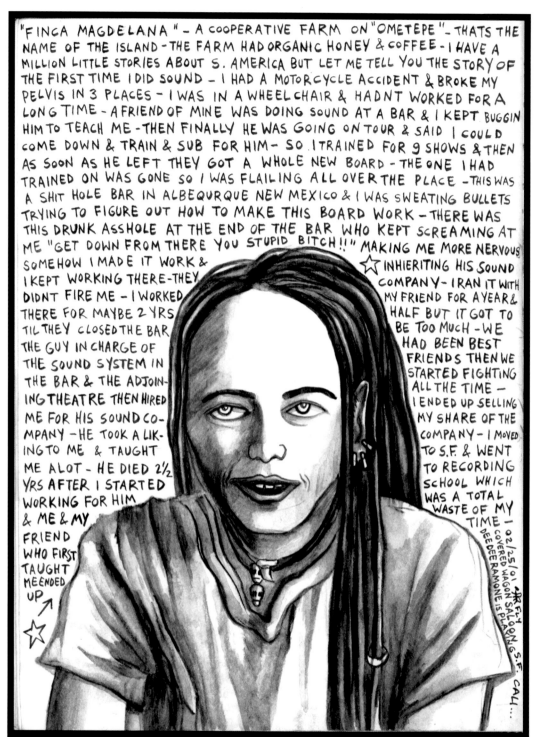

"FINCA MAGDELANA" – A COOPERATIVE FARM ON "OMETEPE" – THATS THE NAME OF THE ISLAND – THE FARM HAD ORGANIC HONEY & COFFEE – I HAVE A MILLION LITTLE STORIES ABOUT S. AMERICA BUT LET ME TELL YOU THE STORY OF THE FIRST TIME I DID SOUND – I HAD A MOTORCYCLE ACCIDENT & BROKE MY PELVIS IN 3 PLACES – I WAS IN A WHEELCHAIR & HADNT WORKED FOR A LONG TIME – A FRIEND OF MINE WAS DOING SOUND AT A BAR & I KEPT BUGGIN HIM TO TEACH ME – THEN FINALLY HE WAS GOING ON TOUR & SAID I COULD COME DOWN & TRAIN & SUB FOR HIM – SO I TRAINED FOR 9 SHOWS & THEN AS SOON AS HE LEFT THEY GOT A WHOLE NEW BOARD – THE ONE I HAD TRAINED ON WAS GONE SO I WAS FLAILING ALL OVER THE PLACE – THIS WAS A SHIT HOLE BAR IN ALBEQURQUE NEW MEXICO & I WAS SWEATING BULLETS TRYING TO FIGURE OUT HOW TO MAKE THIS BOARD WORK – THERE WAS THIS DRUNK ASSHOLE AT THE END OF THE BAR WHO KEPT SCREAMING AT ME "GET DOWN FROM THERE YOU STUPID BITCH!!" MAKING ME MORE NERVOUS

SOMEHOW I MADE IT WORK & I KEPT WORKING THERE – THEY DIDNT FIRE ME – I WORKED THERE FOR MAYBE 2 YRS TIL THEY CLOSED THE BAR THE GUY IN CHARGE OF THE SOUND SYSTEM IN THE BAR & THE ADJOIN-ING THEATRE THEN HIRED ME FOR HIS SOUND CO-MPANY – HE TOOK A LIK-ING TO ME & TAUGHT ME ALOT – HE DIED 2½ YRS AFTER I STARTED WORKING FOR HIM & ME & MY FRIEND WHO FIRST TAUGHT ME ENDED UP ↗ ☆

☆ INHIERITING HIS SOUND COMPANY – I RAN IT WITH MY FRIEND FOR A YEAR & HALF BUT IT GOT TO BE TOO MUCH – WE HAD BEEN BEST FRIENDS THEN WE STARTED FIGHTING ALL THE TIME – I ENDED UP SELLING MY SHARE OF THE COMPANY – I MOVED TO S.F. & WENT TO RECORDING SCHOOL WHICH WAS A TOTAL WASTE OF MY TIME

1 02/25/01 FLY COVERED WAGON SALOON'S.F. CALI DEE DEE RAMONE IS PLAYING S.F. CALI...

DEEDEE RAMONE S BAND – WE HAD TO BE THERE FOR SOUND CHECK & I THOUGHT – COOL! I WILL GET TO MEET DEEDEE RAMONE – BUT HE DIDNT SHOW UP FOR SOUNDCHECK – BY THE TIME THE SHOW HAPPENED THE PLACE WAS TOTALLY PACKED & DEEDEE HAD SNUCK IN – PAIGE WAS IN A FOUL MOOD CUZ SHE WAS SICK – BUT IT WAS STILL REALLY FUN TO HANG OUT WITH HER & I WAS BARELY PAYING ATTENTION TO DEEDEE & HIS BAND – IT WAS A FUN SHOW BUT FELT KIND OF SAD TO ME CUZ I TEND TO ROMANTICIZE THE RAMONES – AFTER THE SHOW THERE WAS A BIG LONG LINE OUTSIDE THE BACKSTAGE DOOR – I ASKED ONE OF THE GIRLS "HEY – IS THIS THE LINE TO GIVE DEEDEE A BLOW JOB?"

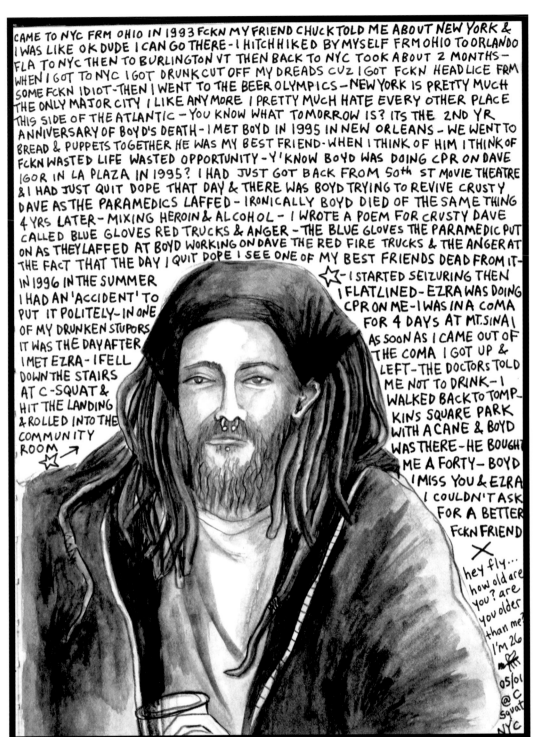

CAME TO NYC FRM OHIO IN 1993 FCKN MY FRIEND CHUCK TOLD ME ABOUT NEW YORK & I WAS LIKE OK DUDE I CAN GO THERE - I HITCHHIKED BY MYSELF FRM OHIO TO ORLANDO FLA TO NYC THEN TO BURLINGTON VT THEN BACK TO NYC TOOK ABOUT 2 MONTHS - WHEN I GOT TO NYC I GOT DRUNK CUT OFF MY DREADS CUZ I GOT FCKN HEAD LICE FRM SOME FCKN IDIOT - THEN I WENT TO THE BEER OLYMPICS - NEW YORK IS PRETTY MUCH THE ONLY MAJOR CITY I LIKE ANYMORE I PRETTY MUCH HATE EVERY OTHER PLACE THIS SIDE OF THE ATLANTIC - YOU KNOW WHAT TOMORROW IS? ITS THE 2ND YR ANNIVERSARY OF BOYD'S DEATH - I MET BOYD IN 1995 IN NEW ORLEANS - WE WENT TO BREAD & PUPPETS TOGETHER HE WAS MY BEST FRIEND - WHEN I THINK OF HIM I THINK OF FCKN WASTED LIFE WASTED OPPORTUNITY - Y'KNOW BOYD WAS DOING CPR ON DAVE IGOR IN LA PLAZA IN 1995? I HAD JUST GOT BACK FROM 50th ST MOVIE THEATRE & I HAD JUST QUIT DOPE THAT DAY & THERE WAS BOYD TRYING TO REVIVE CRUSTY DAVE AS THE PARAMEDICS LAFFED - IRONICALLY BOYD DIED OF THE SAME THING 4 YRS LATER - MIXING HEROIN & ALCOHOL - I WROTE A POEM FOR CRUSTY DAVE CALLED BLUE GLOVES RED TRUCKS & ANGER - THE BLUE GLOVES THE PARAMEDIC PUT ON AS THEY LAFFED AT BOYD WORKING ON DAVE THE RED FIRE TRUCKS & THE ANGER AT THE FACT THAT THE DAY I QUIT DOPE I SEE ONE OF MY BEST FRIENDS DEAD FROM IT -

IN 1996 IN THE SUMMER I HAD AN 'ACCIDENT' TO PUT IT POLITELY - IN ONE OF MY DRUNKEN STUPORS IT WAS THE DAY AFTER I MET EZRA - I FELL DOWN THE STAIRS AT C-SQUAT & HIT THE LANDING & ROLLED INTO THE COMMUNITY ROOM →

☆ - I STARTED SEIZURING THEN I FLATLINED - EZRA WAS DOING CPR ON ME - I WAS IN A COMA FOR 4 DAYS AT MT. SINAI AS SOON AS I CAME OUT OF THE COMA I GOT UP & LEFT - THE DOCTORS TOLD ME NOT TO DRINK - I WALKED BACK TO TOMP- KINS SQUARE PARK WITH A CANE & BOYD WAS THERE - HE BOUGHT ME A FORTY - BOYD I MISS YOU & EZRA I COULDN'T ASK FOR A BETTER FCKN FRIEND
X
hey fly... how old are you? are you older than me? I'M 26
05/01 @ C Squat NYC

CHRIS AT C SQUAT – 05/01/2K1 – LOISAIDA – NYC
I FIRST SAW CHRIS WHEN HE CAME TO TOWN & HE WAS HANGIN OUT IN TOMPKINS SQUARE PARK GETTIN DRUNK WITH THE PUNKS – HE TOLD ME ABOUT BEING A SKATER & THAT USED TO BE HIS LIFE BUT NOT ANYMORE – CHRIS WAS REALLY GOOD FRIENDS WITH A GUY CALLED BOYD & IT WAS REALLY SAD WHEN HE DIED – I JUST SAW CHRIS THE OTHER DAY & HE LOOKED GREAT – HE TOLD ME HE HAD MOVED OUT OF C SQUAT & WAS NOW RENTING A CHEAP PLACE IN BROOKLYN WITH HIS GIRLFRIEND – HE LOOKED REALLY CALM & CLEAR & HEALTHY – BETTER THAN HE EVER SEEMED TO BE AT C SQUAT

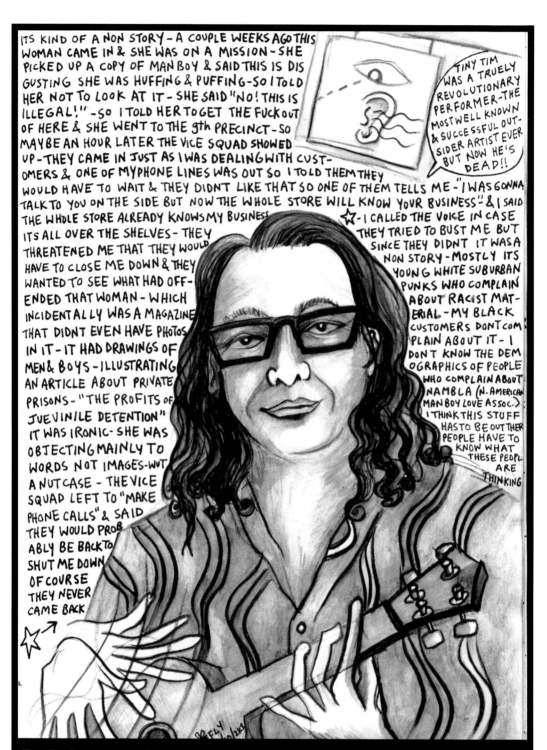

TED R. GOTTFRIED – 07/10/2K1 – SEE HEAR FANZINES MAGAZINES & BOOKS – NYC
SEE HEAR IS A FUNKY LITTLE ZINE STORE ON E. 7TH ST. A FEW BLOCKS WEST OF TOMPKINS
SQUARE PARK – YOU HAVE TO WALK DOWN SOME STEEP STAIRS & ITS A TINY PLACE BUT ITS
GOT SOME OF THE BEST UNDERGROUND MUSIC MAGS & COMICS IN THE CIVILIZED WORLD –
TED IS THE PROPRIETOR & A CONOISSEUR OF FUCKSHITUP PUBLICATIONS – I DREW THIS POR-
TRAIT ON THE STOOP JUST UP THE STAIRS FROM THE SHOP ON A SULTRY LATE SUMMER AFTER-
NOON AS IT WAS THREATENING TO STORM – TED WAS STRUMMING THE UKE & RUNNING UP &
DOWN THE STAIRS FOR CUSTOMERS – WWW.ZINEMART.COM – SONICUKE.COM

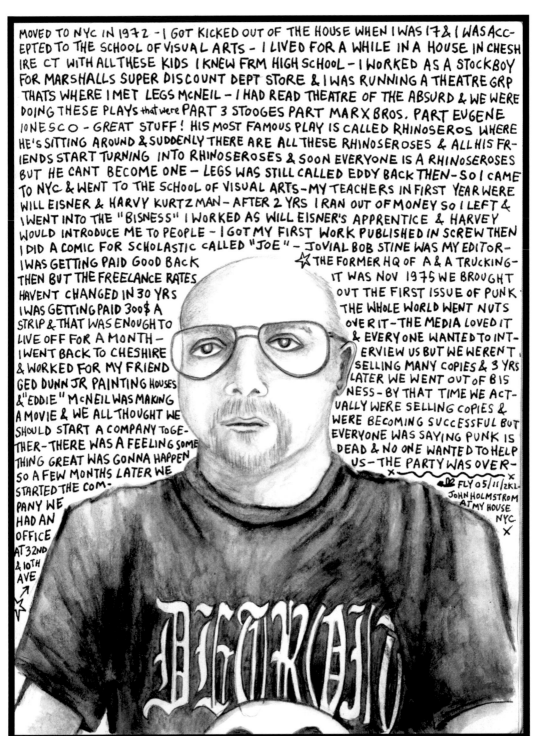

MOVED TO NYC IN 1972 - I GOT KICKED OUT OF THE HOUSE WHEN I WAS 17 & I WAS ACCEPTED TO THE SCHOOL OF VISUAL ARTS - I LIVED FOR A WHILE IN A HOUSE IN CHESHIRE CT WITH ALL THESE KIDS I KNEW FRM HIGH SCHOOL - I WORKED AS A STOCKBOY FOR MARSHALLS SUPER DISCOUNT DEPT STORE & I WAS RUNNING A THEATRE GRP THATS WHERE I MET LEGS McNEIL - I HAD READ THEATRE OF THE ABSURD & WE WERE DOING THESE PLAYS that were PART 3 STOOGES PART MARX BROS. PART EUGENE IONESCO - GREAT STUFF! HIS MOST FAMOUS PLAY IS CALLED RHINOSEROS WHERE HE'S SITTING AROUND & SUDDENLY THERE ARE ALL THESE RHINOSEROSES & ALL HIS FRIENDS START TURNING INTO RHINOSEROSES & SOON EVERYONE IS A RHINOSEROSES BUT HE CANT BECOME ONE - LEGS WAS STILL CALLED EDDY BACK THEN - SO I CAME TO NYC & WENT TO THE SCHOOL OF VISUAL ARTS - MY TEACHERS IN FIRST YEAR WERE WILL EISNER & HARVY KURTZMAN - AFTER 2 YRS I RAN OUT OF MONEY SO I LEFT & I WENT INTO THE "BISNESS" I WORKED AS WILL EISNER'S APPRENTICE & HARVEY WOULD INTRODUCE ME TO PEOPLE - I GOT MY FIRST WORK PUBLISHED IN SCREW THEN I DID A COMIC FOR SCHOLASTIC CALLED "JOE" - JOVIAL BOB STINE WAS MY EDITOR - I WAS GETTING PAID GOOD BACK THEN BUT THE FREELANCE RATES HAVENT CHANGED IN 30 YRS I WAS GETTING PAID 300$ A STRIP & THAT WAS ENOUGH TO LIVE OFF FOR A MONTH - I WENT BACK TO CHESHIRE & WORKED FOR MY FRIEND GED DUNN JR PAINTING HOUSES & "EDDIE" McNEIL WAS MAKING A MOVIE & WE ALL THOUGHT WE SHOULD START A COMPANY TOGETHER - THERE WAS A FEELING SOMETHING GREAT WAS GONNA HAPPEN SO A FEW MONTHS LATER WE STARTED THE COMPANY WE HAD AN OFFICE AT 32ND & 10TH AVE ↗ ✦

☆ THE FORMER HQ OF A & A TRUCKING - IT WAS NOV 1975 WE BROUGHT OUT THE FIRST ISSUE OF PUNK THE WHOLE WORLD WENT NUTS OVER IT - THE MEDIA LOVED IT & EVERYONE WANTED TO INTERVIEW US BUT WE WERENT SELLING MANY COPIES & 3 YRS LATER WE WENT OUT OF BISNESS - BY THAT TIME WE ACTUALLY WERE SELLING COPIES & WERE BECOMING SUCCESSFUL BUT EVERYONE WAS SAYING PUNK IS DEAD & NO ONE WANTED TO HELP US - THE PARTY WAS OVER - ✕

✕ FLY 05/11/2K1 - JOHN HOLMSTROM AT MY HOUSE NYC ✕

JOHN HOLMSTROM – 05/11/2K1 – NYC

JOHN IS FAMOUS FOR STARTING PUNK MAGAZINE BACK AROUND 1975 OR SOMETHING LIKE THAT BUT I DIDNT MEET HIM TIL 1999 WHEN I WAS PART OF A GROUP SHOW AT CBGBs & ONE OF MY PIECES WAS A COMIC THAT I HAD DONE WITH PETER BAGGE & EVERETT TRUE WHERE THERE IS ONE PANEL MENTIONING JOHN HOLMSTROM – SO HE WANTED TO KNOW WHAT WAS UP WITH THAT – WELL WE STARTED CHATTING & HIM & HIS FRIEND KEPT BUYING ME GUINNESS FOR THE REST OF THE NIGHT – WE GOT DRUNK & SMOKED CIGARETTES & YAKKED ALL NIGHT – IT WAS MAD FUN & THEN I GOT TO DO A COMIC FOR THE BIG 25TH ANIVERSARY ISSUE OF PUNK MAGAZINE!!! WWW.JOHNHOLMSTROM.COM

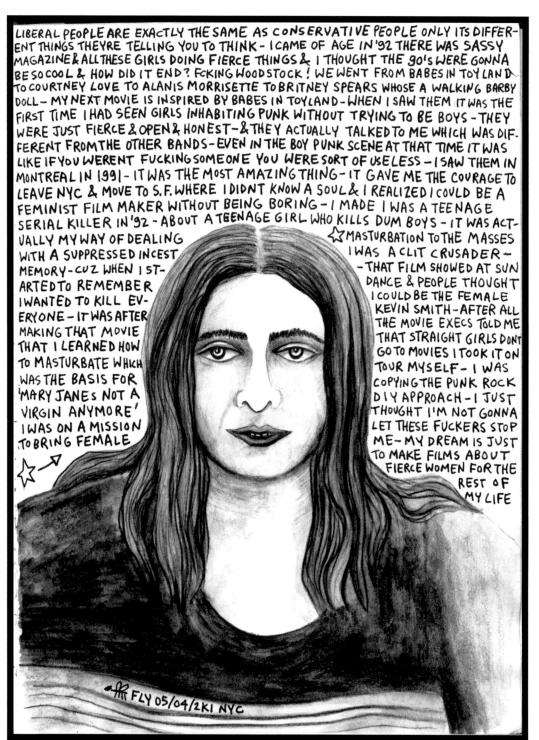

LIBERAL PEOPLE ARE EXACTLY THE SAME AS CONSERVATIVE PEOPLE ONLY ITS DIFFER-
ENT THINGS THEYRE TELLING YOU TO THINK - I CAME OF AGE IN '92 THERE WAS SASSY
MAGAZINE & ALL THESE GIRLS DOING FIERCE THINGS & I THOUGHT THE 90'S WERE GONNA
BE SO COOL & HOW DID IT END? FCKING WOODSTOCK! WE WENT FROM BABES IN TOYLAND
TO COURTNEY LOVE TO ALANIS MORRISETTE TO BRITNEY SPEARS WHOSE A WALKING BARBY
DOLL - MY NEXT MOVIE IS INSPIRED BY BABES IN TOYLAND - WHEN I SAW THEM IT WAS THE
FIRST TIME I HAD SEEN GIRLS INHABITING PUNK WITHOUT TRYING TO BE BOYS - THEY
WERE JUST FIERCE & OPEN & HONEST - & THEY ACTUALLY TALKED TO ME WHICH WAS DIF-
FERENT FROM THE OTHER BANDS - EVEN IN THE BOY PUNK SCENE AT THAT TIME IT WAS
LIKE IF YOU WERENT FUCKING SOMEONE YOU WERE SORT OF USELESS - I SAW THEM IN
MONTREAL IN 1991 - IT WAS THE MOST AMAZING THING - IT GAVE ME THE COURAGE TO
LEAVE NYC & MOVE TO S.F. WHERE I DIDNT KNOW A SOUL & I REALIZED I COULD BE A
FEMINIST FILM MAKER WITHOUT BEING BORING - I MADE I WAS A TEENAGE
SERIAL KILLER IN '92 - ABOUT A TEENAGE GIRL WHO KILLS DUM BOYS - IT WAS ACT-
UALLY MY WAY OF DEALING WITH A SUPPRESSED INCEST MEMORY - CUZ WHEN I ST-
ARTED TO REMEMBER I WANTED TO KILL EV- ERYONE - IT WAS AFTER MAKING THAT MOVIE
THAT I LEARNED HOW TO MASTURBATE WHICH WAS THE BASIS FOR 'MARY JANES NOT A
VIRGIN ANYMORE' I WAS ON A MISSION TO BRING FEMALE ☆—▶ ☆MASTURBATION TO THE MASSES
I WAS A CLIT CRUSADER - - THAT FILM SHOWED AT SUN DANCE & PEOPLE THOUGHT
I COULD BE THE FEMALE KEVIN SMITH - AFTER ALL THE MOVIE EXECS TOLD ME
THAT STRAIGHT GIRLS DONT GO TO MOVIES I TOOK IT ON TOUR MYSELF - I WAS
COPYING THE PUNK ROCK DIY APPROACH - I JUST THOUGHT I'M NOT GONNA
LET THESE FUCKERS STOP ME - MY DREAM IS JUST TO MAKE FILMS ABOUT
FIERCE WOMEN FOR THE REST OF MY LIFE

FLY 05/04/2K1 NYC

SARAH JACOBSON – 05/04/2K1 – NYC
IT WAS NEW YEARS DAY – Y2K – I HAD PUT TOGETHER A SQUATTER MUSEUM SHOW & IT WAS
OPENING AT ABC NO RIO – I WAS TOTALLY HUNG OVER & IN MUCH PAIN BUT OF COURSE I
HAD TO GO TO THE OPENING CUZ IT WAS MY SHOW – THERE WAS A GIRL THERE VIDEOTAPING &
IT TURNED OUT SHE WAS A VERY COOL FILM MAKER & SHE WAS WORKING ON A SEGMENT
ABOUT NO RIO FOR THE OXYGEN CHANNEL – SARAH HAS MADE THE FILMS "I WAS A TEENAGE
SERIAL KILLER" AND "MARY JANE s NOT A VIRGIN ANYMORE." SHE PRODUCES TV, PLAYS
GUITAR, WRITES FOR MAGAZINES ON POP CULTURE & IS TOTALLY GRATEFUL TO HAVE FOUND
LOVE & LIFE IN NYC – WWW.SARAHJACOBSON.COM

15

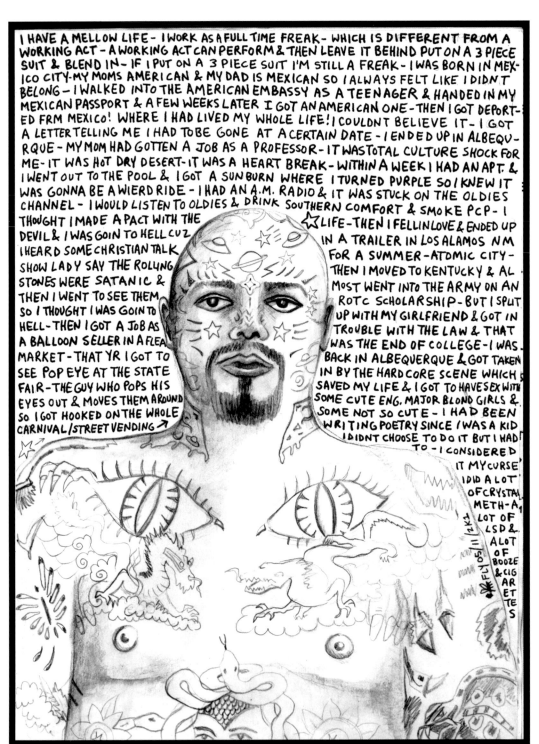

I HAVE A MELLOW LIFE - I WORK AS A FULL TIME FREAK - WHICH IS DIFFERENT FROM A WORKING ACT - A WORKING ACT CAN PERFORM & THEN LEAVE IT BEHIND PUT ON A 3 PIECE SUIT & BLEND IN - IF I PUT ON A 3 PIECE SUIT I'M STILL A FREAK - I WAS BORN IN MEXICO CITY - MY MOMS AMERICAN & MY DAD IS MEXICAN SO I ALWAYS FELT LIKE I DIDN'T BELONG - I WALKED INTO THE AMERICAN EMBASSY AS A TEENAGER & HANDED IN MY MEXICAN PASSPORT & A FEW WEEKS LATER I GOT AN AMERICAN ONE - THEN I GOT DEPORTED FRM MEXICO! WHERE I HAD LIVED MY WHOLE LIFE! I COULDNT BELIEVE IT - I GOT A LETTER TELLING ME I HAD TO BE GONE AT A CERTAIN DATE - I ENDED UP IN ALBEQURQUE - MY MOM HAD GOTTEN A JOB AS A PROFESSOR - IT WAS TOTAL CULTURE SHOCK FOR ME - IT WAS HOT DRY DESERT - IT WAS A HEART BREAK - WITHIN A WEEK I HAD AN APT. & I WENT OUT TO THE POOL & I GOT A SUNBURN WHERE I TURNED PURPLE SO I KNEW IT WAS GONNA BE A WIERD RIDE - I HAD AN A.M. RADIO & IT WAS STUCK ON THE OLDIES CHANNEL - I WOULD LISTEN TO OLDIES & DRINK SOUTHERN COMFORT & SMOKE PCP - I THOUGHT I MADE A PACT WITH THE DEVIL & I WAS GOIN TO HELL CUZ I HEARD SOME CHRISTIAN TALK SHOW LADY SAY THE ROLLING STONES WERE SATANIC & THEN I WENT TO SEE THEM SO I THOUGHT I WAS GOIN TO HELL - THEN I GOT A JOB AS A BALLOON SELLER IN A FLEA MARKET - THAT YR I GOT TO SEE POP EYE AT THE STATE FAIR - THE GUY WHO POPS HIS EYES OUT & MOVES THEM AROUND SO I GOT HOOKED ON THE WHOLE CARNIVAL/STREET VENDING →

LIFE - THEN I FELL IN LOVE & ENDED UP IN A TRAILER IN LOS ALAMOS NM FOR A SUMMER - ATOMIC CITY - THEN I MOVED TO KENTUCKY & ALMOST WENT INTO THE ARMY ON AN ROTC SCHOLARSHIP - BUT I SPLIT UP WITH MY GIRLFRIEND & GOT IN TROUBLE WITH THE LAW & THAT WAS THE END OF COLLEGE - I WAS BACK IN ALBEQUERQUE & GOT TAKEN IN BY THE HARD CORE SCENE WHICH SAVED MY LIFE & I GOT TO HAVE SEX WITH SOME CUTE ENG. MAJOR BLOND GIRLS & SOME NOT SO CUTE - I HAD BEEN WRITING POETRY SINCE I WAS A KID I DIDNT CHOOSE TO DO IT BUT I HAD TO - I CONSIDERED IT MY CURSE I DID A LOT OF CRYSTAL METH - A LOT OF LSD & A LOT OF BOOZE & CIGARETTES

EAK - 05/11/2K1 - LOWER EAST SIDE - NYC
WHEN I FIRST MET EAK I DON T THINK HE HAD ANY TATTOOS - AT LEAST I CANT REMEMBER IF HE DID OR NOT SO IF HE DID THEY WERENT THAT NOTICEABLE - EAK WAS IN A BAND & HE DID THE VOCALS - WHEN HE PERFORMED IT WAS LIKE HE WAS POSSESSED - HE WOULD BE TOTALLY OUT OF CONTROL - TRULY FREAKISH TO BEHOLD - THEN HE STARTED WORKING AT THE FREAK SHOW ON CONEY ISLAND & EVERYTIME I SAW HIM HE WOULD BE MORE INKED - BEING COVERED IN TATTOOS SEEMS TO HAVE MADE HIM MORE VISUALLY EXTROVERTED BUT HIS WHOLE SPIRIT SEEMS TO BE CALMER & MORE INTROVERTED - A TRUE FREAK - ARROCHAEAK@AOL.COM

16

MAKE ME LOOK HANDSOME - I WANT A DATE FROM THIS DRAWING - I COULD TELL YOU THE STORY OF DJ WINGNUT ATTACKING JASON AT THE MAYDAY 2K FEST & I THREW HIM OVER THE FENCE - THIS DRUNKEN WINO WHO JUST SHOWED UP IN TOMPKINS SQR PARK (IMAGINE THAT!) & FIRST HE WAS JUST HELPING SET UP & THEN WE START PLAYING & HE GOES & GETS MORE DRUNK - THEN HE COMES BACK & SAYS HE WANTS TO DJ & HES BEING OBNOXIOUS ABOUT IT SO FINALLY JASON SAYS 'YOU DONT EVEN HAVE ANY RECORDS' SO HE LOOKS ALL CONFUSED FOR A MINIT THEN HE GOES AWAY & GETS MORE DRUNK & DIGS AROUND IN THE GARBAGE & HE FINDS A COUPLE RECORDS - SO HE COMES BACK EVEN MORE OBNOXIOUS & DEMANDING TO DJ & OF COURSE WE SAY 'NO! ARE YOU OUT OF YR MIND?' - ALTHO THAT WAS OBVIOUS - SO HE WAS LURKING AROUND THE STAGE SHITFACE DRUNK & THEN JASON STARTED HIS SET - I WAS WATCHING D.J. WINGNUT - I COULD SEE HIS MIND WORKING & SUDDENLY HE WAS RUNNING AT THE STAGE TO TACKLE JASON SO I WENT RUNNING AT HIM TO INTERCEPT & I JUST REDIRECTED HIS CHARGE SO INSTEAD OF HITTING THE STAGE HE PROJECTILED OVER THE FENCE - THAT WAS LAST YEAR -2000- WHEN WE HAD THE LITTLE STAGE - THIS YR WE DIDNT HAVE ANY FREAKS OR WINGNUTS AT MAY DAY BUT OUR HEADLINE DJ LENNY DEE WAS SHITFACED - REALLY WHAT IM MOST EXCITED ABOUT THESE DAYS IS THE FESTIVAL OF NOW - 3 DAY CAMPOUT ARTS & MUSIC FESTIVAL WE'RE LOOKIN FOR A PIECE OF LAND IN UPSTATE NY WHAT I HAVE PLANNED FOR THIS MONTH IS A CIRCUS PARTY - THE END OF THE WORLD CIRCUS IS COMING TO TOWN - I'M BUMMED ABOUT THE LAST PARTY - IT WAS GONNA BE THE BEST BLACKKAT PRODUCTION TO DATE - WE'VE HAD A YR OF AMAZING PARTYS & THIS WAS GONNA BE THE BEST!

☆ - WE HAD AMAZING PERFORMERS & INDUSTRIAL CIRCUS RIDES & MIDWAY BOOTHS - IT WAS A CARNIVAL THEME - WE FOUND A GREAT SPACE IN DUMBO & THE LANDLORD WAS EASY TO WORK WITH - IT WAS PERFECT - THEN THE NIGHT OF THE PARTY AT 7PM THE REAL LANDLORDS SHOWED UP & WANTED TO KNOW WHAT THE FCK WE WERE DOING IN THIER SPACE - THE OTHER GUY HAD DISSAPPEARED - HE HAD DONE SOME WORK IN THE SPACE & HE KEPT THE KEYS - HE HAD FAKE PAPER WORK & HAD DONE SOME OTHER PARTIES THERE SO WE THOUGHT HE WAS LEGIT - AFTER FAILING TO NEGOTIATE WITH THE REAL LANDLORDS WE SPENT 2 HRS SCRAMBLIN FOR A NEW SPACE - WE FINALLY FOUND A ROOF TOP IN BED-STUY & MOVED IT THERE - ABOUT ↓

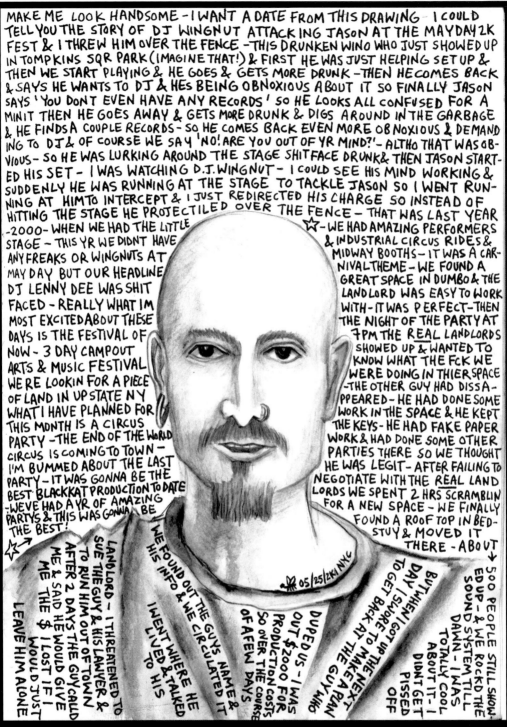

05/25/2K1 NYC

LANDLORD - I THREATENED TO SUE THE GUY & HIS LAWYER & TO RUN HIM OUT OF TOWN AFTER 2 DAYS THE GUY CALLED ME & SAID HE WOULD GIVE ME THE $ I LOST IF I WOULD JUST LEAVE HIM ALONE

WE FOUND OUT THE GUYS NAME & WE CIRCULATED HIS INFO & WE CIRCULATED IT - I WENT WHERE HE LIVED & TALKED TO HIS

DUPED US - I WAS OUT $2000 FOR PRODUCTION COSTS SO OVER THE COURSE OF A FEW DAYS

TO GET BACK AT THE GUY WHO DAY I SHOWED UP TO MAKE A PLAN TO GET BACK AT THE GUY WHO BUT WHEN I GOT UP THE NEXT

500 PEOPLE STILL SHOWED UP - & WE ROCKD THE SOUND SYSTEM TILL DAWN - I WAS TOTALLY COOL ABOUT IT - I DIDNT GET PISSED OFF

ARROW CHROME - 05/25/2K1 - AT SERENITY HOUSE - LOISAIDA - NYC
OK - SO - I KNEW CHROME BACK WHEN HE WAS DOG BOY & HE WAS ALL CRUSTY & NOW HE'S THIS SLICK CYBER-PIMP REVOLUTIONARY DANCIN DOGGY DAD - GODDAM - WHEN I WAS TRYING TO DRAW THIS FELIX (HIS AMAZING DAUGHTER - PG137) WAS BOUNCING OFFA THE WALLS & BOUNCING OFFA ME - THEN SHE WOULD DO THIS THING CALLED THE BUTT SHOW & I WAS TRYING TO TEACH HER THE NAKED BUTT DANCE BUT SHE WASNT INTERESTED - IT WAS ALL ABOUT THE BUTT SHOW - CHROME PUTS ON SOME HUGE SHAKIN & QUAKIN PARITES SO GET HOOKED UP - WWW.BLACKKAT.ORG

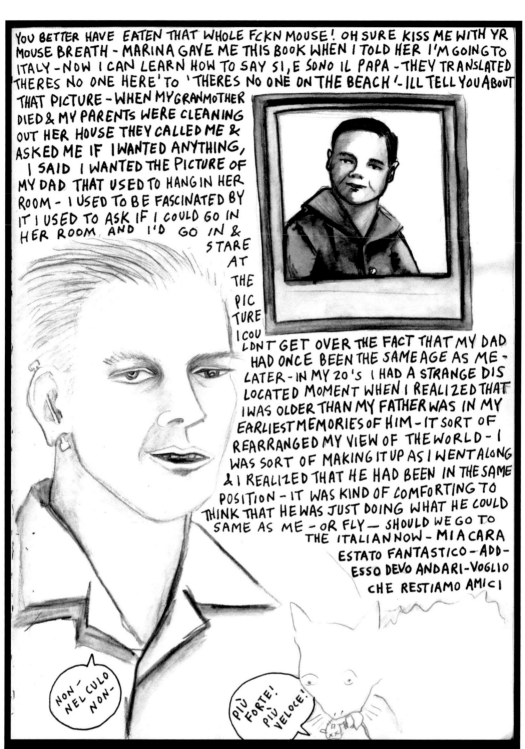

YOU BETTER HAVE EATEN THAT WHOLE FCKN MOUSE! OH SURE KISS ME WITH YR MOUSE BREATH - MARINA GAVE ME THIS BOOK WHEN I TOLD HER I'M GOING TO ITALY - NOW I CAN LEARN HOW TO SAY SI, E SONO IL PAPA - THEY TRANSLATED 'THERES NO ONE HERE' TO 'THERES NO ONE ON THE BEACH' - ILL TELL YOU ABOUT THAT PICTURE - WHEN MY GRANMOTHER DIED & MY PARENTS WERE CLEANING OUT HER HOUSE THEY CALLED ME & ASKED ME IF I WANTED ANYTHING, I SAID I WANTED THE PICTURE OF MY DAD THAT USED TO HANG IN HER ROOM - I USED TO BE FASCINATED BY IT I USED TO ASK IF I COULD GO IN HER ROOM, AND I'D GO IN & STARE AT THE PIC TURE I COU LDN'T GET OVER THE FACT THAT MY DAD HAD ONCE BEEN THE SAME AGE AS ME - LATER - IN MY 20'S I HAD A STRANGE DIS LOCATED MOMENT WHEN I REALIZED THAT I WAS OLDER THAN MY FATHER WAS IN MY EARLIEST MEMORIES OF HIM - IT SORT OF REARRANGED MY VIEW OF THE WORLD - I WAS SORT OF MAKING IT UP AS I WENT ALONG & I REALIZED THAT HE HAD BEEN IN THE SAME POSITION - IT WAS KIND OF COMFORTING TO THINK THAT HE WAS JUST DOING WHAT HE COULD SAME AS ME - OR FLY — SHOULD WE GO TO THE ITALIAN NOW - MIA CARA ESTATO FANTASTICO - ADD- ESSO DEVO ANDARI-VOGLIO CHE RESTIAMO AMICI

NON - NEL CULO NON -

PIÙ FORTE! PIÙ VELOCE!

CRAIG FLANAGIN – MAY 2K1 – NYC
I MET CRAIG FOR THE FIRST TIME IN 1990 AT ABC NO RIO WHERE HE WAS PUTTING UP FLYERS FOR HIS BAND GOD IS MY CO-PILOT & I WAS WORKING ON AN INSTALLATION IN THE BASEMENT WITH THE PURPLE INSTITUTION – ANYWAY – CRAIG WAS VERY SWEET & CHARMING & OF COURSE I WENT TO THE SHOW CUZ IT WAS AT NO RIO – GOD IS MY CO- PILOT THEN BECAME MY FAVORITE BAND & SOON I KNEW ALL THE SONGS & I WOULD GO TO ALL THE SHOWS SO THEY STRAPPED A BASS ON ME & SAID OK NOW YOU ARE IN THE BAND & I SAID WELL OK!!! – GODCO@EARTHLINK.NET

18

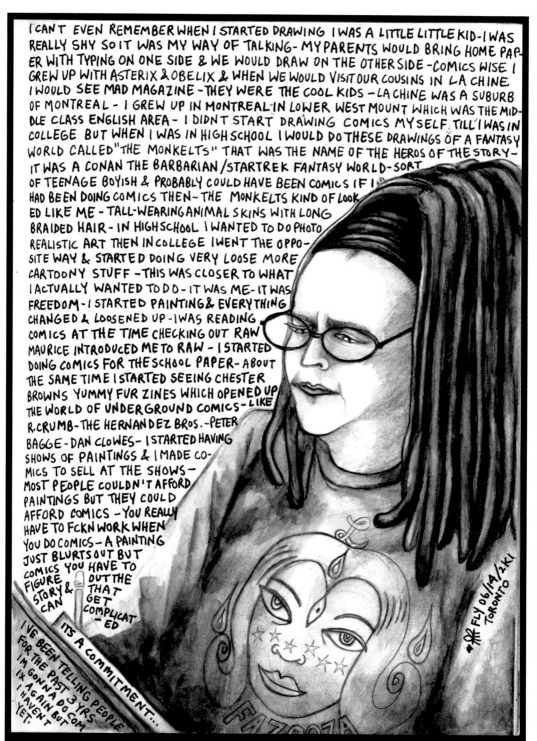

I CAN'T EVEN REMEMBER WHEN I STARTED DRAWING I WAS A LITTLE LITTLE KID-I WAS REALLY SHY SO IT WAS MY WAY OF TALKING- MY PARENTS WOULD BRING HOME PAPER WITH TYPING ON ONE SIDE & WE WOULD DRAW ON THE OTHER SIDE -COMICS WISE I GREW UP WITH ASTERIX & OBELIX & WHEN WE WOULD VISIT OUR COUSINS IN LA CHINE I WOULD SEE MAD MAGAZINE -THEY WERE THE COOL KIDS -LA CHINE WAS A SUBURB OF MONTREAL - I GREW UP IN MONTREAL IN LOWER WEST MOUNT WHICH WAS THE MIDDLE CLASS ENGLISH AREA - I DIDN'T START DRAWING COMICS MYSELF TILL I WAS IN COLLEGE BUT WHEN I WAS IN HIGH SCHOOL I WOULD DO THESE DRAWINGS OF A FANTASY WORLD CALLED "THE MONKELTS" THAT WAS THE NAME OF THE HEROS OF THE STORY- IT WAS A CONAN THE BARBARIAN /STARTREK FANTASY WORLD-SORT OF TEENAGE BOYISH & PROBABLY COULD HAVE BEEN COMICS IF I HAD BEEN DOING COMICS THEN- THE MONKELTS KIND OF LOOKED LIKE ME - TALL-WEARING ANIMAL SKINS WITH LONG BRAIDED HAIR - IN HIGH SCHOOL I WANTED TO DO PHOTO REALISTIC ART THEN IN COLLEGE I WENT THE OPPOSITE WAY & STARTED DOING VERY LOOSE MORE CARTOONY STUFF -THIS WAS CLOSER TO WHAT I ACTUALLY WANTED TO DO - IT WAS ME- IT WAS FREEDOM- I STARTED PAINTING & EVERYTHING CHANGED & LOOSENED UP -I WAS READING COMICS AT THE TIME CHECKING OUT RAW MAURICE INTRODUCED ME TO RAW - I STARTED DOING COMICS FOR THE SCHOOL PAPER- ABOUT THE SAME TIME I STARTED SEEING CHESTER BROWNS YUMMY FUR ZINES WHICH OPENED UP THE WORLD OF UNDERGROUND COMICS- LIKE R.CRUMB-THE HERNANDEZ BROS. -PETER BAGGE-DAN CLOWES- I STARTED HAVING SHOWS OF PAINTINGS & I MADE COMICS TO SELL AT THE SHOWS- MOST PEOPLE COULDN'T AFFORD PAINTINGS BUT THEY COULD AFFORD COMICS -YOU REALLY HAVE TO FCKN WORK WHEN YOU DO COMICS - A PAINTING JUST BLURTS OUT BUT COMICS YOU HAVE TO FIGURE OUT THE STORY & THAT CAN GET COMPLICATED

IT'S A COMMITMENT...

I'VE BEEN TELLING PEOPLE FOR THE PAST 3 YRS I'M GONNA DO COMIX AGAIN BUT I HAVEN'T YET.

✱ FLY 06/14/2K1 TORONTO

FIONA SMYTH – 06/14/2K1 – TORONTO
FIONA IS A PHENOMENAL PAINTER – I MET HER IN THE LATE 80S ALTHOUGH I HAD SEEN HER WORK BEFORE THAT – I WAS A BIG FAN OF HER COMICS WHICH WERE CRAZY FUNKY WONDERFUL HALLUCINATIONAL HYPNOTIZING DRAWINGS WITH MEANDERING STORYLINES – FIONA SAVED ME & OFFERED ME REFUGE AT A TIME WHEN MY LIFE WAS FALLING APART – I STAYED WITH HER FOR A FEW MONTHS & TRIED TO GO THROUGH HER ENTIRE INCREDIBLE COMICS COLLECTION – THESE DAYS SHE CONCENTRATES MOSTLY ON PAINTING THE SENSUOUS STRANGE & WONDERFUL – WWW.FIONASMYTH.COM – LUKKIE@SYMPATICO.CA

IN 1977 I WAS IN LONDON - BORN IN E. LONDON - IN '77 I WAS 17 & I HAD NO FRIENDS & ALL THESE BANDS WERE FORMING & I WENT TO ONE OF THE SHOWS I THINK IT MIGHT HAVE BEEN THE ADVERTS - BUT I WAS HOOKED - THERE WAS NOTHING LIKE THE LIVE ENERGY AT THOSE SHOWS! - AT THE SAME TIME I HAD AN ACOUSTIC GUITAR I WAS LEARNING TO PLAY BEATLES SONGS BUT I DECIDED I HAD TO BECOME A PUNK GUITAR PLAYER - IT WAS 4 YRS LATER I FORMED MY FIRST BAND - I HAD MADE SOME FRIENDS HANGIN OUT AT ALL THE GIGS & I WAS INFLUENCED BY CRASS SO ALL MY WRITING WAS POLITICAL - FIRST IT WAS ME ANOTHER GUITAR PLAYER & DENO THE SINGER - WE CALLED OURSELVES DIRT - I GUESS CUZ ITS THE WAY I FELT I HAD BEEN TREATED FOR YEARS - SOON WE HAD A BASS PLAYER & DRUMMER - OUR FIRST GIGS WERE INCREDIBLE - WE PLAYED WITH THE MOB - THE ERRATICS - HAGAR THE WOMB (A GIRL BAND FRONTED BY 3 GIRLS) - THEY WERE PRETTY BAD AT THE TIME BUT IN HINDSITE THEY WERE ACTUALLY AHEAD OF THEIR TIME - WE EVENTUALLY HOOKED UP WITH CRASS & THEY TOOK US ON TOUR WHICH WE HAD NEVER DONE BEFORE - WE PUT OUT A 7" & 12" ON THEIR LABEL IN 1981/82 - IT WAS WEIRD TOURING WITH CRASS THEY WERE A LOT OLDER THAN US - EXCEPT STEVE - THEY WERE VERY POLITICAL I THINK WE INTRODUCED A SENSE OF FUN TO THEM WHILE DOING SHOWS WITH THEM MADE US A LOT MORE AWARE & CONSCIENTIOUS ABOUT OUR OWN POLITICS →

☆ DIRT EXISTED IN 3 DIFFERENT FORMATS TIL 1996 ME & DENO HAD SOME PERSONALITY CONFLICTS SO PEOPLE HAD A HARD TIME TOURING WITH US - WE WENT THROUGH 21 DIFFERENT PEOPLE IN THE BAND - AFTER DIRT ENDED I WAS THINKING OF MOVING TO OAKLAND - I WAS TALKING TO STEVE ABOUT WORKING TOGETHER THEN I JUST BOOKED A TOUR BEFORE THE BAND EVEN EXISTED - OUR FIRST SHOW WAS AT ABC NO RIO IN 1997 WE DID 4 TOURS IN THE U.S. WE WENT TO JAPAN & TOURED EUROPE - WE WENT ALL OVER THE WORLD
04/07/01
FLY

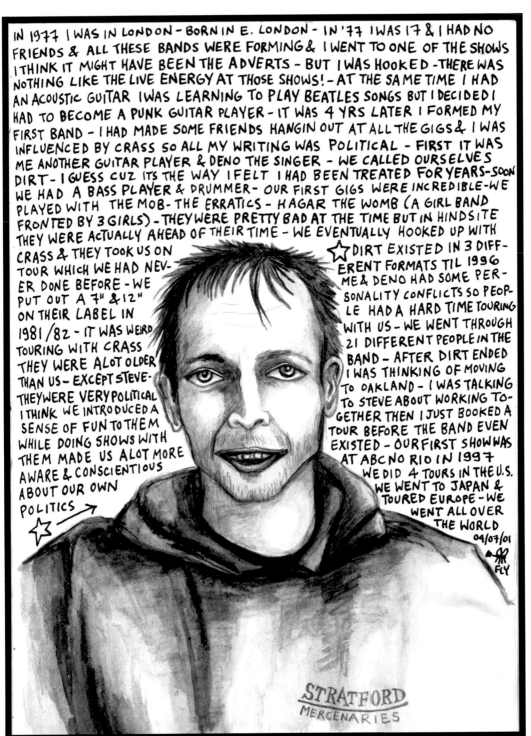

STRATFORD MERCENARIES

GARY DIRT – 04/07/2K1 – NYC

GARY HAS BEEN PUNK SINCE PUNK HAS BEEN PUNK – I MET HIM WHEN DIRT PLAYED AT ABC NO RIO SOME TIME IN THE MID 90S – THEY LET ME DO SOME SPOKEN WORD STUFF BEFORE THEY PLAYED – THIS WAS BACK WHEN THE SHOWS WERE IN THE BASEMENT & EVERYTHING WAS A LITTLE MORE CRUSTY – THE NEXT NIGHT GARY TOOK ME ON A DATE TO GO SEE THE MOVIE NATURAL BORN KILLERS CUZ I GUESS IT WAS BANNED IN THE UK – IT WAS A GREAT MOVIE & THEN WE ATE FALAFEL & YAKKED TIL THE WEE HOURS & I WON T TELL YOU ABOUT THE REST OF THE DATE SINCE IT MIGHT RUIN GARY S NASTY REPUTATION –
WWW.GAGSDIRT.CO.UK

IVE HAD MY LEGS FOR 5 YEARS NOW - I DONT KNOW IF YOU KNOW WHAT HAPPENS WHEN THEY DO AN AMPUTATION BUT WHERE EVER THEY AMPUTATE THERE IS A LOT OF SWELLING WHEN I FIRST GOT LEGS PEOPLE KEPT WANTING TO TALK TO ME ABOUT IT & THEN IT STARTED TO GET EMOTIONALLY DRAINING & I DIDNT WANT TO TALK ABOUT IT BECAUSE THERE IS SO MUCH MORE GOING ON IN MY LIFE SO I GOT THE COSMETICALLY COVERED LEGS WHICH LOOK REAL SO PEOPLE WOULDNT ALWAYS ASK ME ABOUT THEM - SO WHEN YOU FIRST GET AN AMPUTATION THERES LOTS OF SWELLING - IT TAKES A FEW MONTHS FOR THE SWELLING TO GO DOWN & THE MUSCLES ATROPHY - & YOUR LEG HAS CONSTANT PRESSURE ON IT FROM WEARING ARTIFICIAL LIMBS SO IF YOU ARE WALKING A LOT YOUR LEGS ACTUALLY START TO GET SMALLER - SO I WAS HAVING TO GET NEW LEGS MADE EVERY YEAR BECUZ THEY WOULD START TO GET TOO ROOMY-

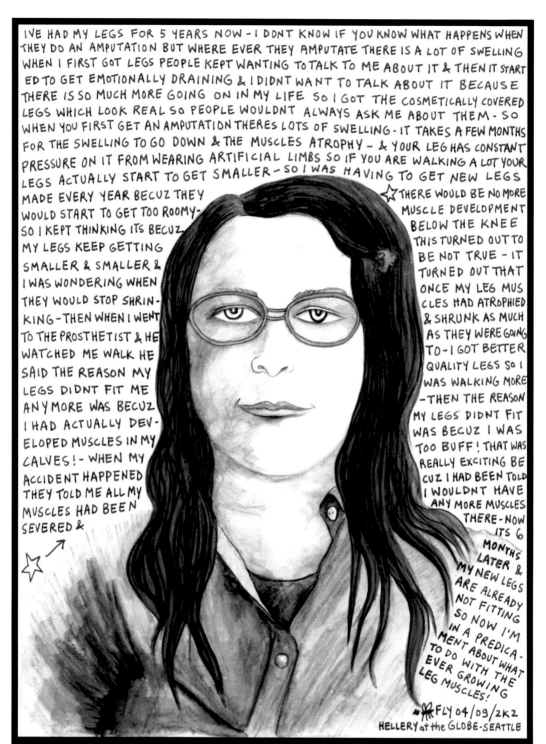

SO I KEPT THINKING ITS BECUZ MY LEGS KEEP GETTING SMALLER & SMALLER & I WAS WONDERING WHEN THEY WOULD STOP SHRINKING - THEN WHEN I WENT TO THE PROSTHETIST & HE WATCHED ME WALK HE SAID THE REASON MY LEGS DIDNT FIT ME ANY MORE WAS BECUZ I HAD ACTUALLY DEVELOPED MUSCLES IN MY CALVES! - WHEN MY ACCIDENT HAPPENED THEY TOLD ME ALL MY MUSCLES HAD BEEN SEVERED &

THERE WOULD BE NO MORE MUSCLE DEVELOPMENT BELOW THE KNEE THIS TURNED OUT TO BE NOT TRUE - IT TURNED OUT THAT ONCE MY LEG MUSCLES HAD ATROPHIED & SHRUNK AS MUCH AS THEY WERE GOING TO - I GOT BETTER QUALITY LEGS SO I WAS WALKING MORE - THEN THE REASON MY LEGS DIDNT FIT WAS BECUZ I WAS TOO BUFF! THAT WAS REALLY EXCITING BECUZ I HAD BEEN TOLD I WOULDNT HAVE ANY MORE MUSCLES THERE - NOW ITS 6 MONTHS LATER & MY NEW LEGS ARE ALREADY NOT FITTING SO NOW I'M IN A PREDICAMENT ABOUT WHAT TO DO WITH THE EVER GROWING LEG MUSCLES!

FLY 04/09/2K2
HELLERY at the GLOBE-SEATTLE

HELLERY – 04/09/2K2 – AT THE GLOBE – SEATTLE
BEFORE I MET HELLERY I HAD READ HER ZINE CALLED RING OF FIRE & IT TOTALLY BLEW ME AWAY – IT WAS THE STORY OF HER FIRST TIME HOPPING TRAINS WHEN SHE HAD AN ACCIDENT & BOTH HER LEGS WERE SEVERED BENEATH THE KNEE – THE ZINE WAS SO IMPRESSIVE BECAUSE HER ATTITUDE WAS SO STRONG & OPTIMISTIC – SHE HAD BIG PLANS FOR HER LIFE & YEAH IT WAS HARD BUT SHE WOULD JUST HAVE TO ADAPT & GET ON WITH IT – I FINALLY MET HER IN 96 IN OLYMPIA WHILE I WAS ON TOUR WITH AUS ROTTEN – SHE WAS ONE OF THE MOST FUN & POSITIVE PEOPLE I VE EVER MET – SHE DOES AMAZING DRAG PERFORMANCES, DRAWS COMICS & GOES TO SCHOOL FOR PHYSIOTHERAPY

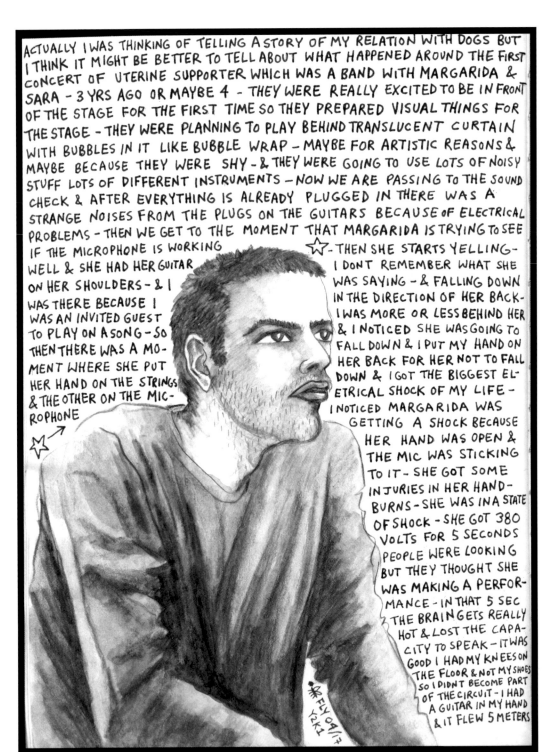

ACTUALLY I WAS THINKING OF TELLING A STORY OF MY RELATION WITH DOGS BUT I THINK IT MIGHT BE BETTER TO TELL ABOUT WHAT HAPPENED AROUND THE FIRST CONCERT OF UTERINE SUPPORTER WHICH WAS A BAND WITH MARGARIDA & SARA - 3 YRS AGO OR MAYBE 4 - THEY WERE REALLY EXCITED TO BE IN FRONT OF THE STAGE FOR THE FIRST TIME SO THEY PREPARED VISUAL THINGS FOR THE STAGE - THEY WERE PLANNING TO PLAY BEHIND TRANSLUCENT CURTAIN WITH BUBBLES IN IT LIKE BUBBLE WRAP - MAYBE FOR ARTISTIC REASONS & MAYBE BECAUSE THEY WERE SHY - & THEY WERE GOING TO USE LOTS OF NOISY STUFF LOTS OF DIFFERENT INSTRUMENTS - NOW WE ARE PASSING TO THE SOUND CHECK & AFTER EVERYTHING IS ALREADY PLUGGED IN THERE WAS A STRANGE NOISES FROM THE PLUGS ON THE GUITARS BECAUSE OF ELECTRICAL PROBLEMS - THEN WE GET TO THE MOMENT THAT MARGARIDA IS TRYING TO SEE IF THE MICROPHONE IS WORKING WELL & SHE HAD HER GUITAR ON HER SHOULDERS - & I WAS THERE BECAUSE I WAS AN INVITED GUEST TO PLAY ON A SONG - SO THEN THERE WAS A MOMENT WHERE SHE PUT HER HAND ON THE STRINGS & THE OTHER ON THE MICROPHONE

☆→

☆ - THEN SHE STARTS YELLING - I DON'T REMEMBER WHAT SHE WAS SAYING - & FALLING DOWN IN THE DIRECTION OF HER BACK - I WAS MORE OR LESS BEHIND HER & I NOTICED SHE WAS GOING TO FALL DOWN & I PUT MY HAND ON HER BACK FOR HER NOT TO FALL DOWN & I GOT THE BIGGEST ELETRICAL SHOCK OF MY LIFE - I NOTICED MARGARIDA WAS GETTING A SHOCK BECAUSE HER HAND WAS OPEN & THE MIC WAS STICKING TO IT - SHE GOT SOME INJURIES IN HER HAND - BURNS - SHE WAS IN A STATE OF SHOCK - SHE GOT 380 VOLTS FOR 5 SECONDS PEOPLE WERE LOOKING BUT THEY THOUGHT SHE WAS MAKING A PERFORMANCE - IN THAT 5 SEC THE BRAIN GETS REALLY HOT & LOST THE CAPACITY TO SPEAK - IT WAS GOOD I HAD MY KNEES ON THE FLOOR & NOT MY SHOES SO I DIDN'T BECOME PART OF THE CIRCUIT - I HAD A GUITAR IN MY HAND & IT FLEW 5 METERS

FLY 04/17 Y2K1

MANUEL MOTA - 04/17/2K1 - FRM PORTUGAL - NYC
I MET MANUEL IN LISBOA WHILE ON TOUR WITH GOD IS MY CO-PILOT - HE HAD ARRANGED OUR SHOW & A PLACE TO STAY & HE WAS PERFORMING WITH US & BEING AN ALL ROUND AMAZING HOST - WE ONLY HAD ONE SHOW IN LISBOA BUT WE WERE THERE FOR ALMOST A WEEK SO HE TOOK US FOR A FEW DAYS TO A HOUSE THAT HIS GRANDMOTHER OWNED LOCATED IN A BEAUTIFUL SEASIDE RESORT TOWN - IT WAS ONE OF THE MOST BEAUTIFUL PLACES I HAVE EVER SEEN BUT I GOT SO SUNBURNT!! - MY LIPS SWELLED UP REALLY BIG! - CRAIG SAID I SHOULD SHOOT MY MODELING PORTFOLIO - IT WAS ACTUALLY REALLY PAINFUL!

I WAS THINKING ABOUT A STORY ABOUT THIS OLD CHAPEL IN PORTUGAL IN EVORA ITS A BONE CHAPEL ON THE INSIDES PART OF THE STRUCTURE OF THE CHAPEL - 5000 SKELETONS ARE THERE - IT WAS MADE IN THE 14th CENTURY - THE BONES WERE THERE BECAUSE THE PEOPLE DIED OF THE PLAGUE & THEY HAD NO WHERE TO BURY THEM - THE INSIDE WALLS ARE COVERED IN BONES & THERE ARE SAYINGS ON THE WALLS LIKE "WE BONES THAT REST HERE ARE FOR YOUR BONES WAITING" ITS HARD TO TRANSLATE THE SAYINGS ITS LIKE ANCIENT PORTUGESE WRITING — ANOTHER ONE SAYS THAT "DEATH IS BETTER THAN BIRTH" ALSO IN THE CHAPEL THERE IS ONE FULL SKELETON OF A MALE & ONE OF A SMALL CHILD MAYBE 2 OR 3 YRS OLD & THEY STILL HAVE PIECES OF MEAT ON THEM BECAUSE THEY WERE CURSED BY THE MANS WIFE - THE CHILDS MOTHER - THE STORY I HEARD WAS THE WIFE WAS BEATEN BY THIS MAN & I DONT KNOW IF THE BOY WAS INVOLVED BUT SHE CURSED THEM BOTH THAT THEIR FLESH WOULD NEVER ROTTEN - THEY ARE NOT PART OF THE STRUCTURE BUT ARE HANGING FROM THE CIELING - THE STRUCTURE IN THE WALLS IS ALL MADE OF BONES & THEY ARE MADE INTO GEOMETRIC PATTERNS - THIS IS A CATHOLIC CHURCH ON THE HALL OF THE CHAPEL THERE ARE SOME DRESSES FROM PRIESTS & OBJECTS OF CEREMONY - TRIANGULAR CANDLE HOLDERS & INSTRUMENTS ON THE ENTRANCE THERE IS A STATUE OF CHRIST SITTING BUT HE HAS

☆ - THE EYES REALLY OPEN & A FACE COVERED IN BLOOD - ITS REALLY WIERD - HE DOESNT HAVE THE SAD LOOK LIKE THE USUAL CHRIST HIS FACE IS FULL OF BLOOD FROM THE NAIL CROWN - THE FIRST TIME I WENT THERE WAS 4 YRS AGO & I WAS GOING TO SEVILLE IN SPAIN & ITS A LONG WAY SO WE STOPPED IN EVORA TO SLEEP & THE NEXT DAY I WENT TO THE CHURCH - ITS A REALLY COLD PLACE & IT HAS A REALLY STRANG SMELL - & ADDING TO ALL THE CORPSES THERE ARE PRIESTS & BISHOPS BURIED AT THE PLACE WHERE THERE SHOULD BE THE ALTER IS A GRAVE - ITS PART OF THE GROUND - THIS IS A TINY CHAPEL THAT IS NEXT TO A BIGGER CHURCH - I HEARD A STORY THAT A GROUP OF OLD MEN CAME INTO THE CHURCH & THEY SAW ALL THE BONES & SAYINGS & THEY STARTED TO PANIC BECAUSE THEY WOULD HAVE TO DIE SOON - BUT THIS IS JUST WHAT I HEARD - THIS IS NOT MY STORY...

AFLY 04/17 Y2K1

MARGARIDA GARCIA - 04/17/2K1 - FRM PORTUGAL - NYC
I MET MARGARIDA IN LISBOA - SHE WAS HANGIN OUT & PLAYING MUSIC WITH OUR FABULOUS HOST MANUEL - WE STAYED IN A SWEET LITTLE APARTMENT THAT WAS HER SISTERS PLACE NEAR THE TAGUS RIVER - IT WAS UP A STEEP HILL & THERE WAS A LITTLE BALCONY WITH CURLY WROUGHT IRON RAILING - IT WAS A GREAT LOCATION NEAR TO ALL THE ACTION - MARGARIDA WAS AT THIS TIME STARTING HER BAND UTERINE SUPPORTER WITH HER FRIEND SARA - THEY PLAYED AT MY BOOK RELEASE PARTY FOR CHRON!IC!-RIOTS!PA!SM! AT ABC NO RIO IN 1999 - MARGARIDA IS NOW IN BARCELONA STILL PLAYING MUSIC!

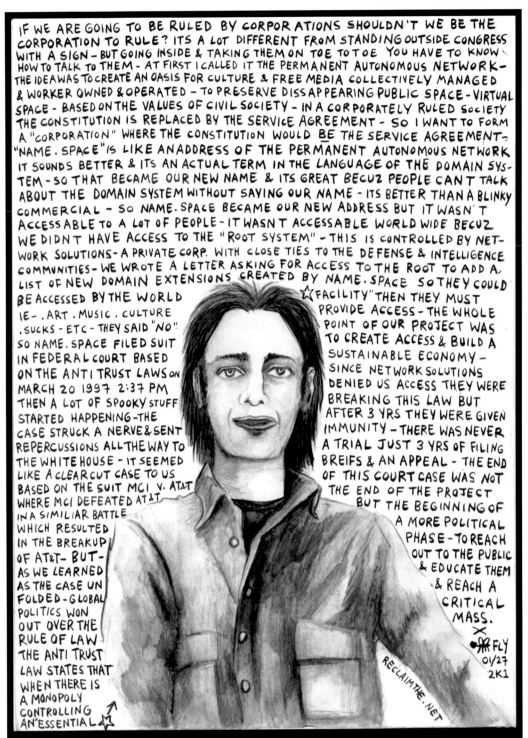

IF WE ARE GOING TO BE RULED BY CORPORATIONS SHOULDN'T WE BE THE CORPORATION TO RULE? ITS A LOT DIFFERENT FROM STANDING OUTSIDE CONGRESS WITH A SIGN - BUT GOING INSIDE & TAKING THEM ON TOE TO TOE YOU HAVE TO KNOW HOW TO TALK TO THEM - AT FIRST I CALLED IT THE PERMANENT AUTONOMOUS NETWORK - THE IDEA WAS TO CREATE AN OASIS FOR CULTURE & FREE MEDIA COLLECTIVELY MANAGED & WORKER OWNED & OPERATED - TO PRESERVE DISSAPPEARING PUBLIC SPACE - VIRTUAL SPACE - BASED ON THE VALUES OF CIVIL SOCIETY - IN A CORPORATELY RULED SOCIETY THE CONSTITUTION IS REPLACED BY THE SERVICE AGREEMENT - SO I WANT TO FORM A "CORPORATION" WHERE THE CONSTITUTION WOULD BE THE SERVICE AGREEMENT - "NAME.SPACE" IS LIKE AN ADDRESS OF THE PERMANENT AUTONOMOUS NETWORK IT SOUNDS BETTER & ITS AN ACTUAL TERM IN THE LANGUAGE OF THE DOMAIN SYSTEM - SO THAT BECAME OUR NEW NAME & ITS GREAT BECUZ PEOPLE CAN'T TALK ABOUT THE DOMAIN SYSTEM WITHOUT SAYING OUR NAME - ITS BETTER THAN A BLINKY COMMERCIAL - SO NAME.SPACE BECAME OUR NEW ADDRESS BUT IT WASN'T ACCESSABLE TO A LOT OF PEOPLE - IT WASN'T ACCESSABLE WORLD WIDE BECUZ WE DIDN'T HAVE ACCESS TO THE "ROOT SYSTEM" - THIS IS CONTROLLED BY NETWORK SOLUTIONS - A PRIVATE CORP. WITH CLOSE TIES TO THE DEFENSE & INTELLIGENCE COMMUNITIES - WE WROTE A LETTER ASKING FOR ACCESS TO THE ROOT TO ADD A LIST OF NEW DOMAIN EXTENSIONS CREATED BY NAME.SPACE SO THEY COULD BE ACCESSED BY THE WORLD IE - .ART .MUSIC .CULTURE .SUCKS - ETC - THEY SAID "NO" SO NAME.SPACE FILED SUIT IN FEDERAL COURT BASED ON THE ANTI TRUST LAWS ON MARCH 20 1997 2:37 PM THEN A LOT OF SPOOKY STUFF STARTED HAPPENING - THE CASE STRUCK A NERVE & SENT REPERCUSSIONS ALL THE WAY TO THE WHITE HOUSE - IT SEEMED LIKE A CLEAR CUT CASE TO US BASED ON THE SUIT MCI V. AT&T WHERE MCI DEFEATED AT&T IN A SIMILIAR BATTLE WHICH RESULTED IN THE BREAKUP OF AT&T - BUT - AS WE LEARNED AS THE CASE UNFOLDED - GLOBAL POLITICS WON OUT OVER THE RULE OF LAW - THE ANTI TRUST LAW STATES THAT WHEN THERE IS A MONOPOLY CONTROLLING AN "ESSENTIAL ☆ FACILITY" THEN THEY MUST PROVIDE ACCESS - THE WHOLE POINT OF OUR PROJECT WAS TO CREATE ACCESS & BUILD A SUSTAINABLE ECONOMY - SINCE NETWORK SOLUTIONS DENIED US ACCESS THEY WERE BREAKING THIS LAW BUT AFTER 3 YRS THEY WERE GIVEN IMMUNITY - THERE WAS NEVER A TRIAL JUST 3 YRS OF FILING BREIFS & AN APPEAL - THE END OF THIS COURT CASE WAS NOT THE END OF THE PROJECT BUT THE BEGINNING OF A MORE POLITICAL PHASE - TO REACH OUT TO THE PUBLIC & EDUCATE THEM & REACH A CRITICAL MASS.

X

FLY
01/27
2K1

RECLAIMTHE.NET

PAUL GARRIN – AT NAME.SPACE – NYC

PAUL IS THE GUY WHO SHOT THAT AMAZING VIDEO DURING THE TOMPKINS SQUARE POLICE RIOT IN 1988 – YOU KNOW THE ONE WHERE HE IS UP A TREE & THE COPS ARE SWINGING THEIR CLUBS AT HIM & HE IS YELLING "OK! OK! I M COMING DOWN!!" – PAUL HAS DONE A LOT OF OTHER STUFF – HE IS DEDICATED TO RECLAIMING THE NET – RECLAIMING CYBERSPACE – HE TELLS ME ABOUT ALL THESE PLANS & INTENSE PROJECTS & I TOTALLY UNDERSTAND EVERYTHING AS HE IS TELLING ME BUT THEN AS I M WALKING AWAY I M THINKING – WHAAAAAT!? – HTTP://PG.MEDIAFILTER.ORG/ – HTTP://RECLAIMTHE.NET/

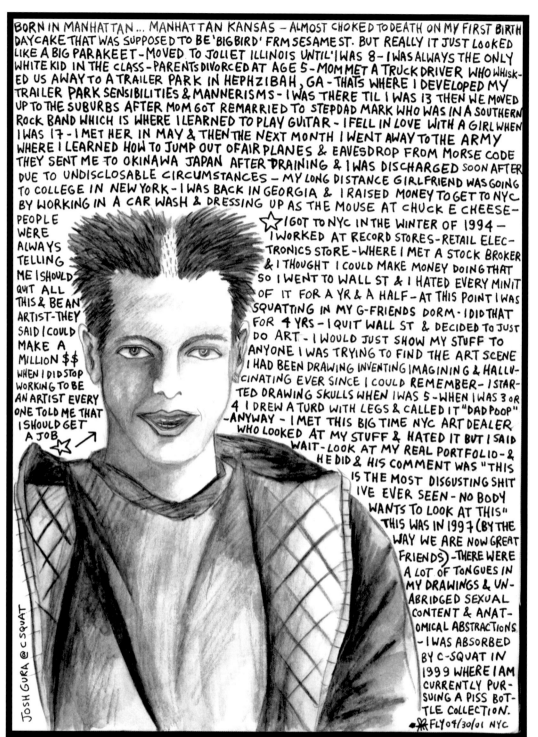

BORN IN MANHATTAN... MANHATTAN KANSAS – ALMOST CHOKED TO DEATH ON MY FIRST BIRTH DAY CAKE THAT WAS SUPPOSED TO BE 'BIG BIRD' FRM SESAME ST. BUT REALLY IT JUST LOOKED LIKE A BIG PARAKEET – MOVED TO JOLIET ILLINOIS UNTIL I WAS 8 – I WAS ALWAYS THE ONLY WHITE KID IN THE CLASS – PARENTS DIVORCED AT AGE 5 – MOM MET A TRUCK DRIVER WHO WHISK-ED US AWAY TO A TRAILER PARK IN HEPHZIBAH, GA – THATS WHERE I DEVELOPED MY TRAILER PARK SENSIBILITIES & MANNERISMS – I WAS THERE TIL I WAS 13 THEN WE MOVED UP TO THE SUBURBS AFTER MOM GOT REMARRIED TO STEPDAD MARK WHO WAS IN A SOUTHERN ROCK BAND WHICH IS WHERE I LEARNED TO PLAY GUITAR – I FELL IN LOVE WITH A GIRL WHEN I WAS 17 – I MET HER IN MAY & THEN THE NEXT MONTH I WENT AWAY TO THE ARMY WHERE I LEARNED HOW TO JUMP OUT OF AIR PLANES & EAVESDROP FROM MORSE CODE THEY SENT ME TO OKINAWA JAPAN AFTER DRAINING & I WAS DISCHARGED SOON AFTER DUE TO UNDISCLOSABLE CIRCUMSTANCES – MY LONG DISTANCE GIRLFRIEND WAS GOING TO COLLEGE IN NEW YORK – I WAS BACK IN GEORGIA & I RAISED MONEY TO GET TO NYC BY WORKING IN A CAR WASH & DRESSING UP AS THE MOUSE AT CHUCK E CHEESE-

PEOPLE WERE ALWAYS TELLING ME I SHOULD QUIT ALL THIS & BE AN ARTIST – THEY SAID I COULD MAKE A MILLION $$ WHEN I DID STOP WORKING TO BE AN ARTIST EVERY ONE TOLD ME THAT I SHOULD GET A JOB

☆ I GOT TO NYC IN THE WINTER OF 1994 – I WORKED AT RECORD STORES – RETAIL ELEC-TRONICS STORE – WHERE I MET A STOCK BROKER & I THOUGHT I COULD MAKE MONEY DOING THAT SO I WENT TO WALL ST & I HATED EVERY MINIT OF IT FOR A YR & A HALF – AT THIS POINT I WAS SQUATTING IN MY G-FRIENDS DORM – I DID THAT FOR 4 YRS – I QUIT WALL ST & DECIDED TO JUST DO ART – I WOULD JUST SHOW MY STUFF TO ANYONE I WAS TRYING TO FIND THE ART SCENE I HAD BEEN DRAWING INVENTING IMAGINING & HALLU-CINATING EVER SINCE I COULD REMEMBER – I STAR-TED DRAWING SKULLS WHEN I WAS 5 – WHEN I WAS 3 OR 4 I DREW A TURD WITH LEGS & CALLED IT "DAD POOP" – ANYWAY – I MET THIS BIG TIME NYC ART DEALER WHO LOOKED AT MY STUFF & HATED IT BUT I SAID WAIT – LOOK AT MY REAL PORTFOLIO – & HE DID & HIS COMMENT WAS "THIS IS THE MOST DISGUSTING SHIT IVE EVER SEEN – NO BODY WANTS TO LOOK AT THIS" THIS WAS IN 1997 (BY THE WAY WE ARE NOW GREAT FRIENDS) – THERE WERE A LOT OF TONGUES IN MY DRAWINGS & UN-ABRIDGED SEXUAL CONTENT & ANAT-OMICAL ABSTRACTIONS – I WAS ABSORBED BY C-SQUAT IN 1999 WHERE I AM CURRENTLY PUR-SUING A PISS BOT-TLE COLLECTION. ✴FLY 04/30/01 NYC

JOSH GURA @ C SQUAT

JOSH GURA – 04/30/2K1 – C SQUAT – LOISAIDA – NYC

I MET JOSH IN A GARDEN IN THE LOWER EAST SIDE – I WAS DOING SOME SPOKEN WORD & HE HAD JUST ARRIVED IN THE NEIGHBORHOOD SO HE INTRODUCED HIMSELF – JOSH DOES PRETTY MUCH EVERYTHING – VISUAL ART, MUSIC, ELECTRONICS, CARPENTRY, CONSTRUC-TION, GRAFFITI, SQUATTING, SHIT DISTURBING, ETC. – I WENT OVER TO C SQUAT TO RECORD THE ZERO CONTENT GREATEST HITS ALBUM WITH JOSH & HIS ROOM WAS A MESS – FULL OF TRASH & SHIT SO HE MOVED IT ALL INTO THE CORNER & SPRAY PAINTED IT FOR ME – I THOUGHT IT WAS REALLY SWEET EXCEPT FOR THE FACT THAT SPRAY PAINT FUMES GIVE ME FCKN BRUTAL HEADACHES BUT HOW COULD HE KNOW? – GEOCITIES.COM/JOSHUAGURA

WE SET FIRE TO A LOT OF THINGS IN THE PARKING LOT TOO
WE HAVE SOME BEAUTIFUL PHOTOS OF THINGS BURNING
IN THE PARKING LOT — WE STARTED CALLING THE BIG
GUY 'BACK HOE' CUZ HE WOULD RIDE AROUND ON
A BACK HOE — WE STARTED THIS WIERD LOW LEVEL WAR
WITH THEM BY THROWING STUFF OUT THE WINDOW — THEY
WOULD BE LOOKING UP AT OUR WINDOWS WITH BINOCULARS
THEN WE STARTED PROJECTING STUFF ONTO THE WALLS OPPOSITE OUR
BUILDING ON THE OTHER SIDE OF THE PARKING LOT — ONCE WE PROJECTED
STUFF WHILE THE COPS WERE BUSTING SOME PEOPLE — EYEBALLS &
WIERD ANIMALS WITH THE WORDS 'FUCK YOU' — AFTER ABOUT A YEAR BACK
HOE DISSAPPEARED — AT THAT TIME WE HAD A DOG & THE DOG WOULD SHIT
IN THE PARKING LOT & ONE TIME THERE WERE SOME GUYS GOING THROUGH
BACK HOE'S CONTAINERS — IT TURNED OUT THAT BACK HOE HAD DIED OF
A MASSIVE CORONARY & THIS WAS HIS SON — EVENTUALLY HE TOOK AWAY THE BACK HOE
THAT HIS DAD USED TO DRIVE & THE CONTAINERS WERE COMPLETELY ABANDONNED — I TRIED
TO GET INTO THEM WITH BOLT CUTTERS SO THAT MY FRIEND C — (THE CONSIDERATE I.V. DRUG USER WHO
WON'T SHOOT UP IN FRIEND'S HOUSES) COULD LIVE IN THEM BUT THAT DIDN'T WORK OUT DUE TO HIS
LACK OF ENTHUSIASM — THEN I TRIED TO GET MY FRIEND UNCLE MATTY TO LIVE THEIR BUT HE DIDNT
FOR SIMILIAR REASONS — MY FRIEND UNCLE MATTY WHO WALKD ONE TIME FROM HERE TO 24th
ST & BACK WITH NO PANTS ON — HE DID IT CUZ ONE DAY HE DECIDED TO WEAR DEPENDS & THEN HE
DECIDED TO WET HIS DEPENDS THEN HE DIDNT WANT TO WALK AROUND WITH WET DEPENDS & HE
HAD NO PANTS — UNCLE MATTY IS PROBABLY 22 YRS OLD BY NOW BUT BACK THEN HE WAS MAYBE
19 — WHAT HAS SINCE HAPPENED IS THE CONTAINERS HAVE FALLEN INTO COMPLETE DISREPAIR
& THEY ARE HOUSING A HUGE EXTENDED FAMILY OF ALLEYCATS — THE HUMANE SOCIETY CAME &
CUT OFF THE BALLS OF THE HEAD ALLEYCAT SO NOW THERE ARE NOT SO MANY — THERE WAS A
WARE HOUSE ACROSS THE ST. FRM THE PARKING LOT WHICH BURNT DOWN & WAS REPLACED BY HUGE
YUPPIE LIVE WORK LOFTS — WE WERE HAVING A PARTY ON THE ROOF & WE NOTICED THIS GUY IN THE
YUPPIE BUILDING WACKING OFF — STANDING UP WITH NO PANTS ON IN FRONT OF A COMPUTER WACKING
OFF — COMPLETELY OBLIVIOUS THAT HE IS ON DISPLAY TO THE ENTIRE NIEGHBORHOOD

AFTER PROLON
GED OBSERVATION IT
WAS OBVIOUS THIS
WAS A NIGHTLY EVENT
FOR HIM — SO I HAVE
VIDEO TAPED HIM
& PLAN TO PROJECT
IT SOME TIME ACROSS
FROM HIS BUILDING
WHILE HE'S WACKING
OFF — BUT HE PROBABLY
WONT NOTICE
CUZ HE IS SO OBLIVIOUS
HE SPENDS
$3000 A MONTH ON
RENT BUT
CANT AFFORD
CURTAINS!

BULK FOODVEYOR – 02/18/2K1 – IN THE MISSION – SF

I FIRST MET PHIL IN NYC – HE WAS ONE OF THE GARGOYLES AT THE GARGOYLE
MECHANIQUE LAB, WHICH WAS A STOREFRONT PERFORMANCE STUDIO ART SPACE ON AVE.
B – PHIL WOULD MAKE THESE INSANE LITTLE MECHANICAL CRITTERS THAT WOULD THRASH
AROUND – HE ALSO DID STRANGE THINGS WITH FOOD & HE STILL DOES STRANGE THINGS
WITH FOOD – IN 1993 A PYROTECHNIC FRIEND OF MINE SENT ME A RAINBOW–COLORED
LOAF OF BREAD IN THE MAIL – I DON T EAT BREAD BUT IT WAS VERY PRETTY SO I DIDNT

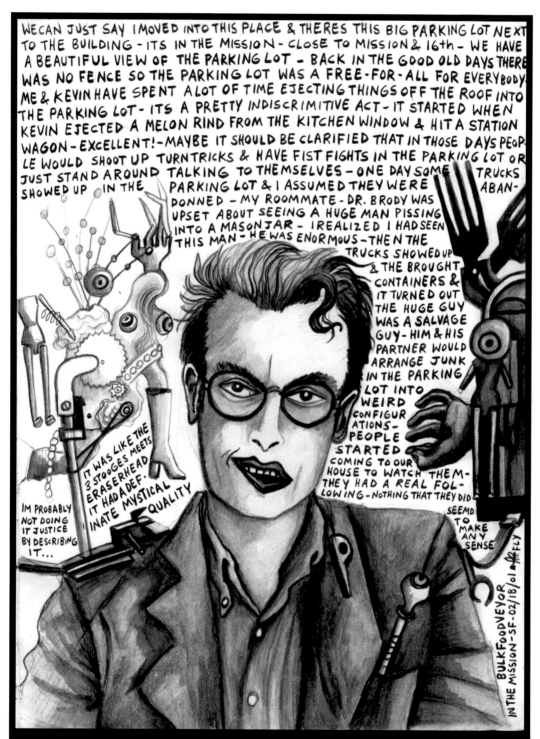

WECAN JUST SAY I MOVED INTO THIS PLACE & THERES THIS BIG PARKING LOT NEXT TO THE BUILDING - ITS IN THE MISSION - CLOSE TO MISSION & 16th - WE HAVE A BEAUTIFUL VIEW OF THE PARKING LOT - BACK IN THE GOOD OLD DAYS THERE WAS NO FENCE SO THE PARKING LOT WAS A FREE-FOR-ALL FOR EVERYBODY. ME & KEVIN HAVE SPENT A LOT OF TIME EJECTING THINGS OFF THE ROOF INTO THE PARKING LOT - ITS A PRETTY INDISCRIMITIVE ACT - IT STARTED WHEN KEVIN EJECTED A MELON RIND FROM THE KITCHEN WINDOW & HIT A STATION WAGON - EXCELLENT! - MAYBE IT SHOULD BE CLARIFIED THAT IN THOSE DAYS PEOP-LE WOULD SHOOT UP TURN TRICKS & HAVE FIST FIGHTS IN THE PARKING LOT OR JUST STAND AROUND TALKING TO THEMSELVES - ONE DAY SOME TRUCKS SHOWED UP IN THE PARKING LOT & I ASSUMED THEY WERE ABAN-DONNED - MY ROOMMATE - DR. BRODY WAS UPSET ABOUT SEEING A HUGE MAN PISSING INTO A MASON JAR - I REALIZED I HAD SEEN THIS MAN - HE WAS ENORMOUS - THEN THE TRUCKS SHOWED UP & THE BROUGHT CONTAINERS & IT TURNED OUT THE HUGE GUY WAS A SALVAGE GUY - HIM & HIS PARTNER WOULD ARRANGE JUNK IN THE PARKING LOT INTO WEIRD CONFIGUR ATIONS - PEOPLE STARTED COMING TO OUR HOUSE TO WATCH THEM - THEY HAD A REAL FOL-LOWING - NOTHING THAT THEY DID SEEMD TO MAKE ANY SENSE

IT WAS LIKE THE 3 STOOGES MEETS ERASERHEAD IT HAD A DEF-INATE MYSTICAL QUALITY

IM PROBABLY NOT DOING IT JUSTICE BY DESCRIBING IT...

BULK FOOD VEYOR IN THE MISSION - SF - 02/18/01 FLY

WANT TO THROW IT OUT — WHEN IT STARTED TO GO MOLDY I GAVE IT TO PHIL AS A GOING-AWAY PRESENT AS HE WAS LEAVING NYC TO LIVE IN SF — A YEAR OR SO LATER WHEN I WENT TO VISIT HIM HE STILL HAD IT — RECENTLY PHIL TOLD ME "LAST I SAW IT IT WAS A BASEBALL—SIZED THING, HAIRY WITH DESSICATED MOLD, BUT THE MOLD HAD ABSORBED THE COLORING FROM THE BREAD." — CURRENTLY PHIL WORKS WITH BENTON BAINBRIDGE AS THE "VIDEO PERFORMANCE DUO" LORD KNOWS COMPOST — HTTP://WWW.TURBULENCE.ORG/WORKS/HOOT/ — FOODVEYOR@HOTMAIL.COM

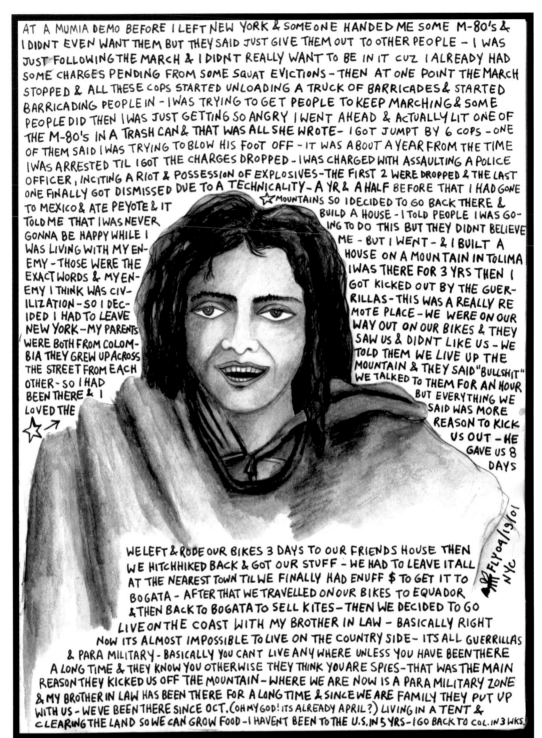

AT A MUMIA DEMO BEFORE I LEFT NEW YORK & SOMEONE HANDED ME SOME M-80's & I DIDN'T EVEN WANT THEM BUT THEY SAID JUST GIVE THEM OUT TO OTHER PEOPLE - I WAS JUST FOLLOWING THE MARCH & I DIDN'T REALLY WANT TO BE IN IT CUZ I ALREADY HAD SOME CHARGES PENDING FROM SOME SQUAT EVICTIONS - THEN AT ONE POINT THE MARCH STOPPED & ALL THESE COPS STARTED UNLOADING A TRUCK OF BARRICADES & STARTED BARRICADING PEOPLE IN - I WAS TRYING TO GET PEOPLE TO KEEP MARCHING & SOME PEOPLE DID THEN I WAS JUST GETTING SO ANGRY I WENT AHEAD & ACTUALLY LIT ONE OF THE M-80's IN A TRASH CAN & THAT WAS ALL SHE WROTE- I GOT JUMPT BY 6 COPS - ONE OF THEM SAID I WAS TRYING TO BLOW HIS FOOT OFF - IT WAS ABOUT A YEAR FROM THE TIME I WAS ARRESTED TIL I GOT THE CHARGES DROPPED - I WAS CHARGED WITH ASSAULTING A POLICE OFFICER, INCITING A RIOT & POSSESSION OF EXPLOSIVES-THE FIRST 2 WERE DROPPED & THE LAST ONE FINALLY GOT DISMISSED DUE TO A TECHNICALITY- A YR & A HALF BEFORE THAT I HAD GONE TO MEXICO & ATE PEYOTE & IT TOLD ME THAT I WAS NEVER GONNA BE HAPPY WHILE I WAS LIVING WITH MY EN- EMY -THOSE WERE THE EXACT WORDS & MY EN- EMY I THINK WAS CIV- ILIZATION - SO I DEC- IDED I HAD TO LEAVE NEW YORK - MY PARENTS WERE BOTH FROM COLOM- BIA THEY GREW UP ACROSS THE STREET FROM EACH OTHER - SO I HAD BEEN THERE & I LOVED THE

☆ MOUNTAINS SO I DECIDED TO GO BACK THERE & BUILD A HOUSE - I TOLD PEOPLE I WAS GO- ING TO DO THIS BUT THEY DIDN'T BELIEVE ME - BUT I WENT - & I BUILT A HOUSE ON A MOUNTAIN IN TOLIMA I WAS THERE FOR 3 YRS THEN I GOT KICKED OUT BY THE GUER- RILLAS- THIS WAS A REALLY RE MOTE PLACE- WE WERE ON OUR WAY OUT ON OUR BIKES & THEY SAW US & DIDN'T LIKE US - WE TOLD THEM WE LIVE UP THE MOUNTAIN & THEY SAID "BULLSHIT" WE TALKED TO THEM FOR AN HOUR BUT EVERYTHING WE SAID WAS MORE REASON TO KICK US OUT - HE GAVE US 8 DAYS

FLY 04/19/01 NYC

WE LEFT & RODE OUR BIKES 3 DAYS TO OUR FRIENDS HOUSE THEN WE HITCHHIKED BACK & GOT OUR STUFF - WE HAD TO LEAVE IT ALL AT THE NEAREST TOWN TIL WE FINALLY HAD ENUFF $ TO GET IT TO BOGATA - AFTER THAT WE TRAVELLED ON OUR BIKES TO EQUADOR & THEN BACK TO BOGATA TO SELL KITES- THEN WE DECIDED TO GO LIVE ON THE COAST WITH MY BROTHER IN LAW - BASICALLY RIGHT NOW ITS ALMOST IMPOSSIBLE TO LIVE ON THE COUNTRY SIDE- ITS ALL GUERRILLAS & PARA MILITARY - BASICALLY YOU CANT LIVE ANY WHERE UNLESS YOU HAVE BEEN THERE A LONG TIME & THEY KNOW YOU OTHERWISE THEY THINK YOU ARE SPIES-THAT WAS THE MAIN REASON THEY KICKED US OFF THE MOUNTAIN - WHERE WE ARE NOW IS A PARA MILITARY ZONE & MY BROTHER IN LAW HAS BEEN THERE FOR A LONG TIME & SINCE WE ARE FAMILY THEY PUT UP WITH US - WE'VE BEEN THERE SINCE OCT. (OH MY GOD! ITS ALREADY APRIL?) LIVING IN A TENT & CLEARING THE LAND SO WE CAN GROW FOOD - I HAVENT BEEN TO THE U.S. IN 5 YRS - I GO BACK TO COL. IN 3 WKS.

LILIANA (FRM COLOMBIA) – 04/19/2K1 – LOISAIDA – NYC
LILI HAS ONE OF THE MOST BEAUTIFUL SMILES! & AN INCREDIBLE SPIRIT – WHEN I MET HER SHE WAS LIVING AT DOS BLOKOS – A SQUAT IN THE LOWER EAST SIDE EVICTED IN 1999 – SHE SANG IN A PUNK BAND CALLED SIN ROSTRO (WITHOUT FACE) WITH MY FRIEND AMANDA (PG. 177)– SHE WAS A POET & A BIKE MESSENGER – BUT SHE ALWAYS SEEMED RESTLESS LIKE SHE DIDNT REALLY FEEL AT HOME IN NYC – & THEN SHE WENT BACK TO COLOMBIA WITH MY BEST FRIEND PAH & SHE STILL LIVES THERE – I'VE SORT OF LOST CONTACT WITH HER BUT PAH SAYS SHE NOW HAS A BEAUTIFUL BABY GIRL NAMED PRIMITIVA

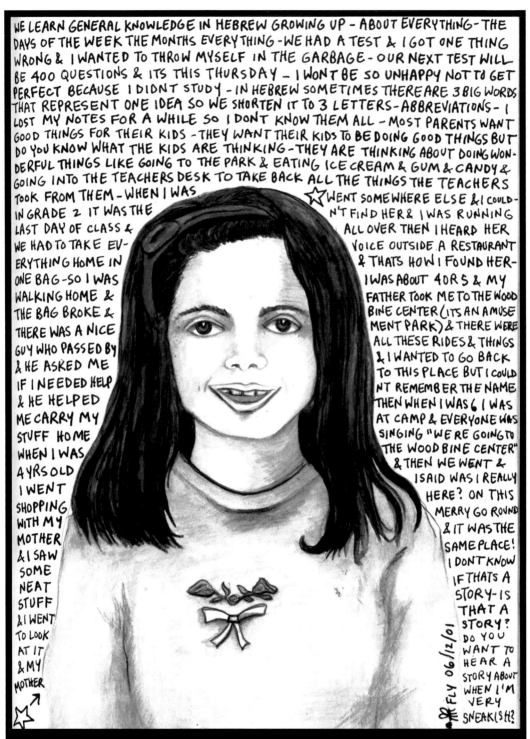

WE LEARN GENERAL KNOWLEDGE IN HEBREW GROWING UP - ABOUT EVERYTHING - THE DAYS OF THE WEEK THE MONTHS EVERYTHING - WE HAD A TEST & I GOT ONE THING WRONG & I WANTED TO THROW MYSELF IN THE GARBAGE - OUR NEXT TEST WILL BE 400 QUESTIONS & ITS THIS THURSDAY - I WONT BE SO UNHAPPY NOT TO GET PERFECT BECAUSE I DIDNT STUDY - IN HEBREW SOMETIMES THERE ARE 3 BIG WORDS THAT REPRESENT ONE IDEA SO WE SHORTEN IT TO 3 LETTERS - ABBREVIATIONS - I LOST MY NOTES FOR A WHILE SO I DONT KNOW THEM ALL - MOST PARENTS WANT GOOD THINGS FOR THEIR KIDS - THEY WANT THEIR KIDS TO BE DOING GOOD THINGS BUT DO YOU KNOW WHAT THE KIDS ARE THINKING - THEY ARE THINKING ABOUT DOING WONDERFUL THINGS LIKE GOING TO THE PARK & EATING ICE CREAM & GUM & CANDY & GOING INTO THE TEACHERS DESK TO TAKE BACK ALL THE THINGS THE TEACHERS TOOK FROM THEM - WHEN I WAS

IN GRADE 2 IT WAS THE LAST DAY OF CLASS & WE HAD TO TAKE EVERYTHING HOME IN ONE BAG - SO I WAS WALKING HOME & THE BAG BROKE & THERE WAS A NICE GUY WHO PASSED BY & HE ASKED ME IF I NEEDED HELP & HE HELPED ME CARRY MY STUFF HOME WHEN I WAS 4 YRS OLD I WENT SHOPPING WITH MY MOTHER & I SAW SOME NEAT STUFF & I WENT TO LOOK AT IT & MY MOTHER

☆ WENT SOMEWHERE ELSE & I COULDN'T FIND HER & I WAS RUNNING ALL OVER THEN I HEARD HER VOICE OUTSIDE A RESTAURANT & THATS HOW I FOUND HER - I WAS ABOUT 4 OR 5 & MY FATHER TOOK ME TO THE WOODBINE CENTER (ITS AN AMUSEMENT PARK) & THERE WERE ALL THESE RIDES & THINGS & I WANTED TO GO BACK TO THIS PLACE BUT I COULDNT REMEMBER THE NAME THEN WHEN I WAS 6 I WAS AT CAMP & EVERYONE WAS SINGING "WE'RE GOING TO THE WOODBINE CENTER" & THEN WE WENT & I SAID WAS I REALLY HERE? ON THIS MERRY GO ROUND & IT WAS THE SAME PLACE! I DONT KNOW IF THATS A STORY - IS THAT A STORY? DO YOU WANT TO HEAR A STORY ABOUT WHEN I'M VERY SNEAKISH?

FLY 06/12/01

WE USED TO HAVE COUSINS WHO LIVED ON THE MOORS - FAR REMOVED COUSINS - THEY LIVED AT KENNYCOOMBS - THAT WAS THE NAME OF THE FARM - THEY HAD ABOUT 3 HORSES - I WOULD RIDE THE ONE HORSE THAT THEY FELT WAS SAFE ENOUGH - I MUST HAVE BEEN 12 OR 13 I GUESS - I WAS BORN NEXT DOOR TO MY GRANDPARENTS HOUSE - WHEN I WAS BORN MY GRANDMOTHER GOT SICK & DIED OF CEREBREAL SPINAL MENENGITIS THEN MY GRANDFATHER WOULDN'T MOVE IN WITH US SO WE MOVED IN WITH HIM - ROSE COTTAGE IS THE NAME OF THE HOUSE WE MOVED INTO - IN TREVELMOND - A VILLAGE NEAR DOBWALLS IN CORNWALL - THE ROADS ALL HAD BIG HEDGES THEY WERE NARROW COUNTRY ROADS WE WOULD CLIMB THE HEDGES & WALK ON THEM & MAKE CAMPS - WE CLIMBED LOTS OF TREES WE WOULD SWING FROM TREE TO TREE & DO LOTS OF CRAZY THINGS - I WOULD HAVE BEEN 7 WHEN THE 2ND WORLD WAR STARTED & THE EVACUEES CAME FROM LONDON FROM A POOR AREA - CAMBERWELL - & THEY OPENED UP A WHOLE NEW WORLD FOR US - WE HAD THE GREATEST FUN! - PEOPLE TOOK THEM INTO THIER HOUSES BUT WE DIDNT HAVE ENOUGH ROOM - WE HAD AN INDIAN FRIEND OF MY MOTHERS STAYING FOR A WHILE - MAYBE ONLY 3 DAYS - NOT WORTH MENTIONING BUT SHE IMPRESSED ME A GREAT DEAL - SHE WAS OF A DIFFERENT WORLD - THE EVACUEES WERE SUCH FUN - THEY WERE SO FULL OF LIFE WE HAD GREAT JOKES - THEY HAD THE CITY MENTALITY & THEY DIDNT KNOW THAT BEANS & PEAS GREW ON STICKS - WE HAD TO MOVE OUT OF OUR SCHOOL - ST. PINOCK & WE WENT TO A PLACE MUCH FURTHER - IT WAS THE RECREATION AREA OF A CHURCH - CONNON - A METHODIST CHURCH - IT WAS A CONSIDERABLE WALK - WE HAD TO MOVE BECAUSE THERE WERE TOO MANY EVACUEES - DURING THE WAR WE WOULD HAVE SCHOOL DINNERS & CERTAIN STUDENTS WOULD HAVE TO HELP WITH WASHING UP - MOSTLY EVACUEES - THEY WERE A BIT OLDER - MY FATHER WAS IN THE HOMEGUARD THEY PATROLED THE AREA - HE WAS UP ON THE MOORS ONCE LOOKING FOR A GERMAN PLANE THAT CAME DOWN & THERE WAS APPARENTLY A GERMAN SOLDIER RUNNING AROUND THE MOORS - PEOPLE WERE EVER SO CONCERNED - IF YOU LOOKED TOWARDS PLYMOUTH DURING THE RAIDS YOU COULD SEE LIGHTS & LOTS OF STUFF COMING DOWN & LOUD BANGS - PLYMOUTH WAS VERY BOMBED - WE WERENT REALLY GETTING BOMBED THATS WHY THE EVACUEES WERE SENT TO US

VISITING MOM IN TORONTO CANADA - WE ARE WATCHING A VERY CHEESEY MOVIE ABOUT GOLF. 06/13/01 FLY.

GLORIA RUTH ORR – 06/13/2K1 – TORONTO

THIS IS MY MOM! – SHE GREW UP IN THE COUNTRYSIDE IN ENGLAND & ALTHOUGH SHE HASNT LIVED THERE FOR A LONG TIME SHE STILL HAS HER PROPER ACCENT & HER GOOD MANNERS UNLIKE US NORTH AMERICAN CRETINS – SHE WOULD BE EMBARRASSED IF I TOLD YOU PERSONAL THINGS ABOUT HER BUT I CAN TELL YOU SHE IS A VERY UNIQUE & INCREDIBLE PERSON & I THINK SHE AFFECTED ME A GREAT DEAL AS A KID – I WAS GIVEN THE FREEDOM TO PURSUE MY CREATIVITY & I WAS EXPOSED TO A LOT OF VERY ALTERNATIVE & SOMETIMES UNSETTLING POINTS OF VIEW – ALL I CAN SAY IS THANKS MOM! I LOVE YOU!

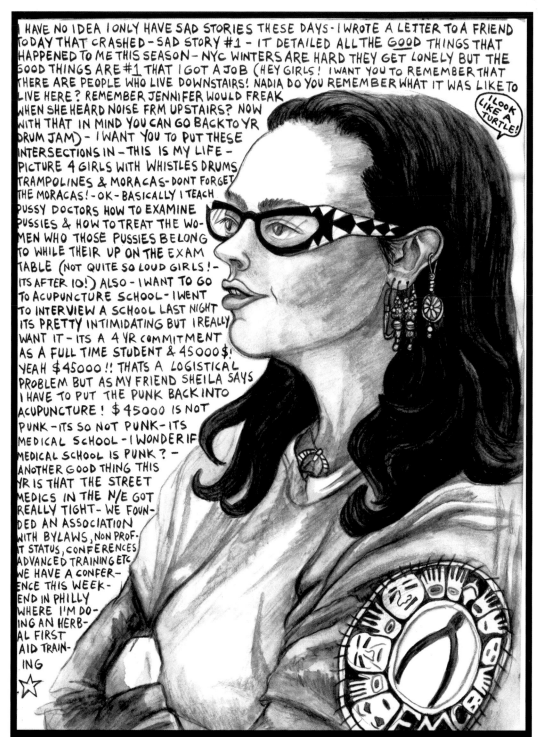

I HAVE NO IDEA I ONLY HAVE SAD STORIES THESE DAYS - I WROTE A LETTER TO A FRIEND TODAY THAT CRASHED - SAD STORY #1 - IT DETAILED ALL THE GOOD THINGS THAT HAPPENED TO ME THIS SEASON - NYC WINTERS ARE HARD THEY GET LONELY BUT THE GOOD THINGS ARE #1 THAT I GOT A JOB (HEY GIRLS! I WANT YOU TO REMEMBER THAT THERE ARE PEOPLE WHO LIVE DOWNSTAIRS! NADIA DO YOU REMEMBER WHAT IT WAS LIKE TO LIVE HERE? REMEMBER JENNIFER WOULD FREAK WHEN SHE HEARD NOISE FRM UPSTAIRS? NOW WITH THAT IN MIND YOU CAN GO BACK TO YR DRUM JAM) - I WANT YOU TO PUT THESE INTERSECTIONS IN - THIS IS MY LIFE - PICTURE 4 GIRLS WITH WHISTLES DRUMS, TRAMPOLINES & MORACAS - DONT FORGET THE MORACAS! - OK - BASICALLY I TEACH PUSSY DOCTORS HOW TO EXAMINE PUSSIES & HOW TO TREAT THE WO-MEN WHO THOSE PUSSIES BELONG TO WHILE THEIR UP ON THE EXAM TABLE (NOT QUITE SO LOUD GIRLS! - ITS AFTER 10!) ALSO - I WANT TO GO TO ACUPUNCTURE SCHOOL - I WENT TO INTERVIEW A SCHOOL LAST NIGHT ITS PRETTY INTIMIDATING BUT I REALLY WANT IT - ITS A 4 YR COMMITMENT AS A FULL TIME STUDENT & 45000 $! YEAH $45000 !! THATS A LOGISTICAL PROBLEM BUT AS MY FRIEND SHEILA SAYS I HAVE TO PUT THE PUNK BACK INTO ACUPUNCTURE! $45000 IS NOT PUNK - ITS SO NOT PUNK - ITS MEDICAL SCHOOL - I WONDER IF MEDICAL SCHOOL IS PUNK? - ANOTHER GOOD THING THIS YR IS THAT THE STREET MEDICS IN THE N/E GOT REALLY TIGHT - WE FOUN-DED AN ASSOCIATION WITH BYLAWS, NON PROF. IT STATUS, CONFERENCES ADVANCED TRAINING ETC WE HAVE A CONFER-ENCE THIS WEEK-END IN PHILLY WHERE I'M DO-ING AN HERB-AL FIRST AID TRAIN-ING

☆

I LOOK LIKE A TURTLE!

FAMOUS - MARCH 2K1 - NYC

WEEELLLLL - I KNEW HER BEFORE SHE WAS FAMOUS - BACK IN THE DAY - SHE S ALWAYS BEEN ONE OF THE COOLEST PEOPLE I KNOW & I HAVE TO APOLOGIZE FOR THE DRAWING BECAUSE IT REALLY ISNT AS BEAUTIFUL AS SHE IS - FAE IS A BADASS SQUATTER BABE - SUPERMOM (SEE PG 137) - STREET MEDIC SUPREME - HERBAL GODDESS - GOURMET - CONSTURCTION QUEEN - & I VE SEEN HER DO SOME AMAZING COREOGRAPHY WITH CHICKEN WIRE IN THE BASEMENT - SHE IS STRAIGHT UP GET SHIT DONE DO IT RIGHT THEN KICK BACK & HAVE FUN!! - SHE KNOWS HOW TO MAKE A HOUSE A HOME

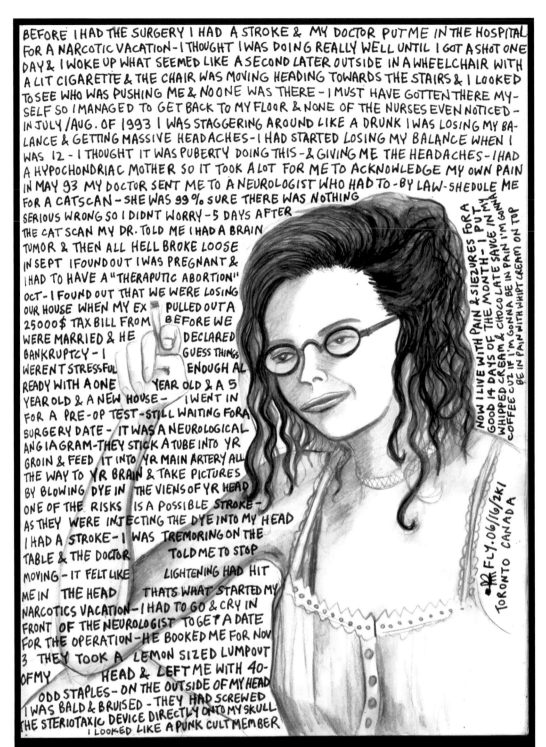

BEFORE I HAD THE SURGERY I HAD A STROKE & MY DOCTOR PUT ME IN THE HOSPITAL FOR A NARCOTIC VACATION - I THOUGHT I WAS DOING REALLY WELL UNTIL I GOT A SHOT ONE DAY & I WOKE UP WHAT SEEMED LIKE A SECOND LATER OUTSIDE IN A WHEELCHAIR WITH A LIT CIGARETTE & THE CHAIR WAS MOVING HEADING TOWARDS THE STAIRS & I LOOKED TO SEE WHO WAS PUSHING ME & NO ONE WAS THERE - I MUST HAVE GOTTEN THERE MYSELF SO I MANAGED TO GET BACK TO MY FLOOR & NONE OF THE NURSES EVEN NOTICED - IN JULY/AUG. OF 1993 I WAS STAGGERING AROUND LIKE A DRUNK I WAS LOSING MY BALANCE & GETTING MASSIVE HEADACHES - I HAD STARTED LOSING MY BALANCE WHEN I WAS 12 - I THOUGHT IT WAS PUBERTY DOING THIS - & GIVING ME THE HEADACHES - I HAD A HYPOCHONDRIAC MOTHER SO IT TOOK A LOT FOR ME TO ACKNOWLEDGE MY OWN PAIN IN MAY 93 MY DOCTOR SENT ME TO A NEUROLOGIST WHO HAD TO - BY LAW - SHEDULE ME FOR A CATSCAN - SHE WAS 99% SURE THERE WAS NOTHING SERIOUS WRONG SO I DIDNT WORRY - 5 DAYS AFTER THE CAT SCAN MY DR. TOLD ME I HAD A BRAIN TUMOR & THEN ALL HELL BROKE LOOSE IN SEPT I FOUND OUT I WAS PREGNANT & I HAD TO HAVE A "THERAPUTIC ABORTION" OCT - I FOUND OUT THAT WE WERE LOSING OUR HOUSE WHEN MY EX PULLED OUT A 25000$ TAX BILL FROM BEFORE WE WERE MARRIED & HE DECLARED BANKRUPTCY - I GUESS THINGS WERENT STRESSFUL ENOUGH ALREADY WITH A ONE YEAR OLD & A 5 YEAR OLD & A NEW HOUSE - I WENT IN FOR A PRE-OP TEST - STILL WAITING FOR A SURGERY DATE - IT WAS A NEUROLOGICAL ANGIAGRAM - THEY STICK A TUBE INTO YR GROIN & FEED IT INTO YR MAIN ARTERY ALL THE WAY TO YR BRAIN & TAKE PICTURES BY BLOWING DYE IN THE VIENS OF YR HEAD ONE OF THE RISKS IS A POSSIBLE STROKE - AS THEY WERE INJECTING THE DYE INTO MY HEAD I HAD A STROKE - I WAS TREMORING ON THE TABLE & THE DOCTOR TOLD ME TO STOP MOVING - IT FELT LIKE LIGHTENING HAD HIT ME IN THE HEAD THATS WHAT STARTED MY NARCOTICS VACATION - I HAD TO GO & CRY IN FRONT OF THE NEUROLOGIST TO GET A DATE FOR THE OPERATION - HE BOOKED ME FOR NOV 3 THEY TOOK A LEMON SIZED LUMP OUT OF MY HEAD & LEFT ME WITH 40-ODD STAPLES - ON THE OUTSIDE OF MY HEAD I WAS BALD & BRUISED - THEY HAD SCREWED THE STERIOTAXIC DEVICE DIRECTLY ONTO MY SKULL I LOOKED LIKE A PUNK CULT MEMBER

NOW I LIVE WITH PAIN & SIEZURES FOR A GOOD 14 DAYS OF THE MONTH - I PUT WHIPPED CREAM & CHOCOLATE SAUCE IN MY COFFEE CUZ IF I'M GONNA BE IN PAIN I'M GONNA BE IN PAIN WITH WHIPT CREAM ON TOP

FLY. 06/16/2K1 TORONTO CANADA

LISA PARTICELLI - 06/16/2K1 - TORONTO - CANADA
LISA IS LIKE A SUPERHERO - WHEN SHE WAS ABOUT 16 SHE HAD TO RUN AWAY & LIVE IN A TENT IN THE WOODS FOR ABOUT 6 MONTHS BECAUSE SOME GUY WAS AFTER HER - SHE HAD TO CATCH FISH TO SURVIVE - LATER SHE TAUGHT HERSELF HOW TO TAKE APART & PUT TOGETHER COMPUTERS SO SHE WORKED AS A COMPUTER TECH - SHE USED TO COME TO THIS PLACE WHERE I WAS WORKING AS ASS. ART. DIC. & SHE WOULD WORK ON OUR MACHINES - AT THE TIME SHE HAD A YOUNG SON - MAX - SHE WOULD COME IN AT NIGHT & WORK TIL THE WEE HOURS & MAX WOULD JUST SLEEP THROUGH IT ALL
(SEE MAX NEXT PAGE)

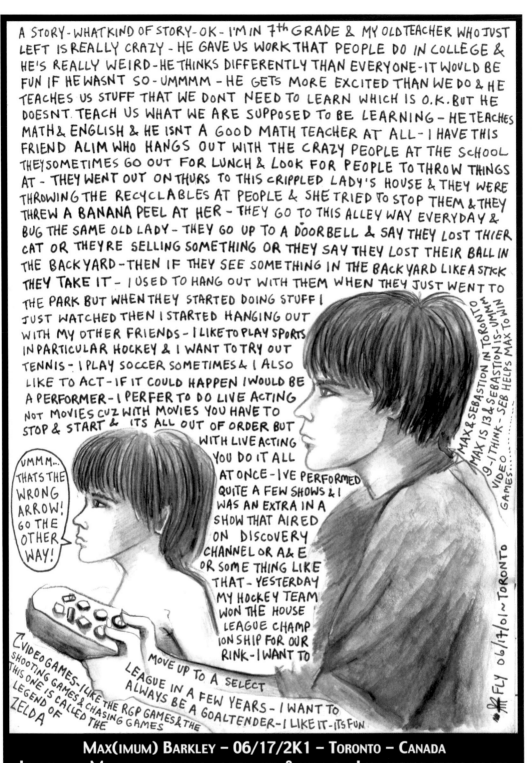

MAX(IMUM) BARKLEY – 06/17/2K1 – TORONTO – CANADA
I FIRST MET MAX WHEN HE WAS A LITTLE KID & HIS MOM LISA WOULD BRING HIM TO WORK WITH HER – I WAS WORKING AT A WEEKLY TABLOID & I WOULD HAVE TO WORK LATE LATE NIGHTS A LOT – LISA WOULD COME IN AT NIGHT TO SERVICE OUR COMPUTERS & SHE WOULD WHEEL HIM IN IN A HUGE STROLLER CUZ HE WAS A PRETTY BIG KID WHICH WAS AMAZING BECAUSE LISA IS SO PETITE – MAX WOULD BE ALL SPRAWLED OUT & NOTHING WOULD WAKE HIM UP – HE WAS 13 WHEN I DREW THIS – ONE OF THE COOLEST KIDS I VE EVER MET – REALLY SWEET & SMART & HE LOVES HIS MAMA!! – MUX@SYMPATICO.CA

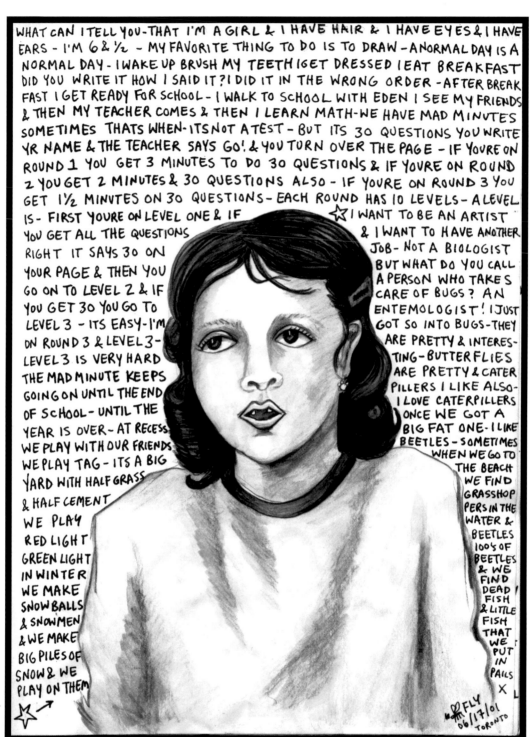

WHAT CAN I TELL YOU - THAT I'M A GIRL & I HAVE HAIR & I HAVE EYES & I HAVE EARS - I'M 6 & ½ - MY FAVORITE THING TO DO IS TO DRAW - A NORMAL DAY IS A NORMAL DAY - I WAKE UP BRUSH MY TEETH I GET DRESSED I EAT BREAKFAST DID YOU WRITE IT HOW I SAID IT?! I DID IT IN THE WRONG ORDER - AFTER BREAK FAST I GET READY FOR SCHOOL - I WALK TO SCHOOL WITH EDEN I SEE MY FRIENDS & THEN MY TEACHER COMES & THEN I LEARN MATH - WE HAVE MAD MINUTES SOMETIMES THATS WHEN - ITS NOT A TEST - BUT ITS 30 QUESTIONS YOU WRITE YR NAME & THE TEACHER SAYS GO! & YOU TURN OVER THE PAGE - IF YOURE ON ROUND 1 YOU GET 3 MINUTES TO DO 30 QUESTIONS & IF YOURE ON ROUND 2 YOU GET 2 MINUTES & 30 QUESTIONS ALSO - IF YOURE ON ROUND 3 YOU GET 1½ MINUTES ON 30 QUESTIONS - EACH ROUND HAS 10 LEVELS - A LEVEL IS - FIRST YOURE ON LEVEL ONE & IF YOU GET ALL THE QUESTIONS RIGHT IT SAYS 30 ON YOUR PAGE & THEN YOU GO ON TO LEVEL 2 & IF YOU GET 30 YOU GO TO LEVEL 3 - ITS EASY - I'M ON ROUND 3 & LEVEL 3 - LEVEL 3 IS VERY HARD THE MAD MINUTE KEEPS GOING ON UNTIL THE END OF SCHOOL - UNTIL THE YEAR IS OVER - AT RECESS WE PLAY WITH OUR FRIENDS WE PLAY TAG - ITS A BIG YARD WITH HALF GRASS & HALF CEMENT WE PLAY RED LIGHT GREEN LIGHT IN WINTER WE MAKE SNOW BALLS & SNOWMEN & WE MAKE BIG PILES OF SNOW & WE PLAY ON THEM

☆ I WANT TO BE AN ARTIST & I WANT TO HAVE ANOTHER JOB - NOT A BIOLOGIST BUT WHAT DO YOU CALL A PERSON WHO TAKES CARE OF BUGS? AN ENTEMOLOGIST! I JUST GOT SO INTO BUGS - THEY ARE PRETTY & INTERES- TING - BUTTERFLIES ARE PRETTY & CATER PILLERS I LIKE ALSO - I LOVE CATERPILLERS ONCE WE GOT A BIG FAT ONE - I LIKE BEETLES - SOMETIMES WHEN WE GO TO THE BEACH WE FIND GRASSHOP PERS IN THE WATER & BEETLES 100's OF BEETLES & WE FIND DEAD FISH & LITTLE FISH THAT WE PUT IN PAILS X L

FLY 06/17/01 TORONTO

NOAH ORR – 06/17/2K1 - TORONTO
I THINK NOAH WAS 5 YEARS OLD WHEN I DREW THIS – I DREW HER AS SHE WAS WATCH- ING A DOCTOR DOLITTLE MOVIE ON TV WHICH IS WHY SHE IS HAS THAT SORT OF BLANK TV EXPRESSION – NOAH IS A VERY TALENTED ARTIST & SHE HAS A VERY SOPHISTICATED SENSE OF HUMOR – SHE IS INCREDIBLY SMART & OBSERVANT – SHE ALWAYS WANTS TO KNOW ALL MY INFORMATION – LIKE WHY DO I HAVE AN EAR RING IN MY LIP? & WHAT ABOUT THAT BIG SPIKE THATS IN MY EAR? & WHY DON T I JUST BUY A NEW PAIR OF SHORTS INSTEAD OF WEARING THOSE BROKEN ONES WITH ALL THE PATCHES ON THEM?

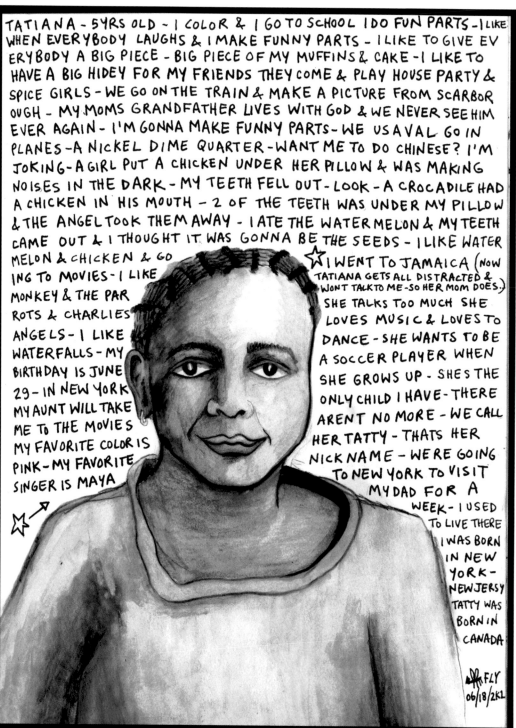

TATIANA CONSTANTINE – 06/18/2K1 – ON THE TRAIN BACK TO NYC
TATIANA WAS SITTING IN THE SEAT IN FRONT OF ME ON MY TRIP BACK TO NEW YORK FROM TORONTO – SHE KEPT TALKING & SINGING & LOOKING AT ME THROUGH THE SEATS – WE ENDED UP HAVING A VERY MIND ALTERING CONVERSATION & THEN WE WERE SITTING TOGETHER & I ASKED IF I COULD DRAW HER – SHE WAS VERY EXCITED ABOUT THIS & SHE WAS VERY GOOD AT SITTING STILL BUT THEN WHEN I WANTED HER TO TALK SHE GOT VERY DISTRACTED BECAUSE ANOTHER LITTLE GIRL HAD COME TO SIT BY US – THIS WAS AN OLDER GIRL WHO THOUGHT SHE KNEW EVERYTHING & SHE WANTED TO TELL US ALL ABOUT IT

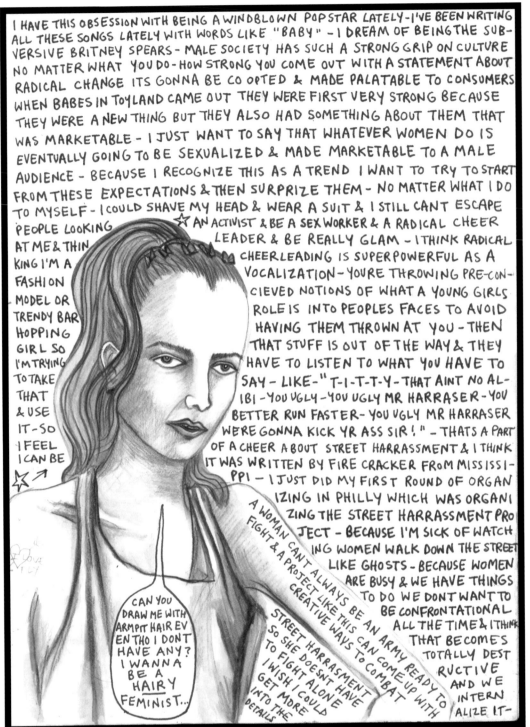

I HAVE THIS OBSESSION WITH BEING A WINDBLOWN POP STAR LATELY - I'VE BEEN WRITING ALL THESE SONGS LATELY WITH WORDS LIKE "BABY" - I DREAM OF BEING THE SUBVERSIVE BRITNEY SPEARS - MALE SOCIETY HAS SUCH A STRONG GRIP ON CULTURE NO MATTER WHAT YOU DO - HOW STRONG YOU COME OUT WITH A STATEMENT ABOUT RADICAL CHANGE ITS GONNA BE CO OPTED & MADE PALATABLE TO CONSUMERS WHEN BABES IN TOYLAND CAME OUT THEY WERE FIRST VERY STRONG BECAUSE THEY WERE A NEW THING BUT THEY ALSO HAD SOMETHING ABOUT THEM THAT WAS MARKETABLE - I JUST WANT TO SAY THAT WHATEVER WOMEN DO IS EVENTUALLY GOING TO BE SEXUALIZED & MADE MARKETABLE TO A MALE AUDIENCE - BECAUSE I RECOGNIZE THIS AS A TREND I WANT TO TRY TO START FROM THESE EXPECTATIONS & THEN SURPRIZE THEM - NO MATTER WHAT I DO TO MYSELF - I COULD SHAVE MY HEAD & WEAR A SUIT & I STILL CANT ESCAPE PEOPLE LOOKING AT ME & THINKING I'M A FASHION MODEL OR TRENDY BAR HOPPING GIRL SO I'M TRYING TO TAKE THAT & USE IT - SO I FEEL I CAN BE

☆ AN ACTIVIST & BE A SEX WORKER & A RADICAL CHEER LEADER & BE REALLY GLAM - I THINK RADICAL CHEERLEADING IS SUPER POWERFUL AS A VOCALIZATION - YOU'RE THROWING PRE-CONCIEVED NOTIONS OF WHAT A YOUNG GIRLS ROLE IS INTO PEOPLES FACES TO AVOID HAVING THEM THROWN AT YOU - THEN THAT STUFF IS OUT OF THE WAY & THEY HAVE TO LISTEN TO WHAT YOU HAVE TO SAY - LIKE - "T-I-T-T-Y - THAT AINT NO ALIBI - YOU UGLY - YOU UGLY MR HARRASER - YOU BETTER RUN FASTER - YOU UGLY MR HARRASER WERE GONNA KICK YR ASS SIR!" - THATS A PART OF A CHEER ABOUT STREET HARRASSMENT & I THINK IT WAS WRITTEN BY FIRE CRACKER FROM MISSISSIPPI - I JUST DID MY FIRST ROUND OF ORGANIZING IN PHILLY WHICH WAS ORGANIZING THE STREET HARRASSMENT PROJECT - BECAUSE I'M SICK OF WATCHING WOMEN WALK DOWN THE STREET LIKE GHOSTS - BECAUSE WOMEN ARE BUSY & WE HAVE THINGS TO DO WE DON'T WANT TO BE CONFRONTATIONAL ALL THE TIME & I THINK THAT BECOMES TOTALLY DESTRUCTIVE AND WE INTERNALIZE IT -

CAN YOU DRAW ME WITH ARMPIT HAIR EVEN THO I DON'T HAVE ANY? I WANNA BE A HAIRY FEMINIST...

A WOMAN CAN'T ALWAYS BE AN ARMY READY TO FIGHT & A PROJECT LIKE THIS CAN COME UP WITH CREATIVE WAYS TO COMBAT STREET HARRASMENT SO SHE DOESNT HAVE TO FIGHT ALONE I WISH I COULD GET MORE INTO THE DETAILS

MARY CHRISTMAS - JUNE - 2K1 - NYC
IT WAS ONE OF THOSE NY HEATWAVE DAYS WHEN I DREW THIS & WE WERE BOTH WILTING & CRANKY - MARY IS ONE OF MY HEROS - SHE IS A RADICAL CHEERLEADER & ALL ROUND STRONG WOMAN WHO DOES NOT WANT TO TAKE ANY SHIT DUE TO HER GENDER (OR DUE TO ANYTHING ELSE FOR THAT MATTER) & SHE HAS THE GUTS TO CALL PEOPLE ON THEIR BULLSHIT - SHE REFUSES TO ALLOW OTHER PEOPLE S HANG UPS & LIMITATIONS STOP HER FROM LIVING HER LIFE TO THE FULLEST - I HAVE MUCH RESPECT & LOVE FOR THIS GIRL! & I WISH SHE WOULD GET MORE SLEEP!

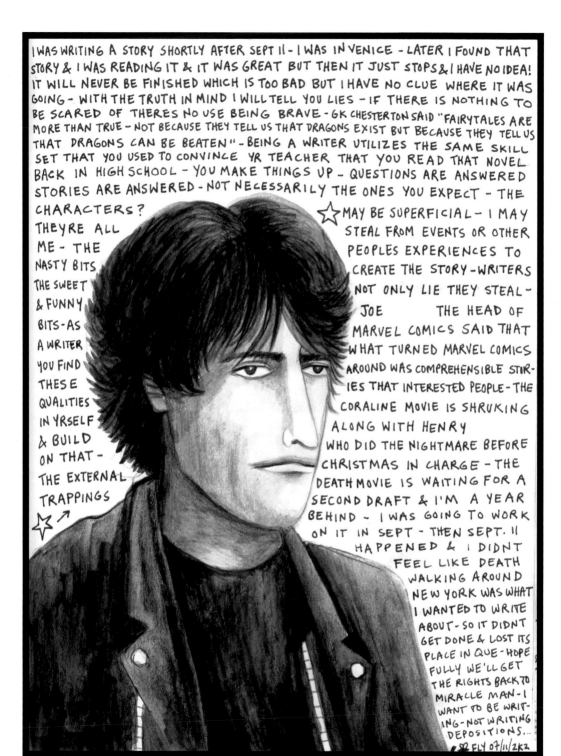

I WAS WRITING A STORY SHORTLY AFTER SEPT 11 - I WAS IN VENICE - LATER I FOUND THAT STORY & I WAS READING IT & IT WAS GREAT BUT THEN IT JUST STOPS & I HAVE NO IDEA! IT WILL NEVER BE FINISHED WHICH IS TOO BAD BUT I HAVE NO CLUE WHERE IT WAS GOING - WITH THE TRUTH IN MIND I WILL TELL YOU LIES - IF THERE IS NOTHING TO BE SCARED OF THERES NO USE BEING BRAVE - GK CHESTERTON SAID "FAIRYTALES ARE MORE THAN TRUE - NOT BECAUSE THEY TELL US THAT DRAGONS EXIST BUT BECAUSE THEY TELL US THAT DRAGONS CAN BE BEATEN" - BEING A WRITER UTILIZES THE SAME SKILL SET THAT YOU USED TO CONVINCE YR TEACHER THAT YOU READ THAT NOVEL BACK IN HIGH SCHOOL - YOU MAKE THINGS UP - QUESTIONS ARE ANSWERED STORIES ARE ANSWERED - NOT NECESSARILY THE ONES YOU EXPECT - THE CHARACTERS?

THEYRE ALL ME - THE NASTY BITS THE SWEET & FUNNY BITS - AS A WRITER YOU FIND THESE QUALITIES IN YRSELF & BUILD ON THAT - THE EXTERNAL TRAPPINGS

MAY BE SUPERFICIAL - I MAY STEAL FROM EVENTS OR OTHER PEOPLES EXPERIENCES TO CREATE THE STORY - WRITERS NOT ONLY LIE THEY STEAL - JOE THE HEAD OF MARVEL COMICS SAID THAT WHAT TURNED MARVEL COMICS AROUND WAS COMPREHENSIBLE STOR-IES THAT INTERESTED PEOPLE - THE CORALINE MOVIE IS SHRUKING ALONG WITH HENRY WHO DID THE NIGHTMARE BEFORE CHRISTMAS IN CHARGE - THE DEATH MOVIE IS WAITING FOR A SECOND DRAFT & I'M A YEAR BEHIND - I WAS GOING TO WORK ON IT IN SEPT - THEN SEPT. 11 HAPPENED & I DIDNT FEEL LIKE DEATH WALKING AROUND NEW YORK WAS WHAT I WANTED TO WRITE ABOUT - SO IT DIDNT GET DONE & LOST ITS PLACE IN QUE - HOPE FULLY WE'LL GET THE RIGHTS BACK TO MIRACLE MAN - I WANT TO BE WRIT-ING - NOT WRITING DEPOSITIONS... SD FLY 07/11/2K2

NEIL GAIMAN – 07/11/2K2 – AT BARNES & NOBLE UNION SQ. – NYC
I FIRST KNEW OF NEIL GAIMAN WHEN I STARTED READING SANDMAN COMICS WHICH HE HAS WRITTEN FOR YEARS – THE STORIES WERE COMPLEX & MESMERIZING & I BECAME A HUGE FAN – THEN I GOT TO MEET HIM ONCE WHEN KELLY BICKMAN WAS HAVING A BOOK-RELEASE PARTY & EXHIBIT OPENING FOR HER NEW COLLECTION OF PHOTOS – NEIL WAS A FRIEND OF HERS & HAD WRITTEN THE INTRO TO HER BOOK SO SHE INTRODUCED ME TO HIM – WELL – I THINK I MIGHT HAVE STUTTERED & TURNED RED & DROOLED – I DONT KNOW – MR. GAIMAN WAS VERY NICE TO ME BUT I MADE A COMPLETE IDIOT OUT OF MYSELF – HONESTLY I DONT USUALLY DO THAT! – FOR REAL

WE WERE JUST IN EUROPE FOR 2 MONTHS & WE MET AMAZING PEOPLE - EUROPE WAS THE FIRST PLACE I HAD EVER TRAVELED WHEN I WAS 16 I WENT THERE AS AN EXCHANGE STUDENT - THIS TIME WE WERE THERE FOR A COUPLE MONTHS - EUROPE IS ALWAYS REALLY PAINFUL FOR ME & I HAVE SPENT YRS THERE BUT IT MAKES ME A LITTLE CRAZY IT ALWAYS SEEMS SO CROWDED - THE FIRST TIME I WENT I WAS SUCH A KID - MY HOST FAMILY KICKED ME OUT - I DROPPED OUT OF SCHOOL & I ATE A LOT OF HASH - IT WAS THE FIRST TIME I WAS AWAY FRM MY TWIN SISTER & WE WOULD WRITE EACH OTHER LONG DETAILED LETTERS - THIS LAST TRIP I WANTED TO GO TO FRANCE & SPEAK FRENCH WE WENT TO AN ANARCHIST BOOK FAIR IN GHENT BELGIUM - I WAS SELLING ZINES & I MET THIS GIRL FRM FRANCE WHOSE BOY FRIEND HAD ALL THE EVIL TWIN STUFF & SHE WAS BUYING SOME FOR HIM SO SHE INVITED US TO HER SQUAT IN DIJON - SO WE WENT IT SEEMED LIKE A STRONG ANARCHIST COMMUNITY - THE SQUAT WAS AN OLD TANNERY OUT OF TOWN THAT STUNK OF CHEMICALS - IT WAS KIND OF NASTY - THERE WERE SOME GUYS THERE WITH A BIZARRE THEORY THEY CALLED THEMSELVES "ANTI-NATURALISTE" THEY WERE LIKE THIS SERIOUS LITTLE INTELLECTUAL SECT - THEY WERE OPPOSED TO A MYSTICAL VIEW OF NATURE

ONE OF THEM HAD READ ALL MY ZINES INCLUDING THE SALMON ZINE & HE HAD WANTED TO MEET ME & TALK TO ME CUZ HE SUSPECTED ME OF HAVING A MYSTICAL VIEW OF NATURE - SOME OF THE EXTREMISTS OF THIS SECT WERE OPPOSED TO PREDATION - ANIMALS WHO EAT OTHER ANIMALS - THEY FELT THIS SHOULD BE STOPPED & ANIMALS SHOULD BE FED SOMETHING ELSE THAT WE NOT HAVE SO MUCH FAITH IN THE ULTIMATE POWER OF NATURE ☆↗

☆ - ALSO THAT WE NOT HAVE SO MUCH FAITH IN OURSELVES - BUT THEY ALSO DIDNT BELIEVE IN GOD SO THERE WASNT MUCH LEFT EXCEPT SCIENCE - THEY BELIEVED IN SCIENCE - THIS WAS VERY DISTURBING - THEY WERE LIKE 23 YR OLD SQUATTER ANARCHIST KIDS & THEY THOUGHT THIS WAS A MORE HUMANE VIEW - WE GOT SENT TO SLEEP IN A BIG MUSTY DORM ROOM - THEN - UNFORTUNATELY - EVERY HALF HOUR MORE DRUNK PEOPLE WOULD BE COMING IN SMOKING & THEIR DOG PEED ON THE FLR - WE DIDNT SLEEP AT ALL - THE NEXT DAY WE HITCH HIKED TO ZURICH & STAYED WITH A FRIEND WHO WORKS IN A BANK - A VERY DIFFERENT SCENE - WE WENT TO A BAR & I GOT CHARGED $25 FOR A GLASS OF WINE!!! I VISITED THE KARL JUNG INSTITUTE - KARL JUNG IS MY HERO - ALL THE JUNGIANS HANG OUT AT THE INSTITUTE THEN WE WENT TO TÜBINGEN WHERE I LIVED WHEN I WAS 16 & VISITED MY BOYFRIEND OF 12 YRS AGO - STAYED WITH HIS ULTRA NURTURING MOTHER WHO WANTED TO FEED US 5 TIMES A DAY ∼∼X ∼☆ FLY∼ 05/10/2K1

AMBER GAYLE — FRM OREGON — 05/10/2K1
BEFORE I MET AMBER I HAD ALREADY MET HER EVIL TWIN STACY IN AMSTERDAM & I HAD READ SOME EVIL TWIN ZINES WHICH WERE MOSTLY AMBER S STORIES & POETRY & STACY S ART & DESIGN — SO I FELT LIKE I KNEW HER ALREADY — I WAS ON TOUR IN THE U.S. WITH GOD IS MY CO-PILOT & AMBER CAME TO THE SHOW IN SEATTLE AT THE O.K. HOTEL — I THOUGHT SHE WAS SO COOL — SHE LOOKED LIKE A WITCH GIRL — I DON T KNOW WHY I THOUGHT THAT — IT WAS LIKE SHE SEEMED TO KNOW SECRETS — IT WAS LIKE SHE HAD SOME STRANGE POWER — WWW.EVILTWINPUBLICATIONS.COM

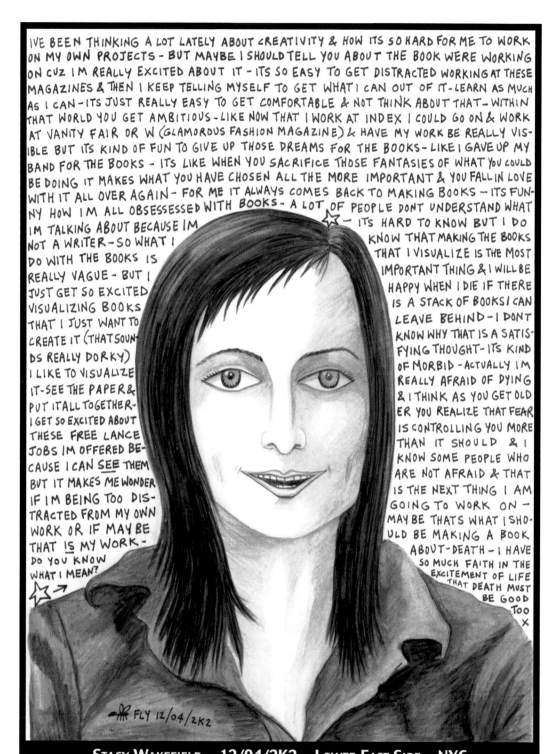

IVE BEEN THINKING A LOT LATELY ABOUT CREATIVITY & HOW ITS SO HARD FOR ME TO WORK ON MY OWN PROJECTS - BUT MAYBE I SHOULD TELL YOU ABOUT THE BOOK WERE WORKING ON CUZ IM REALLY EXCITED ABOUT IT - ITS SO EASY TO GET DISTRACTED WORKING AT THESE MAGAZINES & THEN I KEEP TELLING MYSELF TO GET WHAT I CAN OUT OF IT-LEARN AS MUCH AS I CAN - ITS JUST REALLY EASY TO GET COMFORTABLE & NOT THINK ABOUT THAT- WITHIN THAT WORLD YOU GET AMBITIOUS - LIKE NOW THAT I WORK AT INDEX I COULD GO ON & WORK AT VANITY FAIR OR W (GLAMOROUS FASHION MAGAZINE) & HAVE MY WORK BE REALLY VIS-IBLE BUT ITS KIND OF FUN TO GIVE UP THOSE DREAMS FOR THE BOOKS - LIKE I GAVE UP MY BAND FOR THE BOOKS - ITS LIKE WHEN YOU SACRIFICE THOSE FANTASIES OF WHAT YOU COULD BE DOING IT MAKES WHAT YOU HAVE CHOSEN ALL THE MORE IMPORTANT & YOU FALL IN LOVE WITH IT ALL OVER AGAIN - FOR ME IT ALWAYS COMES BACK TO MAKING BOOKS - ITS FUN-NY HOW IM ALL OBSESSESSED WITH BOOKS - A LOT OF PEOPLE DONT UNDERSTAND WHAT

IM TALKING ABOUT BECAUSE IM NOT A WRITER - SO WHAT I DO WITH THE BOOKS IS REALLY VAGUE - BUT I JUST GET SO EXCITED VISUALIZING BOOKS THAT I JUST WANT TO CREATE IT (THAT SOUN-DS REALLY DORKY) I LIKE TO VISUALIZE IT-SEE THE PAPER & PUT IT ALL TOGETHER- I GET SO EXCITED ABOUT THESE FREE LANCE JOBS IM OFFERED BE-CAUSE I CAN SEE THEM BUT IT MAKES ME WONDER IF IM BEING TOO DIS-TRACTED FROM MY OWN WORK OR IF MAY BE THAT IS MY WORK - DO YOU KNOW WHAT I MEAN?

— ITS HARD TO KNOW BUT I DO KNOW THAT MAKING THE BOOKS THAT I VISUALIZE IS THE MOST IMPORTANT THING & I WILL BE HAPPY WHEN I DIE IF THERE IS A STACK OF BOOKS I CAN LEAVE BEHIND - I DONT KNOW WHY THAT IS A SATIS-FYING THOUGHT - ITS KIND OF MORBID - ACTUALLY IM REALLY AFRAID OF DYING & I THINK AS YOU GET OLD ER YOU REALIZE THAT FEAR IS CONTROLLING YOU MORE THAN IT SHOULD & I KNOW SOME PEOPLE WHO ARE NOT AFRAID & THAT IS THE NEXT THING I AM GOING TO WORK ON — MAY BE THATS WHAT I SHO-ULD BE MAKING A BOOK ABOUT- DEATH - I HAVE SO MUCH FAITH IN THE EXCITEMENT OF LIFE THAT DEATH MUST BE GOOD TOO X

FLY 12/04/2K2

STACY WAKEFIELD – 12/04/2K2 – LOWER EAST SIDE – NYC
I FIRST MET STACY IN AMSTERDAM AT THE LAUNCH PARTY FOR A GORGEOUSLY DESIGNED & HAND–PRINTED BOOK CALLED NOT FOR RENT (INTERVIEWS WITH SQUATTERS & ACTIVISTS COL-LECTIVES ALL OVER THE UK) – STACY & I HAD EXCHANGED LETTERS & WE ALREADY KNEW OF EACH OTHER S WORK BUT I WAS COMPLETELY BLOWN AWAY BY NOT FOR RENT & BY THE OTHER EVIL TWIN PUBLICATIONS SHE GAVE ME – I STAYED IN HER SQUAT – VUUR & VLAMMEN (FIRE & FLAME) & MET HER COOL GIRL SQUAT MATES – STACY CONTINUES TO MAKE BEAUTIFUL BOOKS THAT YOU MUST HAVE – WWW.EVILTWINPUBLICATIONS.COM

I FELT THE NEED TO TRAVEL BECAUSE OF THE MENTAL STAGNATION BROUGHT ON BY TOO MUCH TIME IN NYC & ITS ASSAULT ON THE SENSES - I DECIDED TO GO STRAIGHT NORTH OF NYC - I TOOK A BUS UP TO ALBANY - BELIEVE IT OR NOT BROADWAY GOES ALL THE WAY UP THERE & ITS A CONTINUATION OF NYC BROADWAY AT LEAST THATS WHAT IVE HEARD - I GOT OFF THE BUS IN AL- BANY & I HAD A BACKPACK - I WALKED UP ROUTE 787 FOR A WAYS - I COULDNT GET A RIDE ON THE HIGHWAY - NOBODY WOULD STOP ON THE INTERSTATE - I WALKED TO 378 WHICH WENT TO ROUTE 9 - A BACK ROAD WHERE I COULD HITCH HIKE NORTH AT MY LEISURE - I HALF WALKED & HALF HITCH HIKED UP ROUTE 9 FOR A FEW HOURS & EVENTUALLY GOT TO SARATOGA SPRINGS WHICH IS AN EXPENSIVE BORING TOWN WHERE RICH PEOPLE GO TO GET BORED - THE REALLY COOL THING THEY HAVE IS THE SULFUR SPRINGS - YOU CAN DRINK FROM THEM BUT ITS ONLY RECOMMENDED ONE SWALLOW - IT HAS A CLEANSING EFFECT - PURGES THE SYSTEM - I CONTINUED ALONG ROUTE 9 TO GLENS FALLS WHERE THE HUDSON RIVER GOES THRU & ITS A WATER FALL - I EVENTUALLY MADE IT TO ADIRONDACK STATE PARK - A VAST WILDERNESS - A SEA OF TREES & MOUNTAIN AFTER MOUN TAIN - WHAT I WANTED WAS HIGHWAY IN FRONT OF ME HIGHWAY BEHIND ME & NATURE ON EITHER SIDE - I GOT ON THE INTERSTATE & IN NO TIME AFTER WEA VING IN & OUT OF TRAFFIC AT 80 MPH I GOT TO CHAMPLAIN - GOT A RIDE WITH A COUPLE PRISON GUARDS ON THE WAY & THEN AN OLD GERMAN STONE MASON - I TOLD HIM I COULDNT GO THRU THE BORDER CUZ I HAVE NO I.D. & HE SAYS " YOU CANNOT AVOID THE BORDER!" HE TOLD ME TO GET A RIDE AT A TRUCK STOP THAT A TRUCK DRIVER WOULD TAKE ME ALL THE WAY TO MONT- REAL - I GOT OUT AT THE TRUCK STOP & WALKED SEVERAL HUNDRED METERS THRU THE WOODS - I WAS A COUPLE KILOMETRES S. OF THE BORDER POSTS - I WALKT N.W. THRU ABOUT 1 KM OF FARM LAND OVER FRESHLY MOWED HAY & FIELDS OF GREEN THEN I WALKED THRU MORE WOODS FOR 100's OF METRES THEN I GOT TO A CREEK THAT I TRIED TO WALK ACROSS BUT I SUNK IN THE MUD UP TO MY WAIST - WITH GREAT EFFORT I MANAGED TO EXTRACT MYSELF FRM THE CREEK - MY FINGERNAILS DIGGING IN TO THE ROOTS OF TREES - I GOT ACROSS BY CLIMBING ALONG A TREE THAT GREW HORIZONTALLY ACROSS THE CREEK - I WALKD THRU MORE WOODS & I GOT TO A RIVER 30 METERS WIDE THAT WAS OVER MY HEAD & FLOW- ING SWIFTLY - SO I JUMPT IN WITH MY BACK- PACK & SWAM THE RIVER - ON THE OTHER SIDE IN THE WOODS IT WAS PITCH DARK THO ABOVE THE TREES IT WAS BROAD DAYLIGHT - I SAW SOME MAPLE LEAVES SO I THOUGHT I MUST BE IN CANADA - THEN I GOT TO A

CARY Z – LOWER EAST SIDE – NYC

CARY IS MY DOWNSTAIRS NEIGHBOR – I FIRST MET HIM WHEN I STARTED DOING WORK- DAYS AT THE BUILDING BACK IN 1992 BUT I HAD SEEN HIM BEFORE THAT PLAYING VIOLIN ON THE STREET – CARY REALLY GETS LOST IN THE MUSIC WHEN HE IS PLAYING – AS I WAS DRAWING THIS PORTRAIT HIS BOW WOULD SOMETIMES JUST GO FLYING ACROSS THE ROOM – CARY HAS MORE ENERGY THAN ANYONE I KNOW – HE DOES A LOT OF WORK IN THE BUILDING & THEN RUNS OUT THE DOOR TO HELP SOME ONE ELSE OR TO SPEAK OUT AT A

NOTHER RIVER WHICH WAS EVEN WIDER THAN THE LAST ONE - IT WAS A BRANCH OF THE GREAT CHAZY RIVER - I PLUNGED IN WITH MY BACKPACK & SWAM ACROSS COUGHING UP LUNGFULS OF WATER - I WAS PULLING MY BACKPACK WHICH FLOATED & I WAS TRYING TO REACH THE BRANCHES ON THE FAR SIDE WHEN I TRIED TO GRAB A BRANCH IT BROKE OFF IN MY HAND - I SWAM SOME MORE & GRABBED THE FAT PART OF THE BRANCH & PULLED MYSELF TO SHORE I WAS WONDERING IF I WAS IN CANADA - I GOT TO A ROAD & I ASKED A GUY WHO WAS RIDING HIS MOTORCYCLE ALONG A CORN FIELD - HOW FAR IS CANADA FROM HERE? & HE SAID ITS RIGHT UP THAT ROAD - POINTING TO A DIRT ROAD LEADING INTO THE WOODS - I WALKD THRU THE WOODS FOR A FEW MORE KMs THEN I GOT TO A ROAD & THERE WAS A SIGN THAT SAID " BIERE FROID & VIN " SO I WAS SURELY IN CANADA NOW! - I WALKD TO THE MAIN

ROAD & I GOT A RIDE WITH AN ARAB IM PORTER OF WAT CHES - ALL THE WAY TO DOWNTOWN MONTREAL HE DROP- PED ME OFF

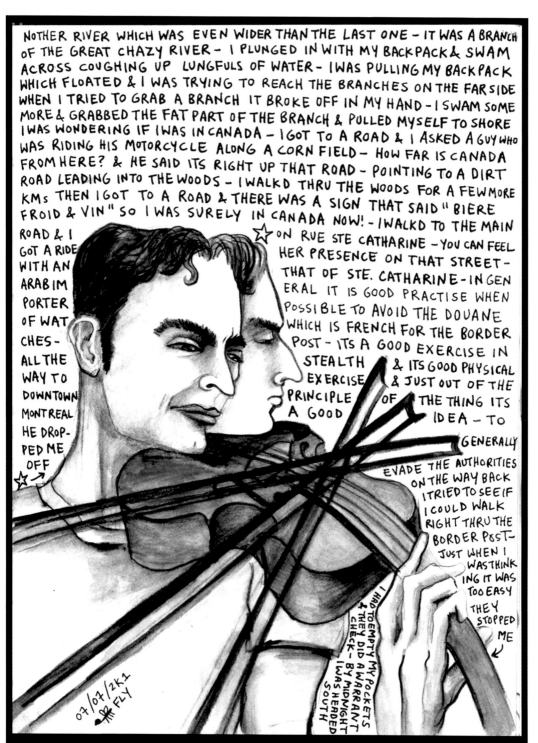

ON RUE STE CATHARINE - YOU CAN FEEL HER PRESENCE ON THAT STREET - THAT OF STE. CATHARINE - IN GEN ERAL IT IS GOOD PRACTISE WHEN POSSIBLE TO AVOID THE DOUANE WHICH IS FRENCH FOR THE BORDER POST - ITS A GOOD EXERCISE IN STEALTH EXERCISE & ITS GOOD PHYSICAL PRINCIPLE & JUST OUT OF THE A GOOD OF THE THING ITS IDEA - TO GENERALLY EVADE THE AUTHORITIES ON THE WAY BACK I TRIED TO SEE IF I COULD WALK RIGHT THRU THE BORDER POST - JUST WHEN I WAS THINK ING IT WAS TOO EASY THEY STOPPED ME

I HAD TO EMPTY MY POCKETS & THEY DID A WARRANT CHECK - BY MIDNIGHT I WAS HEADED SOUTH

07/07/2K1 FLY

DEMO AGAINST OUR OPPRESSIVE REGIME OR TO PLAY VIOLIN ON THE STREET — ONCE I WAS SKATING DOWN FRM UPTOWN & I SAW CARY RUNNING REALLY FAST ALONG THE SIDEWALK JUST WEARING HIS REGULAR CLOTHES — I THINK HE WAS GOING TO RUN ALL THE WAY BACK TO THE LES — ONCE WE HAD TO HAUL 150 CINDERBLOCKS UP TO THE ROOF & CARY WAS LIFTING THEM OVER HIS HEAD & RUNNING UP THE STAIRS — BUT MY FAVORITE THING IS WHEN HE STARTS SINGING WHILE HE S WORKING IN THE BUILDING — HE HAS AN AMAZING REPOTOIRE & THE SOUND CARRIES UP THE AIRSHAFT & ALL THROUGH THE BUILDING

I COME FROM ROCKVILLE MARYLAND & YOU MAY NOT KNOW THIS BUT ROCKVILLE MARYLAND IS JOAN JETT'S HOME TOWN - BEFORE THERE WAS THE RUNAWAYS OR THE BLACK HEARTS THERE WAS MONTGOMERY DONUTS ON ROCKVILLE PIKE HERES THE BOTTOM LINE - MY FIRST GIRL FRIEND'S BROTHER (MAD LAUGHTER) ACTUALLY DATED JOAN JETT (FLY: "GASP!") BUT HERES WHERE IT TAKES A TRAGIC TURN - HE DIED YEARS LATER OF A HEROIN OVER DOSE - THE THING IS THAT YOU HAD TO BE REALLY TOUGH TO DATE JOAN JETT - & DONALD - THAT WAS HIS NAME - FOR ALL OF HIS DRINKING & TALKING & EVEN BULLYING WAS REALLY JUST A LOST KID - I DUNNO - THERES NO MORAL - HMMMMM (PENSIVE LOOK AT THE CEILING) NOW I'M SORT OF THINKING ABOUT IT - SOMETIMES PEOPLE HAVE MISTAKEN ME FOR CHRIS ELLIOT - WHEN I WAS OUT IN L.A. I USE TO DRIVE A CONVERTABLE & PEOPLE WOULD ACTUALLY STOP & TAKE MY PICTURE - BUT BACK TO DONALD - RHONDA - WHO WAS MY GIRLFRIEND - & HIS SISTER - WAS THE OLDEST OF 7 & HER MOM WAS AN ALCOHOLIC & HER DAD USED TO MAKE HER LIE DOWN ON THE FLOOR AT GUN POINT WHILE HE KICKED HER IN THE HEAD - IT WAS KIND OF AN INTENSE DOMESTIC SITUATION & BECAUSE OF THIS SHE BASICALLY RAISED HER BROTHERS & SISTERS & AT DONALDS FUNERAL SHE KEPT SAYING "HE WAS SUCH A SWEET LITTLE BOY & HE NEVER REALLY CHANGED HE NEVER LOST THAT SWEETNESS" THEN SHE WOULD START TO CRY IT WAS LIKE A MOTHER LOSING HER CHILD - IT WAS LIKE SHE HAD FAILED HIM & SHE NEEDED TO KNOW THAT IT WASNT HER FAULT SHE WAS HIS SISTER - NOT HIS MOTHER

WHAT ARE THESE BROWN THINGS?

FLY 07/02/2K1 ANGELIKAS NYC

I THINK THEYRE LENTILS

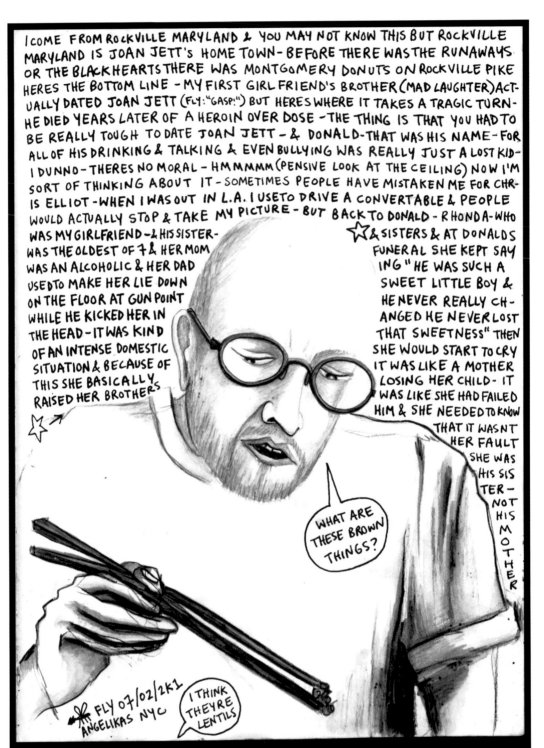

KENT MEREDITH – 07/02/2K1 – NYC

HERE IS A GENTLEMAN WHO APPEARS TO BE NORMAL BUT MOST CERTAINLY IS NOT – HE WORKS IN ANIMATION AND HE S FRIENDS WITH EVERYONE IN THE WORLD WHO MAKES CARTOONS – HE IS CURRENTLY A VOICE DIRECTOR AT CARTOON PIZZA – I GOT TO SIT IN ON SOME SESSIONS IN LA & IT WAS AMAZING TO SEE HIM WORKING WITH THESE KIDS WHO DO THE VOICES OF THE CHARACTERS – I EVEN GOT TO AUDITION MYSELF! WHICH WAS A TONNA FUN BUT I WAS BEING A GROWLY DINOSAUR SO MY THROAT GOT ALL SCRITCHY – KENT ALSO PUTS OUT A ZINE CALLED BIKE CURIOUS

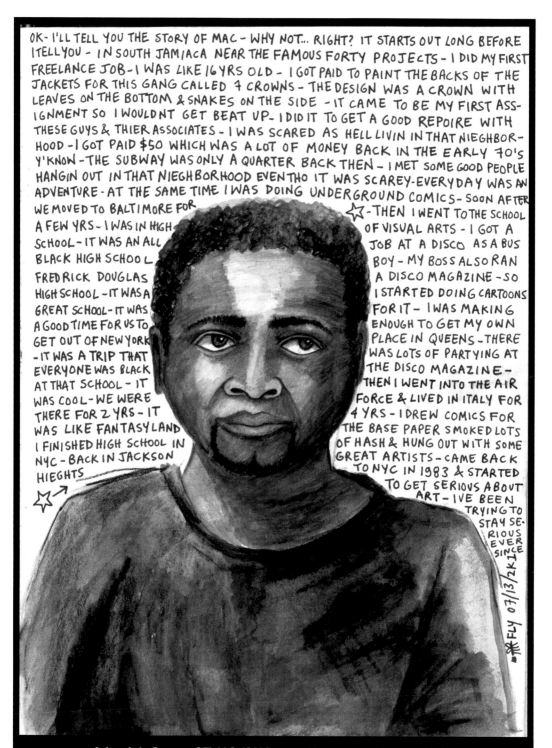

OK- I'LL TELL YOU THE STORY OF MAC - WHY NOT... RIGHT? IT STARTS OUT LONG BEFORE I TELL YOU - IN SOUTH JAMIACA NEAR THE FAMOUS FORTY PROJECTS - I DID MY FIRST FREELANCE JOB - I WAS LIKE 16 YRS OLD - I GOT PAID TO PAINT THE BACKS OF THE JACKETS FOR THIS GANG CALLED 4 CROWNS - THE DESIGN WAS A CROWN WITH LEAVES ON THE BOTTOM & SNAKES ON THE SIDE - IT CAME TO BE MY FIRST ASS-IGNMENT SO I WOULDNT GET BEAT UP - I DID IT TO GET A GOOD REPOIRE WITH THESE GUYS & THIER ASSOCIATES - I WAS SCARED AS HELL LIVIN IN THAT NIEGHBOR-HOOD - I GOT PAID $50 WHICH WAS A LOT OF MONEY BACK IN THE EARLY 70'S Y'KNOW - THE SUBWAY WAS ONLY A QUARTER BACK THEN - I MET SOME GOOD PEOPLE HANGIN OUT IN THAT NIEGHBORHOOD EVEN THO IT WAS SCAREY - EVERYDAY WAS AN ADVENTURE - AT THE SAME TIME I WAS DOING UNDERGROUND COMICS - SOON AFTER

WE MOVED TO BALTIMORE FOR A FEW YRS - I WAS IN HIGH SCHOOL - IT WAS AN ALL BLACK HIGH SCHOOL FREDRICK DOUGLAS HIGH SCHOOL - IT WAS A GREAT SCHOOL - IT WAS A GOOD TIME FOR US TO GET OUT OF NEW YORK - IT WAS A TRIP THAT EVERYONE WAS BLACK AT THAT SCHOOL - IT WAS COOL - WE WERE THERE FOR 2 YRS - IT WAS LIKE FANTASYLAND I FINISHED HIGH SCHOOL IN NYC - BACK IN JACKSON HIEGHTS

☆- THEN I WENT TO THE SCHOOL OF VISUAL ARTS - I GOT A JOB AT A DISCO AS A BUS BOY - MY BOSS ALSO RAN A DISCO MAGAZINE - SO I STARTED DOING CARTOONS FOR IT - I WAS MAKING ENOUGH TO GET MY OWN PLACE IN QUEENS - THERE WAS LOTS OF PARTYING AT THE DISCO MAGAZINE - THEN I WENT INTO THE AIR FORCE & LIVED IN ITALY FOR 4 YRS - I DREW COMICS FOR THE BASE PAPER SMOKED LOTS OF HASH & HUNG OUT WITH SOME GREAT ARTISTS - CAME BACK TO NYC IN 1983 & STARTED TO GET SERIOUS ABOUT ART - IVE BEEN TRYING TO STAY SE-RIOUS EVER SINCE

FLY 07/13/2K1

MAC McGILL – 07/13/2K2 – AT UMBRELLA HAUS – NYC
I DREW THIS DURING A DJ CHROME DANCE PARTY AT UMBRELLA HAUS – MAC WAS VERY SERIOUS ABOUT SITTING VERY STILL – IT WAS GREAT – HE IS ONE OF THE HARDEST WORK-ING ARTISTS I KNOW – YOU MIGHT HAVE SEEN HIS WORK IN WORLD WAR 3 ILLUSTRATED – IF YOU HAVENT YOU SHOULD LOOK FOR IT – INCREDIBLY BEAUTIFUL INTRICATE INK WORK TRUELY WORTH A MILLION WORDS – AN EXQUISITE LARGE SIZE COLLECTION OF LETTERPRESS PRINTS BY MAC McGILL TITLED "IX XI MI" WAS PUBLISHED BY BOOKLYN IN THE WINTER OF 2003 – KATMC3@HOTMAIL.COM – WWW.BOOKLYN.ORG

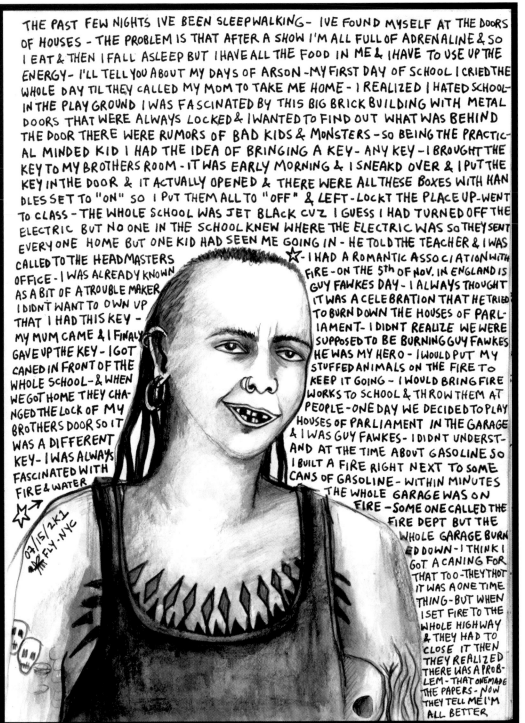

THE PAST FEW NIGHTS IVE BEEN SLEEPWALKING- IVE FOUND MYSELF AT THE DOORS OF HOUSES - THE PROBLEM IS THAT AFTER A SHOW I'M ALL FULL OF ADRENALINE & SO I EAT & THEN I FALL ASLEEP BUT I HAVE ALL THE FOOD IN ME & I HAVE TO USE UP THE ENERGY- I'LL TELL YOU ABOUT MY DAYS OF ARSON - MY FIRST DAY OF SCHOOL I CRIED THE WHOLE DAY TIL THEY CALLED MY MOM TO TAKE ME HOME - I REALIZED I HATED SCHOOL- IN THE PLAYGROUND I WAS FASCINATED BY THIS BIG BRICK BUILDING WITH METAL DOORS THAT WERE ALWAYS LOCKED & I WANTED TO FIND OUT WHAT WAS BEHIND THE DOOR THERE WERE RUMORS OF BAD KIDS & MONSTERS - SO BEING THE PRACTIC- AL MINDED KID I HAD THE IDEA OF BRINGING A KEY - ANY KEY - I BROUGHT THE KEY TO MY BROTHERS ROOM - IT WAS EARLY MORNING & I SNEAKD OVER & I PUT THE KEY IN THE DOOR & IT ACTUALLY OPENED & THERE WERE ALL THESE BOXES WITH HAN DLES SET TO "ON" SO I PUT THEM ALL TO "OFF" & LEFT- LOCKT THE PLACE UP- WENT TO CLASS - THE WHOLE SCHOOL WAS JET BLACK CUZ I GUESS I HAD TURNED OFF THE ELECTRIC BUT NO ONE IN THE SCHOOL KNEW WHERE THE ELECTRIC WAS SO THEY SENT EVERYONE HOME BUT ONE KID HAD SEEN ME GOING IN - HE TOLD THE TEACHER & I WAS

CALLED TO THE HEADMASTERS OFFICE - I WAS ALREADY KNOWN AS A BIT OF A TROUBLE MAKER I DIDNT WANT TO OWN UP THAT I HAD THIS KEY - MY MUM CAME & I FINALY GAVE UP THE KEY - I GOT CANED IN FRONT OF THE WHOLE SCHOOL - & WHEN WE GOT HOME THEY CHA- NGED THE LOCK OF MY BROTHERS DOOR SO IT WAS A DIFFERENT KEY - I WAS ALWAYS FASCINATED WITH FIRE & WATER

07/15/2K1 ☆ FLY-NYC

☆ - I HAD A ROMANTIC ASSOCIATION WITH FIRE - ON THE 5TH OF NOV. IN ENGLAND IS GUY FAWKES DAY - I ALWAYS THOUGHT IT WAS A CELEBRATION THAT HE TRIED TO BURN DOWN THE HOUSES OF PARL- IAMENT - I DIDNT REALIZE WE WERE SUPPOSED TO BE BURNING GUY FAWKES HE WAS MY HERO - I WOULD PUT MY STUFFED ANIMALS ON THE FIRE TO KEEP IT GOING - I WOULD BRING FIRE WORKS TO SCHOOL & THROW THEM AT PEOPLE - ONE DAY WE DECIDED TO PLAY HOUSES OF PARLIAMENT IN THE GARAGE & I WAS GUY FAWKES - I DIDNT UNDERST- AND AT THE TIME ABOUT GASOLINE SO I BUILT A FIRE RIGHT NEXT TO SOME CANS OF GASOLINE - WITHIN MINUTES THE WHOLE GARAGE WAS ON FIRE - SOMEONE CALLED THE FIRE DEPT BUT THE WHOLE GARAGE BURN ED DOWN - I THINK I GOT A CANING FOR THAT TOO - THEY THOT IT WAS A ONE TIME THING - BUT WHEN I SET FIRE TO THE WHOLE HIGHWAY & THEY HAD TO CLOSE IT THEN THEY REALIZED THERE WAS A PROB- LEM - THAT ONE MADE THE PAPERS - NOW THEY TELL ME I'M ALL BETTER

NEIL ROBINSON – 07/15/2K1 – NYC
I DREW THIS WHEN NEIL WAS PASSING THRU TOWN TOURING WITH RESIST & EXIST – I THINK NEIL HAS BEEN PUNK SINCE HE WAS BORN – HE WAS IN SOME OF THOSE LEGENDARY PUNK BANDS LIKE NAUSEA & FINAL WARNING & HE RUNS A RECORD LABEL CALLED TRIBAL WAR – I FIRST MET HIM IN THE LATE 80s / EARLY 90s WHEN HE WAS PART OF THE HARDCORE COLLECTIVE RUNNING SATURDAY MATINEE SHOWS AT ABC NO RIO – I USED TO GIVE HIM THESE FREAKY ARTSY POSTCARDS I MADE & HE ALWAYS SAID THEY WERE GREAT ALTHOUGH HE COULDNT UNDERSTAND WHAT THE FUCK THEY WERE ABOUT

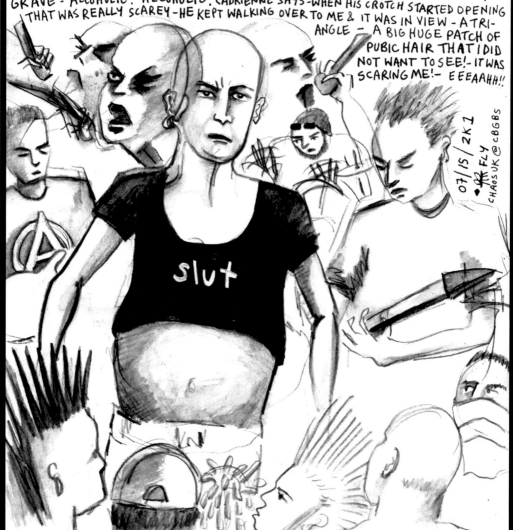

YOU RETARDS ARE SO FULL OF SHIT YOU PUT UP WITH ALL THESE POP BANDS & SAY OH YAH THEY'RE COOL BUT THEY'RE NOT COOL THEY'RE RIPPING YOU OFF NEW YORK NEW YORK - SO SHTEWPIT THEY HAD TO NAME IT TWICE CUZ THEY FORGOT WHERE THEY WERE - THIS T-SHIRT IS SO NEW YORK ITS SO FCKN SHTEWPIT SHE SPENT $400 ON IT - FCKN NEW YORK PUNK - YOU SPEND $400 ON IT - SHTEWPIT FCKN CUNT - BASTARD - FCKN NEW YORK FCKN MORONS - WHY I WASTE MY TIME FCKN COMIN HERE - FCKN CBGBs FCKN BULLSHIT - OH FCKN JOEY RAMONE!! ITS FCKN SHIT - ITS NOT PUNK ROCK - THE ONLY FCKN BAND I WANT IS FRONT & CENTRE FOR THEMSELVES - FCKN IDIOTS - THIS IS OUR LAST SONG OUR LAST SONG THE LAST SONG FOR US - SELL OUT GET OUT ALIVE - 1234! - CELEBRATE MY GRAVE - ALCOHOLIC! ALCOHOLIC! (ADRIENNE SAYS - WHEN HIS CROTCH STARTED OPENING THAT WAS REALLY SCAREY - HE KEPT WALKING OVER TO ME & IT WAS IN VIEW - A TRIANGLE - A BIG HUGE PATCH OF PUBIC HAIR THAT I DID NOT WANT TO SEE! - IT WAS SCARING ME! - EEEAAHH!!

07/15/2K1 FLY CHAOS UK @ CBGBS

CHAOS UK – 07/15/2K1 – CBGB – NYC
THIS IS CHAOS – OF CHAOS UK – HERE TO TELL ALL US RETARDED NEW YORKERS HOW SCHTEEEEEEEEWWWWWWWWWWPIT WE ARE – BUT THATS OK CUZ HE IS HERE TO DEMONSTRATE TO US HOW TO BRING THE AMERICAN CAPITALIST SOCIETY TO ITS KNEES BY GETTING SHITFACED AT CBGB & TELLING EVERYONE WHO PAID MONEY TO SEE HIM THAT THEY ARE IDIOTS – GOOD POINT!!! – AT LEAST I DIDNT HAVE TO PAY SO I DIDN T FEEL LIKE SUCH AN IDIOT – DRUNKS USTED TO BE FUNNY WHEN I WAS DRUNK BUT NOW THEY ARE MOSTLY BORING & DEPRESSING – BUT HELL! THE KIDS WERE LOVIN IT SO IT CAN T BE ALL BAD!

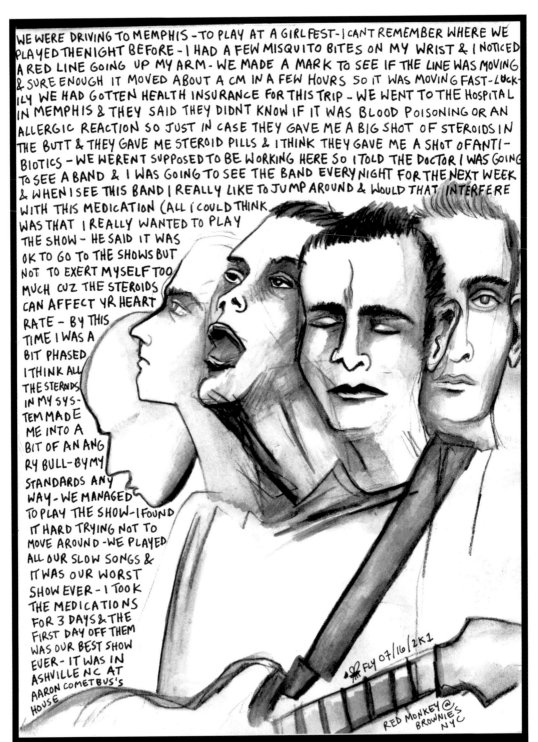

WE WERE DRIVING TO MEMPHIS - TO PLAY AT A GIRLFEST - I CANT REMEMBER WHERE WE PLAYED THE NIGHT BEFORE - I HAD A FEW MISQUITO BITES ON MY WRIST & I NOTICED A RED LINE GOING UP MY ARM - WE MADE A MARK TO SEE IF THE LINE WAS MOVING & SURE ENOUGH IT MOVED ABOUT A CM IN A FEW HOURS SO IT WAS MOVING FAST - LUCKILY WE HAD GOTTEN HEALTH INSURANCE FOR THIS TRIP - WE WENT TO THE HOSPITAL IN MEMPHIS & THEY SAID THEY DIDNT KNOW IF IT WAS BLOOD POISONING OR AN ALLERGIC REACTION SO JUST IN CASE THEY GAVE ME A BIG SHOT OF STEROIDS IN THE BUTT & THEY GAVE ME STEROID PILLS & I THINK THEY GAVE ME A SHOT OF ANTI- BIOTICS - WE WERENT SUPPOSED TO BE WORKING HERE SO I TOLD THE DOCTOR I WAS GOING TO SEE A BAND & I WAS GOING TO SEE THE BAND EVERY NIGHT FOR THE NEXT WEEK & WHEN I SEE THIS BAND I REALLY LIKE TO JUMP AROUND & WOULD THAT INTERFERE WITH THIS MEDICATION (ALL I COULD THINK WAS THAT I REALLY WANTED TO PLAY THE SHOW - HE SAID IT WAS OK TO GO TO THE SHOWS BUT NOT TO EXERT MYSELF TOO MUCH CUZ THE STEROIDS CAN AFFECT YR HEART RATE - BY THIS TIME I WAS A BIT PHASED I THINK ALL THE STEROIDS IN MY SYS- TEM MADE ME INTO A BIT OF AN ANG RY BULL - BY MY STANDARDS ANY WAY - WE MANAGED TO PLAY THE SHOW - I FOUND IT HARD TRYING NOT TO MOVE AROUND - WE PLAYED ALL OUR SLOW SONGS & IT WAS OUR WORST SHOW EVER - I TOOK THE MEDICATIONS FOR 3 DAYS & THE FIRST DAY OFF THEM WAS OUR BEST SHOW EVER - IT WAS IN ASHVILLE NC AT AARON COMETBUS'S HOUSE

FLY 07/16/2K1

RED MONKEY @ BROWNIES NYC

PETE DALE – RED MONKEY – (FRM NEWCASTLE–UPON–TYNE, UK) – NYC
I FIRST MET PETE ON A GOD IS MY CO–PILOT TOUR WHEN HE WAS IN A BAND WITH RACHAEL (SEE NEXT PAGE) CALLED AVOCADO BABY – IT WAS JUST GUITAR & KEYBOARD & VOCALS & A FEW OTHER RANDOM INSTRUMENTS – THEIR SONGS WERE REALLY SIMPLE & SWEET & DIRECT & THEY WERE BOTH SO CUTE!!! PETE HAS THE MOST AMAZING EARS I VE EVER SEEN – WHEN WE PLAYED A SHOW WITH THEM IN NEWCASTLE THEY MADE US AN ENORMOUS POT OF SPAGHETTI – WE STAYED AT THEIR HOUSE WHICH WAS ALSO THE HEAD– QUARTERS OF SLAMPT – THEIR RECORD LABEL – SLAMPT@CLARA.NET

I'LL TELL YOU ABOUT WHY WE GOT A PO BOX - THIS GUY JUST TURNED UP ON OUR DOOR STEP ONE TIME - THIS WAS WHEN SLAMPT WAS A REALLY LITTLE LABEL & WE HADN'T DONE MUCH - HE WAS LIKE A TEENAGER FRM PRESTON & HE'D JUST HAD A FIGHT WITH HIS FATHER - HE WAS 18 & WORKED IN HIS DADS SHOP - HE DECIDED TO DROP ACID & GET ON THE TRAIN & COME TO NEWCASTLE WHERE HED NEVER BEEN BEFORE - SO HE JUST TURNED UP ON OUR DOORSTEP & WE HAD NEVER MET HIM - WE WERE ON OUR WAY TO A GIG - WE FELT WE HAD TO BE POLITE & ENTERTAIN HIM & WE ASKD HIM IF HE WANTED TO COME TO THE SHOW & I THINK WE ACTUALLY FED HIM & GAVE HIM CUPS OF TEA - WE GOT BACK FROM THE SHOW & OUR FRIEND KID LEMON WAS STAYING WITH US & HE STAYED UP ALL NIGHT WITH THIS KID - HE WAS SCARED TO SLEEP CUZ THE KID KEPT TELLING HIM THAT MARKY SMITH FRM THE FALL WAS THE MESSIAH - EVENTUALLY GOT RID OF HIM IN THE MORNING NOTHING BAD HAPPENED IT WAS JUST A BIT UNSETTLING - SO WE DECIDED TO GET A PO BOX - THE KID ENDED UP SENDING US A SUPER 8 CAMERA CUZ PETE HAD MENTIONED HE WANTED ONE

FLY 07/16·2K1 RED MONKEY @ BROWNIES NYC

RACHAEL HOLBOROW – RED MONKEY – 07/16/2K1 – (FRM NEWCASTLE, UK)
I MET RACHAEL THE SAME TIME I MET PETE – AVOCADO BABY WAS OPENING FOR US FOR SOME SHOWS IN HOLLAND & WE ALL JUST FELL IN LOVE WITH THEM – LATER WHEN WE WERE TOURING THROUGH THE UK THEY SET UP A SHOW FOR US IN NEWCASTLE IN A PUB – ONCE AGAIN THEY OPENED FOR US BUT IT WAS THEIR NEW BAND RED MONKEY – THIS TIME THEY HAD A DRUMMER – THEY WERE ALL WEARING RED SHIRTS & ROCKIN OUT BUT THEY WERE STILL VERY SWEET – RACHAEL IS ALSO AN AMAZING VISUAL ARTIST – SHE DRAWS FANTASTIC & UNUSUAL PEOPLE & CREATURES – HTTP://REDMONKEY.KAYUZA.COM/

CANADIAN TOUR IN '96 WE WENT FROM VANCOUVER TO HALIFAX-
BAD IDEA! - WE GOT FOLLOWED BY COPS IN ALBERTA - THEY FOLLOWED US
EVERYWHERE - THEY KNEW OUR NAMES & KEPT WANTING TO KNOW WHAT WE
WERE STILL DOING IN THE PROVINCE CUZ WERENT WE TOLD TO LEAVE? OH-
ALSO WE HAD TO DRIVE THRU A CORNFEILD TO GET INTO CANADA CUZ WE WERE
ALL ILLEGAL - THE BAND'S NAME WAS FUCKFACE - WE HAD A SHOW IN SAULT
SAINT MARIE CUZ THERE IS NUTHIN BTWN ALBERTA & TORONTO- THIS METAL BAND
SAID THEY WOULD SET UP A PARTY FOR US TO PLAY AT & FEED US - WE WERE
INSTRUCTED TO GO TO A GAS STN. JUST OUTSIDE TOWN & ASK FOR SPARKY WHICH
WE DID - THE GUY JUST STARTED SCREAMING OUTSIDE FOR SPARKY AT THE TOP OF HIS
LUNGS & THEN THIS 40 SUMTHIN METH-CASE BIKER LOOKIN DUDE WALKS OUT OF A
TRAILER - WE SAY WE'RE FUCKFACE & HE GRUNTS & GETS ON HIS HARLEY & WE
FOLLOW HIM LITERALLY INTO THE WOODS - WAY TOO FAST ON A WINDY ROAD FOR
3 OR 4 MILES TILL HE STOPS AT SOME DRIVEWAY- THERE IS A SIGN THAT SAYS -

"GRIZZLY PAT'S TOUR GUIDES"
DOWN A GRAVEL ROAD WE COME
TO 2 SHACKS IN THE TREES
ONE GUY IS CHOPPIN WOOD
BLASTING METAL MUSIC
THIS GUY IS OUR CONTACT
WHO SET UP THE "SHOW"
AS WE'RE INTRODUCING
OTHER PEOPLE STARTED
COMIN OUT OF THE SHACKS
ALL BIG REDNECK METAL
TYPES- WE WILL BE PLAYING
AT THE METAL DRUMMER'S
HOUSE WHICH WAS BUILT BY ALL
THESE GUYS - WE ARE VERY HUN-
GRY BY
NOW
&
WISH
ING
FOR
THE
PROMISED
FOOD
☆↗

⭐ EVENTUALLY WE GO TO THE HOUSE
WHERE WE'LL BE PLAYING - A
LOG CABIN - THE PEOPLE AT THE
PARTY ARE ALL THE GUYS WEVE
BIN HANGIN OUT WITH PLUS
GRIZZLY PAT- A LIFE LONG
BIKER WITH GANGRENE
IN HIS LEG-WAITING FOR
AN AMPUTATION - PLUS
THER WAS A HUGE COP NAMED
RODDY - THERE WAS LOTS OF
BEER NO FOOD & WE HAD TO
ENDURE JOKES ABOUT NIGGERS
& FAGGOTS AS EVERYONE GOT
DRUNKER & THEY TOLD US
ABOUT THE P.C. FAGGOT PUNKS
WHO PUT ON SHOWS IN TOWN
& GET 2 OR 3 HUNDRED
PEOPLE BUT WERENT WE
GLAD WE WERE HANGIN
OUT WITH THE COOL
PEOPLE ?- WE WERE
REALLY UNCOM-
FORTABLE-WHEN
THEY WERE DRUNK
ENUFF THIER
METAL BAND
PLAYED & THEY
SUCKT- I WENT
UP STAIRS TO
USE THE BATH
ROOM- & I DONT
KNOW WHY BUT
I HAD TO →

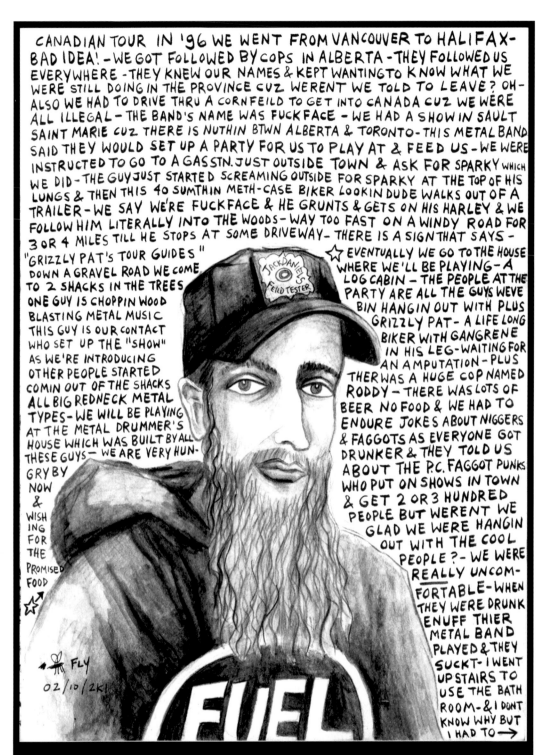

FLY
02/10/2K1

FUEL

ROBERT COLLINS – FEB 2K1 – OAKLAND
ROBERT IS THE SKANKY WHITE TRASH CATTLE RUSTLIN HUSBAND OF THE INFAMOUS ROADIE
GIRL KAROLINE & BASS PLAYER FOR WHAT HAPPENS NEXT (AWESOME PUNK ROCK BAND
– I LOVE THESE GUYS!!!) – THEY TOOK ME TO SEE WILLIE NELSON ON MY BIRTHDAY &
WILLIE SANG FOR LIKE 3 HOURS! WITHOUT TAKING A BREAK & HE THREW HIS HAT TO
ME! THAT WAS AN INCREDIBLE NIGHT – THEY ALSO TOOK ME HIKING IN THE LUSCIOUSLY
BEAUTIFUL MUIR WOODS IN THE POURING RAIN – THEY BOUGHT ME CAKE & ICE CREAM &

MASTURBATE RIGHT AT THAT MOMENT - THE DOOR WAS LOCKT - I WAS TAKIN CARE OF MY BIZNIZ MILKIN THE CHICKEN WHEN I ALMOST REACHED MY CLIMATE I WAS STANDIN IN FRONT OF THE SINK SO I FIGURED THIS WAS CONVENIENT FOR CLEAN UP - AS I WAS EJACULATING THE METAL DRUMMERS WIFE WALKED IN WITHOUT KNOCKING - SO SHE GOT TO SEE ME SPLOOGING IN HER SINK - WE MADE BRIEF EYE CONTACT - SHE LOOKED HORRIFIED - I WAS PETRIFIED - SHE CLOSED THE DOOR & WALKT OFF - I FINISHED UP & HURRIED DOWNSTAIRS TO TELL MY COMRADES WHAT HAD HAPPENED IN CASE WE MIGHT HAVE TO LEAVE IN A HURRY - EVERYONE DECIDES TO STAY & WE START PLAYING BUT THESE GUYS KEEP GRABBING OUR GUITARS CUZ THEY WANT TO JAM - THEN AT SOME POINT RODDY - THE HUGE COP - HAS HIS PANTS DOWN & IS TRYING TO HUMP MATT (OUR SINGER) THIS ASSHOLE HAS BEEN MAKING HOMOPHOBIC JOKES ALL NIGHT & NOW HE'S TRYING TO BUGGER OUR SINGER - IN FRONT OF EVERYONE - I NOTICED THE DRUMMER TALKING TO HIS WIFE & THEN HE GOT IN HIS CAR & DROVE AWAY - WE DIDN'T SEE THE WIFE FOR THE REST OF THE NIGHT - THE "SHOW" IS OVER EVERYONE IS WASTED - WE GET INTO A CONVERSATION WITH GRIZZLY PAT & SPARKY ABOUT SPEED & THEY TELL US HOW BAD IT IS & IT WILL KILL US THEN WE ASK IF THEY CAN GET US SOME & THEY SAY SURE - SPARKY GOES TO GET THE SPEED & WE HEAD TO GRIZZLY PATS FOR THE PROMISED FOOD - EVERYBODY FROM THE PARTY COMES TO GRIZZLY PATS & THERE IS 8 EARS OF RAW CORN FOR ALL OF US TO SHARE - WE EACH GOT HALF AN EAR ALL OUR HOSTS ARE STILL DRUNK - HOOTIN & HOLLERIN & BLASTING METAL MUSIC - WE ARE ALL WANTING TO GO TO SLEEP - THE PLACE WE ARE AT IS ON A PEIR & ITS REALLY BEAUTIFUL - I WENT TO SLEEP & A COUPLE HOURS LATER WOKEN UP BY A MOTORCYCLE REVING REALLY LOUD & SPARKY YELLING FOR HELP & OUR HOSTS ARE ALL STILL PARTYING & LAFFING AT SPARKY - SOON SPARKY EMERGES FROM THE WOODS COVERED IN MUD WITH INSANE EYES & A KNIFE IN ONE HAND SCREAMING - "MUTHERFCKR WHEN I SAY COME N HELP ME I MEAN COME N FCKN HELP ME!!" THEY ALL STARTED FIGHTING & I JUST WENT BACK TO SLEEP - I HAVE NO IDEA WHAT THE OUTCOME OF THE FIGHT WAS I JUST KNOW WE DIDN'T GET OUR DRUGS WE GOT UP THE NEXT MORNING & ALL OUR HOSTS WERE CRASHD OUT - WE LEFT WITHOUT SAYING GOOD BYE... WE WERE IN CANADA FOR 3½ WEEKS (WHICH WAS THE BEGINNING OF 6 MONTHS OF CONSTANT TOURING) - WE WERE SUPPOSED TO PLAY IN NEWFOUNDLAND AT THE END WHICH WOULD HAVE BEEN COOL CUZ WE WOULD HAVE GONE FROM ONE END OF CANADA TO THE OTHER BUT WE COULDNT AFFORD TO GET ON A FERRY...

PATCHES & DINNER – ROBERT WAS MAKING ME LAUGH SO HARD MY FACE HURT & HE COULDNT STOP FARTING – WHEN THEY WERE LIVING AT THE PUNKS WITH PRESSES WARE-HOUSE THEY HAD A GORGEOUS VARNISHED WOOD PORTO-POTTY IN THEIR ROOM THAT ROBERT S MOM MADE FOR THEM IN A WOOD WORKING SHOP CUZ THE COMMUNAL BATH-ROOM WAS SO FAR AWAY & THROUGH LOCKED DOORS – THEN THEY MOVED TO WISCON-SIN!?!? – I HAVEN T BEEN TO THEIR HOUSE YET BUT I KNOW IT MUST HAVE A "WILLIE WOOM" & AT LEAST 3 VELVET WILLIE PAINTINGS – IAMAVERYBADMAN@HOTMAIL.COM

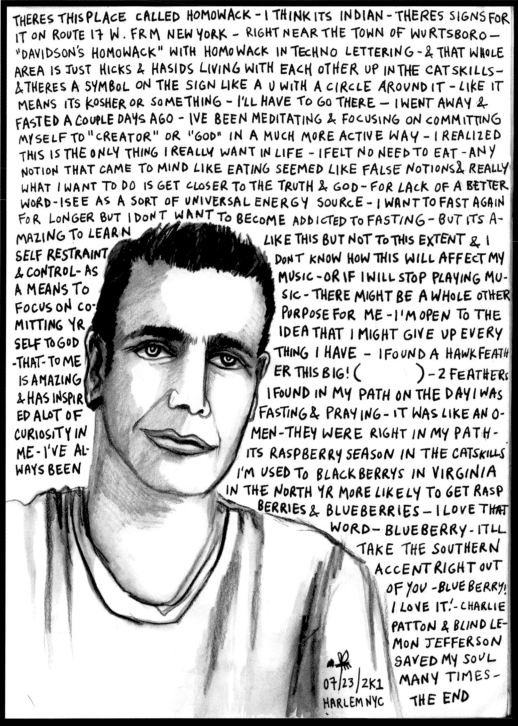

THERES THIS PLACE CALLED HOMOWACK - I THINK ITS INDIAN - THERES SIGNS FOR IT ON ROUTE 17 W. FRM NEW YORK - RIGHT NEAR THE TOWN OF WURTSBORO — "DAVIDSON'S HOMOWACK" WITH HOMOWACK IN TECHNO LETTERING - & THAT WHOLE AREA IS JUST HICKS & HASIDS LIVING WITH EACH OTHER UP IN THE CATSKILLS - & THERES A SYMBOL ON THE SIGN LIKE A U WITH A CIRCLE AROUND IT - LIKE IT MEANS ITS KOSHER OR SOMETHING - I'LL HAVE TO GO THERE — I WENT AWAY & FASTED A COUPLE DAYS AGO - IVE BEEN MEDITATING & FOCUSING ON COMMITTING MYSELF TO "CREATOR" OR "GOD" IN A MUCH MORE ACTIVE WAY - I REALIZED THIS IS THE ONLY THING I REALLY WANT IN LIFE - I FELT NO NEED TO EAT - ANY NOTION THAT CAME TO MIND LIKE EATING SEEMED LIKE FALSE NOTIONS & REALLY WHAT I WANT TO DO IS GET CLOSER TO THE TRUTH & GOD - FOR LACK OF A BETTER WORD - I SEE AS A SORT OF UNIVERSAL ENERGY SOURCE - I WANT TO FAST AGAIN FOR LONGER BUT I DON'T WANT TO BECOME ADDICTED TO FASTING - BUT ITS A- MAZING TO LEARN SELF RESTRAINT & CONTROL - AS A MEANS TO FOCUS ON CO- MITTING YR SELF TO GOD - THAT - TO ME IS AMAZING & HAS INSPIR ED A LOT OF CURIOSITY IN ME - I'VE AL- WAYS BEEN

LIKE THIS BUT NOT TO THIS EXTENT & I DON'T KNOW HOW THIS WILL AFFECT MY MUSIC - OR IF I WILL STOP PLAYING MU- SIC - THERE MIGHT BE A WHOLE OTHER PURPOSE FOR ME - I'M OPEN TO THE IDEA THAT I MIGHT GIVE UP EVERY THING I HAVE - I FOUND A HAWK FEATH ER THIS BIG! () - 2 FEATHERS I FOUND IN MY PATH ON THE DAY I WAS FASTING & PRAYING - IT WAS LIKE AN O- MEN - THEY WERE RIGHT IN MY PATH - ITS RASPBERRY SEASON IN THE CATSKILLS I'M USED TO BLACKBERRYS IN VIRGINIA IN THE NORTH YR MORE LIKELY TO GET RASP BERRIES & BLUEBERRIES - I LOVE THAT WORD - BLUEBERRY - ITLL TAKE THE SOUTHERN ACCENT RIGHT OUT OF YOU - BLUEBERRY! I LOVE IT! - CHARLIE PATTON & BLIND LE- MON JEFFERSON SAVED MY SOUL MANY TIMES - THE END

07/23/2K1
HARLEM NYC

STEPHAN SMITH – 07/23/2K1 – HARLEM – NYC
I FIRST MET STEPHAN WHEN HE SHOWED UP AT THE GARGOYLE MECHANIQUE LAB OPEN MIC WHICH I WAS EMCEEING IN THE EARLY 1990s – HIS NAME THEN WAS STEPHAN SAID (SAH- EED) & HE TOTALLY BLEW EVERYONE AWAY WITH HIS GUITAR PLAYING & AMAZING SONGS & FIDDLE PLAYING – STEPHAN IS GREAT CUZ HE GETS SO TOTALLY EXCITED ABOUT WHAT HE S DOING & ITS EXTREMELY INFECTIOUS – BACK AROUND 92 HE WAS HOMELESS & USED TO CRASH ON THE FLOOR OF MY SQUAT – MY SPACE WAS REALLY SMALL & DOG BOY WAS THERE TOO & THEN I GOT ALL PMS & SCARED THE PANTS OFFA THEM – WWW.STEPHANSMITH.COM

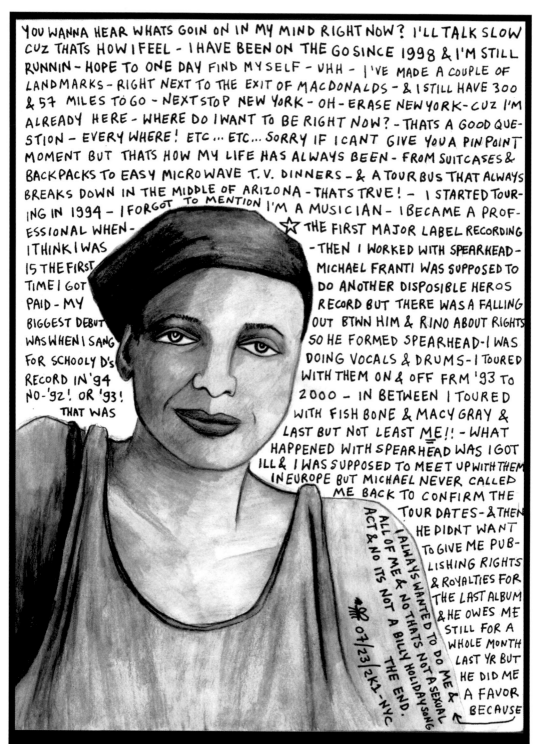

YOU WANNA HEAR WHATS GOIN ON IN MY MIND RIGHT NOW? I'LL TALK SLOW CUZ THATS HOW I FEEL - I HAVE BEEN ON THE GO SINCE 1998 & I'M STILL RUNNIN - HOPE TO ONE DAY FIND MYSELF - UHH - I'VE MADE A COUPLE OF LANDMARKS - RIGHT NEXT TO THE EXIT OF MACDONALDS - & I STILL HAVE 300 & 57 MILES TO GO - NEXT STOP NEW YORK - OH - ERASE NEW YORK - CUZ I'M ALREADY HERE - WHERE DO I WANT TO BE RIGHT NOW? - THATS A GOOD QUE-STION - EVERY WHERE! ETC ... ETC ... SORRY IF I CANT GIVE YOU A PIN POINT MOMENT BUT THATS HOW MY LIFE HAS ALWAYS BEEN - FROM SUITCASES & BACKPACKS TO EASY MICROWAVE T.V. DINNERS - & A TOUR BUS THAT ALWAYS BREAKS DOWN IN THE MIDDLE OF ARIZONA - THATS TRUE! - I STARTED TOUR-ING IN 1994 - I FORGOT TO MENTION I'M A MUSICIAN - I BECAME A PROF-ESSIONAL WHEN - ☆ THE FIRST MAJOR LABEL RECORDING I THINK I WAS - THEN I WORKED WITH SPEARHEAD - 15 THE FIRST MICHAEL FRANTI WAS SUPPOSED TO TIME I GOT DO ANOTHER DISPOSIBLE HEROS PAID - MY RECORD BUT THERE WAS A FALLING BIGGEST DEBUT OUT BTWN HIM & RINO ABOUT RIGHTS WAS WHEN I SANG SO HE FORMED SPEARHEAD - I WAS FOR SCHOOLY D's DOING VOCALS & DRUMS - I TOURED RECORD IN '94 WITH THEM ON & OFF FRM '93 TO NO - '92! OR '93! 2000 - IN BETWEEN I TOURED THAT WAS WITH FISH BONE & MACY GRAY & LAST BUT NOT LEAST ME!! - WHAT HAPPENED WITH SPEARHEAD WAS I GOT ILL & I WAS SUPPOSED TO MEET UP WITH THEM IN EUROPE BUT MICHAEL NEVER CALLED ME BACK TO CONFIRM THE TOUR DATES - & THEN HE DIDNT WANT TO GIVE ME PUB-LISHING RIGHTS & ROYALTIES FOR THE LAST ALBUM & HE OWES ME STILL FOR A WHOLE MONTH LAST YR BUT HE DID ME A FAVOR BECAUSE

I ALWAYS WANTED TO DO ME & ALL OF ME & NO THATS NOT A SEXUAL ACT & NO ITS NOT A BILLY HOLIDAY SONG THE END. 07/23/2K1 - NYC

MARY "SO VERY" HARRIS - 07/23/2K1 - HARLEM - NYC
I MET MARY WHEN SHE STARTED DRUMMING & SINGING WITH STEPHAN SMITH - WOW!
- SHE IS A SUPER-FUNKY GIRL WITH THIS HUGE POWERFUL VOICE THAT CAN TOTALLY
KNOCK OFF YR SOCKS - SHE HAS PERFORMED & TOURED WITH FISH BONE & SPEARHEAD
- WOW! - PLUS SHE S DONE A MILLION OTHER AMAZING THINGS & I CANT WAIT TO HEAR
HER SOLO ALBUM - & ON TOP OF ALL THAT SHE S REALLY FUN TO HANG OUT WITH - SHE
IS ONE OF THOSE PEOPLE WHO SEEMS SO CHILL & RELAXED & NEVER IN A HURRY BUT
THEN SHE ACCOMPLISHES SO MUCH!

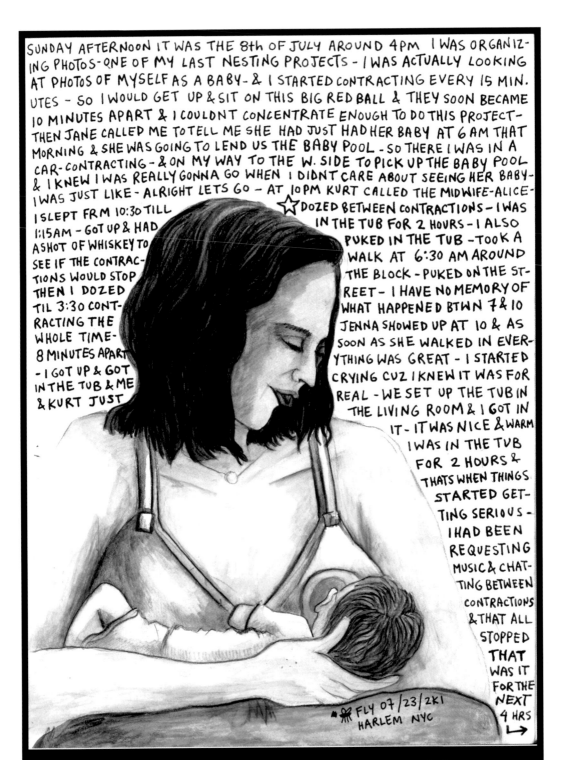

SUNDAY AFTERNOON IT WAS THE 8th OF JULY AROUND 4PM I WAS ORGANIZ-
ING PHOTOS-ONE OF MY LAST NESTING PROJECTS - I WAS ACTUALLY LOOKING
AT PHOTOS OF MYSELF AS A BABY- & I STARTED CONTRACTING EVERY 15 MIN-
UTES - SO I WOULD GET UP & SIT ON THIS BIG RED BALL & THEY SOON BECAME
10 MINUTES APART & I COULDNT CONCENTRATE ENOUGH TO DO THIS PROJECT-
THEN JANE CALLED ME TO TELL ME SHE HAD JUST HAD HER BABY AT 6 AM THAT
MORNING & SHE WAS GOING TO LEND US THE BABY POOL - SO THERE I WAS IN A
CAR-CONTRACTING - & ON MY WAY TO THE W. SIDE TO PICK UP THE BABY POOL
& I KNEW I WAS REALLY GONNA GO WHEN I DIDNT CARE ABOUT SEEING HER BABY-
I WAS JUST LIKE - ALRIGHT LETS GO - AT 10PM KURT CALLED THE MIDWIFE-ALICE-

I SLEPT FRM 10:30 TILL ☆ DOZED BETWEEN CONTRACTIONS - I WAS
1:15 AM - GOT UP & HAD IN THE TUB FOR 2 HOURS - I ALSO
A SHOT OF WHISKEY TO PUKED IN THE TUB - TOOK A
SEE IF THE CONTRAC- WALK AT 6:30 AM AROUND
TIONS WOULD STOP THE BLOCK - PUKED ON THE ST-
THEN I DOZED REET - I HAVE NO MEMORY OF
TIL 3:30 CONT- WHAT HAPPENED BTWN 7 & 10
RACTING THE JENNA SHOWED UP AT 10 & AS
WHOLE TIME- SOON AS SHE WALKED IN EVER-
8 MINUTES APART YTHING WAS GREAT - I STARTED
- I GOT UP & GOT CRYING CUZ I KNEW IT WAS FOR
IN THE TUB & ME REAL - WE SET UP THE TUB IN
& KURT JUST THE LIVING ROOM & I GOT IN
IT- IT WAS NICE & WARM
I WAS IN THE TUB
FOR 2 HOURS &
THATS WHEN THINGS
STARTED GET-
TING SERIOUS -
I HAD BEEN
REQUESTING
MUSIC & CHAT-
TING BETWEEN
CONTRACTIONS
& THAT ALL
STOPPED
THAT
WAS IT
FOR THE
NEXT
4 HRS
↳

✿ FLY 07/23/2K1
HARLEM NYC

SHELA & RUBY MAE - 07/23/2K1 - HARLEM - NYC
I FIRST MET SHELA AT DREAMTIME VILLAGE IN 1992 - SHE WAS HANGIN OUT WITH
THIS REALLY SWEET CUTE GEEKY GUY CALLED KURT THAT SHE LATER GOT MARRIED TO &
THEN RUBY MAE CAME ALONG - SHELA IS ONE OF THE SWEETEST PEOPLE I KNOW - SHE
ALWAYS HAS TIME FOR HER FRIENDS - I HAD THE GREATEST TIME AT THEIR WEDDING - IT
HAPPENED IN RURAL WISCONSIN AT KURT S FAMILY S HOUSE - I DROVE OUT THERE IN A
VAN FULL OF NYC SQUATTERS & HIPHOPPERS - WE DROVE NONSTOP SO WE WERE EVEN

GOING FROM ROOM TO ROOM CHANGING POSITIONS - STANDING - SQU-
ATTING - WE HAD A CROSS BAR ON THE DOOR TO THE BEDROOM SO I
COULD HANG FROM MY ARMPITS & JUST BARE DOWN - SCAREY BUT
EFFECTIVE - 3:30 ALICE SHOWED UP - AT 4 SHE CHECKED ME & DID
AN INTERNAL TO SEE HOW DIALATED MY CERVIX WAS & I WAS AT 6 OR
7 CM - I WAS RELIEVED CUZ I WAS MORE THAN HALF WAY THERE - YOU
START PUSHING AT 10 CM - SO THATS WHEN I SAT ON 2 PHONE BOOKS
BETWEEN CONTRACTIONS & THE SOUNDS GOT REALLY LOW & REALLY
LONG - MARIELLA - 2ND MIDWIFE - SHOWED UP AT 5:30 - RIGHT AFTER
SHE GOT HERE THE CONTRACTIONS GOT REALLY HARD & REALLY LONG &
I GOT SCARED & I SAID I CANT DO THIS ANYMORE - I STARTED TO PUSH
& MADE GRUNTING & PUSHING NOISES AT 6PM - I DID THAT FOR AN
HOUR ON THE PHONE BOOKS - ALL VERY SCAREY I SAID STUFF LIKE I CAN
FEEL MY BONES SPREADING IM SO MISRIBLE ITS FCKN HARD - AT 7PM
ALICE SAID LETS GO TO THE BED YR GETTING TIRED - I STOPPED AT THE
CROSS BAR ON THE WAY & SQUATTED DOWN & MY WATER EXPLODED &
GOT EVERY ONES FEET WET - ON THE BED IN A SIDELYING POSITION I
PUSHED FOR ANOTHER HOUR - THE BABIES HEAD WAS JUST SITTING THERE & I
HAD TO CONQUER MY FEAR - I HAD MY HEAD IN KURTS LAP - JENNA SET UP
A MIRROR SO HE COULD SEE THE BABY COME - I WAS FINALLY ABLE TO DO
IT - SHE ROLLED OUT AT 8PM ON THE DOT - RIGHT AT SUNSET & SHES
2 WEEKS OLD RIGHT NOW - OH OH OH! THE BEST PART ABOUT BEING HOME WAS
BEING ABLE TO JUST THEN SIT UP LATER & HAVE A CELEBRATORY DRINK & JUST
CHAT & NO ONE TOOK HER OUT OF MY ARMS EVER - IT WAS WORTH IT ALL
THE SCAREY PARTS - JUST TO BE TOGETHER.

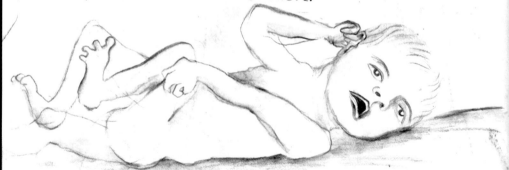

RUBY MAE REYNERTSON - BORN 7 POUNDS 8 PM ON JULY 9 - 2K1
IN HARLEM NYC - THERES A NEW GARDEN THAT WILL BE INSTALLED TOMORROW ON
THIS BLOCK - I WANT TO BURY HER PLACENTA THERE SO SHE CAN ALWAYS FIND
HER WAY HOME - SOMEHOW I WILL DO THIS - ITS GOT TO HAPPEN...

MORE INSANE BY THE TIME WE ARRIVED — WHICH WAS A DAY EARLY SO WE COULD HELP
SET STUFF UP — IT WAS BEAUTIFUL COUNTRYSIDE — THE PLAN WAS TO CUT A PATH IN THE
TALL GRASS LEADING ACROSS THE FIELD TO A LOVELY ARBOR UNDER WHICH THE SMITTEN
COUPLE WOULD BAT THEIR EYELASHES & EXCHANGE THEIR VOWS — THE ONLY PROBLEM
WAS THAT THERE WAS A BEEHIVE IN THE PATH — SO EVERYONE WAS GETTING CHASED BY
BEES — OTHER THAN THAT EVERYTHING WAS SORT OF LIKE A FAIRYTALE — WE GOT ALL
TIPSY WE CAMPED OUT IN TENTS & DIDNT STOP RYHMIN TIL MADISON —
WWW.RUBYMAE.COM

53

OH - THE ATF AGENTS AT THE DOOR! - IT WAS SO FCKN WIERD - WEVE ALWAYS KIND OF JOKED ABOUT THIS PLACE BEING A COMPOUND - A COUPLE OF OUR FRIEND HAVE JOKED ABOUT IT BEING OUR OWN PRIVATE WACO - IN THE AFTERMATH OF THE FIRE WE HAD ALL THESE POLICE & FIREFIGHTERS COMING THROUGH - DAY AFTER THE FIRE THE ATF WAS KNOCKING ON THE DOOR AT 8:30 am ASKING FOR LYNNE ——— & ——— - THIS TAKES A MOMENT OF THOUGHT - OH YOURE LOOKING FOR SILAS & HARRY WHO WERE IN THE OTHER BUILDING & CALLED IN THE FIRE - SO THERE WAS ALWAYS THIS CONFUSION WITH THEM ASKING FOR THE NAMES OF OUR FRIENDS BUT WE KNOW THEM IN A WHOLE OTHER WAY - BEING THE POLITE PEOPLE WE ARE WE LET THESE GUYS IN & THEY ARE LIKE CARTOONS OF THEMSELVES - THEY CAME IN & WERE LOOKING AT THE STUDIO & ASKING US WHAT WE DO HERE WHICH REQUIRED ENDLESS EXPLANATIONS ABOUT THE EQUIPMENT - THEY WERE MORE INTERESTED IN THE EQUIPMENT THAN WHAT THEY WERE SUPPOSED TO BE ASKING ABOUT - THEN THEY

☆ - WANTED ENDLESS DETAILS ABOUT THE FIRE - THEY WERE HERE 3 DAYS IN A ROW - THE ATF - SILAS WOULD COME OVER & THEY WOULD GO OUT TO THE EMPTY LOT & POINT AT WHERE IT STARTED & HOW IT SPREAD OVER & OVER AGAIN - IT WAS VERY SURREAL - THEY SAT THERE WITH NO IMAGINATION & NO CLUE OF WHAT ACTUALLY GOES ON IN THIS STUDIO - THEY PROBABLY THOUGHT WE WERE WANTING TO PRODUCE HOLLYWOOD BLOCKBUSTERS - THEY STILL HAVENT FIGURED OUT WHO STARTED THE FIRE - THE CONDO IS BEING REBUILT - MEANWHILE THERES STILL A GAPING HOLE IN THE FRONT OF OUR PLACE OH...

& THE FIRE FIGHTERS IN TRAINING

THEY BROUGHT THEM BY - & AT THE TIME OF THE ATF VISITS WE DIDNT REALIZE THE ROOF OF THE STUDIO WAS BURNED & HAD TO BE REPLACED

IT WAS LIKE A HAILSTORM OF BURNING EMBERS - I HAD TO BREAK THE POLICE BARRICADES WHEN IT LOOKED LIKE THE STUDIO MIGHT GO UP...

FLY AUGUST 2K1 OAKLAND

KOYOTE AKA ELIOT DAUGHTRY – AUGUST 2K1 – KILLER BANSHEE STUDIOS – OAKLAND I MET ELIOT IN CHICAGO WHILE ON TOUR WITH GOD IS MY CO-PILOT – WE PLAYED AN AMAZING SHOW AT A BOWLING ALLEY & THEN WENT TO A REALLY CRAZY GIRL PARTY AT KRISS & ELIOT S HOUSE – THE KILLER BANSHEES – IT WAS SO MUCH FUN & THEY WERE SUCH INCREDIBLE HOSTS – THEY SPOILED US ROTTEN – WE SLEPT OVER & THEY MADE US A FEAST OF A BREAKFAST BEFORE SENDING US ON OUR WAY – ELIOT IS AN OVERACHEIVER – HE CAN DO EVERYTHING! SERIOUSLY – LATELY HE MAKES GORGEOUS STAINED GLASS PIECES & NAUGHTY DISTURBING EXQUISITE PAINTINGS – WWW.KILLERBANSHEE.COM

I CANT UNDERSTAND HOW SOME PEOPLE CAN SET THE RESISTANCE ON THESE MACHINES UP TO MAXIMUM & ITS STILL NOT ENOUGH FOR THEM - YOU KNOW WHAT I HAVE IT ON? - ONE! - & I CAN HARDLY MOVE IT - WHERE SHOULD I START? - MY BIRTH MOTHER HID OUT WHILE SHE WAS PREGNANT WITH ME AT A FRIENDS UNCLES HOUSE IN IOWA - TAKING CARE OF HIM WHILE HE DIED - SHE DROPPED ACID EVERY DAY & TREATED HER BODY PRETTY VIOLENTLY INCLUDING BREAKING HER LEG - STILL - NOBODY KNEW THAT SHE WAS PREGNANT - SHE WENT INTO LABOR THE DAY HE DIED & TWO DAYS LATER STAYED HOME WHILE EVERYONE WENT TO THE FUNERAL - LOCKING HERSELF INTO THE BATHROOM - SHE LOST CONSCIOUSNESS SOMETIME WHILE I WAS BEING BORN & FROM THE ABRASIONS ON HER & ON ME THEY FIGURED I KICKED MY WAY OUT - WHEN EVERYBODY GOT HOME FROM THE FUNERAL THEY HEARD ME SCREAMING IN THE BATHROOM THEY BROKE DOWN THE DOOR LANDING IT ON TOP OF THE BOTH OF US - THE LAST TIME I SAW HER WAS IN THE AMBULANCE ON THE WAY TO THE HOSPITAL - ONCE THERE THEY TOLD HER SHE NEEDED TO SIGN SOME PAPERS TO HAVE SURGERY THEY WERE REALLY RELEASE FOR ADOPTION PAPERS - MEETING HER 20 YEARS LATER THE FIRST THING I THOUGHT WAS PHEW!! - GOOD GOIN DOC! - AT ABOUT THIS TIME MY COLLEGE FRIENDS STARTED DROPPING ACID & I COULDNT UNDERSTAND WHY THEY NEEDED TO DROP ACID TO THINK THAT ALL OF THE THINGS THEY WERE LOOKING AT LOOKED ☆↗

☆ SO FUNNY - OBVIOUSLY ALL THE PRENATAL ACID EXPOSURE HAD HARD WIRED ME BECUZ THE MAJORITY OF THE EFFECTS ONE SEES ON ACID ARE PART OF THE REGULAR FIELD OF MY VISION - BUT ANYWAY - THIS MACHINE - I ALWAYS THOUGHT IT WAS STUPID TO GO NOWHERE WHILE EXERCISING BUT AS I USE MY ARMS TO PULL MY LEGS BACK & FORTH I REALIZE ITS ABOUT GETTING SOMEWHERE IN THE FUTURE IN THE MEANTIME I'M GETTING THINGS READY - RENOVATING THE STUDIO & WORKIN ON MAKING ART & MUSIC BE MY ONLY WORK X

✖ FLY 03/07/2K2

KBANSHEE AKA KRISS DE JONG – OAKLAND CA

I DREW THIS AT THE FABULOUS KILLER BANSHEE STUDIOS – KRISS IS ONE OF THOSE PEOPLE WHO IS INCREDIBLY GENEROUS & ACCEPTING BUT ALSO WILL NOT PUT UP WITH ANY BULLSHIT – SHE KNOWS HOW TO DO EVERYTHING & I MEAN EVERYTHING & IF SHE DOESNT THEN SHE RESEARCHES & LEARNS HOW – SHE GOES A MILLION MILES A MINUTE DOING TEN THINGS AT A TIME – I MET KRISS THE SAME TIME I MET ELIOT IN CHICAGO – SINCE THEN THEY HAVE MOVED OUT TO CALIFORNIA & established THE KILLER BANSHEE STUDIOS CLOSE TO PICTURESQUE downtown OAKLAND – I M PAINTING A BIG MURAL ON THE EXTERIOR WALL – ITS MY EXCUSE FOR LONG VISITS – WWW.KILLERBANSHEE.COM

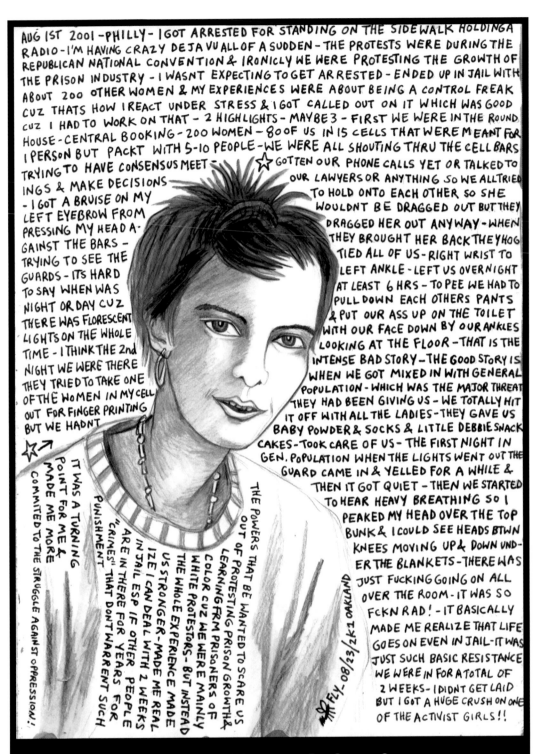

AUG 1ST 2001 – PHILLY – I GOT ARRESTED FOR STANDING ON THE SIDEWALK HOLDING A RADIO – I'M HAVING CRAZY DEJA VU ALL OF A SUDDEN – THE PROTESTS WERE DURING THE REPUBLICAN NATIONAL CONVENTION & IRONICLY WE WERE PROTESTING THE GROWTH OF THE PRISON INDUSTRY – I WASNT EXPECTING TO GET ARRESTED – ENDED UP IN JAIL WITH ABOUT 200 OTHER WOMEN & MY EXPERIENCES WERE ABOUT BEING A CONTROL FREAK CUZ THATS HOW I REACT UNDER STRESS & I GOT CALLED OUT ON IT WHICH WAS GOOD CUZ I HAD TO WORK ON THAT – 2 HIGHLIGHTS – MAYBE 3 – FIRST WE WERE IN THE ROUND HOUSE – CENTRAL BOOKING – 200 WOMEN – 80 OF US IN 15 CELLS THAT WERE MEANT FOR 1 PERSON BUT PACKT WITH 5-10 PEOPLE – WE WERE ALL SHOUTING THRU THE CELL BARS TRYING TO HAVE CONSENSUS MEETINGS & MAKE DECISIONS

– I GOT A BRUISE ON MY LEFT EYEBROW FROM PRESSING MY HEAD AGAINST THE BARS – TRYING TO SEE THE GUARDS – ITS HARD TO SAY WHEN WAS NIGHT OR DAY CUZ THERE WAS FLORESCENT LIGHTS ON THE WHOLE TIME – I THINK THE 2nd NIGHT WE WERE THERE THEY TRIED TO TAKE ONE OF THE WOMEN IN MY CELL OUT FOR FINGER PRINTING BUT WE HADNT

GOTTEN OUR PHONE CALLS YET OR TALKED TO OUR LAWYERS OR ANYTHING SO WE ALL TRIED TO HOLD ONTO EACH OTHER SO SHE WOULDNT BE DRAGGED OUT BUT THEY DRAGGED HER OUT ANYWAY – WHEN THEY BROUGHT HER BACK THEY HOG TIED ALL OF US – RIGHT WRIST TO LEFT ANKLE – LEFT US OVERNIGHT AT LEAST 6 HRS – TO PEE WE HAD TO PULL DOWN EACH OTHERS PANTS & PUT OUR ASS UP ON THE TOILET WITH OUR FACE DOWN BY OUR ANKLES LOOKING AT THE FLOOR – THAT IS THE INTENSE BAD STORY – THE GOOD STORY IS WHEN WE GOT MIXED IN WITH GENERAL POPULATION – WHICH WAS THE MAJOR THREAT THEY HAD BEEN GIVING US – WE TOTALLY HIT IT OFF WITH ALL THE LADIES – THEY GAVE US BABY POWDER & SOCKS & LITTLE DEBBIE SNACK CAKES – TOOK CARE OF US – THE FIRST NIGHT IN GEN. POPULATION WHEN THE LIGHTS WENT OUT THE GUARD CAME IN & YELLED FOR A WHILE & THEN IT GOT QUIET – THEN WE STARTED TO HEAR HEAVY BREATHING SO I PEAKED MY HEAD OVER THE TOP BUNK & I COULD SEE HEADS BTWN KNEES MOVING UP & DOWN UNDER THE BLANKETS – THERE WAS JUST FUCKING GOING ON ALL OVER THE ROOM – IT WAS SO FCKN RAD! – IT BASICALLY MADE ME REALIZE THAT LIFE GOES ON EVEN IN JAIL – IT WAS JUST SUCH BASIC RESISTANCE WE WERE IN FOR A TOTAL OF 2 WEEKS – I DIDNT GET LAID BUT I GOT A HUGE CRUSH ON ONE OF THE ACTIVIST GIRLS!!

IT WAS A TURNING POINT FOR ME & MADE ME MORE COMMITED TO THE STRUGGLE AGAINST OPPRESSION!

THE POWERS THAT BE WANTED TO SCARE US OUT OF PROTESTING PRISON GROWTH & LEARNING FRM PRISONERS OF COLOR CUZ WE WERE MAINLY WHITE PROTESTORS – BUT INSTEAD THE WHOLE EXPERIENCE MADE US STRONGER – MADE ME REALIZE I CAN DEAL WITH 2 WEEKS IN JAIL ESP IF OTHER PEOPLE ARE IN THERE FOR YEARS FOR "CRIMES" THAT DONT WARRENT SUCH PUNISHMENT

FLY – 08/23/2K1 OAKLAND

ISABELL – 08/23/2K2 – AT THE BATCAVE – OAKLAND
I CANT REMEMBER WHEN I FIRST MET ISABELL – SHE WAS JUST SUDDENLY PART OF THAT POSSE OF PEOPLES WHO WERE BUSY TRYING TO GET THINGS DONE TO HELP THE WORLD OUT & SHE IS ONE OF THE RADICAL CHEERLEADERS! – MY HEROS! – RIGHT NOW SHE IS WORKING WITH A GROUP CALLED "OBJECTIVE: COLLECTIVE" ON WHAT WILL BE A BOOK, VIDEO & WEBSITE ABOUT LONG-RANGE ORGANIZING FOR COLLECTIVE LIVING
ZBELLOLA@HOTMAIL.COM

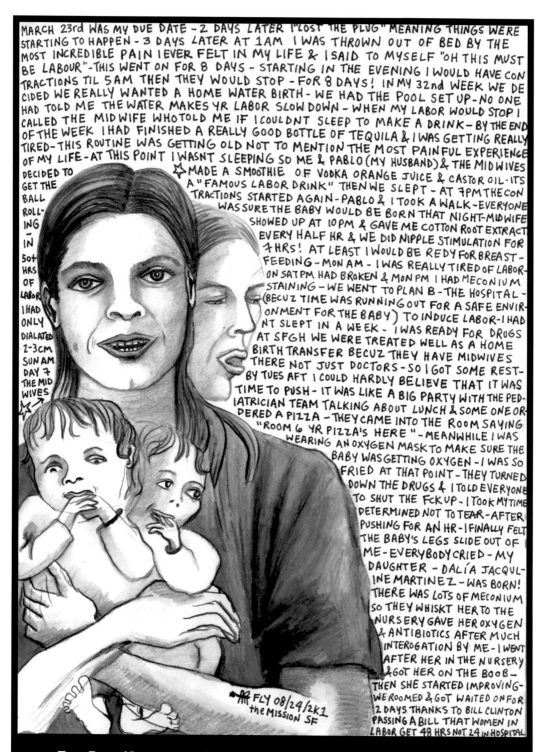

MARCH 23rd WAS MY DUE DATE - 2 DAYS LATER I "LOST THE PLUG" MEANING THINGS WERE STARTING TO HAPPEN - 3 DAYS LATER AT 1AM I WAS THROWN OUT OF BED BY THE MOST INCREDIBLE PAIN I EVER FELT IN MY LIFE & I SAID TO MYSELF "OH THIS MUST BE LABOUR" - THIS WENT ON FOR 8 DAYS - STARTING IN THE EVENING I WOULD HAVE CONTRACTIONS TIL 5AM THEN THEY WOULD STOP - FOR 8 DAYS! IN MY 32nd WEEK WE DECIDED WE REALLY WANTED A HOME WATER BIRTH - WE HAD THE POOL SET UP - NO ONE HAD TOLD ME THE WATER MAKES YR LABOR SLOW DOWN - WHEN MY LABOR WOULD STOP I CALLED THE MIDWIFE WHO TOLD ME IF I COULDNT SLEEP TO MAKE A DRINK - BY THE END OF THE WEEK I HAD FINISHED A REALLY GOOD BOTTLE OF TEQUILA & I WAS GETTING REALLY TIRED - THIS ROUTINE WAS GETTING OLD NOT TO MENTION THE MOST PAINFUL EXPERIENCE OF MY LIFE - AT THIS POINT I WASNT SLEEPING SO ME & PABLO (MY HUSBAND) & THE MIDWIVES

DECIDED TO GET THE BALL ROLLING - IN 50+ HRS OF LABOR I HAD ONLY DIALATED 2-3CM SUN AM DAY 7 THE MIDWIVES

☆ MADE A SMOOTHIE OF VODKA ORANGE JUICE & CASTOR OIL - ITS A "FAMOUS LABOR DRINK" THEN WE SLEPT - AT 7PM THE CONTRACTIONS STARTED AGAIN - PABLO & I TOOK A WALK - EVERYONE WAS SURE THE BABY WOULD BE BORN THAT NIGHT - MIDWIFE SHOWED UP AT 10PM & GAVE ME COTTON ROOT EXTRACT EVERY HALF HR & WE DID NIPPLE STIMULATION FOR 4 HRS! AT LEAST I WOULD BE REDY FOR BREAST-FEEDING - MON AM - I WAS REALLY TIRED OF LABOR - ON SAT PM HAD BROKEN & MON PM I HAD MECONIUM STAINING - WE WENT TO PLAN B - THE HOSPITAL - (BECUZ TIME WAS RUNNING OUT FOR A SAFE ENVIRONMENT FOR THE BABY) TO INDUCE LABOR - I HADNT SLEPT IN A WEEK - I WAS READY FOR DRUGS AT SFGH WE WERE TREATED WELL AS A HOME BIRTH TRANSFER BECUZ THEY HAVE MIDWIVES THERE NOT JUST DOCTORS - SO I GOT SOME REST - BY TUES AFT I COULD HARDLY BELIEVE THAT IT WAS TIME TO PUSH - IT WAS LIKE A BIG PARTY WITH THE PEDIATRICIAN TEAM TALKING ABOUT LUNCH & SOME ONE ORDERED A PIZZA - THEY CAME INTO THE ROOM SAYING "ROOM 6 YR PIZZA'S HERE" - MEANWHILE I WAS WEARING AN OXYGEN MASK TO MAKE SURE THE BABY WAS GETTING OXYGEN - I WAS SO FRIED AT THAT POINT - THEY TURNED DOWN THE DRUGS & I TOLD EVERYONE TO SHUT THE FCK UP - I TOOK MY TIME DETERMINED NOT TO TEAR - AFTER PUSHING FOR AN HR - I FINALLY FELT THE BABY'S LEGS SLIDE OUT OF ME - EVERYBODY CRIED - MY DAUGHTER - DALIA JACQULINE MARTINEZ - WAS BORN! THERE WAS LOTS OF MECONIUM SO THEY WHISKT HER TO THE NURSERY GAVE HER OXYGEN & ANTIBIOTICS AFTER MUCH INTEROGATION BY ME - I WENT AFTER HER IN THE NURSERY & GOT HER ON THE BOOB - THEN SHE STARTED IMPROVING - WE ROOMED & GOT WAITED ON FOR 2 DAYS THANKS TO BILL CLINTON PASSING A BILL THAT WOMEN IN LABOR GET 48 HRS NOT 24 IN HOSPITAL

FLY 08/24/2K1
the MISSION SF

TERI PAIN (& DAUGHTER DALIA) – 08/24/2K1 – IN THE MISSION – SF
I MET TERI BACK IN 92 OR 93 IN NYC – SHE CAME TO THE OPEN MIC I WAS EMCEEING AT THE GARGOYLE MECHANIQUE LAB – SHE WAS DOING SOME PRETTY INTENSE SPOKEN WORD – THEN WE BOTH WENT ON PAUL DERIENZO S RADIO SHOW ON WBAI FM & THAT WAS SUCH A BLAST! – LATER WHEN I WAS TRAVELLING ON THE WEST COAST I STAYED WITH TERI IN THE ATTIC OF A STOREFRONT SPACE IN THE MISSION – SHE STILL LIVES IN THE MISSION BUT IN A DIFFERENT HOUSE & NOW SHE HAS A GORGEOUS BABY GIRL!

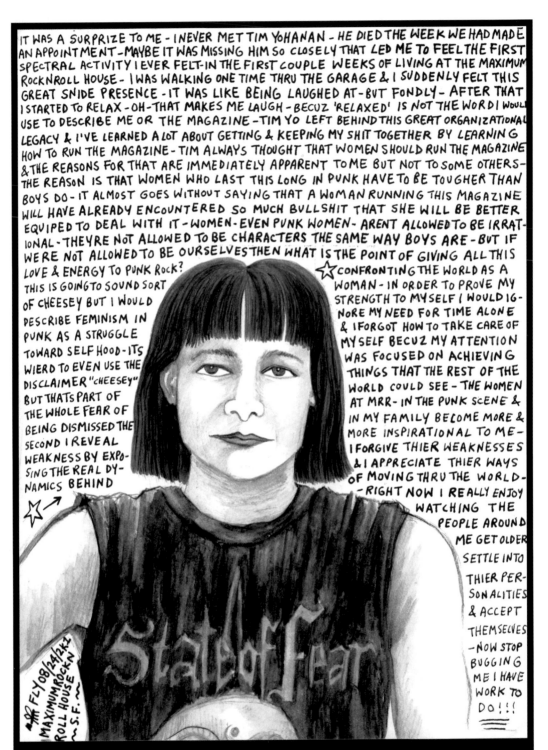

IT WAS A SURPRIZE TO ME - I NEVER MET TIM YOHANAN - HE DIED THE WEEK WE HAD MADE AN APPOINTMENT - MAYBE IT WAS MISSING HIM SO CLOSELY THAT LED ME TO FEEL THE FIRST SPECTRAL ACTIVITY I EVER FELT - IN THE FIRST COUPLE WEEKS OF LIVING AT THE MAXIMUM ROCKNROLL HOUSE - I WAS WALKING ONE TIME THRU THE GARAGE & I SUDDENLY FELT THIS GREAT SNIDE PRESENCE - IT WAS LIKE BEING LAUGHED AT - BUT FONDLY - AFTER THAT I STARTED TO RELAX - OH - THAT MAKES ME LAUGH - BECUZ 'RELAXED' IS NOT THE WORD I WOULD USE TO DESCRIBE ME OR THE MAGAZINE - TIM YO LEFT BEHIND THIS GREAT ORGANIZATIONAL LEGACY & I'VE LEARNED A LOT ABOUT GETTING & KEEPING MY SHIT TOGETHER BY LEARNING HOW TO RUN THE MAGAZINE - TIM ALWAYS THOUGHT THAT WOMEN SHOULD RUN THE MAGAZINE & THE REASONS FOR THAT ARE IMMEDIATELY APPARENT TO ME BUT NOT TO SOME OTHERS - THE REASON IS THAT WOMEN WHO LAST THIS LONG IN PUNK HAVE TO BE TOUGHER THAN BOYS DO - IT ALMOST GOES WITHOUT SAYING THAT A WOMAN RUNNING THIS MAGAZINE WILL HAVE ALREADY ENCOUNTERED SO MUCH BULLSHIT THAT SHE WILL BE BETTER EQUIPED TO DEAL WITH IT - WOMEN - EVEN PUNK WOMEN - ARENT ALLOWED TO BE IRRATIONAL - THEYRE NOT ALLOWED TO BE CHARACTERS THE SAME WAY BOYS ARE - BUT IF WE'RE NOT ALLOWED TO BE OURSELVES THEN WHAT IS THE POINT OF GIVING ALL THIS LOVE & ENERGY TO PUNK ROCK?

THIS IS GOING TO SOUND SORT OF CHEESEY BUT I WOULD DESCRIBE FEMINISM IN PUNK AS A STRUGGLE TOWARD SELFHOOD - ITS WIERD TO EVEN USE THE DISCLAIMER "CHEESEY" BUT THATS PART OF THE WHOLE FEAR OF BEING DISMISSED THE SECOND I REVEAL WEAKNESS BY EXPOSING THE REAL DYNAMICS BEHIND

☆ CONFRONTING THE WORLD AS A WOMAN - IN ORDER TO PROVE MY STRENGTH TO MYSELF I WOULD IGNORE MY NEED FOR TIME ALONE & I FORGOT HOW TO TAKE CARE OF MYSELF BECUZ MY ATTENTION WAS FOCUSED ON ACHIEVING THINGS THAT THE REST OF THE WORLD COULD SEE - THE WOMEN AT MRR - IN THE PUNK SCENE & IN MY FAMILY BECOME MORE & MORE INSPIRATIONAL TO ME - I FORGIVE THIER WEAKNESSES & I APPRECIATE THIER WAYS OF MOVING THRU THE WORLD - - RIGHT NOW I REALLY ENJOY WATCHING THE PEOPLE AROUND ME GET OLDER SETTLE INTO THIER PERSONALITIES & ACCEPT THEMSELVES - NOW STOP BUGGING ME I HAVE WORK TO DO!!!

FLYO 08/24/2K1 MAXIMUMROCKN ROLL HOUSE S.F.

State of Fear

ARWEN CURRY - 08/24/2K1 - AT MAXIMUMROCKNROLL HQ - SF
ARWEN IS ONE OF THE MAJOR FORCES BEHIND MAXIMUMROCKNROLL THESE DAYS - I GOT TO KNOW ARWEN FIRST THROUGH THE INTERNET WHEN I WAS DOING A COVER FOR THE DECEMBER ISSUE Y2K - SHE WAS GREAT TO WORK WITH - JUST NO BULLSHIT - THEN WHEN I GOT TO CALI & MET HER IT WAS REALLY COOL CUZ IT WAS LIKE WE ALREADY KNEW EACH OTHER - ARWEN HAS AN AMAZING WAY WITH WORDS PLUS HAS A LOT OF INSIGHT & COMMON SENSE - READ HER COLUMN IN MAXIMUM!!! - PO BOX 170291, SF, CA 94117 - ARWENC@MINDSPRING.COM - WWW.MAXIMUMROCKNROLL.COM

58

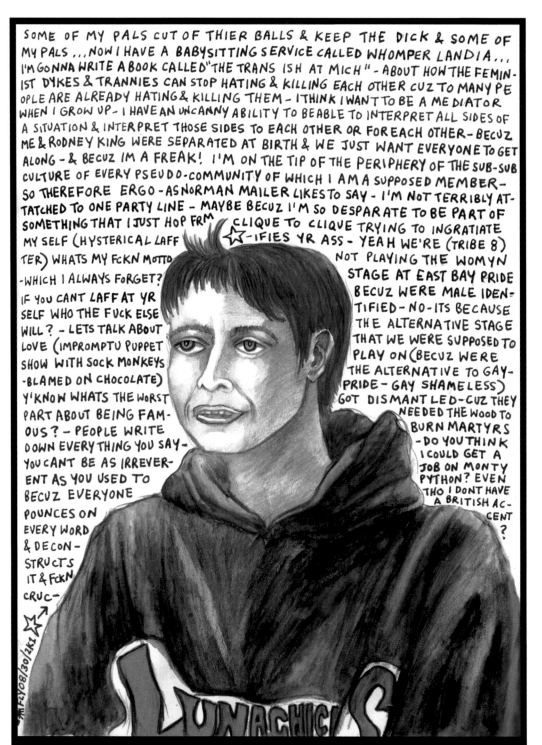

SOME OF MY PALS CUT OF THIER BALLS & KEEP THE DICK & SOME OF MY PALS ...NOW I HAVE A BABYSITTING SERVICE CALLED WHOMPER LANDIA... I'M GONNA WRITE A BOOK CALLED "THE TRANS ISH AT MICH" - ABOUT HOW THE FEMINIST DYKES & TRANNIES CAN STOP HATING & KILLING EACH OTHER CUZ TO MANY PEOPLE ARE ALREADY HATING & KILLING THEM - I THINK I WANT TO BE A MEDIATOR WHEN I GROW UP - I HAVE AN UNCANNY ABILITY TO BE ABLE TO INTERPRET ALL SIDES OF A SITUATION & INTERPRET THOSE SIDES TO EACH OTHER OR FOR EACH OTHER - BECUZ ME & RODNEY KING WERE SEPARATED AT BIRTH & WE JUST WANT EVERYONE TO GET ALONG - & BECUZ IM A FREAK! I'M ON THE TIP OF THE PERIPHERY OF THE SUB-SUB CULTURE OF EVERY PSEUDO-COMMUNITY OF WHICH I AM A SUPPOSED MEMBER - SO THEREFORE ERGO - AS NORMAN MAILER LIKES TO SAY - I'M NOT TERRIBLY ATTATCHED TO ONE PARTY LINE - MAYBE BECUZ I'M SO DESPARATE TO BE PART OF SOMETHING THAT I JUST HOP FRM CLIQUE TO CLIQUE TRYING TO INGRATIATE MY SELF (HYSTERICAL LAFFTER) WHATS MY FCKN MOTTO ☆-IFIES YR ASS - YEAH WE'RE (TRIBE 8) NOT PLAYING THE WOMYN STAGE AT EAST BAY PRIDE BECUZ WERE MALE IDENTIFIED - NO - ITS BECAUSE THE ALTERNATIVE STAGE THAT WE WERE SUPPOSED TO PLAY ON (BECUZ WERE THE ALTERNATIVE TO GAY-PRIDE - GAY SHAMELESS) GOT DISMANTLED - CUZ THEY NEEDED THE WOOD TO BURN MARTYRS - DO YOU THINK I COULD GET A JOB ON MONTY PYTHON? EVEN THO I DONT HAVE A BRITISH ACCENT?

-WHICH I ALWAYS FORGET? IF YOU CANT LAFF AT YR SELF WHO THE FUCK ELSE WILL? - LETS TALK ABOUT LOVE (IMPROMPTU PUPPET SHOW WITH SOCK MONKEYS -BLAMED ON CHOCOLATE) Y'KNOW WHATS THE WORST PART ABOUT BEING FAMOUS? - PEOPLE WRITE DOWN EVERY THING YOU SAY - YOU CANT BE AS IRREVERENT AS YOU USED TO BECUZ EVERYONE POUNCES ON EVERY WORD & DECON- STRUCTS IT & FCKN CRUC-

LYNN BREEDLOVE – 08/30/2K2 – OAKLAND

THIS WAS ONE OF THE FUNNIST PEOPs I EVER DID – I WAS DRAWING LYNNEE WHILE SHE WAS WATCHING THE SIMPSONS AT THE KILLER BANSHEE STUDIO RELAXING AFTER A TOPLESS STINT SWINGIN A SLEDGEHAMMER – SHE WAS EATING CEREAL THEN ICE CREAM THEN CHOCOLATE SO SHE GOT ALL HYPER & STARTED DOING LITTLE IMPOV SKITS WITH SOCK MONKIES & LAUGHING HYSTERICALLY – SHE IS THE LEAD SINGER OF TRIBE 8 & ALSO WROTE A SUPERFASTBADASS NOVEL – GODSPEED (ST. MARTINs PRESS) – WWW.TRIBE8.COM

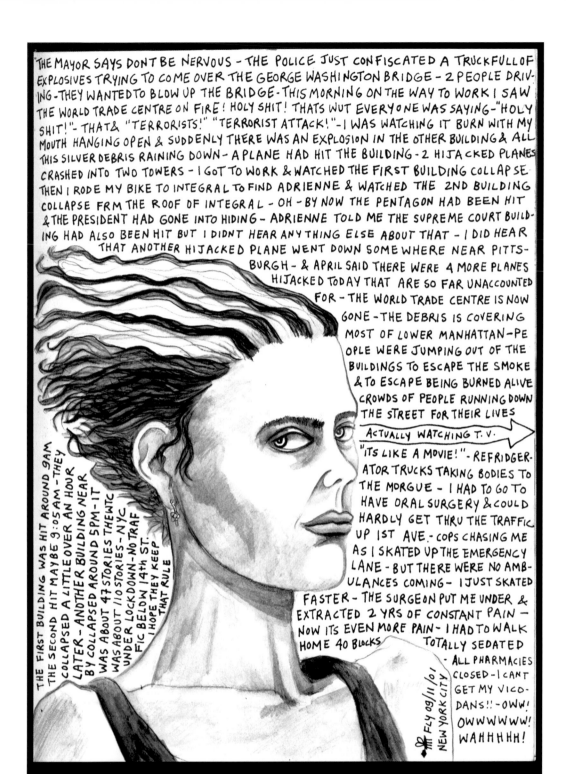

THE MAYOR SAYS DONT BE NERVOUS - THE POLICE JUST CONFISCATED A TRUCKFULL OF EXPLOSIVES TRYING TO COME OVER THE GEORGE WASHINGTON BRIDGE - 2 PEOPLE DRIVING - THEY WANTED TO BLOW UP THE BRIDGE - THIS MORNING ON THE WAY TO WORK I SAW THE WORLD TRADE CENTRE ON FIRE! HOLY SHIT! THATS WUT EVERYONE WAS SAYING - "HOLY SHIT!" - THAT & "TERRORISTS!" "TERRORIST ATTACK!" - I WAS WATCHING IT BURN WITH MY MOUTH HANGING OPEN & SUDDENLY THERE WAS AN EXPLOSION IN THE OTHER BUILDING & ALL THIS SILVER DEBRIS RAINING DOWN - A PLANE HAD HIT THE BUILDING - 2 HIJACKED PLANES CRASHED INTO TWO TOWERS - I GOT TO WORK & WATCHED THE FIRST BUILDING COLLAPSE THEN I RODE MY BIKE TO INTEGRAL TO FIND ADRIENNE & WATCHED THE 2ND BUILDING COLLAPSE FRM THE ROOF OF INTEGRAL - OH - BY NOW THE PENTAGON HAD BEEN HIT & THE PRESIDENT HAD GONE INTO HIDING - ADRIENNE TOLD ME THE SUPREME COURT BUILDING HAD ALSO BEEN HIT BUT I DIDNT HEAR ANYTHING ELSE ABOUT THAT - I DID HEAR THAT ANOTHER HIJACKED PLANE WENT DOWN SOMEWHERE NEAR PITTSBURGH - & APRIL SAID THERE WERE 4 MORE PLANES HIJACKED TODAY THAT ARE SO FAR UNACCOUNTED FOR - THE WORLD TRADE CENTRE IS NOW GONE - THE DEBRIS IS COVERING MOST OF LOWER MANHATTAN - PEOPLE WERE JUMPING OUT OF THE BUILDINGS TO ESCAPE THE SMOKE & TO ESCAPE BEING BURNED ALIVE CROWDS OF PEOPLE RUNNING DOWN THE STREET FOR THEIR LIVES

ACTUALLY WATCHING T.V. ➞

"ITS LIKE A MOVIE!" - REFRIDGERATOR TRUCKS TAKING BODIES TO THE MORGUE - I HAD TO GO TO HAVE ORAL SURGERY & COULD HARDLY GET THRU THE TRAFFIC UP 1ST AVE. - COPS CHASING ME AS I SKATED UP THE EMERGENCY LANE - BUT THERE WERE NO AMBULANCES COMING - I JUST SKATED FASTER - THE SURGEON PUT ME UNDER & EXTRACTED 2 YRS OF CONSTANT PAIN - NOW ITS EVEN MORE PAIN - I HAD TO WALK HOME 40 BLOCKS TOTALLY SEDATED - ALL PHARMACIES CLOSED - I CANT GET MY VICODANS!! - OWW! OWWWWWW! WAHHHHH!

THE FIRST BUILDING WAS HIT AROUND 9AM THE SECOND HIT MAYBE 9:05AM - THEY COLLAPSED A LITTLE OVER AN HOUR LATER - ANOTHER BUILDING NEAR BY COLLAPSED AROUND 5PM - IT WAS ABOUT 47 STORIES THE WTC WAS ABOUT 110 STORIES - NYC UNDER LOCKDOWN - NO TRAFFIC BELOW 14TH ST. I HOPE THEY KEEP THAT RULE

Fly 09/11/01 New York City

SELF-PORTRAIT - 9/11/2K1 - LOWER EAST SIDE NYC
I DREW THIS THE DAY THE WORLD TRADE TOWERS WERE DESTROYED - I HAD BEEN BACK IN NYC FOR ABOUT 24 HOURS & I WAS ON MY WAY TO WORK WHEN IT HAPPENED & I GOT TO WITNESS THE WHOLE THING - LATER THAT AFTERNOON I HAD TO GO HAVE ORAL SURGERY - I DREW THIS WHILE WATCHING TV - JOHN HOLMSTROM HAD GIVEN ME HIS OLD TV SET IN JULY & I HADNT TURNED IT ON UNTIL SEPT. 11 - & THEN IT WAS ALMOST IMPOSSIBLE TO TURN IT OFF - FLY@BWAY.NET - WWW.BWAY.NET/~FLY

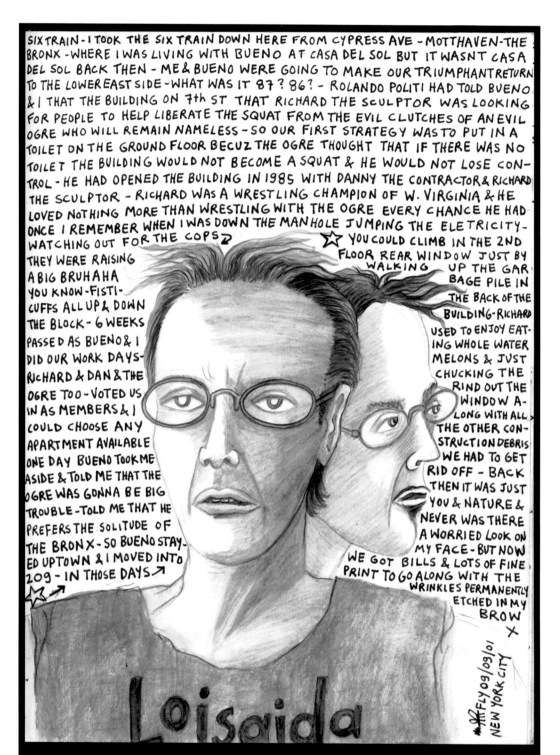

SIX TRAIN - I TOOK THE SIX TRAIN DOWN HERE FROM CYPRESS AVE - MOTT HAVEN - THE BRONX - WHERE I WAS LIVING WITH BUENO AT CASA DEL SOL BUT IT WASNT CASA DEL SOL BACK THEN - ME & BUENO WERE GOING TO MAKE OUR TRIUMPHANT RETURN TO THE LOWER EAST SIDE - WHAT WAS IT 87? 86? - ROLANDO POLITI HAD TOLD BUENO & I THAT THE BUILDING ON 7th ST THAT RICHARD THE SCULPTOR WAS LOOKING FOR PEOPLE TO HELP LIBERATE THE SQUAT FROM THE EVIL CLUTCHES OF AN EVIL OGRE WHO WILL REMAIN NAMELESS - SO OUR FIRST STRATEGY WAS TO PUT IN A TOILET ON THE GROUND FLOOR BECUZ THE OGRE THOUGHT THAT IF THERE WAS NO TOILET THE BUILDING WOULD NOT BECOME A SQUAT & HE WOULD NOT LOSE CON- TROL - HE HAD OPENED THE BUILDING IN 1985 WITH DANNY THE CONTRACTOR & RICHARD THE SCULPTOR - RICHARD WAS A WRESTLING CHAMPION OF W. VIRGINIA & HE LOVED NOTHING MORE THAN WRESTLING WITH THE OGRE EVERY CHANCE HE HAD ONCE I REMEMBER WHEN I WAS DOWN THE MANHOLE JUMPING THE ELETRICITY - WATCHING OUT FOR THE COPS ☆ YOU COULD CLIMB IN THE 2ND FLOOR REAR WINDOW JUST BY WALKING UP THE GAR- BAGE PILE IN THE BACK OF THE BUILDING - RICHARD USED TO ENJOY EAT- ING WHOLE WATER MELONS & JUST CHUCKING THE RIND OUT THE WINDOW A- LONG WITH ALL THE OTHER CON- STRUCTION DEBRIS WE HAD TO GET RID OFF - BACK THEN IT WAS JUST YOU & NATURE & NEVER WAS THERE A WORRIED LOOK ON MY FACE - BUT NOW WE GOT BILLS & LOTS OF FINE PRINT TO GO ALONG WITH THE WRINKLES PERMANENTLY ETCHED IN MY BROW ✗

THEY WERE RAISING A BIG BRUHAHA YOU KNOW - FISTI- CUFFS ALL UP & DOWN THE BLOCK - 6 WEEKS PASSED AS BUENO & I DID OUR WORK DAYS - RICHARD & DAN & THE OGRE TOO - VOTED US IN AS MEMBERS & I COULD CHOOSE ANY APARTMENT AVAILABLE ONE DAY BUENO TOOK ME ASIDE & TOLD ME THAT THE OGRE WAS GONNA BE BIG TROUBLE - TOLD ME THAT HE PREFERS THE SOLITUDE OF THE BRONX - SO BUENO STAY- ED UPTOWN & I MOVED INTO 209 - IN THOSE DAYS ↗

FLY 09/09/01 NEW YORK CITY

Loisaida

MICHAEL SHENKER – 09/10/2K1 – LOISAIDA – NYC

I DREW THIS AT A HOUSE MEETING THE NIGHT BEFORE 9/11 – I HAD JUST GOTTEN OFF A PLANE FROM CALIFORNIA – MICHAEL IS ONE OF THE FIRST PEOPLE WHO REALLY INSPIRED ME ABOUT THE WHOLE SQUATTING MOVEMENT WHEN I FIRST CAME TO THE LOWER EAST SIDE – HE IS ALWAYS COOKING UP SCHEMES & DOING THE DIRTY WORK & PUTTING HIM- SELF IN THE LINE OF FIRE TO SEE TO IT THAT THE SQUATS SURVIVE & THRIVE – HE IS A MASTER ELECTRICIAN & A MAESTRO MUSICIAN .

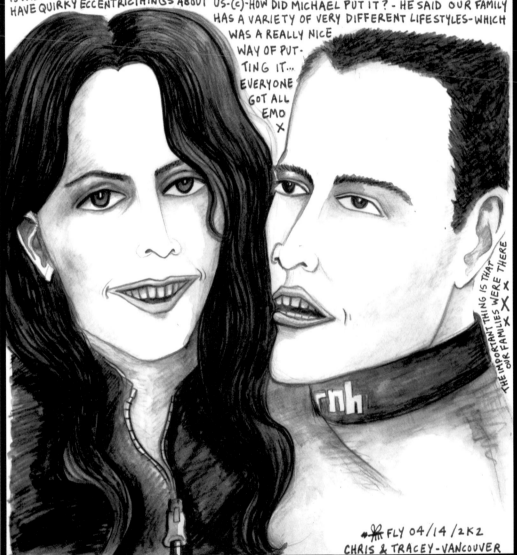

IF YOU CAN PEE WHILE YR SWIMMING THATS A REALLY GOOD SIGN - EFFICIENT SWIMMING IS DIRECTLY PROPORTIONAL TO HOW RELAXED YOU CAN BE WHILE AT THE SAME TIME EXPENDING THE MAXIMUM AMOUNT OF ENERGY IN ORDER TO PROPEL YRSELF THRU THE WATER - (T) - I THOUGHT IT WAS SO DISGUSTING WHEN YOU TOLD ME ABOUT PEEING IN THE POOL BUT THEN I REALIZED SOMETIMES YOU HAVE TO - (C) - TRACEY JUST WANTS TO TALK ABOUT PEE - (T) - WELL THEN THERES THE PEOPLE WHO PEE WHEN THEY RUN - (C) - WHAT - IT RUNS DOWN THEIR LEG!? - (T) - I REMEMBER THE FIRST MARATHON I RAN I HAD THE WORST STOMACH ACHE FOR THE FIRST HALF & THEN IT PASSED! I WAS SO HAPPY! - (C) - WE GOT MARRIED THIS WEEKEND - (T) - WE WENT FROM BODILY FUNCTIONS TO GETTING MARRIED - MY MOM TOLD A FUNNY STORY ABOUT BODILY FUNCTIONS THATS WHY WE STARTED TALKING ABOUT IT - & I CANT BELIEVE SHE SAID YOUR FAMILY IS WIERD! SHE SAID BOTH OF OUR FAMILIES ARE WIERD! - I THINK SHE MEANT THAT WE BOTH HAVE QUIRKY ECCENTRIC THINGS ABOUT US - (C) - HOW DID MICHAEL PUT IT? - HE SAID OUR FAMILY HAS A VARIETY OF VERY DIFFERENT LIFESTYLES - WHICH WAS A REALLY NICE WAY OF PUTTING IT... EVERYONE GOT ALL EMO X

THE IMPORTANT THING IS THAT OUR FAMILIES WERE THERE X X X

FLY 04/14/2K2
CHRIS & TRACEY - VANCOUVER

CHRIS ORR & TRACY SMILLIE – APRIL 2K2 – VANCOUVER
THIS IS MY "LITTLE" BROTHER & HIS WIFE – I DREW THIS THE DAY AFTER THEIR WEDDING – MY WHOLE IMMEDIATE FAMILY HAD SHOWN UP FOR THE SHINDIG WHICH WAS CRAZY CUZ MY OLDER BROTHER HAS FIVE (5!) KIDS & THEY FLEW ALL THE WAY FRM TORONTO – THE WEDDING WAS HELD OUTSIDE ON A BIG HILL OVERLOOKING ENGLISH BAY – VERY BEAUTIFUL – THE CEREMONY HAD NOTHING TO DO WITH RELIGION IT WAS JUST ALL ABOUT COMMON SENSE – I AM SO HAPPY FOR CHRIS & TRACY CUZ THEY REALLY REALLY BELONG TOGETHER – CHRIS WAS A REALLY FUN BROTHER TO GROW UP WITH – WE COULD TOSS HIM AROUND & HE D JUST BE LAUGHING & HAVING THE GREATEST TIME – & HE STILL IS

THIS IS A CHAPTER OUT OF MY BOOK - BUT I CAN'T TELL YOU WHAT ITS ABOUT YET - THIS IS CHAPTER 2 - WHEN CORNERED THE SPECIMEN DISPLAYS A MASCULINE BRAVADO - FUCK OFF YOU FCKN MUTHER FCKRS FCK - THEY'RE JUST AS AFRAID OF YOU AS YOU ARE OF THEM - THE BOYS CROSSED TO THE OTHER SIDE - (OOPS - I CAN'T KEEP UP) CHAPTER 3 IS TOLD FROM THE PERSPECTIVE OF A CAT - "WAKE UP PERSON - I'LL STARE AT YOU TIL YOU WAKE UP! ITS IMPORTANT! TOUCH ME - RIGHT IN THAT PLACE ON MY NECK - LOOK AT ME - DON'T CLOSE YR EYES! WAKE UP PERSON! ITS IMPORTANT!" - & NOW FOR THE RULES (THIS IS NO LONGER THE CAT TALKING) - THIS IS THE GIRLS GUIDE TO DOING WHAT YOURE TOLD - 1 - TAKE NOTES - 2 - DONT SKIP AROUND START AT THE BEGINNING STOP AT THE END DONT LOOK AHEAD YOULL RUIN EVERYTHING OKAY? - 3 - I KNOW THAT ALL YOU ANARCHOTYPES THINK RULES ARE BAD BUT THESE RULES ARE FOR YOUR OWN GOOD - THEY ARE DESIGNED TO MAKE THINGS EASY FOR YOU TRUST ME - 4 - IF THESE RULES DONT MAKE THINGS EASIER FOR YOU THERE IS PROBABLY SOMETHING WRONG WITH YOU - 5 - THE DOCTOR CAN PROBABLY FIX YOU AS LONG AS YOU DONT MIND BEING CONDESCENDED TO - OBJECTIF- IED & TOTALLY FU- CKING INVADED - THE DR. HAS MORE EDUCATION THAN YOU SO SHE PROBABLY KNOWS MORE ABOUT YOU - ITS ALL FOR YOUR OWN GOOD 6 - DO WHAT YOUR PARENTS TELL YOU 7 - THINK FOR YOURSELF 8 - GET A JOB 9 - GET A BOYFRIEND 10 - GET A JOB 11 - GET A BOYFRIEND

I AM THE LIGHT OF THIS WORLD ♪

12 - BRUSH YOUR HAIR 13 - TAKE A SHOWER 14 - 15 - YOUR LIFE HAS MEANING SHUT UP 16 - I WOULD REALLY LIKE TO GET TO KNOW YOU BETTER 17 - FUCK OFF 18 - GET A BOY FRIEND

FLY SEPT 2K1 - NYC NOMY LAMM AT BLUESTOCKING BOOKS FOR MORE RULES WRITE TO NOMY 120 STATE NE # 1510 OLYMPIA WA 98501

NOMY LAMM – SEPT. 2K1 – AT BLUESTOCKINGS BOOKS – LOWER EAST SIDE – NYC I DREW THIS WHILE NOMY WAS PERFORMING – SHE WAS ONLY IN TOWN FOR A DAY SO THERE WAS NO OTHER TIME FOR ME TO DRAW HER – I FIRST MET HER IN OLYMPIA IN 1999 WHEN I WENT TO VISIT HELLERY WHO HAD PUT OUT SOME AMAZING ZINES – NOMY ALSO MAKES INCREDIBLE ZINES & PERFORMS SPOKEN WORD & SINGS & GENERALLY SPREADS HER LIGHT THROUGH THE WORLD – SHE IS A SERIOUS ADVOCATE OF WOMEN LIV- ING THE WAY THEY CHOOSE NOT THE WAY THEY ARE TOLD – WWW.NOMYLAMM.COM

BLACK HOLE-TEENAGE ANGST-GROWING UP IN THE 70'S-THE STYLE IS SOMETHING I'M STUCK WITH ITS NOT SO MUCH RIFFING OFF A 50'S STYLE BUT ITS JUST A STYLE THAT I LIKE - I WAS TEETERING ON THE EDGE-WAS THE FORM OVER SHADOWING THE CONTENT? WHAT SETS UP MY SEVERLY CREEPY STATE? I WAS BORN IN 1955 I WAS GROWING UP IN THE 60'S-THE REALLY RADICAL NONCONFORMIST STUFF WAS MONSTER MAGAZINES & SHOWS LIKE THE OUTER LIMITS REALLY AFFECTED ME MORE THAN THEY SHOULD HAVE - I WANTED THE NON CONFORMIST STUFF - THE ILLUSTRATED MEDICAL JOURNALS CAME LATER - THERE WAS ONE MOVIE "THE TINGLER" I HAD TO LEAVE THE ROOM FOR - I JUST TOOK IT WAY TOO SERIOUSLY I COULDNT SLEEP- UNFORTUNATELY IT JUST TAKES ME WAY TOO LONG TO DO MY COMICS - I HAVE MY STRAIGHT JOB DOING STRAIGHT ILLUSTRATION THAT PAYS THE BILLS & COMICS - I HAVE LIKE 50 NOTEBOOKS OF NOTES REFERING TO THE STORY - I TRY TO WORK LIKE A FILM MAKER NOT TO HAVE THE FORM OVERPOWERING THE CONTENT PAYING MORE ATTENTION TO THE CHARACTERS & WHAT WORKS FOR THEM - I LIKE THE IDEA OF A SERIALIZED STRIP IN A WEEKLY PAPER THAT PEOPLE CAN PICK UP FOR FREE BUT ULTIMATELY THERE GET TO BE SO MANY RESTRICTIONS ON HOW YOU CAN TELL THE STORY SO ITS LIBERATING TO WORK ON A LARGER SELF CONTAINED BOOK - I PUBLISHED SOME OF MY BAD HIGH SCHOOL ART THINKING I MIGHT GET SOME INTERESTING SUBMISSIONS BUT PEOPLE WOULD SEND ME THEIR 40 PAGE EPICS & WANT ME TO PUBLISH THEM IN MY 32 PAGE COMICS - HOW ABOUT THESE TEENAGERS WITH THE HORRIBLE DISEASES & DEFORMITIES? ITS ABOUT THE EXTERNALIZATION OF THE HORRORS OF BEING A TEENAGER - ITS LIKE TAKING THE TEEN ANGST STORY A FEW STEPS FARTHER WHAT IS THE ALLEGORY TO THESE DISEASES? THE AIDS ALLEGORY - ITS DEFINITELY THERE BUT ITS MORE ABOUT TEEN ANGST

-THE TOOLS ARE SIMPLE - BRUSH & INK & RAPIDOGRAPH PEN - AS FAR AS THE ILLUSTRATION WORK A LOT OF THE ART DIRECTORS HAVE NO IDEA THAT I DO COMICS- ARE YOUR 2 ADOLESCENT DAUGHTERS OK? SOME PEOPLE ARE DISSAPOINTED TO MEET ME CUZ I'M SO NORMAL LOOKIN I HAVE NO SKIN LESIONS OR DE FORMITIES- WHAT CAN I SAY

CHARLES BURNS – OCT. 2K1 – AT SOME BAR IN WILLIAMSBURG – NYC
IT WAS A BIG NIGHT OF UNDERGROUND COMIC ARTISTS SHOWING SLIDES OF THEIR WORK & SPEAKING – I WENT ESPECIALLY TO SEE CHARLES BURNS CUZ I HAVE BEEN A BIG FAN OF HIS COMICS FOR A LONG TIME – BLACK HOLE – I HAD TO DRAW THIS FROM FAR AWAY IN A DARK BAR WHILE HE KEPT MOVING AROUND – LATER I SHOWED HIM THE DRAWING & HE WAS REALLY NICE ABOUT IT – HE IS A PERFECT EXAMPLE OF A PERSON WHO LOOKS & SEEMS TOTALLY NORMAL BUT WHO DRAWS & TELLS VERY TWISTED STORIES – YAH!

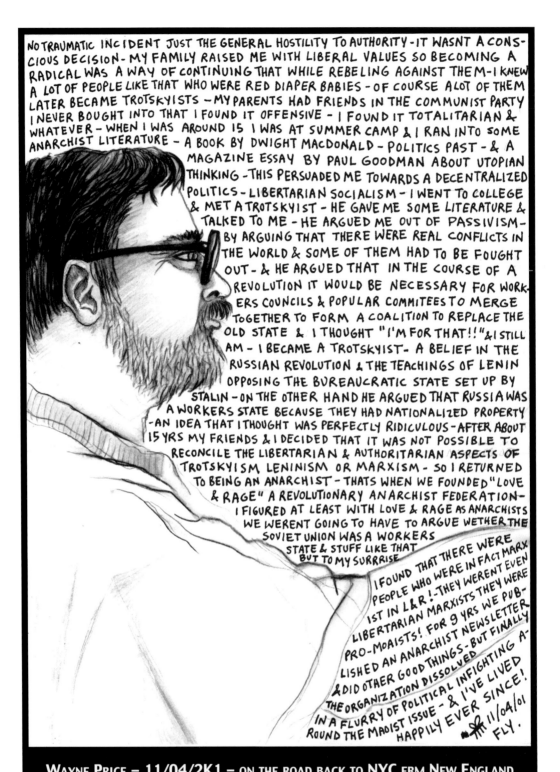

WAYNE PRICE – 11/04/2K1 – ON THE ROAD BACK TO NYC FRM NEW ENGLAND I HAD GOTTEN INVITED TO DO A SLIDE SHOW & TALK AT AN ANARCHIST BOOK FAIR AT HAMPSHIRE COLLEGE IN AMHERST, MA & THE FOLKS ORGANIZING HAD HOOKED ME & MY PAL JOSH UP WITH A RIDE FROM WAYNE WHO WOULD ALSO BE SPEAKING – THATS HOW I MET HIM – THEN I FOUND OUT HE HAD BEEN PART OF THE LOVE & RAGE COLLECTIVE – I REMEMBER READING THEIR PUBLICATION BACK IN THE DAY – ANYWAY ON THIS DAY WE WERE TRYING TO GET BACK TO NYC & WE GOT A FLAT !! (THNX TO JOSH FOR FIXING IT!!)

THEY KILLED INNOCENT PEOPLE FOR POLITICAL PURPOSES-THATS TERRORISM-THE POLICIES OF THE US CREATE A SITUATION OF AGGRAVATED STARVATION IN AFGAN- ASTAN WHICH COULD KILL 7 MILLION INNOCENT AFGHANIS - WHAT ARE THE US MO- TIVES ON SEPT 12? - TO PUNISH THE INFILTRATORS - TO NOT LEGITIMATE INTERNA- TIONAL LAW - THE US DID NOT PURSUE BIN LADIN THRU INTERNATIONAL PEACE KEEPING INSTITUTIONS LIKE THE U.N. & WORLD COURT - THE US DOESNT WANT TO SET THE PRECEDENT OF A WORLD COURT PROSCECUTING A COUNTRY AS A TERRORIST STATE AS THEN THE US MAY BE HELD ACCOUNTABLE FOR ITS POLICIES IN IRAQ & PERHAPS FOR HARBOURING THE TERRORISTS THAT BLEW UP THE WTC - WHY ISNT WASHINGTON BOMBING WASHINGTON - INSTEAD THE US USES VIGILANTE & LYNCH MOB TACTICS - THE US WANTS TO MAINTAIN ITS CREDIBILITY THAT ANYONE WHO MESSES WITH US WILL BE REACTED TO SWIFTLY & VIOLENTLY - THE WAR ON TER RORISM IS A GOOD REPLACEMENT FOR THE COLD WAR - ALLOWING THE GOVT TO RE DIRECT FUNDS TO MILITARY & PASS ALL KINDS OF RESTRICTIVE LAWS TO THEIR OWN PURPOSES - WHAT SENSE IS IT TO PUNISH THE POPULATION WHO ARE THE VICTIMS OF THOSE WHO ENACTED THESE CRIMES- BUSH DID NOT PRESENT ANY EVIDENCE THAT BIN LADIN IS GUILTY - IF HE HAD & BIN LADIN WAS HANDED OVER THEN WE MIGHT HAVE TO HAND OVER HENRY KISSINGER - BECUZ THEY COULD PROVE THAT HE IS GUILTY - THE U.S. IS ALSO NOT INTERESTED IN REDUCING JUST GRIEVANCES IN THE MIDDLE EAST WHICH CREATES THE CLIMATE WHICH PRODUCES SUICIDE BOMBERS - WAR & CAPITALISM & RACISM & SEXISM ARE LIKE NATIONAL INSTITUTIONS IN THE U.S. - CYNICISM IS THE AFFLICTION - THE FEELING THAT THERE IS NOTHING BETTER OR THAT THE CURRENT SYSTEM IS TOO RUTH- LESS TO OVERTHROW - THE IM- PEDIMENT TO BUILDING A MAJOR MOVEMENT AGAINST WAR ETC... THE ANTI-WAR MOVEMENT IN THE VIETNAM ERA DID NOT CONVINCE THOSE IN POWER THAT WHAT THEY WERE DOING WAS AMORAL BUT IT THREATENED TO DESTABILIZE THE DOM ESTIC SYSTEM & THIS IS WHAT MADE SOME PROMINENT FIGURES COME OUT AGAINST THE WAR IT DOESNT TAKE HUGE ACTS - IT TAKES DEDICATION - WE ARE IN A POSITION NOW THAT OUR POLICIES COULD KILL MILLIONS OF INNOCENT PEOPLE - PEASANTS - IN A MATTER OF MONTHS - THIS WILL CREATE EVEN MORE HATRED DIRECTED TOWARDS THE U.S. - WE HAVE TO CONVINCE THEM THAT THESE POLICIES ARE NOT IN THIER BEST INTEREST

MICHAEL ALBERT SPEAKING AT HAMPSHIRE COLLEGE 11/02/2K1 FLY - AMHERST MA @ BOOKFAIR

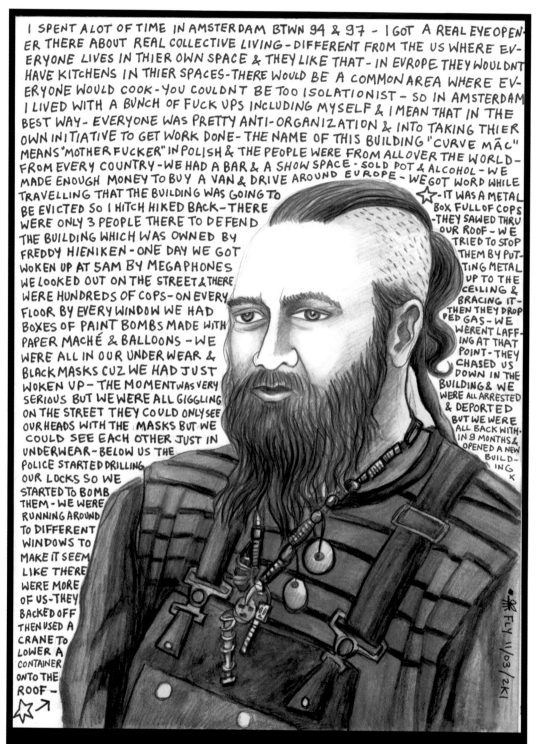

I SPENT A LOT OF TIME IN AMSTERDAM BTWN 94 & 97 - I GOT A REAL EYE OPEN-ER THERE ABOUT REAL COLLECTIVE LIVING - DIFFERENT FROM THE US WHERE EV-ERYONE LIVES IN THIER OWN SPACE & THEY LIKE THAT - IN EVROPE THEY WOULDNT HAVE KITCHENS IN THIER SPACES - THERE WOULD BE A COMMON AREA WHERE EV-ERYONE WOULD COOK - YOU COULDNT BE TOO ISOLATIONIST - SO IN AMSTERDAM I LIVED WITH A BUNCH OF FUCK UPS INCLUDING MYSELF & I MEAN THAT IN THE BEST WAY - EVERYONE WAS PRETTY ANTI-ORGANIZATION & INTO TAKING THIER OWN INITIATIVE TO GET WORK DONE - THE NAME OF THIS BUILDING "CURVE MĀC" MEANS "MOTHER FUCKER" IN POLISH & THE PEOPLE WERE FROM ALL OVER THE WORLD - FROM EVERY COUNTRY - WE HAD A BAR & A SHOW SPACE - SOLD POT & ALCOHOL - WE MADE ENOUGH MONEY TO BUY A VAN & DRIVE AROUND EUROPE - WE GOT WORD WHILE TRAVELLING THAT THE BUILDING WAS GOING TO BE EVICTED SO I HITCH HIKED BACK - THERE WERE ONLY 3 PEOPLE THERE TO DEFEND THE BUILDING WHICH WAS OWNED BY FREDDY HIENIKEN - ONE DAY WE GOT WOKEN UP AT 5AM BY MEGAPHONES WE LOOKED OUT ON THE STREET & THERE WERE HUNDREDS OF COPS - ON EVERY FLOOR BY EVERY WINDOW WE HAD BOXES OF PAINT BOMBS MADE WITH PAPER MACHÉ & BALLOONS - WE WERE ALL IN OUR UNDERWEAR & BLACK MASKS CUZ WE HAD JUST WOKEN UP - THE MOMENT WAS VERY SERIOUS BUT WE WERE ALL GIGGLING ON THE STREET THEY COULD ONLY SEE OUR HEADS WITH THE MASKS BUT WE COULD SEE EACH OTHER JUST IN UNDERWEAR - BELOW US THE POLICE STARTED DRILLING OUR LOCKS SO WE STARTED TO BOMB THEM - WE WERE RUNNING AROUND TO DIFFERENT WINDOWS TO MAKE IT SEEM LIKE THERE WERE MORE OF US - THEY BACKED OFF THEN USED A CRANE TO LOWER A CONTAINER ON TO THE ROOF -

☆ - IT WAS A METAL BOX FULL OF COPS - THEY SAWED THRU OUR ROOF - WE TRIED TO STOP THEM BY PUT-TING METAL UP TO THE CEILING & BRACING IT - THEN THEY DROP-PED GAS - WE WERENT LAFF-ING AT THAT POINT - THEY CHASED US DOWN IN THE BUILDING & WE WERE ALL ARRESTED & DEPORTED BUT WE WERE ALL BACK WITH-IN 9 MONTHS & OPENED A NEW BUILD-ING X

FLY 11/03/2K1

OKRA DINGLE - 11/03/2K1 - AT THE A BOOK FAIR - AMHERST, MA
THE FIRST TIME I MET OKRA HIS NAME WAS ROOFTOP ROB & HE WAS TRYING TO KICK ME & DOG BOY OUT OF ABC NO RIO - IT WAS NEW YEARS & WE HAD HAD A BIG DANCE PARTY & GOTTEN TOTALLY WASTED SO NO WAY WAS ANYONE GONNA TELL US WHAT TO DO MAAAAAANNNNN! - OKRA IS A TRUE INDIVIDUAL LIVING AS FREE FROM SOCIETAL TRAP-PINGS AS HE POSSIBLY CAN - HE DOES A PRETTY GOOD JOB AT THIS & WRITES AMAZING STORIES ABOUT IT - GET YER DINGLE DIVISION ZINES FROM OKRAP@STEALTHISEMAIL.COM

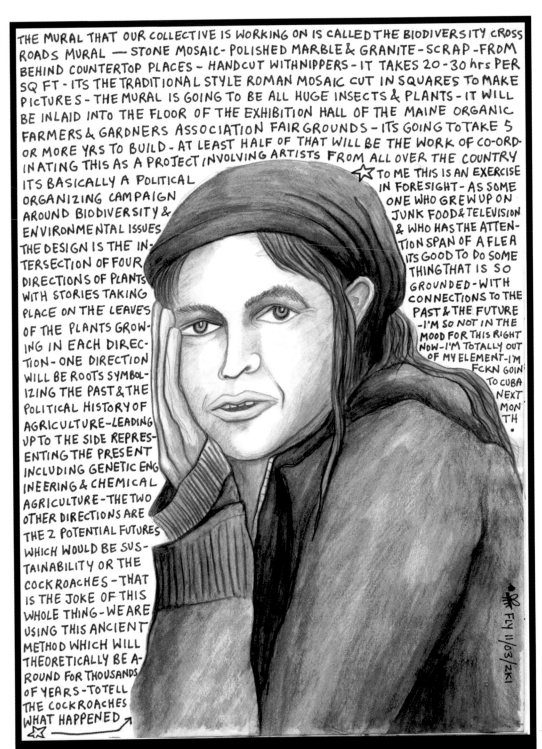

THE MURAL THAT OUR COLLECTIVE IS WORKING ON IS CALLED THE BIODIVERSITY CROSS ROADS MURAL — STONE MOSAIC- POLISHED MARBLE & GRANITE - SCRAP - FROM BEHIND COUNTERTOP PLACES - HANDCUT WITHNIPPERS - IT TAKES 20-30 hrs PER SQ FT - ITS THE TRADITIONAL STYLE ROMAN MOSAIC CUT IN SQUARES TO MAKE PICTURES - THE MURAL IS GOING TO BE ALL HUGE INSECTS & PLANTS - IT WILL BE INLAID INTO THE FLOOR OF THE EXHIBITION HALL OF THE MAINE ORGANIC FARMERS & GARDNERS ASSOCIATION FAIRGROUNDS - ITS GOING TO TAKE 5 OR MORE YRS TO BUILD - AT LEAST HALF OF THAT WILL BE THE WORK OF CO-ORD-INATING THIS AS A PROJECT INVOLVING ARTISTS FROM ALL OVER THE COUNTRY

ITS BASICALLY A POLITICAL ORGANIZING CAMPAIGN AROUND BIODIVERSITY & ENVIRONMENTAL ISSUES THE DESIGN IS THE IN-TERSECTION OF FOUR DIRECTIONS OF PLANTS WITH STORIES TAKING PLACE ON THE LEAVES OF THE PLANTS GROW-ING IN EACH DIREC-TION - ONE DIRECTION WILL BE ROOTS SYMBOL-IZING THE PAST & THE POLITICAL HISTORY OF AGRICULTURE-LEADING UP TO THE SIDE REPRES-ENTING THE PRESENT INCLUDING GENETIC ENG INEERING & CHEMICAL AGRICULTURE-THE TWO OTHER DIRECTIONS ARE THE 2 POTENTIAL FUTURES WHICH WOULD BE SUS-TAINABILITY OR THE COCKROACHES - THAT IS THE JOKE OF THIS WHOLE THING-WE ARE USING THIS ANCIENT METHOD WHICH WILL THEORETICALLY BE A-ROUND FOR THOUSANDS OF YEARS - TO TELL THE COCKROACHES WHAT HAPPENED

☆ TO ME THIS IS AN EXERCISE IN FORESIGHT- AS SOME ONE WHO GREW UP ON JUNK FOOD & TELEVISION & WHO HAS THE ATTEN-TION SPAN OF A FLEA ITS GOOD TO DO SOME THING THAT IS SO GROUNDED - WITH CONNECTIONS TO THE PAST & THE FUTURE - I'M SO NOT IN THE MOOD FOR THIS RIGHT NOW- I'M TOTALLY OUT OF MY ELEMENT-I'M FCKN GOIN TO CUBA NEXT MON TH.

FLY 11/03/2K1

KEHBAN – OF THE BEEHIVE COLLECTIVE – IN AMHERST, MA
I MET KEHBAN AT AN ANARCHIST BOOK FAIR IN NEW ENGLAND – SHE WAS THERE WITH THE BEEHIVE COLLECTIVE PRESENTING A GUIDED TOUR OF A LUSHLY DETAILED POSTER THAT DEPICTS ANIMALS & INSECTS & THE NATURAL ENVIRONMENT AS REAL & METAPHORI-CAL ELEMENTS IN THE STRUGGLE AGAINST THE FREE TRADE AREA OF THE AMERICAS & CORPORATE COLONIALISM – THE BEEHIVE COLLECTIVE IS CONSTANTLY WORKING & NET-WORKING IN THE FIGHT AGAINST CORPORATE GLOBALIZATION –
WWW.BEEHIVECOLLECTIVE.ORG

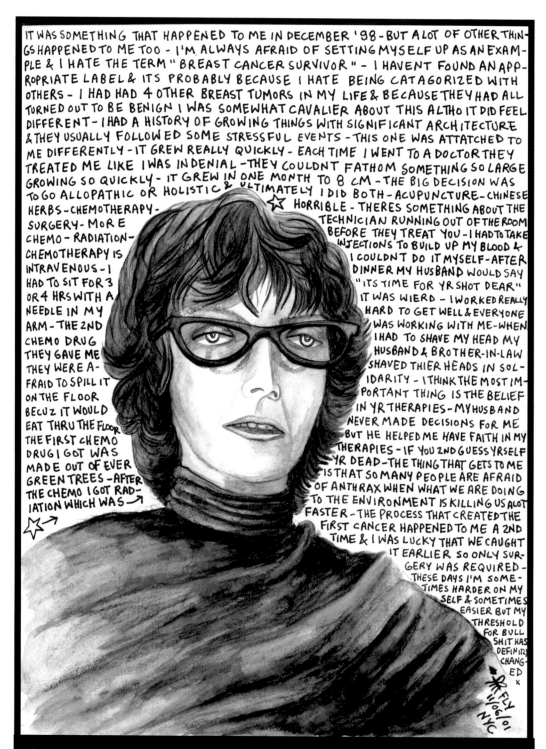

IT WAS SOMETHING THAT HAPPENED TO ME IN DECEMBER '98 - BUT A LOT OF OTHER THINGS HAPPENED TO ME TOO - I'M ALWAYS AFRAID OF SETTING MYSELF UP AS AN EXAMPLE & I HATE THE TERM "BREAST CANCER SURVIVOR" - I HAVENT FOUND AN APPROPRIATE LABEL & ITS PROBABLY BECAUSE I HATE BEING CATAGORIZED WITH OTHERS - I HAD HAD 4 OTHER BREAST TUMORS IN MY LIFE & BECAUSE THEY HAD ALL TURNED OUT TO BE BENIGN I WAS SOMEWHAT CAVALIER ABOUT THIS ALTHO IT DID FEEL DIFFERENT - I HAD A HISTORY OF GROWING THINGS WITH SIGNIFICANT ARCHITECTURE & THEY USUALLY FOLLOWED SOME STRESSFUL EVENTS - THIS ONE WAS ATTATCHED TO ME DIFFERENTLY - IT GREW REALLY QUICKLY - EACH TIME I WENT TO A DOCTOR THEY TREATED ME LIKE I WAS IN DENIAL - THEY COULDNT FATHOM SOMETHING SO LARGE GROWING SO QUICKLY - IT GREW IN ONE MONTH TO 8 CM - THE BIG DECISION WAS TO GO ALLOPATHIC OR HOLISTIC & ULTIMATELY I DID BOTH - ACUPUNCTURE - CHINESE HERBS - CHEMOTHERAPY -

SURGERY - MORE CHEMO - RADIATION - CHEMOTHERAPY IS INTRAVENOUS - I HAD TO SIT FOR 3 OR 4 HRS WITH A NEEDLE IN MY ARM - THE 2ND CHEMO DRUG THEY GAVE ME THEY WERE AFRAID TO SPILL IT ON THE FLOOR BECUZ IT WOULD EAT THRU THE FLOOR THE FIRST CHEMO DRUG I GOT WAS MADE OUT OF EVER GREEN TREES - AFTER THE CHEMO I GOT RADIATION WHICH WAS →

☆ HORRIBLE - THERES SOMETHING ABOUT THE TECHNICIAN RUNNING OUT OF THE ROOM BEFORE THEY TREAT YOU - I HAD TO TAKE INJECTIONS TO BUILD UP MY BLOOD & I COULDNT DO IT MYSELF - AFTER DINNER MY HUSBAND WOULD SAY "ITS TIME FOR YR SHOT DEAR" IT WAS WIERD - I WORKED REALLY HARD TO GET WELL & EVERYONE WAS WORKING WITH ME - WHEN I HAD TO SHAVE MY HEAD MY HUSBAND & BROTHER-IN-LAW SHAVED THIER HEADS IN SOLIDARITY - I THINK THE MOST IMPORTANT THING IS THE BELIEF IN YR THERAPIES - MY HUSBAND NEVER MADE DECISIONS FOR ME BUT HE HELPED ME HAVE FAITH IN MY THERAPIES - IF YOU 2ND GUESS YRSELF YR DEAD - THE THING THAT GETS TO ME IS THAT SO MANY PEOPLE ARE AFRAID OF ANTHRAX WHEN WHAT WE ARE DOING TO THE ENVIRONMENT IS KILLING US ALOT FASTER - THE PROCESS THAT CREATED THE FIRST CANCER HAPPENED TO ME A 2ND TIME & I WAS LUCKY THAT WE CAUGHT IT EARLIER SO ONLY SURGERY WAS REQUIRED - THESE DAYS I'M SOMETIMES HARDER ON MYSELF & SOMETIMES EASIER BUT MY THRESHOLD FOR BULLSHIT HAS DEFINITLY CHANGED x

FLY 11/06/01 NYC

MICHELLE BRYANT - 11/06/2K1 - STUY-TOWN - NYC
I MET MICHELLE WHILE MODELING FOR HER FASHION ILLUSTRATION CLASS AT PARSONS SCHOOL OF DESIGN & SHE WAS JUST RECOVERING FROM BREAST CANCER TREATMENTS THAT HAD BEEN SUCCESSFUL — SHE WAS GROWING HER HAIR BACK — SHE WOULD PLAY REALLY GREAT MUSIC IN CLASS & SHE HAD A CLOSET FULL OF TOTALLY AWESOME CLOTHES FOR ME TO MODEL IN — SOME OF MY FAVORITE THINGS SHE ENDED UP GIVING TO ME — I WAS REALLY SAD WHEN SHE QUIT TEACHING THE MODEL DRAWING CLASSES.

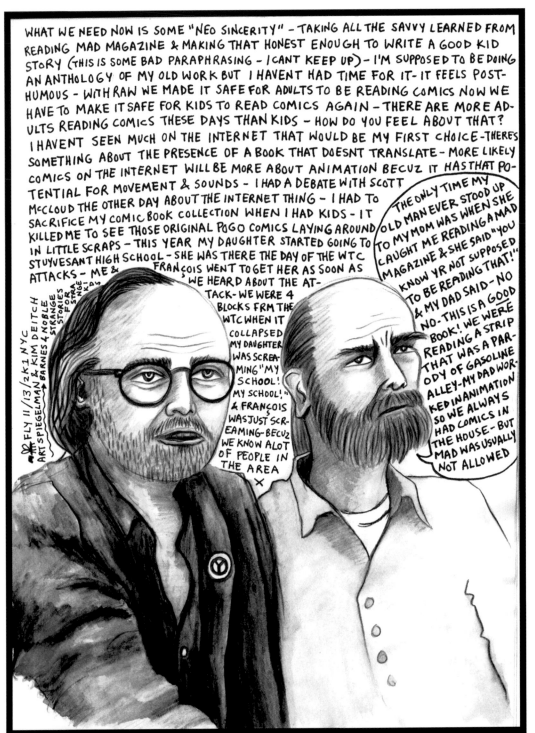

WHAT WE NEED NOW IS SOME "NEO SINCERITY" – TAKING ALL THE SAVVY LEARNED FROM READING MAD MAGAZINE & MAKING THAT HONEST ENOUGH TO WRITE A GOOD KID STORY (THIS IS SOME BAD PARAPHRASING – I CANT KEEP UP) – I'M SUPPOSED TO BE DOING AN ANTHOLOGY OF MY OLD WORK BUT I HAVENT HAD TIME FOR IT – IT FEELS POST-HUMOUS – WITH RAW WE MADE IT SAFE FOR ADULTS TO BE READING COMICS NOW WE HAVE TO MAKE IT SAFE FOR KIDS TO READ COMICS AGAIN – THERE ARE MORE AD-ULTS READING COMICS THESE DAYS THAN KIDS – HOW DO YOU FEEL ABOUT THAT? I HAVENT SEEN MUCH ON THE INTERNET THAT WOULD BE MY FIRST CHOICE – THERES SOMETHING ABOUT THE PRESENCE OF A BOOK THAT DOESNT TRANSLATE – MORE LIKELY COMICS ON THE INTERNET WILL BE MORE ABOUT ANIMATION BECUZ IT HAS THAT PO-TENTIAL FOR MOVEMENT & SOUNDS – I HAD A DEBATE WITH SCOTT McCLOUD THE OTHER DAY ABOUT THE INTERNET THING – I HAD TO SACRIFICE MY COMIC BOOK COLLECTION WHEN I HAD KIDS – IT KILLED ME TO SEE THOSE ORIGINAL POGO COMICS LAYING AROUND IN LITTLE SCRAPS – THIS YEAR MY DAUGHTER STARTED GOING TO STUYVESANT HIGH SCHOOL – SHE WAS THERE THE DAY OF THE WTC ATTACKS – ME & FRANÇOIS WENT TO GET HER AS SOON AS WE HEARD ABOUT THE AT-TACK – WE WERE 4 BLOCKS FRM THE WTC WHEN IT COLLAPSED MY DAUGHTER WAS SCREA-MING "MY SCHOOL! MY SCHOOL!" & FRANÇOIS WAS JUST SCR-EAMING – BECUZ WE KNOW A LOT OF PEOPLE IN THE AREA ✗

FLY 11/13/2K1 NYC ART SPIEGELMAN & KIM DEITCH → BARNES & NOBLE STORIES FOR STRANGE KIDS

THE ONLY TIME MY OLD MAN EVER STOOD UP TO MY MOM WAS WHEN SHE CAUGHT ME READING A MAD MAGAZINE & SHE SAID "YOU KNOW YR NOT SUPPOSED TO BE READING THAT!" & MY DAD SAID – NO NO – THIS IS A GOOD BOOK! WE WERE READING A STRIP THAT WAS A PAR-ODY OF GASOLINE ALLEY – MY DAD WOR-KED IN ANIMATION SO WE ALWAYS HAD COMICS IN THE HOUSE – BUT MAD WAS USUALLY NOT ALLOWED

ART SPIEGELMAN & KIM DEITCH – 11/13/2K1 – NYC
I DREW THIS AT BARNES & NOBLE ON 6TH AVE. AT A "READING" FOR THE RELEASE OF A COMIC CALLED "KID LIT" – BASICALLY TWISTED COMICS FOR KIDS – ART SPIEGELMAN USED TO PUT OUT RAW BACK IN THE 80s & I THINK EARLY 90s – AMAZING STUFF WITH PEOPLE LIKE GARY PANTER & SUE COE & KIM DEITCH – IT WAS REALLY INSPIRING & IT MADE ME WANT TO DRAW COMICS – & THE FIRST TIME I EVER CAME TO NYC I WENT TO THE ADDRESS PRINTED ON THE COMIC BUT NO ONE ANSWERED THE BUZZER SO INSTEAD I WENT TO A BUNCH OF SOHO OPENINGS & GOT WASTED

I WAS BORN IN NEW YORK CITY BUT GREW UP IN RURAL NEW JERSEY & GOT OUT AS SOON AS I COULD BECAUSE OF THE HAMMER OF CONFORMITY I WAS CONSTANTLY BEING HIT WITH - I WANNA BE ME & NYC IS A GREAT PLACE TO BE YRSELF - GOT INTO COMICS AS SOON AS I SAW THEM - I LOVE THE WRITTEN LANGUAGE & LOVE THE VISUAL IMPACT OF THE ART & THERES NOTHING BETTER THAN THE 2 WORKING TOGETHER AS A TEAM - UNLIKE SO MANY OTHER WRITERS I KNOW I'M STILL PROUD OF MY FIRST PUBLISHED STORY - "SWORDS IN THE WORLD SERIES" WHICH APPEARED IN CREEPY 106 FROM WARREN PUBLICATIONS - THE SAME FOLKS WHO DID VAMPIRELLA - I REMEMBER THE BEGINNING OF MY COMIC BOOK COLLECTION - IT WAS IN NEW JERSEY - A NIEGHBOR WANTED HER DAUGHTER TO COME HOME FOR SUPPER & SHE ASKED ME TO GO GET HER I WENT TO THE OTHER NIEGHBORS PLACE TO TELL THEM & I SAW A CARDBOARD BOX FULL OF COMIC BOOKS - I MADE SOME EXCLAMATION SHOWING OBVIOUS ENTHUSIASM & THEY GAVE ME THE BOX LOOKING BACK I THINK THEY WERE GOING TO THROW THEM OUT OTHERWISE - MY CHILDISH MIND RATIONALIZED THAT I NOW HAD A COLLECTION & SHOULD KEEP IT GOING - I STILL AM - BESIDES I COULDNT AFFORD MY OTHER LOVE - MUSIC - AT THE TIME -
I STARTED OUT AT WBAI-FM IN 1991 AS A PUNK ROCK & HEAVY METAL D.J. AT 3:30 AM - ED MENJE HINTED TO ME THAT HE WANTED ME TO JOIN HIM BECUZ DOING A SHOW ALONE IN THE MIDDLE OF THE NIGHT IS NOT AS MUCH FUN AS DOING IT WITH SOME ONE ELSE & I HAVE THIS HUGE RECORD COLLECTION - SO I JOINED HIM - I KNOW ED FRM COMIC BOOK CONVENTIONS GOING BACK TO THE 70's - I HAD GOTTEN BACK IN TOUCH WITH HIM TO INK SOME COMIC BOOKS MERCY VAN VLACK & I WERE PUBLISHING - AT A CONVENTION ED NOTICED THAT WHEN I TALKED ABOUT STUFF IN COMICS I WOULD GATHER A CROWD & SUGGESTED IT AS A RADIO SHOW - THEN JIM FREUND ASKED US "HOUR BECUZ HIS AUD-IENCE WAS INTO COMICS BUT HE WASNT - WE GOT SUCH A RESPONSE FROM THE AUDIENCE & ENJOYED IT SO MUCH THAT WE TURNED "MONSTERS FROM THE ID" INTO "NUFF SAID"! WE GOT A BETTER TIME SLOT TWICE (3:30 AM TO MIDNIGHT TO 10 PM) & AFTER 9 YRS PROGRAM DIRECTOR BERNARD WHITE PUT THE SHOW ON HIATUS - IM ALSO INTO NATURE ESP BIRDS & HAVE TAKEN VACATIONS IN PLACES ESP. TO SEE BIRD SPECIES IVE NEVER SEEN BEFORE - MY LIFE LIST IS UP TO ABOUT 550 - IVE HITCHHIKED ACROSS THE COUNTRY SEVERAL TIMES LOGGING ALMOST 30,000 IN 42 STATES - I WROTE "CHERNOBYL-ON-THE-HUDSON" - ABOUT THE INDIAN POINT NUCLEAR REACTOR IN THE EARLY 80's - RECENTLY PUT BACK INTO PRINT BY NYC FRIENDS OF CLEARWATER - LATELY IVE GOTTEN INTO WEB DESIGN & THATS THE LAST PLACE I'D EXPECT TO BE ～x

*# FLY NOV-2K2 "NUFF SAID" with KEN GALE ON WBAI FM 99.5 NYC

TO GUEST HOST OF THE WOLF"

W B A I www.comicbook radioshow.com

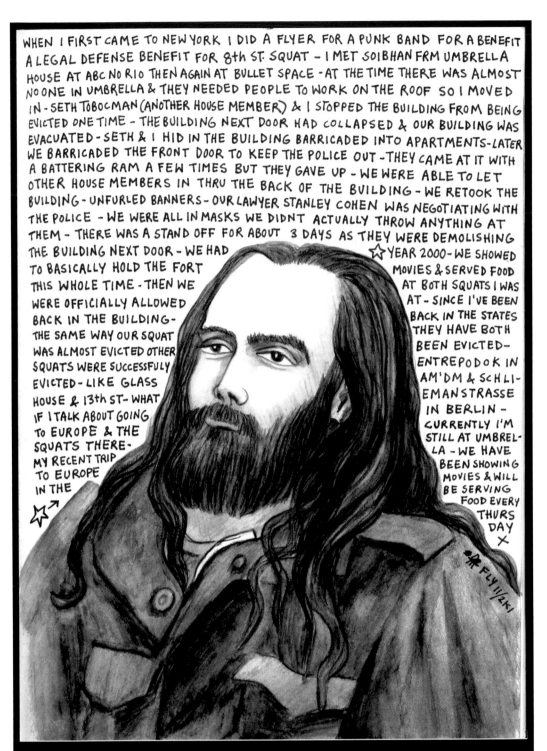

WHEN I FIRST CAME TO NEW YORK I DID A FLYER FOR A PUNK BAND FOR A BENEFIT A LEGAL DEFENSE BENEFIT FOR 8th ST. SQUAT - I MET SOIBHAN FRM UMBRELLA HOUSE AT ABC NO RIO THEN AGAIN AT BULLET SPACE - AT THE TIME THERE WAS ALMOST NO ONE IN UMBRELLA & THEY NEEDED PEOPLE TO WORK ON THE ROOF SO I MOVED IN - SETH TOBOCMAN (ANOTHER HOUSE MEMBER) & I STOPPED THE BUILDING FROM BEING EVICTED ONE TIME - THE BUILDING NEXT DOOR HAD COLLAPSED & OUR BUILDING WAS EVACUATED - SETH & I HID IN THE BUILDING BARRICADED INTO APARTMENTS - LATER WE BARRICADED THE FRONT DOOR TO KEEP THE POLICE OUT - THEY CAME AT IT WITH A BATTERING RAM A FEW TIMES BUT THEY GAVE UP - WE WERE ABLE TO LET OTHER HOUSE MEMBERS IN THRU THE BACK OF THE BUILDING - WE RETOOK THE BUILDING - UNFURLED BANNERS - OUR LAWYER STANLEY COHEN WAS NEGOTIATING WITH THE POLICE - WE WERE ALL IN MASKS WE DIDNT ACTUALLY THROW ANYTHING AT THEM - THERE WAS A STAND OFF FOR ABOUT 3 DAYS AS THEY WERE DEMOLISHING THE BUILDING NEXT DOOR - WE HAD TO BASICALLY HOLD THE FORT THIS WHOLE TIME - THEN WE WERE OFFICIALLY ALLOWED BACK IN THE BUILDING - THE SAME WAY OUR SQUAT WAS ALMOST EVICTED OTHER SQUATS WERE SUCCESSFULY EVICTED - LIKE GLASS HOUSE & 13th ST - WHAT IF I TALK ABOUT GOING TO EUROPE & THE SQUATS THERE - MY RECENT TRIP TO EUROPE IN THE

☆→ YEAR 2000 - WE SHOWED MOVIES & SERVED FOOD AT BOTH SQUATS I WAS AT - SINCE I'VE BEEN BACK IN THE STATES THEY HAVE BOTH BEEN EVICTED - ENTREPODOK IN AM'DM & SCHLIEMANSTRASSE IN BERLIN - CURRENTLY I'M STILL AT UMBRELLA - WE HAVE BEEN SHOWING MOVIES & WILL BE SERVING FOOD EVERY THURSDAY X

FLY 11/2K1

LAWRENCE VANABEEMA – NOV. 2K1 – LOISAIDA – NYC
I MET LAWRENCE SOMETIME IN THE EARLY 90S WHEN I WAS GETTING INVOLVED IN THE SQUATTER SCENE IN THE LOWER EAST SIDE – HE WAS ONE OF THE OLD SCHOOL RESIDENTS OF UMBRELLA HAUS ON AVE. C – HE WAS ALWAYS DOING COMICS FOR THE SHADOW (THE NEIGHBORHOOD ANARCHIST PAPER OF CHOICE) & WORLD WAR 3 ILLUSTRATED – HE ALSO DID A LOT OF FLYERS – HE STILL DOES ALL THAT & HE TOLD ME NOW HE IS DOING ANI– MATION – VANABBEMA@ESCAPE.COM – WWW.VANABBEMA.TRIPOD.COM

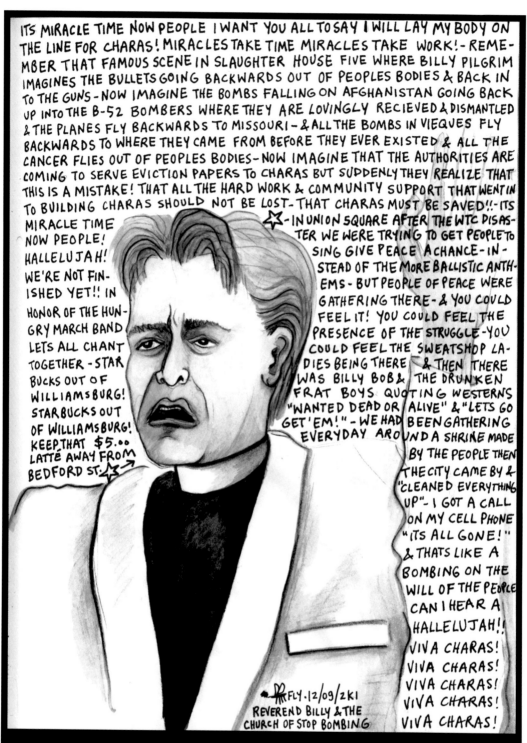

ITS MIRACLE TIME NOW PEOPLE I WANT YOU ALL TO SAY I WILL LAY MY BODY ON THE LINE FOR CHARAS! MIRACLES TAKE TIME MIRACLES TAKE WORK! - REMEMBER THAT FAMOUS SCENE IN SLAUGHTER HOUSE FIVE WHERE BILLY PILGRIM IMAGINES THE BULLETS GOING BACKWARDS OUT OF PEOPLES BODIES & BACK IN TO THE GUNS - NOW IMAGINE THE BOMBS FALLING ON AFGHANISTAN GOING BACK UP INTO THE B-52 BOMBERS WHERE THEY ARE LOVINGLY RECIEVED & DISMANTLED & THE PLANES FLY BACKWARDS TO MISSOURI - & ALL THE BOMBS IN VIEQUES FLY BACKWARDS TO WHERE THEY CAME FROM BEFORE THEY EVER EXISTED & ALL THE CANCER FLIES OUT OF PEOPLES BODIES - NOW IMAGINE THAT THE AUTHORITIES ARE COMING TO SERVE EVICTION PAPERS TO CHARAS BUT SUDDENLY THEY REALIZE THAT THIS IS A MISTAKE! THAT ALL THE HARD WORK & COMMUNITY SUPPORT THAT WENT IN TO BUILDING CHARAS SHOULD NOT BE LOST - THAT CHARAS MUST BE SAVED!! - ITS

MIRACLE TIME NOW PEOPLE! HALLELUJAH! WE'RE NOT FINISHED YET!! IN HONOR OF THE HUNGRY MARCH BAND LETS ALL CHANT TOGETHER - STARBUCKS OUT OF WILLIAMSBURG! STARBUCKS OUT OF WILLIAMSBURG! KEEP THAT $5.00 LATTE AWAY FROM BEDFORD ST. →

☆ - IN UNION SQUARE AFTER THE WTC DISASTER WE WERE TRYING TO GET PEOPLE TO SING GIVE PEACE A CHANCE - INSTEAD OF THE MORE BALLISTIC ANTHEMS - BUT PEOPLE OF PEACE WERE GATHERING THERE - & YOU COULD FEEL IT! YOU COULD FEEL THE PRESENCE OF THE STRUGGLE - YOU COULD FEEL THE SWEATSHOP LADIES BEING THERE & THEN THERE WAS BILLY BOB & THE DRUNKEN FRAT BOYS QUOTING WESTERNS "WANTED DEAD OR ALIVE" & "LETS GO GET 'EM!" - WE HAD BEEN GATHERING EVERYDAY AROUND A SHRINE MADE BY THE PEOPLE THEN THE CITY CAME BY & "CLEANED EVERYTHING UP" - I GOT A CALL ON MY CELL PHONE "ITS ALL GONE!" & THATS LIKE A BOMBING ON THE WILL OF THE PEOPLE CAN I HEAR A HALLELUJAH!! VIVA CHARAS! VIVA CHARAS! VIVA CHARAS! VIVA CHARAS! VIVA CHARAS!

FLY • 12/09/2K1
REVEREND BILLY & THE
CHURCH OF STOP BOMBING

REVEREND BILLY – 12/09/2K1 – AT CHARAS – LOISAIDA – NYC
I DON T REALLY KNOW BILL TALEN WHICH IS THE REVERENDS REAL NAME – I ONLY KNOW THE PERFORMANCE PERSONA – REVEREND BILLY CAN REALLY WIND IT UP – HE PREACHES A LOT AT STARBUCKS & IS THE SPIRITUAL LEADER OF THE CHURCH OF STOP SHOPPING – I DREW HIM WHILE HE WAS PERFORMING AT CHARAS – A COMMUNITY ARTS CENTER IN THE LOWER EAST SIDE – IT WAS LIKE A BIG PEP RALLY CUZ THE BUILDING HAS BEEN SOLD TO A SCUMBAG – UNFORTUNATELY CHARAS WAS EVICTED LATER IN 2K2 –
IT IS MISSED

73

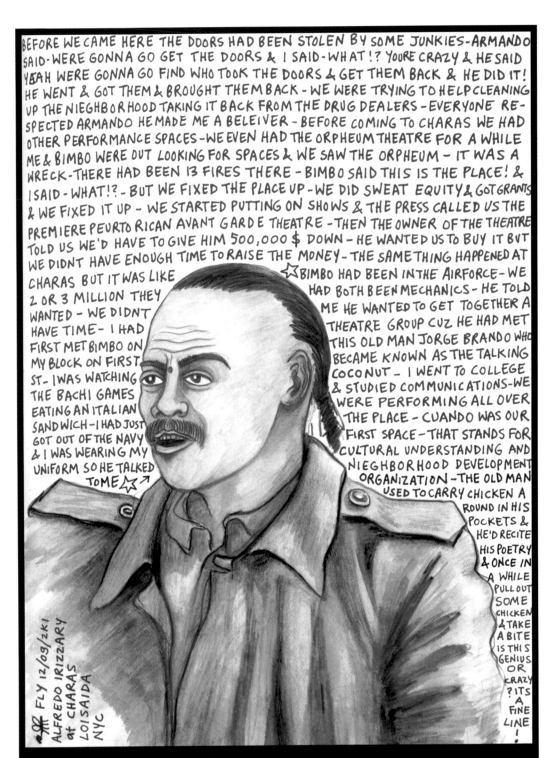

BEFORE WE CAME HERE THE DOORS HAD BEEN STOLEN BY SOME JUNKIES-ARMANDO SAID-WERE GONNA GO GET THE DOORS & I SAID-WHAT!? YOURE CRAZY & HE SAID YEAH WERE GONNA GO FIND WHO TOOK THE DOORS & GET THEM BACK & HE DID IT! HE WENT & GOT THEM & BROUGHT THEM BACK - WE WERE TRYING TO HELP CLEANING UP THE NIEGHBORHOOD TAKING IT BACK FROM THE DRUG DEALERS -EVERYONE RE-SPECTED ARMANDO HE MADE ME A BELEIVER - BEFORE COMING TO CHARAS WE HAD OTHER PERFORMANCE SPACES -WE EVEN HAD THE ORPHEUM THEATRE FOR A WHILE ME & BIMBO WERE OUT LOOKING FOR SPACES & WE SAW THE ORPHEUM - IT WAS A WRECK-THERE HAD BEEN 13 FIRES THERE - BIMBO SAID THIS IS THE PLACE! & I SAID - WHAT!? - BUT WE FIXED THE PLACE UP -WE DID SWEAT EQUITY & GOT GRANTS & WE FIXED IT UP - WE STARTED PUTTING ON SHOWS & THE PRESS CALLED US THE PREMIERE PEURTO RICAN AVANT GARDE THEATRE -THEN THE OWNER OF THE THEATRE TOLD US WE'D HAVE TO GIVE HIM 500,000 $ DOWN - HE WANTED US TO BUY IT BUT WE DIDNT HAVE ENOUGH TIME TO RAISE THE MONEY - THE SAME THING HAPPENED AT CHARAS BUT IT WAS LIKE 2 OR 3 MILLION THEY WANTED - WE DIDNT HAVE TIME- I HAD FIRST MET BIMBO ON MY BLOCK ON FIRST ST- I WAS WATCHING THE BACHI GAMES EATING AN ITALIAN SANDWICH - I HAD JUST GOT OUT OF THE NAVY & I WAS WEARING MY UNIFORM SO HE TALKED TO ME ☆↗

☆ BIMBO HAD BEEN IN THE AIRFORCE-WE HAD BOTH BEEN MECHANICS- HE TOLD ME HE WANTED TO GET TOGETHER A THEATRE GROUP CUZ HE HAD MET THIS OLD MAN JORGE BRANDO WHO BECAME KNOWN AS THE TALKING COCONUT - I WENT TO COLLEGE & STUDIED COMMUNICATIONS-WE WERE PERFORMING ALL OVER THE PLACE - CUANDO WAS OUR FIRST SPACE -THAT STANDS FOR CULTURAL UNDERSTANDING AND NIEGHBORHOOD DEVELOPMENT ORGANIZATION -THE OLD MAN USED TO CARRY CHICKEN A ROUND IN HIS POCKETS & HE'D RECITE HIS POETRY & ONCE IN A WHILE PULL OUT SOME CHICKEN & TAKE A BITE IS THIS GENIUS OR CRAZY ? ITS A FINE LINE !

FLY 12/09/2K1 ALFREDO IRIZZARY at CHARAS LOISAIDA NYC

ALFREDO IRIZZARY – 12/09/2K1 – AT CHARAS – LOISAIDA – NYC
I HAD NEVER MET ALFREDO BUT HE WAS SPEAKING AT A BIG SHOW AT CHARAS & HE WAS TELLING THE CRAZIEST STORIES & I WAS SITTING THERE WITH NOTHING TO DO BUT DRAW – I COULDNT KEEP UP WITH HIM BUT I THINK I GOT THE GENERAL IDEA – HE HAD BEEN OLD FRIENDS WITH ARMANDO PEREZ WHO WAS MURDERED THE PREVIOUS YEAR & THAT CASE HAS NOT YET BEEN RESOLVED – ARMANDO HAD BEEN ONE OF THE MAJOR FORCES BEHIND KEEPING CHARAS OPENED – UNFORTUNATELY CHARAS IS NOW CLOSED

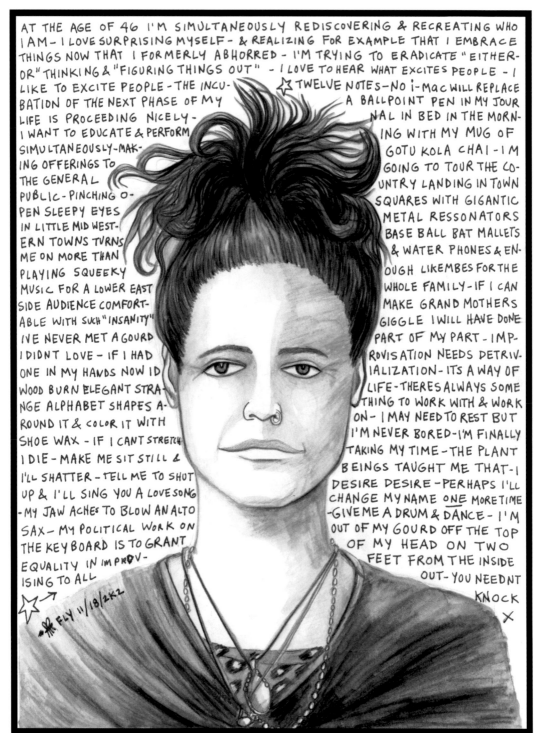

AT THE AGE OF 46 I'M SIMULTANEOUSLY REDISCOVERING & RECREATING WHO I AM - I LOVE SURPRISING MYSELF - & REALIZING FOR EXAMPLE THAT I EMBRACE THINGS NOW THAT I FORMERLY ABHORRED - I'M TRYING TO ERADICATE "EITHER-OR" THINKING & "FIGURING THINGS OUT" - I LOVE TO HEAR WHAT EXCITES PEOPLE - I LIKE TO EXCITE PEOPLE - THE INCU-BATION OF THE NEXT PHASE OF MY LIFE IS PROCEEDING NICELY - I WANT TO EDUCATE & PERFORM SIMULTANEOUSLY - MAK-ING OFFERINGS TO THE GENERAL PUBLIC - PINCHING O-PEN SLEEPY EYES IN LITTLE MID WEST-ERN TOWNS TURNS ME ON MORE THAN PLAYING SQUEEKY MUSIC FOR A LOWER EAST SIDE AUDIENCE COMFORT-ABLE WITH SUCH "INSANITY" I'VE NEVER MET A GOURD I DIDN'T LOVE - IF I HAD ONE IN MY HANDS NOW I'D WOOD BURN ELEGANT STRA-NGE ALPHABET SHAPES A-ROUND IT & COLOR IT WITH SHOE WAX - IF I CAN'T STRETCH I DIE - MAKE ME SIT STILL & I'LL SHATTER - TELL ME TO SHUT UP & I'LL SING YOU A LOVE SONG - MY JAW ACHES TO BLOW AN ALTO SAX - MY POLITICAL WORK ON THE KEYBOARD IS TO GRANT EQUALITY IN IMPROV-ISING TO ALL

✰→ ❀ FLY 11/18/2K2

☆ TWELVE NOTES - NO i-MAC WILL REPLACE A BALLPOINT PEN IN MY JOUR-NAL IN BED IN THE MORN-ING WITH MY MUG OF GOTU KOLA CHAI - I'M GOING TO TOUR THE CO-UNTRY LANDING IN TOWN SQUARES WITH GIGANTIC METAL RESSONATORS BASE BALL BAT MALLETS & WATER PHONES & EN-OUGH LIKEMBES FOR THE WHOLE FAMILY - IF I CAN MAKE GRAND MOTHERS GIGGLE I WILL HAVE DONE PART OF MY PART - IMP-ROVISATION NEEDS DETRIV-IALIZATION - ITS A WAY OF LIFE - THERES ALWAYS SOME THING TO WORK WITH & WORK ON - I MAY NEED TO REST BUT I'M NEVER BORED - I'M FINALLY TAKING MY TIME - THE PLANT BEINGS TAUGHT ME THAT - I DESIRE DESIRE - PERHAPS I'LL CHANGE MY NAME ONE MORE TIME - GIVE ME A DRUM & DANCE - I'M OUT OF MY GOURD OFF THE TOP OF MY HEAD ON TWO FEET FROM THE INSIDE OUT - YOU NEEDNT KNOCK ✗

LYX ISH – 11/18/2K2 – FRM LAFARGE, WI
WHEN I FIRST MET LYX HER NAME WAS ELIZABETH WAS & SHE LIVED AT DREAMTIME VILLAGE IN WEST LIMA, WISCONSIN, WITH MIEKAL AND & THEIRSON LIAIZON WAKEST – I MET HER WHEN THEY WERE VISITING NYC & STAYING AT THE GARGOYLE MECHANIQUE LAB – A YEAR OR SO LATER I TRAVELLED OUT TO DREAMTIME VILLAGE WITH A VAN FULL OF GARGOYLES FOR THE AUGUST CORROBOREE & IT WAS AN UNFORGETABLE EXPERIENCE – I GOT TO SPEND A LITTLE TIME WITH LYX & ABSORB SOME OF HER VAST KNOWLEDGE & ENTHUSIASM FOR LIFE & ART – LYX S LIFE IS FAR TOO COMPLEX TO SUMMARIZE – YOU WILL JUST HAVE TO HOPE YOU CAN MEET HER YRSELF SOMEDAY – LYXISH@MWT.NET

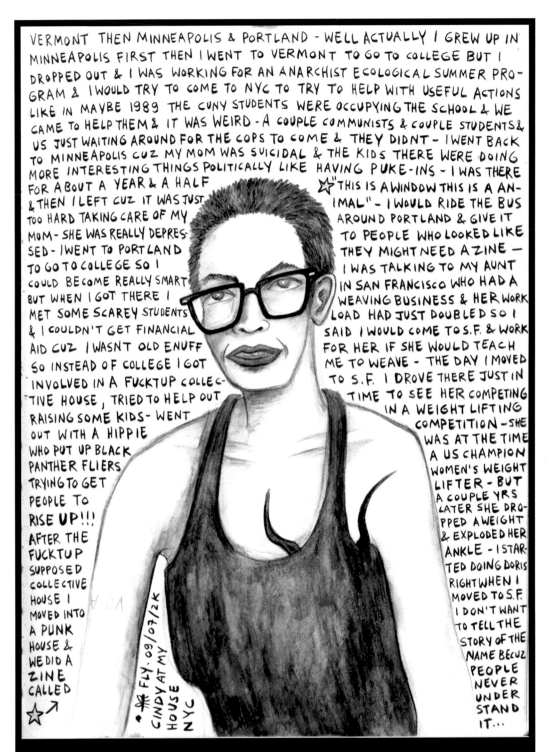

VERMONT THEN MINNEAPOLIS & PORTLAND - WELL ACTUALLY I GREW UP IN MINNEAPOLIS FIRST THEN I WENT TO VERMONT TO GO TO COLLEGE BUT I DROPPED OUT & I WAS WORKING FOR AN ANARCHIST ECOLOGICAL SUMMER PRO- GRAM & I WOULD TRY TO COME TO NYC TO TRY TO HELP WITH USEFUL ACTIONS LIKE IN MAYBE 1989 THE CUNY STUDENTS WERE OCCUPYING THE SCHOOL & WE CAME TO HELP THEM & IT WAS WEIRD - A COUPLE COMMUNISTS & COUPLE STUDENTS & US JUST WAITING AROUND FOR THE COPS TO COME & THEY DIDNT - I WENT BACK TO MINNEAPOLIS CUZ MY MOM WAS SUICIDAL & THE KIDS THERE WERE DOING MORE INTERESTING THINGS POLITICALLY LIKE HAVING PUKE-INS - I WAS THERE FOR ABOUT A YEAR & A HALF & THEN I LEFT CUZ IT WAS JUST TOO HARD TAKING CARE OF MY MOM - SHE WAS REALLY DEPRES- SED - I WENT TO PORTLAND TO GO TO COLLEGE SO I COULD BECOME REALLY SMART BUT WHEN I GOT THERE I MET SOME SCAREY STUDENTS & I COULDN'T GET FINANCIAL AID CUZ I WASNT OLD ENUFF SO INSTEAD OF COLLEGE I GOT INVOLVED IN A FUCKTUP COLLEC- TIVE HOUSE, TRIED TO HELP OUT RAISING SOME KIDS - WENT OUT WITH A HIPPIE WHO PUT UP BLACK PANTHER FLIERS TRYING TO GET PEOPLE TO RISE UP!!! AFTER THE FUCKTUP SUPPOSED COLLECTIVE HOUSE I MOVED INTO A PUNK HOUSE & WE DID A ZINE CALLED ☆↗

☆"THIS IS A WINDOW THIS IS A AN- IMAL" - I WOULD RIDE THE BUS AROUND PORTLAND & GIVE IT TO PEOPLE WHO LOOKED LIKE THEY MIGHT NEED A ZINE — I WAS TALKING TO MY AUNT IN SAN FRANCISCO WHO HAD A WEAVING BUSINESS & HER WORK LOAD HAD JUST DOUBLED SO I SAID I WOULD COME TO S.F. & WORK FOR HER IF SHE WOULD TEACH ME TO WEAVE - THE DAY I MOVED TO S.F. I DROVE THERE JUST IN TIME TO SEE HER COMPETING IN A WEIGHT LIFTING COMPETITION - SHE WAS AT THE TIME A US CHAMPION WOMEN'S WEIGHT LIFTER - BUT A COUPLE YRS LATER SHE DRO- PPED A WEIGHT & EXPLODED HER ANKLE - I STAR- TED DOING DORIS RIGHT WHEN I MOVED TO S.F. I DON'T WANT TO TELL THE STORY OF THE NAME BECUZ PEOPLE NEVER UNDER STAND IT...

✳ FLY-09/07/2K CINDY AT MY HOUSE NYC

CINDY – (DORIS ZINE) – 09/07/Y2K – NYC

I THINK I FIRST READ DORIS IN 1996 WHEN I WAS IN AMSTERDAM – MY PAL GRRRT LENT ME SOME ISSUEWS & TOLD ME IT WAS HIS NEW FAVORITE ZINE – I LOVED IT & WHILE I WAS TRAVELING FROM HOLLAND TO LONDON ON A BOAT I WROTE A POSTCARD TO CINDY BECUZ I FELT LIKE SHE WAS MY NEW BEST FRIEND – I MAILED IT FRM LONDON & LATER I FELT SORT OF EMBARRASSED CUZ I THOUGHT SHE WOULD THINK – WHO IS THIS CRAZY PERSON TELLING ME ALL HER SECRETS? – BUT THEN I MET HER & THERE WAS NO PROBLEM

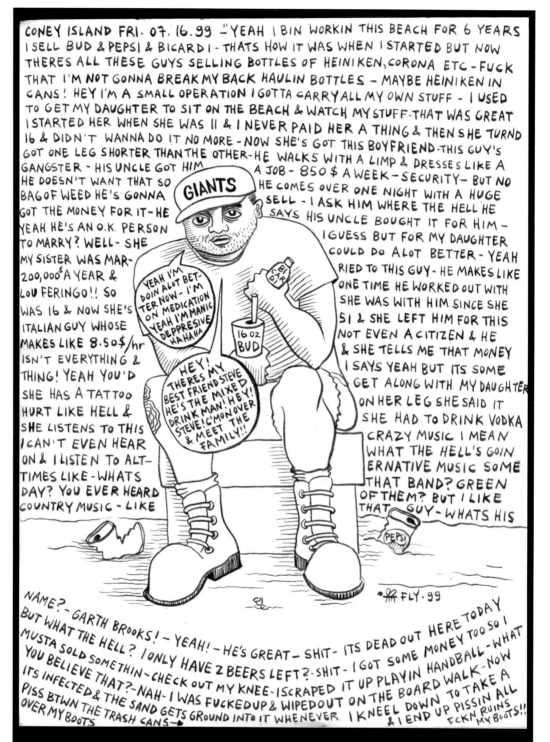

CONEY ISLAND DUDE – JULY 1999

IT WAS A BRUTAL SUMMER & IT WAS ABOUT 110 DEGREES SO ME & COREY HEADED OUT TO CONEY ISLAND TO HANG OUT WITH THOUSANDS OF OTHER PEOPLE — ALL DAY THERE ARE GUYS WHO WALK THE BEACH SELLING BEER & OF COURSE WE GOT TARGETED BY A WIERDO WHO KEPT ASKING US TO WATCH HIS STUFF SO THEN WE BECAME A KIND OF OUTPOST FOR THESE GUYS — THEY WOULD LEAVE THEIRSTUFF WITH US & GIVE US FREE BEER — THIS ONE GUY SAT DOWN WITH US & STARTED TALKING A MILE A MINUTE & DIDNT STOP TIL WE LEFT

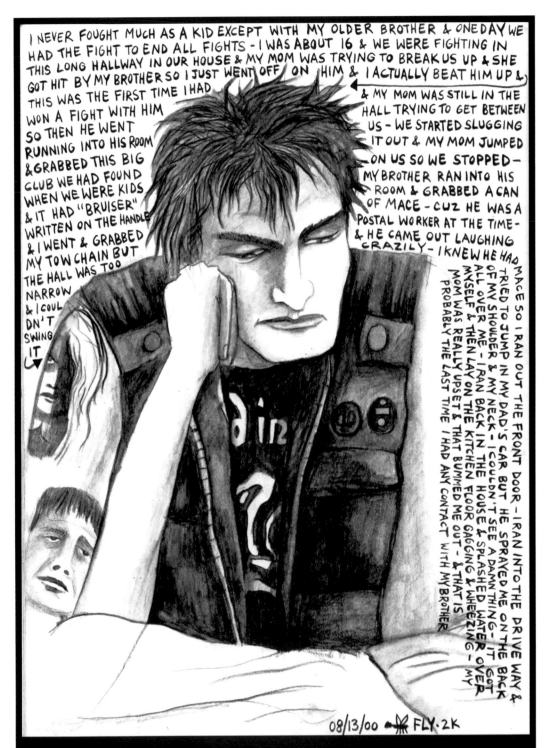

I NEVER FOUGHT MUCH AS A KID EXCEPT WITH MY OLDER BROTHER & ONE DAY WE HAD THE FIGHT TO END ALL FIGHTS - I WAS ABOUT 16 & WE WERE FIGHTING IN THIS LONG HALLWAY IN OUR HOUSE & MY MOM WAS TRYING TO BREAK US UP & SHE GOT HIT BY MY BROTHER SO I JUST WENT OFF ON HIM & I ACTUALLY BEAT HIM UP & THIS WAS THE FIRST TIME I HAD WON A FIGHT WITH HIM SO THEN HE WENT RUNNING INTO HIS ROOM & GRABBED THIS BIG CLUB WE HAD FOUND WHEN WE WERE KIDS & IT HAD "BRUISER" WRITTEN ON THE HANDLE & I WENT & GRABBED MY TOW CHAIN BUT THE HALL WAS TOO NARROW & I COULDN'T SWING IT

& MY MOM WAS STILL IN THE HALL TRYING TO GET BETWEEN US - WE STARTED SLUGGING IT OUT & MY MOM JUMPED ON US SO WE STOPPED - MY BROTHER RAN INTO HIS ROOM & GRABBED A CAN OF MACE - CUZ HE WAS A POSTAL WORKER AT THE TIME - & HE CAME OUT LAUGHING CRAZILY - I KNEW HE HAD MACE SO I RAN OUT THE FRONT DOOR - I RAN INTO THE DRIVE WAY & TRIED TO JUMP IN MY DAD'S CAR BUT HE SPRAYED ME ON THE BACK OF MY SHOULDER & MY NECK - I COULDN'T SEE A DAMN THING - IT GOT ALL OVER ME - I RAN BACK IN THE HOUSE & SPLASHED WATER OVER MYSELF & THEN LAY ON THE KITCHEN FLOOR GAGGING & WHEEZING - MY MOM WAS REALLY UPSET & THAT BUMMED ME OUT - & THAT IS PROBABLY THE LAST TIME I HAD ANY CONTACT WITH MY BROTHER

08/13/00 ✦ FLY·2K

COREY LYONS (AUS ROTTEN) – 08/08/Y2K – PITTSBURGH

MY FAVORITE THING ABOUT VISITING PITTSBURGH WAS THAT MY PAL COREY LIVES A COUPLE BLOCKS FROM A HUGE PARK THAT IS ALL WOODS & BESIDE THAT IS A BIG GRAVEYARD – BOTH REALLY FUN TO HIKE AROUND – COREY IS NOT MUCH OF A HIKER BUT ONE TIME IN SF I MADE HIM WALK ALL THE WAY FRM OCEAN BEACH THROUGH GOLDEN GATE PARK WHERE WE SAW BUFFALO & LOTS OF AMAZING TREES & WE KEPT WALKING THROUGH THE HAIGHT & THROUGH THE CASTRO ALL THE WAY TO THE MISSION – THEN WE DRANK BEER!

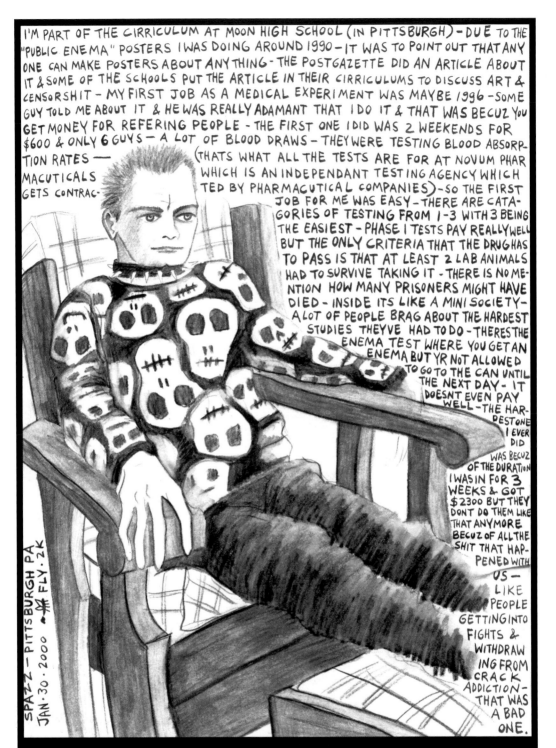

I'M PART OF THE CIRRICULUM AT MOON HIGH SCHOOL (IN PITTSBURGH) - DUE TO THE "PUBLIC ENEMA" POSTERS I WAS DOING AROUND 1990 - IT WAS TO POINT OUT THAT ANY ONE CAN MAKE POSTERS ABOUT ANYTHING - THE POSTGAZETTE DID AN ARTICLE ABOUT IT & SOME OF THE SCHOOLS PUT THE ARTICLE IN THEIR CIRRICULUMS TO DISCUSS ART & CENSORSHIT - MY FIRST JOB AS A MEDICAL EXPERIMENT WAS MAYBE 1996 - SOME GUY TOLD ME ABOUT IT & HE WAS REALLY ADAMANT THAT I DO IT & THAT WAS BECUZ YOU GET MONEY FOR REFERING PEOPLE - THE FIRST ONE I DID WAS 2 WEEKENDS FOR $600 & ONLY 6 GUYS - A LOT OF BLOOD DRAWS - THEY WERE TESTING BLOOD ABSORP-TION RATES — MACUTICALS GETS CONTRAC- (THATS WHAT ALL THE TESTS ARE FOR AT NOVUM PHAR WHICH IS AN INDEPENDANT TESTING AGENCY WHICH TED BY PHARMACUTICAL COMPANIES) - SO THE FIRST JOB FOR ME WAS EASY - THERE ARE CATA-GORIES OF TESTING FROM 1-3 WITH 3 BEING THE EASIEST - PHASE I TESTS PAY REALLY WELL BUT THE ONLY CRITERIA THAT THE DRUG HAS TO PASS IS THAT AT LEAST 2 LAB ANIMALS HAD TO SURVIVE TAKING IT - THERE IS NO ME-NTION HOW MANY PRISONERS MIGHT HAVE DIED - INSIDE ITS LIKE A MINI SOCIETY - A LOT OF PEOPLE BRAG ABOUT THE HARDEST STUDIES THEYVE HAD TO DO - THERES THE ENEMA TEST WHERE YOU GET AN ENEMA BUT YR NOT ALLOWED TO GO TO THE CAN UNTIL THE NEXT DAY - IT DOESNT EVEN PAY WELL - THE HAR-DEST ONE I EVER DID WAS BECUZ OF THE DURATION I WAS IN FOR 3 WEEKS & GOT $2300 BUT THEY DONT DO THEM LIKE THAT ANYMORE BECUZ OF ALL THE SHIT THAT HAP-PENED WITH US - LIKE PEOPLE GETTING INTO FIGHTS & WITHDRAW ING FROM CRACK ADDICTION - THAT WAS A BAD ONE.

SPAZZ - PITTSBURGH PA JAN. 30. 2000 ✳ FLY. 2K

SPAZZ – 01/30/Y2K – PITTSBURGH
SPAZZ LIVES IN THE AUS ROTTEN HOUSE IN PITTS – IF YOU HANG OUT WITH SPAZZ YOU WILL NEVER FORGET HIS VOICE & HE WILL KNOCK OFF YR SOCKS AT KARAOKE AKA THE SPAZZ SHOW (STARRING SPAZZ!!) – THE LAST TIME I WAS IN PITTS WE ALL WENT TO THE IRON MAIDEN CONCERT TO PARTY IN THE PARKING LOT – SPAZZ WAS DRINKING A BIG BOTTLE OF LONG ISLAND ICED TEA SO HE WAS SHITFACED BY THE TIME WE ACTUALLY GOT IN – BRUCE DICKENSON KEPT YELLING "SCREAM FOR ME PITTSBURGH!" & SPAZZ KEPT MOANING – "UUUUHHHOOOOOUUUHHHH"

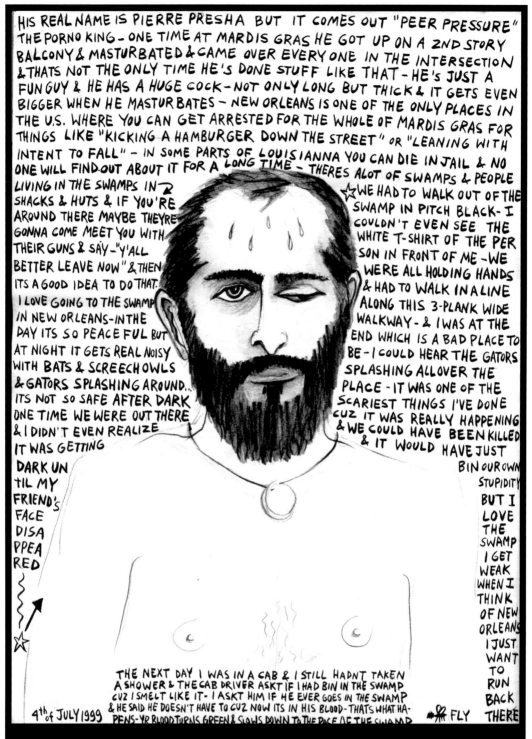

HIS REAL NAME IS PIERRE PRESHA BUT IT COMES OUT "PEER PRESSURE" THE PORNO KING - ONE TIME AT MARDIS GRAS HE GOT UP ON A 2ND STORY BALCONY & MASTURBATED & CAME OVER EVERY ONE IN THE INTERSECTION & THATS NOT THE ONLY TIME HE'S DONE STUFF LIKE THAT - HE'S JUST A FUN GUY & HE HAS A HUGE COCK - NOT ONLY LONG BUT THICK & IT GETS EVEN BIGGER WHEN HE MASTURBATES - NEW ORLEANS IS ONE OF THE ONLY PLACES IN THE U.S. WHERE YOU CAN GET ARRESTED FOR THE WHOLE OF MARDIS GRAS FOR THINGS LIKE "KICKING A HAMBURGER DOWN THE STREET" OR "LEANING WITH INTENT TO FALL" - IN SOME PARTS OF LOUISIANNA YOU CAN DIE IN JAIL & NO ONE WILL FIND OUT ABOUT IT FOR A LONG TIME - THERES ALOT OF SWAMPS & PEOPLE LIVING IN THE SWAMPS IN SHACKS & HUTS & IF YOU'RE AROUND THERE MAYBE THEYRE GONNA COME MEET YOU WITH THEIR GUNS & SAY - "Y'ALL BETTER LEAVE NOW" & THEN ITS A GOOD IDEA TO DO THAT. I LOVE GOING TO THE SWAMP IN NEW ORLEANS - IN THE DAY ITS SO PEACEFUL BUT AT NIGHT IT GETS REAL NOISY WITH BATS & SCREECH OWLS & GATORS SPLASHING AROUND... ITS NOT SO SAFE AFTER DARK ONE TIME WE WERE OUT THERE & I DIDN'T EVEN REALIZE IT WAS GETTING DARK UN TIL MY FRIEND'S FACE DISA PPEA RED

☆ WE HAD TO WALK OUT OF THE SWAMP IN PITCH BLACK - I COULDN'T EVEN SEE THE WHITE T-SHIRT OF THE PER SON IN FRONT OF ME - WE WERE ALL HOLDING HANDS & HAD TO WALK IN A LINE ALONG THIS 3-PLANK WIDE WALKWAY - & I WAS AT THE END WHICH IS A BAD PLACE TO BE - I COULD HEAR THE GATORS SPLASHING ALL OVER THE PLACE - IT WAS ONE OF THE SCARIEST THINGS I'VE DONE CUZ IT WAS REALLY HAPPENING & WE COULD HAVE BEEN KILLED & IT WOULD HAVE JUST BIN OUR OWN STUPIDITY BUT I LOVE THE SWAMP I GET WEAK WHEN I THINK OF NEW ORLEANS I JUST WANT TO RUN BACK THERE

THE NEXT DAY I WAS IN A CAB & I STILL HADNT TAKEN A SHOWER & THE CAB DRIVER ASKT IF I HAD BIN IN THE SWAMP CUZ I SMELT LIKE IT - I ASKT HIM IF HE EVER GOES IN THE SWAMP & HE SAID HE DOESN'T HAVE TO CUZ NOW ITS IN HIS BLOOD - THATS WHAT HA- PENS - YR BLOOD TURNS GREEN & SLOWS DOWN TO THE PACE OF THE SWAMP

4th of JULY 1999

#☆ FLY

JAY (FRM NAWLINS) – FOURTH OF JULY 1999 – NYC
IT WAS ABOUT 110° THAT SUMMER – I MET JAY ON THE 4TH OF JULY – HE WAS STAYING UPSTAIRS WITH FAMOUS – I WAS WAITING TO DRAW A PORTRAIT OF FOREST & JAY JUST STARTED TALKING & I JUST STARTED DRAWING & WE WERE BOTH SWEATING – JAY STAYED IN NYC FOR MOST OF THE YEAR BEFORE RUNNING OFF TO JOIN THE CIRCUS & THE INDE- PENDENT MEDIA CENTER – I FINALLY GOT TO MEET PIERRE PRE$$URE – HE DIDN T SHOW ME HIS "HUGE COCK" BUT THEN I DIDNT ASK EITHER – ONEHANUMANONE@HOTMAIL.COM

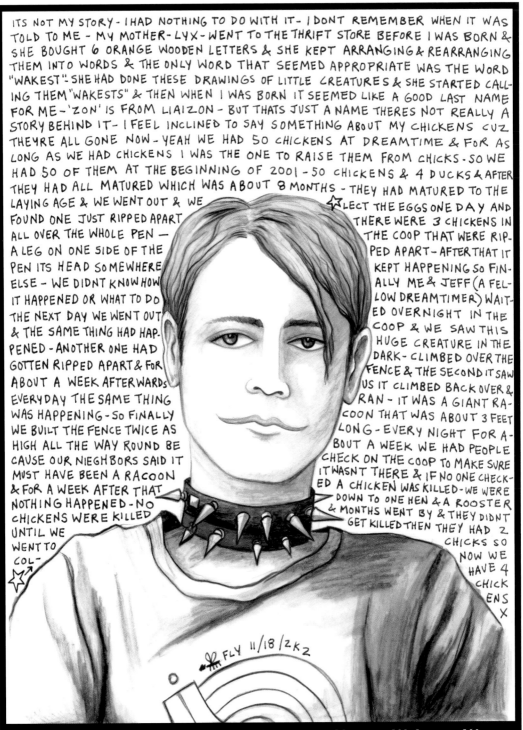

ITS NOT MY STORY - I HAD NOTHING TO DO WITH IT - I DONT REMEMBER WHEN IT WAS TOLD TO ME - MY MOTHER - LYX - WENT TO THE THRIFT STORE BEFORE I WAS BORN & SHE BOUGHT 6 ORANGE WOODEN LETTERS & SHE KEPT ARRANGING & REARRANGING THEM INTO WORDS & THE ONLY WORD THAT SEEMED APPROPRIATE WAS THE WORD "WAKEST" SHE HAD DONE THESE DRAWINGS OF LITTLE CREATURES & SHE STARTED CALLING THEM "WAKESTS" & THEN WHEN I WAS BORN IT SEEMED LIKE A GOOD LAST NAME FOR ME - 'ZON' IS FROM LIAIZON - BUT THATS JUST A NAME THERES NOT REALLY A STORY BEHIND IT - I FEEL INCLINED TO SAY SOMETHING ABOUT MY CHICKENS CUZ THEYRE ALL GONE NOW - YEAH WE HAD 50 CHICKENS AT DREAMTIME & FOR AS LONG AS WE HAD CHICKENS I WAS THE ONE TO RAISE THEM FROM CHICKS - SO WE HAD 50 OF THEM AT THE BEGINNING OF 2001 - 50 CHICKENS & 4 DUCKS & AFTER THEY HAD ALL MATURED WHICH WAS ABOUT 8 MONTHS - THEY HAD MATURED TO THE LAYING AGE AND WE WENT OUT & WE ☆ LECT THE EGGS ONE DAY AND FOUND ONE JUST RIPPED APART THERE WERE 3 CHICKENS IN ALL OVER THE WHOLE PEN — THE COOP THAT WERE RIPPED A LEG ON ONE SIDE OF THE PED APART - AFTER THAT IT PEN ITS HEAD SOMEWHERE KEPT HAPPENING SO FINALLY ELSE - WE DIDNT KNOW HOW ALLY ME & JEFF (A FELLOW IT HAPPENED OR WHAT TO DO LOW DREAMTIMER) WAITED THE NEXT DAY WE WENT OUT ED OVERNIGHT IN THE & THE SAME THING HAD HAPPENED COOP & WE SAW THIS PENED - ANOTHER ONE HAD HUGE CREATURE IN THE GOTTEN RIPPED APART & FOR DARK - CLIMBED OVER THE ABOUT A WEEK AFTERWARDS FENCE & THE SECOND IT SAW EVERYDAY THE SAME THING US IT CLIMBED BACK OVER & WAS HAPPENING - SO FINALLY RAN - IT WAS A GIANT RACOON WE BUILT THE FENCE TWICE AS COON THAT WAS ABOUT 3 FEET HIGH ALL THE WAY ROUND BECAUSE LONG - EVERY NIGHT FOR ABOUT OUR NIEGHBORS SAID IT BOUT A WEEK WE HAD PEOPLE MUST HAVE BEEN A RACOON CHECK ON THE COOP TO MAKE SURE & FOR A WEEK AFTER THAT IT WASNT THERE & IF NO ONE CHECKED NOTHING HAPPENED - NO ED A CHICKEN WAS KILLED - WE WERE CHICKENS WERE KILLED DOWN TO ONE HEN & A ROOSTER UNTIL WE & MONTHS WENT BY & THEY DIDNT WENT TO GET KILLED THEN THEY HAD 2 COL- ☆ CHICKS SO NOW WE HAVE 4 CHICKENS X

FLY 11/18/2K2

LIAIZON WAKEST – 11/18/2K2 – FRM DREAMTIME VILLAGE, W. LIMA – WISCO
I MET LIAIZON WHEN HE WAS MAYBE 3 OR 4 YRS OLD & VISITING NYC – HE WAS THE SMARTEST KID I HAD EVER MET & HE ALSO HAD A HUGE IMAGINATION – ZON LIVES AT DREAMTIME VILLAGE IN WISCONSIN – DREAMTIME IS A HARD PLACE TO DESCRIBE WITH JUST A FEW WORDS – "BOTH AN INFORMAL NETWORK OF FRIENDS AND CONTACTS SPREAD AROUND THE COUNTRY AND ALSO A COLLECTIVE COMMUNITY OF RESIDENTS, BUILDINGS AND LAND LOCATED IN THE DRIFTLESS BIOREGION OF SOUTHWEST WISCONSIN. DREAMTIME ACTIVITIES CENTER ON PERMACULTURE, ART, MEDIA AND LEARNING HOW TO LIVE SUSTAINABLY." – ZEE_ON@MWT.NET – WWW.DREAMTIMEVILLAGE.ORG

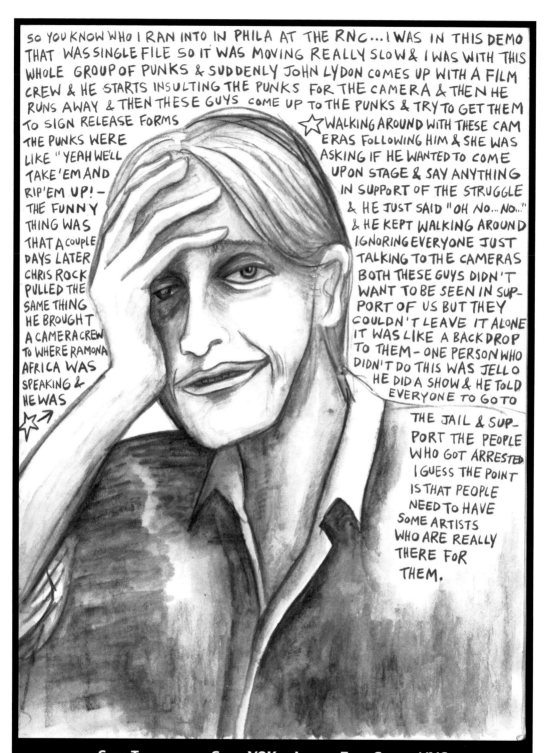

SO YOU KNOW WHO I RAN INTO IN PHILA AT THE RNC... I WAS IN THIS DEMO THAT WAS SINGLE FILE SO IT WAS MOVING REALLY SLOW & I WAS WITH THIS WHOLE GROUP OF PUNKS & SUDDENLY JOHN LYDON COMES UP WITH A FILM CREW & HE STARTS INSULTING THE PUNKS FOR THE CAMERA & THEN HE RUNS AWAY & THEN THESE GUYS COME UP TO THE PUNKS & TRY TO GET THEM TO SIGN RELEASE FORMS THE PUNKS WERE LIKE "YEAH WE'LL TAKE 'EM AND RIP 'EM UP! – THE FUNNY THING WAS THAT A COUPLE DAYS LATER CHRIS ROCK PULLED THE SAME THING HE BROUGHT A CAMERA CREW TO WHERE RAMONA AFRICA WAS SPEAKING & HE WAS

WALKING AROUND WITH THESE CAMERAS FOLLOWING HIM & SHE WAS ASKING IF HE WANTED TO COME UP ON STAGE & SAY ANYTHING IN SUPPORT OF THE STRUGGLE & HE JUST SAID "OH NO... NO..." & HE KEPT WALKING AROUND IGNORING EVERYONE JUST TALKING TO THE CAMERAS BOTH THESE GUYS DIDN'T WANT TO BE SEEN IN SUPPORT OF US BUT THEY COULDN'T LEAVE IT ALONE IT WAS LIKE A BACKDROP TO THEM – ONE PERSON WHO DIDN'T DO THIS WAS JELLO HE DID A SHOW & HE TOLD EVERYONE TO GO TO THE JAIL & SUPPORT THE PEOPLE WHO GOT ARRESTED I GUESS THE POINT IS THAT PEOPLE NEED TO HAVE SOME ARTISTS WHO ARE REALLY THERE FOR THEM.

SETH TOBOCMAN – SEPT. Y2K – LOWER EAST SIDE – NYC
SETH CREATES AMAZING COMICS – HIS BOOK WAR IN THE NEIGHBORHOOD IS AN INTENSE & GORGEOUS EPIC – ALL ABOUT SQUATTING & THE FIGHT AGAINST GENTRIFICATION IN THE LOWER EAST SIDE IN THE LATE 80S EARLY 90S – SETH IS ONE OF THE CO-FOUNDERS OF WORLD WAR 3 ILLUSTRATED WHICH IS A POLITICAL COMIC BOOK – I FIRST WENT TO A WW3 MEETING IN THE EARLY 90S & THATS WHERE I REALLY STARTED TALKING TO SETH & HE REALLY ENCOURAGED ME TO START DRAWING COMICS – I HADNT DONE TOO MANY COMICS BEFORE BUT I FIGURED WHAT THE HELL I LL GIVE IT A TRY

OUUHHH JEEEZ... IM NEVER ANY GOOD AT TALKING - I CAN NEVER START A CON
VERSATION - BACK AT CBGB'S - SEEMS LIKE A LOT HAS CHANGED AROUND
HERE - SEE A LOT OF NEW FACES - ITS WIERD COMING UP HERE WITH A NEW BAND
& ITS LIKE A WHOLE NEW SCENE - ITS LIKE THAT IN PITTSBURGH TOO - ITS LIKE
STARTING THIS NEW BAND IS LIKE STARTING A WHOLE NEW LIFE & THINKING ABOUT
WHEN WE USED TO COME UP & DO SHOWS WITH AUS ROTTEN SEEMS SO LONG AGO - ITS
ENOUGH TO MAKE YOU START FEELING OLD - THIS IS THE 4th TIME WE PLAYED CB'S
AS CAUSTIC CHRIST - WE PLAYED HERE WITH CONFLICT OVER A YEAR AGO - THAT WAS
CRAZY - COMPLETELY PACKED - MORE LIKE THE OLD CROWD WE USED TO PLAY FOR - THE
PUNKY PUNKS - NOW WE GET THE PUNKY PUNKS BUT A LOT OF HARD CORE KIDS TOO -
TONIGHT IS REALLY WIERD - USUALLY I GET BUTTERFLIES BEFORE PLAYING BUT I DONT
FEEL THAT AT ALL -

BASICALLY I STILL
PLAY BECAUSE
ITS THE ONLY
WAY OF LIFE
I KNOW - ITS
LIKE SECOND
NATURE LIKE
BREATHING
DEFINITELY
A CHANNEL
FOR MY PERSONAL
SHIT - ANGER &
AGGRESSION - I WENT
THRU A LOT OF SHIT
ABOUT A YEAR AGO
- I HAD TO QUIT
DRINKING &

I NEEDED SOME POSITIVE SHIT TO KEEP
ME GOING - THIS BAND IS NOT AS
POLITICAL AS AUS ROTTEN WAS BUT
ITS NOT MINDLESS OR STUPID LIKE
THE BAND THAT JUST PLAYED -
THE ATTITUDE OF THIS BAND IS
MORE PERSONAL - DARK & SUI-
CIDAL - ABOUT THE 9 TO 5
GRIND - THE SPREADING DISEASE
OF SUBURBIA - THE CORRUPTION
OF THE VOTING SYSTEM - THE
PUNCH YOUR FIST THRU THE
WALL KIND OF THING - BUT THE
BAND IS ACTUALLY POSITIVE -
& EVERYONE IN THE BAND HAS
A SIMILAIR ATTITUDE IN HOW
TO DEAL WITH THE EVERDAY
BULLSHIT - EVERYBODY HAS A BREAKING
POINT BUT YOU DONT HAVE TO
PUT A GUN TO YR HEAD - I
FIND DOING MUSIC
TO BE VERY
THERA
PUTIC
x

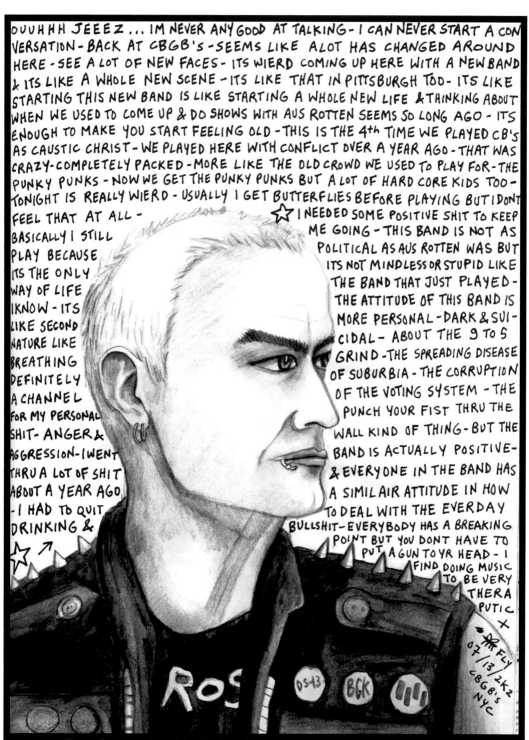

ERIC GOOD – 07/13/2K2 – (FRM PITTSBURGH) AT CBGB – NYC
I MET ERIC IN THE EARLY 90S WHEN I WAS A BIG FAN OF AUS ROTTEN (PUNK ROCK
FRM PITTSBURGH) & I WOULD GO TO THEIR SHOWS WHENEVER THEY CAME THROUGH
NYC – ERIC PLAYED GUITAR & ALSO DID VOCALS – I ENDED UP GOING ON TOUR WITH
THEM A FEW TIMES ON THE WEST COAST WHICH WAS TOTALLY INSANE & A HUGE BLAST
– ONE TIME WE WERE STAYING AT SOME PUNK HOUSE – THE WHOLE BAND PLUS ABOUT
20 PUNK ROCK KIDS WHO WANTED TO PARTY WITH THE BAND – THEY STARTED PLAYING
IRON MAIDEN & ERIC & DAVE (VOCALS) STARTED TO DO THEIR GALLOPING ROUTINE – I
WAS LAUGHING SO HARD I ALMOST PEED – I GUESS YOU HAD TO BE THERE

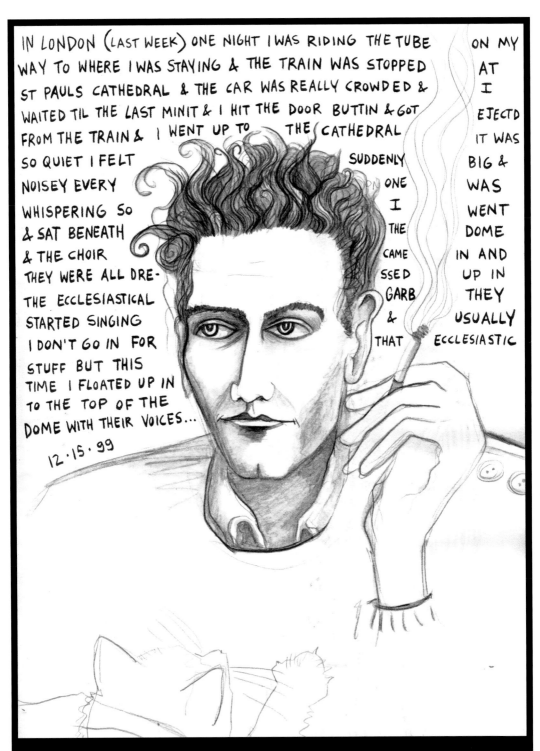

IN LONDON (LAST WEEK) ONE NIGHT I WAS RIDING THE TUBE ON MY
WAY TO WHERE I WAS STAYING & THE TRAIN WAS STOPPED AT
ST PAULS CATHEDRAL & THE CAR WAS REALLY CROWDED & I
WAITED TIL THE LAST MINIT & I HIT THE DOOR BUTTIN & GOT EJECTD
FROM THE TRAIN & I WENT UP TO THE CATHEDRAL IT WAS
SO QUIET I FELT SUDDENLY BIG &
NOISEY EVERY ONE WAS
WHISPERING SO I WENT
& SAT BENEATH THE DOME
& THE CHOIR CAME IN AND
THEY WERE ALL DRE- SSED UP IN
THE ECCLESIASTICAL GARB THEY
STARTED SINGING & USUALLY
I DON'T GO IN FOR THAT ECCLESIASTIC
STUFF BUT THIS
TIME I FLOATED UP IN
TO THE TOP OF THE
DOME WITH THEIR VOICES...

12·15·99

CHRISTOPHER WILDE – 12/15/1999 – BOOKLYN H.Q. – GREENPOINT
BOOKLYN IS A COLLECTIVE OF FABULOUS WEIRDO OBSESSIVE ARTISTS THAT MAKE WEIRDO
OBSESSIVE & METICULOUSLY BEAUTIFUL ART BOOKS – CHRISTOPHER LIVES AT THE FORMER
BOOKLYN H.Q. SURROUNDED BY ART & BOOKS & STUFF TO MAKE ART & BOOKS & HE
DOES – ONE TIME WE ALL WENT TO WISCO TO OUR FRIENDS WEDDING & WE CAMPED OUT
IN A FEILD IN A HUGE TENT THAT COULD FIT 15 OR 20 PEOPLE & WE GOT STUNG BY BEES
& CHRISTOPHER MADE ME A BEAUTIFUL LITTLE KITE – CHECK OUT WWW.BOOKLYN.ORG

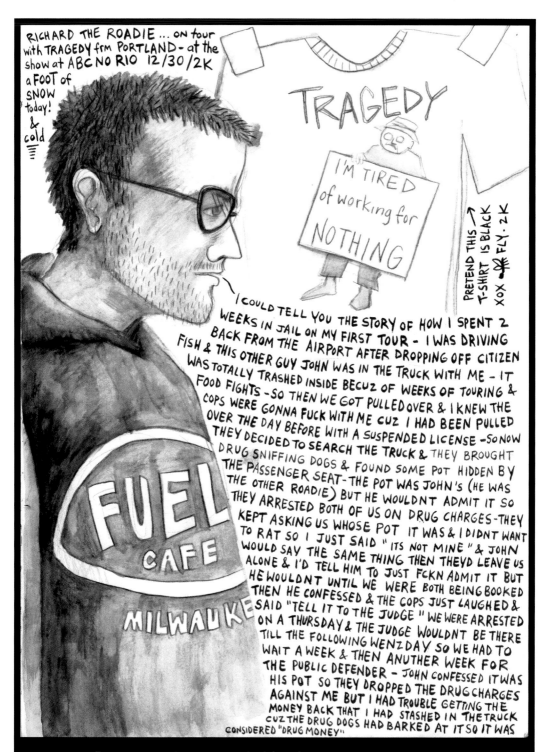

RICHARD THE ROADIE... ON tour with TRAGEDY frm PORTLAND - at the show at ABC NO RIO 12/30/2K a FOOT of SNOW today! & cold

TRAGEDY

I'M TIRED of working for NOTHING

PRETEND THIS → T-SHIRT IS BLACK XOX ✺ FLY · 2K

I COULD TELL YOU THE STORY OF HOW I SPENT 2 WEEKS IN JAIL ON MY FIRST TOUR - I WAS DRIVING BACK FROM THE AIRPORT AFTER DROPPING OFF CITIZEN FISH & THIS OTHER GUY JOHN WAS IN THE TRUCK WITH ME - IT WAS TOTALLY TRASHED INSIDE BECUZ OF WEEKS OF TOURING & FOOD FIGHTS - SO THEN WE GOT PULLED OVER & I KNEW THE COPS WERE GONNA FUCK WITH ME CUZ I HAD BEEN PULLED OVER THE DAY BEFORE WITH A SUSPENDED LICENSE - SO NOW THEY DECIDED TO SEARCH THE TRUCK & THEY BROUGHT DRUG SNIFFING DOGS & FOUND SOME POT HIDDEN BY THE PASSENGER SEAT - THE POT WAS JOHN'S (HE WAS THE OTHER ROADIE) BUT HE WOULDNT ADMIT IT SO THEY ARRESTED BOTH OF US ON DRUG CHARGES - THEY KEPT ASKING US WHOSE POT IT WAS & I DIDNT WANT TO RAT SO I JUST SAID "ITS NOT MINE" & JOHN WOULD SAY THE SAME THING THEN THEYD LEAVE US ALONE & I'D TELL HIM TO JUST FCKN ADMIT IT BUT HE WOULDNT UNTIL WE WERE BOTH BEING BOOKED THEN HE CONFESSED & THE COPS JUST LAUGHED & SAID "TELL IT TO THE JUDGE" WE WERE ARRESTED ON A THURSDAY & THE JUDGE WOULDNT BE THERE TILL THE FOLLOWING WENZDAY SO WE HAD TO WAIT A WEEK & THEN ANUTHER WEEK FOR THE PUBLIC DEFENDER - JOHN CONFESSED IT WAS HIS POT SO THEY DROPPED THE DRUG CHARGES AGAINST ME BUT I HAD TROUBLE GETTING THE MONEY BACK THAT I HAD STASHED IN THE TRUCK CUZ THE DRUG DOGS HAD BARKED AT IT SO IT WAS CONSIDERED "DRUG MONEY"

RICHARD THE ROADIE – 12/30/Y2K – ABC NO RIO – NYC
THE FIRST TIME I EVER MET RICHARD WAS IN POITIERS, FRANCE – I WAS ON TOUR WITH GOD IS MY CO-PILOT & WE WERE WALKING DOWN A STREET IN POITIERS & THERE WAS SUDDENLY A WHOLE POSSE OF TOTAL FREAKS HEADED RIGHT FOR US – OF COURSE THIS WAS AVAIL & RICHARD WAS ROADYING – I DID A COUPLE TOURS WITH RICHARD & AUS ROTTEN ON THE WEST COAST IN 1999 & HAD A BLAST! – I DREW THIS ON A FCKN COLD DAY IN NYC & EVEN RICHARD – WHO ALWAYS WEARS SHORTS – WAS WEARING LONG PANTS – RICHARD LIVES IN OAKLAND & MAKES WICKED HOME BREW

THE WORLD IS MINE CUZ I'M POOR - SAID THE ON THE ROAD ALCOHOLIC - HITCHHIKING & DUMPSTER DIVING - THE JOYS OF LIFE - SOME ONE SAID "WHAT THE HELL ARE YOU DOING GOING INTO THE GARBAGE?" - WE SAID - "TREASURE HUNTING!" - I SEE ALL THESE PEOPLE GOING INTO THE SAME STORE WHERE WE GET THE GARBAGE & THEY DONT LOOK ANY HAPPIER THAN ME - & ALL THESE CARS KILLING ME - PASSING ME BY WHILE IM TRYING TO HITCH HIKE BUT THEYRE GOING TO WORK - YEAH - THEYRE BUSY ACCOMPLISHING - ALL THESE PEOPLE WORKING SO HARD & ENDING UP WITH NOTHING - IVE GOT NOTHING BUT AT LEAST I DIDNT WORK HARD FOR IT - BUT THIS IS NOT A FOLKSONG THIS IS NOT A FOLK SONG NO - I DECIDED TO EXPLOIT THE "ANTI-FOLK" TERM ON MY 1989 TOUR IT WAS USEFUL TO SET YRSELF APART FRM EVERY OTHER WHITE GUY OUT THERE WITH A GUITAR - YOU KNOW YR HEADED FOR SHIT BUT WHAT CAN YOU DO? FUTURE WORRY NEVER WORKED FOR ME - I GOT A MILLION STORIES HOW MANY DO YOU WANT - BOOKS IN THE TRASH LAYING IN WAIT FOR YOU TO CARRY THEM HOME IVE LOST THAT DESPARATE FEELING

☆ - I HAVENT BEEN IN MUSICIAN MODE FOR A COUPLE YEARS - IVE ABDICATED MY CENTRE OF ATTENTIONNESS - DOES THAT MAKE SENSE ?? - PART OF WHAT CAUSED ME TO DO THAT WAS THAT I WAS READING A LOT OF SITUATIONIST LITERATURE & THEY TALK ABOUT ALIENATION WHICH MEANS SEPARATION - IM NOT BEING VERY ARTICULATE TODAY IN ANY CASE I'M HAVING A GREAT LIFE SKATING & DUMPSTER DIVING & HELPING PACIFICA REGAIN THEIR MISSION WHICH IS BASICALLY TO PROMOTE PEACE - & YOGA IS GREAT CUZ IT ADDRESSES RELEASE & LETTING GO & THATS WHAT LIFE IS ALL ABOUT - LETTING GO

at the FORT
FLY 07/18/2K2

ROGER MANNING - 07/18/2K2 - AT THE FORT - LOWER EAST SIDE - NYC
I MET ROGER IN THE LATE 80S WHEN I STARTED HANGIN AROUND ABC NO RIO & THE LOWER EAST SIDE - ROGER WOULD COME TO MATTHEW COURTNEY S WIDE OPEN CABERET ON SUNDAY NIGHTS ("SUNDAY-GO-TA-MEETIN") & HE WOULD PLAY GUITAR - HE IS A REALLY AMAZING GUITAR PLAYER ESP THAT CRAZY OLD BLUEGRASS STUFF - & HE WOULD SING THESE INCREDIBLE SONGS ABOUT LOVE & CONFUSION & POLITICS & DEALING WITH THE BULLSHIT OF LIFE IN GENERAL - IT WAS LIKE PUNK ROCK LOISAIDA BLUES - THESE DAYS ROGER HARDLY EVER PLAYS SHOWS WHICH IS VERY SAD BUT HE S BUSY BUILDING WEBSITES & HELPING PACIFICA - HTTP://WEB.WT.NET/~ROGERM/

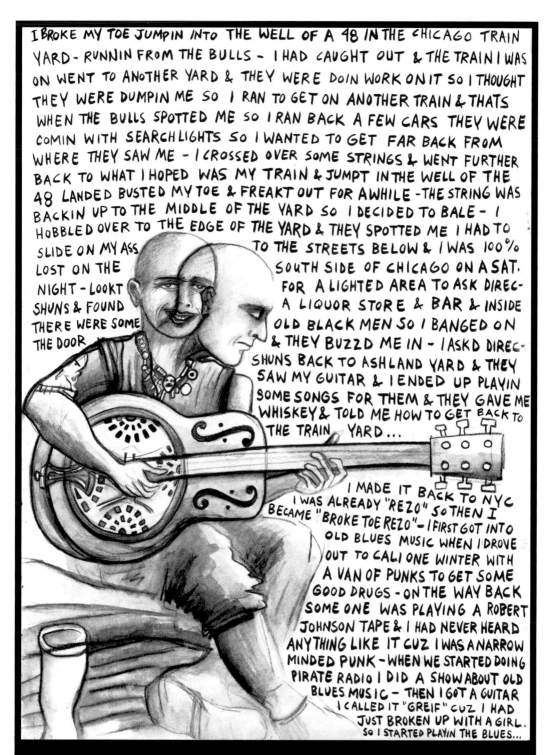

I BROKE MY TOE JUMPIN INTO THE WELL OF A 48 IN THE CHICAGO TRAIN YARD - RUNNIN FROM THE BULLS - I HAD CAUGHT OUT & THE TRAIN I WAS ON WENT TO ANOTHER YARD & THEY WERE DOIN WORK ON IT SO I THOUGHT THEY WERE DUMPIN ME SO I RAN TO GET ON ANOTHER TRAIN & THATS WHEN THE BULLS SPOTTED ME SO I RAN BACK A FEW CARS THEY WERE COMIN WITH SEARCHLIGHTS SO I WANTED TO GET FAR BACK FROM WHERE THEY SAW ME - I CROSSED OVER SOME STRINGS & WENT FURTHER BACK TO WHAT I HOPED WAS MY TRAIN & JUMPT IN THE WELL OF THE 48 LANDED BUSTED MY TOE & FREAKT OUT FOR AWHILE - THE STRING WAS BACKIN UP TO THE MIDDLE OF THE YARD SO I DECIDED TO BALE - I HOBBLED OVER TO THE EDGE OF THE YARD & THEY SPOTTED ME I HAD TO SLIDE ON MY ASS TO THE STREETS BELOW & I WAS 100% LOST ON THE SOUTH SIDE OF CHICAGO ON A SAT. NIGHT - LOOKT FOR A LIGHTED AREA TO ASK DIREC- SHUNS & FOUND A LIQUOR STORE & BAR & INSIDE THERE WERE SOME OLD BLACK MEN SO I BANGED ON THE DOOR & THEY BUZZD ME IN - I ASKD DIREC- SHUNS BACK TO ASHLAND YARD & THEY SAW MY GUITAR & I ENDED UP PLAYIN SOME SONGS FOR THEM & THEY GAVE ME WHISKEY & TOLD ME HOW TO GET BACK TO THE TRAIN YARD...

I MADE IT BACK TO NYC I WAS ALREADY "REZO" SO THEN I BECAME "BROKE TOE REZO" - I FIRST GOT INTO OLD BLUES MUSIC WHEN I DROVE OUT TO CALI ONE WINTER WITH A VAN OF PUNKS TO GET SOME GOOD DRUGS - ON THE WAY BACK SOME ONE WAS PLAYING A ROBERT JOHNSON TAPE & I HAD NEVER HEARD ANYTHING LIKE IT CUZ I WAS A NARROW MINDED PUNK - WHEN WE STARTED DOING PIRATE RADIO I DID A SHOW ABOUT OLD BLUES MUSIC - THEN I GOT A GUITAR I CALLED IT "GREIF" CUZ I HAD JUST BROKEN UP WITH A GIRL. SO I STARTED PLAYIN THE BLUES...

BROKE TOE REZO – JULY Y2K – SERENITY HOUSE – NYC
I DREW THIS JUST DAYS BEFORE REZO WAS GOING TRAVELING — IT SORT OF LOOKS LIKE HIM BUT IT SORT OF DOESNT — WHEN I FIRST MET REZO HIS NAME WAS WORM & HE WAS LIVING AT 5TH ST. SQUAT GOING ON NOCTURNAL MISSIONS GUTTING EMPTY BUILDINGS OF ALL WIRING & ELECTRICAL PARAPHERNALIA — HE DROVE ME & CHOKING VICTIM UP TO THE PUNK FEST IN ONTARIO, CANADA, IN JULY 1994 EATING DUMPSTERED BANANAS & BLASTING PUNK ROCK MUSIC THE WHOLE WAY CUZ HE HADN T DISCOVERED THE BLUES YET

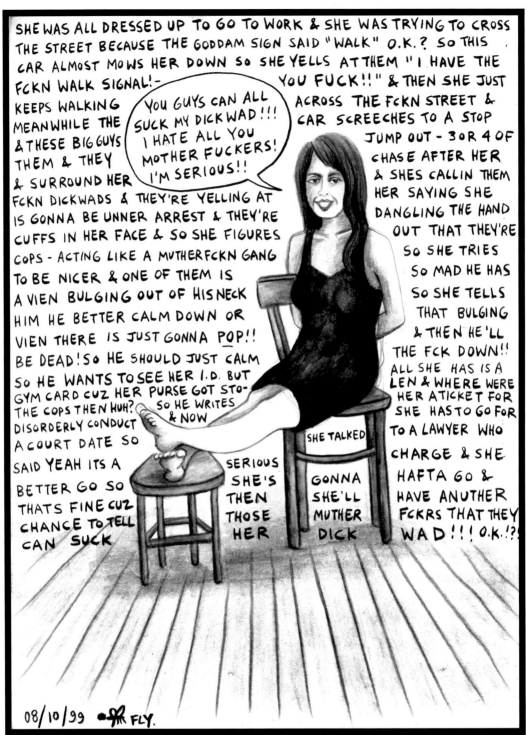

JENNIFER BONILLA – 08/10/1999 – LOWER EAST SIDE – NYC
JENNIFER LIVES IN MY BUILDING– SHE S ONE OF THE ORIGINAL SQUATTERS WHO LIVED HERE BEFORE THE 3 ALARM FIRE THAT GUTTED A THIRD OF THE BUILDING & BLEW THE ROOF OFF – WHEN I MOVED IN THE BUILDING WAS STILL IN PRETTY BAD SHAPE & JENNIFER WAS ONE OF THE FEW WHO HAD DECIDED TO STAY & REBUILD – WHEN SHE WENT FOR HER COURT DATE FOR THE INCIDENT DESCRIBED ABOVE THE JUDGE THREW OUT THE CHARGE "FOR FEAR OF PUBLIC OUTCRY" & SOME OTHER JUDGE RECENTLY RULED THAT ITS NOT ILLEGAL TO CUSS AT THE COPS – SO LETS GET TO IT!!

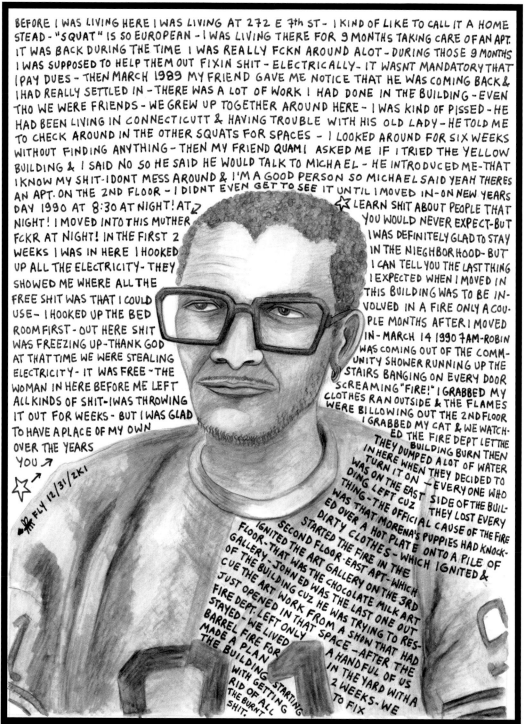

BEFORE I WAS LIVING HERE I WAS LIVING AT 272 E 7th ST - I KIND OF LIKE TO CALL IT A HOME STEAD - "SQUAT" IS SO EUROPEAN - I WAS LIVING THERE FOR 9 MONTHS TAKING CARE OF AN APT. IT WAS BACK DURING THE TIME I WAS REALLY FCKN AROUND ALOT - DURING THOSE 9 MONTHS I WAS SUPPOSED TO HELP THEM OUT FIXIN SHIT - ELECTRICALLY - IT WASNT MANDATORY THAT I PAY DUES - THEN MARCH 1989 MY FRIEND GAVE ME NOTICE THAT HE WAS COMING BACK & I HAD REALLY SETTLED IN - THERE WAS A LOT OF WORK I HAD DONE IN THE BUILDING - EVEN THO WE WERE FRIENDS - WE GREW UP TOGETHER AROUND HERE - I WAS KIND OF PISSED - HE HAD BEEN LIVING IN CONNECTICUTT & HAVING TROUBLE WITH HIS OLD LADY - HE TOLD ME TO CHECK AROUND IN THE OTHER SQUATS FOR SPACES - I LOOKED AROUND FOR SIX WEEKS WITHOUT FINDING ANYTHING - THEN MY FRIEND QUAMI ASKED ME IF I TRIED THE YELLOW BUILDING & I SAID NO SO HE SAID HE WOULD TALK TO MICHAEL - HE INTRODUCED ME - THAT I KNOW MY SHIT - I DONT MESS AROUND & I'M A GOOD PERSON SO MICHAEL SAID YEAH THERES AN APT. ON THE 2ND FLOOR - I DIDNT EVEN GET TO SEE IT UNTIL I MOVED IN - ON NEW YEARS DAY 1990 AT 8:30 AT NIGHT! AT NIGHT! I MOVED INTO THIS MUTHER FCKR AT NIGHT! IN THE FIRST 2 WEEKS I WAS IN HERE I HOOKED UP ALL THE ELECTRICITY - THEY SHOWED ME WHERE ALL THE FREE SHIT WAS THAT I COULD USE - I HOOKED UP THE BED ROOM FIRST - OUT HERE SHIT WAS FREEZING UP - THANK GOD AT THAT TIME WE WERE STEALING ELECTRICITY - IT WAS FREE - THE WOMAN IN HERE BEFORE ME LEFT ALL KINDS OF SHIT - I WAS THROWING IT OUT FOR WEEKS - BUT I WAS GLAD TO HAVE A PLACE OF MY OWN OVER THE YEARS YOU →

FLY 12/31/2K1

LEARN SHIT ABOUT PEOPLE THAT YOU WOULD NEVER EXPECT - BUT I WAS DEFINITELY GLAD TO STAY IN THE NIEGHBORHOOD - BUT I CAN TELL YOU THE LAST THING I EXPECTED WHEN I MOVED IN THIS BUILDING WAS TO BE IN- VOLVED IN A FIRE ONLY A COU- PLE MONTHS AFTER I MOVED IN - MARCH 14 1990 7AM - ROBIN WAS COMING OUT OF THE COMM- UNITY SHOWER RUNNING UP THE STAIRS BANGING ON EVERY DOOR SCREAMING "FIRE!" I GRABBED MY CLOTHES RAN OUTSIDE & THE FLAMES WERE BILLOWING OUT THE 2ND FLOOR I GRABBED MY CAT & WE WATCH- ED THE FIRE DEPT LET THE BUILDING BURN THEN THEY DUMPED A LOT OF WATER IN HERE WHEN THEY DECIDED TO TURN IT ON - EVERYONE WHO WAS ON THE EAST SIDE OF THE BUIL- DING LEFT CUZ THEY LOST EVERY THING - THE OFFICIAL CAUSE OF THE FIRE WAS THAT MORENA'S PUPPIES HAD KNOCK- ED OVER A HOT PLATE ONTO A PILE OF DIRTY CLOTHES - WHICH IGNITED & STARTED THE FIRE IN THE SECOND FLOOR EAST APT - WHICH IGNITED THE ART GALLERY ON THE 3RD FLOOR - THAT WAS THE CHOCOLATE MILK ART GALLERY - JOHN ED WAS THE LAST ONE OUT OF THE BUILDING CUZ HE WAS TRYING TO RES- CUE THE ART WORK FROM A SHOW THAT HAD JUST OPENED IN THAT SPACE - AFTER THE FIRE DEPT. LEFT ONLY A HANDFUL OF US STAYED - WE LIVED IN THE YARD WITH A BARREL FIRE FOR 2 WEEKS - WE MADE A PLAN TO FIX THE BUILDING WITH GETTING RID OF ALL THE BURNT SHIT.

MAXIE MARSHALL – 12/31/2K1 – LOWER EAST SIDE – NYC

MAXIE ALSO LIVES IN MY BUILDING & IS ONE OF THE ORIGINAL SQUATTERS – I MET MAX IN THE SUMMER OF 92 WHEN I STARTED DOING WORK DAYS AT 209 – HE WAS ALWAYS NICE TO ME BUT LOOK OUT IF YOURE NOT SUPPOSED TO BE HERE – & ANY MEMBER OF THE BUILDING WHO MAYBE LOST THEIR KEY TO THE FRONT DOOR & NEEDS A NEW ONE HAS TO GO SEE MAXIE & LET ME TELL YOU IT WON T BE EASY – KEYS ARE A VERY SENSITIVE ISSUE SINCE LOST KEYS CAN ALWAYS BE FOUND BY THE WRONG PEOPLE – WELL – IT MIGHT BE EASIER IF YOU HAVE A LITTLE EXTRA CHANGE – BUT DONT FCK WITH MAX MAAAAAAN DON T *MAKE* HIM HAVE TO COME TO YOUR HOUSE & DEAL WITH YOU – SHIIIITT

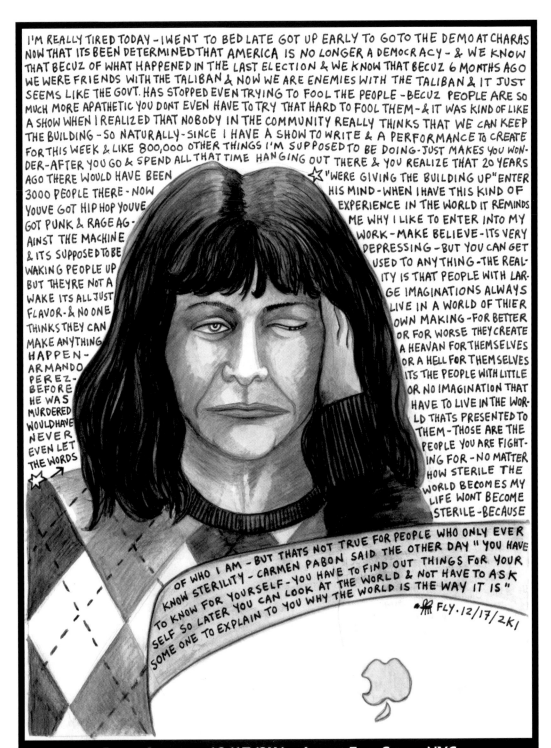

I'M REALLY TIRED TODAY - I WENT TO BED LATE GOT UP EARLY TO GO TO THE DEMO AT CHARAS NOW THAT ITS BEEN DETERMINED THAT AMERICA IS NO LONGER A DEMOCRACY - & WE KNOW THAT BECUZ OF WHAT HAPPENED IN THE LAST ELECTION & WE KNOW THAT BECUZ 6 MONTHS AGO WE WERE FRIENDS WITH THE TALIBAN & NOW WE ARE ENEMIES WITH THE TALIBAN & IT JUST SEEMS LIKE THE GOVT. HAS STOPPED EVEN TRYING TO FOOL THE PEOPLE - BECUZ PEOPLE ARE SO MUCH MORE APATHETIC YOU DONT EVEN HAVE TO TRY THAT HARD TO FOOL THEM - & IT WAS KIND OF LIKE A SHOW WHEN I REALIZED THAT NOBODY IN THE COMMUNITY REALLY THINKS THAT WE CAN KEEP THE BUILDING - SO NATURALLY - SINCE I HAVE A SHOW TO WRITE & A PERFORMANCE TO CREATE FOR THIS WEEK & LIKE 800,000 OTHER THINGS I'M SUPPOSED TO BE DOING - JUST MAKES YOU WON- DER - AFTER YOU GO & SPEND ALL THAT TIME HANGING OUT THERE & YOU REALIZE THAT 20 YEARS AGO THERE WOULD HAVE BEEN 3000 PEOPLE THERE - NOW YOUVE GOT HIP HOP YOUVE GOT PUNK & RAGE AG- AINST THE MACHINE & ITS SUPPOSED TO BE WAKING PEOPLE UP BUT THEYRE NOT A WAKE ITS ALL JUST FLAVOR - & NO ONE THINKS THEY CAN MAKE ANYTHING HAPPEN - ARMANDO PEREZ - BEFORE HE WAS MURDERED WOULD HAVE NEVER EVEN LET THE WORDS

"WERE GIVING THE BUILDING UP" ENTER HIS MIND - WHEN I HAVE THIS KIND OF EXPERIENCE IN THE WORLD IT REMINDS ME WHY I LIKE TO ENTER INTO MY WORK - MAKE BELIEVE - ITS VERY DEPRESSING - BUT YOU CAN GET USED TO ANYTHING - THE REAL- ITY IS THAT PEOPLE WITH LAR- GE IMAGINATIONS ALWAYS LIVE IN A WORLD OF THIER OWN MAKING - FOR BETTER OR FOR WORSE THEY CREATE A HEAVAN FOR THEMSELVES OR A HELL FOR THEMSELVES ITS THE PEOPLE WITH LITTLE OR NO IMAGINATION THAT HAVE TO LIVE IN THE WOR- LD THATS PRESENTED TO THEM - THOSE ARE THE PEOPLE YOU ARE FIGHT- ING FOR - NO MATTER HOW STERILE THE WORLD BECOMES MY LIFE WONT BECOME STERILE - BECAUSE OF WHO I AM - BUT THATS NOT TRUE FOR PEOPLE WHO ONLY EVER KNOW STERILITY - CARMEN PABON SAID THE OTHER DAY " YOU HAVE TO KNOW FOR YOURSELF - YOU HAVE TO FIND OUT THINGS FOR YOUR SELF SO LATER YOU CAN LOOK AT THE WORLD & NOT HAVE TO ASK SOME ONE TO EXPLAIN TO YOU WHY THE WORLD IS THE WAY IT IS "

FLY · 12/17/2K1

PENNY ARCADE – 12/17/2K1 – LOWER EAST SIDE – NYC
THE FIRST TIME I SAW PENNY PERFORM WAS AT CBGB & SHE WAS DOING A SPOKEN WORD PIECE – IT WAS MESMERIZING & HILARIOUS – SHE LOOKED LIKE SHE WAS ABOUT 17 YEARS OLD BUT HOW COULD SHE BE SO SMART? – THEN I FOUND OUT SHE HAS BEEN AROUND THE TRUE LOWER EAST SIDE SCENE SINCE THE 60s!! & SHE IS OR WAS FRIENDS & OR COLLABORATED WITH EVERYONE WHO WAS ANYONE – SHE WRTES & PERFORMS & PRODUCES COMPLEX THEATRICAL PIECES THAT GET RAVE REVIEWS – I LOVE WATCHING PENNY PERFORM CUZ SHE HAS MANAGED TO STAY GENUINE – SHE DOESNT TAKE ANY SHIT & SHE S NOT AFRAID TO CALL PEOPLE OUT ON THEIRS – WWW.PENNYARCADE.COM

90

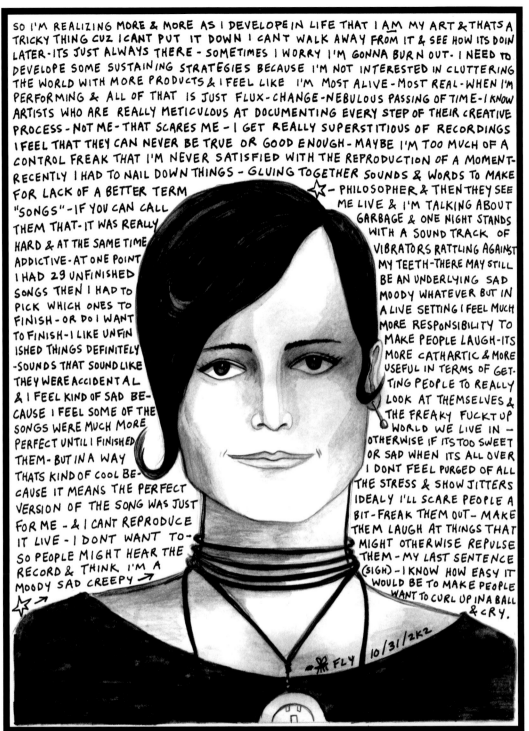

SO I'M REALIZING MORE & MORE AS I DEVELOPE IN LIFE THAT I A̲M MY ART & THATS A TRICKY THING CUZ I CANT PUT IT DOWN I CAN'T WALK AWAY FROM IT & SEE HOW ITS DOIN LATER - ITS JUST ALWAYS THERE - SOMETIMES I WORRY I'M GONNA BURN OUT. I NEED TO DEVELOPE SOME SUSTAINING STRATEGIES BECAUSE I'M NOT INTERESTED IN CLUTTERING THE WORLD WITH MORE PRODUCTS & I FEEL LIKE I'M MOST ALIVE - MOST REAL - WHEN I'M PERFORMING & ALL OF THAT IS JUST FLUX - CHANGE - NEBULOUS PASSING OF TIME - I KNOW ARTISTS WHO ARE REALLY METICULOUS AT DOCUMENTING EVERY STEP OF THEIR CREATIVE PROCESS - NOT ME - THAT SCARES ME - I GET REALLY SUPERSTITIOUS OF RECORDINGS I FEEL THAT THEY CAN NEVER BE TRUE OR GOOD ENOUGH - MAYBE I'M TOO MUCH OF A CONTROL FREAK THAT I'M NEVER SATISFIED WITH THE REPRODUCTION OF A MOMENT - RECENTLY I HAD TO NAIL DOWN THINGS - GLUING TOGETHER SOUNDS & WORDS TO MAKE FOR LACK OF A BETTER TERM ☆ - PHILOSOPHER & THEN THEY SEE "SONGS" - IF YOU CAN CALL ME LIVE & I'M TALKING ABOUT THEM THAT - IT WAS REALLY GARBAGE & ONE NIGHT STANDS HARD & AT THE SAME TIME WITH A SOUND TRACK OF ADDICTIVE - AT ONE POINT VIBRATORS RATTLING AGAINST I HAD 29 UNFINISHED MY TEETH - THERE MAY STILL SONGS THEN I HAD TO BE AN UNDERLYING SAD PICK WHICH ONES TO MOODY WHATEVER BUT IN FINISH - OR DO I WANT A LIVE SETTING I FEEL MUCH TO FINISH - I LIKE UNFIN MORE RESPONSIBILITY TO ISHED THINGS DEFINITELY MAKE PEOPLE LAUGH - ITS - SOUNDS THAT SOUND LIKE MORE CATHARTIC & MORE THEY WERE ACCIDENTAL USEFUL IN TERMS OF GET- & I FEEL KIND OF SAD BE- TING PEOPLE TO REALLY CAUSE I FEEL SOME OF THE LOOK AT THEMSELVES & SONGS WERE MUCH MORE THE FREAKY FUCKT UP PERFECT UNTIL I FINISHED WORLD WE LIVE IN — THEM - BUT IN A WAY OTHERWISE IF ITS TOO SWEET THATS KIND OF COOL BE- OR SAD WHEN ITS ALL OVER CAUSE IT MEANS THE PERFECT I DONT FEEL PURGED OF ALL VERSION OF THE SONG WAS JUST THE STRESS & SHOW JITTERS FOR ME - & I CANT REPRODUCE IDEALY I'LL SCARE PEOPLE A IT LIVE - I DONT WANT TO- BIT - FREAK THEM OUT - MAKE SO PEOPLE MIGHT HEAR THE THEM LAUGH AT THINGS THAT RECORD & THINK I'M A MIGHT OTHERWISE REPULSE MOODY SAD CREEPY → THEM - MY LAST SENTENCE ☆ → (SIGH) - I KNOW HOW EASY IT WOULD BE TO MAKE PEOPLE WANT TO CURL UP IN A BALL & CRY.

✻ FLY 10/31/2K2

ALEXIS O'HARA AKA **LX6** – 10/31/2K2 – (FRM MONTREAL) – NYC
I MET **LX6** IN THE LATE 80s IN TORONTO WHEN SHE STARTED PERFORMING WITH JAWBONE LOOSELEAF IN HER MULTI-CHARACTERED PERFORMANCE PIECES – LATER I RAN INTO HER IN GENEVE WHERE SHE WAS SQUATTING FOR A FEW YEARS – I WAS ON TOUR WITH GOD IS MY CO-PILOT & AFTER OUR SHOW **LX6** TOOK ME & JASON OUT TO A HUGE PUNK ROCK SHOW THEN TO AN INCREDIBLY SMOKEY BAR WHERE SOME CUTE BOYS WERE RAPPING IN FRENCH IN THE BASEMENT THEN TO A SUPER FUNKY ARTY BAR THAT PLAYED OLD SCHOOL EURODISCO – **LX6** NOW LIVES IN MONTREAL & DOES AMAZING SPOKEN WORD & WRITES FUNKY BOOKS – ELEX6@HOTMAIL.COM – WWW.GRENADINERECORDS.COM

91

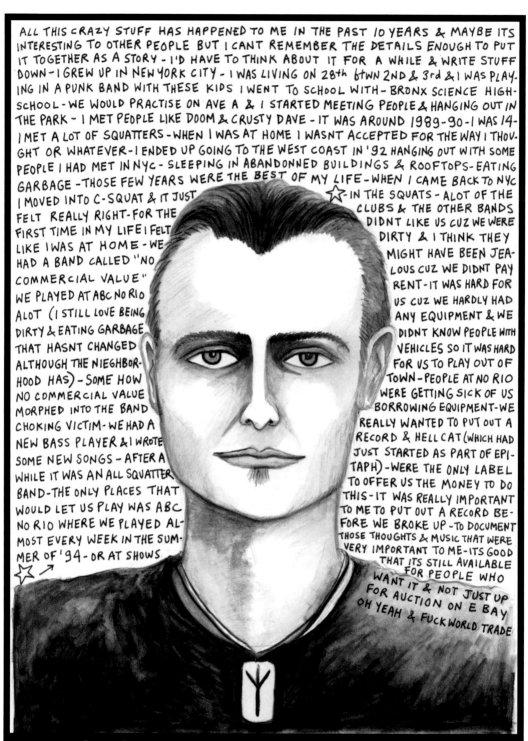

ALL THIS CRAZY STUFF HAS HAPPENED TO ME IN THE PAST 10 YEARS & MAYBE ITS INTERESTING TO OTHER PEOPLE BUT I CANT REMEMBER THE DETAILS ENOUGH TO PUT IT TOGETHER AS A STORY - I'D HAVE TO THINK ABOUT IT FOR A WHILE & WRITE STUFF DOWN - I GREW UP IN NEW YORK CITY - I WAS LIVING ON 28th bTWN 2ND & 3rd & I WAS PLAY-ING IN A PUNK BAND WITH THESE KIDS I WENT TO SCHOOL WITH - BRONX SCIENCE HIGH-SCHOOL - WE WOULD PRACTISE ON AVE A & I STARTED MEETING PEOPLE & HANGING OUT IN THE PARK - I MET PEOPLE LIKE DOOM & CRUSTY DAVE - IT WAS AROUND 1989-90 - I WAS 14-I MET A LOT OF SQUATTERS - WHEN I WAS AT HOME I WASNT ACCEPTED FOR THE WAY I THOU-GHT OR WHATEVER - I ENDED UP GOING TO THE WEST COAST IN '92 HANGING OUT WITH SOME PEOPLE I HAD MET IN NYC - SLEEPING IN ABANDONNED BUILDINGS & ROOFTOPS - EATING GARBAGE - THOSE FEW YEARS WERE THE BEST OF MY LIFE - WHEN I CAME BACK TO NYC I MOVED INTO C-SQUAT & IT JUST FELT REALLY RIGHT - FOR THE FIRST TIME IN MY LIFE I FELT LIKE I WAS AT HOME - WE HAD A BAND CALLED "NO COMMERCIAL VALUE" WE PLAYED AT ABC NO RIO ALOT (I STILL LOVE BEING DIRTY & EATING GARBAGE THAT HASNT CHANGED ALTHOUGH THE NIEGHBOR-HOOD HAS) - SOME HOW NO COMMERCIAL VALUE MORPHED INTO THE BAND CHOKING VICTIM - WE HAD A NEW BASS PLAYER & I WROTE SOME NEW SONGS - AFTER A WHILE IT WAS AN ALL SQUATTER BAND - THE ONLY PLACES THAT WOULD LET US PLAY WAS ABC NO RIO WHERE WE PLAYED AL-MOST EVERY WEEK IN THE SUM-MER OF '94 - OR AT SHOWS

☆ IN THE SQUATS - ALOT OF THE CLUBS & THE OTHER BANDS DIDNT LIKE US CUZ WE WERE DIRTY & I THINK THEY MIGHT HAVE BEEN JEA-LOUS CUZ WE DIDNT PAY RENT - IT WAS HARD FOR US CUZ WE HARDLY HAD ANY EQUIPMENT & WE DIDNT KNOW PEOPLE WITH VEHICLES SO IT WAS HARD FOR US TO PLAY OUT OF TOWN - PEOPLE AT NO RIO WERE GETTING SICK OF US BORROWING EQUIPMENT - WE REALLY WANTED TO PUT OUT A RECORD & HELL CAT (WHICH HAD JUST STARTED AS PART OF EPI-TAPH) - WERE THE ONLY LABEL TO OFFER US THE MONEY TO DO THIS - IT WAS REALLY IMPORTANT TO ME TO PUT OUT A RECORD BE-FORE WE BROKE UP - TO DOCUMENT THOSE THOUGHTS & MUSIC THAT WERE VERY IMPORTANT TO ME - ITS GOOD THAT ITS STILL AVAILABLE FOR PEOPLE WHO WANT IT & NOT JUST UP FOR AUCTION ON E BAY OH YEAH & FUCK WORLD TRADE

SCOTT STURGEON – SUMMER 2K2 – LOWER EAST SIDE – NYC
I MET SCOTT IN THE EARLY 90S WHEN HE WAS IN THE BAND NO COMMERCIAL VALUE – & HE USED TO COME TO THE OPEN MIC AT GARGOYLE MECHANIQUE LAB & PLAY PUNK ROCK SONGS WITH AN ACOUSTIC GUITAR – THEN HE FORMED THE BAND CHOKING VICTIM WHICH BECAME A HUGE LOWER EAST SIDE SQUATTER FAVORITE BUT NOT EVERYONE LIKED THEM – "FOR FURTHER PROOF THAT STURGEON IS THE SCUM OF THE EARTH CHECK OUT LEFTÖVER CRACK OR ASK A VOLUNTEER/EMPLOYEE OF ABC NO RIO, GILMAN ST., OR CBGB WHERE CHOKING VICTIM/LEFTÖVER CRACK IS CURRENTLY BANNED FOR THEIR POLITICAL VIEWS & SCUMBAG LIFESTYLE" & THATS STRAIT FRM THE PUNK SMOUTH

I THINK I WANT TO TALK ABOUT THE WAY ART & CULTURE INTERSECT WITH RADICAL POLITICS - IT SEEMS TO ME THAT IN ORDER FOR A REALLY FULL & ORDERED & ENERGETIC MOVEMENT TO BE EFFECTIVE IN THE UNITED STATES WE NEED TO LAY THE GROUND WORK WITH SOCIAL CHANGE ORGANIZING & PUSH THAT FORWARD USING & TRESPASSING INTO THE IMAGINATIONS OF PEOPLE INCLUDING THE PEOPLE WE ARE & THE PEOPLE WE WANT TO EFFECT - ALSO WHEN WE TALK ABOUT ART & CULTURE WE HAVE TO REALIZE ITS NOT JUST MUSIC FORMS OR ART FORMS THAT REPRESENT THE DISENFRANCHISEMENT & CONSUMER ALIENATION OF YOUNG STRAIGHT WHITE PEOPLE BUT ALSO THE ART & MUSIC THAT IS BEING CRUSHED BY CULTURAL HOMOGENIZATION & THE DESTRUCTION & IRRADICATION OF INDIGENOUS PEOPLES & LANDS - THIS MEANS EXPANDING OUR COMMUNITIES & CREATING SPACES FOR PEOPLE WHO DONT NECESSARILY WEAR THE CORRECT RADICAL ATTIRE OF BLACK HOODIE OR REQUISITE PIERCINGS - BUT WHO MAY COME IN TURBANS, BURQAS OR KHAFFIAS - SUBCULTURE IS A MOTION - A VERB NOT A NOUN - & THE MOVEMENT MUST BE FLUID & ABLE TO ADAPT TO CREVICES & OBSTACLES THAT GET IN ITS WAY - CREATING SPACE & GIVING LIGHT FOR CHANGE & RECREATION MEANS SINGING THE NECESSARY WORDS AT THE TOP OF YOUR LUNGS & DISSOLVING THE PRECONDITIONED AGENDAS

INTO A MILLION MICROSCOPIC PIECES & EXAMINING THEM ALL - REALIZING & UNDERSTANDING YOUR ENEMY IS AS IMPORTANT AS KNOWING WHAT YOU ARE FIGHTING FOR - WHAT DOES THE LIGHT AT THE END OF THE TUNNEL LOOK LIKE - IS IT BEAUTIFUL? IS IT VIBRANT? DO YOU WANT TO LIVE THERE? CHAOS ECSTACY & JOY ARE SOME OF THE GREATEST WEAPONS THAT WE AS ACTIVISTS, ARTISTS, PEOPLE ON THIS EARTH HOLD AS INSTRUMENTS TO AID OUR OUTRAGE & FOMENT OUR LIBERATION.

X

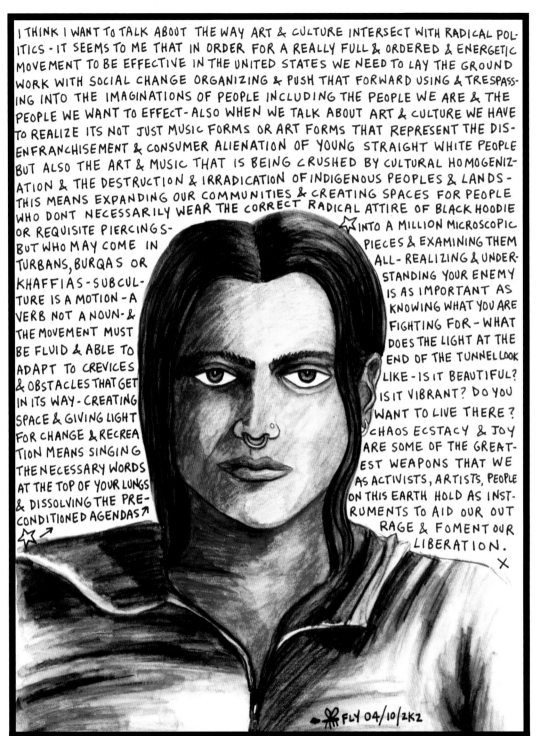

FLY 04/10/2K2

RONICA SANYAL – 04/10/2K2 – SEATTLE

I MET RONICA THE SAME TIME I MET RONNI (PG. 192) – THEY WERE BOTH SUPER BUSY BUT ALSO KNEW HOW TO HAVE FUN ALONG WITH THEIR ACTIVISM – AFTER I DREW THIS PORTRAIT RONICA GAVE ME A CD OF THE INFERNAL NOISE BRIGADE (AN ACTIVIST MARCHING BAND SHE WAS INVOLVED WITH AT THE TIME – WWW.INFERNALNOISE.ORG) & A ZINE CALLED "WHAT THE LADIES HAVE TO SAY" WHICH CONTAINS SOME INTERVIEWS WITH MIDDLE EASTERN WOMEN THAT SHE CONDUCTED – CURRENTLY SHE IS FINISHING ACUPUNCTURE SCHOOL & WORKING AT A DOMESTIC VIOLENCE AGENCY FOR SOUTH AISAN WOMEN (WWW.CHAYA-SEATTLE.ORG) – & SHE SINGS IN A BAND CALLED F.O.B. NATION – RONICARANI@YAHOO.COM

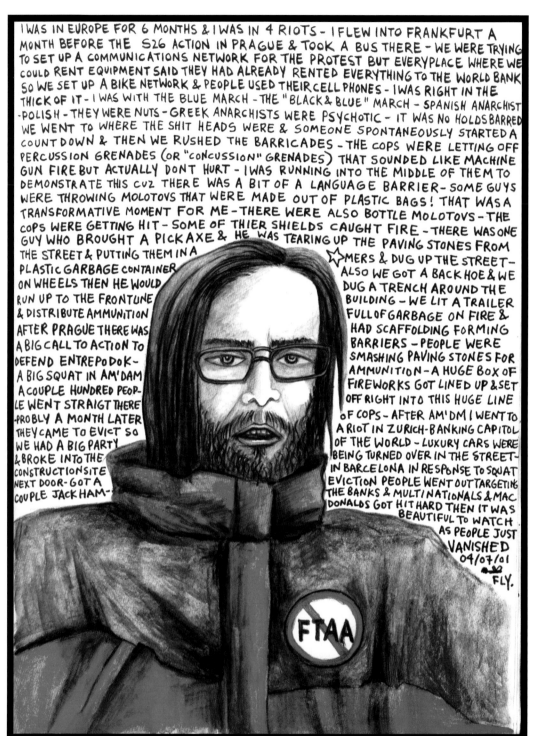

I WAS IN EUROPE FOR 6 MONTHS & I WAS IN 4 RIOTS - I FLEW INTO FRANKFURT A MONTH BEFORE THE S26 ACTION IN PRAGUE & TOOK A BUS THERE - WE WERE TRYING TO SET UP A COMMUNICATIONS NETWORK FOR THE PROTEST BUT EVERYPLACE WHERE WE COULD RENT EQUIPMENT SAID THEY HAD ALREADY RENTED EVERYTHING TO THE WORLD BANK SO WE SET UP A BIKE NETWORK & PEOPLE USED THEIR CELL PHONES - I WAS RIGHT IN THE THICK OF IT - I WAS WITH THE BLUE MARCH - THE "BLACK & BLUE" MARCH - SPANISH ANARCHIST -POLISH - THEY WERE NUTS - GREEK ANARCHISTS WERE PSYCHOTIC - IT WAS NO HOLDS BARRED WE WENT TO WHERE THE SHIT HEADS WERE & SOMEONE SPONTANEOUSLY STARTED A COUNT DOWN & THEN WE RUSHED THE BARRICADES - THE COPS WERE LETTING OFF PERCUSSION GRENADES (OR "CONCUSSION" GRENADES) THAT SOUNDED LIKE MACHINE GUN FIRE BUT ACTUALLY DON'T HURT - I WAS RUNNING INTO THE MIDDLE OF THEM TO DEMONSTRATE THIS CUZ THERE WAS A BIT OF A LANGUAGE BARRIER- SOME GUYS WERE THROWING MOLOTOVS THAT WERE MADE OUT OF PLASTIC BAGS! THAT WAS A TRANSFORMATIVE MOMENT FOR ME - THERE WERE ALSO BOTTLE MOLOTOVS - THE COPS WERE GETTING HIT - SOME OF THIER SHIELDS CAUGHT FIRE - THERE WAS ONE GUY WHO BROUGHT A PICK AXE & HE WAS TEARING UP THE PAVING STONES FROM THE STREET & PUTTING THEM IN A PLASTIC GARBAGE CONTAINER ON WHEELS THEN HE WOULD RUN UP TO THE FRONTLINE & DISTRIBUTE AMMUNITION

AFTER PRAGUE THERE WAS A BIG CALL TO ACTION TO DEFEND ENTREPODOK - A BIG SQUAT IN AM'DAM A COUPLE HUNDRED PEOPLE WENT STRAIGT THERE -PROBLY A MONTH LATER THEY CAME TO EVICT SO WE HAD A BIG PARTY & BROKE INTO THE CONSTRUCTION SITE NEXT DOOR - GOT A COUPLE JACK HAM-

MERS & DUG UP THE STREET- ALSO WE GOT A BACK HOE & WE DUG A TRENCH AROUND THE BUILDING - WE LIT A TRAILER FULL OF GARBAGE ON FIRE & HAD SCAFFOLDING FORMING BARRIERS - PEOPLE WERE SMASHING PAVING STONES FOR AMMUNITION - A HUGE BOX OF FIREWORKS GOT LINED UP & SET OFF RIGHT INTO THIS HUGE LINE OF COPS - AFTER AM'DM I WENT TO A RIOT IN ZURICH - BANKING CAPITOL OF THE WORLD - LUXURY CARS WERE BEING TURNED OVER IN THE STREET- IN BARCELONA IN RESPONSE TO SQUAT EVICTION PEOPLE WENT OUT TARGETING THE BANKS & MULTI NATIONALS & MAC DONALDS GOT HIT HARD THEN IT WAS BEAUTIFUL TO WATCH AS PEOPLE JUST VANISHED

04/07/01

FLY.

BRAD WILL - 04/07/2K1 - NYC

I FIRST MET BRAD AT DREAMTIME VILLAGE IN WISCONSIN IN 1993 - I HAD BEEN TRAVELING WITH DOG BOY & WE GOT SEPARATED IN CHICAGO WHILE TRAINHOPPING - SO I HITCHHIKED FRM THERE TO WEST LIMA, WISCO - IT TOOK ME A WHOLE DAY & THE LAST 2 HOURS I HAD TO WALK ALONG A DIRT ROAD & NOT A GODDAM CAR PASSED ME BUT THEN I WAS FINALLY AT DREAMTIME & I RAN THRU THE TREES TO WHERE EVERYONE WAS EATING DINNER OUTSIDE & EVERYONE WAS SO SURPRISED THEY COULDNT STOP ASKING ME QUESTIONS & I WAS TALKING A MILE A MINUTE & TELLING ABOUT MY SQUAT IN NYC & THIS ONE KID LOOKS AT ME WITH THIS WIDE EYED PUZZLED LOOK & HIS VOICE IS FULL OF WONDER & HE SAYS "WHATS SQUATTING?" - & THAT WAS HOW I FIRST MET BRAD

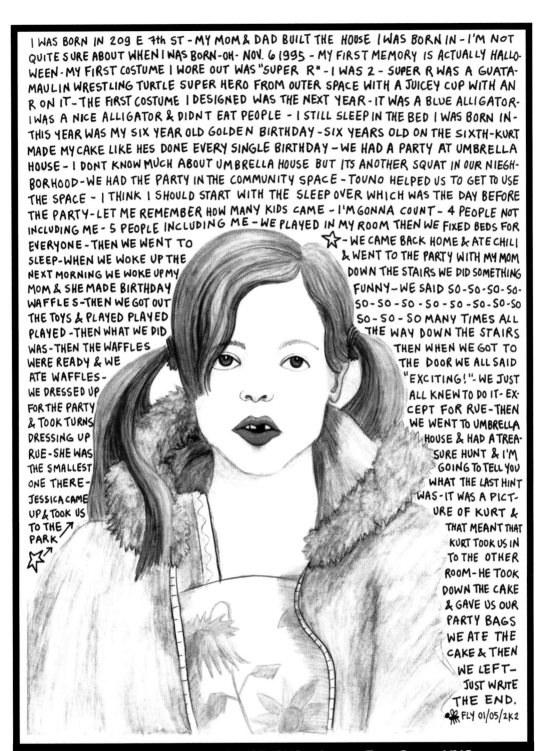

I WAS BORN IN 209 E 7th ST - MY MOM & DAD BUILT THE HOUSE I WAS BORN IN - I'M NOT QUITE SURE ABOUT WHEN I WAS BORN - OH - NOV. 6 1995 - MY FIRST MEMORY IS ACTUALLY HALLOWEEN - MY FIRST COSTUME I WORE OUT WAS "SUPER R" - I WAS 2 - SUPER R WAS A GUATAMAULIN WRESTLING TURTLE SUPER HERO FROM OUTER SPACE WITH A JUICEY CUP WITH AN R ON IT - THE FIRST COSTUME I DESIGNED WAS THE NEXT YEAR - IT WAS A BLUE ALLIGATOR - I WAS A NICE ALLIGATOR & DIDN'T EAT PEOPLE - I STILL SLEEP IN THE BED I WAS BORN IN - THIS YEAR WAS MY SIX YEAR OLD GOLDEN BIRTHDAY - SIX YEARS OLD ON THE SIXTH - KURT MADE MY CAKE LIKE HES DONE EVERY SINGLE BIRTHDAY - WE HAD A PARTY AT UMBRELLA HOUSE - I DONT KNOW MUCH ABOUT UMBRELLA HOUSE BUT ITS ANOTHER SQUAT IN OUR NIEGHBORHOOD - WE HAD THE PARTY IN THE COMMUNITY SPACE - TOUNO HELPED US TO GET TO USE THE SPACE - I THINK I SHOULD START WITH THE SLEEP OVER WHICH WAS THE DAY BEFORE THE PARTY - LET ME REMEMBER HOW MANY KIDS CAME - I'M GONNA COUNT - 4 PEOPLE NOT INCLUDING ME - 5 PEOPLE INCLUDING ME - WE PLAYED IN MY ROOM THEN WE FIXED BEDS FOR EVERYONE - THEN WE WENT TO SLEEP - WHEN WE WOKE UP THE NEXT MORNING WE WOKE UP MY MOM & SHE MADE BIRTHDAY WAFFLES - THEN WE GOT OUT THE TOYS & PLAYED PLAYED PLAYED - THEN WHAT WE DID WAS - THEN THE WAFFLES WERE READY & WE ATE WAFFLES - WE DRESSED UP FOR THE PARTY & TOOK TURNS DRESSING UP RUE - SHE WAS THE SMALLEST ONE THERE - JESSICA CAME UP & TOOK US TO THE PARK ☆↗

☆ - WE CAME BACK HOME & ATE CHILI & WENT TO THE PARTY WITH MY MOM DOWN THE STAIRS WE DID SOMETHING FUNNY - WE SAID SO-SO-SO-SO-SO-SO-SO-SO-SO-SO-SO-SO SO-SO - SO MANY TIMES ALL THE WAY DOWN THE STAIRS THEN WHEN WE GOT TO THE DOOR WE ALL SAID "EXCITING!" - WE JUST ALL KNEW TO DO IT - EXCEPT FOR RUE - THEN WE WENT TO UMBRELLA HOUSE & HAD A TREASURE HUNT & I'M GOING TO TELL YOU WHAT THE LAST HINT WAS - IT WAS A PICTURE OF KURT & THAT MEANT THAT KURT TOOK US IN TO THE OTHER ROOM - HE TOOK DOWN THE CAKE & GAVE US OUR PARTY BAGS WE ATE THE CAKE & THEN WE LEFT - JUST WRITE THE END. ☆ FLY 01/05/2K2

FELIX ASHRA CHROME – 01/05/2K2 – LOWER EAST SIDE – NYC
FELIX IS ONE OF MY FAVORITE PEOPLE IN THE WORLD! – SHE WAS BORN IN MY BUILDING SO SHE WAS A SQUATTER FROM DAY ONE – WHEN FELIX WAS MAYBE 2 OR 3 SHE HELPED THE BUILDING GET A LEGAL ELECTRICAL HOOK-UP WHEN SHE ASKED THE CON-ED GUY WHO WAS CUTTING OUR PIRATE CABLE IF HE COULD "PLEEZE GIVE US LEGAL LECTRICTY?" – SHE FINALLY HAD HER BIG ACTING DEBUT LAST SUMMER (2K2) PERFORMING STREET THEATRE WITH THE THEATRE FOR THE NEW CITY – FELIX HAS AN AMAZING FASHION SENSE – SHE ALWAYS HAS THE FUNKIEST COORDINATED OUTFITS – SHE S A STAR! & SHE S GONNA BE A BIGGER STAR ! – SHE DRAWS BEAUTIFUL PICTURES & HER MOM IS FAMOUS! (PG . 31)

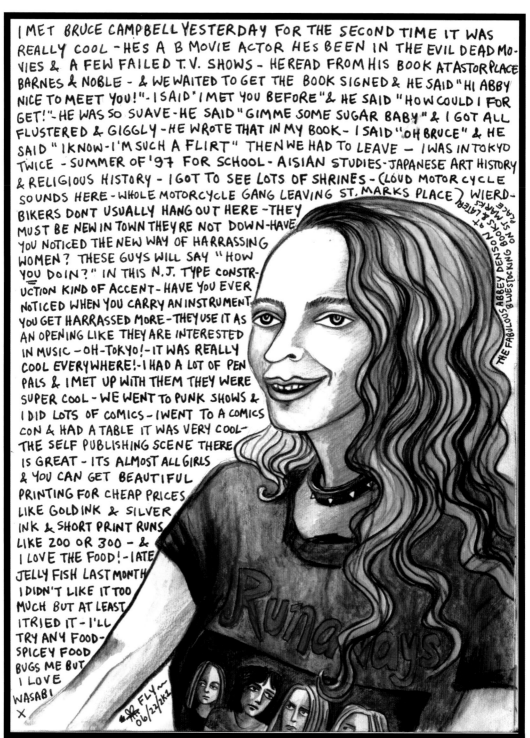

I MET BRUCE CAMPBELL YESTERDAY FOR THE SECOND TIME IT WAS REALLY COOL - HES A B MOVIE ACTOR HES BEEN IN THE EVIL DEAD MOVIES & A FEW FAILED T.V. SHOWS - HE READ FROM HIS BOOK AT ASTOR PLACE BARNES & NOBLE - & WE WAITED TO GET THE BOOK SIGNED & HE SAID "HI ABBY NICE TO MEET YOU!" - I SAID "I MET YOU BEFORE" & HE SAID "HOW COULD I FORGET!" - HE WAS SO SUAVE - HE SAID "GIMME SOME SUGAR BABY" & I GOT ALL FLUSTERED & GIGGLY - HE WROTE THAT IN MY BOOK - I SAID "OH BRUCE" & HE SAID "I KNOW - I'M SUCH A FLIRT" THEN WE HAD TO LEAVE — I WAS IN TOKYO TWICE - SUMMER OF '97 FOR SCHOOL - AISIAN STUDIES - JAPANESE ART HISTORY & RELIGIOUS HISTORY - I GOT TO SEE LOTS OF SHRINES - (LOUD MOTORCYCLE SOUNDS HERE - WHOLE MOTORCYCLE GANG LEAVING ST. MARKS PLACE) WIERD - BIKERS DONT USUALLY HANG OUT HERE - THEY MUST BE NEW IN TOWN THEY'RE NOT DOWN - HAVE YOU NOTICED THE NEW WAY OF HARRASSING WOMEN? THESE GUYS WILL SAY "HOW YOU DOIN?" IN THIS N.J. TYPE CONSTRUCTION KIND OF ACCENT - HAVE YOU EVER NOTICED WHEN YOU CARRY AN INSTRUMENT YOU GET HARRASSED MORE - THEY USE IT AS AN OPENING LIKE THEY ARE INTERESTED IN MUSIC - OH - TOKYO! - IT WAS REALLY COOL EVERYWHERE! - I HAD A LOT OF PEN PALS & I MET UP WITH THEM THEY WERE SUPER COOL - WE WENT TO PUNK SHOWS & I DID LOTS OF COMICS - I WENT TO A COMICS CON & HAD A TABLE IT WAS VERY COOL - THE SELF PUBLISHING SCENE THERE IS GREAT - ITS ALMOST ALL GIRLS & YOU CAN GET BEAUTIFUL PRINTING FOR CHEAP PRICES LIKE GOLD INK & SILVER INK & SHORT PRINT RUNS LIKE 200 OR 300 - & I LOVE THE FOOD! - I ATE JELLY FISH LAST MONTH I DIDN'T LIKE IT TOO MUCH BUT AT LEAST I TRIED IT - I'LL TRY ANY FOOD - SPICEY FOOD BUGS ME BUT I LOVE WASABI X

THE FABULOUS ABBEY DENSON ON BLUESTOCKING BOOKS AT ST. MARKS & LATER

FLY 06/22/2K2

ABBY DENSON – 06/22/2K1 – AT BLUESTOCKINGS BOOKS – NYC
I THINK THE FIRST TIME I MET ABBY WAS AT ABC NO RIO IN THE MID 90S & SHE WANTED TO INTERVIEW ME ABOUT COMICS FOR A CABLE SHOW SHE WAS DOING WITH JENNY GONZALEZ SO WE DID A VIDEOTAPE THING RIGHT THERE – ABBY DOES REALLY SWEET & FUNNY COMICS – I LOVE HER STRIP ABOUT JAMIE STARR THE TEENAGE DRAG QUEEN!! – HER LATEST MINI COMIC IS CALLED DOLLTOPIA – SHE ALSO WRITES FOR THE POWERPUFF GIRLS – AND SHE IS ALSO IN A BAND CALLED MZ. PAKMAN THEY ROCK THE HOUSE – CHECK HER WEBSITE!! – WWW.AUDIOKIO.COM/ABBYCOMIX

I USED TO SLEEP ONLY ON WENSDAYS - I'D BE WALKING & IT SEEMED LIKE EVERYTHING WAS GOING BY ME REALLY FAST LIKE I WAS POWER WALKING BUT REALLY I WOULD ONLY GO THIS FAR 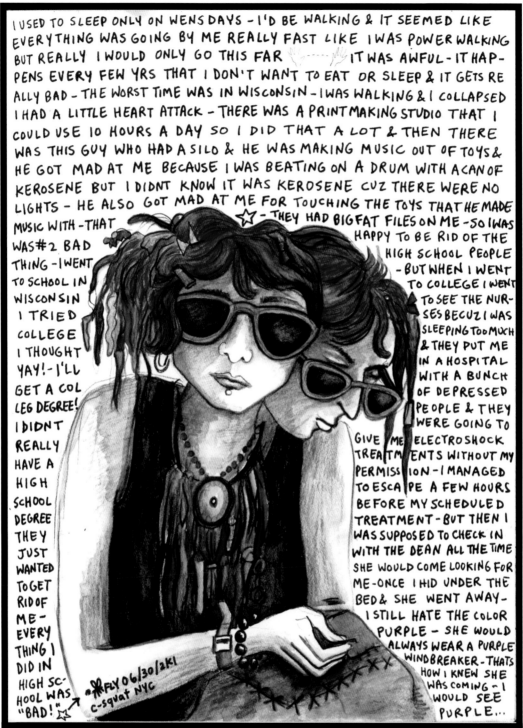 IT WAS AWFUL - IT HAPPENS EVERY FEW YRS THAT I DON'T WANT TO EAT OR SLEEP & IT GETS REALLY BAD - THE WORST TIME WAS IN WISCONSIN - I WAS WALKING & I COLLAPSED I HAD A LITTLE HEART ATTACK - THERE WAS A PRINTMAKING STUDIO THAT I COULD USE 10 HOURS A DAY SO I DID THAT A LOT & THEN THERE WAS THIS GUY WHO HAD A SILO & HE WAS MAKING MUSIC OUT OF TOYS & HE GOT MAD AT ME BECAUSE I WAS BEATING ON A DRUM WITH A CAN OF KEROSENE BUT I DIDNT KNOW IT WAS KEROSENE CUZ THERE WERE NO LIGHTS - HE ALSO GOT MAD AT ME FOR TOUCHING THE TOYS THAT HE MADE MUSIC WITH - THAT WAS #2 BAD THING -

I WENT TO SCHOOL IN WISCONSIN I TRIED COLLEGE I THOUGHT YAY! - I'LL GET A COLLEG DEGREE! I DIDN'T REALLY HAVE A HIGH SCHOOL DEGREE THEY JUST WANTED TO GET RID OF ME - EVERY THING I DID IN HIGH SCHOOL WAS "BAD!" ☆

☆ - THEY HAD BIG FAT FILES ON ME - SO I WAS HAPPY TO BE RID OF THE HIGH SCHOOL PEOPLE - BUT WHEN I WENT TO COLLEGE I WENT TO SEE THE NURSES BECUZ I WAS SLEEPING TOO MUCH & THEY PUT ME IN A HOSPITAL WITH A BUNCH OF DEPRESSED PEOPLE & THEY WERE GOING TO GIVE ME ELECTROSHOCK TREATMENTS WITHOUT MY PERMISSION - I MANAGED TO ESCAPE A FEW HOURS BEFORE MY SCHEDULED TREATMENT - BUT THEN I WAS SUPPOSED TO CHECK IN WITH THE DEAN ALL THE TIME SHE WOULD COME LOOKING FOR ME - ONCE I HID UNDER THE BED & SHE WENT AWAY - I STILL HATE THE COLOR PURPLE - SHE WOULD ALWAYS WEAR A PURPLE WINDBREAKER - THATS HOW I KNEW SHE WAS COMING - I WOULD SEE PURPLE...

#FLY 06/30/2K1 c-squat NYC

BUG – 06/30/2K1 – C SQUAT NYC

BUG IS SORT OF LIKE A LITTLE SISTER OR SOMETHING — ITS LIKE SHE SPEAKS HER OWN STRANGE & POETIC LANGUAGE BUT I UNDERSTAND WHAT SHE MEANS — SHE SEEMS TO LIVE IN A SORT OF PARALLEL UNIVERSE & I THINK SOMETIMES SHE BECOMES INVISIBLE IN THIS WORLD & THIS IS HOW I HAVE FELT AT TIMES ALTHOUGH WE ARE IN DIFFERENT PARALLEL UNIVERSES WE EXPERIENCE THIS SIMILAIR PHENOMENON — THE IDEA OF DISSAPPEARANCE & OFTEN THE DESIRE TO BECOME INVISIBLE IS SOMETHING WE ARE BOTH AFFLICTED BY — I DON T KNOW WHERE BUG IS NOW — SHE SEEMS TO HAVE DISSAPPEARED

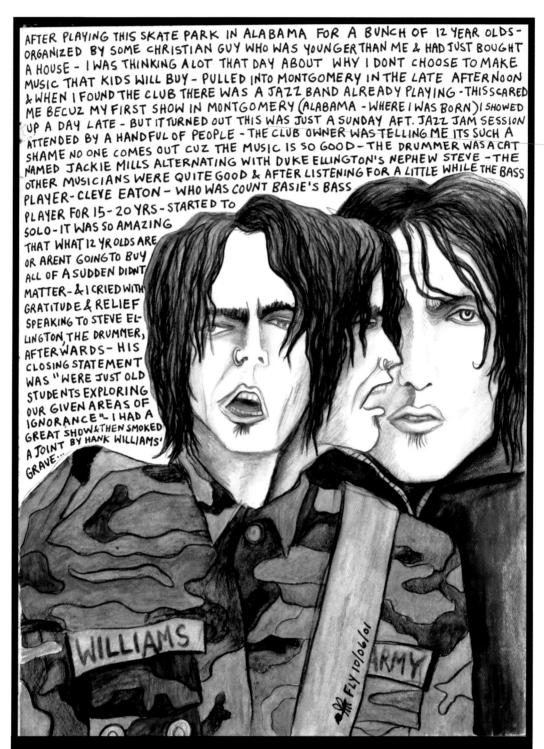

AFTER PLAYING THIS SKATE PARK IN ALABAMA FOR A BUNCH OF 12 YEAR OLDS - ORGANIZED BY SOME CHRISTIAN GUY WHO WAS YOUNGER THAN ME & HAD JUST BOUGHT A HOUSE - I WAS THINKING A LOT THAT DAY ABOUT WHY I DONT CHOOSE TO MAKE MUSIC THAT KIDS WILL BUY - PULLED INTO MONTGOMERY IN THE LATE AFTERNOON & WHEN I FOUND THE CLUB THERE WAS A JAZZ BAND ALREADY PLAYING - THIS SCARED ME BECUZ MY FIRST SHOW IN MONTGOMERY (ALABAMA - WHERE I WAS BORN) I SHOWED UP A DAY LATE - BUT IT TURNED OUT THIS WAS JUST A SUNDAY AFT. JAZZ JAM SESSION ATTENDED BY A HANDFUL OF PEOPLE - THE CLUB OWNER WAS TELLING ME ITS SUCH A SHAME NO ONE COMES OUT CUZ THE MUSIC IS SO GOOD - THE DRUMMER WAS A CAT NAMED JACKIE MILLS ALTERNATING WITH DUKE ELLINGTON'S NEPHEW STEVE - THE OTHER MUSICIANS WERE QUITE GOOD & AFTER LISTENING FOR A LITTLE WHILE THE BASS PLAYER - CLEVE EATON - WHO WAS COUNT BASIE'S BASS PLAYER FOR 15 - 20 YRS - STARTED TO SOLO - IT WAS SO AMAZING THAT WHAT 12 YR OLDS ARE OR ARENT GOING TO BUY ALL OF A SUDDEN DIDNT MATTER - & I CRIED WITH GRATITUDE & RELIEF SPEAKING TO STEVE EL- LINGTON, THE DRUMMER, AFTERWARDS - HIS CLOSING STATEMENT WAS "WERE JUST OLD STUDENTS EXPLORING OUR GIVEN AREAS OF IGNORANCE" - I HAD A GREAT SHOW & THEN SMOKED A JOINT BY HANK WILLIAMS' GRAVE...

MIKE ILL – 10/06/2K1 – LA PETIT VERSAILLES GARDEN – LOWER EAST SIDE – NYC
I DREW THIS AS MIKE ILL WAS PERFORMING IN THE LITTLE GARDEN ON E. 2ND ST. – YEARS AGO HE WAS IN A BAND CALLED SWEET LIZARD ILLTET – THEY WERE A BUNCH OF SQUATTERS DOING THIS AWESOME INDUSTRIAL STYLE FUNKY HARDCORE HIPHOP – (IF ANY- ONE HAS THEIR CD PLEASE MAKE ME A COPY!) – I DIDNT ACTUALLY MEET MIKE TIL AROUND 95 – WHEN I TOLD HIM MY NAME IS FLY HE GAVE ME THIS COOL FAT CHAIN HE WAS WEARING THAT HAD A METAL FLY ON IT – WOW! – I STILL HAVE IT
WWW.OBLITERATION.COM

THIS IS MY SURF JACKET - FIRST IT WAS MY SURF SWEATER - WHO KNOWS WHAT IT WILL BE NEXT - I WAS IN PHILA & I HAD LOST MY COAT & SOME GUY LENT ME A SWEATER THAT HAD THUMB HOLES IN THE ARMS & I REALIZED I COULD KEEP MY HANDS COVERED & THEN I WAS IN MACHU PEECHU (PERU) & I GOT THESE GLOVES & SEWED THEM ONTO THE SWEATER WE WENT TO THIS PLACE CALLED CHICAMA WHICH MEANS "THE LONGEST LEFT HANDED WAVE IN THE WORLD" TO SURF - IT WAS A MUDDY LITTLE TOWN & THE MAIN THING TO DO THERE WAS EAT FISH & SURF - THE LONGEST BOARD I COULD GET WAS A 7' BOARD & I WASNT SO GOOD BACK THEN THE WATER WAS REALLY COLD & MY FRIEND WAS JUST STARING AT ME TRYING TO CATCH WAVES IT WAS KIND OV A DEPRESSING TOWN - IN PERU ITS NOT SO WARM & THE WATERS COLD BUT EVERY ONE SURFS! EVERYONE! BUT ITS KIND OF DEPRESSING ITS JUST MILES & MILES OF BARREN HILLS & MUDDY LITTLE TOWNS - I NEVER THOUGHT I COULD SURF ON A SHORT BOARD BUT LAST WINTER

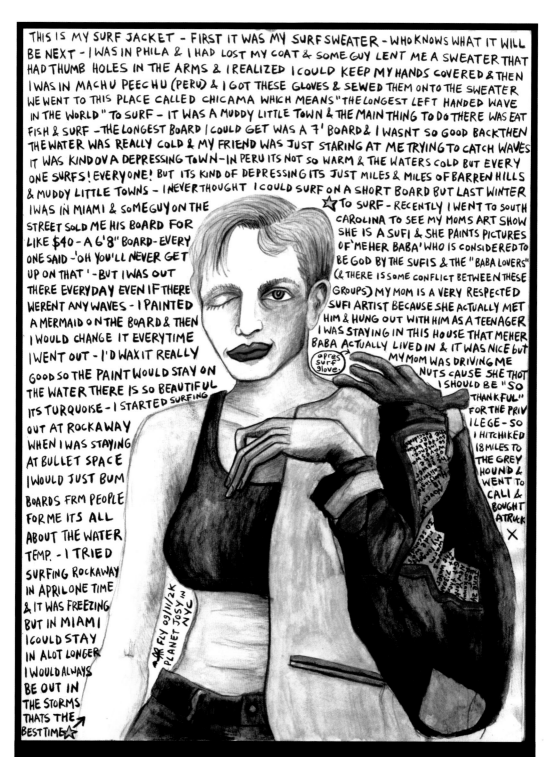

I WAS IN MIAMI & SOME GUY ON THE STREET SOLD ME HIS BOARD FOR LIKE $40 - A 6'8" BOARD - EVERY ONE SAID - 'OH YOU'LL NEVER GET UP ON THAT ' - BUT I WAS OUT THERE EVERYDAY EVEN IF THERE WERENT ANY WAVES - I PAINTED A MERMAID ON THE BOARD & THEN I WOULD CHANGE IT EVERY TIME I WENT OUT - I'D WAX IT REALLY GOOD SO THE PAINT WOULD STAY ON THE WATER THERE IS SO BEAUTIFUL ITS TURQUOISE - I STARTED SURFING OUT AT ROCKAWAY WHEN I WAS STAYING AT BULLET SPACE I WOULD JUST BUM BOARDS FRM PEOPLE FOR ME ITS ALL ABOUT THE WATER TEMP. - I TRIED SURFING ROCKAWAY IN APRIL ONE TIME & IT WAS FREEZING BUT IN MIAMI I COULD STAY IN A LOT LONGER I WOULD ALWAYS BE OUT IN THE STORMS THATS THE BEST TIME

apres surf glove.

FLY 09/11/2K PLANET JOSY IN NYC

TO SURF - RECENTLY I WENT TO SOUTH CAROLINA TO SEE MY MOMS ART SHOW SHE IS A SUFI & SHE PAINTS PICTURES OF 'MEHER BABA' WHO IS CONSIDERED TO BE GOD BY THE SUFIS & THE "BABA LOVERS" (& THERE IS SOME CONFLICT BETWEEN THESE GROUPS) MY MOM IS A VERY RESPECTED SUFI ARTIST BECAUSE SHE ACTUALLY MET HIM & HUNG OUT WITH HIM AS A TEENAGER I WAS STAYING IN THIS HOUSE THAT MEHER BABA ACTUALLY LIVED IN & IT WAS NICE BUT MY MOM WAS DRIVING ME NUTS CAUSE SHE THOT I SHOULD BE "SO THANKFUL" FOR THE PRIVILEGE - SO I HITCHIKED 18 MILES TO THE GREY HOUND & WENT TO CALI & BOUGHT A TRUCK X

JOSY COBB - 09/11/Y2K - NYC

JOSY IS A TRIP - SHE ALSO LIKES TO TRAVEL A LOT & SHE HAS MANY AMAZING SKETCH BOOKS FULL OF HER TRIPS TO AFRICA OR PERU OR MIAMI OR AROUND THE BLOCK - I GOT TO HANG OUT WITH JOSY WHEN WE WERE BOTH IN A GROUP SHOW TOGETHER IN ITALY IN 98 - ON THE ISLAND OF SARDEGNA - WE HAD LOTS OF FUN GOIN TO THE CAVE OF THE GODDESS & WALKING FOR HOURS ON THE PLATEAU TO SEE REAL GENUINE BEAUTIFUL WILD HORSES! - WE ALSO GOT SOME CORK FROM A SPECIAL TREE THAT GROWS CORK FOR BARK

THE FLAMING IRON IS A SYMBOL OF THE NEOISTS ... WE WERE IN VÁC (HUNGARY) AN HOUR FRM BUDAPEST - THERE WAS A NEOIST FEST - IN THE NAME OF NEOIST - AN ANTI EVENT - ONE GUY HAD DONATED HIS APARTMNT TO US & WE WERE ALLOWED TO DO WHATEVER WE WANTED - THERE WERE LOTS OF EASELS & SMOCKS & PAINT BRUSHES SO †ENTATIVELY a CONVEN-IENCE - BEING A FORMER ARTIST MODEL - REVERSED THE ROLES OF THE TYPICAL LIFE DRAWING SO THE MODEL WOULD BE THE ONLY ONE ALLO-WED TO MOVE & ALL THE ARTISTS HAD TO STAY COMPLETELY STILL - POSED & READY TO PAINT - FOR MAYBE HALF AN HOUR - †ENT WAS NAKED JUMPING AROUND WALKING ON ALL THE OBJECTS IN THE ROOM & TOTALLY FUCKING WITH US - HE WAS PUTTING WET TOWELS ON OUR HEADS - SCRATCHING OUR ITCHES - THE BEST PART OF THIS PER FORMANCE WAS THAT NO ART WAS PRODUCED - THEN I SET UP THE HAND DEVIL REMO- VAL SERVICE AND PEOPLE LINED UP TO GET THE DEVIL REMOVED - THEN WE WERE ON THE BALCONY & MONTY CANTSIN HAD SET UP AN ALTER OF IRONS & HIS DECEASED FATHER'S OBJECTS & HE STARTD GIVING A SPEECH & THERE WERE 2 TRANSLATORS - ONE WAS HUNGARIAN TO ITALIAN & ONE WAS HUNGARIAN TO ENGLISH BUT HE DIDNT KNOW HUNGARIAN THEN WE ALL STARTED TRANSLAT-ING - IT ERUPTED & OVERTOOK WHAT MONTY CANTSIN WAS DOING BUT AMONGST THE NEOISTS - DESPITE THE STRIFE - THERE IS THE UNIFY ING LOVE OF THIS TRANSCENDANT ABSURDISM

FLY-2K-08/10/00-POLISH-HILL-PITTS

TOP

Tale of the Cross Addresser

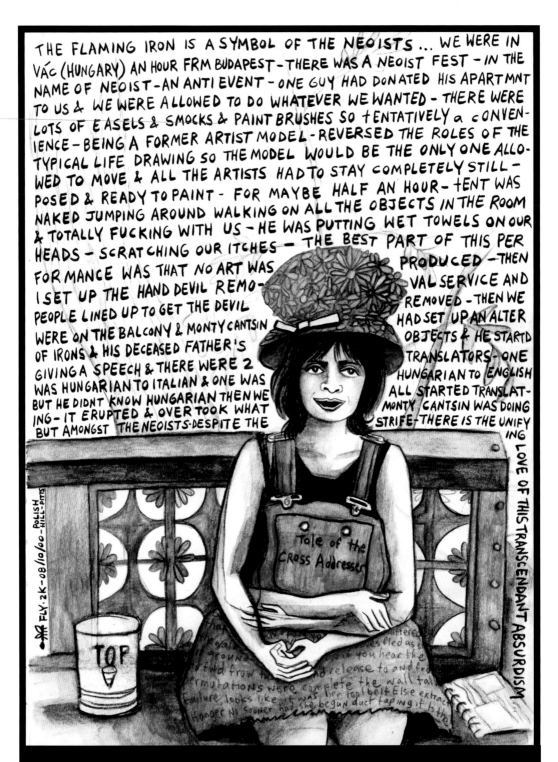

ETTA CETERA AKA EDUH SEDERUH – 08/10/Y2K – PITTSBURGH
ETTA CETERA LIVES IN A LITTLE HOUSE RIGHT ABOVE THE TRAIN TRACKS – ITS IN THE MID-DLE OF PITTS BUT IT SEEMS LIKE ITS OUT IN THE COUNTRY – HER HOUSE IS THE H.Q. OF THE STREET RAT (ZINE) – THE BATHROOM IS OBSESSED WITH BEING A DARKROOM – SHE HAS AN AMAZING COLLECTION OF MINI BOOKS & HUNDREDS OF AGING VINTAGE BOOKS IN THE BASEMENT – NEXT DOOR THERE IS A CRAZY LADY WHO YELLS & SCREAMS & BLASTS OUT TOP 40 MUSIC & TRIES TO BORROW MONEY – DE_TRITUS@YAHOO.COM

100

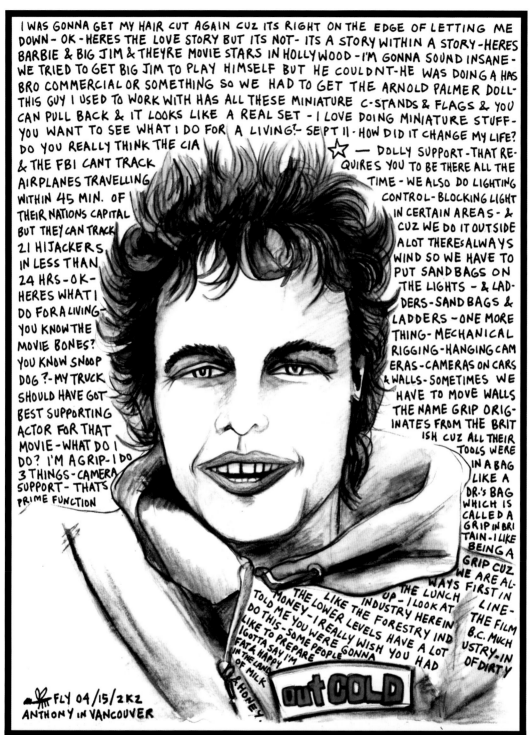

ANTHONY CREERY – 04/15/2K2 – VANCOUVER – CANADA
I MET ANTHONY IN THE LATE 80S AT A PARTY ON VICTORIA ISLAND – I WAS ON CRUTCHES
IN A BIG LEG BRACE CUZ I HAD TORN MY LIGAMENTS SKIING – I HAD BEEN PAINTING
T-SHIRTS TO MAKE MONEY & THE GUYS I WAS SELLING THEM TO HAD INVITED ME TO THIS
BIG WAREHOUSE PARTY – WE TOOK THE FERRY TO THE ISLAND & THE WHOLE NIGHT WAS A
TOTAL BLAST – ANTHONY HAD BRIGHT ORANGE HAIR AT THE TIME & WAS A HILARIOUS
PARTY MANIAC – HE LIVED AT A PLACE CALLED OUR NOSE WHERE I ENDED UP CRASHING
FOR A FEW MONTHS AT A LATER DATE – ANTHONY IS STILL A HILARIOUS AWESOME MANIAC
& HE HAS AN AMAZING VOICE YOU WILL NEVER FORGET

I'M IN A BATHROOM IN SYOSSET NY & I FEEL SO UNPROTECTED BECUZ I'M TRYING TO WASH THIS STICKY PAINT OFF MY EYELID - I WAS USING A BOTTLE OF LACQUER THINNER WHICH I GOT FROM MY BOSS'S TRUCK & I'M KIND OF HAPPY THIS OLD LADY WE ARE WORKING FOR CAME IN & GOT IN MY WAY BECUZ SHE WAS VERY MATERNAL & IN HER RASPY RUINED VOICE SAID "YOU'RE GONNA GO BLIND" & I WAS LIKE - SHIT! SHE'S RIGHT!! - I MEAN I'M TRYING TO BE CAREFUL BUT WHAT IF I GET THIS STUFF IN MY EYE? - MY POINT HERE IS THEN I WOULDNT BE ABLE TO READ & DO ALL THE OTHER THINGS I DO (BESIDES WORKING CONSTRUCTION) - I FELT SO IRRESPONSIBLE TO MYSELF - IT WOULD BE SO EASY TO RUIN MYSELF OR DO PERMANANT DAMAGE AT THIS JOB - I LIVE & WORK ON LONG ISLAND NOW & ITS GOOD BECAUSE I NEED TO GET SOME PERSPECTIVE ON THE CITY - ON SOFT SKULL - THAT GODDAMMED PUBLISHING COMPANY - & TRY TO GET A GLIMPSE OF THE BIG PICTURE OF MY LIFE - I'VE BEEN READING ALOT OF WHITMAN & ERIC FROMM - & RECHARGING & REBUILDING & REDISCOVERING MY CORE PRINCIPLES - WHITE COLLAR CRIME SHOWS HAVE BECOME SPIRITUAL POLITICAL ART EXPERIENCES & I REALLY LIKE THAT THE NEW CD IS GETTING COMPARED TO CRASS & D.K. BECAUSE THAT LEVEL OF INTELLIGENT ATTACK IS SOMETHING IVE ALWAYS ASPIRED TO WITH THIS BAND SO MAYBE ALL MY EXPERIENCES AT SOFT SKULL - HATFIELD DYING - HIS BUSH BIO TAKING US THROUGH HELL & BACK A COUPLE TIMES - BELIEVING IN THE WORK SO MUCH THAT I USED TO THINK NOTHING OF WORKING A 12 HOUR DAY & THEN DOING THE TRASH BECUZ I USED TO BE→

FLY 12/30/2K1

A SUPER & THEN GOING TO BAND PRACTISE - AFTER ALL THAT THE COMPANY STILL ALMOST WENT BANKRUPT & SO I NEEDED A BREAK - PART OF THIS BREAK IS THAT I'M WRITING A POLITICAL BIOGRAPHY OF KARL ROVE & I KNOW YOU JOKE WITH ME - DONT I THINK I'LL BE KILLED - I KNOW YOURE SERIOUS - BUT I FEEL LIKE I'M TAKING A STEP BACK TO BE ABLE TO RENEW THE ATTACK - I'M SMART & ENERGETIC & OVER TIME HAVE LEARNED TO BE CAREFUL SO I DONT BECOME BLINDED - I'M GOING THROUGH A TRANSITION & ITS FUNNY BECUZ SO IS THE WORLD I - PERSONALLY - AM IN BETTER HANDS
X

BEVERAGE DISTRIBUTORS INC.

STROH LIGHT BEER

SIGNATU

SANDER HICKS – 12/30/2K1 – LOWER EAST SIDE – NYC
I MET SANDER BACK IN THE EARLY 90S WHEN HE CAME TO THE OPEN MIC NIGHT I WAS EMCEEING AT THE GARGOYLE MECHANIQUE LAB – HE WAS AN INTENSE HYPER SKATER PUNK KID READY TO DISCOVER SOME NEW KIND OF REVOLUTIONARY PUNK ROCK POLITICS – HE STARTED WRITING & PRODUCING PLAYS – HE WAS WORKING AT KINKOS SO HE STARTED PUBLISHING BOOKS THAT HE BELIEVED IN & THAT WAS THE BEGINNING OF SOFT SKULL – I WORKED THE OVERNIGHT SHIFT WITH SANDER A FEW TIMES & IT WAS NONSTOP ENTERTAINMENT – MY FAVORITE WAS WHEN HE WOULD LEAP UP ONTO THE COUNTER TOPS TWITCHING VIOLENTLY & SCREAMING OUT OLD SCHOOL PUNK SONGS – SANDERHICKS.COM

YAREAK & I HAD TALKED ABOUT TRAVELING IN AN RV CUZ HER GIRLFRIEND AT THE TIME WAS GONNA BE GIVEN AN R.V. - THERE WOULD BE 5 OF US INCLUDING ME & MY GIRL FRIEND & HER DAUGHTER - THE PLAN WAS TO LIVE IN COLUMBUS FOR ANOTHER YEAR & THEN LEAVE TO GO TRAVELING - SUMMER 2000 YAREAK & I WENT UP TO PHILLY TO THE RNC & THE NEXT DAY AFTER WE GOT BACK BOTH OF OUR GIRL FRIENDS BROKE UP WITH US ON THE SAME DAY - WE DECIDED TO CONTINUE WITH OUR PLAN TO TRAVEL TOGETHER BUT IN THE MEANTIME I WENT TRAVELING FOR 6 MONTHS BY MYSELF AROUND THE U.S. THEN I CAME BACK TO COLUMBUS FOR 3 WEEKS - WE NEEDED TO FIND AN R.V. TO LIVE IN BY THE END OF MARCH - THE FIRST ONE WE FOUND SEEMED LIKE A GREAT DEAL BUT WHEN WE DROVE IT OFF THE LOT IT DIED A MILE DOWN THE ROAD - WE GOT IT TOWED BACK & STOPPED PAYMENT ON OUR CHECKS - WE DECIDED TO GET AN R.V. IN INDIANNA FROM THE BIGGEST R.V. DEALER - THATS WHERE WE FOUND TANTRUM - THATS THE NAME OF OUR R.V. - THE DAY WE GOT IT WE DROVE STRAIGHT TO PHILLY FOR AN ACTION MEDICAL TRAINING - WE WENT BACK TO COLUMBUS & PACKED UP THE REST OF OUR STUFF & OUR FIRST DESTINATION WAS TORONTO WHERE WE GOT READY FOR THE FTAA - I WAS DOING ACTION MEDICAL & WE WERE HANGING OUT WITH A.R.A. PEOPLE - HELPING THEM WHEAT PASTE - MAKING SHEILDS & PADDING FOR THE STREET DEMOS

WE'VE BEEN TRAVELING FOR ALMOST A YEAR NOW DOING WORKSHOPS ON DOMESTIC VIOLENCE WITHIN RADICAL COMMUNITIES - WE'RE ON TOUR RIGHT NOW WITH THE BEEHIVE COLLECTIVE - UP THE WEST COAST & OUT TO THE MIDWEST - WE ALSO HAVE A TRAVELING INFO-SHOP WHICH FOCUSES ON WOMEN - TRANS - JEWISH - ANARCHIST ISSUES - WERE ALSO ORGANIZING A RADICAL TRANNY & WOMENS CONFERENCE CALLED "PLAN Z" TO HAPPEN AT IDA WHICH IS ONE OF THE FAIRYLANDS IN TENNESEE - SO WE PLAN ON TRAVELING EITHER UNTIL TANTRUM DOESNT WANT TO GO ANY MORE OR UNTIL WE FIND A PLACE TO SETTLE - TODAY WE WALKED AROUND BERKELEY FOR HOURS & THEN GOT FREE FOOD! LIKE THE POT OF GOLD AT THE END OF THE RAINBOW

FLY 02/24/2K2

RATH – 02/24/2K2 – OAKLAND

I FIRST MET RATH IN NYC WHEN HE WAS STAYING UPSTAIRS WITH FAMOUS – HE WAS IN TOWN DOING SOME STREET MEDIC TRAINING – THEN HE WENT ON THE ROAD WITH HIS POSSE IN TANTRUM THE R.V. TOURING THE COUNTRY PRESENTING DEVIANT INFORMATION & WORKSHOPS ON HOW TO CONFRONT DOMESTIC VIOLENCE IN ALTERNATIVE COMMUNITIES & BASICALLY NETWORKING WITH OTHER GROUPS OF ACTIVISTS – RATH & CREW – & SOME FOLKS FRM THE BEEHIVE COLLECTIVE SHOWED UP IN OAKLAND JUST IN TIME TO COME TO MY BIRTHDAY PARTY AT THE KILLER BANSHEE STUDIO – THEY PARKED THE R.V. OUTSIDE THE GATE & STAYED PARKED THERE FOR ABOUT A WEEK! GRITTY44@ANGELFIRE.COM

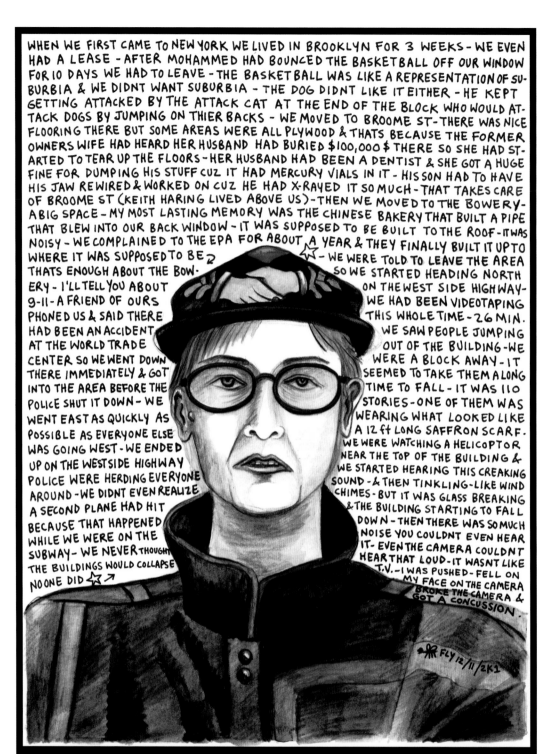

WHEN WE FIRST CAME TO NEW YORK WE LIVED IN BROOKLYN FOR 3 WEEKS - WE EVEN HAD A LEASE - AFTER MOHAMMED HAD BOUNCED THE BASKETBALL OFF OUR WINDOW FOR 10 DAYS WE HAD TO LEAVE - THE BASKETBALL WAS LIKE A REPRESENTATION OF SUBURBIA & WE DIDNT WANT SUBURBIA - THE DOG DIDNT LIKE IT EITHER - HE KEPT GETTING ATTACKED BY THE ATTACK CAT AT THE END OF THE BLOCK WHO WOULD ATTACK DOGS BY JUMPING ON THIER BACKS - WE MOVED TO BROOME ST - THERE WAS NICE FLOORING THERE BUT SOME AREAS WERE ALL PLYWOOD & THATS BECAUSE THE FORMER OWNERS WIFE HAD HEARD HER HUSBAND HAD BURIED $100,000 $ THERE SO SHE HAD STARTED TO TEAR UP THE FLOORS - HER HUSBAND HAD BEEN A DENTIST & SHE GOT A HUGE FINE FOR DUMPING HIS STUFF CUZ IT HAD MERCURY VIALS IN IT - HIS SON HAD TO HAVE HIS JAW REWIRED & WORKED ON CUZ HE HAD X-RAYED IT SO MUCH - THAT TAKES CARE OF BROOME ST (KEITH HARING LIVED ABOVE US) - THEN WE MOVED TO THE BOWERY - A BIG SPACE - MY MOST LASTING MEMORY WAS THE CHINESE BAKERY THAT BUILT A PIPE THAT BLEW INTO OUR BACK WINDOW - IT WAS SUPPOSED TO BE BUILT TO THE ROOF - IT WAS NOISY - WE COMPLAINED TO THE EPA FOR ABOUT A YEAR & THEY FINALLY BUILT IT UP TO WHERE IT WAS SUPPOSED TO BE ⟳ ☆↗ - WE WERE TOLD TO LEAVE THE AREA

THATS ENOUGH ABOUT THE BOWERY - I'LL TELL YOU ABOUT 9-11 - A FRIEND OF OURS PHONED US & SAID THERE HAD BEEN AN ACCIDENT AT THE WORLD TRADE CENTER SO WE WENT DOWN THERE IMMEDIATELY & GOT INTO THE AREA BEFORE THE POLICE SHUT IT DOWN - WE WENT EAST AS QUICKLY AS POSSIBLE AS EVERYONE ELSE WAS GOING WEST - WE ENDED UP ON THE WEST SIDE HIGHWAY POLICE WERE HERDING EVERYONE AROUND - WE DIDNT EVEN REALIZE A SECOND PLANE HAD HIT BECAUSE THAT HAPPENED WHILE WE WERE ON THE SUBWAY - WE NEVER THOUGHT THE BUILDINGS WOULD COLLAPSE NO ONE DID ☆↗

SO WE STARTED HEADING NORTH ON THE WEST SIDE HIGHWAY - WE HAD BEEN VIDEOTAPING THIS WHOLE TIME - 26 MIN. WE SAW PEOPLE JUMPING OUT OF THE BUILDING - WE WERE A BLOCK AWAY - IT SEEMED TO TAKE THEM A LONG TIME TO FALL - IT WAS 110 STORIES - ONE OF THEM WAS WEARING WHAT LOOKED LIKE A 12 ft LONG SAFFRON SCARF. WE WERE WATCHING A HELICOPTOR NEAR THE TOP OF THE BUILDING & WE STARTED HEARING THIS CREAKING SOUND - & THEN TINKLING - LIKE WIND CHIMES - BUT IT WAS GLASS BREAKING & THE BUILDING STARTING TO FALL DOWN - THEN THERE WAS SO MUCH NOISE YOU COULDNT EVEN HEAR IT - EVEN THE CAMERA COULDNT HEAR THAT LOUD - IT WASNT LIKE T.V. - I WAS PUSHED - FELL ON MY FACE ON THE CAMERA BROKE THE CAMERA & GOT A CONCUSSION.

FLY 12/11/2K1

ELSA RENSAA – 12/11/2K1 – LOWER EAST SIDE – NYC
I DON T THINK I WAS EVER FORMALLY INTRODUCED TO ELSA – SHE WAS JUST ALWAYS AROUND VIDEO-TAPING WITH CLAYTON – DOCUMENTING ALL THE INSANITY OF THE LOWER EAST SIDE DURING THE WAR TORN DAYS BEFORE GENTRIFICATION HAD FULLY TAKEN OVER – ELSA & CLAYTON WOULD BE THERE FOR THE DEMOS OR THE RIOTS OR THE IMPROPTU PERFORMANCES OR THE SPEAK OUTS OR WHENEVER SHIT WAS JUST GOIN DOWN – THIS IS A TOTALLY HIDDEN HISTORY THAT THEY HAVE BEEN DOCUMENTING FOR DECADES NOW – ESSENTIAL & IMPORTANT WORK THAT DOESNT USUALLY GET THE RECOGNITION IT DESERVES

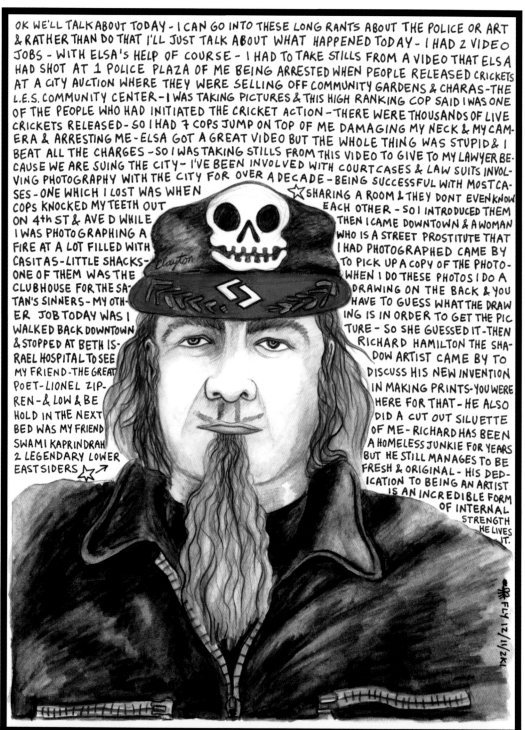

OK WE'LL TALK ABOUT TODAY - I CAN GO INTO THESE LONG RANTS ABOUT THE POLICE OR ART & RATHER THAN DO THAT I'LL JUST TALK ABOUT WHAT HAPPENED TODAY - I HAD 2 VIDEO JOBS - WITH ELSA'S HELP OF COURSE - I HAD TO TAKE STILLS FROM A VIDEO THAT ELSA HAD SHOT AT 1 POLICE PLAZA OF ME BEING ARRESTED WHEN PEOPLE RELEASED CRICKETS AT A CITY AUCTION WHERE THEY WERE SELLING OFF COMMUNITY GARDENS & CHARAS-THE L.E.S. COMMUNITY CENTER - I WAS TAKING PICTURES & THIS HIGH RANKING COP SAID I WAS ONE OF THE PEOPLE WHO HAD INITIATED THE CRICKET ACTION - THERE WERE THOUSANDS OF LIVE CRICKETS RELEASED - SO I HAD 7 COPS JUMP ON TOP OF ME DAMAGING MY NECK & MY CAMERA & ARRESTING ME - ELSA GOT A GREAT VIDEO BUT THE WHOLE THING WAS STUPID & I BEAT ALL THE CHARGES - SO I WAS TAKING STILLS FROM THIS VIDEO TO GIVE TO MY LAWYER BECAUSE WE ARE SUING THE CITY - I'VE BEEN INVOLVED WITH COURT CASES & LAW SUITS INVOLVING PHOTOGRAPHY WITH THE CITY FOR OVER A DECADE - BEING SUCCESSFUL WITH MOST CASES - ONE WHICH I LOST WAS WHEN COPS KNOCKED MY TEETH OUT ON 4th ST & AVE D WHILE I WAS PHOTOGRAPHING A FIRE AT A LOT FILLED WITH CASITAS - LITTLE SHACKS - ONE OF THEM WAS THE CLUBHOUSE FOR THE SATAN'S SINNERS - MY OTHER JOB TODAY WAS I WALKED BACK DOWNTOWN & STOPPED AT BETH ISRAEL HOSPITAL TO SEE MY FRIEND - THE GREAT POET - LIONEL ZIPREN - & LOW & BEHOLD IN THE NEXT BED WAS MY FRIEND SWAMI KAPRINDRAH 2 LEGENDARY LOWER EAST SIDERS ☆↗

☆ SHARING A ROOM & THEY DONT EVEN KNOW EACH OTHER - SO I INTRODUCED THEM THEN I CAME DOWNTOWN & A WOMAN WHO IS A STREET PROSTITUTE THAT I HAD PHOTOGRAPHED CAME BY TO PICK UP A COPY OF THE PHOTO - WHEN I DO THESE PHOTOS I DO A DRAWING ON THE BACK & YOU HAVE TO GUESS WHAT THE DRAWING IS IN ORDER TO GET THE PICTURE - SO SHE GUESSED IT - THEN RICHARD HAMILTON THE SHADOW ARTIST CAME BY TO DISCUSS HIS NEW INVENTION IN MAKING PRINTS - YOU WERE HERE FOR THAT - HE ALSO DID A CUT OUT SILUETTE OF ME - RICHARD HAS BEEN A HOMELESS JUNKIE FOR YEARS BUT HE STILL MANAGES TO BE FRESH & ORIGINAL - HIS DEDICATION TO BEING AN ARTIST IS AN INCREDIBLE FORM OF INTERNAL STRENGTH HE LIVES IT.

CLAYTON PATTERSON – 12/11/2K1 – LOWER EAST SIDE – NYC
SAME AS WITH ELSA I DON T THINK I WAS EVER REALLY INTRODUCED TO CLAYTON – THE FIRST I KNEW OF HIM WAS WHEN I WALKED BY HIS STOREFRONT ON ESSEX SOME TIME IN THE LATE 80S & I SAW HIS AMAZING HATS! – BEAUTIFUL COLORFULLY EMBROIDERED BLACK HATS – THEN I WOULD SEE CLAYTON & ELSA EVERYWHERE WITH THEIR CAMERAS DOCUMENTING THE EVOLUTION OF LOWER EAST SIDE CULTURE – THIS IS LIKE A LIFE S WORK – CLAYTON BECAME "FAMOUS" AFTER THE 1988 TOMPKINS SQUARE PARK POLICE RIOT WHEN HE TAPED COPS BRUTALLY BEATING UP INNOCENT BYSTANDERS – THE COPS DIDNT LIKE HIM TOO MUCH AFTER THAT ONE

THERES JUST SOMETHING ABOUT SAN FRANCISCO THATS MAKING ME INSANE LATELY - CUZ I THINK THAT EVERYBODY WHO COMES HERE ARE FLEEING THIER TEENAGE PERSECUTION YEARS & EVERYONES DEPRESSED & EVERYONES BEEN FIGHTING SO EVERYONE IS IN FIGHTING MODE & RESISTANCE MODE & THEY GET HERE & THERES NO ONE HERE TO FIGHT & RESIST LIKE THERE WAS SO THEY ALL START FIGHTING & RESISTING EACH OTHER - DOES THIS SOUND LIKE ITS TOTALLY INSANE & PARANOID - I JUST THINK PEOPLE BRING A HIGH SCHOOL AS MODEL FOR THE UNIVERSE FRAME WORK WITH THEM WHEN THEY LIVE HERE - & IT DOESNT MATTER IF YOU KNOW THIS IS HAPPENING BUT YOU ARE BEING CAST IN SOME ONE ELSES HIGH SCHOOL MELLOW DRAMA WITHOUT YOU EVEN REALIZING!! IT JUST STINKS FOR PEOPLE WHO CAME HERE TO HAVE AN ANTI-HIGH SCHOOL EXPERIENCE - EVERYBODY BEING FRIENDLY WITH EACH OTHER INSTEAD OF DIVIDING YOUR ENVIRONMENT INTO SOCIAL SUBGROUPS THAT ARE ALL OPPOSING EACH OTHER FOR SOME STUPID REASON - ITS A GREAT PLACE TO DO THINGS BECAUSE YOU GET SO MUCH SUPPORT BUT THEN THERES ALL THIS BACK STABBING & CRITICISM - ITS REALLY WIERD - WHEN I CAME HERE I WANTED TO BE IN A PLACE WHERE THERE WERE OTHER PEOPLE LIKE ME CUZ I FELT SO ISOLATED - I CAME HERE IN 1992 OR 93 - I HAD THIS CHILDHOOD FANTASY OF THE LAND OF FRIENDS WHERE EVERYONE JUST PLAYS TOGETHER & ↗

☆ PUTS ON SHOWS & EVERYONE IS THE AUDIENCE & THE ACTORS - SAN FRANCISCO IS THE CLOSEST IVE EVER FOUND TO THAT - ONCE I DID A TOUR CALLED THE LOVE PROJECT BUT NOBODY COULD GET ALONG SO WE HAD TO CANCEL IT - WHEN I FIRST CAME TO S.F. I WENT TO THIS CLUB CALLED JUNK & IT WAS A PUNK ROCK CLUB FOR GIRLS & BOYS - I COULDNT BELIEVE THERE WAS A ROOM FULL OF ALL THESE AMAZING LOOKING PUNK ROCK LEZZIES GETTING DRUNK & SLAMMING INTO EACH OTHER - THEY WERE SO GREAT LOOKING & I LOOKED TERRIBLE CUZ I HAD JUST HAD A LESBIAN FEMINIST NERVOUS BREAKDOWN THAT TOTALLY COMPROMISED MY FASHION - BUT I FELT THIS INTENSE EXCITEMENT THAT I WAS GONNA GET TO BE FRIENDS WITH ALL OF THEM X

FLY 03/13/2K2

MICHELLE TEA – 03/13/2K2 – OAKLAND
I MET MICHELLE IN SF IN 1993 – SHE WAS THIS CUTE LITTLE GIRL WITH GREEN HAIR DOING SOME AMAZING SPOKEN WORD – SINCE THEN SHE HAS WRITTEN 3 BOOKS – PUBLISHED BY AUTONOMEDIA & SEAL – & SHE HAS DONE SEVERAL CROSSCOUNTRY TOURS EMCEEING & PERFROMING WITH THE TRAVELLING BAD GIRL ROAD SHOW "SISTER SPIT" – MICHELLE IS FULLY LOADED FUN & CHARISMA – SHE IS SO POPULAR THAT I HAD TO MAKE 3 OR 4 DATES WITH HER BEFORE WE ACTUALLY WERE ABLE TO GET TOGETHER TO DO THIS PORTRAIT – BUT IT WAS TOTALLY WORTH IT – THIS IS PROBABLY MY MOST FAVORITE OF ALL THE PORTRAITS I HAVE DRAWN ! – SFSUNDAY@AOL.COM

ITS A GERALDINE STORY - ABOUT PEOPLE WHO CANT ADAPT TO THE WORKPLACE - SHE GREW UP IN EXTREME POVERTY & AS AN ADULT SHE TRAVELED EXTENSIVELY - SHE WAS VERY BEAUTIFUL & THIS FACILITATED HER TRAVELS IN MANY WAYS & AS SHE GOT OLDER SHE COULDNT ADAPT OUT OF THAT MODE BECUZ BEAUTY WAS HER CURRENCY & POVERTY WAS HER COMFORT LEVEL SO SHE WAS OUT OF HER REALM IN THE WORK FORCE OR IN OVER HER HEAD - I HAD BEEN DODGING HER AT THE PLANT FOR MOST OF THE TIME & THEN BEGAN WALKING HOME WITH HER & ANOTHER FRIEND - SO A FRIENDSHIP BEGAN WE WOULD CALL EACH OTHER - SHE WOULD TALK TO ME FOR ½ HR ABOUT HER BROTHERS & I'D BE SAYING LOOK I GOTTA GO - WHEN SHE FIRST GOT THE JOB SHE WAS GIVING BLOW JOBS TO A SUPERVISOR & SHE USED THAT AS THE BASIS FOR A CIVIL RIGHTS COMPLAINT - BASICALLY THE SHORT THING ABOUT GERALDINE IN THE PLANT IS THAT SHE WOULDNT BE HAPPY UNLESS SHE WAS THE CENTRE OF ATTENTION & IT DIDNT MATTER HOW THE ATTENTION HAPPENED - SHE KEPT CALLING ME ONE DAY SHE WAS REQUESTING THESE YOGURT CONTAINERS SHE HAD GIVEN ME SOME FOOD IN TO DEMONSTRATE SHE COULD NOW COOK - I HAD ALREDY GIVEN HER ENUFF TIME SO I TOLD HER I WOULD DROP THEM AT HER DOOR BUT SHE REFUSED THEM SO I PUT THEM ON THE ⭐↗

⭐ DUMPSTER - SHE STARTED SWEARING AT ME - I WAS WALKING AWAY - I STARTED CLAPPING & SAID "BRILLIANT PERFORMANCE - BRAVO!" - SHE RAN UP & SLAPPED ME ON THE SIDE OF THE HEAD & CONTINUED RUNNING LIKE A GLEEFUL LEPRECHAN SHE REALLY WANTED TO GET CHASED - I WAS SURPRIZED BY THE ATTACK - I CALLED THE COPS & WENT & MADE A STATEMENT SO THEY WENT & TALKED TO HER & SHE HASNT BOTHERED ME SINCE - NIETHER HAS SHE RETURNED TO WORK THO FOR A LITTLE WHILE SHE WAS SITTING OUTSIDE THE PLANT THEN SHE DISSAPEARED.

FLY 04/15/2K2
JACKIE IN VANCOUVER

JACKIE DIONNE- 04/15/2K2 – VANCOUVER – CANADA
I MET JACKIE IN THE LATE 80S WHEN I WAS LIVING IN VANCOUVER FOR A FEW YEARS – SHE KNEW THE GUYS WHO LIVED AT OUR NOSE WHICH WAS A STRANGE COMBINATION OF HOUSE & STOREFRONT WHERE I WAS SHACKED UP FOR A WHILE – JACKIE IS A PAINTER & SHE HAD A STUDIO DOWN THE STREET – THIS WAS A CRAZY NEIGHBORHOOD NEAR HASTINGS & MAIN – THERE WAS A JAIL ON THE NEXT BLOCK ACROSS THE STREET FROM THE WELFARE OFFICE AROUND THE CORNER FROM A SOUP KITCHEN – SOMETIMES THINGS WERE KIND OF SKETCHY – JACKIE IS ALWAYS GREAT TO TALK TO – VERY DIRECT – SHE IS QUITE PETITE & BEAUTIFUL – WORKS AT THE POST OFFICE & PAINTS ENORMOUSLY EXQUISITE PAINTINGS

WHEN I VERY FIRST STARTED IT WAS NEW YEARS DAY 1996 & MY BAND-TRIBE 8 HAD BEEN ON TOUR ALOT & SOMETIMES I WOULD COME HOME FROM TOUR WITH MONEY BUT A LOT OF TIMES I DIDNT - IT WAS REALLY HARD TO FIND A JOB - I HAD BEEN WORKING IN FACTORIES IN THE TEXTILE INDUSTRY & I HATED IT PLUS IT GAVE ME SINUS INFECTIONS - IT WAS TERRIBLE - IT WAS REALLY HARD TO GO TO SCHOOL I WENT TO CITY COLLEGE WHEN I GOT THE CHANCE BUT IT WAS IMPOSSIBLE TO HAVE A CAREER CUZ I WOULD GO ON TOUR SO MUCH - I WENT OUT TO BREAKFAST ON JAN IST NOT REALLY FEELING FRESH & HAPPY - THERE WAS THIS FOXY BABE THERE WHO TOLD ME THAT HER GIRL FRIEND DIANE DIMASSA OF HOT HEAD PAISAN FAME WAS STARTING TO TATTOO & SHE KNEW OF AN ALL DYKE

TATTOO SHOP & THEY WERE LOOKING FOR AN APRRENTICE - ITS PROBABLY THE LUCKIEST DAY OF MY LIFE THIS AMAZING MIRACLE - I MEAN I HAD TO WORK REALLY HARD TO BECOME A TATTOOIST - BUT I DONT KNOW WHAT WOULD HAVE HAPPENED - FOR YEARS I APPRENTICED AT THE SHOP & WORKED IN THE FACTORY & WENT TO SCHOOL & DID THE BAND THING & TRIED TO HAVE A NON MONOGAMOUS RELATIONSHIP - I WAS AN INSOMNIAC

I BLEW A FEW FUSES

FLY 05/07/2K2

LESLIE MAH – 05/07/2K2 – BLACK & BLUE TATTOO – IN THE MISSION – SF OFFICIALLY I MET LESLIE AT BLACK & BLUE TATTOO – FABULOUS WORLD FAMOUS ALL WOMAN TATTOO SHOP IN THE MISSION – MY KILLER BANSHEE COMRADES AND I WERE GETTING INKED BY LESLIE – I WAS GETTING ONE OF KRISS' FIGURES ON MY SOLAR PLEXUS – IT WAS VERY PAINFUL BUT LESLIE DID AN INCREDIBLE JOB! I LOVE IT! I HAD – OF COURSE – SEEN LESLIE PERFORMING BEFORE I ACTUALLY MET HER – SHE S THE HOT ROCKIN GUITAR PLAYER FOR THE BADASS HARDCORE DYKE BAND TRIBE 8 – THE KILLER BANSHEES & I WENT TO SEE THEM OPEN FOR SOUXIE & THE BANSHEES (NO RELATION) NOW <u>THAT</u> AUDIENCE HAD NO IDEA WHAT HIT EM! – WWW.TRIBE8.COM

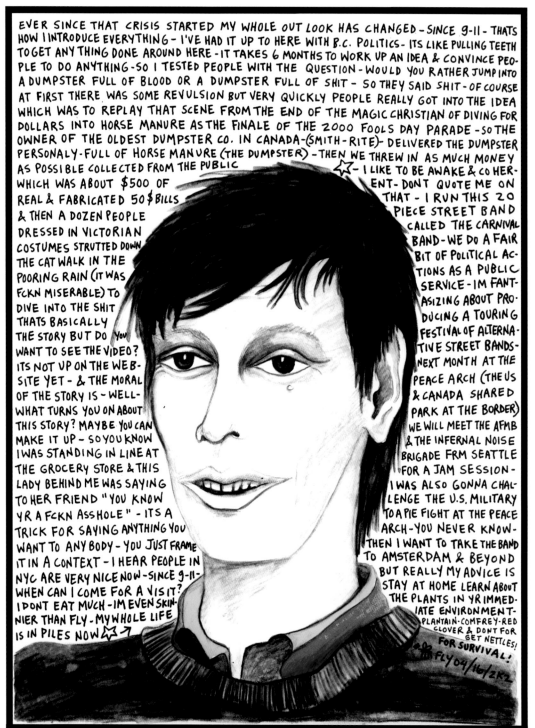

EVER SINCE THAT CRISIS STARTED MY WHOLE OUT LOOK HAS CHANGED - SINCE 9-11 - THATS HOW I INTRODUCE EVERYTHING - I'VE HAD IT UP TO HERE WITH B.C. POLITICS - ITS LIKE PULLING TEETH TO GET ANYTHING DONE AROUND HERE - IT TAKES 6 MONTHS TO WORK UP AN IDEA & CONVINCE PEOPLE TO DO ANYTHING - SO I TESTED PEOPLE WITH THE QUESTION - WOULD YOU RATHER JUMP INTO A DUMPSTER FULL OF BLOOD OR A DUMPSTER FULL OF SHIT - SO THEY SAID SHIT - OF COURSE AT FIRST THERE WAS SOME REVULSION BUT VERY QUICKLY PEOPLE REALLY GOT INTO THE IDEA WHICH WAS TO REPLAY THAT SCENE FROM THE END OF THE MAGIC CHRISTIAN OF DIVING FOR DOLLARS INTO HORSE MANURE AS THE FINALE OF THE 2000 FOOLS DAY PARADE - SO THE OWNER OF THE OLDEST DUMPSTER CO. IN CANADA - (SMITH-RITE) - DELIVERED THE DUMPSTER PERSONALY - FULL OF HORSE MANURE (THE DUMPSTER) - THEN WE THREW IN AS MUCH MONEY AS POSSIBLE COLLECTED FROM THE PUBLIC

WHICH WAS ABOUT $500 OF REAL & FABRICATED 50$ BILLS & THEN A DOZEN PEOPLE DRESSED IN VICTORIAN COSTUMES STRUTTED DOWN THE CAT WALK IN THE POORING RAIN (IT WAS FCKN MISERABLE) TO DIVE INTO THE SHIT THATS BASICALLY THE STORY BUT DO YOU WANT TO SEE THE VIDEO? ITS NOT UP ON THE WEB-SITE YET - & THE MORAL OF THE STORY IS - WELL - WHAT TURNS YOU ON ABOUT THIS STORY? MAYBE YOU CAN MAKE IT UP - SO YOU KNOW I WAS STANDING IN LINE AT THE GROCERY STORE & THIS LADY BEHIND ME WAS SAYING TO HER FRIEND "YOU KNOW YR A FCKN ASSHOLE" - ITS A TRICK FOR SAYING ANYTHING YOU WANT TO ANYBODY - YOU JUST FRAME IT IN A CONTEXT - I HEAR PEOPLE IN NYC ARE VERY NICE NOW - SINCE 9-11 - WHEN CAN I COME FOR A VISIT? I DONT EAT MUCH - IM EVEN SKIN-NIER THAN FLY - MY WHOLE LIFE IS IN PILES NOW →

☆ - I LIKE TO BE AWAKE & CO HER-ENT - DONT QUOTE ME ON THAT - I RUN THIS 20 PIECE STREET BAND CALLED THE CARNIVAL BAND - WE DO A FAIR BIT OF POLITICAL AC-TIONS AS A PUBLIC SERVICE - IM FANT-ASIZING ABOUT PRO-DUCING A TOURING FESTIVAL OF ALTERNA-TIVE STREET BANDS - NEXT MONTH AT THE PEACE ARCH (THE US & CANADA SHARED PARK AT THE BORDER) WE WILL MEET THE AFMB & THE INFERNAL NOISE BRIGADE FRM SEATTLE FOR A JAM SESSION - I WAS ALSO GONNA CHAL-LENGE THE U.S. MILITARY TO A PIE FIGHT AT THE PEACE ARCH - YOU NEVER KNOW - THEN I WANT TO TAKE THE BAND TO AMSTERDAM & BEYOND BUT REALLY MY ADVICE IS STAY AT HOME LEARN ABOUT THE PLANTS IN YR IMMED-IATE ENVIRONMENT - PLANTAIN · COMFREY · RED CLOVER & DONT FOR GET NETTLES! FOR SURVIVAL! FLY 04/16/2K2

DAN VIE – 04/16/2K2 – VANCOUVER

I MET DAN ON MY 2ND DAY IN VANCOUVER (1986?) – I DIDNT REALLY KNOW ANYONE & I WAS JUST WALKING AROUND & I SAW THESE INTERESTING STOREFRONTS SO I THOUGHT I WOULD JUST KNOCK ON THE DOOR & SEE WHAT HAPPENED – THE DOOR OPENED & DAN MOTIONED ME IN WITH A FLOURISH – THE SPACE WAS FULL OF PEOPLE & IT WAS LIKE THE END OF A REHEARS-AL FOR A CLOWN BAND – DAN & HIS PAL GLEN WERE GOING OUT TO GET FALAFEL SO I WENT ALONG WITH THEM – IN THE MIDDLE OF EATING THEY BOTH SUDDENLY REALIZED THAT NEITHER OF THEM KNEW ME & I DIDNT KNOW ANYONE & NO ONE KNEW ME & WHY DID I KNOCK ON THEIR DOOR? – IT WAS THE BEGINNING OF A GREAT FRIENDSHIP – WWW.FOOLS-SOCIETY.COM

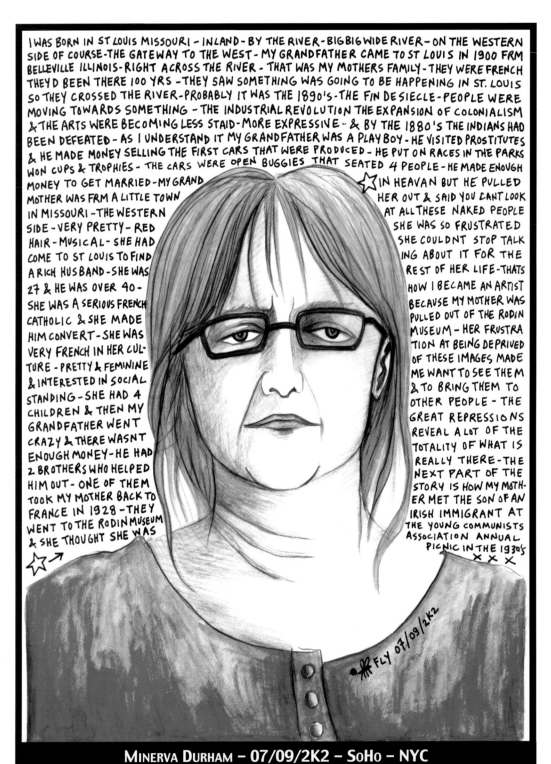

I WAS BORN IN ST LOUIS MISSOURI - INLAND - BY THE RIVER - BIG BIG WIDE RIVER - ON THE WESTERN SIDE OF COURSE - THE GATEWAY TO THE WEST - MY GRANDFATHER CAME TO ST LOUIS IN 1900 FRM BELLEVILLE ILLINOIS - RIGHT ACROSS THE RIVER - THAT WAS MY MOTHERS FAMILY - THEY WERE FRENCH THEY'D BEEN THERE 100 YRS - THEY SAW SOMETHING WAS GOING TO BE HAPPENING IN ST. LOUIS SO THEY CROSSED THE RIVER - PROBABLY IT WAS THE 1890'S - THE FIN DE SIECLE - PEOPLE WERE MOVING TOWARDS SOMETHING - THE INDUSTRIAL REVOLUTION THE EXPANSION OF COLONIALISM & THE ARTS WERE BECOMING LESS STAID - MORE EXPRESSIVE - & BY THE 1880'S THE INDIANS HAD BEEN DEFEATED - AS I UNDERSTAND IT MY GRANDFATHER WAS A PLAY BOY - HE VISITED PROSTITUTES & HE MADE MONEY SELLING THE FIRST CARS THAT WERE PRODUCED - HE PUT ON RACES IN THE PARKS WON CUPS & TROPHIES - THE CARS WERE OPEN BUGGIES THAT SEATED 4 PEOPLE - HE MADE ENOUGH MONEY TO GET MARRIED - MY GRAND MOTHER WAS FRM A LITTLE TOWN IN MISSOURI - THE WESTERN SIDE - VERY PRETTY - RED HAIR - MUSICAL - SHE HAD COME TO ST LOUIS TO FIND A RICH HUSBAND - SHE WAS 27 & HE WAS OVER 40 - SHE WAS A SERIOUS FRENCH CATHOLIC & SHE MADE HIM CONVERT - SHE WAS VERY FRENCH IN HER CUL- TURE - PRETTY & FEMININE & INTERESTED IN SOCIAL STANDING - SHE HAD 4 CHILDREN & THEN MY GRANDFATHER WENT CRAZY & THERE WASNT ENOUGH MONEY - HE HAD 2 BROTHERS WHO HELPED HIM OUT - ONE OF THEM TOOK MY MOTHER BACK TO FRANCE IN 1928 - THEY WENT TO THE RODIN MUSEUM & SHE THOUGHT SHE WAS

☆→

IN HEAVAN BUT HE PULLED HER OUT & SAID YOU CANT LOOK AT ALL THESE NAKED PEOPLE SHE WAS SO FRUSTRATED SHE COULDNT STOP TALK ING ABOUT IT FOR THE REST OF HER LIFE - THATS HOW I BECAME AN ARTIST BECAUSE MY MOTHER WAS PULLED OUT OF THE RODIN MUSEUM - HER FRUSTRA TION AT BEING DEPRIVED OF THESE IMAGES MADE ME WANT TO SEE THEM & TO BRING THEM TO OTHER PEOPLE - THE GREAT REPRESSIONS REVEAL A LOT OF THE TOTALITY OF WHAT IS REALLY THERE - THE NEXT PART OF THE STORY IS HOW MY MOTH- ER MET THE SON OF AN IRISH IMMIGRANT AT THE YOUNG COMMUNISTS ASSOCIATION ANNUAL PICNIC IN THE 1930'S
× × ×

FLY 07/09/2K2

MINERVA DURHAM - 07/09/2K2 - SoHo - NYC
I MET MINERVA IN 92 WHEN I STARTED MODELING AT SPRING STUDIO WHICH IS A DRAWING STUDIO IN SoHo THAT IS OPEN EVERY DAY FOR MORNING AFTERNOON & EVENING DRAWING SESSIONS — MINERVA USED TO TEACH ANATOMY AND FIGURE DRAWING AT PARSONS SCHOOL OF DESIGN & SHE STILL TEACHES AT SPRING STUDIO — SHE HAS REGULAR ANATOMY SESSIONS SEVERAL TIMES A WEEK — MINERVA IS AWESOME — SHE REALLY KNOWS HER STUFF — BESIDES THAT SHE IS GENUINELY ENTHUSIATIC ABOUT DRAW— ING & ABOUT PEOPLE LEARNING TO DRAW — ITS LIKE HER LIFE BLOOD — MINERVA IS ONE OF MY HERO(INE)S & SHE S ALSO A BIT LIKE A MOM TO ME — SPRINGSTUDIOSOHO.COM

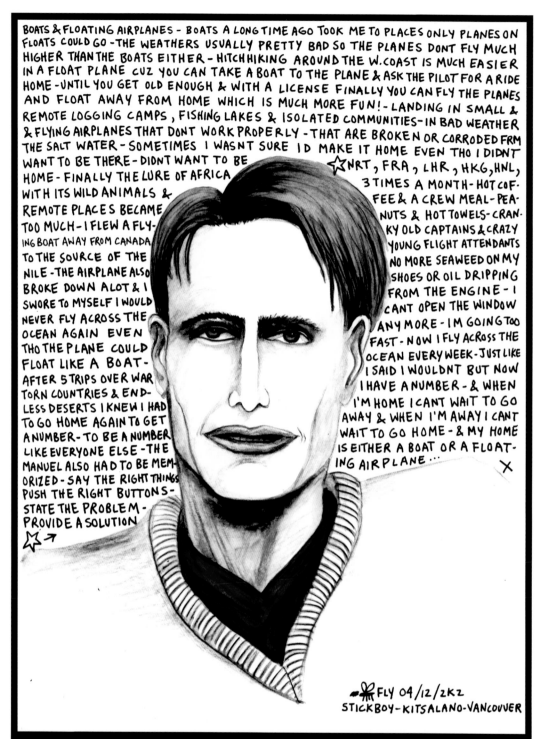

BOATS & FLOATING AIRPLANES - BOATS A LONG TIME AGO TOOK ME TO PLACES ONLY PLANES ON FLOATS COULD GO - THE WEATHERS USUALLY PRETTY BAD SO THE PLANES DONT FLY MUCH HIGHER THAN THE BOATS EITHER - HITCHHIKING AROUND THE W. COAST IS MUCH EASIER IN A FLOAT PLANE CUZ YOU CAN TAKE A BOAT TO THE PLANE & ASK THE PILOT FOR A RIDE HOME - UNTIL YOU GET OLD ENOUGH & WITH A LICENSE FINALLY YOU CAN FLY THE PLANES AND FLOAT AWAY FROM HOME WHICH IS MUCH MORE FUN! - LANDING IN SMALL & REMOTE LOGGING CAMPS, FISHING LAKES & ISOLATED COMMUNITIES - IN BAD WEATHER & FLYING AIRPLANES THAT DONT WORK PROPERLY - THAT ARE BROKEN OR CORRODED FRM THE SALT WATER - SOMETIMES I WASNT SURE ID MAKE IT HOME EVEN THO I DIDNT WANT TO BE THERE - DIDNT WANT TO BE HOME - FINALLY THE LURE OF AFRICA WITH ITS WILD ANIMALS & REMOTE PLACES BECAME TOO MUCH - I FLEW A FLYING BOAT AWAY FROM CANADA TO THE SOURCE OF THE NILE - THE AIRPLANE ALSO BROKE DOWN ALOT & I SWORE TO MYSELF I WOULD NEVER FLY ACROSS THE OCEAN AGAIN EVEN THO THE PLANE COULD FLOAT LIKE A BOAT - AFTER 5 TRIPS OVER WAR TORN COUNTRIES & ENDLESS DESERTS I KNEW I HAD TO GO HOME AGAIN TO GET A NUMBER - TO BE A NUMBER LIKE EVERYONE ELSE - THE MANUEL ALSO HAD TO BE MEMORIZED - SAY THE RIGHT THINGS PUSH THE RIGHT BUTTONS - STATE THE PROBLEM - PROVIDE A SOLUTION

☆→

☆ NRT, FRA, LHR, HKG, HNL, 3 TIMES A MONTH - HOT COFFEE & A CREW MEAL - PEANUTS & HOT TOWELS - CRANKY OLD CAPTAINS & CRAZY YOUNG FLIGHT ATTENDANTS NO MORE SEAWEED ON MY SHOES OR OIL DRIPPING FROM THE ENGINE - I CANT OPEN THE WINDOW ANY MORE - IM GOING TOO FAST - NOW I FLY ACROSS THE OCEAN EVERY WEEK - JUST LIKE I SAID I WOULDNT BUT NOW I HAVE A NUMBER - & WHEN I'M HOME I CANT WAIT TO GO AWAY & WHEN I'M AWAY I CANT WAIT TO GO HOME - & MY HOME IS EITHER A BOAT OR A FLOATING AIRPLANE ...

X

🦟 FLY 04/12/2K2
STICKBOY - KITSALANO - VANCOUVER

STICK BOY AKA OLIVER – 04/12/2K2 – KITSILANO – VANCOUVER
I MET OLIVER IN 1988 IN VANCOUVER WHEN HE CAME BACK FROM A FEW YEARS WORKING IN AFRICA AS A BUSH PILOT – HE HAD GROWN UP WITH THE GUYS AT OUR NOSE STUDIO WHERE I HAD BEEN STAYING & THEY WOULD HAVE ALL NIGHT JAM SESSIONS TRADING INSTRUMENTS & MAKING UP SONGS – OLLIE TOLD ME AMAZING STORIES & SHOWED ME PICTURES HE HAD TAKEN FROM A DIRT BIKE AS HE WAS RIDING ALONG IN THE MIDDLE OF AN ELEPHANT STAMPEDE – IF HE DOESNT FLY FOR A FEW DAYS STICK BOY STARTS TO GET A LITTLE TENSE – THESE DAYS HE FLIES FOR AIR CANADA – HE HAS A HOUSE IN KITSILANO (WHERE I GET TO CRASH!) & A BEAUTIFUL LITTLE DAUGHTER

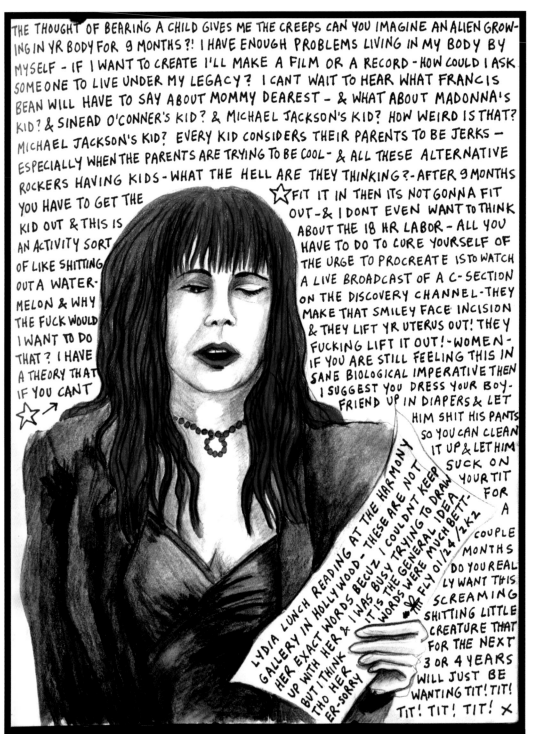

LYDIA LUNCH – 01/24/2K2 – AT THE HARMONY GALLERY – HOLLYWOOD – LA
I DREW THIS WHILE LYDIA LUNCH WAS DOING A SPOKEN WORD PERFORMANCE IN THIS LITTLE GALLERY IN HOLLYWOOD – MICHELLE TEA HAD TOLD ME ABOUT IT CUZ SHE WAS PERFORMING TOO – OF COURSE I GOT THERE LATE & THE PLACE WAS SO PACKED I COULD HARDLY GET IN THE DOOR – THERE WAS NOWHERE TO STOP SO I JUST KEPT GOING FURTHER & FURTHER IN UNTIL I WAS RIGHT UP AT THE FRONT & THERE WAS AN EMPTY SEAT FRONT ROW CENTER – AMAZING – I'VE ALWAYS HAD A LOT OF RESPECT FOR LYDIA LUNCH – HER MUSIC & FILMS & WORDS HAVE INCREDIBLE IMPACT – & I WAS TRYING TO KEEP UP WITH HER BUT I KNOW I GOT IT ALL WRONG – SHE'S MUCH BETTER IN PERSON

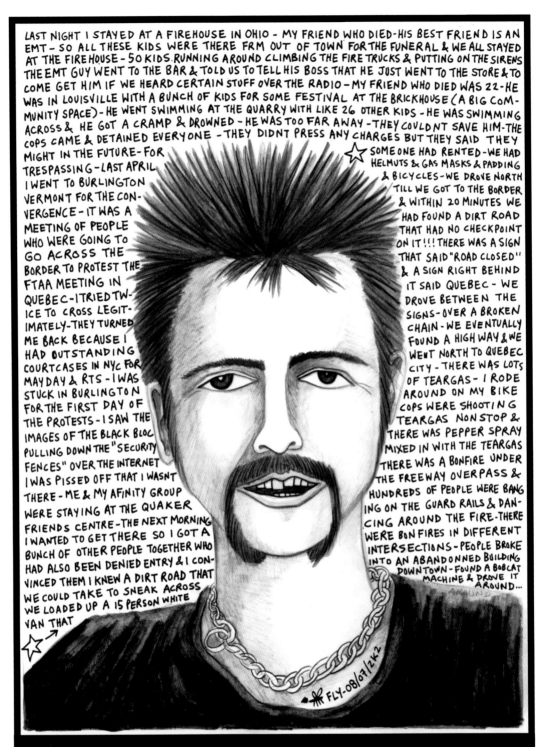

LAST NIGHT I STAYED AT A FIREHOUSE IN OHIO - MY FRIEND WHO DIED-HIS BEST FRIEND IS AN EMT - SO ALL THESE KIDS WERE THERE FRM OUT OF TOWN FOR THE FUNERAL & WE ALL STAYED AT THE FIREHOUSE - 50 KIDS RUNNING AROUND CLIMBING THE FIRE TRUCKS & PUTTING ON THE SIRENS THE EMT GUY WENT TO THE BAR & TOLD US TO TELL HIS BOSS THAT HE JUST WENT TO THE STORE & TO COME GET HIM IF WE HEARD CERTAIN STUFF OVER THE RADIO - MY FRIEND WHO DIED WAS 22-HE WAS IN LOUISVILLE WITH A BUNCH OF KIDS FOR SOME FESTIVAL AT THE BRICKHOUSE (A BIG COMMUNITY SPACE) - HE WENT SWIMMING AT THE QUARRY WITH LIKE 26 OTHER KIDS - HE WAS SWIMMING ACROSS & HE GOT A CRAMP & DROWNED - HE WAS TOO FAR AWAY - THEY COULDNT SAVE HIM-THE COPS CAME & DETAINED EVERYONE - THEY DIDNT PRESS ANY CHARGES BUT THEY SAID THEY MIGHT IN THE FUTURE-FOR TRESPASSING - LAST APRIL I WENT TO BURLINGTON VERMONT FOR THE CONVERGENCE - IT WAS A MEETING OF PEOPLE WHO WERE GOING TO GO ACROSS THE BORDER TO PROTEST THE FTAA MEETING IN QUEBEC - I TRIED TWICE TO CROSS LEGITIMATELY - THEY TURNED ME BACK BECAUSE I HAD OUTSTANDING COURTCASES IN NYC FOR MAYDAY & RTS - I WAS STUCK IN BURLINGTON FOR THE FIRST DAY OF THE PROTESTS - I SAW THE IMAGES OF THE BLACK BLOC PULLING DOWN THE "SECURITY FENCES" OVER THE INTERNET I WAS PISSED OFF THAT I WASNT THERE - ME & MY AFINITY GROUP WERE STAYING AT THE QUAKER FRIENDS CENTRE - THE NEXT MORNING I WANTED TO GET THERE SO I GOT A BUNCH OF OTHER PEOPLE TOGETHER WHO HAD ALSO BEEN DENIED ENTRY & I CONVINCED THEM I KNEW A DIRT ROAD THAT WE COULD TAKE TO SNEAK ACROSS WE LOADED UP A 15 PERSON WHITE VAN THAT

SOMEONE HAD RENTED-WE HAD HELMUTS & GAS MASKS & PADDING & BICYCLES-WE DROVE NORTH TILL WE GOT TO THE BORDER & WITHIN 20 MINUTES WE HAD FOUND A DIRT ROAD THAT HAD NO CHECKPOINT ON IT!!! THERE WAS A SIGN THAT SAID "ROAD CLOSED" & A SIGN RIGHT BEHIND IT SAID QUEBEC - WE DROVE BETWEEN THE SIGNS-OVER A BROKEN CHAIN - WE EVENTUALLY FOUND A HIGHWAY & WE WENT NORTH TO QUEBEC CITY - THERE WAS LOTS OF TEARGAS - I RODE AROUND ON MY BIKE COPS WERE SHOOTING TEARGAS NON STOP & THERE WAS PEPPER SPRAY MIXED IN WITH THE TEARGAS THERE WAS A BONFIRE UNDER THE FREEWAY OVERPASS & HUNDREDS OF PEOPLE WERE BANGING ON THE GUARD RAILS & DANCING AROUND THE FIRE-THERE WERE BONFIRES IN DIFFERENT INTERSECTIONS-PEOPLE BROKE INTO AN ABANDONNED BUILDING DOWNTOWN-FOUND A BOBCAT MACHINE & DROVE IT AROUND...

FLY-08/07/2K2

DEADBOLT – 08/07/2K2 – AT MAY DAY BOOKS – NYC
I MET DEADBOLT WHEN HE FIRST STARTED SHOWING UP AT ABC NO RIO SOMETIME IN THE LATE 90S – HERE WAS A PUNK ROCK KID WHO TRULY WANTED TO FUCK WITH THE SYSTEM – HE GOT INVOLVED DOING FOOD NOT BOMBS & CRITICAL MASS & MAY DAY BOOKS (OUR LOCAL INFOSHOP) & DUMPSTER DIVING & SQUATTING & HE ALWAYS SEEMS TO BE AROUND WHEN ANY KIND OF SHIT IS GOING DOWN – HE GOT ARRESTED AT A MAY DAY DEMO Y2K IN UNION SQUARE WHEN HE TIED A BANDANA OVER HIS FACE – THE POLICE WERE ARRESTING ANYONE WHO WAS COVERING THEIR FACES – DEADBOLT IS ALWAYS OPENING NEW SQUATS & ATTEMPTING TO INSTIGATE THE LIBERATION OF SPACE & MINDS

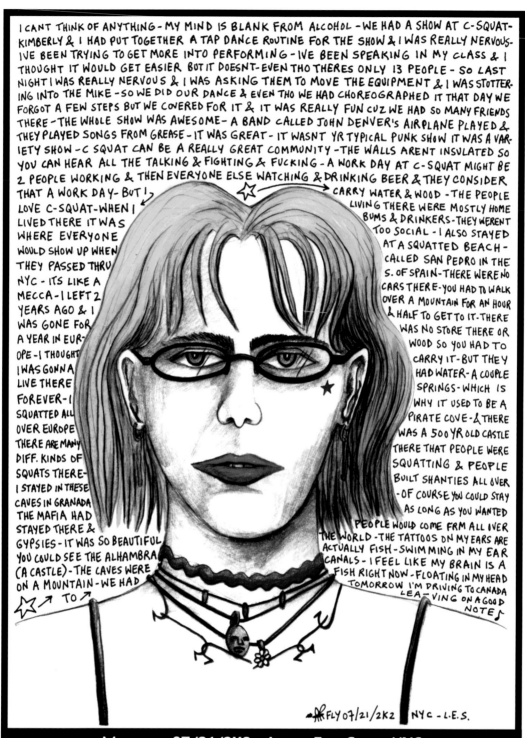

I CANT THINK OF ANYTHING - MY MIND IS BLANK FROM ALCOHOL - WE HAD A SHOW AT C-SQUAT - KIMBERLY & I HAD PUT TOGETHER A TAP DANCE ROUTINE FOR THE SHOW & I WAS REALLY NERVOUS - IVE BEEN TRYING TO GET MORE INTO PERFORMING - IVE BEEN SPEAKING IN MY CLASS & I THOUGHT IT WOULD GET EASIER BUT IT DOESNT - EVEN THO THERES ONLY 13 PEOPLE - SO LAST NIGHT I WAS REALLY NERVOUS & I WAS ASKING THEM TO MOVE THE EQUIPMENT & I WAS STOTTER- ING INTO THE MIKE - SO WE DID OUR DANCE & EVEN THO WE HAD CHOREOGRAPHED IT THAT DAY WE FORGOT A FEW STEPS BUT WE COVERED FOR IT & IT WAS REALLY FUN CUZ WE HAD SO MANY FRIENDS THERE - THE WHOLE SHOW WAS AWESOME - A BAND CALLED JOHN DENVER'S AIRPLANE PLAYED & THEY PLAYED SONGS FROM GREASE - IT WAS GREAT - IT WASNT YR TYPICAL PUNK SHOW IT WAS A VAR- IETY SHOW - C SQUAT CAN BE A REALLY GREAT COMMUNITY - THE WALLS ARENT INSULATED SO YOU CAN HEAR ALL THE TALKING & FIGHTING & FUCKING - A WORK DAY AT C-SQUAT MIGHT BE 2 PEOPLE WORKING & THEN EVERYONE ELSE WATCHING & DRINKING BEER & THEY CONSIDER THAT A WORK DAY - BUT I LOVE C-SQUAT - WHEN I LIVED THERE IT WAS WHERE EVERYONE WOULD SHOW UP WHEN THEY PASSED THRU NYC - ITS LIKE A MECCA - I LEFT 2 YEARS AGO & I WAS GONE FOR A YEAR IN EUR- OPE - I THOUGHT I WAS GONNA LIVE THERE FOREVER - I SQUATTED ALL OVER EUROPE THERE ARE MANY DIFF. KINDS OF SQUATS THERE - I STAYED IN THESE CAVES IN GRANADA THE MAFIA HAD STAYED THERE & GYPSIES - IT WAS SO BEAUTIFUL YOU COULD SEE THE ALHAMBRA (A CASTLE) - THE CAVES WERE ON A MOUNTAIN - WE HAD TO CARRY WATER & WOOD - THE PEOPLE LIVING THERE WERE MOSTLY HOME BUMS & DRINKERS - THEY WERENT TOO SOCIAL - I ALSO STAYED AT A SQUATTED BEACH - CALLED SAN PEDRO IN THE S. OF SPAIN - THERE WERE NO CARS THERE - YOU HAD TO WALK OVER A MOUNTAIN FOR AN HOUR & HALF TO GET TO IT - THERE WAS NO STORE THERE OR WOOD SO YOU HAD TO CARRY IT - BUT THEY HAD WATER - A COUPLE SPRINGS - WHICH IS WHY IT USED TO BE A PIRATE COVE - & THERE WAS A 500 YR OLD CASTLE THERE THAT PEOPLE WERE SQUATTING & PEOPLE BUILT SHANTIES ALL OVER - OF COURSE YOU COULD STAY AS LONG AS YOU WANTED PEOPLE WOULD COME FRM ALL OVER THE WORLD - THE TATTOOS ON MY EARS ARE ACTUALLY FISH - SWIMMING IN MY EAR CANALS - I FEEL LIKE MY BRAIN IS A FISH RIGHT NOW - FLOATING IN MY HEAD TOMORROW I'M DRIVING TO CANADA LEA-VING ON A GOOD NOTE♪

FLY 07/21/2K2 NYC - L.E.S.

MARTINE – 07/21/2K2 – LOWER EAST SIDE – NYC

I MET MARTINE IN THE MID 90S WHEN SHE SHOWED UP IN THE LOWER EAST SIDE JUST IN TIME TO GO ON DOG BOYS BIG CARNIVAL OF CHAOS – (THE TRAVELING PUNKROCK SQUATTER ANARCHIST FIRE–SPEWING DUMPSTER–DIVING FREAKSHOW) – THEN SHE WAS LIVING AT C SQUAT FOR A WHILE – SHE WOULD WRITE AMAZING STORIES & WHENEVER I VE SEEN HER PER– FORM IT HAS BEEN HYPNOTIZING – I SAW HER DO A FIRE DANCE PERFORMANCE ONCE AT BULLET SPACE & IT WAS INCREDIBLE – NO ONE COULD TAKE THEIR EYES OFF HER – SHE HAS THIS QUALITY OF A PERSON WHO COULD BE DANGEROUS & MAYBE ITS BECAUSE SHE S NOT AFRAID TO EXPERIENCE LIFE FULLY & MANY PEOPLE FIND THAT THREATENING
MARTINEBLUE@CANADA.COM

HOW I CAME TO E. 7TH ST. IS I CAME FRM 13TH ST. - I CAME TO E 13TH ST. AFTER I HAD LEFT NYC FOR A YEAR - BEFORE I LEFT NY I HAD BEEN MOVING AROUND CONSTANTLY - AS AN ARTIST I COULDNT AFFORD TO ALWAYS HAVE A STABLE PLACE TO LIVE - I GREW UP IN PHILADELPHIA BUT AFTER THE MOVE BOMBING - IN 1985 - I MOVED TO NYC - I WAS 10 BLOCKS FROM THE BOMBING - I SAW THE WHOLE THING - I'LL NEVER FORGET THAT DAY - I DECIDED PHILA-DELPHIA DIDN'T HAVE MUCH TO OFFER ME AFTER THAT - THERE WAS A CLOUD OVER THE CITY IT SEEMED TO DRAW THE LINES OF WHO WAS WHO - THE CITY WAS BECOMING NARROWER - AS A CREATIVE PERSON I WASNT FINDING MUCH OF A COMMUNITY SO I CAME TO NYC & SLEPT IN THE TRAIN STN. FOR A WEEK OR SO - I LIVED IN NYC FOR ABOUT A YR WORKING ODD JOBS & DOING PORTRAITS ON THE STREET - THEN ME & MY LOVER HOPPED TRAINS OUT TO S.F. WHERE I DROVE A FORKLIFT FOR A PRODUCE DISTRIBUTOR - A YEAR LATER I CAME BACK TO NYC - MY GIRLFRIEND WAS LIVING IN A BUILDING ON 11TH ST RUN BY A SLUMLORD IT WAS REALLY DILAPIDATED - THERE WAS SOME SPACE AVAILABLE THERE & THIS GUY SNOOKY

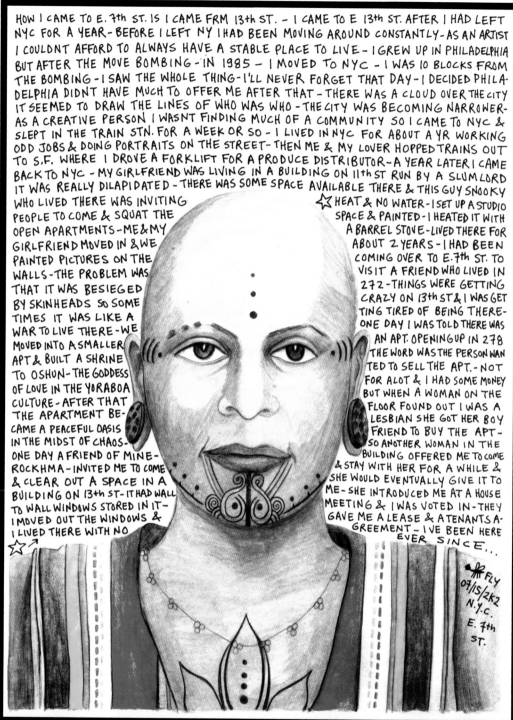

WHO LIVED THERE WAS INVITING PEOPLE TO COME & SQUAT THE OPEN APARTMENTS - ME & MY GIRLFRIEND MOVED IN & WE PAINTED PICTURES ON THE WALLS - THE PROBLEM WAS THAT IT WAS BESIEGED BY SKINHEADS SO SOME TIMES IT WAS LIKE A WAR TO LIVE THERE - WE MOVED INTO A SMALLER APT & BUILT A SHRINE TO OSHUN - THE GODDESS OF LOVE IN THE YORABOA CULTURE - AFTER THAT THE APARTMENT BE- CAME A PEACEFUL OASIS IN THE MIDST OF CHAOS - ONE DAY A FRIEND OF MINE - ROCKHMA - INVITED ME TO COME & CLEAR OUT A SPACE IN A BUILDING ON 13TH ST - IT HAD WALL TO WALL WINDOWS STORED IN IT - I MOVED OUT THE WINDOWS & I LIVED THERE WITH NO

☆ HEAT & NO WATER - I SET UP A STUDIO SPACE & PAINTED - I HEATED IT WITH A BARREL STOVE - LIVED THERE FOR ABOUT 2 YEARS - I HAD BEEN COMING OVER TO E.7TH ST. TO VISIT A FRIEND WHO LIVED IN 272 - THINGS WERE GETTING CRAZY ON 13TH ST & I WAS GET- TING TIRED OF BEING THERE - ONE DAY I WAS TOLD THERE WAS AN APT. OPENING UP IN 278 THE WORD WAS THE PERSON WAN- TED TO SELL THE APT. - NOT FOR A LOT & I HAD SOME MONEY BUT WHEN A WOMAN ON THE FLOOR FOUND OUT I WAS A LESBIAN SHE GOT HER BOY FRIEND TO BUY THE APT - SO ANOTHER WOMAN IN THE BUILDING OFFERED ME TO COME & STAY WITH HER FOR A WHILE & SHE WOULD EVENTUALLY GIVE IT TO ME - SHE INTRODUCED ME AT A HOUSE MEETING & I WAS VOTED IN - THEY GAVE ME A LEASE & A TENANTS A- GREEMENT - IVE BEEN HERE EVER SINCE...

FLY 07/15/2K2 N.Y.C. E. 7th ST.

ZENZELE BROWN – 07/15/2K2 – E. 7TH ST. – NYC

I HAD A GREAT TIME DRAWING ZENZELE BECAUSE SHE IS ALREADY A PIECE OF ART HERSELF – I MET HER JUST BY LIVING DOWN THE STREET & ALWAYS SEEING HER ON MY BLOCK & AT VARIOUS LOISAIDA EVENTS – I WENT TO HER STUDIO TO DRAW THIS PORTRAIT & I GOT TO SEE ALOT OF HER BEAUTIFUL PAINTINGS THAT ARE QUITE LARGE & VERY RICH SENSUAL & COLORFUL – SHE TOLD ME LOTS OF STORIES ABOUT BEING A STREET ARTIST – DRAWING PORTRAITS & HAVING TO COMPETE WITH ALL THE OTHER PORTRAIT ARTISTS & SELLING HER PAINTINGS OR PRINTS OF HER PAINTINGS – THIS IS HOW SHE HAS SURVIVED FOR YEARS ALTHOUGH NOW SHE IS ALSO TEACHING – ZENZELEBROWNE@AOL.COM

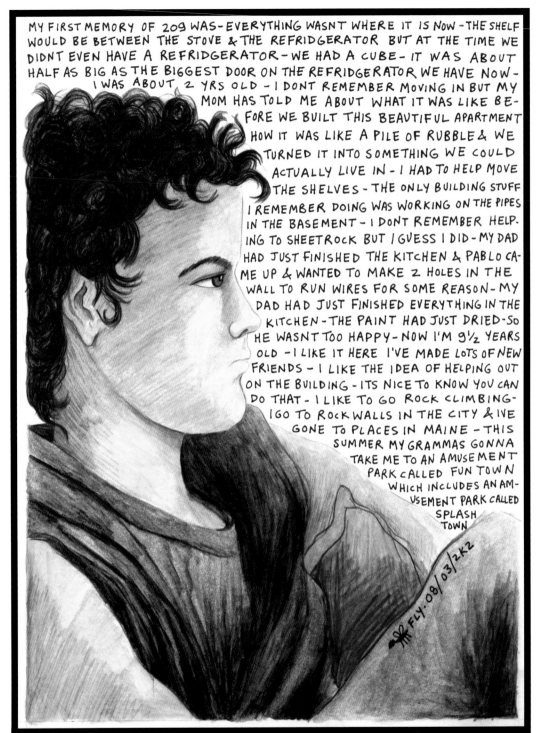

MY FIRST MEMORY OF 209 WAS - EVERYTHING WASNT WHERE IT IS NOW - THE SHELF WOULD BE BETWEEN THE STOVE & THE REFRIDGERATOR BUT AT THE TIME WE DIDNT EVEN HAVE A REFRIDGERATOR - WE HAD A CUBE - IT WAS ABOUT HALF AS BIG AS THE BIGGEST DOOR ON THE REFRIDGERATOR WE HAVE NOW - I WAS ABOUT 2 YRS OLD - I DONT REMEMBER MOVING IN BUT MY MOM HAS TOLD ME ABOUT WHAT IT WAS LIKE BEFORE WE BUILT THIS BEAUTIFUL APARTMENT HOW IT WAS LIKE A PILE OF RUBBLE & WE TURNED IT INTO SOMETHING WE COULD ACTUALLY LIVE IN - I HAD TO HELP MOVE THE SHELVES - THE ONLY BUILDING STUFF I REMEMBER DOING WAS WORKING ON THE PIPES IN THE BASEMENT - I DONT REMEMBER HELPING TO SHEETROCK BUT I GUESS I DID - MY DAD HAD JUST FINISHED THE KITCHEN & PABLO CAME UP & WANTED TO MAKE 2 HOLES IN THE WALL TO RUN WIRES FOR SOME REASON - MY DAD HAD JUST FINISHED EVERYTHING IN THE KITCHEN - THE PAINT HAD JUST DRIED - SO HE WASNT TOO HAPPY - NOW I'M 9½ YEARS OLD - I LIKE IT HERE I'VE MADE LOTS OF NEW FRIENDS - I LIKE THE IDEA OF HELPING OUT ON THE BUILDING - ITS NICE TO KNOW YOU CAN DO THAT - I LIKE TO GO ROCK CLIMBING - I GO TO ROCK WALLS IN THE CITY & IVE GONE TO PLACES IN MAINE - THIS SUMMER MY GRAMMAS GONNA TAKE ME TO AN AMUSEMENT PARK CALLED FUN TOWN WHICH INCLUDES AN AMUSEMENT PARK CALLED SPLASH TOWN

FLY · 08/03/2K2

AIDAN FLORES-HALL – 08/03/2K2 – LOWER EAST SIDE – NYC
WHEN I FIRST MET AIDAN HE MUST HAVE BEEN ABOUT 2 YEARS OLD & ALREADY HE WAS A TOUGH LITTLE GUY WITH STRONG OPINIONS – I REMEMBER HIM BEING MAYBE 4 YEARS OLD & TELLING SOMEONE – I CANT REMEMBER WHO – THAT THEY COULDNT COME INTO THE BUILDING BECAUSE HE DIDN'T KNOW THEM – AIDAN HATES WAITING FOR PEOPLE – THIS IS SOMETHING I CAN RELATE TO – I WAS TRYING TO HELP HIM WAIT ONE DAY BY SUGGESTING ALL THE THINGS HE COULD DO WHILE HE WAS WAITING BUT HE HAD ARGUMENTS AGAINST ALL OF MY IDEAS – I DREW THIS WHILE HE WAS WATCHING THE DEXTERS LABORATORY MOVIE SO HE WAS ABLE TO STAY STILL – & QUIET

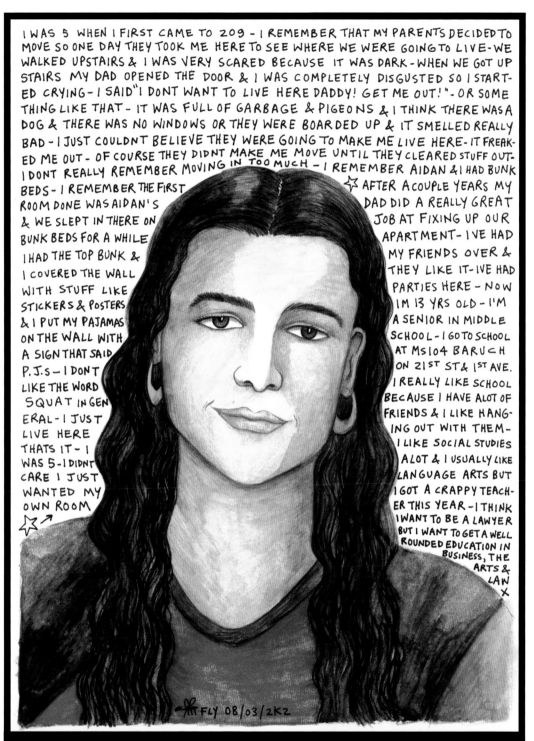

I WAS 5 WHEN I FIRST CAME TO 209 - I REMEMBER THAT MY PARENTS DECIDED TO MOVE SO ONE DAY THEY TOOK ME HERE TO SEE WHERE WE WERE GOING TO LIVE - WE WALKED UPSTAIRS & I WAS VERY SCARED BECAUSE IT WAS DARK - WHEN WE GOT UP STAIRS MY DAD OPENED THE DOOR & I WAS COMPLETELY DISGUSTED SO I STARTED CRYING - I SAID "I DONT WANT TO LIVE HERE DADDY! GET ME OUT!" - OR SOMETHING LIKE THAT - IT WAS FULL OF GARBAGE & PIGEONS & I THINK THERE WAS A DOG & THERE WAS NO WINDOWS OR THEY WERE BOARDED UP & IT SMELLED REALLY BAD - I JUST COULDNT BELIEVE THEY WERE GOING TO MAKE ME LIVE HERE - IT FREAKED ME OUT - OF COURSE THEY DIDNT MAKE ME MOVE UNTIL THEY CLEARED STUFF OUT - I DONT REALLY REMEMBER MOVING IN TOO MUCH - I REMEMBER AIDAN & I HAD BUNK BEDS - I REMEMBER THE FIRST ROOM DONE WAS AIDAN'S & WE SLEPT IN THERE ON BUNK BEDS FOR A WHILE I HAD THE TOP BUNK & I COVERED THE WALL WITH STUFF LIKE STICKERS & POSTERS & I PUT MY PAJAMAS ON THE WALL WITH A SIGN THAT SAID P.J.s - I DONT LIKE THE WORD SQUAT IN GENERAL - I JUST LIVE HERE THATS IT - I WAS 5 - I DIDNT CARE I JUST WANTED MY OWN ROOM

AFTER A COUPLE YEARS MY DAD DID A REALLY GREAT JOB AT FIXING UP OUR APARTMENT - I'VE HAD MY FRIENDS OVER & THEY LIKE IT - I'VE HAD PARTIES HERE - NOW IM 13 YRS OLD - I'M A SENIOR IN MIDDLE SCHOOL - I GO TO SCHOOL AT MS 104 BARUCH ON 21ST ST & 1ST AVE. I REALLY LIKE SCHOOL BECAUSE I HAVE ALOT OF FRIENDS & I LIKE HANGING OUT WITH THEM - I LIKE SOCIAL STUDIES ALOT & I USUALLY LIKE LANGUAGE ARTS BUT I GOT A CRAPPY TEACHER THIS YEAR - I THINK I WANT TO BE A LAWYER BUT I WANT TO GET A WELL ROUNDED EDUCATION IN BUSINESS, THE ARTS & LAW X

FLY 08/03/2K2

ARIEL FLORES-HALL – 08/03/2K2 – LOWER EAST SIDE – NYC
I GUESS I MET ARIEL WHEN SHE WAS ABOUT 5 SO I'VE BASICALLY SEEN HER GO FROM A VERY CUTE LITTLE GIRL TO A BEAUTIFUL YOUNG LADY – I'VE BEEN TO A FEW OF HER BIRTHDAY PARTIES & THEY WERE USUALLY BIG SHINDIGS WITH LOTS OF KIDS GOING NUTS OVERDOSING ON SUGAR & PLAYING GAMES & DANCING TO THE SOUNDTRACK OF GREASE (THAT WAS A LONG TIME AGO – SORRY ARIEL) – I DON T THINK SHE HAS THOSE KIND OF PARTIES ANYMORE – NOW SHE IS ALL GROWN UP & SOPHISTICATED & LAST TIME I PASSED HER IN THE HALL I THINK SHE WAS SINGING AN EMINEM SONG – & SHE RECENTLY STAGED A ONE–PERSON WALKOUT IN HER SCHOOL TO PROTEST THE EXTENDED SCHOOL DAY

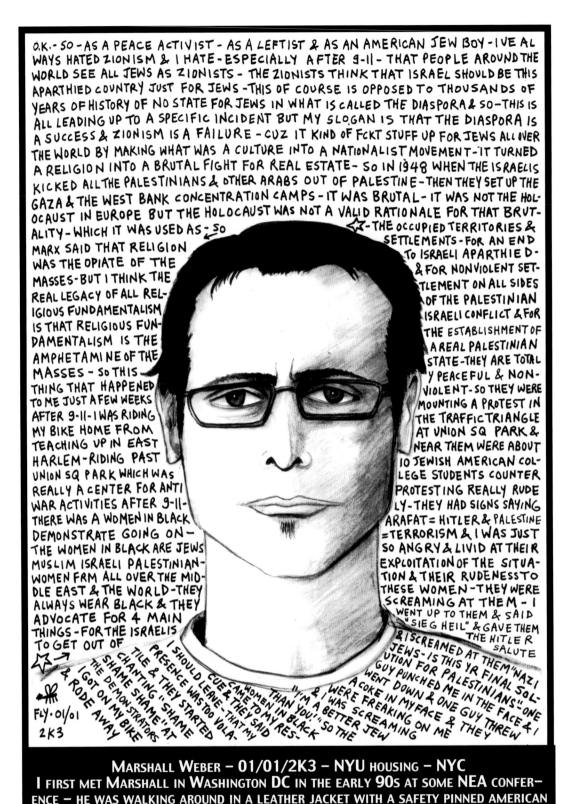

O.K. - SO - AS A PEACE ACTIVIST - AS A LEFTIST & AS AN AMERICAN JEW BOY - I'VE ALWAYS HATED ZIONISM & I HATE - ESPECIALLY AFTER 9-11 - THAT PEOPLE AROUND THE WORLD SEE ALL JEWS AS ZIONISTS - THE ZIONISTS THINK THAT ISRAEL SHOULD BE THIS APARTHIED COUNTRY JUST FOR JEWS - THIS OF COURSE IS OPPOSED TO THOUSANDS OF YEARS OF HISTORY OF NO STATE FOR JEWS IN WHAT IS CALLED THE DIASPORA & SO - THIS IS ALL LEADING UP TO A SPECIFIC INCIDENT BUT MY SLOGAN IS THAT THE DIASPORA IS A SUCCESS & ZIONISM IS A FAILURE - CUZ IT KIND OF FCKT STUFF UP FOR JEWS ALL OVER THE WORLD BY MAKING WHAT WAS A CULTURE INTO A NATIONALIST MOVEMENT - IT TURNED A RELIGION INTO A BRUTAL FIGHT FOR REAL ESTATE - SO IN 1948 WHEN THE ISRAELIS KICKED ALL THE PALESTINIANS & OTHER ARABS OUT OF PALESTINE - THEN THEY SET UP THE GAZA & THE WEST BANK CONCENTRATION CAMPS - IT WAS BRUTAL - IT WAS NOT THE HOLOCAUST IN EUROPE BUT THE HOLOCAUST WAS NOT A VALID RATIONALE FOR THAT BRUTALITY - WHICH IT WAS USED AS - SO

MARX SAID THAT RELIGION WAS THE OPIATE OF THE MASSES - BUT I THINK THE REAL LEGACY OF ALL RELIGIOUS FUNDAMENTALISM IS THAT RELIGIOUS FUNDAMENTALISM IS THE AMPHETAMINE OF THE MASSES - SO THIS THING THAT HAPPENED TO ME JUST A FEW WEEKS AFTER 9-11 - I WAS RIDING MY BIKE HOME FROM TEACHING UP IN EAST HARLEM - RIDING PAST UNION SQ PARK WHICH WAS REALLY A CENTER FOR ANTI WAR ACTIVITIES AFTER 9-11 - THERE WAS A WOMEN IN BLACK DEMONSTRATE GOING ON - THE WOMEN IN BLACK ARE JEWS MUSLIM ISRAELI PALESTINIAN - WOMEN FRM ALL OVER THE MIDDLE EAST & THE WORLD - THEY ALWAYS WEAR BLACK & THEY ADVOCATE FOR 4 MAIN THINGS - FOR THE ISRAELIS TO GET OUT OF

☆ - THE OCCUPIED TERRITORIES & SETTLEMENTS - FOR AN END TO ISRAELI APARTHIED - & FOR NONVIOLENT SETTLEMENT ON ALL SIDES OF THE PALESTINIAN ISRAELI CONFLICT & FOR THE ESTABLISHMENT OF A REAL PALESTINIAN STATE - THEY ARE TOTALLY PEACEFUL & NON-VIOLENT - SO THEY WERE MOUNTING A PROTEST IN THE TRAFFIC TRIANGLE AT UNION SQ PARK & NEAR THEM WERE ABOUT 10 JEWISH AMERICAN COLLEGE STUDENTS COUNTER PROTESTING REALLY RUDELY - THEY HAD SIGNS SAYING ARAFAT = HITLER & PALESTINE = TERRORISM & I WAS JUST SO ANGRY & LIVID AT THEIR EXPLOITATION OF THE SITUATION & THEIR RUDENESS TO THESE WOMEN - THEY WERE SCREAMING AT THEM - I WENT UP TO THEM & SAID "SIEG HEIL" & GAVE THEM THE HITLER SALUTE

& I SCREAMED AT THEM "NAZI JEWS - IS THIS YR FINAL SOLUTION FOR PALESTINIANS" - ONE GUY PUNCHED ME IN THE FACE & I WENT DOWN & ONE GUY THREW A COKE IN MY FACE & THEY WERE FREAKING ON ME & I WAS SCREAMING "I'M A BETTER JEW THAN YOU!" - SO THE WOMEN IN BLACK CAME TO MY RESCUE & THEY SAID I SHOULD LEAVE - THAT MY PRESENCE WAS TOO VOLATILE & THEY STARTED CHANTING "SHAME SHAME SHAME" AT THE DEMONSTRATORS & I GOT ON MY BIKE & RODE AWAY

FLY · 01/01 2K3

MARSHALL WEBER - 01/01/2K3 - NYU HOUSING - NYC

I FIRST MET MARSHALL IN WASHINGTON DC IN THE EARLY 90S AT SOME NEA CONFERENCE - HE WAS WALKING AROUND IN A LEATHER JACKET WITH A SAFETY PINNED AMERICAN FLAG WITH SWASTIKAS FOR STARS - HE WAS ONE OF THE ONLY PEOPLE I REALLY TALKED TO - AT THE TIME HE WAS LIVING IN SF & INVOLVED AT ATA - MARSHALL DOES A LOT OF PERFORMANCE ART & CONCEPTUAL ART - HIS IDEAS ARE USUALLY VERY SIMPLE BUT PACK A PUNCH IN THEIR PRESENTATION - HE DID A VERY ELEGANT PERFORMANCE AT OUR FRIENDS WEDDING IN A FIELD IN WISCONSIN WHERE HE WALKED BACKWARDS INTO THE NIGHT HOLDING A LIGHTED CANDLE UNTIL HE DISSAPPEARED - MWEBER@BOOKLYN.ORG

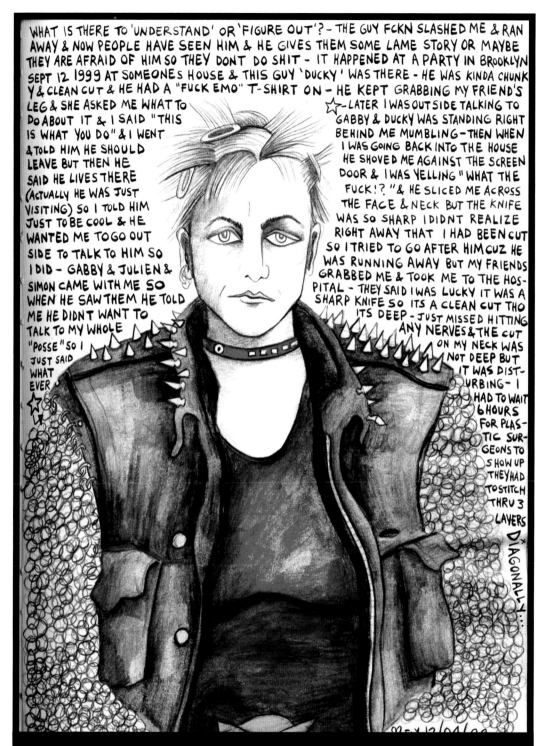

WHAT IS THERE TO 'UNDERSTAND' OR 'FIGURE OUT'? - THE GUY FCKN SLASHED ME & RAN AWAY & NOW PEOPLE HAVE SEEN HIM & HE GIVES THEM SOME LAME STORY OR MAYBE THEY ARE AFRAID OF HIM SO THEY DONT DO SHIT - IT HAPPENED AT A PARTY IN BROOKLYN SEPT 12 1999 AT SOMEONES HOUSE & THIS GUY 'DUCKY' WAS THERE - HE WAS KINDA CHUNKY & CLEAN CUT & HE HAD A "FUCK EMO" T-SHIRT ON - HE KEPT GRABBING MY FRIEND'S LEG & SHE ASKED ME WHAT TO DO ABOUT IT & I SAID "THIS IS WHAT YOU DO" & I WENT & TOLD HIM HE SHOULD LEAVE BUT THEN HE SAID HE LIVES THERE (ACTUALLY HE WAS JUST VISITING) SO I TOLD HIM JUST TO BE COOL & HE WANTED ME TO GO OUTSIDE TO TALK TO HIM SO I DID - GABBY & JULIEN & SIMON CAME WITH ME SO WHEN HE SAW THEM HE TOLD ME HE DIDNT WANT TO TALK TO MY WHOLE "POSSE" SO I JUST SAID WHATEVER

☆ - LATER I WAS OUTSIDE TALKING TO GABBY & DUCKY WAS STANDING RIGHT BEHIND ME MUMBLING - THEN WHEN I WAS GOING BACK INTO THE HOUSE HE SHOVED ME AGAINST THE SCREEN DOOR & I WAS YELLING "WHAT THE FUCK!?" & HE SLICED ME ACROSS THE FACE & NECK BUT THE KNIFE WAS SO SHARP I DIDNT REALIZE RIGHT AWAY THAT I HAD BEEN CUT SO I TRIED TO GO AFTER HIM CUZ HE WAS RUNNING AWAY BUT MY FRIENDS GRABBED ME & TOOK ME TO THE HOSPITAL - THEY SAID I WAS LUCKY IT WAS A SHARP KNIFE SO ITS A CLEAN CUT THO ITS DEEP - JUST MISSED HITTING ANY NERVES & THE CUT ON MY NECK WAS NOT DEEP BUT IT WAS DISTURBING - I HAD TO WAIT 6 HOURS FOR PLASTIC SURGEONS TO SHOW UP THEY HAD TO STITCH THRU 3 LAYERS DIAGONALLY...

AMYL NITRATE - 12/04/1999 - NYC
I FIRST MET AMYL ON MARKET ST. IN SF HANGIN OUT ON THE SIDEWALK WITH ALL THE PUNKS - SHE INTRODUCED ME TO FRANKS DEPRESSION WHO WAS SITTING THERE LOOKING LIKE AN ALIEN - AMYL WAS THE LEAD SINGER OF THE AWESOME BAND THE SPIDER CUNTS - DO NOT FUCK WITH AMYL SHE WILL PUNCH YOU BUT SHE IS SWEET TO ALL HER FRIENDS - I DREW THIS A LITTLE WHILE AFTER SHE HAD BEEN SLASHED IN THE FACE BY A GUY CALLED DUCKY WHO HAS STILL NOT ANSWERED FOR THIS BULLSHIT
WWW.COMMUNICHAOS.COM

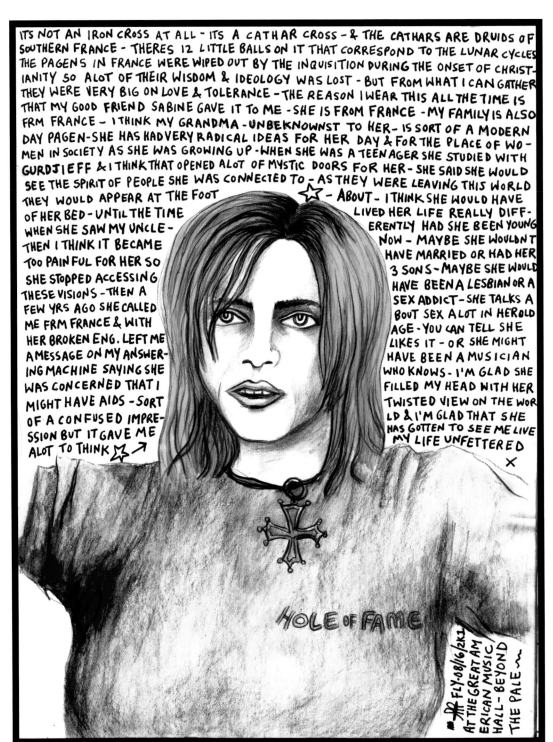

ITS NOT AN IRON CROSS AT ALL – ITS A CATHAR CROSS – & THE CATHARS ARE DRUIDS OF SOUTHERN FRANCE – THERES 12 LITTLE BALLS ON IT THAT CORRESPOND TO THE LUNAR CYCLES THE PAGENS IN FRANCE WERE WIPED OUT BY THE INQUISITION DURING THE ONSET OF CHRISTIANITY SO ALOT OF THEIR WISDOM & IDEOLOGY WAS LOST – BUT FROM WHAT I CAN GATHER THEY WERE VERY BIG ON LOVE & TOLERANCE – THE REASON I WEAR THIS ALL THE TIME IS THAT MY GOOD FRIEND SABINE GAVE IT TO ME – SHE IS FROM FRANCE – MY FAMILY IS ALSO FRM FRANCE – I THINK MY GRANDMA – UNBEKNOWNST TO HER – IS SORT OF A MODERN DAY PAGEN – SHE HAS HAD VERY RADICAL IDEAS FOR HER DAY & FOR THE PLACE OF WOMEN IN SOCIETY AS SHE WAS GROWING UP – WHEN SHE WAS A TEENAGER SHE STUDIED WITH GURDJIEFF & I THINK THAT OPENED ALOT OF MYSTIC DOORS FOR HER – SHE SAID SHE WOULD SEE THE SPIRIT OF PEOPLE SHE WAS CONNECTED TO – AS THEY WERE LEAVING THIS WORLD THEY WOULD APPEAR AT THE FOOT ☆ – ABOUT – I THINK SHE WOULD HAVE OF HER BED – UNTIL THE TIME LIVED HER LIFE REALLY DIFFERENTLY HAD SHE BEEN YOUNG WHEN SHE SAW MY UNCLE – NOW – MAYBE SHE WOULDNT THEN I THINK IT BECAME HAVE MARRIED OR HAD HER TOO PAINFUL FOR HER SO 3 SONS – MAYBE SHE WOULD SHE STOPPED ACCESSING HAVE BEEN A LESBIAN OR A THESE VISIONS – THEN A SEX ADDICT – SHE TALKS A FEW YRS AGO SHE CALLED BOUT SEX ALOT IN HER OLD ME FRM FRANCE & WITH AGE – YOU CAN TELL SHE HER BROKEN ENG. LEFT ME LIKES IT – OR SHE MIGHT A MESSAGE ON MY ANSWERING MACHINE SAYING SHE HAVE BEEN A MUSICIAN WHO KNOWS. I'M GLAD SHE WAS CONCERNED THAT I FILLED MY HEAD WITH HER MIGHT HAVE AIDS – SORT TWISTED VIEW ON THE WORLD & I'M GLAD THAT SHE OF A CONFUSED IMPRESSION BUT IT GAVE ME HAS GOTTEN TO SEE ME LIVE MY LIFE UNFETTERED ALOT TO THINK ☆↗ ✕

HOLE OF FAME

FLY · 08/16/2K1 AT THE GREAT AMERICAN MUSIC HALL – BEYOND THE PALE

ERICA STOLTZ – 08/16/2K1 – SAN FRANCISCO CA
I FIRST MET ERICA IN 93 IN SF – I WAS TRAVELING DOWN THE WEST COAST TO ESCAPE THE NYC WINTER & MY FRIEND FAE HAD GIVEN ME ERICA S PHONE # – IT TURNED OUT SHE LIVED A FEW BLOCKS AWAY FRM WHERE I WAS STAYING IN THE MISSION – ERICA WAS JUST STARTING TO PLAY BASS AT THAT POINT – SINCE THEN SHE HAS PLAYED WITH LOST GOAT & AMBER ASYLUM – I DREW THIS PORTRAIT JUST A FEW MINUTES BEFORE A BIG BEYOND THE PALE GIG WITH AMBER ASYLUM – ERICA IS NOW LIVING IN NYC DOING SOUND & LOOKING TO START A NEW BAND – ERICASTOLTZZ@HOTMAIL.COM

120

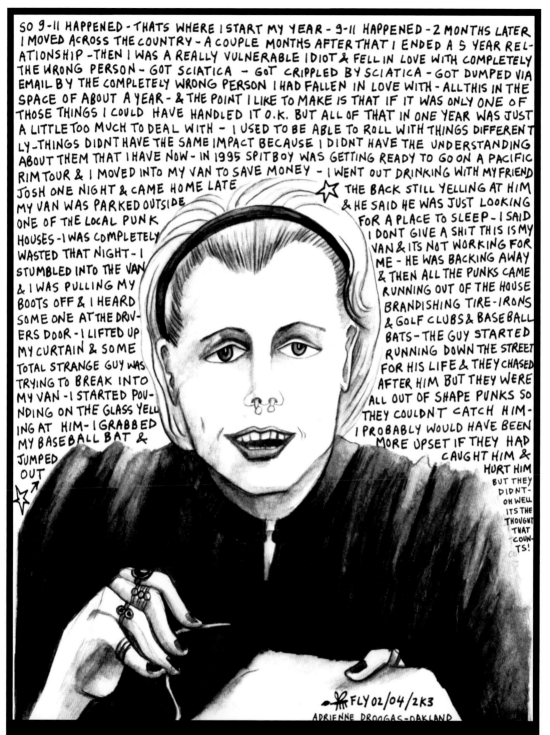

SO 9-11 HAPPENED - THATS WHERE I START MY YEAR - 9-11 HAPPENED - 2 MONTHS LATER I MOVED ACROSS THE COUNTRY - A COUPLE MONTHS AFTER THAT I ENDED A 5 YEAR RELATIONSHIP - THEN I WAS A REALLY VULNERABLE IDIOT & FELL IN LOVE WITH COMPLETELY THE WRONG PERSON - GOT SCIATICA - GOT CRIPPLED BY SCIATICA - GOT DUMPED VIA EMAIL BY THE COMPLETELY WRONG PERSON I HAD FALLEN IN LOVE WITH - ALL THIS IN THE SPACE OF ABOUT A YEAR - & THE POINT I LIKE TO MAKE IS THAT IF IT WAS ONLY ONE OF THOSE THINGS I COULD HAVE HANDLED IT O.K. BUT ALL OF THAT IN ONE YEAR WAS JUST A LITTLE TOO MUCH TO DEAL WITH - I USED TO BE ABLE TO ROLL WITH THINGS DIFFERENTLY - THINGS DIDNT HAVE THE SAME IMPACT BECAUSE I DIDNT HAVE THE UNDERSTANDING ABOUT THEM THAT I HAVE NOW - IN 1995 SPITBOY WAS GETTING READY TO GO ON A PACIFIC RIM TOUR & I MOVED INTO MY VAN TO SAVE MONEY - I WENT OUT DRINKING WITH MY FRIEND JOSH ONE NIGHT & CAME HOME LATE MY VAN WAS PARKED OUTSIDE ONE OF THE LOCAL PUNK HOUSES - I WAS COMPLETELY WASTED THAT NIGHT - I STUMBLED INTO THE VAN & I WAS PULLING MY BOOTS OFF & I HEARD SOME ONE AT THE DRIVERS DOOR - I LIFTED UP MY CURTAIN & SOME TOTAL STRANGE GUY WAS TRYING TO BREAK INTO MY VAN - I STARTED POUNDING ON THE GLASS YELLING AT HIM - I GRABBED MY BASEBALL BAT & JUMPED OUT

THE BACK STILL YELLING AT HIM & HE SAID HE WAS JUST LOOKING FOR A PLACE TO SLEEP - I SAID I DONT GIVE A SHIT THIS IS MY VAN & ITS NOT WORKING FOR ME - HE WAS BACKING AWAY & THEN ALL THE PUNKS CAME RUNNING OUT OF THE HOUSE BRANDISHING TIRE-IRONS & GOLF CLUBS & BASEBALL BATS - THE GUY STARTED RUNNING DOWN THE STREET FOR HIS LIFE & THEY CHASED AFTER HIM BUT THEY WERE ALL OUT OF SHAPE PUNKS SO THEY COULDNT CATCH HIM - I PROBABLY WOULD HAVE BEEN MORE UPSET IF THEY HAD CAUGHT HIM & HURT HIM BUT THEY DIDNT - OH WELL ITS THE THOUGHT THAT COUNTS!

FLY 02/04/2K3
ADRIENNE DROOGAS - OAKLAND

ADRIENNE DROOGAS – 02/04/2K3 – OAKLAND
I CANT REMEMBER WHEN I MET ADRIENNE – IT SEEMS LIKE I HAVE KNOWN HER FOR LONGER THAN I HAVE – I HEARD HER SINGING IN SPITBOY MANY YEARS AGO & WAS BLOWN AWAY BY THE POWER OF HER VOICE – I READ HER ZINE TOO FAR WHICH TRUE TO ITS TITLE DEALT WITH EXTREME ISSUES – AS DID HER COLUMN IN MAXIMUMROCKNROLL – SOMETIME IN THERE WE STARTED CORRESPONDING THROUGH POST & AT SOME POINT WE DID MEET – ADRIENNE SPENT A FEW YEARS IN NYC WHICH WAS HARD FOR HER BUT IT WAS GREAT TO HAVE HER HERE & WE MISS HER!! – THESE DAYS SHE WRITES KICK–ASS COLUMNS FOR MRR, SLUG & LETTUCE & PROFANE EXISTENCE – BUFFYPUGS@HOTMAIL.COM

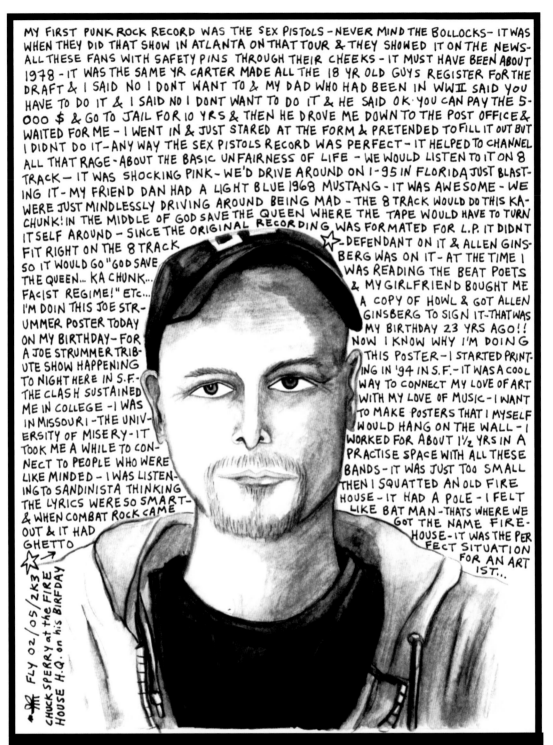

MY FIRST PUNK ROCK RECORD WAS THE SEX PISTOLS - NEVER MIND THE BOLLOCKS- IT WAS WHEN THEY DID THAT SHOW IN ATLANTA ON THAT TOUR & THEY SHOWED IT ON THE NEWS- ALL THESE FANS WITH SAFETY PINS THROUGH THEIR CHEEKS - IT MUST HAVE BEEN ABOUT 1978 - IT WAS THE SAME YR CARTER MADE ALL THE 18 YR OLD GUYS REGISTER FOR THE DRAFT & I SAID NO I DONT WANT TO & MY DAD WHO HAD BEEN IN WWII SAID YOU HAVE TO DO IT & I SAID NO I DONT WANT TO DO IT & HE SAID OK. YOU CAN PAY THE 5-000 $ & GO TO JAIL FOR 10 YRS & THEN HE DROVE ME DOWN TO THE POST OFFICE & WAITED FOR ME - I WENT IN & JUST STARED AT THE FORM & PRETENDED TO FILL IT OUT BUT I DIDNT DO IT- ANY WAY THE SEX PISTOLS RECORD WAS PERFECT - IT HELPED TO CHANNEL ALL THAT RAGE - ABOUT THE BASIC UNFAIRNESS OF LIFE - WE WOULD LISTEN TO IT ON 8 TRACK - IT WAS SHOCKING PINK - WE'D DRIVE AROUND ON I-95 IN FLORIDA JUST BLAST- ING IT - MY FRIEND DAN HAD A LIGHT BLUE 1968 MUSTANG - IT WAS AWESOME - WE WERE JUST MINDLESSLY DRIVING AROUND BEING MAD - THE 8 TRACK WOULD DO THIS KA- CHUNK! IN THE MIDDLE OF GOD SAVE THE QUEEN WHERE THE TAPE WOULD HAVE TO TURN ITSELF AROUND - SINCE THE ORIGINAL RECORDING WAS FORMATED FOR L.P. IT DIDNT FIT RIGHT ON THE 8 TRACK SO IT WOULD GO "GOD SAVE THE QUEEN... KA CHUNK... FACIST REGIME!" ETC...

I'M DOIN THIS JOE STR- UMMER POSTER TODAY ON MY BIRTHDAY - FOR A JOE STRUMMER TRIB- UTE SHOW HAPPENING TO NIGHT HERE IN S.F.- THE CLASH SUSTAINED ME IN COLLEGE - I WAS IN MISSOURI - THE UNIV- ERSITY OF MISERY - IT TOOK ME A WHILE TO CON- NECT TO PEOPLE WHO WERE LIKE MINDED - I WAS LISTEN- ING TO SANDINISTA THINKING THE LYRICS WERE SO SMART- & WHEN COMBAT ROCK CAME OUT & IT HAD GHETTO

FLY 02/05/2K3 at the FIRE HOUSE H.Q. on his BIRFDAY CHUCK SPERRY

DEFENDANT ON IT & ALLEN GINS- BERG WAS ON IT - AT THE TIME I WAS READING THE BEAT POETS & MY GIRLFRIEND BOUGHT ME A COPY OF HOWL & GOT ALLEN GINSBERG TO SIGN IT - THAT WAS MY BIRTHDAY 23 YRS AGO!! NOW I KNOW WHY I'M DOING THIS POSTER - I STARTED PRINT- ING IN '94 IN S.F. - IT WAS A COOL WAY TO CONNECT MY LOVE OF ART WITH MY LOVE OF MUSIC - I WANT TO MAKE POSTERS THAT I MYSELF WOULD HANG ON THE WALL - I WORKED FOR ABOUT 1½ YRS IN A PRACTISE SPACE WITH ALL THESE BANDS - IT WAS JUST TOO SMALL THEN I SQUATTED AN OLD FIRE HOUSE - IT HAD A POLE - I FELT LIKE BAT MAN - THATS WHERE WE GOT THE NAME FIRE- HOUSE - IT WAS THE PER FECT SITUATION FOR AN ART IST...

CHUCK SPERRY – 02/05/2K3 – FIREHOUSE HQ – SF
I HAVE BEEN SEEING POSTERS PRINTED BY CHUCK SPERRY FOR A LONG TIME – STRONG GRAPHICS & BEAUTIFUL SATURATED COLORS – GORGEOUS WORKS OF ART – CHUCK HAD SPENT SOME TIME IN NYC HANGIN OUT IN THE SQUATS IN THE LOWER EAST SIDE IN THE LATE 80s & EARLY 90s BUT I NEVER MET HIM BACK THEN – I FINALLY DID MEET HIM IN SF IN FEB 2K3 AT AN OPENING OF A GROUP SHOW OF SCIFI-WESTERN THEMED PAINT- INGS WHERE HE HAD A PAINTING OF MULTIARMED GUN-TOTIN BABES – A FEW DAYS LATER I WENT TO VISIT HIM AT THE FIREHOUSE HQ – IT WAS REALLY STINKY BUT IT WAS WORTH IT CUZ I GOT SOME BEAUTIFUL POSTERS!! – YOSQUIRT@STEAKHAUS.COM – WWW.STEAKHAUS.COM

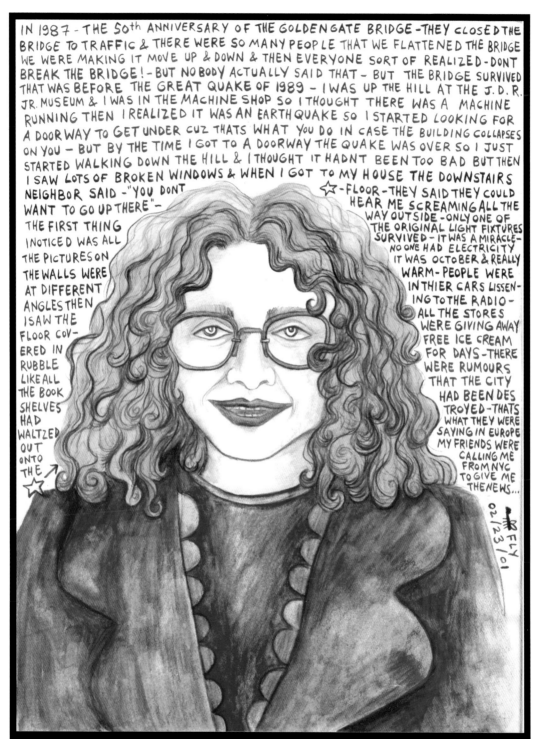

IN 1987 - THE 50th ANNIVERSARY OF THE GOLDEN GATE BRIDGE - THEY CLOSED THE BRIDGE TO TRAFFIC & THERE WERE SO MANY PEOPLE THAT WE FLATTENED THE BRIDGE WE WERE MAKING IT MOVE UP & DOWN & THEN EVERYONE SORT OF REALIZED - DON'T BREAK THE BRIDGE! - BUT NOBODY ACTUALLY SAID THAT - BUT THE BRIDGE SURVIVED THAT WAS BEFORE THE GREAT QUAKE OF 1989 - I WAS UP THE HILL AT THE J.D.R. JR. MUSEUM & I WAS IN THE MACHINE SHOP SO I THOUGHT THERE WAS A MACHINE RUNNING THEN I REALIZED IT WAS AN EARTHQUAKE SO I STARTED LOOKING FOR A DOORWAY TO GET UNDER CUZ THATS WHAT YOU DO IN CASE THE BUILDING COLLAPSES ON YOU - BUT BY THE TIME I GOT TO A DOORWAY THE QUAKE WAS OVER SO I JUST STARTED WALKING DOWN THE HILL & I THOUGHT IT HADN'T BEEN TOO BAD BUT THEN I SAW LOTS OF BROKEN WINDOWS & WHEN I GOT TO MY HOUSE THE DOWNSTAIRS NEIGHBOR SAID - "YOU DON'T WANT TO GO UP THERE" -

THE FIRST THING I NOTICED WAS ALL THE PICTURES ON THE WALLS WERE AT DIFFERENT ANGLES THEN I SAW THE FLOOR COVERED IN RUBBLE LIKE ALL THE BOOK SHELVES HAD WALTZED OUT ONTO THE ☆↗

☆-FLOOR - THEY SAID THEY COULD HEAR ME SCREAMING ALL THE WAY OUTSIDE - ONLY ONE OF THE ORIGINAL LIGHT FIXTURES SURVIVED - IT WAS A MIRACLE - NO ONE HAD ELECTRICITY IT WAS OCTOBER & REALLY WARM - PEOPLE WERE IN THIER CARS LISSEN- ING TO THE RADIO - ALL THE STORES WERE GIVING AWAY FREE ICE CREAM FOR DAYS - THERE WERE RUMOURS THAT THE CITY HAD BEEN DES- TROYED - THATS WHAT THEY WERE SAYING IN EUROPE MY FRIENDS WERE CALLING ME FROM NYC TO GIVE ME THE NEWS...

FLY
02/23/01

TRINA ROBBINS - 02/23/2K1 - THE MISSION - SF
TRINA IS WHO I WANT TO BE WHEN I GROW UP - SHE IS ALL ABOUT COMICS - SHE'S BEEN DRAWING & WRITING COMICS SINCE THE 60S - I THINK SHE WAS THE ONLY WOMAN TO WORK ON THE WONDER WOMAN COMIC - I MET TRINA IN 2K1 AT THE APE (ALTERNATIVE PRESS EXPO) IN SF WHERE SHE GOT ME IN FOR FREE BY LETTING ME VOL- UNTEER AT HER TABLE - I ACTUALLY MET HER FOR THE FIRST TIME AT A PARTY THE NIGHT BEFORE & SHE WAS SITTING WITH SCOTT MCCLOUD & THEY WERE BOTH SURROUNDED BY DROOLING ADMIRERERS INCLUDING ME - WWW.TRINAROBBINS.COM

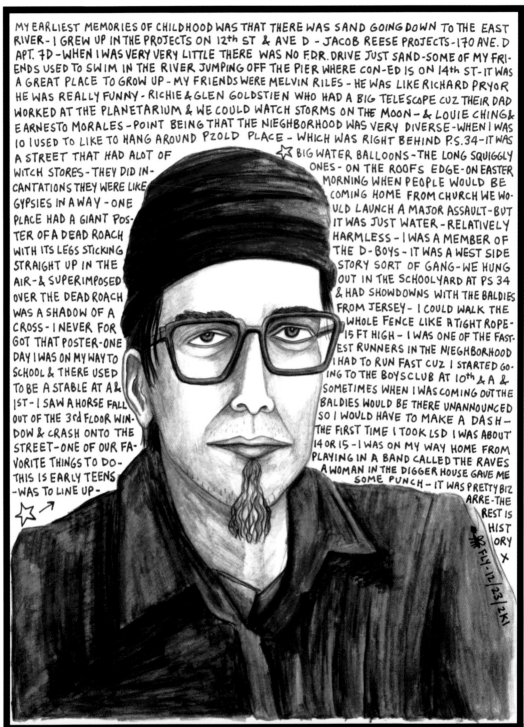

MY EARLIEST MEMORIES OF CHILDHOOD WAS THAT THERE WAS SAND GOING DOWN TO THE EAST RIVER - I GREW UP IN THE PROJECTS ON 12th ST & AVE D - JACOB REESE PROJECTS - 170 AVE. D APT. 7D - WHEN I WAS VERY VERY LITTLE THERE WAS NO F.D.R. DRIVE JUST SAND - SOME OF MY FRIENDS USED TO SWIM IN THE RIVER JUMPING OFF THE PIER WHERE CON-ED IS ON 14th ST - IT WAS A GREAT PLACE TO GROW UP - MY FRIENDS WERE MELVIN RILES - HE WAS LIKE RICHARD PRYOR HE WAS REALLY FUNNY - RICHIE & GLEN GOLDSTIEN WHO HAD A BIG TELESCOPE CUZ THEIR DAD WORKED AT THE PLANETARIUM & WE COULD WATCH STORMS ON THE MOON - & LOUIE CHING & EARNESTO MORALES - POINT BEING THAT THE NIEGHBORHOOD WAS VERY DIVERSE - WHEN I WAS 10 I USED TO LIKE TO HANG AROUND P2OLD PLACE - WHICH WAS RIGHT BEHIND P.S.34 - IT WAS

A STREET THAT HAD ALOT OF WITCH STORES - THEY DID INCANTATIONS THEY WERE LIKE GYPSIES IN A WAY - ONE PLACE HAD A GIANT POSTER OF A DEAD ROACH WITH ITS LEGS STICKING STRAIGHT UP IN THE AIR - & SUPERIMPOSED OVER THE DEAD ROACH WAS A SHADOW OF A CROSS - I NEVER FORGOT THAT POSTER - ONE DAY I WAS ON MY WAY TO SCHOOL & THERE USED TO BE A STABLE AT A & IST - I SAW A HORSE FALL OUT OF THE 3rd FLOOR WINDOW & CRASH ONTO THE STREET - ONE OF OUR FAVORITE THINGS TO DO - THIS IS EARLY TEENS - WAS TO LINE UP -

☆↗

☆ BIG WATER BALLOONS - THE LONG SQUIGGLY ONES - ON THE ROOFS EDGE - ON EASTER MORNING WHEN PEOPLE WOULD BE COMING HOME FROM CHURCH WE WOULD LAUNCH A MAJOR ASSAULT - BUT IT WAS JUST WATER - RELATIVELY HARMLESS - I WAS A MEMBER OF THE D-BOYS - IT WAS A WEST SIDE STORY SORT OF GANG - WE HUNG OUT IN THE SCHOOLYARD AT PS 34 & HAD SHOWDOWNS WITH THE BALDIES FROM JERSEY - I COULD WALK THE WHOLE FENCE LIKE A TIGHT ROPE - 15 FT HIGH - I WAS ONE OF THE FASTEST RUNNERS IN THE NIEGHBORHOOD I HAD TO RUN FAST CUZ I STARTED GOING TO THE BOYSCLUB AT 10th & A & SOMETIMES WHEN I WAS COMING OUT THE BALDIES WOULD BE THERE UNANNOUNCED SO I WOULD HAVE TO MAKE A DASH - THE FIRST TIME I TOOK LSD I WAS ABOUT 14 OR 15 - I WAS ON MY WAY HOME FROM PLAYING IN A BAND CALLED THE RAVES A WOMAN IN THE DIGGER HOUSE GAVE ME SOME PUNCH - IT WAS PRETTY BIZARRE - THE REST IS HISTORY ✗

FLY - 12/23/2K1

FRANK MORALES – 12/23/2K1 – CHARAS – LOISAIDA – NYC
I DREW THIS ON XMESS EVE AT CHARAS COMMUNITY CENTER IN THE LOWER EAST SIDE – THE WELFARE POETS WERE PLAYING & LOTS OF PEOPLE WERE THERE – I CORNERED FRANK & MADE HIM SIT FOR ME BECAUSE I WAS REALLY RESTLESS – I THINK HE WAS WANTING TO PUT UP POSTERS OR HAND OUT FLYERS FOR SOME EVENT HE WAS DOING – FRANK ALWAYS HAS SOMETHING GOING ON – HE S BEEN IN THE LOWER EAST SIDE HIS WHOLE LIFE & HAS AMAZING STORIES TO TELL – IT WAS REALLY HARD TO ONLY WRITE ONE PAGE ABOUT HIM BECAUSE HE KEPT GOING OFF ON ALL THESE INCREDIBLE TANGENTS – CHECK OUT HIS LATEST BOOK – POLICE STATE AMERICA (ARM THE SPIRIT, MONTREAL, 2001)

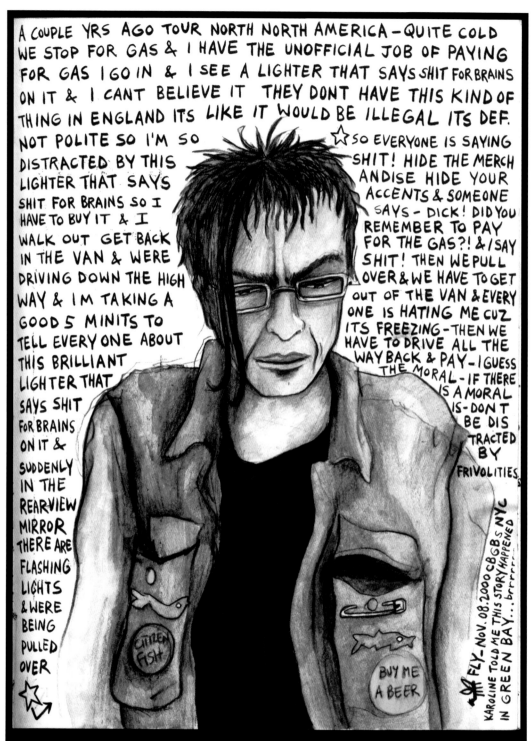

A COUPLE YRS AGO TOUR NORTH NORTH AMERICA - QUITE COLD WE STOP FOR GAS & I HAVE THE UNOFFICIAL JOB OF PAYING FOR GAS I GO IN & I SEE A LIGHTER THAT SAYS SHIT FOR BRAINS ON IT & I CANT BELIEVE IT THEY DONT HAVE THIS KIND OF THING IN ENGLAND ITS LIKE IT WOULD BE ILLEGAL ITS DEF. NOT POLITE SO I'M SO DISTRACTED BY THIS LIGHTER THAT SAYS SHIT FOR BRAINS SO I HAVE TO BUY IT & I WALK OUT GET BACK IN THE VAN & WERE DRIVING DOWN THE HIGH WAY & I'M TAKING A GOOD 5 MINITS TO TELL EVERY ONE ABOUT THIS BRILLIANT LIGHTER THAT SAYS SHIT FOR BRAINS ON IT & SUDDENLY IN THE REARVIEW MIRROR THERE ARE FLASHING LIGHTS & WERE BEING PULLED OVER ☆↘

☆ SO EVERYONE IS SAYING SHIT! HIDE THE MERCH ANDISE HIDE YOUR ACCENTS & SOMEONE SAYS - DICK! DID YOU REMEMBER TO PAY FOR THE GAS?! & I SAY SHIT! THEN WE PULL OVER & WE HAVE TO GET OUT OF THE VAN & EVERY ONE IS HATING ME CUZ ITS FREEZING - THEN WE HAVE TO DRIVE ALL THE WAY BACK & PAY - I GUESS THE MORAL - IF THERE IS A MORAL IS - DONT BE DIS TRACTED BY FRIVOLITIES

FLY - NOV. 08. 2000 CBGBS NYC KAROLINE TOLD ME THIS STORY HAPPENED IN GREEN BAY... brrrrr...

DICK LUCAS – CITIZEN FISH (FRM UK) – 11/08/Y2K – CBGB – NYC
I DREW THIS FRANTICALLY BECUZ CITIZEN FISH WAS SUPPOSED TO PLAY IN A COUPLE MINUTES – DICK WAS BUSILY CONCENTRATING ON WRITING SET LISTS WHICH IS WHY HE HAS THAT SERIOUS LOOK OF CONCENTRATION & PURPOSE! – I SPENT THE WHOLE NIGHT HANGIN OUT WITH KAROLINE (ROADY GIRL) & ADRIENNE IN THE BACK AT THE MERCH TABLES & DISCOVERED THAT THE SOUND IS ACTUALLY BETTER FROM THE BACK OF THE CLUB – AFTER THE SHOW THEY HAD TO JUMP IN THE TRUCK & LEAVE IMMEDIATELY
WWW.CITIZENFISH.COM

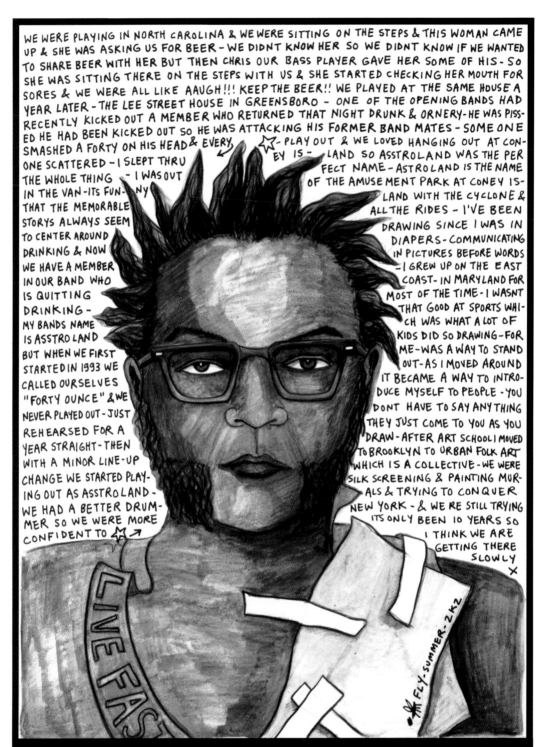

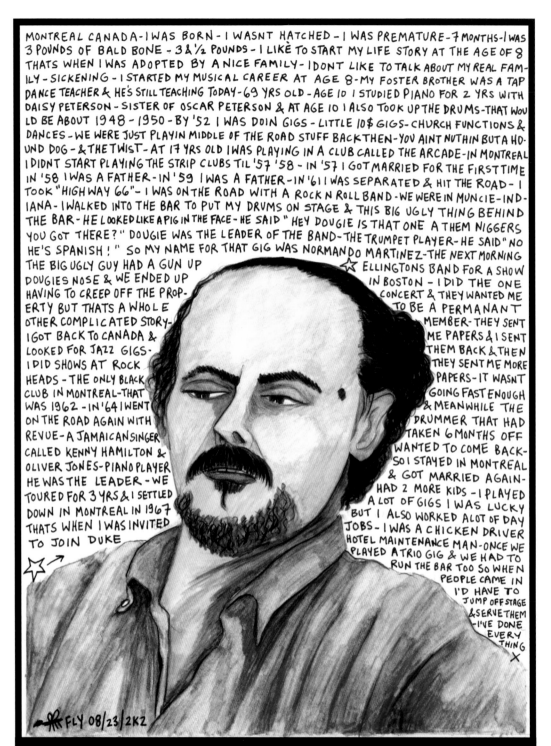

MONTREAL CANADA - I WAS BORN - I WASNT HATCHED - I WAS PREMATURE - 7 MONTHS - I WAS 3 POUNDS OF BALD BONE - 3 & ½ POUNDS - I LIKE TO START MY LIFE STORY AT THE AGE OF 8 THATS WHEN I WAS ADOPTED BY A NICE FAMILY - I DONT LIKE TO TALK ABOUT MY REAL FAMILY - SICKENING - I STARTED MY MUSICAL CAREER AT AGE 8 - MY FOSTER BROTHER WAS A TAP DANCE TEACHER & HE'S STILL TEACHING TODAY - 69 YRS OLD - AGE 10 I STUDIED PIANO FOR 2 YRS WITH DAISY PETERSON - SISTER OF OSCAR PETERSON & AT AGE 10 I ALSO TOOK UP THE DRUMS - THAT WOULD BE ABOUT 1948 - 1950 - BY '52 I WAS DOIN GIGS - LITTLE 10$ GIGS - CHURCH FUNCTIONS & DANCES - WE WERE JUST PLAYIN MIDDLE OF THE ROAD STUFF BACK THEN - YOU AINT NUTHIN BUT A HOUND DOG - & THE TWIST - AT 17 YRS OLD I WAS PLAYING IN A CLUB CALLED THE ARCADE - IN MONTREAL I DIDNT START PLAYING THE STRIP CLUBS TIL '57 '58 - IN '57 I GOT MARRIED FOR THE FIRST TIME IN '58 I WAS A FATHER - IN '59 I WAS A FATHER - IN '61 I WAS SEPARATED & HIT THE ROAD - I TOOK "HIGHWAY 66" - I WAS ON THE ROAD WITH A ROCK N ROLL BAND - WE WERE IN MUNCIE - INDIANA - I WALKED INTO THE BAR TO PUT MY DRUMS ON STAGE & THIS BIG UGLY THING BEHIND THE BAR - HE LOOKED LIKE A PIG IN THE FACE - HE SAID "HEY DOUGIE IS THAT ONE A THEM NIGGERS YOU GOT THERE?" DOUGIE WAS THE LEADER OF THE BAND - THE TRUMPET PLAYER - HE SAID "NO HE'S SPANISH!" SO MY NAME FOR THAT GIG WAS NORMANDO MARTINEZ - THE NEXT MORNING

THE BIG UGLY GUY HAD A GUN UP DOUGIES NOSE & WE ENDED UP HAVING TO CREEP OFF THE PROPERTY BUT THATS A WHOLE OTHER COMPLICATED STORY - I GOT BACK TO CANADA & LOOKED FOR JAZZ GIGS - I DID SHOWS AT ROCK HEADS - THE ONLY BLACK CLUB IN MONTREAL - THAT WAS 1962 - IN '64 I WENT ON THE ROAD AGAIN WITH REVUE - A JAMAICAN SINGER CALLED KENNY HAMILTON & OLIVER JONES - PIANO PLAYER HE WAS THE LEADER - WE TOURED FOR 3 YRS & I SETTLED DOWN IN MONTREAL IN 1967 THATS WHEN I WAS INVITED TO JOIN DUKE

☆ ELLINGTONS BAND FOR A SHOW IN BOSTON - I DID THE ONE CONCERT & THEY WANTED ME TO BE A PERMANANT MEMBER - THEY SENT ME PAPERS & I SENT THEM BACK & THEN THEY SENT ME MORE PAPERS - IT WASNT GOING FAST ENOUGH & MEANWHILE THE DRUMMER THAT HAD TAKEN 6 MONTHS OFF WANTED TO COME BACK - SO I STAYED IN MONTREAL & GOT MARRIED AGAIN - HAD 2 MORE KIDS - I PLAYED A LOT OF GIGS I WAS LUCKY BUT I ALSO WORKED A LOT OF DAY JOBS - I WAS A CHICKEN DRIVER HOTEL MAINTENANCE MAN - ONCE WE PLAYED A TRIO GIG & WE HAD TO RUN THE BAR TOO SO WHEN PEOPLE CAME IN I'D HAVE TO JUMP OFF STAGE & SERVE THEM - I'VE DONE EVERY THING

FLY 08/23/2K2

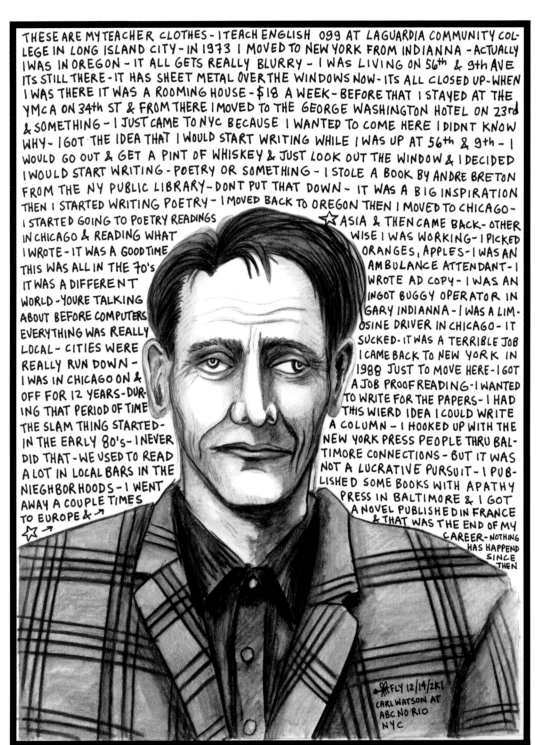

THESE ARE MY TEACHER CLOTHES - I TEACH ENGLISH 099 AT LAGUARDIA COMMUNITY COLLEGE IN LONG ISLAND CITY - IN 1973 I MOVED TO NEW YORK FROM INDIANNA - ACTUALLY I WAS IN OREGON - IT ALL GETS REALLY BLURRY - I WAS LIVING ON 56th & 9th AVE ITS STILL THERE - IT HAS SHEET METAL OVER THE WINDOWS NOW - ITS ALL CLOSED UP - WHEN I WAS THERE IT WAS A ROOMING HOUSE - $18 A WEEK - BEFORE THAT I STAYED AT THE YMCA ON 34th ST & FROM THERE I MOVED TO THE GEORGE WASHINGTON HOTEL ON 23rd & SOMETHING - I JUST CAME TO NYC BECAUSE I WANTED TO COME HERE I DIDNT KNOW WHY - I GOT THE IDEA THAT I WOULD START WRITING WHILE I WAS UP AT 56th & 9th - I WOULD GO OUT & GET A PINT OF WHISKEY & JUST LOOK OUT THE WINDOW & I DECIDED I WOULD START WRITING - POETRY OR SOMETHING - I STOLE A BOOK BY ANDRE BRETON FROM THE NY PUBLIC LIBRARY - DONT PUT THAT DOWN - IT WAS A BIG INSPIRATION THEN I STARTED WRITING POETRY - I MOVED BACK TO OREGON THEN I MOVED TO CHICAGO -

I STARTED GOING TO POETRY READINGS IN CHICAGO & READING WHAT I WROTE - IT WAS A GOOD TIME THIS WAS ALL IN THE 70's IT WAS A DIFFERENT WORLD - YOURE TALKING ABOUT BEFORE COMPUTERS EVERYTHING WAS REALLY LOCAL - CITIES WERE REALLY RUN DOWN - I WAS IN CHICAGO ON & OFF FOR 12 YEARS - DURING THAT PERIOD OF TIME THE SLAM THING STARTED - IN THE EARLY 80's - I NEVER DID THAT - WE USED TO READ A LOT IN LOCAL BARS IN THE NIEGHBORHOODS - I WENT AWAY A COUPLE TIMES TO EUROPE & →
☆ →

☆ ASIA & THEN CAME BACK - OTHERWISE I WAS WORKING - I PICKED ORANGES, APPLES - I WAS AN AMBULANCE ATTENDANT - I WROTE AD COPY - I WAS AN INGOT BUGGY OPERATOR IN GARY INDIANNA - I WAS A LIMOSINE DRIVER IN CHICAGO - IT SUCKED - IT WAS A TERRIBLE JOB I CAME BACK TO NEW YORK IN 1988 JUST TO MOVE HERE - I GOT A JOB PROOFREADING - I WANTED TO WRITE FOR THE PAPERS - I HAD THIS WIERD IDEA I COULD WRITE A COLUMN - I HOOKED UP WITH THE NEW YORK PRESS PEOPLE THRU BALTIMORE CONNECTIONS - BUT IT WAS NOT A LUCRATIVE PURSUIT - I PUBLISHED SOME BOOKS WITH APATHY PRESS IN BALTIMORE & I GOT A NOVEL PUBLISHED IN FRANCE & THAT WAS THE END OF MY CAREER - NOTHING HAS HAPPEND SINCE THEN

FLY 12/14/2K1 CARL WATSON AT ABC NO RIO NYC

CARL WATSON – 12/14/2K1 – ABC NO RIO – NYC

I DREW THIS AT NO RIO WHICH IS WHERE I FIRST MET CARL (& NO HIS EYES ARE NOT REALLY COCK-EYED – I JUST DREW IT LIKE THAT CUZ HE WAS ALL SELF CONSCIOUS & KEPT LOOKIN OVER AT HIS FRIENDS) – BACK IN 1989 WAS THE FIRST TIME I WENT TO MATTHEW COURTNEYS WIDE OPEN CABERET WHICH WAS FAMOUS IN THE LOWER EAST SIDE – CARL READ SOMETHING THAT NIGHT & I BECAME AN INSTANT FAN – A LOT OF HIS STORIES ARE REALLY DARK BUT THERE IS ALWAYS SO MUCH DEPTH & TEXTURE THAT ITS SORT OF LIKE A PAINTING – WELL – I GUESS THATS THE BEST I CAN DO TO DESCRIBE IT CUZ I M A VISUAL ARTIST – CARL WOULD ALSO PERFORM SONGS WITH THE ACOUSTIC GUITAR AS ROY DERIEN – & THAT WAS THE SHIT!!

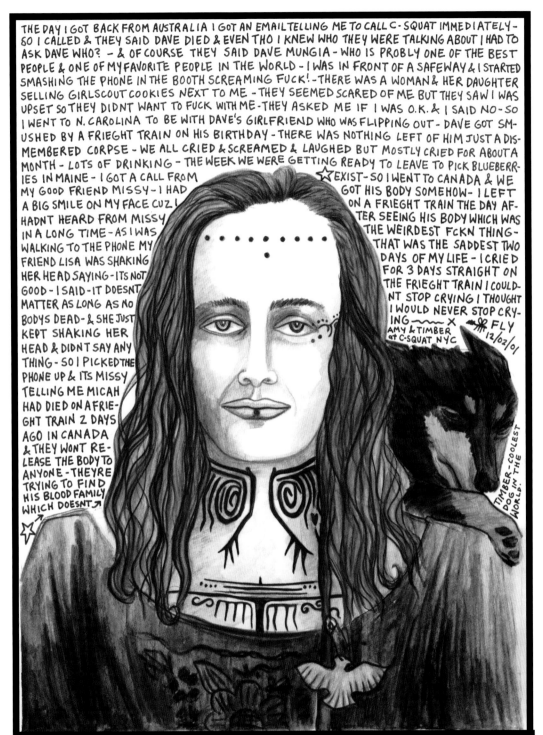

THE DAY I GOT BACK FROM AUSTRALIA I GOT AN EMAIL TELLING ME TO CALL C-SQUAT IMMEDIATELY - SO I CALLED & THEY SAID DAVE DIED & EVEN THO I KNEW WHO THEY WERE TALKING ABOUT I HAD TO ASK DAVE WHO? - & OF COURSE THEY SAID DAVE MUNGIA - WHO IS PROBLY ONE OF THE BEST PEOPLE & ONE OF MY FAVORITE PEOPLE IN THE WORLD - I WAS IN FRONT OF A SAFEWAY & I STARTED SMASHING THE PHONE IN THE BOOTH SCREAMING FUCK! - THERE WAS A WOMAN & HER DAUGHTER SELLING GIRLSCOUT COOKIES NEXT TO ME - THEY SEEMED SCARED OF ME BUT THEY SAW I WAS UPSET SO THEY DIDNT WANT TO FUCK WITH ME - THEY ASKED ME IF I WAS O.K. & I SAID NO - SO I WENT TO N. CAROLINA TO BE WITH DAVE'S GIRLFRIEND WHO WAS FLIPPING OUT - DAVE GOT SMUSHED BY A FRIEGHT TRAIN ON HIS BIRTHDAY - THERE WAS NOTHING LEFT OF HIM JUST A DISMEMBERED CORPSE - WE ALL CRIED & SCREAMED & LAUGHED BUT MOSTLY CRIED FOR ABOUT A MONTH - LOTS OF DRINKING - THE WEEK WE WERE GETTING READY TO LEAVE TO PICK BLUEBERRIES IN MAINE - I GOT A CALL FROM MY GOOD FRIEND MISSY - I HAD A BIG SMILE ON MY FACE CUZ I HADNT HEARD FROM MISSY IN A LONG TIME - AS I WAS WALKING TO THE PHONE MY FRIEND LISA WAS SHAKING HER HEAD SAYING - ITS NOT GOOD - I SAID - IT DOESNT MATTER AS LONG AS NO BODYS DEAD - & SHE JUST KEPT SHAKING HER HEAD & DIDNT SAY ANY THING - SO I PICKED THE PHONE UP & ITS MISSY TELLING ME MICAH HAD DIED ON A FRIEGHT TRAIN 2 DAYS AGO IN CANADA & THEY WONT RELEASE THE BODY TO ANYONE - THEYRE TRYING TO FIND HIS BLOOD FAMILY WHICH DOESNT ↗

☆ EXIST - SO I WENT TO CANADA & WE GOT HIS BODY SOMEHOW - I LEFT ON A FRIEGHT TRAIN THE DAY AFTER SEEING HIS BODY WHICH WAS THE WEIRDEST FCKN THING - THAT WAS THE SADDEST TWO DAYS OF MY LIFE - I CRIED FOR 3 DAYS STRAIGHT ON THE FRIEGHT TRAIN I COULDNT STOP CRYING I THOUGHT I WOULD NEVER STOP CRYING ——— X ——— FLY
AMY & TIMBER at C-SQUAT NYC 12/02/01

TIMBER - COOLEST DOG IN THE WORLD.

AMY & TIMBER - 12/02/2K1 - C SQUAT - NYC

I MET AMY IN THE EARLY 90S - SHE WAS ONE OF THE BADDEST GIRLS IN THE LOWER EAST SIDE - LIVING AT C SQUAT WITH HER DOG TIMBER WHO WAS THE COOLEST DOG I HAVE EVER MET & HE WAS REALLY SMART - WOULDNT BE PUT ON A LEASH - AMY & TIMBER WOULD TRAVEL A LOT AROUND THE US HOPPING TRAINS OR CATCHING RIDES - WHEN I WAS DRAWING THIS AT C SQUAT AMY WAS PLANNING TO GO TO NEW ORLEANS THE NEXT DAY WITH SOME OTHER FOLKS & SHE WAS TELLNG ME HOW SHE WAS WORKING AS A DANCER DOWN THERE & MAKING GOOD MONEY - THE SAD THING IS THAT IN THE SPRING OF 2K2 TIMBER WAS KILLED - RUN OVER BY A TRACTOR - ITS REALLY FCKN SAD

I WAS BORN & RAISED ON MANHATTAN ISLAND ON EAST END AVE.-ABOUT A BLOCK A-WAY FROM THE EAST RIVER-MY FAMILY LIVED ON 14th ST. & AVE.B.-I WAS CONSTANTLY HANGING OUT IN TOMPKINS SQUARE PARK-PLAYING THERE-IN THE 60'S THERE WERE HIPPIES & PEURTO RICAN KIDS-IVE BEEN CREATING IMAGES SINCE I CAN REMEMBER-PICTURES ARE MY NATIVE TONGUE-LEARNING TO READ & WRITE CAME SLOWLY & WITH MUCH DIFFICULTY-BUT I WAS ALWAYS EXPRESSING MYSELF WITH PAINTING OR DRAWINGS SINCE EARLIEST CHILDHOOD-SO I THINK OF ART AS A LANGUAGE WITH WHICH TO COM-MUNICATE SPECIFIC FEELINGS OR EMOTIONS THAT WORDS COULD NOT HAVE EXPRESSED-IVE LONG FELT THAT SOCIETY PLACES AN UNDUE EMPHASIS ON "THE WORD" & REGARDS OTHER FORMS OF EXPRESSION AS SUPERFLUOUS-IVE ALWAYS RESPONDED TO ART THAT WAS TELLING A STORY-WHAT YOU WOULD CALL "NARRATIVE ART"-THIS IS THE KIND OF ART THAT I MYSELF HAVE BEEN CREATING OVER THE YEARS-IVE CHALLENGED MYSELF TO WRITE STORIES & ENTIRE NOVELS WITHOUT USING ANY WORDS OF TEXT-IVE FOUND IT EXTREME-LY DIFFICULT BUT IT SUITS ME-THE CHALLENGE-IVE RISEN TO THE OCCASSION-I LOVE THE IDEA OF CREA-TING STORY BOOKS THAT ALL PEOPLE REGARDLESS OF AGE & BACKGROUND WILL BE ABLE TO UNDER-STAND & ENJOY-LIKE MUSIC-I'M CREATING-I'M IMPROVISING A UNIVERSAL LANGUAGE-LIKE A MUSICIAN-THE MOST RECENT BOOK OF MINE-WORDLESS BOOK-"BLOODSONG" IS A POLITICAL FAIRY TALE OF SORTS-A MYTHICAL TALE FOR THE 21ST CENTURY-WHEREAS MY FIRST ATTEMPT AT A WORDLESS NOVEL ☆→

☆-"FLOOD" WAS LARGELY AUTO-BIOGRAPHICAL-ABOUT A CITY DWELLER LIVING IN THE LAST DAYS OF THE 20th CENTURY WITH HIS CAT-"BLOODSONG" IS PURELY A WORK OF IMAG-INATION ABOUT A YOUNG WO-MAN LIVING IN THE JUNGLE WITH HER DOG-I PLAN TO CONTINUE IN THIS VIEN OF EXPLORATION-HOW MUCH IN-FORMATION CAN BE COM-MUNICATED WITHOUT WORDS? PICTURES-AFTER ALL-ARE THE EARLIEST FORMS OF WRITING-I THINK PEOPLE RESPOND TO STOR-IES & LOVE TO BE TOLD STORIES LOVE TO HEAR STORIES-BECAUSE THIS IS THE WAY WE PERCIEVE RE-ALITY AS HUMANS-EVERYONE IS A STORY TELLER WETHER THEY LIKE IT OR NOT BECAUSE EVERYONE HAS DREAMS EVERY NIGHT-AS DREAM-ERS WE ARE THE SCREEN WRITERS' ARTISTIC DIRECTORS & EXECU-TIVE PRO-DUCERS EVERY NITE

FLY-11/20/2K2-NYC

ERIC DROOKER – 11/20/2K2 – LOISAIDA – NYC
I MET ERIC IN THE EARLY 90S – HE WAS ALWAYS AROUND THE NEIGHBORHOOD EVENTS & DEMOS & ACTIONS – A LOT OF TIMES HE WOULD BE DRUMMING & SOMETIMES HE WOULD DO SPOKEN WORD – BUT MOSTLY I GOT TO KNOW ERIC THROUGH HIS INCREDIBLE ART WORK – BEAUTIFUL & BOLD BLACK & WHITE LIKE WOODCUTS – I WOULD SEE HIS STUFF A LOT IN WORLD WAR 3 ILLUSTRATED – ERIC WAS ALSO VERY INVOLVED IN STEAL THIS RADIO OUR LOCAL PIRATE RADIO STATION & ALWAYS SUPPORTED THE SQUATTERS – THEN A FEW YEARS AGO HE MOVED OUT TO CALIFORNIA & IS NOW LIVING IN BERKELEY – I M REALLY HAPPY FOR HIM FOR GETTING OUT OF HERE BUT WE SURE DO MISS HIM
WWW.DROOKER.COM

THE FIRST SENTENCE I EVER TELL ANYONE IS THAT I GOT OFF THE BUS WITH 38¢ IN MY POCKET - I WAS COMING FROM MINNESOTA VIA OHIO - THESE DAYS I'M DOING A LITTLE BETTER - I HAVE 69¢ IN MY POCKET - I LIVE IN CHELSEA NOW I'VE MOVED TO THE EPICENTER OF ART AGAIN - I USED TO LIVE AT THE ORIGINAL EPICENTER OF ART - 7th & A - I WORKED AT RAY'S NEWSTAND THEN - IVE HAD 1-2-3-4-5-6-7 DIFFERENT APARTMENTS ON OR ALONG AVE A - IVE MET ALMOST ANY BODY THAT MATTERS IN NEW YORK - THE FIRST PERSON I EVER MET WAS MEAD ESPOSITO - HE WAS A BIG DEMOCRATIC BOSS IN BROOKLYN - YOU DID NOT GET ELECTED IN BROOKLYN WITHOUT MEAD ESPOSITO'S OK TIL LIKE 1980 - FIRST RESTAURANT I EVER ATE IN WAS RATNERS - IT WAS MY FIRST RUN IN WITH JEWISH MEN WAITERS - WHEN I CAME TO NEW YORK IN EARNEST I WOUND UP ON 11th & A IN A RAILROAD CAR FLAT - 99% OF THE TIME I WAS TOTALLY TERRIFIED - CUZ IT WAS 1980 & IT WAS STILL A WARZONE - WEBB TURNER GAVE ME A SPACE AT THE 539 E 5th ST HOMESTEAD - WE DID NOT EVER USE THE TERM "SQUAT" WE WERE THERE TO STAY - NEEDLESS TO SAY WE WERE THE FIRST TO GO - EVEN AFTER THEY THREW EVERYONE OUT IT TOOK ANOTHER 10 YEARS TO DEMOLISH THE BUILDING - I WAS APALLED WHEN I FOUND OUT THAT ALL THE PEOPLE ON 9th ST HAD BEEN THROWN OUT TO MAKE AN EPISODE OF NYPD BLUE THERE WAS AN OPENING SHOT OF ALL THE BUILDINGS ON 9th ST BEING IMPLODED & ☆→ ☆ NYPD BLUE PAID FOR IT - WE HAVE ABC TO THANK FOR ALL THE PEOPLE ON 9th ST BEING THROWN OUT - IVE HAD FUN IN MY PERFORMANCE ART CAREER I SPENT 10,000 HOURS CLEANING UP NEW YORK CITY IN THE 1980's EVERY SUBWAY CAR EVERY SUBWAY STOP EVERY PARK BELOW 42ND 4 MONTHS STRAIGHT IN WASHINGTON SQUARE PARK - PUBLISHED A NEWSLETTER CALLED OUTSIDER TRADING NEWS DISTRIBUTED ONLY AT THE MEMBERS DOOR OF THE NEW YORK STOCK EXCHANGE - WAS THE HOST OF THE GREATEST PERFORMANCE VIDEO EVER ON NEW YEARS EVE OF 1990 - WITH 242 PERFORMERS IN 12 HOURS - I SPENT 8 YEARS WEARING NOTHING BUT RED - IF IT WASNT RED I DIDNT TOUCH IT - THESE DAYS I'M TAKING LOTS OF PICTURES - THIS YEAR ALONE I'VE DONE OVER 30,000 I HOPE IN MY FUTURE YEARS I CAN STAY AS PROLIFIC AS I HAVE BEEN UP TO NOW THANK YOU NEW YORK.

Voline
TOTAL
⚓ FLY 12/14/2K1
RED ED AT ABC NO RIO NYC
Valvoline
UNITED UNITED UNITED Van Lines

RED ED – 12/14/2K1 – ABC NO RIO – NYC

I MET RED ED IN THE LATE 80S BACK WHEN HE WAS STILL WEARING ALL RED ALL THE TIME WITH THE ODD BONDAGE GEAR – & THEN FOR A WHILE HE HAD A GIRLFRIEND CALLED GREEN GINA – THERE WAS ONE NIGHT AT NO RIO WHEN THEY ALMOST CAUSED A RIOT CUZ THEY DID THIS PERFORMANCE WHICH INVOLVED RED ED PULLING DOWN GREEN GINAS PANTS & SPANKING HER & THIS OTHER GIRL GOT UP & STARTED WACKING RED ED & EVERYONE WAS FREAKING OUT THEN STEVE & MIKE DID A PERFORMANCE WHERE MIKE WAS SPANKING STEVE – OR WAS IT THE OTHER WAY AROUND? – THEN GREEN GINA STARTED SPANKING RED ED & – WELL – JUST ANOTHER OPEN MIC –
WWW.WEBBITTOWN.NET

I GREW UP IN SHIRAZ - IRAN - LAND OF POETS & GARDENS - I REMEMBER MY GRAND FATHER EVERY MORNING AS THE SUN CAME UP WATERING THE GARDEN & MY SISTER & I PICKING JASMINES & FILLING UP THE HOUSE WITH THEIR AROMA - THE GARDENS ARE A PLACE OF MAGIC & MYSTERY - IN THE SOUTH BRONX IS CHERRY TREE GARDEN - I LEARNED THE MEANING OF COMMUNITY, PUPPETRY & LOVE - I CAME TO THE U.S. IN SEARCH OF MECHANICAL ENGINEERING AT LOUISIANA STATE UNIVERSITY AND FOUND MY TRUE LOVE IN PHOTOGRAPHY & SOCIAL ARTS AT NYU & THE REAL SCHOOL OF LIFE IN NEW YORK - REAL TEACHERS BEING STUDENTS THAT TAUGHT ME THE MEANING OF COMMUNITY & ACCEPTED ME INTO THEIR FAMILIES MAKING POETRY & PHOTOGRAPHS OF THEIR LIVES IN CROWN HIEGHTS & PROSPECT HIEGHTS - THE GARDENERS TAUGHT ME THE REAL MEANING OF REVOLUTION - TAKING BACK THE LAND STOLEN FROM THE PEOPLE WHO WERE FIRST HERE ONE SEED AT A TIME - ALISIA TORRES AT ESPERANZA TAUGHT ME THE MEANING OF CONSENSUS ONE SENTENCE AT A TIME NO MATTER HOW PAINFULLY SLOW - TRUE CONSENSUS IS EVENTUALLY REACHED - & WHAT THE MEANING OF OPENING UP YOUR HEART ↵

FLY 12/29/2K1
ARESH at ST MARKS CHURCH - NYC

TO COMPLETE STRANGERS - COMPLETE CRAZY GARDEN ACTIVISTS - TOGETHER CREATING A MAGICAL COQUI - THE GIANT LIVE-IN VERSION OF THE PEURTO RICAN LAND FROG - THE NATIONAL SYMBOL OF PEURTO RICO - I DONT THINK IVE EVER CRIED AS DEEPLY AS I DID AFTER THAT GARDEN WAS TURNED TO FALLOW LAND BY THE SHORT SIGHTED DEVELOPERS BULLDOZERS - THE SEEDS OF ESPERANZA - IM ALWAYS SEEING THEM GROWING IN ALL DIFFERENT WAYS; THE IMMEDIATE INJUNCTION BY STATE ATTORNY GENERAL KEEPING OVER 400 REMAINING COMMUNITY GARDENS SAFE FOR 2 YEARS - SHOWING PEOPLE THAT HOUSING & GARDENS GO HAND IN HAND - THAT ART, EDUCATION & LIFE ARE ONE & THE SAME & THAT GARDENS & PEOPLE OF ALL RACES & KINDS TOGETHER SHARE THEIR STORIES & TO FEED THEM WITH FOOD LAUGHTER DANCE & CELEBRATION OF LIFE - VIVA ESPERANZA! - I'M LOOKING FORWARD IN SEEING ALL THE REMAINING COMMUNITY GARDENS BECOMING PERMANANT & STARTING TO CREATE MORE VIBRANT LIFE ENHANCING COMMUNITY GREEN SPACES - MORE GARDENS! MORE PEAS!

ARESH – 12/29/2K1 – ST. MARKS CHURCH – NYC
I CANT REMEMBER WHEN I MET ARESH – IT WAS LIKE HE JUST APPEARED ONE DAY IN ONE OF THE GARDENS – NOW EVERY TIME I SEE HIM HE IS INVOLVED IN A PROJECT HELPING OUT COMMUNITY GARDENS – HE WAS ON MY STREET FOR MONTHS TO HELP PROTECT THE ESPERANZA GARDEN WITH A LOT OF OTHER PEOPLE – THEY BUILT & LIVED INSIDE A GIANT COQUI (FROG) WHICH IS THE 4-LEGGED NATIONAL SYMBOL OF PUERTO RICO – I DREW THIS PORTRAIT AT ST. MARKS CHURCH WHILE ARESH WAS WAITING TO PARTICIPATE IN A MORE GARDENS! PERFORMANCE – IT WAS REALLY DARK & I COULD HARDLY SEE HIM BUT I THINK IT TURNED OUT OK – WWW.MOREGARDENS.ORG – ARESH@MOREGARDENS.ORG

I WOULD LOVE TO GIVE YOU A TIRADE ABOUT THAT FCKN MORON - I WOULD CRINGE WHEN I SAW HIM WALKING AROUND MY HOUSE - "KALENDERPANDEN" - CALENDAR BUILDINGS - IT WAS 12 WAREHOUSES IN A ROW - OPENED IN NOV. 96 - 4 OR 5 PEOPLE OPENED IT - I MOVED IN A FEW MONTHS LATER CUZ I WAS IN NEW YORK - THERE WERE 15 PEOPLE LIVING THERE WHEN WE GOT EVICTED - FOR AGES NOTHING WENT ON AS WE HAD TO CLEAN THE PLACE OUT & GET WATER & ELECTRIC & TRY TO KEEP WARM - LOTS OF SHIT HAPPENED LATER - PARTIES POETRY READINGS FILMS INFO SHOP FLAMENCO DANCING MEETINGS RIGHT NOW THERES A FORMER FILM ACADEMY THATS BEEN SQUATTED & THEY DO SHOWS LIKE ELECTRONIC MUSIC - DANCE - FILMS - PIRATE RADIO - THEY HAVE A VEGAN CAFE - ENVIRONMENTAL GROUPS HAVE OFFICES THERE - THEY ARE GETTING LEGALIZED - THERES ONE OTHER BUILDING GETTING LEGALIZED & THIS MIGHT SET A TREND AT LEAST THEY ARE TEST CASES - SQUATTING IS GETTING HARDER BUT PEOPLE ARE STILL DOING IT - I DONT WANT TO SPOT LIGHT MY LIVING SITU- ATION - I'M BORED WITH IT - I SIT IN THE INFO SHOP & I READ SHIT LO- ADS OF BOOKS & ZINES & I'M JUST BORING ME I JUST WANT TO SIT IN A CORNER & READ...

STOP

BUGGING

. ME

!

FLY - 06/21/2K1 at the EX show at the knit fact. NYC Summer Solstice

GRRRT - 06/21/2K1 - AT THE KNITTING FACTORY - NYC

GRRRT WAS ONLY IN TOWN FOR A FEW HOURS - ON TOUR WITH THE EX (FROM HOLLAND) - HE WAS MANNING THE MERCH TABLE WHILE I DREW THIS SO HE WAS MOVING AROUND A LOT - I WANTED GRRRT TO TELL ME STORIES ABOUT SOME OF HIS AMAZING EXPLOITS BECAUSE HE HAS BEEN INVOLVED IN SOME INCREDIBLE PROJECTS BUT HE DIDNT WANT TO TALK ABOUT ANY OF THAT CUZ IT WAS ALL COLLECTIVE ACTIONS & NOT JUST ABOUT HIM - I HUNG OUT WITH GRRRT FOR A WHILE IN AMSTERDAM IN 97 - HE HAD AN AMAZING SQUAT & WE WOULD GO NUTS DANCING TO ATARI TEENAGE RIOT!! - GRRRT@SQUAT.NET

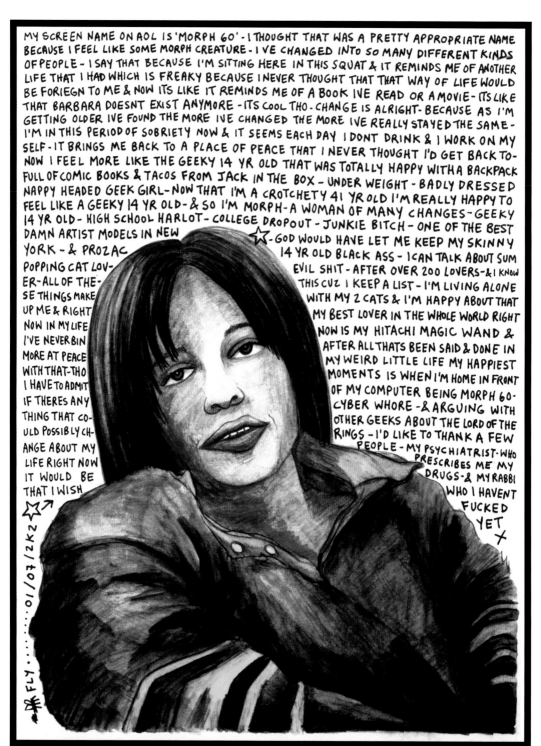

MY SCREEN NAME ON AOL IS 'MORPH 60' - I THOUGHT THAT WAS A PRETTY APPROPRIATE NAME BECAUSE I FEEL LIKE SOME MORPH CREATURE - I'VE CHANGED INTO SO MANY DIFFERENT KINDS OF PEOPLE - I SAY THAT BECAUSE I'M SITTING HERE IN THIS SQUAT & IT REMINDS ME OF ANOTHER LIFE THAT I HAD WHICH IS FREAKY BECAUSE I NEVER THOUGHT THAT THAT WAY OF LIFE WOULD BE FORIEGN TO ME & NOW ITS LIKE IT REMINDS ME OF A BOOK IVE READ OR A MOVIE - ITS LIKE THAT BARBARA DOESNT EXIST ANYMORE - ITS COOL THO - CHANGE IS ALRIGHT - BECAUSE AS I'M GETTING OLDER IVE FOUND THE MORE IVE CHANGED THE MORE IVE REALLY STAYED THE SAME - I'M IN THIS PERIOD OF SOBRIETY NOW & IT SEEMS EACH DAY I DONT DRINK & I WORK ON MY SELF - IT BRINGS ME BACK TO A PLACE OF PEACE THAT I NEVER THOUGHT I'D GET BACK TO - NOW I FEEL MORE LIKE THE GEEKY 14 YR OLD THAT WAS TOTALLY HAPPY WITH A BACKPACK FULL OF COMIC BOOKS & TACOS FROM JACK IN THE BOX - UNDER WEIGHT - BADLY DRESSED NAPPY HEADED GEEK GIRL - NOW THAT I'M A CROTCHETY 41 YR OLD I'M REALLY HAPPY TO FEEL LIKE A GEEKY 14 YR OLD - & SO I'M MORPH - A WOMAN OF MANY CHANGES - GEEKY 14 YR OLD - HIGH SCHOOL HARLOT - COLLEGE DROPOUT - JUNKIE BITCH - ONE OF THE BEST DAMN ARTIST MODELS IN NEW YORK - & PROZAC POPPING CAT LOVER - ALL OF THESE THINGS MAKE UP ME & RIGHT NOW IN MY LIFE I'VE NEVER BIN MORE AT PEACE WITH THAT - THO I HAVE TO ADMIT IF THERES ANY THING THAT COULD POSSIBLY CHANGE ABOUT MY LIFE RIGHT NOW IT WOULD BE THAT I WISH ☆↗ GOD WOULD HAVE LET ME KEEP MY SKINNY 14 YR OLD BLACK ASS - I CAN TALK ABOUT SUM EVIL SHIT - AFTER OVER 200 LOVERS - & I KNOW THIS CUZ I KEEP A LIST - I'M LIVING ALONE WITH MY 2 CATS & I'M HAPPY ABOUT THAT MY BEST LOVER IN THE WHOLE WORLD RIGHT NOW IS MY HITACHI MAGIC WAND & AFTER ALL THATS BEEN SAID & DONE IN MY WEIRD LITTLE LIFE MY HAPPIEST MOMENTS IS WHEN I'M HOME IN FRONT OF MY COMPUTER BEING MORPH 60 - CYBER WHORE - & ARGUING WITH OTHER GEEKS ABOUT THE LORD OF THE RINGS - I'D LIKE TO THANK A FEW PEOPLE - MY PSYCHIATRIST - WHO PRESCRIBES ME MY DRUGS - & MY RABBI WHO I HAVENT FUCKED YET ✗

FLY ······ 01/07/2K2

BARBARA LEE – 01/07/2K2 – LOWER EAST SIDE – NYC
WHEN I FIRST MET BARBARA LEE I THINK I WAS A LITTLE INTIMIDATED – SHE WAS ALWAYS REALLY SWEET TO ME BUT SHE WAS SUCH A TOUGH GIRL – I CAN REMEMBER IN THE EARLY & MID 90S WE D ALL BE OUT ON THE STREET AT SOME DEMO OR POLICE RIOT OR SOMETHING & BARBARA WOULD HAVE NO FEAR – SHE WOULD JUST BE GETTING RIGHT UP IN THE COPS FACES – & ANYONE WHO FCKT WITH HER WOULD BE IN SERIOUS PHYSICAL DANGER – BUT LIKE I SAID – SHE HAS ALWAYS BEEN REALLY SWEET TO ME – I DON T SEE HER AROUND MUCH ANYMORE CUZ NOW SHE LIVES IN BROOKLYN WHERE SHE ENJOYS HER SOBRIETY & EXPLORING ALL AVENUES OF HER SPIRITUALITY – MORPH60@AOL.COM

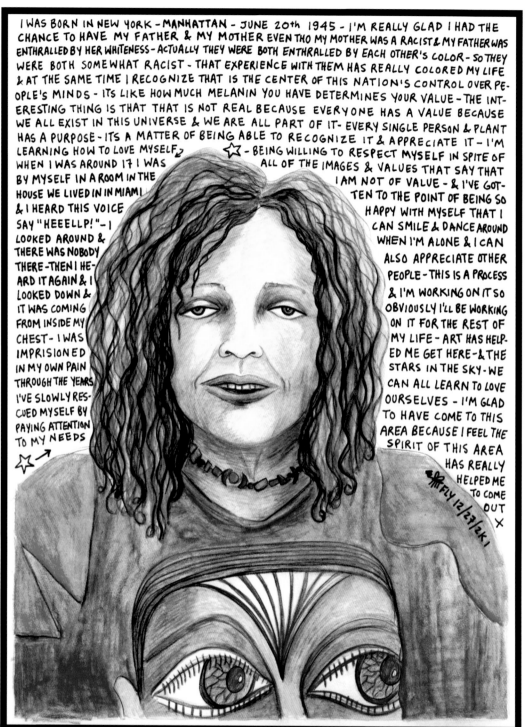

I WAS BORN IN NEW YORK - MANHATTAN - JUNE 20th 1945 - I'M REALLY GLAD I HAD THE CHANCE TO HAVE MY FATHER & MY MOTHER EVEN THO MY MOTHER WAS A RACIST & MY FATHER WAS ENTHRALLED BY HER WHITENESS - ACTUALLY THEY WERE BOTH ENTHRALLED BY EACH OTHER'S COLOR - SO THEY WERE BOTH SOMEWHAT RACIST - THAT EXPERIENCE WITH THEM HAS REALLY COLORED MY LIFE & AT THE SAME TIME I RECOGNIZE THAT IS THE CENTER OF THIS NATION'S CONTROL OVER PEOPLE'S MINDS - ITS LIKE HOW MUCH MELANIN YOU HAVE DETERMINES YOUR VALUE - THE INTERESTING THING IS THAT THAT IS NOT REAL BECAUSE EVERYONE HAS A VALUE BECAUSE WE ALL EXIST IN THIS UNIVERSE & WE ARE ALL PART OF IT - EVERY SINGLE PERSON & PLANT HAS A PURPOSE - ITS A MATTER OF BEING ABLE TO RECOGNIZE IT & APPRECIATE IT - I'M LEARNING HOW TO LOVE MYSELF

WHEN I WAS AROUND 17 I WAS BY MYSELF IN A ROOM IN THE HOUSE WE LIVED IN IN MIAMI & I HEARD THIS VOICE SAY "HEEELLP!" - I LOOKED AROUND & THERE WAS NOBODY THERE - THEN I HEARD IT AGAIN & I LOOKED DOWN & IT WAS COMING FROM INSIDE MY CHEST - I WAS IMPRISONED IN MY OWN PAIN THROUGH THE YEARS I'VE SLOWLY RESCUED MYSELF BY PAYING ATTENTION TO MY NEEDS

☆ - BEING WILLING TO RESPECT MYSELF IN SPITE OF ALL OF THE IMAGES & VALUES THAT SAY THAT I AM NOT OF VALUE - & I'VE GOTTEN TO THE POINT OF BEING SO HAPPY WITH MYSELF THAT I CAN SMILE & DANCE AROUND WHEN I'M ALONE & I CAN ALSO APPRECIATE OTHER PEOPLE - THIS IS A PROCESS & I'M WORKING ON IT SO OBVIOUSLY I'LL BE WORKING ON IT FOR THE REST OF MY LIFE - ART HAS HELPED ME GET HERE - & THE STARS IN THE SKY - WE CAN ALL LEARN TO LOVE OURSELVES - I'M GLAD TO HAVE COME TO THIS AREA BECAUSE I FEEL THE SPIRIT OF THIS AREA HAS REALLY HELPED ME TO COME OUT X

FLY 12/27/2K1

Cenén - 12/27/2K1 - Loisaida - NYC

DRAWING CENÉN WAS ONE OF THE BEST EXPERIENCES I'VE HAD IN ALL OF THE PORTRAITS THAT I'VE DRAWN - I HAD NEVER REALLY HAD A CHANCE TO SIT & TALK TO HER BEFORE & I DON'T KNOW HOW TO DESCRIBE IT EXCEPT TO SAY THAT IT MADE ME FEEL VERY PEACEFUL & THAT IS NOT SOMETHING I'M USED TO - CENÉN HAD BEEN AROUND THE LES FOR YEARS PERFORMING HER POETRY & PAINTING & PARTICIPATING FULLY IN THE SPIRIT OF THE LOISAIDA COMMUNITY - FOR A WHILE SHE HAD A SHOW ON STEAL THIS RADIO (OUR LOCAL PIRATE STATION) - IT WAS VERY SAD WHEN SHE DIED IN THE SUMMER OF 2K2 - WE ALL THOUGHT WE WOULD HAVE MORE TIME WITH HER - CENÉN YOU ARE SORELY MISSED

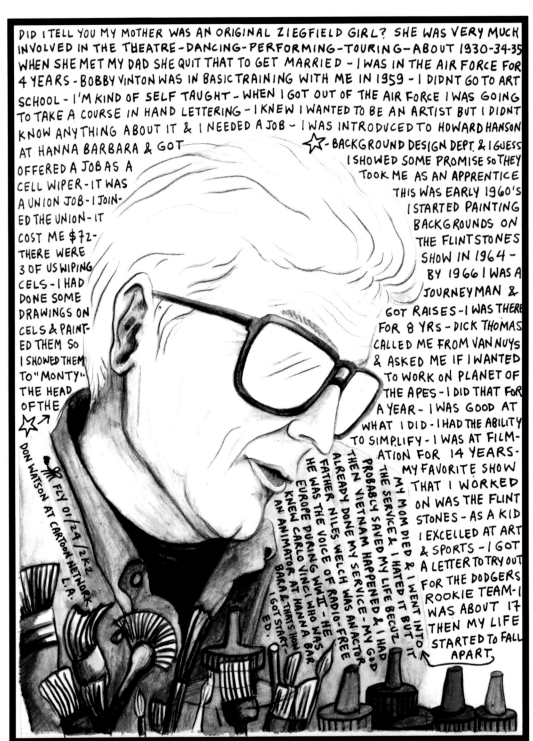

DID I TELL YOU MY MOTHER WAS AN ORIGINAL ZIEGFIELD GIRL? SHE WAS VERY MUCH INVOLVED IN THE THEATRE-DANCING-PERFORMING-TOURING-ABOUT 1930-34-35 WHEN SHE MET MY DAD SHE QUIT THAT TO GET MARRIED - I WAS IN THE AIR FORCE FOR 4 YEARS - BOBBY VINTON WAS IN BASIC TRAINING WITH ME IN 1959 - I DIDNT GO TO ART SCHOOL - I'M KIND OF SELF TAUGHT - WHEN I GOT OUT OF THE AIR FORCE I WAS GOING TO TAKE A COURSE IN HAND LETTERING - I KNEW I WANTED TO BE AN ARTIST BUT I DIDNT KNOW ANYTHING ABOUT IT & I NEEDED A JOB - I WAS INTRODUCED TO HOWARD HANSON AT HANNA BARBARA & GOT OFFERED A JOB AS A CELL WIPER - IT WAS A UNION JOB - I JOINED THE UNION - IT COST ME $72 - THERE WERE 3 OF US WIPING CELS - I HAD DONE SOME DRAWINGS ON CELS & PAINTED THEM SO I SHOWED THEM TO "MONTY" THE HEAD OF THE ☆↗

☆ - BACKGROUND DESIGN DEPT. & I GUESS I SHOWED SOME PROMISE SO THEY TOOK ME AS AN APPRENTICE THIS WAS EARLY 1960'S I STARTED PAINTING BACKGROUNDS ON THE FLINTSTONES SHOW IN 1964 - BY 1966 I WAS A JOURNEYMAN & GOT RAISES - I WAS THERE FOR 8 YRS - DICK THOMAS CALLED ME FROM VAN NUYS & ASKED ME IF I WANTED TO WORK ON PLANET OF THE APES - I DID THAT FOR A YEAR - I WAS GOOD AT WHAT I DID - I HAD THE ABILITY TO SIMPLIFY - I WAS AT FILMATION FOR 14 YEARS - MY FAVORITE SHOW THAT I WORKED ON WAS THE FLINTSTONES - AS A KID I EXCELLED AT ART & SPORTS - I GOT A LETTER TO TRY OUT FOR THE DODGERS ROOKIE TEAM - I WAS ABOUT 17 THEN MY LIFE STARTED TO FALL APART.

FLY 01/24/2K2 CARTOON NETWORK L.A.

DON WATSON AT CARTOON NETWORK

MY MOM DIED & I WENT INTO THE SERVICE & I HATED IT BUT IT PROBABLY SAVED MY LIFE BECUZ THEN VIETNAM HAPPENED & I HAD ALREADY DONE MY SERVICE - MY GOD FATHER NILES WELCH WAS AN ACTOR HE WAS THE VOICE OF RADIO - FREE EUROPE DURING WWII - HE KNEW CARLO VINCI WHO WAS AN ANIMATOR AT HANNA BARBARA & THAT'S HOW I GOT START - ED.

DON WATSON – 01/24/2K2 – CARTOON NETWORK – LOS ANGELES
DON WATSON IS ONE OF THE ORIGINAL COLORISTS ON THE FLINTSTONES SHOW – I MET HIM WHEN MY PAL Q TOOK ME TO CARTOON NETWORK CUZ HE S FRIENDS WITH ALL THOSE ANIMATION FOLKS – IT WAS REALLY EXCITING TO MEET DON BECAUSE THE FLINTSTONES SHOW WAS SUCH A HUGE INFLUENCE ON ME – & THOSE BACKGROUND SCENES THAT JUST REPEAT OVER & OVER WHEN FRED OR BARNEY ARE RUNNING FROM SOME CRAZY DINOSAUR OR WHATEVER – PURE GENIUS – I WAS DRAWING DON AS HE WAS WORKING ON PAINTING SOME CELLS – AFTER THAT WE HAD A WHOLE TOUR OF PLACE – GOT TO MEET LOTS OF ANIMATORS & THEN WE GOT GIVEN SOME AWESOME DEXTER S LABORATORY TOYS!!

I JUST LIKE DRESSING UP IN FURRY COSTUMES CUZ ITS RIDICULOUS - IF YOU ARE FEELING REALLY SAD YOU JUST PUT ON YR SUIT & GET ON YR BIKE & HIT THE STREETS- SEE WHAT HAPPENS-YOU CAN CAUSE QUITE A STIR- I DONT KNOW HOW IT IS FOR ANYONE ELSE BUT FOR ME RIDING AROUND IN AN ANIMAL SUIT YOU CAN MAKE THE MEANEST PERSON LAUGH- IT WAS THE YEAR OF THE RABBIT & CHINESE NEW YEAR WAS COMING UP- I KNEW AESOP HAD A RABBIT SUIT SO I ASKT HIM IF I COULD BORROW IT- I HAD TO LIBERATE SOME RABBIT EARS FROM WALGREENS WHICH THEY HAD BECUZ IT WAS EASTER SEASON - ME & A FRIEND WENT TO JOIN THE PARADE-THEY WOULDNT LET HIM IN BUT THEY LET ME IN SINCE I FIT THE PART- I ENDED UP RIDING IN THE PARADE WANING AT CHILDREN & ASTONISHED FRIENDS FRM MY BIKE - I WAS CHASING THE DRAGON BUT THEN THE DRAGON ENDED UP CHASING ME - ANOTHER FURRY STORY - I'VE BEEN WORKING ON A SUPER 8 FILM ABOUT ANIMAL SUITED FRIENDS WHO HOP TRAINS & GO ON A TRIP TO L.A. - I WAS ASKT TO DO A SLIDE SHOW & I DECIDED TO DO THE BEGINNING OF THE MOVIE IN SLIDES SO A FEW OF US WENT DOWN TO THE OAKLAND TRAIN YARD TO SHOOT & DURING THE COURSE OF STROLLING THRU THE TRAIN YARD AS A BEAR A FOX & 2 RABBITS WE CAUGHT THE ATTENTION OF THE BULLS-WE TRIED TO

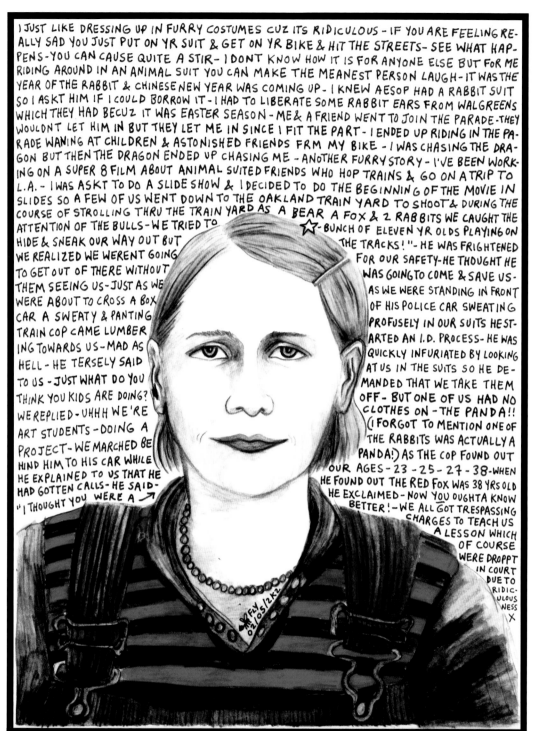

HIDE & SNEAK OUR WAY OUT BUT WE REALIZED WE WERENT GOING TO GET OUT OF THERE WITHOUT THEM SEEING US-JUST AS WE WERE ABOUT TO CROSS A BOX CAR A SWEATY & PANTING TRAIN COP CAME LUMBERING TOWARDS US-MAD AS HELL - HE TERSELY SAID TO US - JUST WHAT DO YOU THINK YOU KIDS ARE DOING? WE REPLIED- UHHH WE'RE ART STUDENTS -DOING A PROJECT-WE MARCHED BEHIND HIM TO HIS CAR WHILE HE EXPLAINED TO US THAT HE HAD GOTTEN CALLS- HE SAID- "I THOUGHT YOU WERE A →

☆- BUNCH OF ELEVEN YR OLDS PLAYING ON THE TRACKS! "- HE WAS FRIGHTENED FOR OUR SAFETY-HE THOUGHT HE WAS GOING TO COME & SAVE US- AS WE WERE STANDING IN FRONT OF HIS POLICE CAR SWEATING PROFUSELY IN OUR SUITS HE STARTED AN I.D. PROCESS- HE WAS QUICKLY INFURIATED BY LOOKING AT US IN THE SUITS SO HE DEMANDED THAT WE TAKE THEM OFF- BUT ONE OF US HAD NO CLOTHES ON -THE PANDA!! (I FORGOT TO MENTION ONE OF THE RABBITS WAS ACTUALLY A PANDA!) AS THE COP FOUND OUT OUR AGES - 23 -25- 27- 38-WHEN HE FOUND OUT THE RED FOX WAS 38 YRS OLD HE EXCLAIMED- NOW YOU OUGHTA KNOW BETTER!-WE ALL GOT TRESPASSING CHARGES TO TEACH US A LESSON WHICH OF COURSE WERE DROPPT IN COURT DUE TO RIDICULOUSNESS X

IVY – 02/05/2K2 – THE TENDERLOIN – SF
I KNEW IVY BEFORE I MET HER CUZ I HAD READ ABOUT HER A LOT IN SCAM ZINE PUT OUT BY IGGY SCAM – THEY BOTH USED TO LIVE & SCAM AROUND MIAMI FLA & SCAM ZINE WAS ALWAYS FULL OF THEIR AWE-INSPIRING EXPLOITS – I ALMOST MET IVY ONE TIME IN NYC WHEN SHE LEFT ME A NOTE AT KINKOS BUT THEN WE FINALLY DID MEET IN SF – SHE TOOK ME ON A TOUR OF SOME COOL SPOTS IN CHINATOWN & THE MISSION & THE TENDERLOIN – WE WENT TO A BANK WHICH WAS LIKE A LITTLE OFFICE IN THE 2ND FLR OF A BUILDING WITH LOTS OF REALLY COOL MURALS DONE BY NEIGHBORHOOD ARTISTS – WE GOT TONS OF FREE STUFF FRM RAINBOW FOODS – WE WALKED A LOT – YAY IVY!

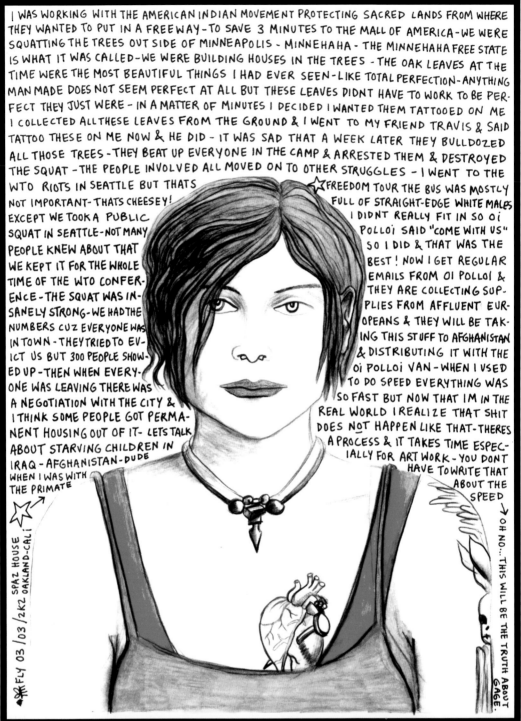

I WAS WORKING WITH THE AMERICAN INDIAN MOVEMENT PROTECTING SACRED LANDS FROM WHERE THEY WANTED TO PUT IN A FREEWAY - TO SAVE 3 MINUTES TO THE MALL OF AMERICA - WE WERE SQUATTING THE TREES OUTSIDE OF MINNEAPOLIS - MINNEHAHA - THE MINNEHAHA FREE STATE IS WHAT IT WAS CALLED - WE WERE BUILDING HOUSES IN THE TREES - THE OAK LEAVES AT THE TIME WERE THE MOST BEAUTIFUL THINGS I HAD EVER SEEN - LIKE TOTAL PERFECTION - ANYTHING MAN MADE DOES NOT SEEM PERFECT AT ALL BUT THESE LEAVES DIDNT HAVE TO WORK TO BE PERFECT THEY JUST WERE - IN A MATTER OF MINUTES I DECIDED I WANTED THEM TATTOOED ON ME I COLLECTED ALL THESE LEAVES FROM THE GROUND & I WENT TO MY FRIEND TRAVIS & SAID TATTOO THESE ON ME NOW & HE DID - IT WAS SAD THAT A WEEK LATER THEY BULLDOZED ALL THOSE TREES - THEY BEAT UP EVERYONE IN THE CAMP & ARRESTED THEM & DESTROYED THE SQUAT - THE PEOPLE INVOLVED ALL MOVED ON TO OTHER STRUGGLES - I WENT TO THE WTO RIOTS IN SEATTLE BUT THATS NOT IMPORTANT - THATS CHEESEY! EXCEPT WE TOOK A PUBLIC SQUAT IN SEATTLE - NOT MANY PEOPLE KNEW ABOUT THAT WE KEPT IT FOR THE WHOLE TIME OF THE WTO CONFERENCE - THE SQUAT WAS INSANELY STRONG - WE HAD THE NUMBERS CUZ EVERYONE WAS IN TOWN - THEY TRIED TO EVICT US BUT 300 PEOPLE SHOWED UP - THEN WHEN EVERYONE WAS LEAVING THERE WAS A NEGOTIATION WITH THE CITY & I THINK SOME PEOPLE GOT PERMANENT HOUSING OUT OF IT - LETS TALK ABOUT STARVING CHILDREN IN IRAQ - AFGHANISTAN - DUDE WHEN I WAS WITH THE PRIMATE

☆FREEDOM TOUR THE BUS WAS MOSTLY FULL OF STRAIGHT-EDGE WHITE MALES I DIDNT REALLY FIT IN SO OÏ POLLOÏ SAID "COME WITH US" SO I DID & THAT WAS THE BEST! NOW I GET REGULAR EMAILS FROM OÏ POLLOÏ & THEY ARE COLLECTING SUPPLIES FROM AFFLUENT EUROPEANS & THEY WILL BE TAKING THIS STUFF TO AFGHANISTAN & DISTRIBUTING IT WITH THE OÏ POLLOÏ VAN - WHEN I USED TO DO SPEED EVERYTHING WAS SO FAST BUT NOW THAT IM IN THE REAL WORLD I REALIZE THAT SHIT DOES NOT HAPPEN LIKE THAT - THERES A PROCESS & IT TAKES TIME ESPECIALLY FOR ART WORK - YOU DONT HAVE TO WRITE THAT ABOUT THE SPEED ↓ OH NO... THIS WILL BE THE TRUTH ABOUT GAGE.

✴FLY 03/03/2K2 SPAZ HOUSE OAKLAND-CALI

Gage – 03/03/2K2 – Oakland
I HAD SEEN A PHOTO OF GAGE YEARS BEFORE I MET HER - SASCHA HAD SENT ME THE PHOTO BECAUSE THIS GIRL GAGE HAD TATTOOED ON HER CHEST A DRAWING THAT I HAD DONE OF A HEART WITH A NAIL THROUGH IT - WHEN SHE CAME TO MY BIRTHDAY PARTY AT THE KILLER BANSHEE STUDIOS I DIDNT RECOGNIZE HER BECAUSE SHE HAD CUT HER HAIR BUT THEN SHE SHOWED ME THE TATTOO & INTRODUCED HERSELF - SHE ALSO GAVE ME SOME LITTLE COLLAGE-COVERED NOTEBOOKS SHE HAD MADE - GAGE WAS LIVING AT THE SPAZ PORT & WE TRIED TO SET UP A SHOW THERE BUT AT THE LAST MINUTE WE HAD TO RE-LOCATE - MOMENTARILY STRESSFUL BUT IT ALL WORKED OUT - THNX GAGE!

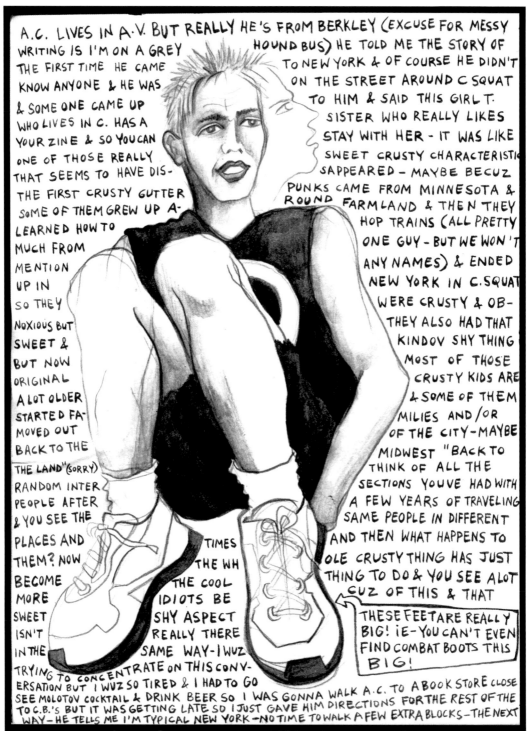

A.C. LIVES IN A.V. BUT REALLY HE'S FROM BERKLEY (EXCUSE FOR MESSY
WRITING IS I'M ON A GREY HOUND BUS) HE TOLD ME THE STORY OF
THE FIRST TIME HE CAME TO NEW YORK & OF COURSE HE DIDN'T
KNOW ANYONE & HE WAS ON THE STREET AROUND C SQUAT
& SOME ONE CAME UP TO HIM & SAID THIS GIRL T.
WHO LIVES IN C. HAS A SISTER WHO REALLY LIKES
YOUR ZINE & SO YOU CAN STAY WITH HER - IT WAS LIKE
ONE OF THOSE REALLY SWEET CRUSTY CHARACTERISTIC
THAT SEEMS TO HAVE DIS- SAPPEARED - MAYBE BECUZ
THE FIRST CRUSTY GUTTER PUNKS CAME FROM MINNESOTA &
SOME OF THEM GREW UP A- ROUND FARMLAND & THEN THEY
LEARNED HOW TO HOP TRAINS (ALL PRETTY
MUCH FROM ONE GUY - BUT WE WON'T
MENTION ANY NAMES) & ENDED
UP IN NEW YORK IN C.SQUAT
SO THEY WERE CRUSTY & OB-
NOXIOUS BUT THEY ALSO HAD THAT
SWEET & KINDOV SHY THING
BUT NOW MOST OF THOSE
ORIGINAL CRUSTY KIDS ARE
A LOT OLDER & SOME OF THEM
STARTED FA- MILIES AND/OR
MOVED OUT OF THE CITY-MAYBE
BACK TO THE MIDWEST "BACK TO
THE LAND" (SORRY) THINK OF ALL THE
RANDOM INTER SECTIONS YOU'VE HAD WITH
PEOPLE AFTER A FEW YEARS OF TRAVELING
& YOU SEE THE SAME PEOPLE IN DIFFERENT
PLACES AND AND THEN WHAT HAPPENS TO
THEM? NOW OLE CRUSTY THING HAS JUST
BECOME THING TO DO & YOU SEE A LOT
MORE CUZ OF THIS & THAT
SWEET
ISN'T
IN THE

TIMES
THE WH
THE COOL
IDIOTS BE
SHY ASPECT
REALLY THERE
SAME WAY-I WUZ

THESE FEET ARE REALLY
BIG! iE-YOU CAN'T EVEN
FIND COMBAT BOOTS THIS
BIG!

TRYING TO CONCENTRATE ON THIS CONV-
ERSATION BUT I WUZ SO TIRED & I HAD TO GO
SEE MOLOTOV COCKTAIL & DRINK BEER SO I WAS GONNA WALK A.C. TO A BOOK STORE CLOSE
TO C.B.'S BUT IT WAS GETTING LATE SO I JUST GAVE HIM DIRECTIONS FOR THE REST OF THE
WAY-HE TELLS ME I'M TYPICAL NEW YORK-NO TIME TO WALK A FEW EXTRA BLOCKS-THE NEXT

AARON COMETBUS - JULY 1999 - LOISAIDA - NYC
I HAD BEEN READING AARONS ZINE COMETBUS FOR YEARS BEFORE I MET HIM - AT SOME
POINT I SENT HIM ONE OF MY FLY POSTCARDS & HE WROTE ME BACK - I THINK HE
THOUGHT I WAS A LITTLE NUTTY AT THAT POINT - EVENTUALLY I MET HIM IN CHICAGO
WHILE I WAS ON TOUR WITH GOD IS MY CO-PILOT & HE WAS ON TOUR WITH GREEN
DAY - I DREW THIS PAGE AFTER AARON & COREY (FRM AUS ROTTEN) HAD A BONDING
MOMENT SOAPING UP THEIR HAIRS TOGETHER - IT WAS SO SWEET - AARON WOULDNT
LET ME WRITE ANYTHING DOWN WHILE WE WERE TALKING SO I MADE UP ALL THE WORDS
WEEKS LATER AS I WAS RIDING A GREYHOUND TO PITTSBURGH TO VISIT THE ROTTENS

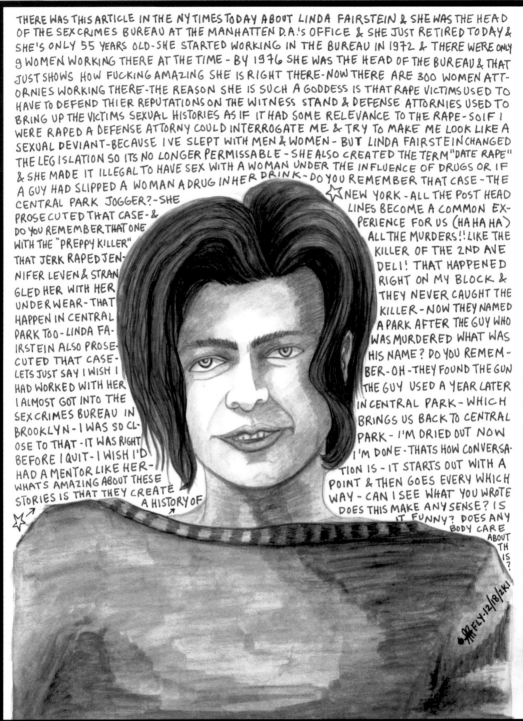

THERE WAS THIS ARTICLE IN THE NY TIMES TODAY ABOUT LINDA FAIRSTEIN & SHE WAS THE HEAD OF THE SEX CRIMES BUREAU AT THE MANHATTEN D.A.'s OFFICE & SHE JUST RETIRED TODAY & SHE'S ONLY 55 YEARS OLD - SHE STARTED WORKING IN THE BUREAU IN 1972 & THERE WERE ONLY 9 WOMEN WORKING THERE AT THE TIME - BY 1976 SHE WAS THE HEAD OF THE BUREAU & THAT JUST SHOWS HOW FUCKING AMAZING SHE IS RIGHT THERE - NOW THERE ARE 300 WOMEN ATTORNIES WORKING THERE - THE REASON SHE IS SUCH A GODDESS IS THAT RAPE VICTIMS USED TO HAVE TO DEFEND THIER REPUTATIONS ON THE WITNESS STAND & DEFENSE ATTORNIES USED TO BRING UP THE VICTIMS SEXUAL HISTORIES AS IF IT HAD SOME RELEVANCE TO THE RAPE - SO IF I WERE RAPED A DEFENSE ATTORNY COULD INTERROGATE ME & TRY TO MAKE ME LOOK LIKE A SEXUAL DEVIANT - BECAUSE I'VE SLEPT WITH MEN & WOMEN - BUT LINDA FAIRSTEIN CHANGED THE LEGISLATION SO ITS NO LONGER PERMISSABLE - SHE ALSO CREATED THE TERM "DATE RAPE" & SHE MADE IT ILLEGAL TO HAVE SEX WITH A WOMAN UNDER THE INFLUENCE OF DRUGS OR IF A GUY HAD SLIPPED A WOMAN A DRUG IN HER DRINK - DO YOU REMEMBER THAT CASE - THE CENTRAL PARK JOGGER? - SHE PROSECUTED THAT CASE - & DO YOU REMEMBER THAT ONE WITH THE "PREPPY KILLER" THAT JERK RAPED JENNIFER LEVEN & STRANGLED HER WITH HER UNDERWEAR - THAT HAPPEN IN CENTRAL PARK TOO - LINDA FAIRSTEIN ALSO PROSECUTED THAT CASE - LETS JUST SAY I WISH I HAD WORKED WITH HER I ALMOST GOT INTO THE SEX CRIMES BUREAU IN BROOKLYN - I WAS SO CLOSE TO THAT - IT WAS RIGHT BEFORE I QUIT - I WISH I'D HAD A MENTOR LIKE HER - WHATS AMAZING ABOUT THESE STORIES IS THAT THEY CREATE A HISTORY OF

NEW YORK - ALL THE POST HEAD LINES BECOME A COMMON EXPERIENCE FOR US (HA HA HA) ALL THE MURDERS!! LIKE THE KILLER OF THE 2ND AVE DELI! THAT HAPPENED RIGHT ON MY BLOCK & THEY NEVER CAUGHT THE KILLER - NOW THEY NAMED A PARK AFTER THE GUY WHO WAS MURDERED WHAT WAS HIS NAME? DO YOU REMEMBER - OH - THEY FOUND THE GUN THE GUY USED A YEAR LATER IN CENTRAL PARK - WHICH BRINGS US BACK TO CENTRAL PARK - I'M DRIED OUT NOW I'M DONE - THATS HOW CONVERSATION IS - IT STARTS OUT WITH A POINT & THEN GOES EVERY WHICH WAY - CAN I SEE WHAT YOU WROTE DOES THIS MAKE ANY SENSE? IS IT FUNNY? DOES ANY BODY CARE ABOUT THIS?

FLY·12/18/2K1

SHARON TOPPER – 12/18/2K1 – NYC
SHARON IS PROBABLY THE FIRST BEST GIRL FRIEND I HAD IN NYC – I MET HER IN 1990 WHEN I WENT TO MY FIRST GOD IS MY CO-PILOT SHOW AT ABC NO RIO – WOW! – I HAD NEVER SEEN A BAND LIKE THAT BEFORE – THEY WERE LIKE PUNK ROCK BUT UMMMM INTERESTING! – & SHARON WAS SO CUTE! – SHE LOOKED LIKE SHE WAS ABOUT 14 YEARS OLD BUT THEN I FOUND OUT SHE S A LAWYER! FOR A WHILE AN ASSISTANT D.A. (YIKES!) – I ENDED UP BEING IN THE BAND FOR SEVERAL YEARS IN THE MID 90s & WE TOURED THE WORLD – IT WAS ACTUALLY REALLY HARD WORK BUT WE HAD SO MUCH FUN!! – WE WERE ROCK STARS IN JAPAN & IN VIENNA THEY MADE US SLEEP IN A ROOM FULL OF DOG SHIT

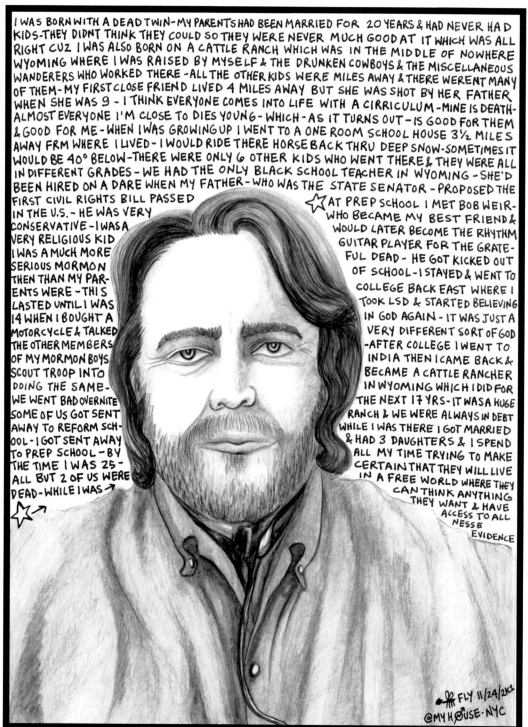

I WAS BORN WITH A DEAD TWIN - MY PARENTS HAD BEEN MARRIED FOR 20 YEARS & HAD NEVER HAD KIDS - THEY DIDNT THINK THEY COULD SO THEY WERE NEVER MUCH GOOD AT IT WHICH WAS ALL RIGHT CUZ I WAS ALSO BORN ON A CATTLE RANCH WHICH WAS IN THE MIDDLE OF NOWHERE WYOMING WHERE I WAS RAISED BY MYSELF & THE DRUNKEN COWBOYS & THE MISCELLANEOUS WANDERERS WHO WORKED THERE - ALL THE OTHER KIDS WERE MILES AWAY & THERE WERENT MANY OF THEM - MY FIRST CLOSE FRIEND LIVED 4 MILES AWAY BUT SHE WAS SHOT BY HER FATHER WHEN SHE WAS 9 - I THINK EVERYONE COMES INTO LIFE WITH A CIRRICULUM - MINE IS DEATH - ALMOST EVERYONE I'M CLOSE TO DIES YOUNG - WHICH - AS IT TURNS OUT - IS GOOD FOR THEM & GOOD FOR ME - WHEN I WAS GROWING UP I WENT TO A ONE ROOM SCHOOL HOUSE 3½ MILES AWAY FRM WHERE I LIVED - I WOULD RIDE THERE HORSEBACK THRU DEEP SNOW - SOMETIMES IT WOULD BE 40° BELOW - THERE WERE ONLY 6 OTHER KIDS WHO WENT THERE & THEY WERE ALL IN DIFFERENT GRADES - WE HAD THE ONLY BLACK SCHOOL TEACHER IN WYOMING - SHE'D BEEN HIRED ON A DARE WHEN MY FATHER - WHO WAS THE STATE SENATOR - PROPOSED THE FIRST CIVIL RIGHTS BILL PASSED IN THE U.S. - HE WAS VERY CONSERVATIVE - I WAS A VERY RELIGIOUS KID I WAS A MUCH MORE SERIOUS MORMON THEN THAN MY PARENTS WERE - THIS LASTED UNTIL I WAS 14 WHEN I BOUGHT A MOTORCYCLE & TALKED THE OTHER MEMBERS OF MY MORMON BOYS SCOUT TROOP INTO DOING THE SAME - WE WENT BAD OVERNITE SOME OF US GOT SENT AWAY TO REFORM SCHOOL - I GOT SENT AWAY TO PREP SCHOOL - BY THE TIME I WAS 25 - ALL BUT 2 OF US WERE DEAD - WHILE I WAS →

☆→

☆ AT PREP SCHOOL I MET BOB WEIR - WHO BECAME MY BEST FRIEND & WOULD LATER BECOME THE RHYTHM GUITAR PLAYER FOR THE GRATEFUL DEAD - HE GOT KICKED OUT OF SCHOOL - I STAYED & WENT TO COLLEGE BACK EAST WHERE I TOOK LSD & STARTED BELIEVING IN GOD AGAIN - IT WAS JUST A VERY DIFFERENT SORT OF GOD - AFTER COLLEGE I WENT TO INDIA THEN I CAME BACK & BECAME A CATTLE RANCHER IN WYOMING WHICH I DID FOR THE NEXT 17 YRS - IT WAS A HUGE RANCH & WE WERE ALWAYS IN DEBT WHILE I WAS THERE I GOT MARRIED & HAD 3 DAUGHTERS & I SPEND ALL MY TIME TRYING TO MAKE CERTAIN THAT THEY WILL LIVE IN A FREE WORLD WHERE THEY CAN THINK ANYTHING THEY WANT & HAVE ACCESS TO ALL NESSE EVIDENCE

FLY 11/24/2K1
@MY HOUSE - NYC

JOHN PERRY BARLOW - 11/24/2K1 - NYC
I HAD HEARD OF BARLOW & THE ELECTRONIC FRONTIER FOUNDATION LONG BEFORE I MET HIM - BARLOW WAS ONE OF THE FOUNDERS OF THE EFF WHICH WAS FORMED IN 1990 WHEN SOME PARTICULARLY BRUTAL HACKER BUSTS WENT DOWN - THE EFF WAS INTERESTED IN TRYING TO FORGE A SORT OF CITIZENS RIGHTS CONSTITUTION FOR CYBERSPACE AMONG OTHER THINGS - I MET BARLOW ONE NIGHT WHEN WE WERE BOTH HANGIN OUT WITH THE INFAMOUS HAKIM BEY & WE BECAME INSTANT PALS - AFTER THAT HE WOULD JUST MATERIALIZE AT ODD TIMES COMPLETE WITH LAPTOP & PLUG INS & ASSORTED VIRTUALITIES - BARLOW IS A TRUE ANOMALY - WWW.EFF.ORG/~BARLOW

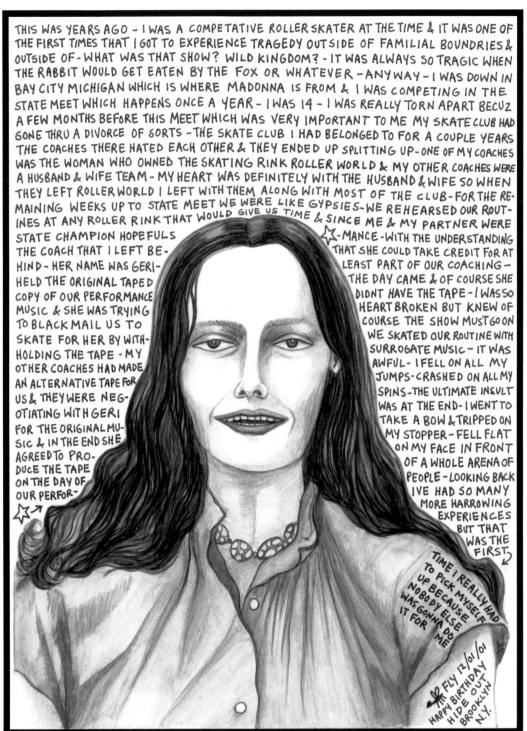

THIS WAS YEARS AGO - I WAS A COMPETATIVE ROLLER SKATER AT THE TIME & IT WAS ONE OF THE FIRST TIMES THAT I GOT TO EXPERIENCE TRAGEDY OUTSIDE OF FAMILIAL BOUNDRIES & OUTSIDE OF - WHAT WAS THAT SHOW? WILD KINGDOM? - IT WAS ALWAYS SO TRAGIC WHEN THE RABBIT WOULD GET EATEN BY THE FOX OR WHATEVER - ANYWAY - I WAS DOWN IN BAY CITY MICHIGAN WHICH IS WHERE MADONNA IS FROM & I WAS COMPETING IN THE STATE MEET WHICH HAPPENS ONCE A YEAR - I WAS 14 - I WAS REALLY TORN APART BECUZ A FEW MONTHS BEFORE THIS MEET WHICH WAS VERY IMPORTANT TO ME MY SKATE CLUB HAD GONE THRU A DIVORCE OF SORTS - THE SKATE CLUB I HAD BELONGED TO FOR A COUPLE YEARS THE COACHES THERE HATED EACH OTHER & THEY ENDED UP SPLITTING UP - ONE OF MY COACHES WAS THE WOMAN WHO OWNED THE SKATING RINK ROLLER WORLD & MY OTHER COACHES WERE A HUSBAND & WIFE TEAM - MY HEART WAS DEFINITELY WITH THE HUSBAND & WIFE SO WHEN THEY LEFT ROLLER WORLD I LEFT WITH THEM ALONG WITH MOST OF THE CLUB - FOR THE RE-MAINING WEEKS UP TO STATE MEET WE WERE LIKE GYPSIES - WE REHEARSED OUR ROUT-INES AT ANY ROLLER RINK THAT WOULD GIVE US TIME & SINCE ME & MY PARTNER WERE STATE CHAMPION HOPEFULS

THE COACH THAT I LEFT BE-HIND - HER NAME WAS GERI- HELD THE ORIGINAL TAPED COPY OF OUR PERFORMANCE MUSIC & SHE WAS TRYING TO BLACKMAIL US TO SKATE FOR HER BY WITH-HOLDING THE TAPE - MY OTHER COACHES HAD MADE AN ALTERNATIVE TAPE FOR US & THEY WERE NEG-OTIATING WITH GERI FOR THE ORIGINAL MU-SIC & IN THE END SHE AGREED TO PRO-DUCE THE TAPE ON THE DAY OF OUR PERFOR-

-MANCE - WITH THE UNDERSTANDING THAT SHE COULD TAKE CREDIT FOR AT LEAST PART OF OUR COACHING - THE DAY CAME & OF COURSE SHE DIDNT HAVE THE TAPE - I WAS SO HEART BROKEN BUT KNEW OF COURSE THE SHOW MUST GO ON WE SKATED OUR ROUTINE WITH SURROGATE MUSIC - IT WAS AWFUL - I FELL ON ALL MY JUMPS - CRASHED ON ALL MY SPINS - THE ULTIMATE INSULT WAS AT THE END - I WENT TO TAKE A BOW & TRIPPED ON MY STOPPER - FELL FLAT ON MY FACE IN FRONT OF A WHOLE ARENA OF PEOPLE - LOOKING BACK IVE HAD SO MANY MORE HARROWING EXPERIENCES BUT THAT WAS THE FIRST.

TIME I REALLY HAD TO PICK MYSELF UP BECAUSE NOBODY ELSE WAS GONNA DO IT FOR ME

FLY 12/01/01 HAPPY BIRTHDAY HIDE OUT BROOKLYN N.Y.

DREIKY CAPRICE – 12/01/2K1 – WILLIAMSBURG – NYC
I FIRST MET DREIKY WHEN SHE WAS DRUMMING WITH CRASH WORSHIP IN THE MID 90s & LET ME TELL YOU SHE IS ONE BADASS DRUMMER – CRASH WORSHIP WAS THIS INSANE INDUSTRIAL TRIBAL ELECTRONICAL DRUMMING ENSEMBLE – THEIRSHOWS WOULD ALWAYS GET REALLY OUT OF CONTROL WITH THE BLOOD & WINE FLYING – DREIKY ENDED UP STAY-ING IN MY BUILDING FOR ONE WINTER SO I GOT TO HANG OUT WITH HER & SETH & THEIR DOGS CAIN & BEAN – DREIKY NOW LIVES AT THE HAPPY BIRTHDAY HIDEOUT WITH BEAN & SOME OTHER COOL FOLKS – SHE SINGS AND PLAYS DRUMS WITH HER NEW BAND T.V.X. & SHE MAKES THE FCKN BEST PUNKIN PIE!! – DREIKY@HOTMAIL.COM

WE CANT TALK ABOUT PERSONAL SHIT CUZ WHO KNOWS WHO WILL BE READING THIS - TORTILLA CHIPS ARE BULLSHIT - ITS ALL ABOUT POTATOE CHIPS - LATELY IVE BEEN GETTING INTO CHEDDAR CHEESE - I USED TO EAT POTATOE CHIPS AS A KID - I WOULD EAT A ONE POUND BAG IN ONE SITTING - THAT WAS BACK WHEN A POUND WAS A POUND - CAN YOU BELIEVE A 2X4 IS ACTUALLY... (HA HA HA) MODERN WORLD - EVERYTIME I OPEN MY MOUTH I GET INTO MORE TROUBLE - I'M SO TIRED OF PEOPLE USING THE INFORMATION I GIVE THEM TO BEAT ME OVER THE HEAD - WHY CANT THEY THINK FOR THEMSELVES - PICK UP THIER OWN WEAPONS - DONT USE MINE - IVE BEEN HAVING THE WIERDEST MEMORY FLASHBACKS SINCE 9-11 - I REMEMBER SWIMMING IN A POOL - NO I WASNT SWIMMING - I WAS DROWNING - I MUST HAVE BEEN ABOUT 7 OR 8 YRS OLD & I DIDNT REALLY KNOW HOW TO SWIM BUT I JUMPED INTO THE DEEP PART OF THE POOL AT SOME HOTEL IN MEXICO & I STARTED SINKING - YOU KNOW HOW YOU DO THE DOG PADDLE TO STAY UP - I WAS GRABBING HANDFULS OF WATER & I WAS

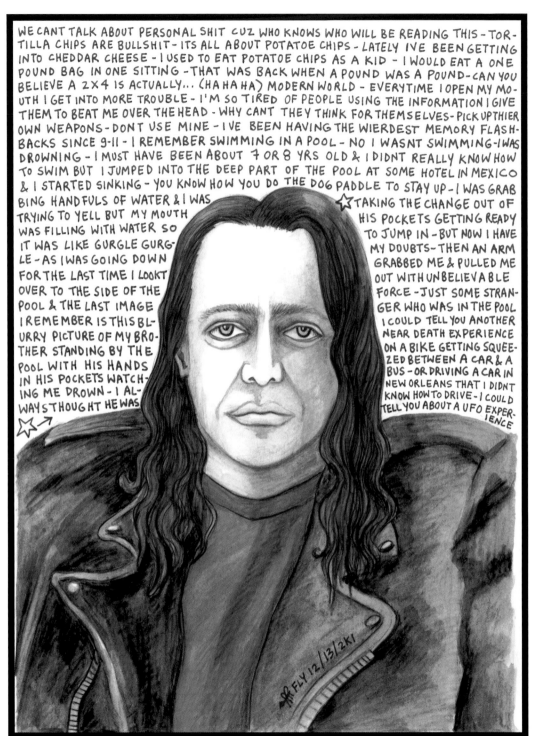

TRYING TO YELL BUT MY MOUTH WAS FILLING WITH WATER SO IT WAS LIKE GURGLE GURGLE - AS I WAS GOING DOWN FOR THE LAST TIME I LOOKT OVER TO THE SIDE OF THE POOL & THE LAST IMAGE I REMEMBER IS THIS BLURRY PICTURE OF MY BROTHER STANDING BY THE POOL WITH HIS HANDS IN HIS POCKETS WATCHING ME DROWN - I ALWAYS THOUGHT HE WAS

TAKING THE CHANGE OUT OF HIS POCKETS GETTING READY TO JUMP IN - BUT NOW I HAVE MY DOUBTS - THEN AN ARM GRABBED ME & PULLED ME OUT WITH UNBELIEVABLE FORCE - JUST SOME STRANGER WHO WAS IN THE POOL I COULD TELL YOU ANOTHER NEAR DEATH EXPERIENCE ON A BIKE GETTING SQUEEZED BETWEEN A CAR & A BUS - OR DRIVING A CAR IN NEW ORLEANS THAT I DIDNT KNOW HOW TO DRIVE - I COULD TELL YOU ABOUT A UFO EXPERIENCE

JOHN ZORN – 12/13/2K1 – LOWER EAST SIDE – NYC
ZORN LIVES ACROSS THE STREET FROM ME & I SEE HIM ALL THE TIME RUNNING TO GIGS OR JUMPING IN A CAB TO GO TO THE AIRPORT TO GO TO JAPAN – ZORN IS FAMOUS FOR MAKING INSANE SOUNDS ON A SAX & ALSO FOR TOTALLY SHAKING UP THE JAZZ WORLD – I REALLY DON T KNOW TOO MUCH ABOUT JAZZ BUT I KNOW THAT ZORN S MUSIC CAN REALLY TWIST MY HEAD – HE S PRODUCED A LOT OF CD S ON HIS LABEL – TZADIK – WHENEVER I SEE HIM HE ALWAYS HAS A BIG SMILE – ONE TIME LAW & ORDER WAS FILMING ON OUR STREET & THEY WERE TRYING TO MAKE EVERYONE BE QUIET & ZORN WAS ACROSS THE STREET FROM ME & WE BOTH JUST STARTED YELLING & RUINED THE WHOLE TAKE – HA!

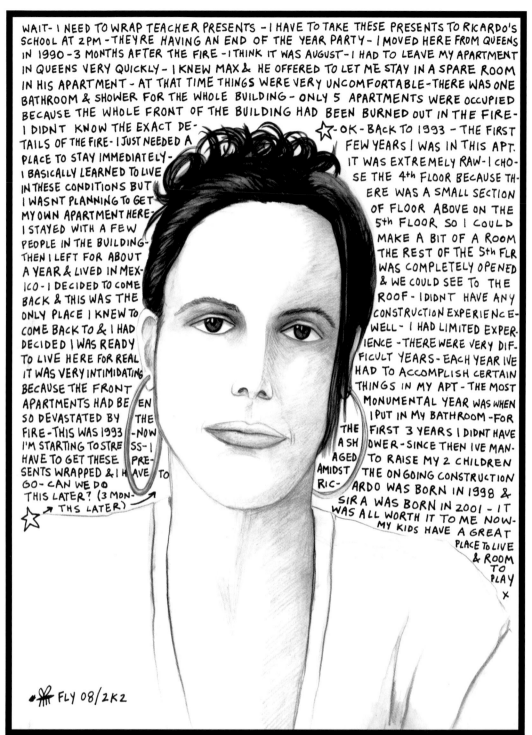

WAIT- I NEED TO WRAP TEACHER PRESENTS - I HAVE TO TAKE THESE PRESENTS TO RICARDO'S SCHOOL AT 2PM - THEY'RE HAVING AN END OF THE YEAR PARTY - I MOVED HERE FROM QUEENS IN 1990 - 3 MONTHS AFTER THE FIRE - I THINK IT WAS AUGUST - I HAD TO LEAVE MY APARTMENT IN QUEENS VERY QUICKLY - I KNEW MAX & HE OFFERED TO LET ME STAY IN A SPARE ROOM IN HIS APARTMENT - AT THAT TIME THINGS WERE VERY UNCOMFORTABLE - THERE WAS ONE BATHROOM & SHOWER FOR THE WHOLE BUILDING - ONLY 5 APARTMENTS WERE OCCUPIED BECAUSE THE WHOLE FRONT OF THE BUILDING HAD BEEN BURNED OUT IN THE FIRE -

I DIDN'T KNOW THE EXACT DETAILS OF THE FIRE - I JUST NEEDED A PLACE TO STAY IMMEDIATELY - I BASICALLY LEARNED TO LIVE IN THESE CONDITIONS BUT I WASN'T PLANNING TO GET MY OWN APARTMENT HERE - I STAYED WITH A FEW PEOPLE IN THE BUILDING - THEN I LEFT FOR ABOUT A YEAR & LIVED IN MEXICO - I DECIDED TO COME BACK & THIS WAS THE ONLY PLACE I KNEW TO COME BACK TO & I HAD DECIDED I WAS READY TO LIVE HERE FOR REAL IT WAS VERY INTIMIDATING BECAUSE THE FRONT APARTMENTS HAD BEEN SO DEVASTATED BY THE FIRE - THIS WAS 1993 - NOW I'M STARTING TO STRESS - I HAVE TO GET THESE PRESENTS WRAPPED & I HAVE TO GO - CAN WE DO THIS LATER? (3 MONTHS LATER)

-OK- BACK TO 1993 - THE FIRST FEW YEARS I WAS IN THIS APT. IT WAS EXTREMELY RAW - I CHOSE THE 4th FLOOR BECAUSE THERE WAS A SMALL SECTION OF FLOOR ABOVE ON THE 5th FLOOR SO I COULD MAKE A BIT OF A ROOM THE REST OF THE 5th FLR WAS COMPLETELY OPENED & WE COULD SEE TO THE ROOF - I DIDN'T HAVE ANY CONSTRUCTION EXPERIENCE - WELL- I HAD LIMITED EXPERIENCE - THERE WERE VERY DIFFICULT YEARS - EACH YEAR I'VE HAD TO ACCOMPLISH CERTAIN THINGS IN MY APT - THE MOST MONUMENTAL YEAR WAS WHEN I PUT IN MY BATHROOM - FOR THE FIRST 3 YEARS I DIDN'T HAVE A SHOWER - SINCE THEN I'VE MANAGED TO RAISE MY 2 CHILDREN AMIDST THE ONGOING CONSTRUCTION RICARDO WAS BORN IN 1998 & SIRA WAS BORN IN 2001 - IT WAS ALL WORTH IT TO ME NOW - MY KIDS HAVE A GREAT PLACE TO LIVE & ROOM TO PLAY

x

FLY 08/2K2

APRIL MERLIN – AUGUST 2K2 – LOWER EAST SIDE – NYC
I MET APRIL IN 1993 WHEN SHE ARRIVED BACK IN NYC FROM MEXICO & SHE MOVED INTO THE 4TH FLOOR OF MY BUILDING – IT WAS REALLY RAW BACK THEN & SHE HAD TO DO A LOT OF WORK BUT SHE HAD THE FRONT SECTION OF THE APARTMENT DONE VERY QUICKLY SO SHE COULD LIVE THERE – & THE WORK WAS BEAUTIFULLY DONE – APRIL IS ONE OF THE BUSIEST PEOPLE I KNOW & SHE MANAGES TO GET A HELL OF A LOT DONE SUCH AS BUILDING HER APARTMENT WHILE RAISING 2 KIDS WHILE TAKING CARE OF A LOT OF THE BUSINESS & ORGANIZING BEHIND KEEPING OUR BUILDING TOGETHER – IT LOOKS LIKE WE ARE ALL GONNA BE PRETTY DAMN BUSY FOR A WHILE YET.

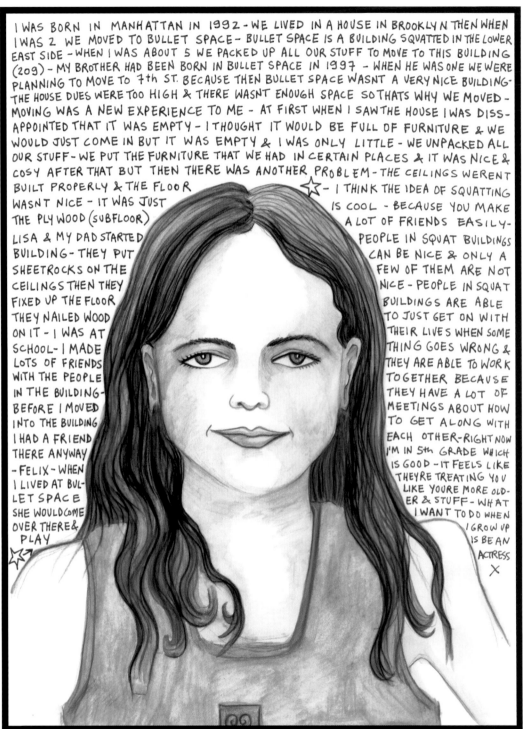

I WAS BORN IN MANHATTAN IN 1992 - WE LIVED IN A HOUSE IN BROOKLYN THEN WHEN I WAS 2 WE MOVED TO BULLET SPACE - BULLET SPACE IS A BUILDING SQUATTED IN THE LOWER EAST SIDE - WHEN I WAS ABOUT 5 WE PACKED UP ALL OUR STUFF TO MOVE TO THIS BUILDING (209) - MY BROTHER HAD BEEN BORN IN BULLET SPACE IN 1997 - WHEN HE WAS ONE WE WERE PLANNING TO MOVE TO 7th ST. BECAUSE THEN BULLET SPACE WASNT A VERY NICE BUILDING - THE HOUSE DUES WERE TOO HIGH & THERE WASNT ENOUGH SPACE SO THATS WHY WE MOVED - MOVING WAS A NEW EXPERIENCE TO ME - AT FIRST WHEN I SAW THE HOUSE I WAS DISS- APPOINTED THAT IT WAS EMPTY - I THOUGHT IT WOULD BE FULL OF FURNITURE & WE WOULD JUST COME IN BUT IT WAS EMPTY & I WAS ONLY LITTLE - WE UNPACKED ALL OUR STUFF - WE PUT THE FURNITURE THAT WE HAD IN CERTAIN PLACES & IT WAS NICE & COSY AFTER THAT BUT THEN THERE WAS ANOTHER PROBLEM - THE CEILINGS WERENT BUILT PROPERLY & THE FLOOR WASNT NICE - IT WAS JUST THE PLYWOOD (SUBFLOOR) LISA & MY DAD STARTED BUILDING - THEY PUT SHEETROCKS ON THE CEILINGS THEN THEY FIXED UP THE FLOOR THEY NAILED WOOD ON IT - I WAS AT SCHOOL - I MADE LOTS OF FRIENDS WITH THE PEOPLE IN THE BUILDING - BEFORE I MOVED INTO THE BUILDING I HAD A FRIEND THERE ANYWAY - FELIX - WHEN I LIVED AT BUL- LET SPACE SHE WOULD COME OVER THERE & PLAY

☆ - I THINK THE IDEA OF SQUATTING IS COOL - BECAUSE YOU MAKE A LOT OF FRIENDS EASILY - PEOPLE IN SQUAT BUILDINGS CAN BE NICE & ONLY A FEW OF THEM ARE NOT NICE - PEOPLE IN SQUAT BUILDINGS ARE ABLE TO JUST GET ON WITH THEIR LIVES WHEN SOMETHING GOES WRONG & THEY ARE ABLE TO WORK TOGETHER BECAUSE THEY HAVE A LOT OF MEETINGS ABOUT HOW TO GET ALONG WITH EACH OTHER - RIGHT NOW I'M IN 5th GRADE WHICH IS GOOD - IT FEELS LIKE THEYRE TREATING YOU LIKE YOURE MORE OLD- ER & STUFF - WHAT I WANT TO DO WHEN I GROW UP IS BE AN ACTRESS X

GILLIAN MUNIZ-ROBERTS - SUMMER 2K2 - LOWER EAST SIDE - NYC
GILLIAN IS A VERY TALENTED & BEAUTIFUL 9 YEAR OLD - SHE LIVES ON THE SIXTH FLOOR OF MY BUILDING WITH LISA & HER DAD & BROTHER & SISTER - I FIRST MET GILLIAN JUST A WEEK OR SO AFTER SHE HAD BEEN BORN WHEN I RAN INTO HER MOM IN TOMPKINS SQUARE PARK - SHE WAS AN INCREDIBLE BABY WITH THE BIGGEST MOST BEAUTIFUL EYES - GILLIAN IS A WRITER & SHE HAS ALREADY WRITTEN A FEW BOOKS WHICH SHE HAS ALSO ILLUSTRATED - SHE IS ALSO A PERFORMER & RECENTLY GOT A PART DOING VOCAL ACTING ON A PILOT FOR AN ANIMATED SERIES - ON TOP OF ALL THAT SHE CAN SING! - GILLIANS FIRST ZINE WILL HOPEFULLY BE OUT BEFORE 2K4 SO KEEP YR EYES OUT!

145

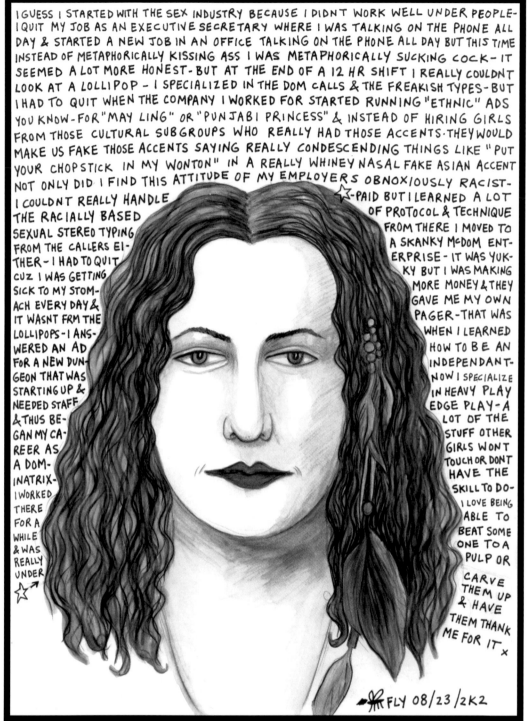

I GUESS I STARTED WITH THE SEX INDUSTRY BECAUSE I DIDN'T WORK WELL UNDER PEOPLE-I QUIT MY JOB AS AN EXECUTIVE SECRETARY WHERE I WAS TALKING ON THE PHONE ALL DAY & STARTED A NEW JOB IN AN OFFICE TALKING ON THE PHONE ALL DAY BUT THIS TIME INSTEAD OF METAPHORICALLY KISSING ASS I WAS METAPHORICALLY SUCKING COCK-IT SEEMED A LOT MORE HONEST-BUT AT THE END OF A 12 HR SHIFT I REALLY COULDN'T LOOK AT A LOLLIPOP - I SPECIALIZED IN THE DOM CALLS & THE FREAKISH TYPES-BUT I HAD TO QUIT WHEN THE COMPANY I WORKED FOR STARTED RUNNING "ETHNIC" ADS YOU KNOW-FOR "MAY LING" OR "PUNJABI PRINCESS" & INSTEAD OF HIRING GIRLS FROM THOSE CULTURAL SUBGROUPS WHO REALLY HAD THOSE ACCENTS. THEY WOULD MAKE US FAKE THOSE ACCENTS SAYING REALLY CONDESCENDING THINGS LIKE "PUT YOUR CHOPSTICK IN MY WONTON" IN A REALLY WHINEY NASAL FAKE ASIAN ACCENT NOT ONLY DID I FIND THIS ATTITUDE OF MY EMPLOYERS OBNOXIOUSLY RACIST-

I COULDN'T REALLY HANDLE THE RACIALLY BASED SEXUAL STEREO TYPING FROM THE CALLERS EI-THER - I HAD TO QUIT CUZ I WAS GETTING SICK TO MY STOM-ACH EVERY DAY & IT WASN'T FRM THE LOLLIPOPS-I ANS-WERED AN AD FOR A NEW DUN-GEON THAT WAS STARTING UP & NEEDED STAFF & THUS BE-GAN MY CA-REER AS A DOM-INATRIX-I WORKED THERE FOR A WHILE & WAS REALLY UNDER ☆→

☆-PAID BUT I LEARNED A LOT OF PROTOCOL & TECHNIQUE FROM THERE I MOVED TO A SKANKY McDOM ENT-ERPRISE - IT WAS YUK-KY BUT I WAS MAKING MORE MONEY & THEY GAVE ME MY OWN PAGER-THAT WAS WHEN I LEARNED HOW TO BE AN INDEPENDANT-NOW I SPECIALIZE IN HEAVY PLAY EDGE PLAY-A LOT OF THE STUFF OTHER GIRLS WON'T TOUCH OR DON'T HAVE THE SKILL TO DO-I LOVE BEING ABLE TO BEAT SOME ONE TO A PULP OR CARVE THEM UP & HAVE THEM THANK ME FOR IT x

→FLY 08/23/2K2

MISS BARBRA FISCH – 08/23/2K2 – TORONTO
I MET MISS FISCH BACK IN THE 80S WHEN SHE WAS A SALMON HUT KID – THEY WERE CRAZY MULTITALENTED ART KIDS – SINCE THEN I HAVE CONTINUED TO SEE MISS FISCH – UMMMMM – "DEVELOP" – I HAD A BLAST HANGIN OUT WITH HER THIS PAST SUMMER IN TORONTO – WE WENT SHOE SHOPPING ONE DAY BUT WE DIDNT END UP BUYING ANY SHOES BECAUSE WE WERE TOO BUSY POSING WITH ALL THE MOST DANGEROUS SPIKE HEELS – LICKING THEM & TAKING PICTURES OF OURSELVES – THEN SHE GOT ME INTO THE LE TIGRE SHOW WHERE SHE WAS DJING & I EVEN GOT TO MEET KATHLEEN HANNA! – MISS FISCH HAS A KICK ASS RADIO SHOW ALL ABOUT METAL – SATANTAKESAHOLIDAY@DEVIL.COM

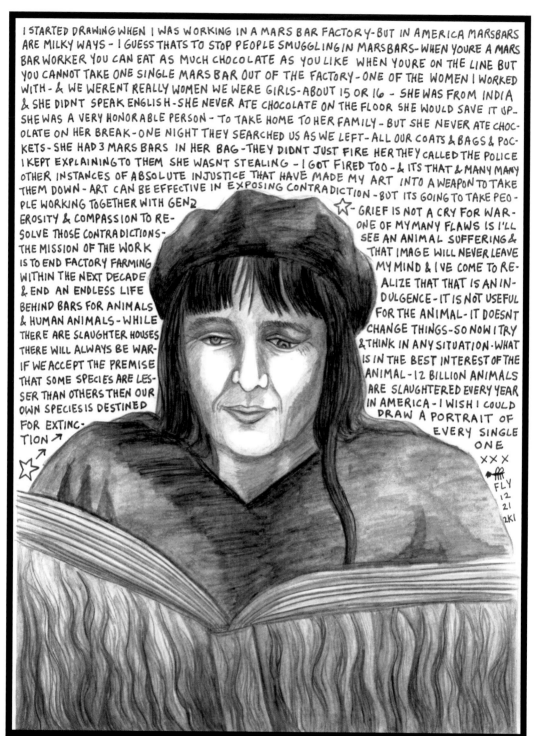

I STARTED DRAWING WHEN I WAS WORKING IN A MARS BAR FACTORY - BUT IN AMERICA MARSBARS ARE MILKY WAYS - I GUESS THATS TO STOP PEOPLE SMUGGLING IN MARSBARS - WHEN YOURE A MARS BAR WORKER YOU CAN EAT AS MUCH CHOCOLATE AS YOU LIKE WHEN YOURE ON THE LINE BUT YOU CANNOT TAKE ONE SINGLE MARS BAR OUT OF THE FACTORY - ONE OF THE WOMEN I WORKED WITH - & WE WERENT REALLY WOMEN WE WERE GIRLS - ABOUT 15 OR 16 - SHE WAS FROM INDIA & SHE DIDNT SPEAK ENGLISH - SHE NEVER ATE CHOCOLATE ON THE FLOOR SHE WOULD SAVE IT UP - SHE WAS A VERY HONORABLE PERSON - TO TAKE HOME TO HER FAMILY - BUT SHE NEVER ATE CHOCOLATE ON HER BREAK - ONE NIGHT THEY SEARCHED US AS WE LEFT - ALL OUR COATS & BAGS & POCKETS - SHE HAD 3 MARS BARS IN HER BAG - THEY DIDNT JUST FIRE HER THEY CALLED THE POLICE I KEPT EXPLAINING TO THEM SHE WASNT STEALING - I GOT FIRED TOO - & ITS THAT & MANY MANY OTHER INSTANCES OF ABSOLUTE INJUSTICE THAT HAVE MADE MY ART INTO A WEAPON TO TAKE THEM DOWN - ART CAN BE EFFECTIVE IN EXPOSING CONTRADICTION - BUT ITS GOING TO TAKE PEOPLE WORKING TOGETHER WITH GENEROSITY & COMPASSION TO RESOLVE THOSE CONTRADICTIONS - THE MISSION OF THE WORK IS TO END FACTORY FARMING WITHIN THE NEXT DECADE & END AN ENDLESS LIFE BEHIND BARS FOR ANIMALS & HUMAN ANIMALS - WHILE THERE ARE SLAUGHTER HOUSES THERE WILL ALWAYS BE WAR - IF WE ACCEPT THE PREMISE THAT SOME SPECIES ARE LESSER THAN OTHERS THEN OUR OWN SPECIES IS DESTINED FOR EXTINCTION →

GRIEF IS NOT A CRY FOR WAR - ONE OF MY MANY FLAWS IS I'LL SEE AN ANIMAL SUFFERING & THAT IMAGE WILL NEVER LEAVE MY MIND & I'VE COME TO REALIZE THAT THAT IS AN INDULGENCE - IT IS NOT USEFUL FOR THE ANIMAL - IT DOESNT CHANGE THINGS - SO NOW I TRY & THINK IN ANY SITUATION - WHAT IS IN THE BEST INTEREST OF THE ANIMAL - 12 BILLION ANIMALS ARE SLAUGHTERED EVERY YEAR IN AMERICA - I WISH I COULD DRAW A PORTRAIT OF EVERY SINGLE ONE XXX

FLY
12
21
2K1

SUE COE - 12/21/2K1 - WEST VILLAGE - NYC

SUE COE IS A POWERFUL PAINTER - I FIRST SAW HER WORK IN THE 80 S WHEN I WAS STILL IN SCHOOL - I SAW SOME OF HER PAINTINGS OF SCENES IN SLAUGHTER HOUSES & I WAS COMPLETELY BLOWN AWAY - HER SKILL AS A PAINTER & THE INTENSITY OF THE SUBJECT MATTER HAD A HUGE IMPACT ON ME - IT MADE ME START TO QUESTION WHAT I WAS DOING WITH MY OWN "ART" & WHAT DID I WANT TO DO - SUDDENLY I WAS SERIOUSLY CONSIDERING THE POLITIAL POWER OF IMAGES - ALSO I WISHED I COULD PAINT AS WELL AS HER - I FINALLY GOT TO MEET HER WHEN SETH TOBOCMAN SET UP A SLIDE SHOW WITH SUE & HIM & ME - THAT WAS A HUGE THRILL!!

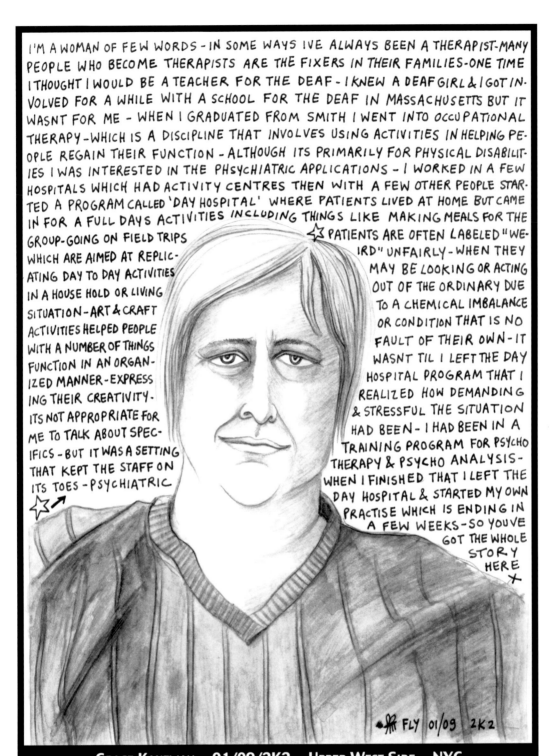

I'M A WOMAN OF FEW WORDS - IN SOME WAYS IVE ALWAYS BEEN A THERAPIST-MANY PEOPLE WHO BECOME THERAPISTS ARE THE FIXERS IN THEIR FAMILIES-ONE TIME I THOUGHT I WOULD BE A TEACHER FOR THE DEAF - I KNEW A DEAF GIRL & I GOT INVOLVED FOR A WHILE WITH A SCHOOL FOR THE DEAF IN MASSACHUSETTS BUT IT WASNT FOR ME - WHEN I GRADUATED FROM SMITH I WENT INTO OCCUPATIONAL THERAPY -WHICH IS A DISCIPLINE THAT INVOLVES USING ACTIVITIES IN HELPING PEOPLE REGAIN THEIR FUNCTION - ALTHOUGH ITS PRIMARILY FOR PHYSICAL DISABILITIES I WAS INTERESTED IN THE PHSYCIATRIC APPLICATIONS - I WORKED IN A FEW HOSPITALS WHICH HAD ACTIVITY CENTRES THEN WITH A FEW OTHER PEOPLE STARTED A PROGRAM CALLED 'DAY HOSPITAL' WHERE PATIENTS LIVED AT HOME BUT CAME IN FOR A FULL DAYS ACTIVITIES INCLUDING THINGS LIKE MAKING MEALS FOR THE GROUP-GOING ON FIELD TRIPS WHICH ARE AIMED AT REPLICATING DAY TO DAY ACTIVITIES IN A HOUSE HOLD OR LIVING SITUATION-ART & CRAFT ACTIVITIES HELPED PEOPLE WITH A NUMBER OF THINGS FUNCTION IN AN ORGANIZED MANNER-EXPRESSING THEIR CREATIVITY. ITS NOT APPROPRIATE FOR ME TO TALK ABOUT SPECIFICS - BUT IT WAS A SETTING THAT KEPT THE STAFF ON ITS TOES -PSYCHIATRIC

☆→ PATIENTS ARE OFTEN LABELED "WEIRD" UNFAIRLY -WHEN THEY MAY BE LOOKING OR ACTING OUT OF THE ORDINARY DUE TO A CHEMICAL IMBALANCE OR CONDITION THAT IS NO FAULT OF THEIR OWN - IT WASNT TIL I LEFT THE DAY HOSPITAL PROGRAM THAT I REALIZED HOW DEMANDING & STRESSFUL THE SITUATION HAD BEEN - I HAD BEEN IN A TRAINING PROGRAM FOR PSYCHO THERAPY & PSYCHO ANALYSIS- WHEN I FINISHED THAT I LEFT THE DAY HOSPITAL & STARTED MY OWN PRACTISE WHICH IS ENDING IN A FEW WEEKS -SO YOUVE GOT THE WHOLE STORY HERE ✗

FLY 01/09 2K2

GRACE KAUFMAN – 01/09/2K2 – UPPER WEST SIDE – NYC
OK - SO FOR A WHILE I GOT REALLY DEPRESSED & IT WAS REALLY BAD & I TRIED LOTS OF THINGS BUT IT WAS JUST GETTING WORSE & I WAS GETTING REALLY SKINNY & SCARING PEOPLE SO I THOUGHT OK I WILL TRY GOING TO A THERAPIST – SO I GOT ACCEPTED INTO A SPECIAL PROGRAM FOR STARVING FCKTUP ARTISTS & GRACE ENDED UP BEING MY THERAPIST – I DREW THIS DURING OUR LAST FEW SESSIONS – I HAD BEEN SEEING HER FOR ABOUT A YEAR & NOW SHE WAS RETIRING & I WAS VERY SAD ABOUT THIS BECAUSE I HAD SORT OF GOTTEN USED TO TALKING TO HER – I NEVER HAD A THERAPIST BEFORE SO I HAVE NOTHING TO COMPARE HER TO BUT SHE SORT OF BECAME A MOM TYPE FIGURE
& I MISS HER

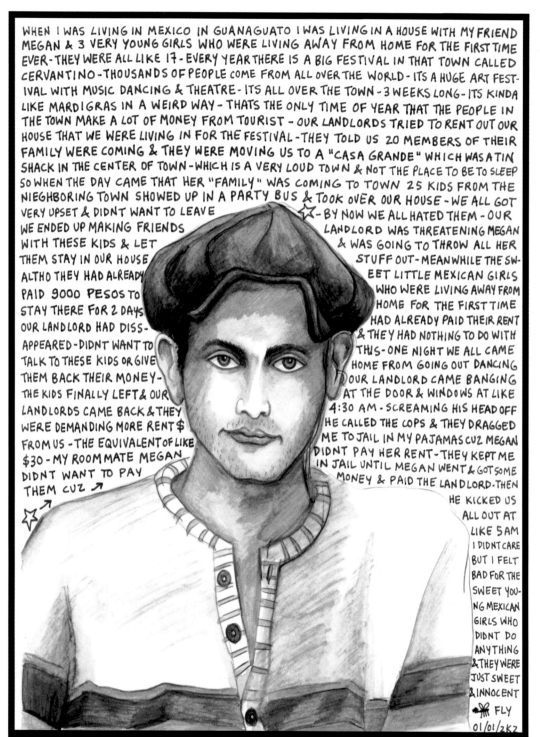

WHEN I WAS LIVING IN MEXICO IN GUANAGUATO I WAS LIVING IN A HOUSE WITH MY FRIEND MEGAN & 3 VERY YOUNG GIRLS WHO WERE LIVING AWAY FROM HOME FOR THE FIRST TIME EVER - THEY WERE ALL LIKE 17 - EVERY YEAR THERE IS A BIG FESTIVAL IN THAT TOWN CALLED CERVANTINO - THOUSANDS OF PEOPLE COME FROM ALL OVER THE WORLD - ITS A HUGE ART FESTIVAL WITH MUSIC DANCING & THEATRE - ITS ALL OVER THE TOWN - 3 WEEKS LONG - ITS KINDA LIKE MARDI GRAS IN A WEIRD WAY - THATS THE ONLY TIME OF YEAR THAT THE PEOPLE IN THE TOWN MAKE A LOT OF MONEY FROM TOURIST - OUR LANDLORDS TRIED TO RENT OUT OUR HOUSE THAT WE WERE LIVING IN FOR THE FESTIVAL - THEY TOLD US 20 MEMBERS OF THEIR FAMILY WERE COMING & THEY WERE MOVING US TO A "CASA GRANDE" WHICH WAS A TIN SHACK IN THE CENTER OF TOWN - WHICH IS A VERY LOUD TOWN & NOT THE PLACE TO BE TO SLEEP SO WHEN THE DAY CAME THAT HER "FAMILY" WAS COMING TO TOWN 25 KIDS FROM THE NIEGHBORING TOWN SHOWED UP IN A PARTY BUS & TOOK OVER OUR HOUSE - WE ALL GOT VERY UPSET & DIDNT WANT TO LEAVE

WE ENDED UP MAKING FRIENDS WITH THESE KIDS & LET THEM STAY IN OUR HOUSE ALTHO THEY HAD ALREADY PAID 9000 PESOS TO STAY THERE FOR 2 DAYS OUR LANDLORD HAD DISSAPPEARED - DIDNT WANT TO TALK TO THESE KIDS OR GIVE THEM BACK THEIR MONEY - THE KIDS FINALLY LEFT & OUR LANDLORDS CAME BACK & THEY WERE DEMANDING MORE RENT $ FROM US - THE EQUIVALENT OF LIKE $30 - MY ROOMMATE MEGAN DIDNT WANT TO PAY THEM CUZ ↗

- BY NOW WE ALL HATED THEM - OUR LANDLORD WAS THREATENING MEGAN & WAS GOING TO THROW ALL HER STUFF OUT - MEANWHILE THE SWEET LITTLE MEXICAN GIRLS WHO WERE LIVING AWAY FROM HOME FOR THE FIRST TIME HAD ALREADY PAID THEIR RENT & THEY HAD NOTHING TO DO WITH THIS - ONE NIGHT WE ALL CAME HOME FROM GOING OUT DANCING OUR LANDLORD CAME BANGING AT THE DOOR & WINDOWS AT LIKE 4:30 AM - SCREAMING HIS HEAD OFF HE CALLED THE COPS & THEY DRAGGED ME TO JAIL IN MY PAJAMAS CUZ MEGAN DIDNT PAY HER RENT - THEY KEPT ME IN JAIL UNTIL MEGAN WENT & GOT SOME MONEY & PAID THE LANDLORD - THEN HE KICKED US ALL OUT AT LIKE 5 AM I DIDNT CARE BUT I FELT BAD FOR THE SWEET YOUNG MEXICAN GIRLS WHO DIDNT DO ANYTHING & THEY WERE JUST SWEET & INNOCENT FLY 01/01/2K2

ROB – 01/01/2K2 – LOWER EAST SIDE – NYC

ROB WAS FAMOUS' ROOMMATE UPSTAIRS IN MY BUILDING FOR A LONG TIME — HE HAD THIS DOG JAKE WHO WOULD GO NUTS BARKING & SOUNDED LIKE HE WANTED TO KILL YOU IF YOU KNOCKED ON THEIR DOOR — & THEN EVERYONE WOULD START SCREAMING SHUT UP JAKE SHUT UP SHUT UP!!! — BEFORE HE LIVED WITH FAE I THINK HE WAS STAYING OVER AT C SQUAT — I DON T WANT TO TELL STORIES BUT I THINK I REMEMBER HIM SHAKIN HIS GROOVE THING TO SOME SERIOUS OLD–SCHOOL MICHAEL JACKSON ON A COLD & SWEATY DRUNKEN NEW YEARS EVE — ROB STAYED IN OUR BUILDING FOR A LONG TIME & NOW I DONT KNOW WHERE HE S GONE BUT I MISS SEEING HIM & HIS CRAZY DOG IN THE HALLS

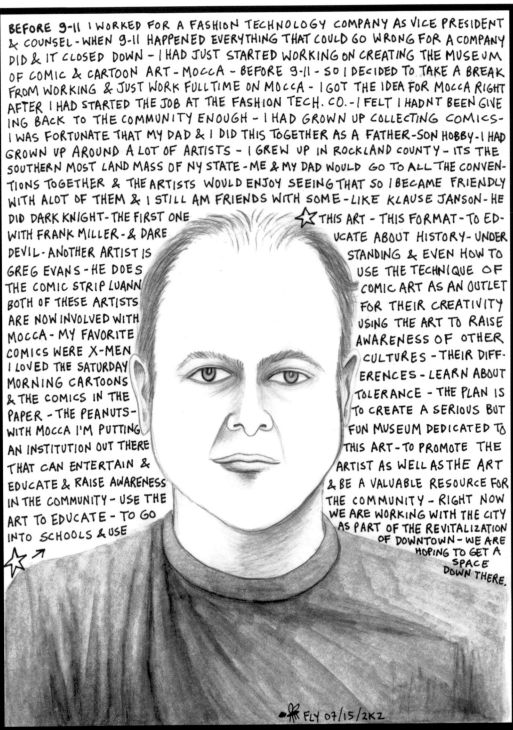

BEFORE 9-11 I WORKED FOR A FASHION TECHNOLOGY COMPANY AS VICE PRESIDENT & COUNSEL - WHEN 9-11 HAPPENED EVERYTHING THAT COULD GO WRONG FOR A COMPANY DID & IT CLOSED DOWN - I HAD JUST STARTED WORKING ON CREATING THE MUSEUM OF COMIC & CARTOON ART - MOCCA - BEFORE 9-11 - SO I DECIDED TO TAKE A BREAK FROM WORKING & JUST WORK FULLTIME ON MOCCA - I GOT THE IDEA FOR MOCCA RIGHT AFTER I HAD STARTED THE JOB AT THE FASHION TECH. CO. - I FELT I HADN'T BEEN GIVING BACK TO THE COMMUNITY ENOUGH - I HAD GROWN UP COLLECTING COMICS - I WAS FORTUNATE THAT MY DAD & I DID THIS TOGETHER AS A FATHER-SON HOBBY - I HAD GROWN UP AROUND A LOT OF ARTISTS - I GREW UP IN ROCKLAND COUNTY - ITS THE SOUTHERN MOST LAND MASS OF NY STATE - ME & MY DAD WOULD GO TO ALL THE CONVENTIONS TOGETHER & THE ARTISTS WOULD ENJOY SEEING THAT SO I BECAME FRIENDLY WITH A LOT OF THEM & I STILL AM FRIENDS WITH SOME - LIKE KLAUSE JANSON - HE DID DARK KNIGHT - THE FIRST ONE WITH FRANK MILLER - & DARE DEVIL - ANOTHER ARTIST IS GREG EVANS - HE DOES THE COMIC STRIP LUANN BOTH OF THESE ARTISTS ARE NOW INVOLVED WITH MOCCA - MY FAVORITE COMICS WERE X-MEN I LOVED THE SATURDAY MORNING CARTOONS & THE COMICS IN THE PAPER - THE PEANUTS - WITH MOCCA I'M PUTTING AN INSTITUTION OUT THERE THAT CAN ENTERTAIN & EDUCATE & RAISE AWARENESS IN THE COMMUNITY - USE THE ART TO EDUCATE - TO GO INTO SCHOOLS & USE

☆ THIS ART - THIS FORMAT - TO EDUCATE ABOUT HISTORY - UNDERSTANDING & EVEN HOW TO USE THE TECHNIQUE OF COMIC ART AS AN OUTLET FOR THEIR CREATIVITY USING THE ART TO RAISE AWARENESS OF OTHER CULTURES - THEIR DIFFERENCES - LEARN ABOUT TOLERANCE - THE PLAN IS TO CREATE A SERIOUS BUT FUN MUSEUM DEDICATED TO THIS ART - TO PROMOTE THE ARTIST AS WELL AS THE ART & BE A VALUABLE RESOURCE FOR THE COMMUNITY - RIGHT NOW WE ARE WORKING WITH THE CITY AS PART OF THE REVITALIZATION OF DOWNTOWN - WE ARE HOPING TO GET A SPACE DOWN THERE.

FLY 07/15/2K2

LAWRENCE KLEIN – 07/15/2K2 – LOWER EAST SIDE – NYC
LAWRENCE IS THE FOUNDER & PRINCIPAL ADVOCATE OF THE MUSEUM OF COMIC & CARTOON ART NYC – & HE S SORT OF LIKE A KID IN HIS ENTHUSIASM – LAST SUMMER (2K2) HE ORGANIZED & PULLED OFF THE MOST AWESOME COMIC CON I VE YET BEEN TO IN NYC – THE MOCCA FEST – ALL THE BEST OF THE UNDERGROUND COMICS & UNDERGROUND PRESS IN GENERAL WERE THERE – I GOT TO BE ON A PANEL WHICH WAS VERY COOL & THEN I SQUATTED ONE OF THE ABANDONED VENDORS TABLES & SOLD LOTS OF BOOKS – MOOCA 32 UNION SQ. E SUITE 600 NYC NY 10003 USA – 212 254 3590

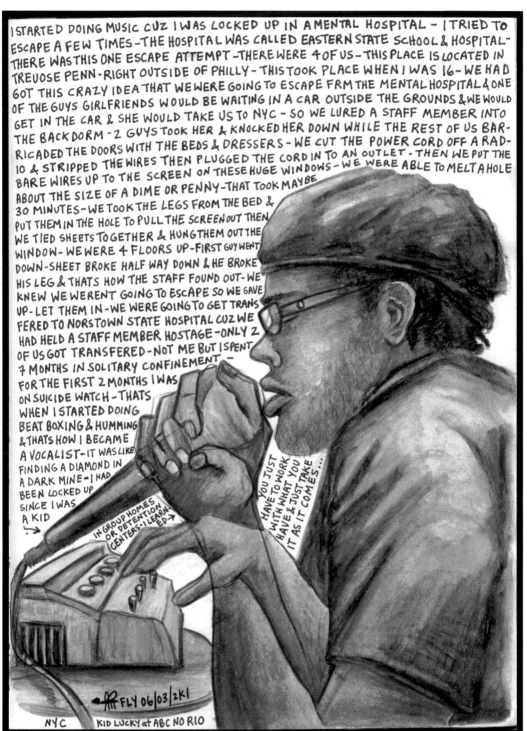

I STARTED DOING MUSIC CUZ I WAS LOCKED UP IN A MENTAL HOSPITAL - I TRIED TO ESCAPE A FEW TIMES - THE HOSPITAL WAS CALLED EASTERN STATE SCHOOL & HOSPITAL - THERE WAS THIS ONE ESCAPE ATTEMPT - THERE WERE 4 OF US - THIS PLACE IS LOCATED IN TREUOSE PENN - RIGHT OUTSIDE OF PHILLY - THIS TOOK PLACE WHEN I WAS 16 - WE HAD GOT THIS CRAZY IDEA THAT WE WERE GOING TO ESCAPE FRM THE MENTAL HOSPITAL & ONE OF THE GUYS GIRLFRIENDS WOULD BE WAITING IN A CAR OUTSIDE THE GROUNDS & WE WOULD GET IN THE CAR & SHE WOULD TAKE US TO NYC - SO WE LURED A STAFF MEMBER INTO THE BACK DORM - 2 GUYS TOOK HER & KNOCKED HER DOWN WHILE THE REST OF US BAR- RICADED THE DOORS WITH THE BEDS & DRESSERS - WE CUT THE POWER CORD OFF A RAD- IO & STRIPPED THE WIRES THEN PLUGGED THE CORD INTO AN OUTLET - THEN WE PUT THE BARE WIRES UP TO THE SCREEN ON THESE HUGE WINDOWS - WE WERE ABLE TO MELT A HOLE ABOUT THE SIZE OF A DIME OR PENNY - THAT TOOK MAYBE 30 MINUTES - WE TOOK THE LEGS FROM THE BED & PUT THEM IN THE HOLE TO PULL THE SCREEN OUT THEN WE TIED SHEETS TOGETHER & HUNG THEM OUT THE WINDOW - WE WERE 4 FLOORS UP - FIRST GUY WENT DOWN - SHEET BROKE HALF WAY DOWN & HE BROKE HIS LEG & THATS HOW THE STAFF FOUND OUT - WE KNEW WE WERENT GOING TO ESCAPE SO WE GAVE UP - LET THEM IN - WE WERE GOING TO GET TRANS FERED TO NORSTOWN STATE HOSPITAL CUZ WE HAD HELD A STAFF MEMBER HOSTAGE - ONLY 2 OF US GOT TRANSFERED - NOT ME BUT I SPENT 7 MONTHS IN SOLITARY CONFINEMENT - FOR THE FIRST 2 MONTHS I WAS ON SUICIDE WATCH - THATS WHEN I STARTED DOING BEAT BOXING & HUMMING & THATS HOW I BECAME A VOCALIST - IT WAS LIKE FINDING A DIAMOND IN A DARK MINE - I HAD BEEN LOCKED UP SINCE I WAS A KID

IN GROUP HOMES OR DETENTION CENTERS - I LEARNED →

YOU JUST HAVE TO WORK WITH WHAT YOU HAVE & JUST TAKE IT AS IT COMES...

FLY 06/03/2K1

NYC KID LUCKY at ABC NO RIO

KID LUCKY – 06/03/2K1 – PERFORMING AT ABC NO RIO – NYC
WHEN I FIRST MET THE KID HE WAS PERFORMING UNDER THE NAME PRIMAL – HE CAME TO
THE OPEN MIC NIGHT I WAS EMCEEING FOR A WHILE AT ABC NO RIO – HE WOULD DO
THESE SPOKEN WORD PIECES & DO ALL THESE STRANGE EFFECTS WITH HIS VOICE WITHOUT
USING ANY ELECTRONICS – HE WOULD DO THIS CRAZY PIECE ABOUT THE CRUSTY KIDS AT LA
PLAZA SUNG TO THE TUNE OF THE ADDAMS FAMILY – IT WAS AWESOME! – THEN HE
BECAME KID LUCKY & GOT A MIC & SOME EFFECTS BOXES SO HIS SHIT GOT ALL FCKTUP
FOR REAL – I MEAN IN A REALLY GOOD WAY

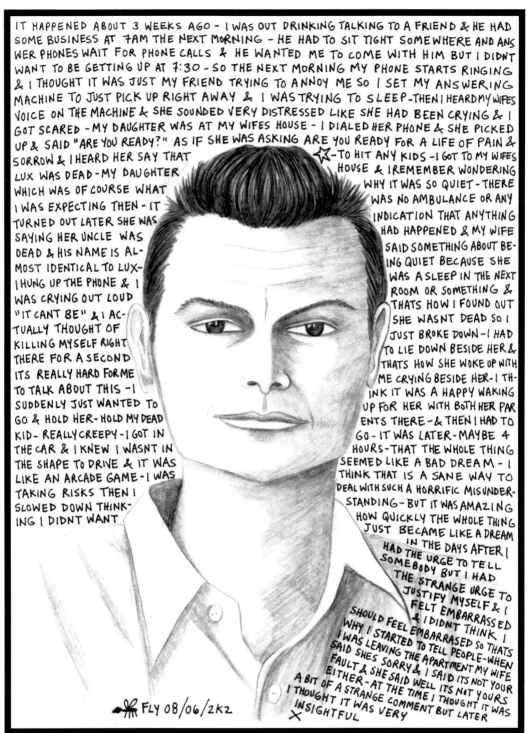

IT HAPPENED ABOUT 3 WEEKS AGO - I WAS OUT DRINKING TALKING TO A FRIEND & HE HAD SOME BUSINESS AT 7AM THE NEXT MORNING - HE HAD TO SIT TIGHT SOMEWHERE AND ANSWER PHONES WAIT FOR PHONE CALLS & HE WANTED ME TO COME WITH HIM BUT I DIDNT WANT TO BE GETTING UP AT 7:30 - SO THE NEXT MORNING MY PHONE STARTS RINGING & I THOUGHT IT WAS JUST MY FRIEND TRYING TO ANNOY ME SO I SET MY ANSWERING MACHINE TO JUST PICK UP RIGHT AWAY & I WAS TRYING TO SLEEP - THEN I HEARD MY WIFES VOICE ON THE MACHINE & SHE SOUNDED VERY DISTRESSED LIKE SHE HAD BEEN CRYING & I GOT SCARED - MY DAUGHTER WAS AT MY WIFES HOUSE - I DIALED HER PHONE & SHE PICKED UP & SAID "ARE YOU READY?" AS IF SHE WAS ASKING ARE YOU READY FOR A LIFE OF PAIN & SORROW & I HEARD HER SAY THAT LUX WAS DEAD - MY DAUGHTER WHICH WAS OF COURSE WHAT I WAS EXPECTING THEN - IT TURNED OUT LATER SHE WAS SAYING HER UNCLE WAS DEAD & HIS NAME IS ALMOST IDENTICAL TO LUX - I HUNG UP THE PHONE & I WAS CRYING OUT LOUD "IT CANT BE" & I ACTUALLY THOUGHT OF KILLING MYSELF RIGHT THERE FOR A SECOND ITS REALLY HARD FOR ME TO TALK ABOUT THIS - I SUDDENLY JUST WANTED TO GO & HOLD HER - HOLD MY DEAD KID - REALLY CREEPY - I GOT IN THE CAR & I KNEW I WASNT IN THE SHAPE TO DRIVE & IT WAS LIKE AN ARCADE GAME - I WAS TAKING RISKS THEN I SLOWED DOWN THINKING I DIDNT WANT

☆ - TO HIT ANY KIDS - I GOT TO MY WIFES HOUSE & I REMEMBER WONDERING WHY IT WAS SO QUIET - THERE WAS NO AMBULANCE OR ANY INDICATION THAT ANYTHING HAD HAPPENED & MY WIFE SAID SOMETHING ABOUT BEING QUIET BECAUSE SHE WAS ASLEEP IN THE NEXT ROOM OR SOMETHING & THATS HOW I FOUND OUT SHE WASNT DEAD SO I JUST BROKE DOWN - I HAD TO LIE DOWN BESIDE HER & THATS HOW SHE WOKE UP WITH ME CRYING BESIDE HER - I THINK IT WAS A HAPPY WAKING UP FOR HER WITH BOTH HER PARENTS THERE - & THEN I HAD TO GO - IT WAS LATER - MAYBE 4 HOURS - THAT THE WHOLE THING SEEMED LIKE A BAD DREAM - I THINK THAT IS A SANE WAY TO DEAL WITH SUCH A HORRIFIC MISUNDERSTANDING - BUT IT WAS AMAZING HOW QUICKLY THE WHOLE THING JUST BECAME LIKE A DREAM IN THE DAYS AFTER I HAD THE URGE TO TELL SOMEBODY BUT I HAD THE STRANGE URGE TO JUSTIFY MYSELF & I FELT EMBARRASSED & I DIDNT THINK I SHOULD FEEL EMBARRASED SO THATS WHY I STARTED TO TELL PEOPLE - WHEN I WAS LEAVING THE APARTMENT MY WIFE SAID SHES SORRY & I SAID ITS NOT YOUR FAULT & SHE SAID WELL ITS NOT YOURS EITHER - AT THE TIME I THOUGHT IT WAS A BIT OF A STRANGE COMMENT BUT LATER I THOUGHT IT WAS VERY INSIGHTFUL ✗

⚘ FLY 08/06/2K2

MARKUS ZUST – 08/06/2K2 – FRM ZURICH – SWITZERLAND
I MET MARKUS WHILE TOURING EUROPE WITH GOD IS MY CO-PILOT – HE WAS DRIVING THE VAN FOR A FEW TOURS & HE WAS SO GREAT – HE COULD FIGURE OUT HOW TO GET ANYWHERE – HE COULD DRIVE & READ A MAP AT THE SAME TIME – DURING ONE TOUR HE GOT MARRIED & THE RECEPTION PARTY WAS HELD IN THIS CRAZY SQUATTED MANSION IN THE MOUNTAINS – THERE WAS AN INDOOR SWIMMING POOL WITH REALLY TACKY DECOR & THATS WHERE THE BAND (US) PLAYED – EVERYONE WAS GOIN NUTS DANCING IN THIS POOL – MARKUS IS REALLY GOOD AT FOOLING PEOPLE BECAUSE HE ALWAYS SEEMS SO SERIOUS – ONE TIME HE GOT ME TO STEAL A BOOK FOR HIM & I DIDNT EVEN KNOW I WAS DOING IT

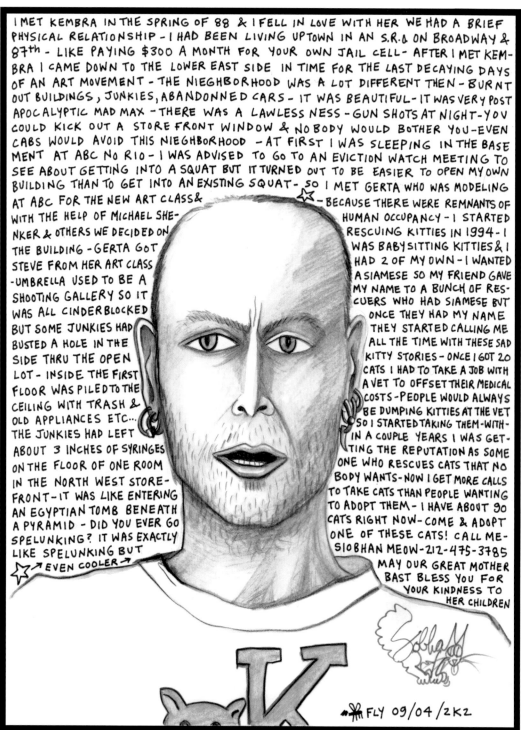

I MET KEMBRA IN THE SPRING OF 88 & I FELL IN LOVE WITH HER WE HAD A BRIEF PHYSICAL RELATIONSHIP - I HAD BEEN LIVING UPTOWN IN AN S.R.O ON BROADWAY & 87th - LIKE PAYING $300 A MONTH FOR YOUR OWN JAIL CELL - AFTER I MET KEMBRA I CAME DOWN TO THE LOWER EAST SIDE IN TIME FOR THE LAST DECAYING DAYS OF AN ART MOVEMENT - THE NIEGHBORHOOD WAS A LOT DIFFERENT THEN - BURNT OUT BUILDINGS, JUNKIES, ABANDONNED CARS - IT WAS BEAUTIFUL - IT WAS VERY POST APOCALYPTIC MAD MAX - THERE WAS A LAWLESSNESS - GUN SHOTS AT NIGHT - YOU COULD KICK OUT A STORE FRONT WINDOW & NOBODY WOULD BOTHER YOU - EVEN CABS WOULD AVOID THIS NIEGHBORHOOD - AT FIRST I WAS SLEEPING IN THE BASE MENT AT ABC NO RIO - I WAS ADVISED TO GO TO AN EVICTION WATCH MEETING TO SEE ABOUT GETTING INTO A SQUAT BUT IT TURNED OUT TO BE EASIER TO OPEN MY OWN BUILDING THAN TO GET INTO AN EXISTING SQUAT - SO I MET GERTA WHO WAS MODELING AT ABC FOR THE NEW ART CLASS&

WITH THE HELP OF MICHAEL SHENKER & OTHERS WE DECIDED ON THE BUILDING - GERTA GOT STEVE FROM HER ART CLASS - UMBRELLA USED TO BE A SHOOTING GALLERY SO IT WAS ALL CINDERBLOCKED BUT SOME JUNKIES HAD BUSTED A HOLE IN THE SIDE THRU THE OPEN LOT - INSIDE THE FIRST FLOOR WAS PILED TO THE CEILING WITH TRASH & OLD APPLIANCES ETC... THE JUNKIES HAD LEFT ABOUT 3 INCHES OF SYRINGES ON THE FLOOR OF ONE ROOM IN THE NORTH WEST STOREFRONT - IT WAS LIKE ENTERING AN EGYPTIAN TOMB BENEATH A PYRAMID - DID YOU EVER GO SPELUNKING? IT WAS EXACTLY LIKE SPELUNKING BUT EVEN COOLER →

★ - BECAUSE THERE WERE REMNANTS OF HUMAN OCCUPANCY - I STARTED RESCUING KITTIES IN 1994 - I WAS BABYSITTING KITTIES & I HAD 2 OF MY OWN - I WANTED A SIAMESE SO MY FRIEND GAVE MY NAME TO A BUNCH OF RESCUERS WHO HAD SIAMESE BUT ONCE THEY HAD MY NAME THEY STARTED CALLING ME ALL THE TIME WITH THESE SAD KITTY STORIES - ONCE I GOT 20 CATS I HAD TO TAKE A JOB WITH A VET TO OFFSET THEIR MEDICAL COSTS - PEOPLE WOULD ALWAYS BE DUMPING KITTIES AT THE VET SO I STARTED TAKING THEM - WITHIN A COUPLE YEARS I WAS GETTING THE REPUTATION AS SOMEONE WHO RESCUES CATS THAT NOBODY WANTS - NOW I GET MORE CALLS TO TAKE CATS THAN PEOPLE WANTING TO ADOPT THEM - I HAVE ABOUT 90 CATS RIGHT NOW - COME & ADOPT ONE OF THESE CATS! CALL ME - SIOBHAN MEOW - 212-475-3785 MAY OUR GREAT MOTHER BAST BLESS YOU FOR YOUR KINDNESS TO HER CHILDREN

FLY 09/04/2K2

SOIBHAN MEOW – 09/04/2K2 – LOWER EAST SIDE – NYC
I MET SOIBHAN IN 1990 WHEN HE WOULD SOMTIMES COME TO THE OPEN MIC AT THE GARGOYLE MECHANIQUE LAB - HE WAS LIVING AT UMBRELLA HAUS (STILL IS) - ONE OF THE MORE ESTABLISHED SQUATS IN THE LES - I WENT TO VISIT HIM THERE ONCE & HE SHOWED ME SOME BEAUTIFUL DRAWINGS DONE BY HIS DAUGHTER - AT THE TIME I THINK HE ONLY HAD 3 CATS - HE ALSO GAVE ME ONE OF HIS PEP GIRLS COMICS WHICH IS TOTALLY CLASSIC & HE LET ME BORROW SOME AWESOME OLD GARY PANTER COMICS - ONCE I THOUGHT I WAS GOING NUTS & SOIBHAN CAME & STOOD BESIDE ME & KEPT CALLING ME PUDDIN HEAD - I FELT MUCH BETTER. TO ADOPT A CAT CALL 212 475 3785

PSYCHICS SAY THAT PEOPLE BORN DURING GREAT WARS OR CATACLYSM HAVE AN ADDED DIMENSION OF PAIN & SENSITIVENESS - SINCE I WAS BORN IN 1943 THAT WOULD COVER ME & ALSO A WHOLE LOT OF OTHER PEOPLE - IF ITS TRUE I DONT MIND IN THE LEAST BIT BECAUSE DESPITE THIS POSSIBLE INCREASED PAIN, THE MORE SENSITIVITY I HAVE THE MORE DEEPLY I CAN EXPERIENCE EVERYTHING - & I WANT TO EXPERIENCE EVERYTHING - I WANT TO BE AN ELEPHANT & A DOLPHIN - I WANT TO BE SALOMÉ BUT I DONT WANT TO BE JOAN OF ARC - I ALSO WANT TO BE A TRAPEZE ARTIST WORKING WITH ANOTHER TRAPEZE ARTIST BECAUSE I WANT TO BE ABLE TO TRUST ANOTHER SOUL SO COMPLETELY TO HANG BY MY TEETH FROM A BATON MY PARTNER IS HOLDING IN HIS TEETH AS HE SWINGS FROM A TRAPEZE 200 FT. ABOVE THE CIRCUS FLOOR - MY DREAM IS TO BE ABLE TO EXPERIENCE THAT QUALITY OF TRUST BUT I HAVE TO SAY SO FAR I HAVE NOT HAD MUCH SUCCESS - BUT I WILL KEEP TRYING UNTIL MY LAST CONSCIOUS BREATH - I'M VERY HAPPY NOW BECAUSE DESPITE MY DAILY FRUSTRATIONS & PARANOIAS I'M A WRITER WHICH IVE WANTED TO BE SINCE I WAS 7 - BUT ONLY STARTED TO REALLY DO 12 YEARS AGO SO MY LIFE NOW IS THE FULLFILLMENT OF A CHILDHOOD DREAM - HOW MANY PEOPLE CAN SAY THAT? - THERE IS SO MUCH SUFFERING THAT I SOME

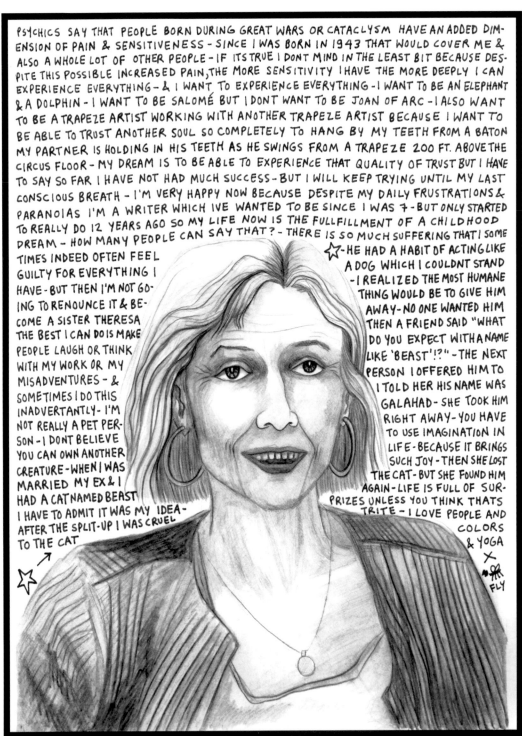

TIMES INDEED OFTEN FEEL GUILTY FOR EVERYTHING I HAVE - BUT THEN I'M NOT GOING TO RENOUNCE IT & BECOME A SISTER THERESA THE BEST I CAN DO IS MAKE PEOPLE LAUGH OR THINK WITH MY WORK OR MY MISADVENTURES - & SOMETIMES I DO THIS INADVERTANTLY - I'M NOT REALLY A PET PERSON - I DONT BELIEVE YOU CAN OWN ANOTHER CREATURE - WHEN I WAS MARRIED MY EX & I HAD A CAT NAMED BEAST I HAVE TO ADMIT IT WAS MY IDEA - AFTER THE SPLIT-UP I WAS CRUEL TO THE CAT

☆ - HE HAD A HABIT OF ACTING LIKE A DOG WHICH I COULDNT STAND - I REALIZED THE MOST HUMANE THING WOULD BE TO GIVE HIM AWAY - NO ONE WANTED HIM THEN A FRIEND SAID "WHAT DO YOU EXPECT WITH A NAME LIKE 'BEAST'!?" - THE NEXT PERSON I OFFERED HIM TO I TOLD HER HIS NAME WAS GALAHAD - SHE TOOK HIM RIGHT AWAY - YOU HAVE TO USE IMAGINATION IN LIFE - BECAUSE IT BRINGS SUCH JOY - THEN SHE LOST THE CAT - BUT SHE FOUND HIM AGAIN - LIFE IS FULL OF SURPRIZES UNLESS YOU THINK THATS TRITE - I LOVE PEOPLE AND COLORS & YOGA

FLY

TSAURAH LITZKY - JANUARY 2K2 - NYC
I MET TSAURAH AT ABC NO RIO - SHE WAS PART OF THE LOWER EAST SIDE POETRY & PERFORMANCE SCENE - EVERY TIME I SEE HER SHE IS SMILING & FULL OF LIFE & ENERGY - SHE SAYS SHE WAS BORN IN 1943 BUT SHE EXUDES A MUCH YOUNGER SPIRIT - SHE WRITES A LOT OF EROTIC POETRY & STORIES WHICH SEEM TO COME FROM PERSONAL EXPERIENCES SO THAT MIGHT BE HOW SHE STAYS SO YOUNG - I NEVER REALLY HUNG OUT WITH TSAURAH BEFORE SO IT WAS REALLY COOL JUST BEING ABLE TO SIT & DRAW THIS PORTRAIT & LISTEN TO HER STORIES - SHE SEEMS TO HAVE A REAL SENSE OF PEACE ABOUT HER
TSAURAH@MINDSPRING.COM

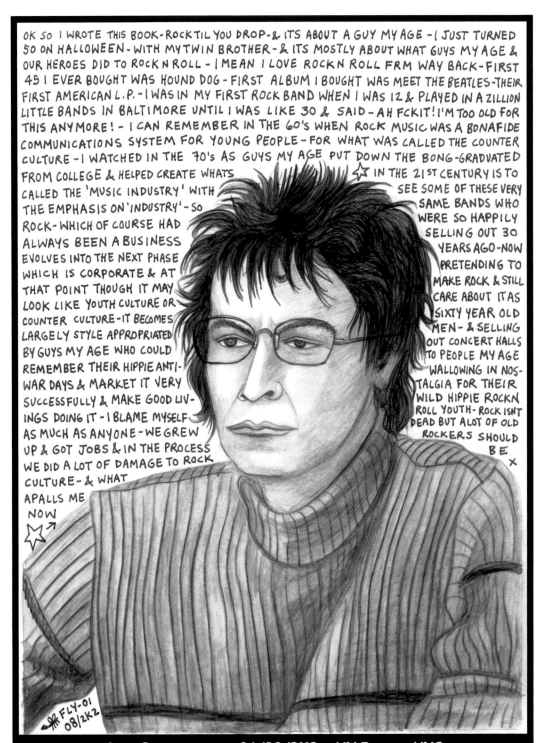

OK SO I WROTE THIS BOOK - ROCK TIL YOU DROP - & ITS ABOUT A GUY MY AGE - I JUST TURNED 50 ON HALLOWEEN - WITH MY TWIN BROTHER - & ITS MOSTLY ABOUT WHAT GUYS MY AGE & OUR HEROES DID TO ROCK N ROLL - I MEAN I LOVE ROCK N ROLL FRM WAY BACK - FIRST 45 I EVER BOUGHT WAS HOUND DOG - FIRST ALBUM I BOUGHT WAS MEET THE BEATLES - THEIR FIRST AMERICAN L.P. - I WAS IN MY FIRST ROCK BAND WHEN I WAS 12 & PLAYED IN A ZILLION LITTLE BANDS IN BALTIMORE UNTIL I WAS LIKE 30 & SAID - AH FCK IT! I'M TOO OLD FOR THIS ANY MORE! - I CAN REMEMBER IN THE 60'S WHEN ROCK MUSIC WAS A BONAFIDE COMMUNICATIONS SYSTEM FOR YOUNG PEOPLE - FOR WHAT WAS CALLED THE COUNTER CULTURE - I WATCHED IN THE 70'S AS GUYS MY AGE PUT DOWN THE BONG - GRADUATED FROM COLLEGE & HELPED CREATE WHATS CALLED THE 'MUSIC INDUSTRY' WITH THE EMPHASIS ON 'INDUSTRY' - SO ROCK - WHICH OF COURSE HAD ALWAYS BEEN A BUSINESS EVOLVES INTO THE NEXT PHASE WHICH IS CORPORATE & AT THAT POINT THOUGH IT MAY LOOK LIKE YOUTH CULTURE OR COUNTER CULTURE - IT BECOMES LARGELY STYLE APPROPRIATED BY GUYS MY AGE WHO COULD REMEMBER THEIR HIPPIE ANTI-WAR DAYS & MARKET IT VERY SUCCESSFULLY & MAKE GOOD LIV-INGS DOING IT - I BLAME MYSELF AS MUCH AS ANYONE - WE GREW UP & GOT JOBS & IN THE PROCESS WE DID A LOT OF DAMAGE TO ROCK CULTURE - & WHAT APALLS ME NOW

IN THE 21ST CENTURY IS TO SEE SOME OF THESE VERY SAME BANDS WHO WERE SO HAPPILY SELLING OUT 30 YEARS AGO - NOW PRETENDING TO MAKE ROCK & STILL CARE ABOUT IT AS SIXTY YEAR OLD MEN - & SELLING OUT CONCERT HALLS TO PEOPLE MY AGE WALLOWING IN NOS-TALGIA FOR THEIR WILD HIPPIE ROCK N ROLL YOUTH - ROCK ISNT DEAD BUT A LOT OF OLD ROCKERS SHOULD BE x

FLY-01 08/2K2

JOHN STRAUSBAUGH – 01/08/2K2 – NY PRESS – NYC
MISTER STRAUSBAUGH WAS THE EDITOR OF THE NEW YORK PRESS – A NOTORIOUS NYC WEEKLY NEWS & ENTERTAINMENT TABLOID – I'VE BEEN DOING ILLUSTRATIONS FOR THEM SINCE THE MID 90S – JOHN WROTE A COLUMN CALLED "PUBLISHING" MOSTLY TALKING ABOUT NEW BOOKS – I GOT TO DO AN ILLUSTRATION FOR HIS COLUMN WHEN HE WAS WRITING A REVIEW OF A BOOK ABOUT MISHEARD LYRICS – STUFF LIKE "NO ONE KNOWS WHAT ITS LIKE TO BE THE FAT MAN" & "DONUTS MAKE MY BROWN EYES BLUE" & "HEY! YOU! GET OFFA MY COW!" – THE ONE THAT MADE ME PEE MY PANTS WAS "HOLD ME CLOSER TONY DANZA" – WWW.NYPRESS.COM

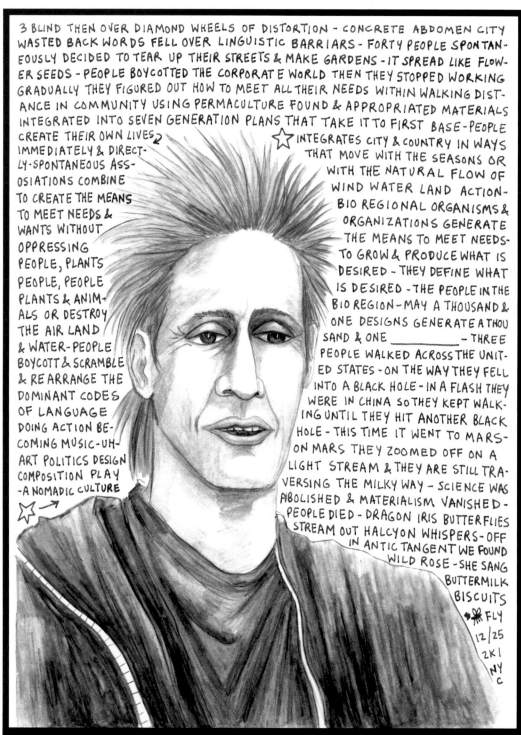

3 BLIND THEN OVER DIAMOND WHEELS OF DISTORTION - CONCRETE ABDOMEN CITY WASTED BACK WORDS FELL OVER LINGUISTIC BARRIARS - FORTY PEOPLE SPONTANEOUSLY DECIDED TO TEAR UP THEIR STREETS & MAKE GARDENS - IT SPREAD LIKE FLOWER SEEDS - PEOPLE BOYCOTTED THE CORPORATE WORLD THEN THEY STOPPED WORKING GRADUALLY THEY FIGURED OUT HOW TO MEET ALL THEIR NEEDS WITHIN WALKING DISTANCE IN COMMUNITY USING PERMACULTURE FOUND & APPROPRIATED MATERIALS INTEGRATED INTO SEVEN GENERATION PLANS THAT TAKE IT TO FIRST BASE - PEOPLE CREATE THEIR OWN LIVES

IMMEDIATELY & DIRECTLY - SPONTANEOUS ASSOSIATIONS COMBINE TO CREATE THE MEANS TO MEET NEEDS & WANTS WITHOUT OPPRESSING PEOPLE, PLANTS PEOPLE, PEOPLE PLANTS & ANIMALS OR DESTROY THE AIR LAND & WATER - PEOPLE BOYCOTT & SCRAMBLE & REARRANGE THE DOMINANT CODES OF LANGUAGE DOING ACTION BECOMING MUSIC - UH - ART POLITICS DESIGN COMPOSITION PLAY - A NOMADIC CULTURE

INTEGRATES CITY & COUNTRY IN WAYS THAT MOVE WITH THE SEASONS OR WITH THE NATURAL FLOW OF WIND WATER LAND ACTION - BIO REGIONAL ORGANISMS & ORGANIZATIONS GENERATE THE MEANS TO MEET NEEDS - TO GROW & PRODUCE WHAT IS DESIRED - THEY DEFINE WHAT IS DESIRED - THE PEOPLE IN THE BIO REGION - MAY A THOUSAND & ONE DESIGNS GENERATE A THOUSAND & ONE _____ - THREE PEOPLE WALKED ACROSS THE UNITED STATES - ON THE WAY THEY FELL INTO A BLACK HOLE - IN A FLASH THEY WERE IN CHINA SO THEY KEPT WALKING UNTIL THEY HIT ANOTHER BLACK HOLE - THIS TIME IT WENT TO MARS - ON MARS THEY ZOOMED OFF ON A LIGHT STREAM & THEY ARE STILL TRAVERSING THE MILKY WAY - SCIENCE WAS ABOLISHED & MATERIALISM VANISHED - PEOPLE DIED - DRAGON IRIS BUTTERFLIES STREAM OUT HALCYON WHISPERS - OFF IN ANTIC TANGENT WE FOUND WILD ROSE - SHE SANG BUTTERMILK BISCUITS FLY 12/25 2K1 NYC

ERIC HILTNER – 12/25/2K1 – LOWER EAST SIDE – NYC
I MET ERIC ON MY FIRST TRIP TO DREAMTIME VILLAGE IN 1992 – LOCATED IN WEST LIMA, WISCONSIN – AN OLD POST OFFICE HOUSE, AN OLD SCHOOLHOUSE, AN OLD MANSION HOUSE, AN OLD HOTEL, A FEW ACRES OF LAND, A FEW EXTREMELY INDUSTRIOUS & HARD WORKING ARTISTS – ERIC WAS ONE OF THE SEMI–PERMANANT RESIDENTS AT DREAMTIME – HE LIVED IN AN OLD SCHOOL BUS PARKED OUT IN THE BACK OF THE SCHOOLHOUSE – ERIC WAS TONS OF FUN TO HANG OUT WITH – HE TAUGHT ME HOW TO MAKE BREAD & SOY MILK & HE TOLD ME STRANGE STORIES ABOUT RHIZOMES – HIS HAIR ALWAYS LOOKS LIKE HE IS GOING REALLY FAST – USUALLY HE IS
AKAPHRATES@HOTMAIL.COM

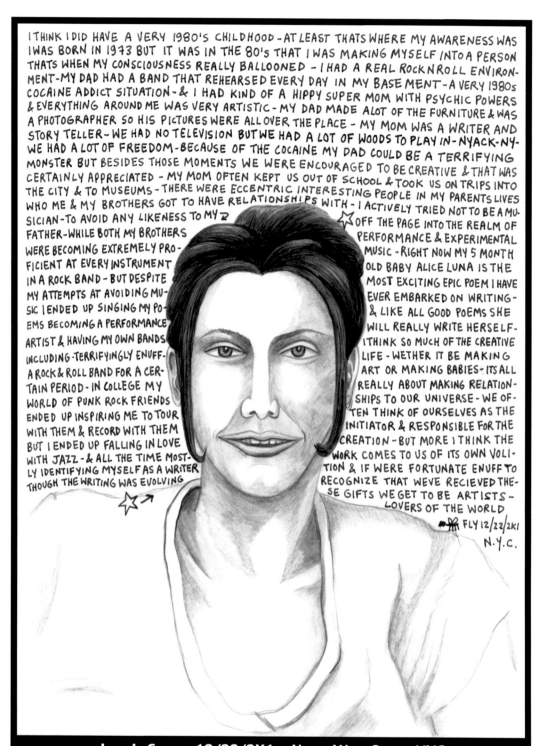

I THINK I DID HAVE A VERY 1980'S CHILDHOOD - AT LEAST THATS WHERE MY AWARENESS WAS I WAS BORN IN 1973 BUT IT WAS IN THE 80'S THAT I WAS MAKING MYSELF INTO A PERSON THATS WHEN MY CONSCIOUSNESS REALLY BALLOONED - I HAD A REAL ROCK N ROLL ENVIRON- MENT-MY DAD HAD A BAND THAT REHEARSED EVERY DAY IN MY BASEMENT - A VERY 1980s COCAINE ADDICT SITUATION - & I HAD KIND OF A HIPPY SUPER MOM WITH PSYCHIC POWERS & EVERYTHING AROUND ME WAS VERY ARTISTIC - MY DAD MADE A LOT OF THE FURNITURE & WAS A PHOTOGRAPHER SO HIS PICTURES WERE ALL OVER THE PLACE - MY MOM WAS A WRITER AND STORY TELLER - WE HAD NO TELEVISION BUT WE HAD A LOT OF WOODS TO PLAY IN - NYACK-NY- WE HAD A LOT OF FREEDOM - BECAUSE OF THE COCAINE MY DAD COULD BE A TERRIFYING MONSTER BUT BESIDES THOSE MOMENTS WE WERE ENCOURAGED TO BE CREATIVE & THAT WAS CERTAINLY APPRECIATED - MY MOM OFTEN KEPT US OUT OF SCHOOL & TOOK US ON TRIPS INTO THE CITY & TO MUSEUMS - THERE WERE ECCENTRIC INTERESTING PEOPLE IN MY PARENTS LIVES WHO ME & MY BROTHERS GOT TO HAVE RELATIONSHIPS WITH - I ACTIVELY TRIED NOT TO BE A MU- SICIAN - TO AVOID ANY LIKENESS TO MY ⟲

FATHER - WHILE BOTH MY BROTHERS WERE BECOMING EXTREMELY PRO- FICIENT AT EVERY INSTRUMENT IN A ROCK BAND - BUT DESPITE MY ATTEMPTS AT AVOIDING MU- SIC I ENDED UP SINGING MY PO- EMS BECOMING A PERFORMANCE ARTIST & HAVING MY OWN BANDS INCLUDING - TERRIFYINGLY ENUFF- A ROCK & ROLL BAND FOR A CER- TAIN PERIOD - IN COLLEGE MY WORLD OF PUNK ROCK FRIENDS ENDED UP INSPIRING ME TO TOUR WITH THEM & RECORD WITH THEM BUT I ENDED UP FALLING IN LOVE WITH JAZZ - & ALL THE TIME MOST- LY IDENTIFYING MYSELF AS A WRITER THOUGH THE WRITING WAS EVOLVING

☆ OFF THE PAGE INTO THE REALM OF PERFORMANCE & EXPERIMENTAL MUSIC - RIGHT NOW MY 5 MONTH OLD BABY ALICE LUNA IS THE MOST EXCITING EPIC POEM I HAVE EVER EMBARKED ON WRITING - & LIKE ALL GOOD POEMS SHE WILL REALLY WRITE HERSELF- I THINK SO MUCH OF THE CREATIVE LIFE - WETHER IT BE MAKING ART OR MAKING BABIES- ITS ALL REALLY ABOUT MAKING RELATION- SHIPS TO OUR UNIVERSE - WE OF- TEN THINK OF OURSELVES AS THE INITIATOR & RESPONSIBLE FOR THE CREATION - BUT MORE I THINK THE WORK COMES TO US OF ITS OWN VOLI- TION & IF WERE FORTUNATE ENUFF TO RECOGNIZE THAT WEVE RECIEVED THE- SE GIFTS WE GET TO BE ARTISTS - LOVERS OF THE WORLD

FLY 12/22/2K1 N.Y.C.

JANE LECROY – 12/22/2K1 – UPPER WEST SIDE – NYC
JANE HAS AN AMAZING WAY WITH WORDS – WHEN I MET HER YEARS AGO SHE WAS DOING SPOKEN WORD OPENING FOR THE BAND VITA-PUP – & HER PERFORMANCES JUST KEPT EVOLVING & CHANGING – A LOT OF TIMES SHE SINGS HER POEMS & THEY ARE THE MOST BEAUTIFUL SONGS – SHE WAS ON TOUR WITH SISTER SPIT – (SOME OF THE COOLEST WOMEN PERFORMERS IN THE UNIVERSE) – FOR MANY PERFORMANCES SHE WILL DO A SEC- TION WHERE SHE WILL JUST MAKE IT UP AS SHE GOES ALONG & SHE HAS GOTTEN REALLY GOOD AT THIS – SHE IS BEAUTIFUL & CAPTIVATING & INSPIRING & YOU SHOULD CHECK HER WEBSITE – WWW.JANELECROY.COM – & LISTEN TO HER WORDS !

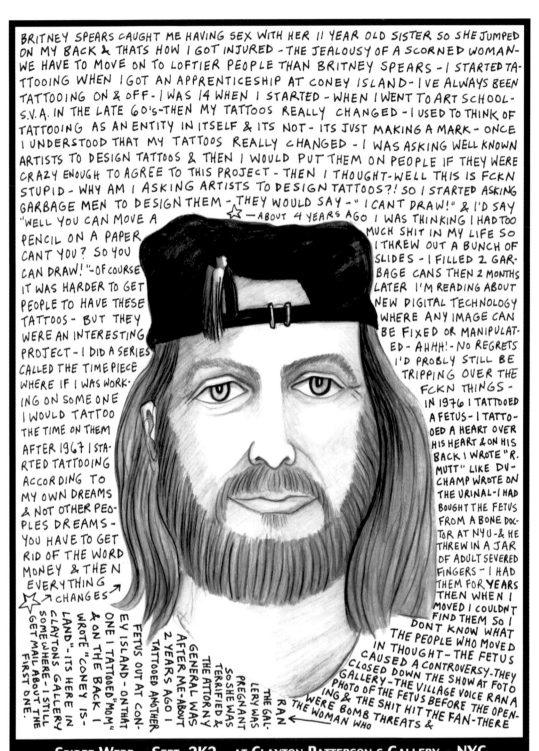

BRITNEY SPEARS CAUGHT ME HAVING SEX WITH HER 11 YEAR OLD SISTER SO SHE JUMPED ON MY BACK & THATS HOW I GOT INJURED - THE JEALOUSY OF A SCORNED WOMAN - WE HAVE TO MOVE ON TO LOFTIER PEOPLE THAN BRITNEY SPEARS - I STARTED TATTOOING WHEN I GOT AN APPRENTICESHIP AT CONEY ISLAND - I'VE ALWAYS BEEN TATTOOING ON & OFF - I WAS 14 WHEN I STARTED - WHEN I WENT TO ART SCHOOL - S.V.A. IN THE LATE 60's - THEN MY TATTOOS REALLY CHANGED - I USED TO THINK OF TATTOOING AS AN ENTITY IN ITSELF & ITS NOT - ITS JUST MAKING A MARK - ONCE I UNDERSTOOD THAT MY TATTOOS REALLY CHANGED - I WAS ASKING WELL KNOWN ARTISTS TO DESIGN TATTOOS & THEN I WOULD PUT THEM ON PEOPLE IF THEY WERE CRAZY ENOUGH TO AGREE TO THIS PROJECT - THEN I THOUGHT - WELL THIS IS FCKN STUPID - WHY AM I ASKING ARTISTS TO DESIGN TATTOOS?! SO I STARTED ASKING GARBAGE MEN TO DESIGN THEM - THEY WOULD SAY - "I CANT DRAW!" & I'D SAY "WELL YOU CAN MOVE A PENCIL ON A PAPER CANT YOU? SO YOU CAN DRAW!" - OF COURSE IT WAS HARDER TO GET PEOPLE TO HAVE THESE TATTOOS - BUT THEY WERE AN INTERESTING PROJECT - I DID A SERIES CALLED THE TIME PIECE WHERE IF I WAS WORKING ON SOME ONE I WOULD TATTOO THE TIME ON THEM AFTER 1967 I STARTED TATTOOING ACCORDING TO MY OWN DREAMS & NOT OTHER PEOPLES DREAMS - YOU HAVE TO GET RID OF THE WORD MONEY & THEN EVERYTHING CHANGES

- ABOUT 4 YEARS AGO I WAS THINKING I HAD TOO MUCH SHIT IN MY LIFE SO I THREW OUT A BUNCH OF SLIDES - I FILLED 2 GARBAGE CANS THEN 2 MONTHS LATER I'M READING ABOUT NEW DIGITAL TECHNOLOGY WHERE ANY IMAGE CAN BE FIXED OR MANIPULATED - AHHH! - NO REGRETS I'D PROBLY STILL BE TRIPPING OVER THE FCKN THINGS - IN 1976 I TATTOOED A FETUS - I TATTOOED A HEART OVER HIS HEART & ON HIS BACK I WROTE "R. MUTT" LIKE DUCHAMP WROTE ON THE URINAL - I HAD BOUGHT THE FETUS FROM A BONE DOCTOR AT NYU - & HE THREW IN A JAR OF ADULT SEVERED FINGERS - I HAD THEM FOR YEARS THEN WHEN I MOVED I COULDNT FIND THEM SO I DONT KNOW WHAT THE PEOPLE WHO MOVED THOUGHT - THE FETUS CAUSED A CONTROVERSY - THEY CLOSED DOWN THE SHOW AT FOTO GALLERY - THE VILLAGE VOICE RAN A PHOTO OF THE FETUS BEFORE THE OPENING & THE SHIT HIT THE FAN - THERE WERE BOMB THREATS & THE WOMAN WHO RAN THE GALLERY WAS PREGNANT SO SHE WAS TERRIFIED & THE ATTORNY GENERAL WAS AFTER ME - ABOUT 2 YEARS AGO I TATTOOED ANOTHER FETUS OUT AT CONEY ISLAND - ON THAT ONE I TATTOOED "MOM" & ON THE BACK I WROTE "CONEY IS-LAND" - ITS HERE IN CLAYTONS GALLERY SOMEWHERE - I STILL GET MAIL ABOUT THE FIRST ONE.

SPIDER WEBB – SEPT. 2K2 – AT CLAYTON PATTERSONS GALLERY – NYC
I MET SPIDER WEBB AT HIS OPENING AT CLAYTONS GALLERY – THE FIRST TIME I HAD HEARD OF SPIDER WAS FROM MY OLD FRIEND TED WHO I WOULD STAY WITH SOMETIMES IN THE 80s WHEN I WOULD COME TO NYC – TED LIVED IN THE WEST VILLAGE & WORKED AS A BARTENDER – HE LIKED TO PARTY HARD & IT WAS ALWAYS A LITTLE NUTS VISITING HIM – HE HAD SOME TATTOOS THAT HE SAID WERE DONE BY THE INFAMOUS SPIDER WEBB & HE SHOWED ME PHOTOS OF HIM & SPIDER & TOLD ME HE WOULD INTRODUCE ME & GET SPIDER TO TATTOO ME – I SORT OF LOST TRACK OF TED & I WAS SAD BUT NOT SURPRISED WHEN SPIDER TOLD ME HE HAD DIED OF A MASSIVE CORONARY.

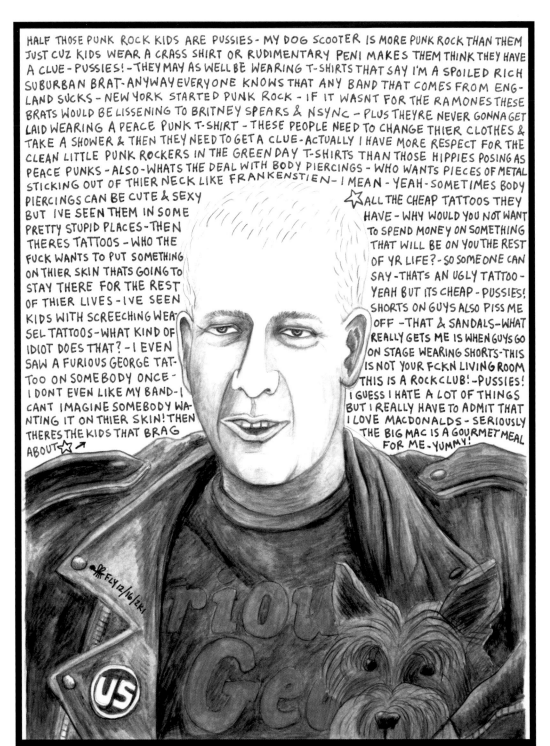

GEORGE TABB – 12/16/2K1 – WEST VILLAGE – NYC
I HAD READ GEORGES COLUMN IN MAXIMUMROCKNROLL LONG BEFORE I EVER MET HIM – THEN THE NEW YORK PRESS STARTED RUNNING HIS COLUMN RIGHT AT THE TIME I STARTED DOING ILLUSTRATIONS FOR THEM SO I BECAME GEORGES PERSONAL ILLUSTRATOR – FOR A FEW YEARS THEY WERE RUNNING IT EVERY WEEK & IT WAS A GREAT GIG – LOTS OF FUN DRAWING PICTURES OF GEORGE TRYING TO HIT ON LITTLE PUNK GIRLS & GETTING BEAT UP BY LITTLE PUNK GIRLS OR GETTING PUNCHED BY FLAT CHESTED ROCK CHICKS OR GETTING PICKED UP BY MODELS WHO REALLY ONLY WANT HIS SON SCOOTER – & THEN OF COURSE THERE IS HIS BAND FURIOUS GEORGE – BETTER THAN CARTOONS!– WWW.GEORGETABB.COM

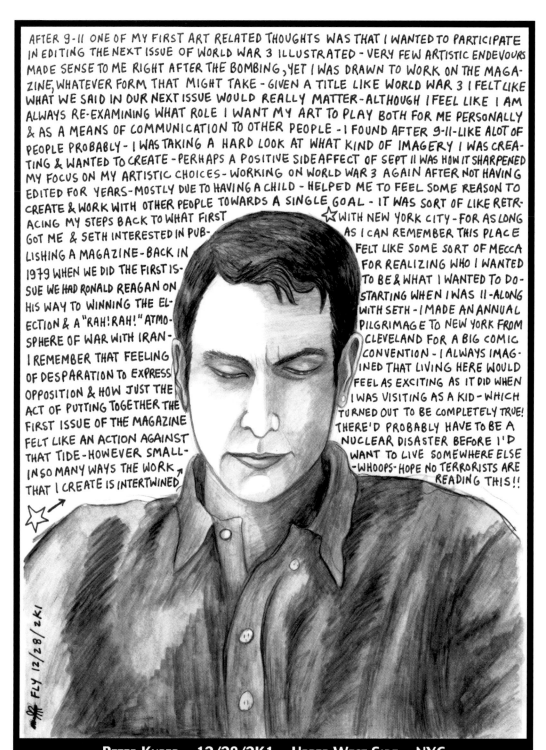

AFTER 9-11 ONE OF MY FIRST ART RELATED THOUGHTS WAS THAT I WANTED TO PARTICIPATE IN EDITING THE NEXT ISSUE OF WORLD WAR 3 ILLUSTRATED - VERY FEW ARTISTIC ENDEVOURS MADE SENSE TO ME RIGHT AFTER THE BOMBING, YET I WAS DRAWN TO WORK ON THE MAGA-ZINE, WHATEVER FORM THAT MIGHT TAKE - GIVEN A TITLE LIKE WORLD WAR 3 I FELT LIKE WHAT WE SAID IN OUR NEXT ISSUE WOULD REALLY MATTER - ALTHOUGH I FEEL LIKE I AM ALWAYS RE-EXAMINING WHAT ROLE I WANT MY ART TO PLAY BOTH FOR ME PERSONALLY & AS A MEANS OF COMMUNICATION TO OTHER PEOPLE - I FOUND AFTER 9-11 LIKE A LOT OF PEOPLE PROBABLY - I WAS TAKING A HARD LOOK AT WHAT KIND OF IMAGERY I WAS CREA-TING & WANTED TO CREATE - PERHAPS A POSITIVE SIDE AFFECT OF SEPT 11 WAS HOW IT SHARPENED MY FOCUS ON MY ARTISTIC CHOICES - WORKING ON WORLD WAR 3 AGAIN AFTER NOT HAVING EDITED FOR YEARS - MOSTLY DUE TO HAVING A CHILD - HELPED ME TO FEEL SOME REASON TO CREATE & WORK WITH OTHER PEOPLE TOWARDS A SINGLE GOAL - IT WAS SORT OF LIKE RETR-ACING MY STEPS BACK TO WHAT FIRST GOT ME & SETH INTERESTED IN PUB-LISHING A MAGAZINE - BACK IN 1979 WHEN WE DID THE FIRST IS-SUE WE HAD RONALD REAGAN ON HIS WAY TO WINNING THE EL-ECTION & A "RAH! RAH!" ATMO-SPHERE OF WAR WITH IRAN - I REMEMBER THAT FEELING OF DESPARATION TO EXPRESS OPPOSITION & HOW JUST THE ACT OF PUTTING TOGETHER THE FIRST ISSUE OF THE MAGAZINE FELT LIKE AN ACTION AGAINST THAT TIDE - HOWEVER SMALL - IN SO MANY WAYS THE WORK THAT I CREATE IS INTERTWINED

WITH NEW YORK CITY - FOR AS LONG AS I CAN REMEMBER THIS PLACE FELT LIKE SOME SORT OF MECCA FOR REALIZING WHO I WANTED TO BE & WHAT I WANTED TO DO - STARTING WHEN I WAS 11 - ALONG WITH SETH - I MADE AN ANNUAL PILGRIMAGE TO NEW YORK FROM CLEVELAND FOR A BIG COMIC CONVENTION - I ALWAYS IMAG-INED THAT LIVING HERE WOULD FEEL AS EXCITING AS IT DID WHEN I WAS VISITING AS A KID - WHICH TURNED OUT TO BE COMPLETELY TRUE! THERE'D PROBABLY HAVE TO BE A NUCLEAR DISASTER BEFORE I'D WANT TO LIVE SOMEWHERE ELSE - WHOOPS - HOPE NO TERRORISTS ARE READING THIS!!

FLY 12/28/2K1

PETER KUPER – 12/28/2K1 – UPPER WEST SIDE – NYC
WHEN I WAS DRAWING THIS PETER WAS WORKING ON AN UPCOMING PROJECT – ILLUS-TRATING KAFKA S "THE METAMORPHOSIS" (NOW IN PRINT!) – AS I WAS DRAWING HIS HEAD KEPT FALLING LOWER & LOWER & I WANTED TO SAY SOMETHING BUT I DIDNT WANT TO RUIN HIS CONCENTRATION – IT WAS REALLY TANGIBLE – & THEN LATER HE TOLD ME THAT HE HAD HAD A BIT OF A BREAKTHROUGH WHILE SITTING THERE – PETER IS ONE OF THE CO–FOUNDERS OF WORLD WAR 3 ILLUSTRATED – I HAD SEEN HIS AMAZING STENCIL COMICS WORK IN THAT MAGAZINE BEFORE I EVER MET HIM – NOW PETER DOES ILLUSTRA-TION WORK FOR A LOT OF MAJOR PAPERS & MAGAZINES – WWW.PETERKUPER.COM

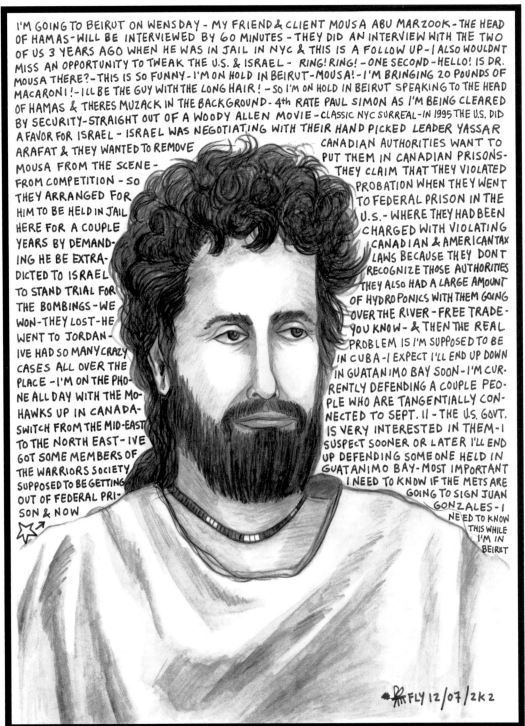

I'M GOING TO BEIRUT ON WENSDAY - MY FRIEND & CLIENT MOUSA ABU MARZOOK - THE HEAD OF HAMAS - WILL BE INTERVIEWED BY 60 MINUTES - THEY DID AN INTERVIEW WITH THE TWO OF US 3 YEARS AGO WHEN HE WAS IN JAIL IN NYC & THIS IS A FOLLOW UP - I ALSO WOULDNT MISS AN OPPORTUNITY TO TWEAK THE U.S. & ISRAEL - RING! RING! - ONE SECOND - HELLO! IS DR. MOUSA THERE? - THIS IS SO FUNNY - I'M ON HOLD IN BEIRUT - MOUSA! - I'M BRINGING 20 POUNDS OF MACARONI! - ILL BE THE GUY WITH THE LONG HAIR! - SO I'M ON HOLD IN BEIRUT SPEAKING TO THE HEAD OF HAMAS & THERES MUZACK IN THE BACKGROUND - 4th RATE PAUL SIMON AS I'M BEING CLEARED BY SECURITY - STRAIGHT OUT OF A WOODY ALLEN MOVIE - CLASSIC NYC SURREAL - IN 1995 THE U.S. DID A FAVOR FOR ISRAEL - ISRAEL WAS NEGOTIATING WITH THEIR HAND PICKED LEADER YASSAR ARAFAT & THEY WANTED TO REMOVE MOUSA FROM THE SCENE - FROM COMPETITION - SO THEY ARRANGED FOR HIM TO BE HELD IN JAIL HERE FOR A COUPLE YEARS BY DEMANDING HE BE EXTRADICTED TO ISRAEL TO STAND TRIAL FOR THE BOMBINGS - WE WON - THEY LOST - HE WENT TO JORDAN - IVE HAD SO MANY CRAZY CASES ALL OVER THE PLACE - I'M ON THE PHONE ALL DAY WITH THE MOHAWKS UP IN CANADA - SWITCH FROM THE MID-EAST TO THE NORTH EAST - IVE GOT SOME MEMBERS OF THE WARRIORS SOCIETY SUPPOSED TO BE GETTING OUT OF FEDERAL PRISON & NOW

CANADIAN AUTHORITIES WANT TO PUT THEM IN CANADIAN PRISONS - THEY CLAIM THAT THEY VIOLATED PROBATION WHEN THEY WENT TO FEDERAL PRISON IN THE U.S. - WHERE THEY HAD BEEN CHARGED WITH VIOLATING CANADIAN & AMERICAN TAX LAWS BECAUSE THEY DONT RECOGNIZE THOSE AUTHORITIES THEY ALSO HAD A LARGE AMOUNT OF HYDROPONICS WITH THEM GOING OVER THE RIVER - FREE TRADE - YOU KNOW - & THEN THE REAL PROBLEM IS I'M SUPPOSED TO BE IN CUBA - I EXPECT I'LL END UP DOWN IN GUATANIMO BAY SOON - I'M CURRENTLY DEFENDING A COUPLE PEOPLE WHO ARE TANGENTIALLY CONNECTED TO SEPT. 11 - THE U.S. GOVT. IS VERY INTERESTED IN THEM - I SUSPECT SOONER OR LATER I'LL END UP DEFENDING SOMEONE HELD IN GUATANIMO BAY - MOST IMPORTANT I NEED TO KNOW IF THE METS ARE GOING TO SIGN JUAN GONZALES - I NEED TO KNOW THIS WHILE I'M IN BEIRUT

FLY 12/07/2k2

STANLEY COHEN – 12/07/2K1 – LOWER EAST SIDE – NYC

STANLEY IS A LAWYER WHO ALWAYS SEEMS TO BE REPRESENTING THE UNREPRESENTED – THE UNDERDOGS & MAJOR SHIT DISTURBERS WHO DONT SEEM TO HAVE A SNOWBALLS CHANCE BUT WHO DESERVE IT – LIKE SQUATTERS – LIKE MOHAWK INDIANS – LIKE MEMBERS OF HAMAS – I REMEMBER BEING AT A RIOT AT COOPER UNION BACK IN **93** & THE COPS WERE BEATING EVERYONE UP & IT WAS SERIOUS CHAOS – I WAS STANDING REALLY CLOSE TO WHERE STANELY WAS & THE COPS WERE NOT COMING NEAR THAT AREA – I THINK THEY DIDNT WANT TO FCK WITH HIM – IT WAS FUN TO DRAW THIS PORTRAIT – STANLEY WAS ON THE PHONE A LOT & I GOT TO HEAR SOME WILD CONVERSATIONS

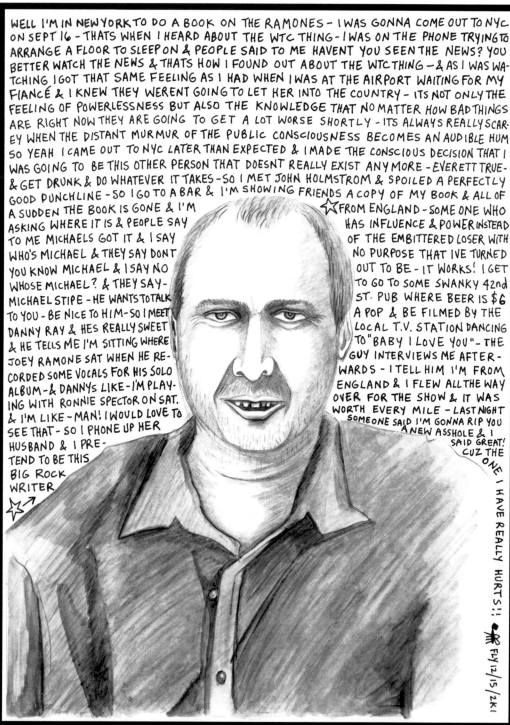

WELL I'M IN NEW YORK TO DO A BOOK ON THE RAMONES - I WAS GONNA COME OUT TO NYC ON SEPT 16 - THATS WHEN I HEARD ABOUT THE WTC THING - I WAS ON THE PHONE TRYING TO ARRANGE A FLOOR TO SLEEP ON & PEOPLE SAID TO ME HAVENT YOU SEEN THE NEWS? YOU BETTER WATCH THE NEWS & THATS HOW I FOUND OUT ABOUT THE WTC THING — & AS I WAS WATCHING I GOT THAT SAME FEELING AS I HAD WHEN I WAS AT THE AIRPORT WAITING FOR MY FIANCÉ & I KNEW THEY WERENT GOING TO LET HER INTO THE COUNTRY - ITS NOT ONLY THE FEELING OF POWERLESSNESS BUT ALSO THE KNOWLEDGE THAT NO MATTER HOW BAD THINGS ARE RIGHT NOW THEY ARE GOING TO GET A LOT WORSE SHORTLY - ITS ALWAYS REALLY SCAREY WHEN THE DISTANT MURMUR OF THE PUBLIC CONSCIOUSNESS BECOMES AN AUDIBLE HUM SO YEAH I CAME OUT TO NYC LATER THAN EXPECTED & I MADE THE CONSCIOUS DECISION THAT I WAS GOING TO BE THIS OTHER PERSON THAT DOESNT REALLY EXIST ANY MORE - EVERETT TRUE - & GET DRUNK & DO WHATEVER IT TAKES - SO I MET JOHN HOLMSTROM & SPOILED A PERFECTLY GOOD PUNCHLINE - SO I GO TO A BAR & I'M SHOWING FRIENDS A COPY OF MY BOOK & ALL OF

A SUDDEN THE BOOK IS GONE & I'M ASKING WHERE IT IS & PEOPLE SAY TO ME MICHAELS GOT IT & I SAY WHO'S MICHAEL & THEY SAY DONT YOU KNOW MICHAEL & I SAY NO WHOSE MICHAEL? & THEY SAY - MICHAEL STIPE - HE WANTS TO TALK TO YOU - BE NICE TO HIM - SO I MEET DANNY RAY & HES REALLY SWEET & HE TELLS ME I'M SITTING WHERE JOEY RAMONE SAT WHEN HE RECORDED SOME VOCALS FOR HIS SOLO ALBUM - & DANNYS LIKE - I'M PLAYING WITH RONNIE SPECTOR ON SAT. & I'M LIKE - MAN! I WOULD LOVE TO SEE THAT - SO I PHONE UP HER HUSBAND & I PRETEND TO BE THIS BIG ROCK WRITER

☆FROM ENGLAND - SOME ONE WHO HAS INFLUENCE & POWER INSTEAD OF THE EMBITTERED LOSER WITH NO PURPOSE THAT IVE TURNED OUT TO BE - IT WORKS! I GET TO GO TO SOME SWANKY 42nd ST. PUB WHERE BEER IS $6 A POP & BE FILMED BY THE LOCAL T.V. STATION DANCING TO "BABY I LOVE YOU" - THE GUY INTERVIEWS ME AFTERWARDS - I TELL HIM I'M FROM ENGLAND & I FLEW ALL THE WAY OVER FOR THE SHOW & IT WAS WORTH EVERY MILE - LAST NIGHT SOMEONE SAID I'M GONNA RIP YOU A NEW ASSHOLE & I SAID GREAT! CUZ THE ONE I HAVE REALLY HURTS!!

FLY 12/15/2K1

EVERETT TRUE – 12/15/2K1 – (FRM THE UK) – LOWER EAST SIDE – NYC
I MET EVERETT BACK IN 1999 IN SEATTLE – I WENT OUT DRINKING BEER WITH HIM & PETER BAGGE & IT WAS A RIOT! WE ENDED UP WRITING SOME COMIC STRIPS TOGETHER & I EVEN ILLUSTRATED ONE OF THEM LATER WHICH LED TO ME MEETING JOHN HOLMSTROM – BUT THATS ANOTHER STORY (SEE PG. 14) – EVERETT IS A MUSIC CRITIC – A CYNICAL BASTARD – BUT FUNNY AS HELL – WHEN I MET HIM HE WAS WRITING FOR THE STRANGER IN SEATTLE – HE USED TO HANG OUT WITH NIRVANA OUT THERE IN GRUNGELAND & HE WAS THE FIRST JOURNALIST TO RECOGNIZE THEIR TALENT & POTENTIAL – NOW HE S BACK IN THE UK RUNNING HIS OWN MAGAZINE – WWW.CARELESSTALKCOSTSLIVES.COM

TOILETS ARE A WONDERFUL LUXURY - SQUATTER KIDS SEEM TO RECOGNIZE THEM FOR THE TREA-
SURES THEY ARE BUT FOR THE MOST PART THEY ARE UNDER APPRECIATED & TAKEN FOR GRANTED
I GREW UP ON A FARM IN PENNSYLVANIA NEAR AMISH COUNTRY. OUR NIEGHBORS WERE ALL AM-
ISH & MENNONITE - THERE WAS LIKE 5 FACIAL TYPES IN THE AREA - I DIDNT REALIZE THAT UN
TIL NEW PEOPLE STARTED MOVING INTO THE AREA - A COUPLE YRS AGO THERE WAS A BIG COCAINE
PROBLEM WITH THE AMISH BUT THEY BUSTED THE KIDS WHO WERE RESPONSIBLE & I HAVENT HEARD
ANYTHING SINCE - WHEN I WAS 15 THE SCHOOL I WENT TO WENT ON THIS THING CALLED THE BIG
TRIP & WE WENT TO NEW ORLEANS & I WAS BLOWN AWAY THEN THAT SUMMER I WENT TO THE
RAINBOW GATHERING & HITCH HIKED BACK - I REALLY LIKED THE IDEA OF TRAVELING - IN MY LAST
YEAR OF HIGH SCHOOL I NEEDED PHYS-ED CREDITS SO I WENT ON A 2 MONTH HIKE THEN WHEN I
GOT BACK I HAD PROBLEMS RE-ADJUSTING -

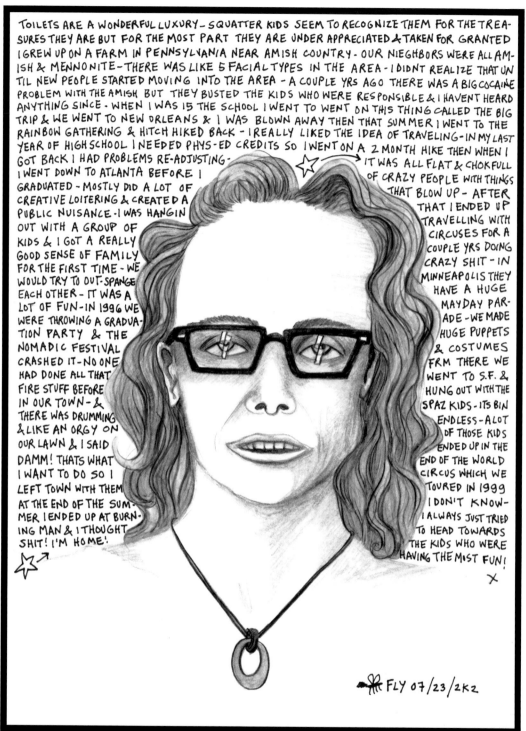

I WENT DOWN TO ATLANTA BEFORE I
GRADUATED - MOSTLY DID A LOT OF
CREATIVE LOITERING & CREATED A
PUBLIC NUISANCE - I WAS HANGIN
OUT WITH A GROUP OF
KIDS & I GOT A REALLY
GOOD SENSE OF FAMILY
FOR THE FIRST TIME - WE
WOULD TRY TO OUT-SPANGE
EACH OTHER - IT WAS A
LOT OF FUN - IN 1996 WE
WERE THROWING A GRADUA-
TION PARTY & THE
NOMADIC FESTIVAL
CRASHED IT - NO ONE
HAD DONE ALL THAT
FIRE STUFF BEFORE
IN OUR TOWN - &
THERE WAS DRUMMING
& LIKE AN ORGY ON
OUR LAWN & I SAID
DAMM! THATS WHAT
I WANT TO DO SO I
LEFT TOWN WITH THEM
AT THE END OF THE SUM-
MER I ENDED UP AT BURN-
ING MAN & I THOUGHT
SHIT! I'M HOME'.

IT WAS ALL FLAT & CHOKFULL
OF CRAZY PEOPLE WITH THINGS
THAT BLOW UP - AFTER
THAT I ENDED UP
TRAVELLING WITH
CIRCUSES FOR A
COUPLE YRS DOING
CRAZY SHIT - IN
MINNEAPOLIS THEY
HAVE A HUGE
MAYDAY PAR-
ADE - WE MADE
HUGE PUPPETS
& COSTUMES
FRM THERE WE
WENT TO S.F. &
HUNG OUT WITH THE
SPAZ KIDS - ITS BIN
ENDLESS - A LOT
OF THOSE KIDS
ENDED UP IN THE
END OF THE WORLD
CIRCUS WHICH WE
TOURED IN 1999
I DON'T KNOW -
I ALWAYS JUST TRIED
TO HEAD TOWARDS
THE KIDS WHO WERE
HAVING THE MOST FUN!
X

FLY 07/23/2K2

PIERRE PRE$$URE – 07/23/2K2 – LOWER EAST SIDE – NYC
WHEN I FIRST MET PIERRE PRE$$URE I DIDNT REALIZE I WAS MEETING PIERRE PRE$$URE
– IT WAS IN 1993 & ME & DOG BOY WERE ON THE ROAD – WE HAD STOPPED IN PHILLY
FOR THE "ANARCHIST" CONVENTION – I HAD SOME ZINES WITH ME & THEY WOULDNT LET
ME SELL ANY AT THE CONVENTION BECAUSE THEY SAID THEY WERE NONPROFIT & I DIDNT
UNDERSTAND THIS BECAUSE OTHER PEOPLE WERE SELLING STUFF & SOLICITING DONATIONS
SO I WAS HANGIN OUTSIDE COMMISERATIN WITH THIS VERY SWEET CRUSTY KID – THEN
YEARS LATER I FOUND OUT IT WAS PIERRE PRE$$URE!!! – HE WENT ON TO FAME & FOR-
TUNE EMCEEING FOR THE END OF THE WORLD CIRCUS – PIERREPRESSURE@SPAZ.ORG

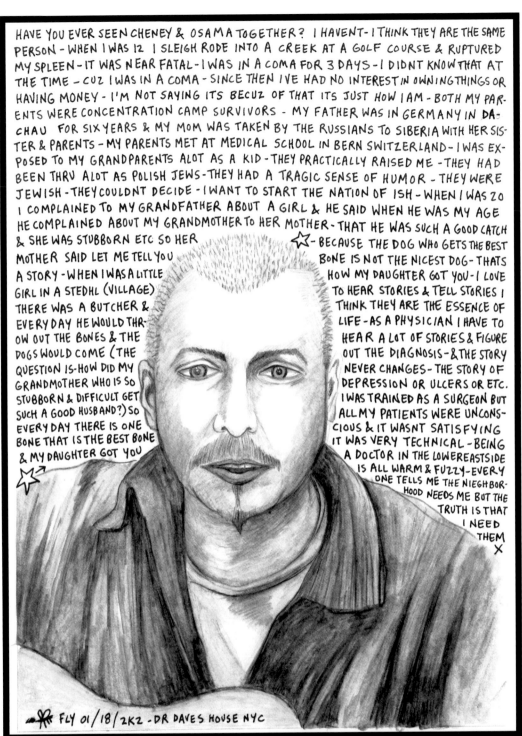

HAVE YOU EVER SEEN CHENEY & OSAMA TOGETHER? I HAVENT - I THINK THEY ARE THE SAME PERSON - WHEN I WAS 12 I SLEIGH RODE INTO A CREEK AT A GOLF COURSE & RUPTURED MY SPLEEN - IT WAS NEAR FATAL - I WAS IN A COMA FOR 3 DAYS - I DIDNT KNOW THAT AT THE TIME - CUZ I WAS IN A COMA - SINCE THEN IVE HAD NO INTEREST IN OWNING THINGS OR HAVING MONEY - I'M NOT SAYING ITS BECUZ OF THAT ITS JUST HOW I AM - BOTH MY PARENTS WERE CONCENTRATION CAMP SURVIVORS - MY FATHER WAS IN GERMANY IN DACHAU FOR SIX YEARS & MY MOM WAS TAKEN BY THE RUSSIANS TO SIBERIA WITH HER SISTER & PARENTS - MY PARENTS MET AT MEDICAL SCHOOL IN BERN SWITZERLAND - I WAS EXPOSED TO MY GRANDPARENTS ALOT AS A KID - THEY PRACTICALLY RAISED ME - THEY HAD BEEN THRU ALOT AS POLISH JEWS - THEY HAD A TRAGIC SENSE OF HUMOR - THEY WERE JEWISH - THEY COULDNT DECIDE - I WANT TO START THE NATION OF ISH - WHEN I WAS 20 I COMPLAINED TO MY GRANDFATHER ABOUT A GIRL & HE SAID WHEN HE WAS MY AGE HE COMPLAINED ABOUT MY GRANDMOTHER TO HER MOTHER - THAT HE WAS SUCH A GOOD CATCH & SHE WAS STUBBORN ETC SO HER MOTHER SAID LET ME TELL YOU A STORY - WHEN I WAS A LITTLE GIRL IN A STEDHL (VILLAGE) THERE WAS A BUTCHER & EVERY DAY HE WOULD THROW OUT THE BONES & THE DOGS WOULD COME (THE QUESTION IS - HOW DID MY GRANDMOTHER WHO IS SO STUBBORN & DIFFICULT GET SUCH A GOOD HUSBAND?) SO EVERY DAY THERE IS ONE BONE THAT IS THE BEST BONE & MY DAUGHTER GOT YOU

- BECAUSE THE DOG WHO GETS THE BEST BONE IS NOT THE NICEST DOG - THATS HOW MY DAUGHTER GOT YOU - I LOVE TO HEAR STORIES & TELL STORIES I THINK THEY ARE THE ESSENCE OF LIFE - AS A PHYSICIAN I HAVE TO HEAR A LOT OF STORIES & FIGURE OUT THE DIAGNOSIS - & THE STORY NEVER CHANGES - THE STORY OF DEPRESSION OR ULCERS OR ETC. I WAS TRAINED AS A SURGEON BUT ALL MY PATIENTS WERE UNCONSCIOUS & IT WASNT SATISFYING IT WAS VERY TECHNICAL - BEING A DOCTOR IN THE LOWER EAST SIDE IS ALL WARM & FUZZY - EVERYONE TELLS ME THE NIEGHBORHOOD NEEDS ME BUT THE TRUTH IS THAT I NEED THEM X

FLY 01/18/2K2 - DR DAVES HOUSE NYC

DOCTOR DAVE ORES – 01/18/2K2 – LOWER EAST SIDE – NYC
DR. DAVE IS THE ANARCHIST DOCTOR OF THE LOWER EAST SIDE – THE FIRST TIME I MET HIM WAS WHEN I WAS WORKING AT KINKOS & HE CAME IN TO COPY SOME FLYERS FOR A SHOW HE WAS DOING – A COMEDY SHOW – SO I THOUGHT HE WAS A COMEDIAN – SO WHEN HE TOLD ME HE WAS ALSO A DOCTOR I THOUGHT HE WAS KIDDING!! – WHEN I WAS DRAWING THIS PORTRAIT HE WAS CONCENTRATING VERY HARD ON TRYING TO PLAY GUITAR & SING A SONG THAT I CANT REMEMBER RIGHT NOW BUT AT THE TIME HE PLAYED IT OVER & OVER – I THINK IT WAS CAT STEVENS – ANYWAY THATS WHY HE LOOKS SO INTENSE – CHECK DR. DAVE S WEBSITE – WWW.DAVIDJORESMD.COM

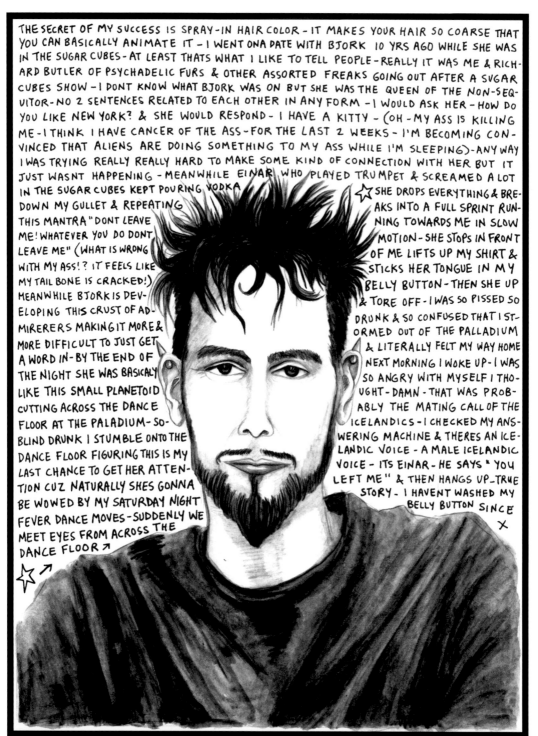

THE SECRET OF MY SUCCESS IS SPRAY-IN HAIR COLOR - IT MAKES YOUR HAIR SO COARSE THAT YOU CAN BASICALLY ANIMATE IT - I WENT ON A DATE WITH BJORK 10 YRS AGO WHILE SHE WAS IN THE SUGAR CUBES - AT LEAST THATS WHAT I LIKE TO TELL PEOPLE - REALLY IT WAS ME & RICHARD BUTLER OF PSYCHADELIC FURS & OTHER ASSORTED FREAKS GOING OUT AFTER A SUGAR CUBES SHOW - I DONT KNOW WHAT BJORK WAS ON BUT SHE WAS THE QUEEN OF THE NON-SEQUITOR - NO 2 SENTENCES RELATED TO EACH OTHER IN ANY FORM - I WOULD ASK HER - HOW DO YOU LIKE NEW YORK? & SHE WOULD RESPOND - I HAVE A KITTY - (OH - MY ASS IS KILLING ME - I THINK I HAVE CANCER OF THE ASS - FOR THE LAST 2 WEEKS - I'M BECOMING CONVINCED THAT ALIENS ARE DOING SOMETHING TO MY ASS WHILE I'M SLEEPING) - ANY WAY I WAS TRYING REALLY REALLY HARD TO MAKE SOME KIND OF CONNECTION WITH HER BUT IT JUST WASNT HAPPENING - MEANWHILE EINAR WHO PLAYED TRUMPET & SCREAMED A LOT IN THE SUGAR CUBES KEPT POURING VODKA DOWN MY GULLET & REPEATING THIS MANTRA "DONT LEAVE ME! WHATEVER YOU DO DONT LEAVE ME" (WHAT IS WRONG WITH MY ASS!? IT FEELS LIKE MY TAIL BONE IS CRACKED!) MEANWHILE BJORK IS DEVELOPING THIS CRUST OF ADMIRERERS MAKING IT MORE & MORE DIFFICULT TO JUST GET A WORD IN - BY THE END OF THE NIGHT SHE WAS BASICALY LIKE THIS SMALL PLANETOID CUTTING ACROSS THE DANCE FLOOR AT THE PALADIUM - SO BLIND DRUNK I STUMBLE ONTO THE DANCE FLOOR FIGURING THIS IS MY LAST CHANCE TO GET HER ATTENTION CUZ NATURALLY SHES GONNA BE WOWED BY MY SATURDAY NIGHT FEVER DANCE MOVES - SUDDENLY WE MEET EYES FROM ACROSS THE DANCE FLOOR ↗

☆ ↗

☆ SHE DROPS EVERYTHING & BREAKS INTO A FULL SPRINT RUNNING TOWARDS ME IN SLOW MOTION - SHE STOPS IN FRONT OF ME LIFTS UP MY SHIRT & STICKS HER TONGUE IN MY BELLY BUTTON - THEN SHE UP & TORE OFF - I WAS SO PISSED SO DRUNK & SO CONFUSED THAT I STORMED OUT OF THE PALLADIUM & LITERALLY FELT MY WAY HOME NEXT MORNING I WOKE UP - I WAS SO ANGRY WITH MYSELF I THOUGHT - DAMN - THAT WAS PROBABLY THE MATING CALL OF THE ICELANDICS - I CHECKED MY ANSWERING MACHINE & THERES AN ICELANDIC VOICE - A MALE ICELANDIC VOICE - ITS EINAR - HE SAYS " YOU LEFT ME" & THEN HANGS UP - TRUE STORY - I HAVENT WASHED MY BELLY BUTTON SINCE

X

VOLTAIRE – JANUARY 2K2 – LOWER EAST SIDE – NYC
I MET VOLTAIRE IN JAN. 1988 – ME & A FRIEND HAD BEEN IN NYC FOR BARELY 24 HOURS – IT WAS LIKE 40 BELOW OUTSIDE WITH WINDCHILL FACTORS & WE HAD NOWHERE TO STAY SO AFTER FREEZING ON THE STREET ALL DAY WE WERE CAMPING OUT WITH COFFEE IN A 24 HOUR DINER ON 2ND AVE. – SUDDENLY THIS VAMPIRIC GENTLEMAN BLEW IN THE DOOR & WAFTED OVER TO OUR TABLE – HE WAS DRESSED IN BLACK & HIS SKIN WAS ALMOST TRANSLUCENT IT WAS SO PALE – HIS LONG BLACK HAIR FLOWED AROUND HIM AS IF POSSESSED AS HE OPENED HIS THIN BLOOD RED LIPS & SLID A SNAKE S TONGUE OVER SHARP TEETH – "HI" – HE SAID – "I M VOLTAIRE" – WWW.VOLTAIRE.NET

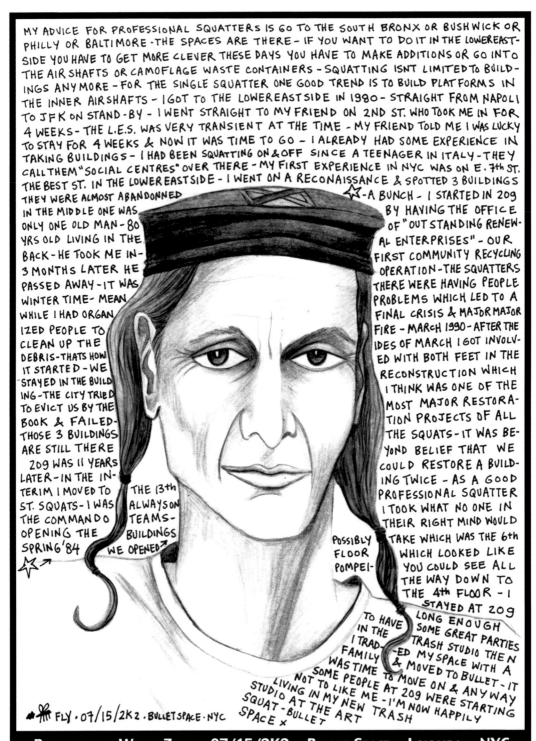

MY ADVICE FOR PROFESSIONAL SQUATTERS IS GO TO THE SOUTH BRONX OR BUSHWICK OR PHILLY OR BALTIMORE - THE SPACES ARE THERE - IF YOU WANT TO DO IT IN THE LOWER EAST-SIDE YOU HAVE TO GET MORE CLEVER THESE DAYS YOU HAVE TO MAKE ADDITIONS OR GO INTO THE AIR SHAFTS OR CAMOFLAGE WASTE CONTAINERS - SQUATTING ISNT LIMITED TO BUILD-INGS ANY MORE - FOR THE SINGLE SQUATTER ONE GOOD TREND IS TO BUILD PLATFORMS IN THE INNER AIRSHAFTS - I GOT TO THE LOWER EAST SIDE IN 1980 - STRAIGHT FROM NAPOLI TO JFK ON STAND-BY - I WENT STRAIGHT TO MY FRIEND ON 2ND ST. WHO TOOK ME IN FOR 4 WEEKS - THE L.E.S. WAS VERY TRANSIENT AT THE TIME - MY FRIEND TOLD ME I WAS LUCKY TO STAY FOR 4 WEEKS & NOW IT WAS TIME TO GO - I ALREADY HAD SOME EXPERIENCE IN TAKING BUILDINGS - I HAD BEEN SQUATTING ON & OFF SINCE A TEENAGER IN ITALY - THEY CALL THEM "SOCIAL CENTRES" OVER THERE - MY FIRST EXPERIENCE IN NYC WAS ON E. 7TH ST. THE BEST ST. IN THE LOWER EAST SIDE - I WENT ON A RECONAISSANCE & SPOTTED 3 BUILDINGS THEY WERE ALMOST ABANDONNED

IN THE MIDDLE ONE WAS ONLY ONE OLD MAN - 80 YRS OLD LIVING IN THE BACK - HE TOOK ME IN - 3 MONTHS LATER HE PASSED AWAY - IT WAS WINTER TIME - MEAN WHILE I HAD ORGAN IZED PEOPLE TO CLEAN UP THE DEBRIS - THATS HOW IT STARTED - WE STAYED IN THE BUILD ING - THE CITY TRIED TO EVICT US BY THE BOOK & FAILED - THOSE 3 BUILDINGS ARE STILL THERE

209 WAS 11 YEARS LATER - IN THE IN-TERIM I MOVED TO ST. SQUATS - I WAS THE COMMANDO OPENING THE SPRING '84

THE 13th ALWAYS ON TEAMS - BUILDINGS WE OPENED →

☆ - A BUNCH - I STARTED IN 209 BY HAVING THE OFFICE OF "OUTSTANDING RENEW-AL ENTERPRISES" - OUR FIRST COMMUNITY RECYCLING OPERATION - THE SQUATTERS THERE WERE HAVING PEOPLE PROBLEMS WHICH LED TO A FINAL CRISIS & MAJOR MAJOR FIRE - MARCH 1990 - AFTER THE IDES OF MARCH I GOT INVOLV-ED WITH BOTH FEET IN THE RECONSTRUCTION WHICH I THINK WAS ONE OF THE MOST MAJOR RESTORA-TION PROJECTS OF ALL THE SQUATS - IT WAS BE-YOND BELIEF THAT WE COULD RESTORE A BUILD-ING TWICE - AS A GOOD PROFESSIONAL SQUATTER I TOOK WHAT NO ONE IN THEIR RIGHT MIND WOULD TAKE WHICH WAS THE 6th WHICH LOOKED LIKE YOU COULD SEE ALL THE WAY DOWN TO THE 4th FLOOR - I STAYED AT 209 LONG ENOUGH SOME GREAT PARTIES TRASH STUDIO THEN -ED MY SPACE WITH A & MOVED TO BULLET - IT

POSSIBLY FLOOR POMPEI-

TO HAVE IN THE I TRAD-FAMILY WAS TIME TO MOVE ON & ANY WAY SOME PEOPLE AT 209 WERE STARTING NOT TO LIKE ME - I'M NOW HAPPILY LIVING IN MY NEW TRASH STUDIO AT THE ART SQUAT - BULLET SPACE ×

FLY · 07/15/2K2 · BULLET SPACE · NYC

ROLANDO AKA WASTE ZERO – 07/15/2K2 – BULLET SPACE – LOISAIDA – NYC

I MET ROLANDO SOMETIME AROUND 1990 WHEN I WENT TO HIS SHOW AT BULLET SPACE – I WAS VERY IMPRESSED BY HIS INVENTIVE RECYCLED OBJECTS – & HE GAVE ME A BEAUTIFULLY CRAFTED & VERY STURDY LITTLE PURSE MADE OUT OF A BUSTELLO COFFEE TIN – ROLANDO WAS INVOLVED WITH A SQUATTED BUILDING ON E. 7TH ST. & HE ENCOURAGED ME TO COME & APPLY FOR A SPACE WHICH I DID IN 92 – I WORKED ON THE BUILDING FOR 3 MONTHS & DID A LOT OF MASONRY WORK – ROLANDO TAUGHT ME HOW TO DO CEMENT STUCCO ON THE WALLS – HE IS THE ITALIAN MIX MASTER – ROLANDO CONTINUES TO RECY-CLE & PRAY – WASTE ZERO & USE LESS INFORMATION – WWW.TRASHWORSHIP.ORG

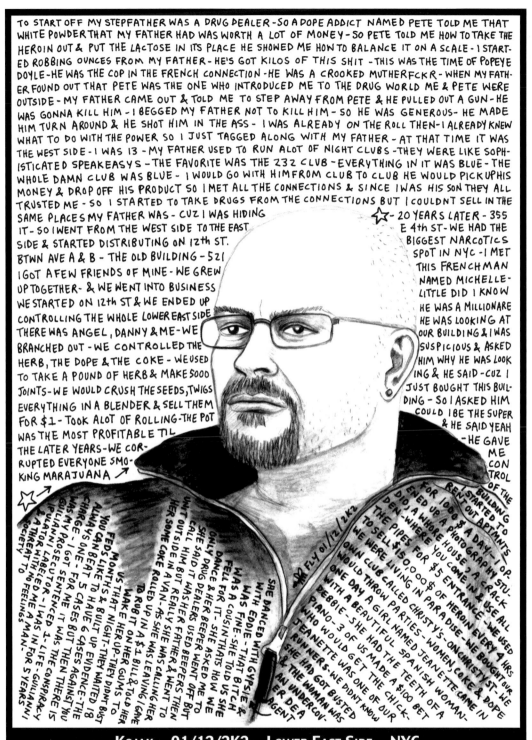

TO START OFF MY STEPFATHER WAS A DRUG DEALER - SO A DOPE ADDICT NAMED PETE TOLD ME THAT WHITE POWDER THAT MY FATHER HAD WAS WORTH A LOT OF MONEY - SO PETE TOLD ME HOW TO TAKE THE HEROIN OUT & PUT THE LACTOSE IN ITS PLACE HE SHOWED ME HOW TO BALANCE IT ON A SCALE - I STARTED ROBBING OUNCES FROM MY FATHER - HE'S GOT KILOS OF THIS SHIT - THIS WAS THE TIME OF POPEYE DOYLE - HE WAS THE COP IN THE FRENCH CONNECTION - HE WAS A CROOKED MUTHERFCKR - WHEN MY FATHER FOUND OUT THAT PETE WAS THE ONE WHO INTRODUCED ME TO THE DRUG WORLD ME & PETE WERE OUTSIDE - MY FATHER CAME OUT & TOLD ME TO STEP AWAY FROM PETE & HE PULLED OUT A GUN - HE WAS GONNA KILL HIM - I BEGGED MY FATHER NOT TO KILL HIM - SO HE WAS GENEROUS - HE MADE HIM TURN AROUND & HE SHOT HIM IN THE ASS - I WAS ALREADY ON THE ROLL THEN - I ALREADY KNEW WHAT TO DO WITH THE POWER SO I JUST TAGGED ALONG WITH MY FATHER - AT THAT TIME IT WAS THE WEST SIDE - I WAS 13 - MY FATHER USED TO RUN ALOT OF NIGHT CLUBS - THEY WERE LIKE SOPHISTICATED SPEAKEASYS - THE FAVORITE WAS THE 232 CLUB - EVERYTHING IN IT WAS BLUE - THE WHOLE DAMN CLUB WAS BLUE - I WOULD GO WITH HIM FROM CLUB TO CLUB HE WOULD PICK UP HIS MONEY & DROP OFF HIS PRODUCT SO I MET ALL THE CONNECTIONS & SINCE I WAS HIS SON THEY ALL TRUSTED ME - SO I STARTED TO TAKE DRUGS FROM THE CONNECTIONS BUT I COULDNT SELL IN THE SAME PLACES MY FATHER WAS - CUZ I WAS HIDING IT - SO I WENT FROM THE WEST SIDE TO THE EAST SIDE & STARTED DISTRIBUTING ON 12th ST. BTWN AVE A & B - THE OLD BUILDING - 521 I GOT A FEW FRIENDS OF MINE - WE GREW UP TOGETHER - & WE WENT INTO BUSINESS WE STARTED ON 12th ST & WE ENDED UP CONTROLLING THE WHOLE LOWER EAST SIDE THERE WAS ANGEL, DANNY & ME - WE BRANCHED OUT - WE CONTROLLED THE HERB, THE DOPE & THE COKE - WE USED TO TAKE A POUND OF HERB & MAKE 5000 JOINTS - WE WOULD CRUSH THE SEEDS, TWIGS EVERYTHING IN A BLENDER & SELL THEM FOR $1 - TOOK ALOT OF ROLLING - THE POT WAS THE MOST PROFITABLE TIL THE LATER YEARS - WE CORRUPTED EVERYONE SMOKING MARAJUANA ↗

☆ - 20 YEARS LATER - 355 E 4th ST - WE HAD THE BIGGEST NARCOTICS SPOT IN NYC - I MET THIS FRENCHMAN NAMED MICHELLE - LITTLE DID I KNOW HE WAS A MILLIONARE HE WAS LOOKING AT OUR BUILDING & I WAS SUSPICIOUS & ASKED HIM WHY HE WAS LOOKING & HE SAID - CUZ I JUST BOUGHT THIS BUILDING - SO I ASKED HIM COULD I BE THE SUPER & HE SAID YEAH - HE GAVE ME CONTROL OF THE BUILDING I STARTED TO RENT OUT APTMNTS

[text written across the jacket:]

A THREAT TO SOCIETY & A THREAT WITH NO FEELINGS - MANIPULATOR - GUILIANI LABELED - I WAS A CONSPIRACY - 1 - LIFE - GUILIANI WAS MY PROSECUTOR - I GOT SENTENCED - THE CHARGE - THEN THERE IS ALWAYS ONE - FOR ME IT WAS THE FEDS - YOU CAN BEAT 5 CASES BUT THEN THEY BUILT UP 6 CASES AGAINST YOU - THE FEDS LIKE TO HAVE EVIDENCE - THEY WAITED 18 MONTHS & BUILT UP EVIDENCE - THEY DIDNT BUST US THAT NIGHT - THEY WANTED TO MAKE HER UP - THEY WAITED TO RUB IT ON HER GUMS TO MAKE HER UP - SHE DANCED WITH EDDIE - THAT BITCH - WAS FINE - SHE TOLD US SHE FELL FOR IT - SHE TOLD US SHE WAS A COUSIN THATS HOW SHE ONLY DRUG DEALERS USED BEEPERS THEN I FELL FOR IT - SHE ASKED ME TO DANCE FOR IT - HER BEEPER WENT OFF BUT SHE SAID IT WAS HER FATHER & WENT TO CALL HIM BUT REALLY SHE WAS CALLING HER UNIT OUTSIDE IN A VAN - AS SHE WAS LEAVING I GAVE HER SOME COKE ROLLED UP IN A $1 BILL & TOLD HER

FLY 01/12/2K2

FOR 1000 $ A DAY - I OP... ENDED UP A PHOTOGRAPHY STUDIO - DID A WHORE HOUSE 2 & A CRACK DEN - WHERE YOU COME IN & USE ALL THE PIPES FOR $5 OF HEROIN EVERY 4 HRS - TO SELL $150,000$ OF HEROIN - WE USED TO SELL CLUB CALLED CHRISTY'S - ON CHRISTY ST - WE WE WERE LIVING IN PARADISE - WE BOUGHT OUR OWN CLUB CALLED CHRISTY'S - WOULD THROW PARTIES - WOMEN COKE & DOPE ONE DAY A GIRL NAMED JEANETTE CAME IN WITH A BEAUTIFUL SPANISH WOMAN - DEBBIE - SHE HAD THE TEETH OF A PIANO - 3 OF US MADE A $100 BET WHO WOULD GET THE CHICK - JEANETTE WAS ONE OF OUR RUNNERS - WE DIDNT KNOW SHE HAD GOT BUSTED & THE WOMAN WAS AN UNDERCOV. ER DEA AGENT

KOJAK - 01/12/2K2 - LOWER EAST SIDE - NYC

I MET KOJAK WHEN HE CAME TO WORK AT KINKOS - I WAS WORKING THERE AS THE OVERNIGHT SHIFT MANAGER - IT WAS A 12-HOUR SHIFT & I WAS THE ONLY ONE WORKING - IT WAS GETTING A LITTLE OUT OF HAND SO KOJAK GOT HIRED - THE FIRST THING HE TOLD ME WAS THAT HE HAD JUST GOTTEN OUT OF PRISON FOR DEALING DRUGS - KOJAK WAS NONSTOP ENTERTAINMENT - HE WOULD TELL ME THE MOST UNBELIEVABLE STORIES BUT I KNEW THEY WERE ALL TRUE BECAUSE THEN A LOT OF THE CHARACTERS IN THE STORIES STARTED SHOWING UP AT KINKOS - KOJAK FINALLY QUIT WHEN HE GOT SICK OF THE ASS-HOLES WHO OFTEN MASQUERADE AS CUSTOMERS & HE DECIDED TO PUNCH ONE OF THEM

THE COOL THING ABOUT SOUTH AMERICA IS THAT IF YOU SEE SOME ONE WITH A MOHAWK & YOU ARE ALSO A FREAK THEN THEY WILL PROBABLY TAKE YOU HOME & FEED YOU - ITS IMPORTANT TO LOOK PUNK IN S.AMERICA - THAT WAS A DISSAPOINTING THING IN D.C. - NOBODY LOOKED PUNK - I THINK IN SOUTH AMERICA ITS BECAUSE EXISTENCE IS SO MUCH MORE PRECARIOUS SO LOOKING PUNK CONNECTS YOU TO THIS TRIBE OF CLASS WARRIORS WHO ARE INTERESTED IN DEFENDING THE RIGHTS OF THE UNDERCLASS & PEOPLE HAVE RESPECT FOR THAT - IT WOULD HAVE BEEN HARD IN MY NIEGHBORHOOD IN BUENOS AIRES TO WALK AROUND AS A BLOND HAIRED WHITE GUY BUT LOOKING PUNK CONNECTED ME TO A RECOGNIZED & VALUED GROUP IN THAT SOCIETY - I LIVED IN SOUTH AMERICA IN 2 DIFFERENT STINTS - IN 1997-98 I WAS AN EXCHANGE STUDENT - I HADNT PLANNED ON LIVING IN ARGENTINA & CHILE BUT IT TURNED OUT TO BE THE ONLY PLACES I COULD GO & NOT LOSE MY SCHOLARSHIPS - BEFORE GOING I STARTED WRITING TO ZINES & GOT ANY CONTACTS I COULD IN THAT PART OF THE WORLD SO I

HAD A PRETTY COOL GROUP OF FOLKS WAITING FOR ME WHEN I GOT THERE - EVEN THO I WAS IN SCHOOL I WAS ABLE TO SPEND ALOT OF TIME TRAVELING & SQUATTING DOING HUMAN RIGHTS WORK GOING TO SHOWS & DRINKING - RIGHT NOW I JUST CAME BACK FROM A YEAR & A HALF IN S.AMERICA - I STARTED OUT IN D.C. WITH MY BUDDY BUZZARD - WE HITCHED & TRAIN HOPPED DOWN TO MIAMI WHERE WE GOT A CHEAP FLIGHT TO CARACAS VENEZUELA - FROM THERE IT WAS A 4 & HALF MONTH HITCH TO BUENOS AIRES - WE STOPPED ALONG THE WAY

☆ VISITING ANARCHIST LAND SQUATS COMMUNES & SOME FOLKS FROM THE GUYANESE MAFIA - IN THE CITY OF TERESINA IN N.E. BRAZIL WE LIVED IN THE SECOND LARGEST LAND SQUAT IN LATIN AMERICA - AN AUTONOMOUS COMMUNITY OF 5000 FAMILIES - THERE THE LOCAL PUNKS DECIDED THAT ME & BUZZARD WERE A PUNK BAND & WE HAD TO PLAY IN THE NEXT SHOW SO WE FORMED AN OI! BAND CALLED TOM JOAD - NAMED AFTER THE MAIN CHARACTER OF THE GRAPES OF WRATH - MOST OF OUR SONGS WERE ABOUT HITCH HIKING, NOT WORKING, NOT UNDERSTANDING ENOUGH PORTUGUESE, DRINKING - BUZZARD HAD NEVER BEEN IN A BAND → BEFORE - HE PRETTY MUCH LEARNED HOW TO PLAY BASS AS WE WENT ALONG - ALONG WITH THE WORKSHOPS WE WERE GIVING ON SQUATTING IN N. AMERICA & EUROPE THE BAND WAS A COOL MEANS OF EXPRESSION - ONCE WE GOT TO BUENOS AIRES WE FOCUSED OUR ATTENTION ON SQUATTING FOR BUZZARD & ANTI-FASCIST ORGANIZING FOR ME - A.R.A. BUENOS AIRES HAS BEEN STICKIN IT TO THE NAZI PARTIES FOR OVER A YEAR NOW & THE LAFE SQUAT HAS BEEN AROUND FOR OVER A YEAR & DOES AMAZING COMMUNITY ORGANIZING LIKE FEEDING UPWARDS OF 50 CHILDREN PER DAY - I'M ALSO PSYCHED THAT WE GOT TO HELP CREATE & TAKE PART IN THE ANARCHIST OI! SCENE IN S. AMERICA - THESE DAYS I CONSIDER MYSELF A SKIN HEAD BUT I FIND THAT THE SKINHEAD SCENE IN THE U.S. IS DISSAPOINTING - I THINK THERE IS A LOT OF POTENTIAL FOR RADICAL CLASS STRUGGLE IN SKIN CULTURE UNFORTUNATELY IN THE U.S. IT DOESNT GET CARRIED OUT TO ITS LOGICAL CONCLUSION OF STRUGGLE AS & ON BEHALF OF THE OPPRESSED.

FLY 02/28/2K2

ROOSTER - 02/28/2K2 - OAKLAND

ROOSTER SHOWED UP ONE DAY AT THE KILLER BANSHEE COMPOUND LOOKING FOR RATH & HIS CREW WHO WERE TRAVELING AROUND THE COUNTRY DISSEMINATING DEVIANT INFORMATION FROM AN R.V. CALLED TANTRUM THAT THEY PARKED OUTSIDE THE COMPOUND - I DONT REALLY KNOW MUCH ABOUT ROOSTER CUZ HE WAS ONLY AROUND FOR A FEW DAYS - I WAS LETTING THEM TAKE SHOWERS IN THE HOUSE I WAS STAYING IN ADJACENT TO THE BANSHEE STUDIO & LET THEM CHECK EMAIL ON MY LAPTOP - I DID ROOSTER S PORTRAIT SITTING OUTSIDE BY THE MURAL THAT IS STILL IN PROGRESS ON THE SIDE OF THE STUDIO - HE DEFINITELY HAD A LOT OF STORIES TO TELL

I WAS PASSING BY ONE DAY & I SAW PEOPLE WORKING ON THE BUILDING & I ASKED IF I COULD HELP - HAULING BUCKETS - I WAS HOMELESS & PENNILESS - I WAS LIVING IN A SHELTER - SUMMER OF '91 - I GOT TO 209 APPROXIMATELY 6 MONTHS AFTER THE FIRE - BEFORE THE SHELTER I LIVED IN DIFFERENT SQUATS BUT I REALLY WANTED TO STABALIZE MY LIFE - AMONG THE PLACES I TRIED TO LIVE WAS A HORRIFIC PLACE CALLED 3BC - I LIVED THERE A COUPLE MONTHS IN 1990 - KIDS FROM THE NIEGHBORHOOD WERE TERRORIZING PEOPLE WITH BASE BALL BATS - DRUG DEALERS ACROSS THE STREET - THEN I LIVED IN A SQUAT ON LUDLOW - IT WAS JUST ME & A HUNGARIAN GUY & AN ETHIOPIAN - THAT WAS BETTER BUT IT WAS HARD TO BE ACCEPTED IN THE NIEGHBORHOOD & THERE WAS NO PROGRESS ON THE BUILDING - IT WAS A LOT OF WORK & I COULDNT SEE A FUTURE IN FIXING IT - BY THEN IT WAS FUN CAMPING OUT IN THE PARK CUZ IT WAS US AGAINST THE COPS - SO I CAMPED OUT IN THE PARK - I HAD A TENT IT WAS GOOD WHILE IT LASTED THEN I MOVED INTO A SHELTER - I DIDNT HAVE AMERICAN CITIZENSHIP MY ONLY ADDRESS WAS A CHURCH ON 9TH ST - IT WAS DIFFICULT - I WAS AFRAID I MIGHT GET THROWN OUT - I HAD A FEELING THEY WOULD CRACK DOWN ON THE PEOPLE IN THE PARK I DIDNT WANT TO GET ARRESTED - I WANTED A PLACE TO CALL HOME - I WANTED A CITIZENSHIP SINCE ITS SUCH A BIG DEAL ON THIS PLANET - I WANTED TO BE ABLE TO TRAVEL FREELY - I'M NOT AN ANARCHIST BUT I CAN AGREE WITH THE IDEA OF WANTING TO LIVE WITHOUT OBSTRUCTIONS LIKE PAYING RENT & HAVING TO APPLY FOR VISAS TO TRAVEL

☆ - SOMEONE SAID "FREEDOM INTERFERES WITH PROGRESS" - IT WAS VERY CLEAR TO ME THAT I WANTED FREEDOM & NOT THE ILLUSION OF FREEDOM WHICH IS OFTEN DEFINED AS PROGRESS - I WAS IN THE SHELTER MAYBE 2 OR 3 MONTHS I WAS A TAXI DRIVER - I MET ROLANDO WHEN HE WAS WORKING ON THE STOREFRONT AT 209 & I LIKED HIS MEDITERRANEAN ATTITUDE - I HAD ALSO MET JOHN SUTCLIFF WHILE I WAS LIVING IN THE PARK & IT WAS A COINCIDENCE THAT THEY BOTH LIVED AT 209 - I LIKED THE PEOPLE AT 209 - THEIR GENERAL ATTITUDE TOWARDS LIFE - I WORKED ON THE BUILDING ABOUT 6 MONTHS & THEN GOT VOTED IN - LIVING HERE HAS GIVEN ME THE FREEDOM TO GET ON MY FEET & ITS THE BIGGEST BREAK OF MY LIFE - TO BE GIVEN A CHANCE X

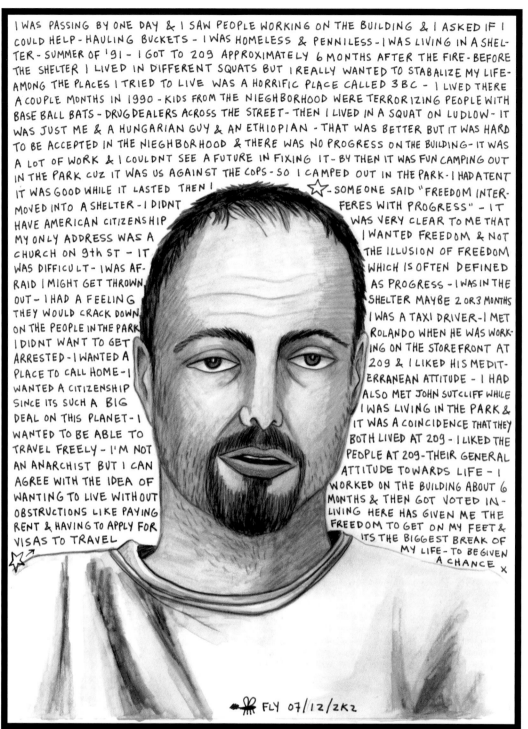

FLY 07/12/2K2

MANNI AZZIZI – 07/12/2K2 – LOISADIA – NYC
MANNI LIVES ON THE TOP FLOOR OF MY BUILDING – THE PENTHOUSE – I MET MANNI THROUGH ROLANDO BEFORE I MOVED INTO THE BUILDING – HE & ROLANDO WERE BOTH WORKING AS YELLOW CAB DRIVERS & THEY TOLD ME SOME CRAZY STORIES – MANNI IS ONE OF THE STRONGEST PEOPLE I KNOW – HE CARRIES INSANELY HUGE & HEAVY OBJECTS UP & DOWN 6 FLIGHTS OF STAIRS – ONE TIME WE WERE CLEANING OUT THE BUILDING & HE HAD CARRIED OUT A BUCKET FULL OF DRIED CEMENT THAT WEIGHED ABOUT 500 POUNDS & I TOLD HIM A SOHO GALLERY WOULD PROBABLY PAY $10 000 FOR IT SO HE CARRIED IT BACK INTO THE BUILDING BUT THE SOHO PEOPLE NEVER CAME TO GET IT – FCKKERS!

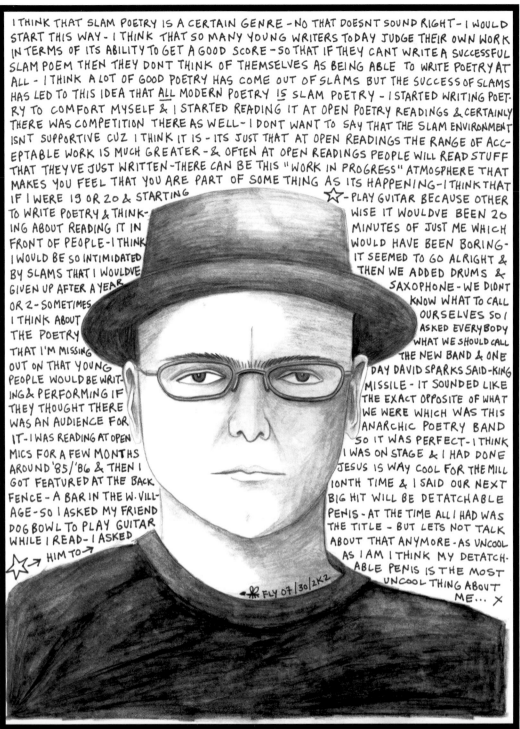

I THINK THAT SLAM POETRY IS A CERTAIN GENRE - NO THAT DOESNT SOUND RIGHT - I WOULD START THIS WAY - I THINK THAT SO MANY YOUNG WRITERS TODAY JUDGE THEIR OWN WORK IN TERMS OF ITS ABILITY TO GET A GOOD SCORE - SO THAT IF THEY CANT WRITE A SUCCESSFUL SLAM POEM THEN THEY DONT THINK OF THEMSELVES AS BEING ABLE TO WRITE POETRY AT ALL - I THINK A LOT OF GOOD POETRY HAS COME OUT OF SLAMS BUT THE SUCCESS OF SLAMS HAS LED TO THIS IDEA THAT ALL MODERN POETRY IS SLAM POETRY - I STARTED WRITING POET-RY TO COMFORT MYSELF & I STARTED READING IT AT OPEN POETRY READINGS & CERTAINLY THERE WAS COMPETITION THERE AS WELL - I DONT WANT TO SAY THAT THE SLAM ENVIRONMENT ISNT SUPPORTIVE CUZ I THINK IT IS - ITS JUST THAT AT OPEN READINGS THE RANGE OF ACC-EPTABLE WORK IS MUCH GREATER - & OFTEN AT OPEN READINGS PEOPLE WILL READ STUFF THAT THEYVE JUST WRITTEN - THERE CAN BE THIS "WORK IN PROGRESS" ATMOSPHERE THAT MAKES YOU FEEL THAT YOU ARE PART OF SOME THING AS ITS HAPPENING - I THINK THAT IF I WERE 19 OR 20 & STARTING

TO WRITE POETRY & THINK-ING ABOUT READING IT IN FRONT OF PEOPLE - I THINK I WOULD BE SO INTIMIDATED BY SLAMS THAT I WOULDVE GIVEN UP AFTER A YEAR OR 2 - SOMETIMES I THINK ABOUT THE POETRY THAT I'M MISSING OUT ON THAT YOUNG PEOPLE WOULD BE WRIT-ING & PERFORMING IF THEY THOUGHT THERE WAS AN AUDIENCE FOR IT - I WAS READING AT OPEN MICS FOR A FEW MONTHS AROUND '85/'86 & THEN I GOT FEATURED AT THE BACK FENCE - A BAR IN THE W. VILL-AGE - SO I ASKED MY FRIEND DOG BOWL TO PLAY GUITAR WHILE I READ - I ASKED HIM TO →

☆ - PLAY GUITAR BECAUSE OTHER WISE IT WOULDVE BEEN 20 MINUTES OF JUST ME WHICH WOULD HAVE BEEN BORING - IT SEEMED TO GO ALRIGHT & THEN WE ADDED DRUMS & SAXOPHONE - WE DIDNT KNOW WHAT TO CALL OURSELVES SO I ASKED EVERYBODY WHAT WE SHOULD CALL THE NEW BAND & ONE DAY DAVID SPARKS SAID - KING MISSILE - IT SOUNDED LIKE THE EXACT OPPOSITE OF WHAT WE WERE WHICH WAS THIS ANARCHIC POETRY BAND SO IT WAS PERFECT - I THINK I WAS ON STAGE & I HAD DONE JESUS IS WAY COOL FOR THE MILL IONTH TIME & I SAID OUR NEXT BIG HIT WILL BE DETATCHABLE PENIS - AT THE TIME ALL I HAD WAS THE TITLE - BUT LETS NOT TALK ABOUT THAT ANYMORE - AS UNCOOL AS I AM I THINK MY DETATCH-ABLE PENIS IS THE MOST UNCOOL THING ABOUT ME... X

FLY 07/30/2K2

JOHN S. HALL – (KING MISSILE III) – 07/30/2K2 – LOWER EAST SIDE – NYC
I MET JOHN S. HALL IN THE LATE 80S WHEN I WAS HELPING TO ORGANIZE A PERFORM-ANCE EXCHANGE BETWEEN TORONTO & NYC – JOHN WAS PART OF THE NYC POSSE & HE WAS DOING SPOKEN WORD – I THOUGHT HE WAS BRILLIANT & HILARIOUS & I BECAME A HUGE FAN – JOHN ALSO SAVED MY ASS WHEN I WAS HOMELESS IN NYC & LET ME STAY AT HIS APT WHILE HE WOULD GO ON TOUR FOR MONTHS WITH KING MISSILE – THEN IN 92 I WAS TOURING WITH ZERO BOY & THE CYBER CIRCUS ON THE WEST COAST & JOHN CAME ALONG FOR A FEW SHOWS – HE SAT BESIDE ME IN THE VAN & MADE HORRIBLE NOISES & POKED ME & ASKED ME IF HE WAS BOTHERING ME – WWW.KINGMISSILE.COM

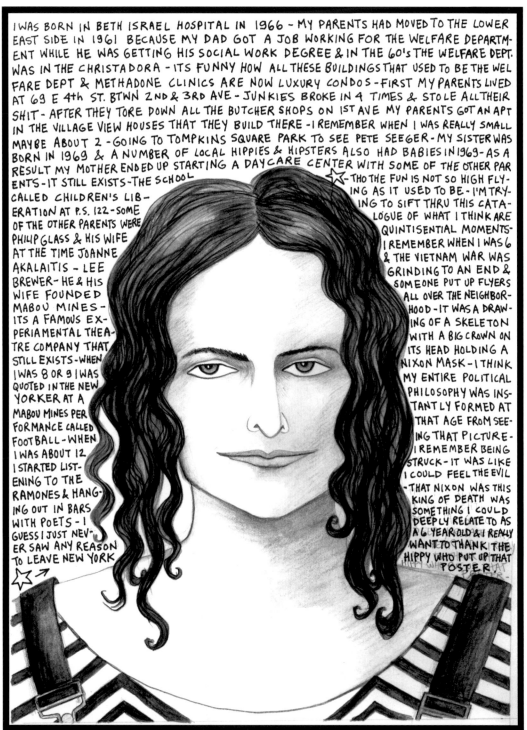

I WAS BORN IN BETH ISRAEL HOSPITAL IN 1966 - MY PARENTS HAD MOVED TO THE LOWER EAST SIDE IN 1961 BECAUSE MY DAD GOT A JOB WORKING FOR THE WELFARE DEPARTMENT WHILE HE WAS GETTING HIS SOCIAL WORK DEGREE & IN THE 60's THE WELFARE DEPT. WAS IN THE CHRISTADORA - ITS FUNNY HOW ALL THESE BUILDINGS THAT USED TO BE THE WELFARE DEPT & METHADONE CLINICS ARE NOW LUXURY CONDOS - FIRST MY PARENTS LIVED AT 69 E 4th ST. BTWN 2ND & 3RD AVE - JUNKIES BROKE IN 4 TIMES & STOLE ALL THEIR SHIT - AFTER THEY TORE DOWN ALL THE BUTCHER SHOPS ON 1ST AVE MY PARENTS GOT AN APT IN THE VILLAGE VIEW HOUSES THAT THEY BUILD THERE - I REMEMBER WHEN I WAS REALLY SMALL MAYBE ABOUT 2 - GOING TO TOMPKINS SQUARE PARK TO SEE PETE SEEGER - MY SISTER WAS BORN IN 1969 & A NUMBER OF LOCAL HIPPIES & HIPSTERS ALSO HAD BABIES IN 1969 - AS A RESULT MY MOTHER ENDED UP STARTING A DAYCARE CENTER WITH SOME OF THE OTHER PARENTS - IT STILL EXISTS - THE SCHOOL CALLED CHILDREN'S LIBERATION AT P.S. 122 - SOME OF THE OTHER PARENTS WERE PHILIP GLASS & HIS WIFE AT THE TIME JOANNE AKALAITIS - LEE BREWER - HE & HIS WIFE FOUNDED MABOU MINES - ITS A FAMOUS EXPERIAMENTAL THEATRE COMPANY THAT STILL EXISTS - WHEN I WAS 8 OR 9 I WAS QUOTED IN THE NEW YORKER AT A MABOU MINES PERFORMANCE CALLED FOOTBALL - WHEN I WAS ABOUT 12 I STARTED LISTENING TO THE RAMONES & HANGING OUT IN BARS WITH POETS - I GUESS I JUST NEVER SAW ANY REASON TO LEAVE NEW YORK ☆→

☆ - THO THE FUN IS NOT SO HIGH FLYING AS IT USED TO BE - I'M TRYING TO SIFT THRU THIS CATALOGUE OF WHAT I THINK ARE QUINTISENTIAL MOMENTS - I REMEMBER WHEN I WAS 6 & THE VIETNAM WAR WAS GRINDING TO AN END & SOMEONE PUT UP FLYERS ALL OVER THE NEIGHBORHOOD - IT WAS A DRAWING OF A SKELETON WITH A BIG CROWN ON ITS HEAD HOLDING A NIXON MASK - I THINK MY ENTIRE POLITICAL PHILOSOPHY WAS INSTANTLY FORMED AT THAT AGE FROM SEEING THAT PICTURE - I REMEMBER BEING STRUCK - IT WAS LIKE I COULD FEEL THE EVIL - THAT NIXON WAS THIS KING OF DEATH WAS SOMETHING I COULD DEEPLY RELATE TO AS A 6 YEAR OLD & I REALLY WANT TO THANK THE HIPPY WHO PUT UP THAT POSTER

SASHA FORTÉ - (KING MISSILE III) - OCTOBER 2K2 - LOWER EAST SIDE - NYC
I MET SASHA FORTÉ AT ABC NO RIO IN THE LATE 80s - HER & LOU ACERNO & MATTHEW COURTNEY WERE PUTTING TOGETHER A BIG ZINE OF STUFF DONE BY OPEN MIC PEOPLES (THE QUEENS PHONEBOOK) & I CAME BY TO GIVE THEM MY CONTRIBUTION - I HAD SEEN SASHA DO SOME CRAZY PERFORMANCES BEFORE THAT BUT I HAD NEVER REALLY MET HER SO I WAS A LITTLE SHY ALSO VERY DISTRACTED BY THE FACT THAT MY SOCKS KEPT FALLING DOWN IN MY BOOTS - I MENTIONED THIS FACT & SHE SO TOTALLY UNDERSTOOD MY FRUSTRATION THAT I GOT OVER MY SHYNESS - SINCE THEN I HAVE SEEN SASHA DO MANY MORE INCREDIBLE & INSPIRATIONAL PERFORMANCES - SASHA40@EARTHLINK.NET

CORN ISLAND - YEAH - I WAS TRYING TO CATCH A BOAT - I WAS MISLED THINKING I COULD CATCH A BOAT FROM BLUE FIELDS NICARAGUA BACK TO BELIZE - THERES NO ROADS IN THAT AREA ITS ALL OCEAN OR RIVER BOAT - SO I GOT THIS 8 HR RIDE ON A FISHING BOAT - SUPER TREACHEROUS SEAS WITH EVERYONE PUKING - WHEN I GOT TO BIG CORN ISLAND I WAS TOLD THERES NO BOATS FOR WEEKS & IT WAS CHOCK FULL OF CRACKHEADS - WHAT I DIDNT KNOW IS ITS RIGHT IN THE MIDDLE OF THE DRUG TRAFFICING TRADE BTWN NICARAGUA & COLUMBIA - SO YOU CANT REALLY SLEEP ON THE BEACH WITHOUT BEING CASED BY ZOMBIE CRACKHEADS BUT THEN I MET THESE ARGENTINE HIPPY TRAVELERS & WE ALL PITCHED IN ON A COCKROACH INFESTED ROOM - ENDED UP GETTING A COURTESY CHRISTMAS DINNER SEVERAL TIMES OVER FROM THE LOCALS - I GOT STUCK THERE FOR MAYBE 10 DAYS - THE INTERESTING THING IS THAT THE PEOPLE THERE LISTEN TO AMERICAN MUSIC FROM THE 1930'S - 40'S - ITS ALL ROY ROGERS HANK WILLIAMS JIMMY ROGERS HANK SNOW PATSY CLINE - ITS ALL OLD COUNTRY MUSIC -

AFTER 10 DAYS OF WAITING FOR THE BOAT THAT NEVER CAME & MEETING PEOPLE THAT HAD BEEN STRANDED FOR TWICE AS LONG - I ENDED UP GETTING THIS WEEKLY HELL FLIGHT IN A TWIN PROPELLOR SESNA PLANE THRU A THUNDER STORM BACK TO BLUE FIELDS - THE MAINLAND - THEN THERE WAS THE HEMMORHOID CAUSING 60MPH SPEED BOAT - UP THE RIVER TO GRENEDA WHICH IS →

LIKE A TRAVELERS ENCLAVE - LOTS OF VEGAN TREATS & ENDLESS SUPPLY OF COFFEE & BEER - EVERY THING WAS FINE TIL LEAVING BELIZE 2 WEEKS LATER BELIZIAN IMMIGRATION WANTED TO TOSS ME IN JAIL BECUZ THEY WERE SURE I HAD POT CUZ MY EYES WERE BRIGHT RED - I WAS WITH MY FRIEND'S FATHER WHO WAS IN A WHEELCHAIR - I WAS ESCORTING HIM ON THE PLANE BACK TO THE STATES - THE COPS KEPT INSISTING THAT I HAD POT & SEARCHED THE WHEELCHAIR - FINALLY THEY RELEASED ME WHEN I EXPLAINED MY EYES WERE RED CUZ I HAD BEEN IN THE BACK OF PICK UP TRUCKS KICKING UP DIRT FOR 50 MILES ON DIRT ROADS SO I FLEW BACK TO THE STATES... & THEN...

FLY 03/06/2K2

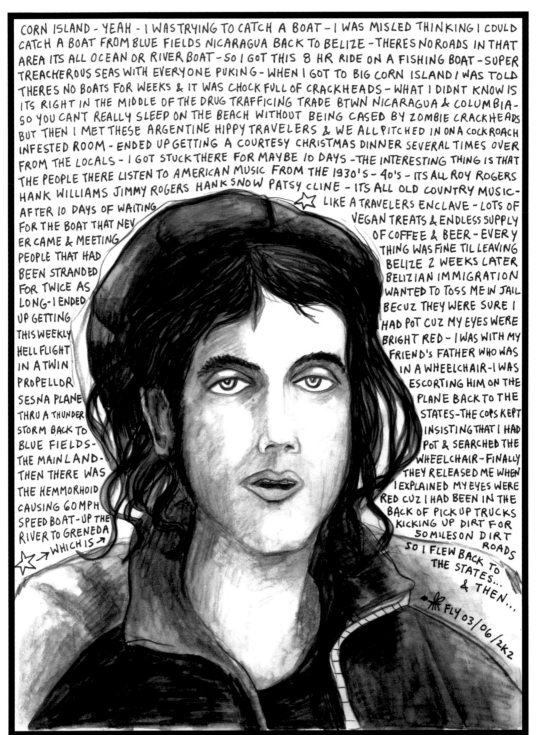

DUMPY – 03/06/2K2 – OAKLAND
I FIRST MET DUMPY IN 1993 IN PHILLY & HE TOLD ME SOME REALLY SCARY STORIES ABOUT HOBOS GETTING ALL CHOPPED UP WHILE TRYING TO HOP TRAINS – GREAT – JUST WHEN ME & DOG BOY WERE ABOUT TO JUMP ON A TRAIN – THNKS DUMPY! – I DIDNT SEE HIM FOR YEARS & THEN HE SHOWED UP IN NYC WITH CRAZY STORIES ABOUT LIVING IN COLOMBIA & LIVING IN INDONESIA & LIVING IN AUSTRALIA & OF COURSE ALL THE LATEST GOSSIP ABOUT ALL OUR TRAVELING PALS – THEN HE SHOWED UP IN CALI & WAS THERE FOR MONTHS – HE CAME TO MY BIRTHDAY PARTY & BROUGHT SOME DELICIOUS DUMP- STERED CAKE – HOOKED ME UP A LOT WITH FREE STUFF FOR A COUPLE MONTHS – YAH!

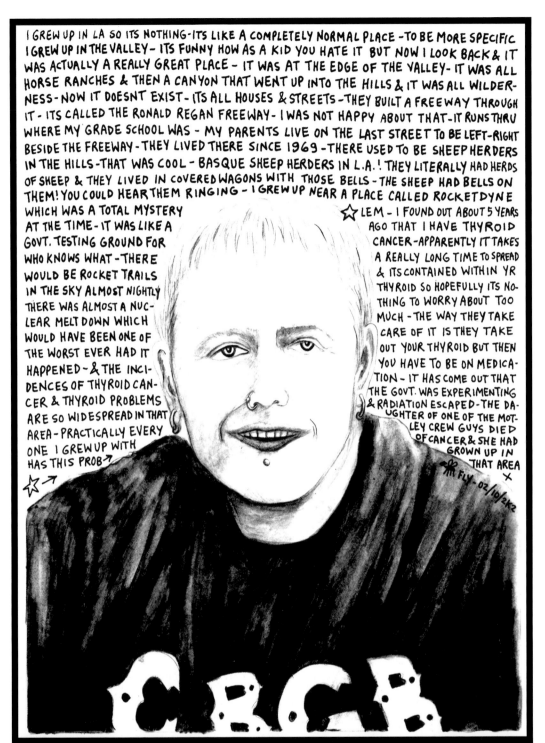

I GREW UP IN LA SO ITS NOTHING - ITS LIKE A COMPLETELY NORMAL PLACE - TO BE MORE SPECIFIC I GREW UP IN THE VALLEY - ITS FUNNY HOW AS A KID YOU HATE IT BUT NOW I LOOK BACK & IT WAS ACTUALLY A REALLY GREAT PLACE - IT WAS AT THE EDGE OF THE VALLEY - IT WAS ALL HORSE RANCHES & THEN A CANYON THAT WENT UP INTO THE HILLS & IT WAS ALL WILDERNESS - NOW IT DOESNT EXIST - ITS ALL HOUSES & STREETS - THEY BUILT A FREEWAY THROUGH IT - ITS CALLED THE RONALD REGAN FREEWAY - I WAS NOT HAPPY ABOUT THAT - IT RUNS THRU WHERE MY GRADE SCHOOL WAS - MY PARENTS LIVE ON THE LAST STREET TO BE LEFT - RIGHT BESIDE THE FREEWAY - THEY LIVED THERE SINCE 1969 - THERE USED TO BE SHEEP HERDERS IN THE HILLS - THAT WAS COOL - BASQUE SHEEP HERDERS IN L.A.! THEY LITERALLY HAD HERDS OF SHEEP & THEY LIVED IN COVERED WAGONS WITH THOSE BELLS - THE SHEEP HAD BELLS ON THEM! YOU COULD HEAR THEM RINGING - I GREW UP NEAR A PLACE CALLED ROCKETDYNE

WHICH WAS A TOTAL MYSTERY AT THE TIME - IT WAS LIKE A GOVT. TESTING GROUND FOR WHO KNOWS WHAT - THERE WOULD BE ROCKET TRAILS IN THE SKY ALMOST NIGHTLY THERE WAS ALMOST A NUCLEAR MELT DOWN WHICH WOULD HAVE BEEN ONE OF THE WORST EVER HAD IT HAPPENED - & THE INCIDENCES OF THYROID CANCER & THYROID PROBLEMS ARE SO WIDESPREAD IN THAT AREA - PRACTICALLY EVERYONE I GREW UP WITH HAS THIS PROB→

☆→

☆ LEM - I FOUND OUT ABOUT 5 YEARS AGO THAT I HAVE THYROID CANCER - APPARENTLY IT TAKES A REALLY LONG TIME TO SPREAD & ITS CONTAINED WITHIN YR THYROID SO HOPEFULLY ITS NOTHING TO WORRY ABOUT TOO MUCH - THE WAY THEY TAKE CARE OF IT IS THEY TAKE OUT YOUR THYROID BUT THEN YOU HAVE TO BE ON MEDICATION - IT HAS COME OUT THAT THE GOVT. WAS EXPERIMENTING & RADIATION ESCAPED - THE DAUGHTER OF ONE OF THE MOTLEY CREW GUYS DIED OF CANCER & SHE HAD GROWN UP IN THAT AREA
FLY - 02/10/2K2 ✗

CARRIE MCNINCH – 02/10/2K2 – OAKLAND
I DREW THIS IN THE EVENING OF THE LAST DAY OF THE APE (ALTERNATIVE PRESS EXPO) IN SF – CARRIE HAS BEEN DOING AN AMAZING COMIC ZINE CALLED THE ASSASIN & THE WHINER SINCE 95 – ITS BASICALLY ABOUT HER LIFE & RELATIONSHIPS & INSECURITIES & ITS REALLY GOOD – SHE HAS AN EXCELLENT BALANCE BETWEEN HUMOR & TRAGEDY – HER DRAWINGS ARE GREAT – VERY GRAPHIC & SIMPLE & TO THE POINT – I WAS HAPPY TO HAVE A CHANCE TO HANG OUT WITH HER EVEN THO SHE WAS FEELING SICK – SHE ALSO DOES ANOTHER GREAT ZINE CALLED FOOD GEEK – WRTE TO HER & CHECK THEM OUT – CARRIE MCN, PO BOX 481051, LOS ANGELES, CA 90048-9651 USA

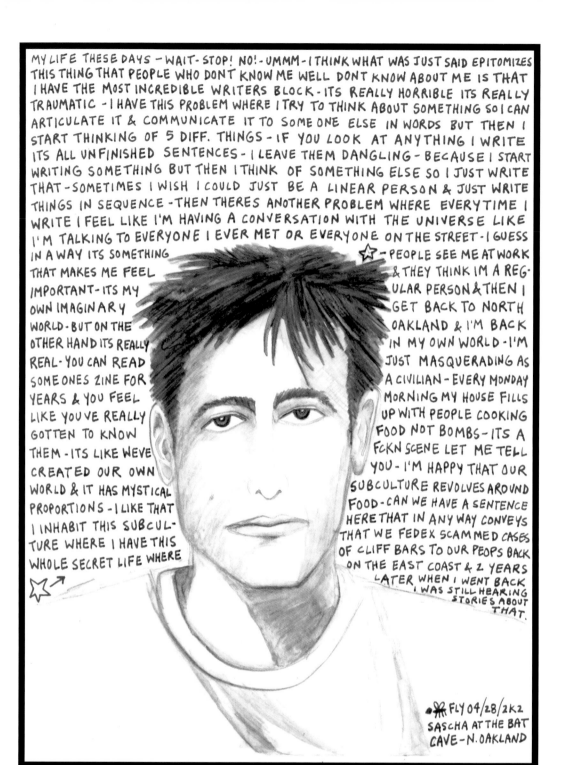

MY LIFE THESE DAYS - WAIT- STOP! NO! - UMMM - I THINK WHAT WAS JUST SAID EPITOMIZES THIS THING THAT PEOPLE WHO DONT KNOW ME WELL DONT KNOW ABOUT ME IS THAT I HAVE THE MOST INCREDIBLE WRITERS BLOCK - ITS REALLY HORRIBLE ITS REALLY TRAUMATIC - I HAVE THIS PROBLEM WHERE I TRY TO THINK ABOUT SOMETHING SO I CAN ARTICULATE IT & COMMUNICATE IT TO SOME ONE ELSE IN WORDS BUT THEN I START THINKING OF 5 DIFF. THINGS - IF YOU LOOK AT ANYTHING I WRITE ITS ALL UNFINISHED SENTENCES - I LEAVE THEM DANGLING - BECAUSE I START WRITING SOMETHING BUT THEN I THINK OF SOMETHING ELSE SO I JUST WRITE THAT - SOMETIMES I WISH I COULD JUST BE A LINEAR PERSON & JUST WRITE THINGS IN SEQUENCE - THEN THERES ANOTHER PROBLEM WHERE EVERYTIME I WRITE I FEEL LIKE I'M HAVING A CONVERSATION WITH THE UNIVERSE LIKE I'M TALKING TO EVERYONE I EVER MET OR EVERYONE ON THE STREET - I GUESS IN A WAY ITS SOMETHING THAT MAKES ME FEEL IMPORTANT - ITS MY OWN IMAGINARY WORLD - BUT ON THE OTHER HAND ITS REALLY REAL - YOU CAN READ SOME ONES ZINE FOR YEARS & YOU FEEL LIKE YOU'VE REALLY GOTTEN TO KNOW THEM - ITS LIKE WE'VE CREATED OUR OWN WORLD & IT HAS MYSTICAL PROPORTIONS - I LIKE THAT I INHABIT THIS SUBCULTURE WHERE I HAVE THIS WHOLE SECRET LIFE WHERE

☆ - PEOPLE SEE ME AT WORK & THEY THINK IM A REGULAR PERSON & THEN I GET BACK TO NORTH OAKLAND & I'M BACK IN MY OWN WORLD - I'M JUST MASQUERADING AS A CIVILIAN - EVERY MONDAY MORNING MY HOUSE FILLS UP WITH PEOPLE COOKING FOOD NOT BOMBS - ITS A FCKN SCENE LET ME TELL YOU - I'M HAPPY THAT OUR SUBCULTURE REVOLVES AROUND FOOD - CAN WE HAVE A SENTENCE HERE THAT IN ANY WAY CONVEYS THAT WE FEDEX SCAMMED CASES OF CLIFF BARS TO OUR PEOPS BACK ON THE EAST COAST & 2 YEARS LATER WHEN I WENT BACK I WAS STILL HEARING STORIES ABOUT THAT.

FLY 04/28/2K2
SASCHA AT THE BAT CAVE - N. OAKLAND

SASCHA ALTMAN DUBRUL - 04/28/2K2 - AT THE BAT CAVE - OAKLAND CA
I MET SASCHA A MILLION YEARS AGO ON THE LOWER EAST SIDE WHEN HE WAS JUST A TEENAGE KID WITH A FRESHLY SHAVED HEAD PLAYING IN A PUNK ROCK BAND - SASCHA IS LIKE MY LITTLE BROTHER - HE S DONE A LOT OF TRAVELING: HOPPING TRAINS ALL OVER THE USA & INTO CENTRAL AMERICA - RESEARCHING LIFE IN GENERAL & WRITING CONSTANTLY ABOUT IT - SASCHA HAS A BOOK CALLED CARNIVAL OF CHAOS (AUTONOMEDIA) - HE S BEEN LOCKED UP IN PSYCH WARDS A BUNCH OF TIMES AND LATELY HE S BEEN TRAVELING AROUND ORGANIZING ALTERNATIVE MENTAL HEALTH SUPPORT NETWORKS IN THE PUNK COMMUNITY FOR MADNESS AND MANIC DEPRESSION - WWW.THEICARUSPROJECT.NET

174

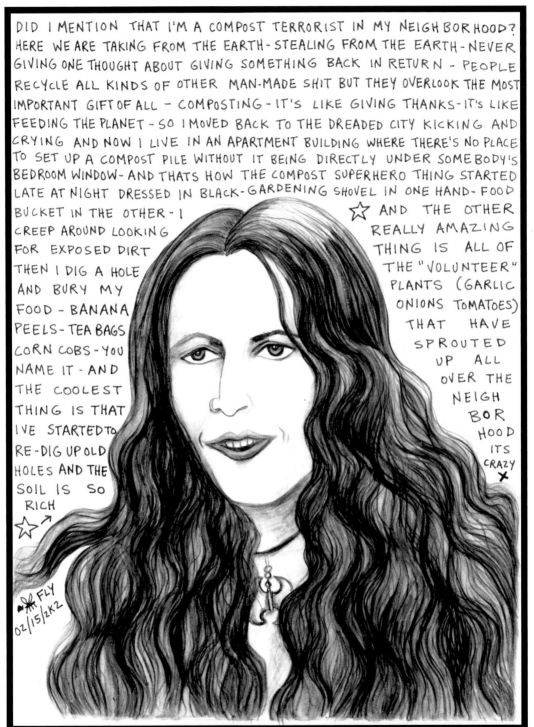

DID I MENTION THAT I'M A COMPOST TERRORIST IN MY NEIGHBORHOOD? HERE WE ARE TAKING FROM THE EARTH-STEALING FROM THE EARTH-NEVER GIVING ONE THOUGHT ABOUT GIVING SOMETHING BACK IN RETURN - PEOPLE RECYCLE ALL KINDS OF OTHER MAN-MADE SHIT BUT THEY OVERLOOK THE MOST IMPORTANT GIFT OF ALL - COMPOSTING - IT'S LIKE GIVING THANKS-IT'S LIKE FEEDING THE PLANET - SO I MOVED BACK TO THE DREADED CITY KICKING AND CRYING AND NOW I LIVE IN AN APARTMENT BUILDING WHERE THERE'S NO PLACE TO SET UP A COMPOST PILE WITHOUT IT BEING DIRECTLY UNDER SOMEBODY'S BEDROOM WINDOW- AND THATS HOW THE COMPOST SUPERHERO THING STARTED LATE AT NIGHT DRESSED IN BLACK-GARDENING SHOVEL IN ONE HAND- FOOD BUCKET IN THE OTHER - I CREEP AROUND LOOKING FOR EXPOSED DIRT THEN I DIG A HOLE AND BURY MY FOOD - BANANA PEELS-TEA BAGS CORN COBS-YOU NAME IT - AND THE COOLEST THING IS THAT IVE STARTED TO RE-DIG UP OLD HOLES AND THE SOIL IS SO RICH

☆ AND THE OTHER REALLY AMAZING THING IS ALL OF THE "VOLUNTEER" PLANTS (GARLIC ONIONS TOMATOES) THAT HAVE SPROUTED UP ALL OVER THE NEIGHBORHOOD ITS CRAZY ✗

FLY 02/15/2K2

WENDY-O-MATIK – 02/15/2K2 – BERKELEY

WENDY IS A WOMAN OF WORDS – ITS HER LIFE & BLOOD & WHEN SHE PERFORMS YOU GET THAT FEELING ON THE BACK OF YR NECK LIKE THE HAIR IS STANDING UP WITH THE ELECTRICAL CHARGE VIBRATING IN THE AIR FROM HER VOICE RESONATING HER EMOTION THAT IS SO RAW & COMING FROM A PLACE THAT MOST PEOPLE KEEP BURIED – SHE IS NOT AFRAID TO CALL IT OUT – SCREAM IT OUT – WHAT SHE SEES & FEELS IN THE RHYTHM OF LIVING IN THIS COMPLICATED WEB OF A WORLD – SPENDING TIME WITH WENDY IS LIKE COMING OUT OF A SHELL & SHAKING OFF SOME OF THE SAND – SHE IS NOT AFRAID TO TELL IT ALL LIKE IT IS BUT YOUR SECRETS ARE ALWAYS SAFE WITH HER – WENDY-OMATIK@LYCOS.COM

WHAT DO YOU MEAN HOW I GOT THE NAME BUCKY SINISTER - THATS MY REAL NAME! - ITS MY REAL NAME NOW! I THINK PEOPLE SHOULD ALWAYS RENAME THEMSELVES - YOU SHOULD HAVE A NAME YOUR FAMILY CALLS YOU & THEN A NAME THE AUTHORITY FIGURES CALL YOU & THEN YOU SHOULD GIVE YOURSELF A NAME THAT YOUR FRIENDS CAN CALL YOU - THEN YOU CAN ALWAYS KNOW WHO IS CALLING YOU ON THE PHONE BY WHO THEY ASK FOR - IT COULD BE A FRIEND OR IT COULD BE THE BANK - I HARDLY EVER WAS CALLED BY MY BIRTH CERTIFICATE NAME - I ALWAYS HAD LITTLE NICKNAMES OR PEOPLE WOULD CALL ME JERRY'S SON - JERRY'S BOY - I USED TO TRAVEL WITH MY DAD ALOT - HE'S AN EVANGELIST - IT WAS ALOT OF FUN - I HAD 2 SISTERS & HE WOULD TAKE TURNS TAKING US - IT WAS COOL TO GET TO SPEND ALOT OF TIME WITH ONE PARENT - MOST OF THE TIME WE TRAVELED BY CAR TO LITTLE COUNTRY CHURCHES MOSTLY

IN ARKANSAS BUT ALSO IN KENTUCKY & LOUISIANNA HE'D USUALLY DO A 3 DAY GIG - FRI SAT SUN - SOME TIMES A WHOLE WEEK - WE WOULD ROLL INTO TOWN & HE WOULD HAVE TO CHANGE IN THE BACK OF THE CHURCH INTO HIS LITTLE EVANGELISTS SUIT & GET ALL HAIR SPRAYED UP & GO OUT & DO THE SHOW - NO SNAKE HANDLING - WE WERE FUNDAMENTALISTS SO WE COULDNT EVEN USE MUSIC - ALL OUR SINGING WAS ACAPELLA - NO DANCING

☆→

- NO "MIXED SWIMMING" - BOYS & GIRLS COULDNT SWIM TOGETHER BE CUZ IT MIGHT LEAD TO IMPURE THOUGHTS - AS I GOT OLDER I DIDNT TRAVEL WITH MY DAD AS MUCH CUZ I HAD SCHOOL BUT WHEN WE DID TRAVEL HE TRIED TO MAKE IT A LITTLE MORE ELABORATE - LIKE WE WOULD GO SEE THINGS BESIDES THE CHURCH - LIKE DISNEYLAND & WE'D GET TO STAY IN HOTELS & SEE CARTOONS IN COLOR! I THINK THIS MIGHT BE WHY I'M CONTENT TO JUST STAY IN SAN FRANCISCO SO MUCH - I DON'T REALLY HAVE THAT URGE TO TAKE ROAD TRIPS ✗

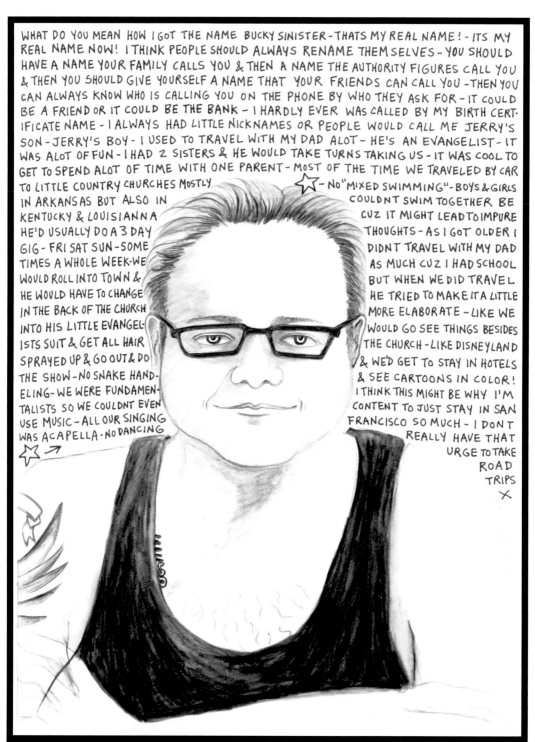

BUCKY SINISTER - APRIL 2K2 - IN THE MISSION - SF
THE FIRST TIME I MET BUCKY WAS IN 1993 - HE HAD LONG HAIR & MAYBE SOME KIND OF GOATEE THING - HE WAS EMCEEING THE OPEN MIC AT THE CHAMELEON IN THE MISSION - IT WAS THE MOST POPULAR OPEN MIC & BUCKY WAS A GREAT EMCEE - HE TOLD SOME HILARIOUS STORIES & MADE ME LAUGH TIL I ALMOST PEED - BUCKY STILL TELLS HILARIOUS STORIES BUT NOW HE HAS SHORT BLOND HAIR & CLEAN SHAVEN FACE & HE S ALL BUFF FROM WORKING OUT - HE WORKS AT LAST GASP & HE TOOK ME ON A TOUR OF THEIR HQ & I WAS DROOLING OVER ALL THE AWESOME BOOKS THEY HAVE THERE - CHECK OUT BUCKY SINISTERS BOOKS IF YOU EVER GET A CHANCE - BUCKYOFOAKLAND@YAHOO.COM

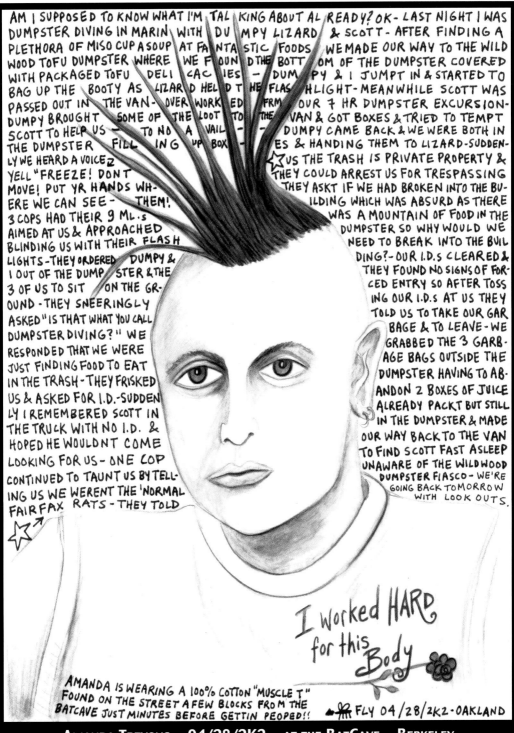

AM I SUPPOSED TO KNOW WHAT I'M TALKING ABOUT ALREADY? OK - LAST NIGHT I WAS DUMPSTER DIVING IN MARIN WITH DUMPY LIZARD & SCOTT - AFTER FINDING A PLETHORA OF MISO CUP A SOUP AT FANTASTIC FOODS WE MADE OUR WAY TO THE WILD WOOD TOFU DUMPSTER WHERE WE FOUND THE BOTTOM OF THE DUMPSTER COVERED WITH PACKAGED TOFU DELICACIES - DUMPY & I JUMPT IN & STARTED TO BAG UP THE BOOTY AS LIZARD HELD THE FLASHLIGHT - MEANWHILE SCOTT WAS PASSED OUT IN THE VAN - OVERWORKED FRM OUR 7 HR DUMPSTER EXCURSION - DUMPY BROUGHT SOME OF THE LOOT TO THE VAN & GOT BOXES & TRIED TO TEMPT SCOTT TO HELP US - TO NO AVAIL - DUMPY CAME BACK & WE WERE BOTH IN THE DUMPSTER FILLING UP BOXES & HANDING THEM TO LIZARD - SUDDENLY WE HEARD A VOICE YELL "FREEZE! DON'T MOVE! PUT YR HANDS WHERE WE CAN SEE THEM! 3 COPS HAD THEIR 9 ML.s AIMED AT US & APPROACHED BLINDING US WITH THEIR FLASH LIGHTS - THEY ORDERED DUMPY & I OUT OF THE DUMPSTER & THE 3 OF US TO SIT ON THE GROUND - THEY SNEERINGLY ASKED "IS THAT WHAT YOU CALL DUMPSTER DIVING?" WE RESPONDED THAT WE WERE JUST FINDING FOOD TO EAT IN THE TRASH - THEY FRISKED US & ASKED FOR I.D. - SUDDENLY I REMEMBERED SCOTT IN THE TRUCK WITH NO I.D. & HOPED HE WOULDN'T COME LOOKING FOR US - ONE COP CONTINUED TO TAUNT US BY TELLING US WE WERENT THE 'NORMAL FAIRFAX RATS - THEY TOLD

US THE TRASH IS PRIVATE PROPERTY & THEY COULD ARREST US FOR TRESPASSING THEY ASKT IF WE HAD BROKEN INTO THE BUILDING WHICH WAS ABSURD AS THERE WAS A MOUNTAIN OF FOOD IN THE DUMPSTER SO WHY WOULD WE NEED TO BREAK INTO THE BUILDING? - OUR I.D.s CLEARED & THEY FOUND NO SIGNS OF FORCED ENTRY SO AFTER TOSSING OUR I.D.s AT US THEY TOLD US TO TAKE OUR GARBAGE & TO LEAVE - WE GRABBED THE 3 GARBAGE BAGS OUTSIDE THE DUMPSTER HAVING TO ABANDON 2 BOXES OF JUICE ALREADY PACKT BUT STILL IN THE DUMPSTER & MADE OUR WAY BACK TO THE VAN TO FIND SCOTT FAST ASLEEP UNAWARE OF THE WILDWOOD DUMPSTER FIASCO - WE'RE GOING BACK TOMORROW WITH LOOK OUTS.

I worked HARD for this Body

AMANDA IS WEARING A 100% COTTON "MUSCLE T" FOUND ON THE STREET A FEW BLOCKS FROM THE BATCAVE JUST MINUTES BEFORE GETTIN PEOPED!!

FLY 04/28/2K2 - OAKLAND

AMANDA TREVONS – 04/28/2K2 – AT THE BATCAVE – BERKELEY
I MET AMANDA IN THE MID 90S WHEN SHE GOT INVOLVED WITH THE PUNK & HARDCORE COLLECTIVE AT ABC NO RIO – SHE STAYED AROUND THE LOWER EAST SIDE FOR YEARS & EVEN SQUATTED AT NO RIO FOR A WHILE – THEN SHE WENT TO LIVE IN GERMANY FOR A FEW YEARS – WE THOUGHT SHE WAS GONE FOR GOOD BUT THEN SHE SHOWED UP AGAIN BUT QUICKLY LEFT NYC HEADING FOR THE WEST COAST – RIGHT BEFORE DRAWING THIS WE HAD BEEN AT A BIG FEST IN PEOPLE S PARK WHERE THE HIPPIES WERE DRIVING US NUTS – THEN BACK AT THE BAT CAVE SHE MADE ME SOME AWESOME VEGAN PIZZA OUT OF DELICIOUS DUMPSTERED INGREDIENTS – YUMMMMMMM!!! – AMANDAAA41@HOTMAIL.COM

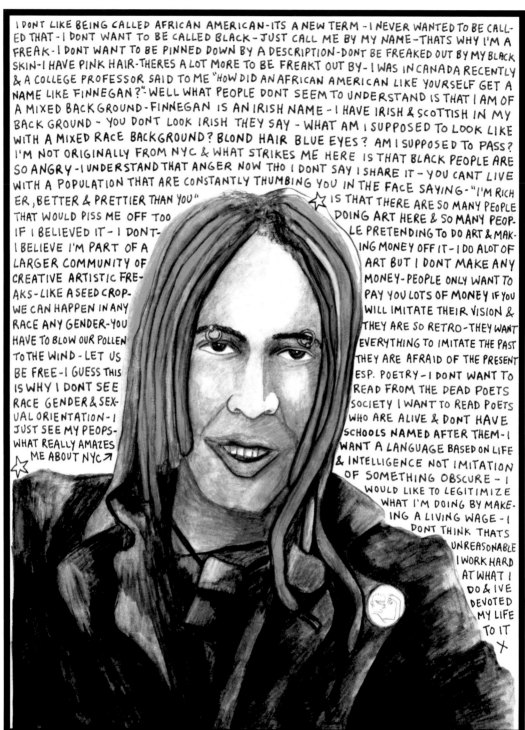

I DONT LIKE BEING CALLED AFRICAN AMERICAN-ITS A NEW TERM - I NEVER WANTED TO BE CALL-ED THAT - I DONT WANT TO BE CALLED BLACK - JUST CALL ME BY MY NAME-THATS WHY I'M A FREAK-I DONT WANT TO BE PINNED DOWN BY A DESCRIPTION-DONT BE FREAKED OUT BY MY BLACK SKIN-I HAVE PINK HAIR-THERES A LOT MORE TO BE FREAKT OUT BY- I WAS IN CANADA RECENTLY & A COLLEGE PROFESSOR SAID TO ME "HOW DID AN AFRICAN AMERICAN LIKE YOURSELF GET A NAME LIKE FINNEGAN?" WELL WHAT PEOPLE DONT SEEM TO UNDERSTAND IS THAT I AM OF A MIXED BACKGROUND-FINNEGAN IS AN IRISH NAME - I HAVE IRISH & SCOTTISH IN MY BACKGROUND - YOU DONT LOOK IRISH THEY SAY - WHAT AM I SUPPOSED TO LOOK LIKE WITH A MIXED RACE BACKGROUND? BLOND HAIR BLUE EYES? AM I SUPPOSED TO PASS? I'M NOT ORIGINALLY FROM NYC & WHAT STRIKES ME HERE IS THAT BLACK PEOPLE ARE SO ANGRY-I UNDERSTAND THAT ANGER NOW THO I DONT SAY I SHARE IT - YOU CANT LIVE WITH A POPULATION THAT ARE CONSTANTLY THUMBING YOU IN THE FACE SAYING- "I'M RICH-ER, BETTER & PRETTIER THAN YOU"

THAT WOULD PISS ME OFF TOO IF I BELIEVED IT - I DONT-I BELIEVE I'M PART OF A LARGER COMMUNITY OF CREATIVE ARTISTIC FRE-AKS-LIKE A SEED CROP. WE CAN HAPPEN IN ANY RACE ANY GENDER-YOU HAVE TO BLOW OUR POLLEN TO THE WIND - LET US BE FREE-I GUESS THIS IS WHY I DONT SEE RACE GENDER & SEX-UAL ORIENTATION-I JUST SEE MY PEOPS-WHAT REALLY AMAZES ME ABOUT NYC ↗

☆ IS THAT THERE ARE SO MANY PEOPLE DOING ART HERE & SO MANY PEOP-LE PRETENDING TO DO ART & MAK-ING MONEY OFF IT - I DO ALOT OF ART BUT I DONT MAKE ANY MONEY-PEOPLE ONLY WANT TO PAY YOU LOTS OF MONEY IF YOU WILL IMITATE THEIR VISION & THEY ARE SO RETRO-THEY WANT EVERYTHING TO IMITATE THE PAST THEY ARE AFRAID OF THE PRESENT ESP. POETRY-I DONT WANT TO READ FROM THE DEAD POETS SOCIETY I WANT TO READ POETS WHO ARE ALIVE & DONT HAVE SCHOOLS NAMED AFTER THEM-I WANT A LANGUAGE BASED ON LIFE & INTELLIGENCE NOT IMITATION OF SOMETHING OBSCURE - I WOULD LIKE TO LEGITIMIZE WHAT I'M DOING BY MAKE-ING A LIVING WAGE-I DONT THINK THATS UNREASONABLE I WORK HARD AT WHAT I DO & IVE DEVOTED MY LIFE TO IT ✗

FINNEGAN – JANUARY 2K2 – LOWER EAST SIDE – NYC
THE FIRST TIME I SAW FINNEGAN PERFORM I THINK HE WAS STILL IN HIGH SCHOOL & HE WAS PART OF A GROUP OF AMAZING POET KIDS CALLED DARK STAR COLLECTIVE – THEY WERE REALLY SMART & REALLY STREET SMART & THEY JUST BLEW ME AWAY THE FEW TIMES I SAW THEM – THAT WAS MAYBE 12 YEARS AGO – SINCE THEN I VE RUN INTO FINNEGAN ON & OFF & HE IS ALWAYS VISUALLY STUNNING & MENTALLY STIMULATING – WHILE I WAS DRAWING THIS PORTRAIT HE WAS TALKING SO FAST ABOUT HIS LIFE & HIS IDEAS – I TRIED BUT I COULDNT KEEP UP – WE CAME UP WITH SOME FULL ON REVELA-TIONS THAT DAY BUT NOW I DON T HAVE ROOM TO ELABORATE.

178

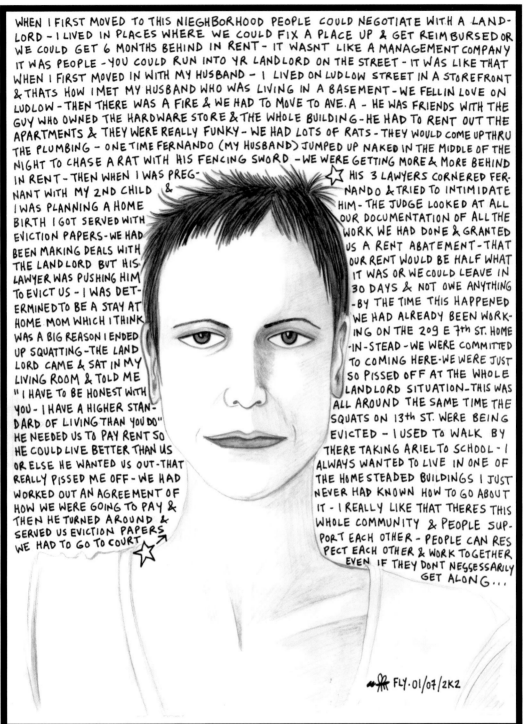

WHEN I FIRST MOVED TO THIS NIEGHBORHOOD PEOPLE COULD NEGOTIATE WITH A LAND- LORD - I LIVED IN PLACES WHERE WE COULD FIX A PLACE UP & GET REIMBURSED OR WE COULD GET 6 MONTHS BEHIND IN RENT - IT WASNT LIKE A MANAGEMENT COMPANY IT WAS PEOPLE - YOU COULD RUN INTO YR LANDLORD ON THE STREET - IT WAS LIKE THAT WHEN I FIRST MOVED IN WITH MY HUSBAND - I LIVED ON LUDLOW STREET IN A STOREFRONT & THATS HOW I MET MY HUSBAND WHO WAS LIVING IN A BASEMENT - WE FELL IN LOVE ON LUDLOW - THEN THERE WAS A FIRE & WE HAD TO MOVE TO AVE. A - HE WAS FRIENDS WITH THE GUY WHO OWNED THE HARDWARE STORE & THE WHOLE BUILDING - HE HAD TO RENT OUT THE APARTMENTS & THEY WERE REALLY FUNKY - WE HAD LOTS OF RATS - THEY WOULD COME UP THRU THE PLUMBING - ONE TIME FERNANDO (MY HUSBAND) JUMPED UP NAKED IN THE MIDDLE OF THE NIGHT TO CHASE A RAT WITH HIS FENCING SWORD - WE WERE GETTING MORE & MORE BEHIND IN RENT - THEN WHEN I WAS PREG- NANT WITH MY 2ND CHILD & I WAS PLANNING A HOME BIRTH I GOT SERVED WITH EVICTION PAPERS - WE HAD BEEN MAKING DEALS WITH THE LANDLORD BUT HIS LAWYER WAS PUSHING HIM TO EVICT US - I WAS DET- ERMINED TO BE A STAY AT HOME MOM WHICH I THINK WAS A BIG REASON I ENDED UP SQUATTING - THE LAND LORD CAME & SAT IN MY LIVING ROOM & TOLD ME " I HAVE TO BE HONEST WITH YOU - I HAVE A HIGHER STAN- DARD OF LIVING THAN YOU DO" HE NEEDED US TO PAY RENT SO HE COULD LIVE BETTER THAN US OR ELSE HE WANTED US OUT - THAT REALLY PISSED ME OFF - WE HAD WORKED OUT AN AGREEMENT OF HOW WE WERE GOING TO PAY & THEN HE TURNED AROUND & SERVED US EVICTION PAPERS WE HAD TO GO TO COURT

HIS 3 LAWYERS CORNERED FER- NANDO & TRIED TO INTIMIDATE HIM - THE JUDGE LOOKED AT ALL OUR DOCUMENTATION OF ALL THE WORK WE HAD DONE & GRANTED US A RENT ABATEMENT - THAT OUR RENT WOULD BE HALF WHAT IT WAS OR WE COULD LEAVE IN 30 DAYS & NOT OWE ANYTHING - BY THE TIME THIS HAPPENED WE HAD ALREADY BEEN WORK- ING ON THE 209 E 7TH ST. HOME - IN - STEAD - WE WERE COMMITTED TO COMING HERE - WE WERE JUST SO PISSED OFF AT THE WHOLE LANDLORD SITUATION - THIS WAS ALL AROUND THE SAME TIME THE SQUATS ON 13TH ST. WERE BEING EVICTED - I USED TO WALK BY THERE TAKING ARIEL TO SCHOOL - I ALWAYS WANTED TO LIVE IN ONE OF THE HOMESTEADED BUILDINGS I JUST NEVER HAD KNOWN HOW TO GO ABOUT IT - I REALLY LIKE THAT THERES THIS WHOLE COMMUNITY & PEOPLE SUP- PORT EACH OTHER - PEOPLE CAN RES PECT EACH OTHER & WORK TOGETHER EVEN IF THEY DONT NEGGESSARILY GET ALONG...

FLY · 01/07/2K2

JESSICA HALL – 01/07/2K2 – LOWER EAST SIDE – NYC
JESSICA CAME INTO MY BUILDING WITH HER HUSBAND FERNANDO & 2 KIDS – ARIEL & AIDAN – IN 1995 – THEIRSPACE ON THE 2ND FLOOR WAS PRETTY RAW AT THE TIME ALTHOUGH THE FLOOR WAS GOOD & SOLID CUZ BACK IN 1990 A MOVIE CREW SHOT SOME SCENES THERE & THEY HAD TO PUT THE FLOOR IN TO DO THAT – JESSICA & FERNANDO STILL HAD TO DO A LOT OF WORK JUST TO BE ABLE TO MOVE IN – JESSICA IS ALWAYS FUN TO WORK WITH CUZ SHE WORKS REALLY HARD & SHE S REALLY GOOD AT JUST FIGURING STUFF OUT – SHE S ONE OF THOSE SMART ORGANIZED PEOPLE WHO CAN ALSO CARRY HUN- DREDS OF HEAVY BUCKETS OF RUBBLE.

179

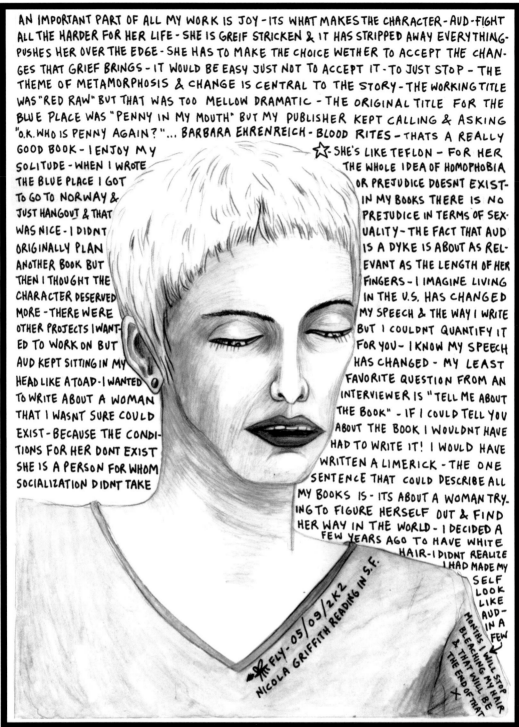

AN IMPORTANT PART OF ALL MY WORK IS JOY - ITS WHAT MAKES THE CHARACTER - AUD - FIGHT ALL THE HARDER FOR HER LIFE - SHE IS GREIF STRICKEN & IT HAS STRIPPED AWAY EVERYTHING - PUSHES HER OVER THE EDGE - SHE HAS TO MAKE THE CHOICE WETHER TO ACCEPT THE CHANGES THAT GRIEF BRINGS - IT WOULD BE EASY JUST NOT TO ACCEPT IT - TO JUST STOP - THE THEME OF METAMORPHOSIS & CHANGE IS CENTRAL TO THE STORY - THE WORKING TITLE WAS "RED RAW" BUT THAT WAS TOO MELLOW DRAMATIC - THE ORIGINAL TITLE FOR THE BLUE PLACE WAS "PENNY IN MY MOUTH" BUT MY PUBLISHER KEPT CALLING & ASKING "O.K. WHO IS PENNY AGAIN?"... BARBARA EHRENREICH - BLOOD RITES - THATS A REALLY GOOD BOOK - I ENJOY MY

SOLITUDE - WHEN I WROTE THE BLUE PLACE I GOT TO GO TO NORWAY & JUST HANGOUT & THAT WAS NICE - I DIDNT ORIGINALLY PLAN ANOTHER BOOK BUT THEN I THOUGHT THE CHARACTER DESERVED MORE - THERE WERE OTHER PROJECTS I WANTED TO WORK ON BUT AUD KEPT SITTING IN MY HEAD LIKE A TOAD - I WANTED TO WRITE ABOUT A WOMAN THAT I WASNT SURE COULD EXIST - BECAUSE THE CONDITIONS FOR HER DONT EXIST SHE IS A PERSON FOR WHOM SOCIALIZATION DIDNT TAKE

☆ - SHE'S LIKE TEFLON - FOR HER THE WHOLE IDEA OF HOMOPHOBIA OR PREJUDICE DOESNT EXIST - IN MY BOOKS THERE IS NO PREJUDICE IN TERMS OF SEXUALITY - THE FACT THAT AUD IS A DYKE IS ABOUT AS RELEVANT AS THE LENGTH OF HER FINGERS - I IMAGINE LIVING IN THE U.S. HAS CHANGED MY SPEECH & THE WAY I WRITE BUT I COULDNT QUANTIFY IT FOR YOU - I KNOW MY SPEECH HAS CHANGED - MY LEAST FAVORITE QUESTION FROM AN INTERVIEWER IS "TELL ME ABOUT THE BOOK" - IF I COULD TELL YOU ABOUT THE BOOK I WOULDNT HAVE HAD TO WRITE IT! I WOULD HAVE WRITTEN A LIMERICK - THE ONE SENTENCE THAT COULD DESCRIBE ALL MY BOOKS IS - ITS ABOUT A WOMAN TRYING TO FIGURE HERSELF OUT & FIND HER WAY IN THE WORLD - I DECIDED A FEW YEARS AGO TO HAVE WHITE HAIR - I DIDNT REALIZE I HAD MADE MY SELF LOOK LIKE AUD - IN A FEW MONTHS I WILL STOP BLEACHING MY HAIR & THAT WILL BE THE END OF THAT ✗

FLY - 05/09/2K2 - NICOLA GRIFFITH READING IN S.F.

NICOLA GRIFFITH – 05/09/2K2 – SF

NICOLA GRIFFITH IS ONE OF MY FAVORITE NOVELISTS – I DREW THIS PORTRAIT AT A READING IN SAN FRANCISCO TO LAUNCH HER NEW BOOK "STAY" – ITS A REALLY GREAT THING TO BE ABLE TO SIT & DRAW A BEAUTIFUL ETHEREAL CREATURE WHILST BEING READ TO – ESPECIALLY BEING READ SOMETHING SO CAPTIVATING – ONE OF MY FAVORITE BOOKS OF HERS IS AMMONITE – ITS THE FIRST ONE THAT I READ & I THINK ITS THE MOST SCI–FI – HER MAIN CHARACTERS ARE ALWAYS WOMEN & THEY ARE ALWAYS CAPABLE & STRONG & NOT JUDGED BY THEIRSEXUALITY – ON THE OTHER HAND THEY CAN ALSO BE VIOLENT SELF– DESTRUCTIVE & AT THE SAME TIME INCREDIBLY VULNERABLE – IN OTHER WORDS – HUMAN

THE HOUSE WHERE I WAS BORN IN PANČEVO IS NOW A PINBALL ARCADE - NOW WHEN I PASS THAT HOUSE I HAVE THE FEELING THAT I WANT TO BE SMALL - ITS LIKE A TRICK OF PERCEPTION - THAT HOUSE FOR ME IS LIKE A PERSONAL HEAVAN & I SOMETIMES VISIT IT IN MY DREAMS - IT WAS AN OLD HOUSE & ITS LIKE IT WAS FULL OF MYSTERY - NOW THEY HAVE DESTROYED THE WINDOWS WHICH USED TO PROTRUDE ONTO THE STREET - MY PARENT WERE REALLY YOUNG WHEN I WAS BORN - THEY LISTENED TO POP MUSIC & READ COMICS - I ALWAYS FELT LIKE THEY WERE ON MY SIDE - THEY APPROVED WHATEVER I WAS DOING IN MY ARTISTIC ATTEMPTS - WHEN I HAD MY EXCURSIONS IN DREAMS ITS SOMETHING THAT HAPPENED EARLY ON WHEN I WAS A KID - I WAS FLOATING IN POPULAR MEDIA & THERE WAS ALWAYS ROCK N ROLL MUSIC TO HEAR - VERY OFTEN I HAD DREAMS OF CARTOON CHARACTERS & SOMETIMES I WOULD HAVE MOMENTS ALMOST LIKE MEDITATION WHERE I COULD SIT FOR HOURS & THINK ABOUT THE CARTOON CHARACTERS & EVEN NOW I THINK THEY HAVE A MIND OF THEIR OWN - WE WERE POOR BUT WE WERE HAPPY BECUZ WE NEVER HAD MORE THAN WE NEEDED - THESE THINGS YOU CAN REALIZE AFTER SOMETIME I REMEMBER I HAD THE FEELING OF BEING LUCID IN DREAMS SINCE I WAS A KID BUT THEN CONSCIOUSLY I STARTED WORKING ON IT IN THE 80's AFTER READING ABOUT IT IN CASTENADA'S BOOK & I CAN TELL YOU THESE TECHNIQUES ARE BASED ON A REAL THING - WHEN YOU ARE IN A LUCID DREAM STATE YOU HAVE TO LEARN TO MOVE AGAIN - ITS LIKE LEARNING TO WALK BUT ITS NOT WALKING - I GOT TO THE POINT I COULD BE LUCID IN DREAMS

☆↗

SEVERAL TIMES A WEEK - USUALLY WHAT HAPPENS IN LUCID DREAMS IS YOU FIND YRSELF IN A LONELY TOWN & THERE IS AN ATMOSPHERE THAT IS SOMETHING LIKE YOUR REAL LIFE - LIKE THE MOMENT BEFORE A STORM - ITS LIKE A COMBINATION OF ANTICIPATION & JOY & THIS IS THE CLOSEST THING TO THE FEELING OF LUCID DREAM - A FUNNY THING IS THAT YOU CANT USE ELECTRICITY IN A STATE OF LUCID DREAM ITS A WASTE OF TIME TO TURN ON THE LIGHT BECAUSE THE LIGHT WONT WORK - USUALLY YOU CANT USE ANY MACHINES - AT FIRST YOU CAN WASTE A LOT OF TIME TRYING TO USE THEM BUT THEN YOU WILL REALIZE...

ALEKSANDAR ZOGRAF – MARCH 2K2 – (FRM SERBIA) – SF

ALEKSANDAR IS ONE OF MY FAVORITE COMICS ARTISTS – HE MANAGES TO DRAW STORIES THAT ARE BASED ON HIS DREAMS WHICH ARE VERY INTRIGUING & ALSO HAVE SOCIAL & POLITICAL RELEVENCE CONSIDERING THAT MANY OF THEM HAVE BEEN PRODUCED DURING THE MID 90s PERIOD OF SERIOUS POLITCAL TURMOIL IN SERBIA AKA WAR – DURING THE NATO BOMBING OF SERBIA HIS HOMETOWN PANCEVO WAS A FREQUENT TARGET – HIS COMICS MIX THE ABSURDITY OF THE REALITY WITH THE SURREALITY OF DREAMS & THE RESULT IS LIKE A SITUATION WHERE NOTHING CAN BE RELIED ON & THINGS JUST GET CRAZIER & MORE OUT OF CONTROL – MAYBE LIKE WAR.

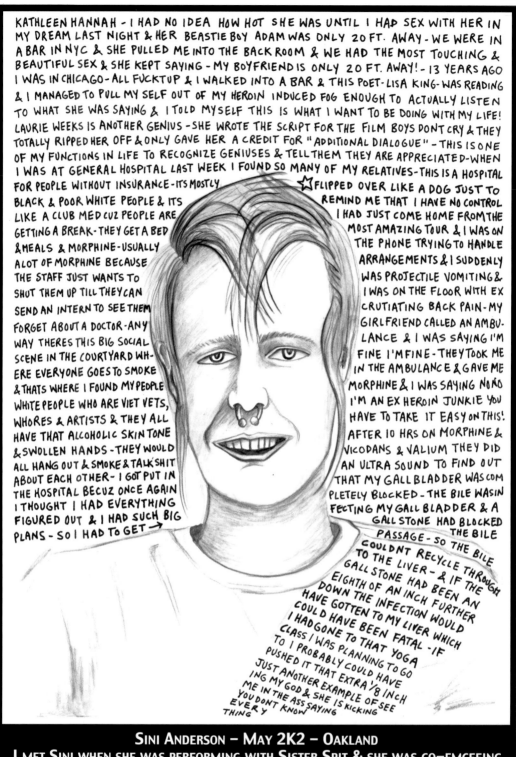

KATHLEEN HANNAH - I HAD NO IDEA HOW HOT SHE WAS UNTIL I HAD SEX WITH HER IN MY DREAM LAST NIGHT & HER BEASTIE BOY ADAM WAS ONLY 20 FT. AWAY - WE WERE IN A BAR IN NYC & SHE PULLED ME INTO THE BACK ROOM & WE HAD THE MOST TOUCHING & BEAUTIFUL SEX & SHE KEPT SAYING - MY BOYFRIEND IS ONLY 20 FT. AWAY! - 13 YEARS AGO I WAS IN CHICAGO - ALL FUCKTUP & I WALKED INTO A BAR & THIS POET - LISA KING - WAS READING & I MANAGED TO PULL MY SELF OUT OF MY HEROIN INDUCED FOG ENOUGH TO ACTUALLY LISTEN TO WHAT SHE WAS SAYING & I TOLD MYSELF THIS IS WHAT I WANT TO BE DOING WITH MY LIFE! LAURIE WEEKS IS ANOTHER GENIUS - SHE WROTE THE SCRIPT FOR THE FILM BOYS DONT CRY & THEY TOTALLY RIPPED HER OFF & ONLY GAVE HER A CREDIT FOR "ADDITIONAL DIALOGUE" - THIS IS ONE OF MY FUNCTIONS IN LIFE TO RECOGNIZE GENIUSES & TELL THEM THEY ARE APPRECIATED - WHEN I WAS AT GENERAL HOSPITAL LAST WEEK I FOUND SO MANY OF MY RELATIVES - THIS IS A HOSPITAL FOR PEOPLE WITHOUT INSURANCE - ITS MOSTLY BLACK & POOR WHITE PEOPLE & ITS LIKE A CLUB MED CUZ PEOPLE ARE GETTING A BREAK - THEY GET A BED & MEALS & MORPHINE - USUALLY A LOT OF MORPHINE BECAUSE THE STAFF JUST WANTS TO SHUT THEM UP TILL THEY CAN SEND AN INTERN TO SEE THEM FORGET ABOUT A DOCTOR - ANY WAY THERES THIS BIG SOCIAL SCENE IN THE COURTYARD WH- ERE EVERYONE GOES TO SMOKE & THATS WHERE I FOUND MY PEOPLE WHITE PEOPLE WHO ARE VIET VETS, WHORES & ARTISTS & THEY ALL HAVE THAT ALCOHOLIC SKIN TONE & SWOLLEN HANDS - THEY WOULD ALL HANG OUT & SMOKE & TALK SHIT ABOUT EACH OTHER - I GOT PUT IN THE HOSPITAL BECUZ ONCE AGAIN I THOUGHT I HAD EVERYTHING FIGURED OUT & I HAD SUCH BIG PLANS - SO I HAD TO GET →

☆FLIPPED OVER LIKE A DOG JUST TO REMIND ME THAT I HAVE NO CONTROL I HAD JUST COME HOME FROM THE MOST AMAZING TOUR & I WAS ON THE PHONE TRYING TO HANDLE ARRANGEMENTS & I SUDDENLY WAS PROJECTILE VOMITING & I WAS ON THE FLOOR WITH EX CRUTIATING BACK PAIN - MY GIRLFRIEND CALLED AN AMBU- LANCE & I WAS SAYING I'M FINE I'M FINE - THEY TOOK ME IN THE AMBULANCE & GAVE ME MORPHINE & I WAS SAYING NO NO I'M AN EX HEROIN JUNKIE YOU HAVE TO TAKE IT EASY ON THIS! AFTER 10 HRS ON MORPHINE & VICODANS & VALIUM THEY DID AN ULTRA SOUND TO FIND OUT THAT MY GALL BLADDER WAS COM PLETELY BLOCKED - THE BILE WAS IN FECTING MY GALL BLADDER & A GALL STONE HAD BLOCKED THE BILE PASSAGE - SO THE BILE COULDNT RECYCLE THROUGH TO THE LIVER - & IF THE GALL STONE HAD BEEN AN EIGHTH OF AN INCH FURTHER DOWN THE INFECTION WOULD HAVE GOTTEN TO MY LIVER WHICH COULD HAVE BEEN FATAL - IF I HAD GONE TO THAT YOGA CLASS I WAS PLANNING TO GO TO I PROBABLY COULD HAVE PUSHED IT THAT EXTRA 1/8 INCH JUST ANOTHER EXAMPLE OF SEE ING MY GOD & SHE IS KICKING ME IN THE ASS SAYING YOU DONT KNOW EVERY THING

SINI ANDERSON – MAY 2K2 – OAKLAND
I MET SINI WHEN SHE WAS PERFORMING WITH SISTER SPIT & SHE WAS CO-EMCEEING WITH MICHELLE TEA AT A BENEFIT IN SF – THEY WERE SUCH A GOOD TEAM! – CUTE & CHARISMATIC – & SINI WAS HILARIOUS WHEN SHE DID HER OWN SPOKEN WORD – SHE S DONE A LOT OF PERFORMING AROUND THE USA & AROUND THE WORLD – SHE IS INVOLVED IN A LOT OF ORGANIZING & SUPPORT FOR QUEER ARTS PERFORMANCE & LITERATURE – HER NEW WORK IS ALL MULTIMEDIA COMBINING VIDEO PROJECTED STILL SLIDES & LIVE SOUND SCORES WITH HER SPOKEN WORD PERFORMANCE – SHE RELEASED HER SECOND SOLO CD IN THE FALL OF 2002 – SINI@MINDSPRING.COM

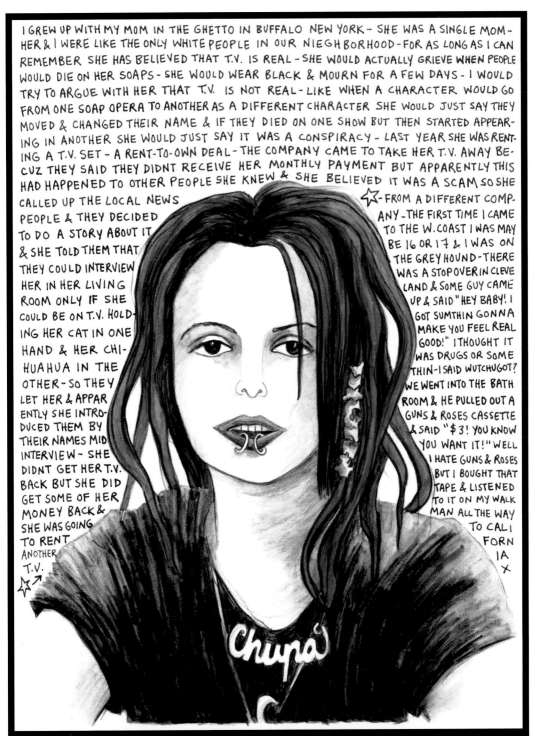

I GREW UP WITH MY MOM IN THE GHETTO IN BUFFALO NEW YORK - SHE WAS A SINGLE MOM - HER & I WERE LIKE THE ONLY WHITE PEOPLE IN OUR NIEGHBORHOOD - FOR AS LONG AS I CAN REMEMBER SHE HAS BELIEVED THAT T.V. IS REAL - SHE WOULD ACTUALLY GRIEVE WHEN PEOPLE WOULD DIE ON HER SOAPS - SHE WOULD WEAR BLACK & MOURN FOR A FEW DAYS - I WOULD TRY TO ARGUE WITH HER THAT T.V. IS NOT REAL - LIKE WHEN A CHARACTER WOULD GO FROM ONE SOAP OPERA TO ANOTHER AS A DIFFERENT CHARACTER SHE WOULD JUST SAY THEY MOVED & CHANGED THEIR NAME & IF THEY DIED ON ONE SHOW BUT THEN STARTED APPEARING IN ANOTHER SHE WOULD JUST SAY IT WAS A CONSPIRACY - LAST YEAR SHE WAS RENTING A T.V. SET - A RENT-TO-OWN DEAL - THE COMPANY CAME TO TAKE HER T.V. AWAY BECUZ THEY SAID THEY DIDNT RECEIVE HER MONTHLY PAYMENT BUT APPARENTLY THIS HAD HAPPENED TO OTHER PEOPLE SHE KNEW & SHE BELIEVED IT WAS A SCAM SO SHE CALLED UP THE LOCAL NEWS PEOPLE & THEY DECIDED TO DO A STORY ABOUT IT & SHE TOLD THEM THAT THEY COULD INTERVIEW HER IN HER LIVING ROOM ONLY IF SHE COULD BE ON T.V. HOLDING HER CAT IN ONE HAND & HER CHIHUAHUA IN THE OTHER - SO THEY LET HER & APPARENTLY SHE INTRODUCED THEM BY THEIR NAMES MID INTERVIEW - SHE DIDNT GET HER T.V. BACK BUT SHE DID GET SOME OF HER MONEY BACK & SHE WAS GOING TO RENT ANOTHER T.V. ☆↗

☆ - FROM A DIFFERENT COMPANY - THE FIRST TIME I CAME TO THE W. COAST I WAS MAYBE 16 OR 17 & I WAS ON THE GREYHOUND - THERE WAS A STOPOVER IN CLEVELAND & SOME GUY CAME UP & SAID "HEY BABY! I GOT SUMTHIN GONNA MAKE YOU FEEL REAL GOOD!" I THOUGHT IT WAS DRUGS OR SOMETHIN - I SAID WUTCHUGOT? WE WENT INTO THE BATHROOM & HE PULLED OUT A GUNS & ROSES CASSETTE & SAID "$3! YOU KNOW YOU WANT IT!" WELL I HATE GUNS & ROSES BUT I BOUGHT THAT TAPE & LISTENED TO IT ON MY WALKMAN ALL THE WAY TO CALIFORNIA ✗

CHUPA CABRAS (COVER GIRL) - APRIL 2K2 - THE MISSION - SF
BUCKY SINISTER INTRODUCED ME TO CHUPA ON A RAINY DAY IN THE MISSION AT THE LAST GASP HQ - CHUPA GAVE ME A PILE OF STICKERS SHE HAD MADE - LATER I GOT TO SEE SOME OF HER SCULPTURES & PAINTINGS WHICH ARE SUBLIMELY GOTHIC & ELEGANTLY CREEPY - SHE PUT SOME OF THEM UP AS AN INSTALLATION IN A SHOW WITH ME & THE KILLER BANSHEES (KBANSHEE & KOYOTE) CALLED THE LAND OF FRIENZ - SHE IS HARDCORE & STREET SMART BUT FUN LIKE AN UNPREDICTABLE ENERGETIC KID & SHE CANTELL YOU THE BEST PLACES TO FIND SANRIO STUFF - CHUPA IS ALSO A FAMOUS BARTENDER AT THE FABULOUS SACRIFICE BAR LOCATED IN THE MISSION SF - WWW.CRISISTHEATER.COM

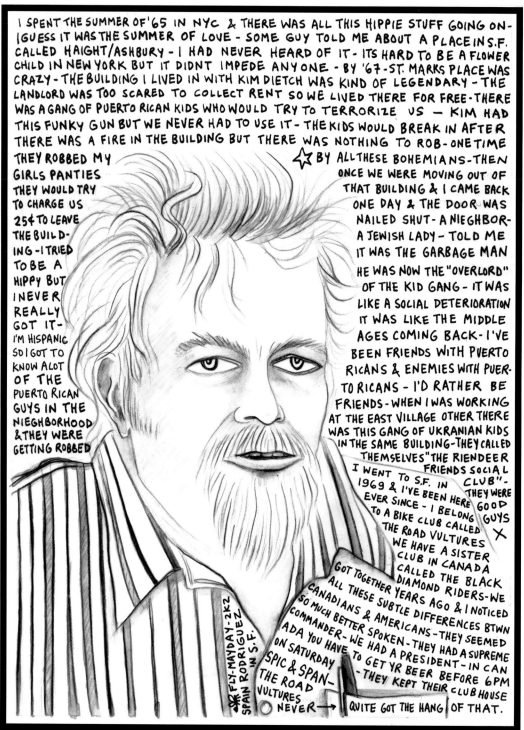

SPAIN RODRIGUEZ – MAY DAY 2K2 – THE MISSION – SF
I MET SPAIN AT THE APE – ALTERNATIVE PRESS EXPO – HE WAS ON A PANEL WITH S. CLAY WILSON – THEY WERE SHOWING SLIDES & TALKING ABOUT THEIR COMICS – SPAIN HAS BEEN DOING COMICS SINCE THE 60S & WAS PART OF THE WHOLE UNDERGROUND COMIC MOVEMENT THAT WAS BASED IN SAN FRANSICO – HE DID THE BIG BITCH STRIP (AMONGST OTHERS) – PULISHED IN ZAP & ARCADE ETC – SPAIN WAS NICE ENOUGH TO MEET UP WITH ME ON MAY DAY IN THE MISSION AT A REALLY COOL LITTLE CAFE RIGHT ACROSS FRM WHERE A BIG DEMO WAS STARTING TO HAPPEN – HIS NEW BOOK "NIGHTMARE ALLEY" WILL BE PUBLISHED NEXT YEAR BY FANTAGRAPHICS – 130 PAGES!

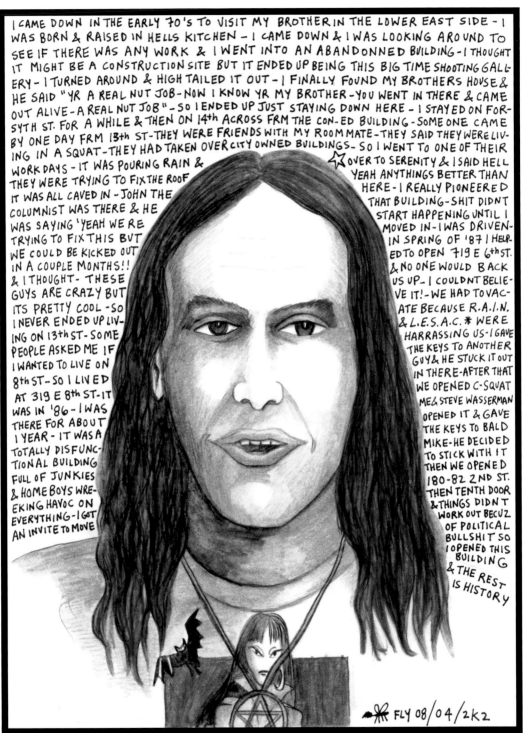

I CAME DOWN IN THE EARLY 70's TO VISIT MY BROTHER IN THE LOWER EAST SIDE - I WAS BORN & RAISED IN HELLS KITCHEN - I CAME DOWN & I WAS LOOKING AROUND TO SEE IF THERE WAS ANY WORK & I WENT INTO AN ABANDONNED BUILDING - I THOUGHT IT MIGHT BE A CONSTRUCTION SITE BUT IT ENDED UP BEING THIS BIG TIME SHOOTING GALLERY - I TURNED AROUND & HIGH TAILED IT OUT - I FINALLY FOUND MY BROTHERS HOUSE & HE SAID "YR A REAL NUT JOB - NOW I KNOW YR MY BROTHER - YOU WENT IN THERE & CAME OUT ALIVE - A REAL NUT JOB" - SO I ENDED UP JUST STAYING DOWN HERE - I STAYED ON FORSYTH ST. FOR A WHILE & THEN ON 14th ACROSS FRM THE CON-ED BUILDING - SOME ONE CAME BY ONE DAY FRM 13th ST - THEY WERE FRIENDS WITH MY ROOMMATE - THEY SAID THEY WERE LIVING IN A SQUAT - THEY HAD TAKEN OVER CITY OWNED BUILDINGS - SO I WENT TO ONE OF THEIR WORK DAYS - IT WAS POURING RAIN & THEY WERE TRYING TO FIX THE ROOF IT WAS ALL CAVED IN - JOHN THE COLUMNIST WAS THERE & HE WAS SAYING 'YEAH WE RE TRYING TO FIX THIS BUT WE COULD BE KICKED OUT IN A COUPLE MONTHS!! & I THOUGHT - THESE GUYS ARE CRAZY BUT ITS PRETTY COOL - SO I NEVER ENDED UP LIVING ON 13th ST - SOME PEOPLE ASKED ME IF I WANTED TO LIVE ON 8th ST - SO I LIVED AT 319 E 8th ST - IT WAS IN '86 - I WAS THERE FOR ABOUT 1 YEAR - IT WAS A TOTALLY DISFUNCTIONAL BUILDING FULL OF JUNKIES & HOME BOYS WREEKING HAVOC ON EVERYTHING - I GOT AN INVITE TO MOVE OVER TO SERENITY & I SAID HELL YEAH ANYTHINGS BETTER THAN HERE - I REALLY PIONEERED THAT BUILDING - SHIT DIDNT START HAPPENING UNTIL I MOVED IN - I WAS DRIVEN - IN SPRING OF '87 I HELPED TO OPEN 719 E 6th ST. & NO ONE WOULD BACK US UP - I COULDNT BELIEVE IT! - WE HAD TO VACATE BECAUSE R.A.I.N. & L.E.S.A.C. * WERE HARRASSING US - I GAVE THE KEYS TO ANOTHER GUY & HE STUCK IT OUT IN THERE - AFTER THAT WE OPENED C-SQUAT ME & STEVE WASSERMAN OPENED IT & GAVE THE KEYS TO BALD MIKE - HE DECIDED TO STICK WITH IT THEN WE OPENED 180-82 2ND ST. THEN TENTH DOOR & THINGS DIDNT WORK OUT BECUZ OF POLITICAL BULLSHIT SO I OPENED THIS BUILDING & THE REST IS HISTORY

FLY 08/04/2k2

GEORGE VLAD MARCO – 08/04/2K2 – E. 4TH ST. – NYC
I MET GEORGE WHEN MY PAL DOG BOY WAS STAYING WITH HIM AFTER FETUS HOUSE BURNED DOWN – GEORGE WAS IN A SQUAT ON E. 4TH ST. WHICH EVENTUALLY WENT "LEGAL" IN THE SUMMER OF 1997 – GEORGE WAS A TRIP – HE WORE A TOP HAT & HAD A ROTTWEILER – HE DRESSED IN BLACK & LEATHER & WOULD READ TAROT CARDS ON ST. MARKS PLACE & OUT AT CLUBS LIKE THE "SLIMELIGHT" – GEORGE HAS BEEN FEATURED IN SEVERAL PUBLICATIONS ALONG WITH HIS ETHEREALLY VAMPIRICALLY BEAUTIFUL GIRLFRIEND – THEY HAVE A DECADENTLY ELEGANT LIFE REVELLING IN THE POWERS OF THE DARK & SECRET NETHERWORLDS MOST OF US AVOID.

I HATE TO PLAY THE MARXIST SOUR PUSS HERE BUT THE PROBLEM IS THE CAPITAL-IST SYSTEM - IF I'M GOING TO BE TAKEN OFF THE AIR FOR NOT CENSORING MY SELF THEN SO BE IT - IN THE SPIRIT OF THE LAKOTA WARRIOR CRAZY HORSE - "ITS A GOOD DAY TO DIE" - I BELIEVE YOU HAVE TO DO EVERY SHOW ON WBAI AS IF ITS YOUR LAST - YOU CANT CALL IT FREE SPEECH RADIO IF YOU'RE CENSORING YOUR SELF - THERES ABSOLUTELY NO POINT IN DOING IT IF YOU ARE CENSORING YOUR SELF - FREE SPEECH IS AN ALL OR NOTHING PROPOSITION - ITS NOT THE PERSONALITIES INVOLVED - THE LARGER ISSUE IS THAT CORPORATE AMERICA IS TRYING TO SHUT DOWN ONE OF THE LAST VOICES OF DISSENT IN THE COUNTRY - BEHIND ALL OF THE PERSONALITY POLITICS BEHIND ALL OF THE IN-FIGHTING & BACK STABBING, BEHIND ALL THE RACE-BAIT-ING & JEW-BAITING - THATS THE REALITY: CORPORATE POWER & THE FEDERAL GOVT. ARE TRYING TO SHUT DOWN (OR EVISCE-RATE) THE ONLY RADIO NETWORK IN THE COUNTRY FOUNDED BY ANARCHISTS & PAC-IF-ISTS, THE ONLY RELENTLESSLY RADICAL VOICE ON THE PUBLIC AIRWAVES SO I INTEND TO GO DOWN FIGHTING - THIS ISNT SLAVERY OR THE HOLOCAUST - THEY ARENT GOING TO WHIP ME OR PUT ME IN A GAS CHAMBER FOR SPEAKING MY MIND - THE WORST THING THEY CAN DO IS TAKE AWAY MY RADIO SHOW - & IF I'M NOT WILLING TO TAKE THAT RISK I CANT LOOK AT MYSELF IN THE MIRROR

BILL WEINBERG - AUTHOR OF HOMAGE TO CHIAPAS (VERSO 2000)

MOORISH ORTHODOX RADIO CRUSADE... TUES MAY 29 2K FLY.

BILL WEINBERG – 05/29/Y2K – WBAI 99.5 FM – NYC
I DREW THIS WHILE I WAS A GUEST ON THE MOORISH ORTHODOX RADIO CRUSADE HOSTED BY BILL WEINBERG (TUES. AT MIDNITE ON WBAI 99.5FM NYC)– AT THE TIME WBAI WAS IN THE MIDDLE OF AN ATTEMPTED (ULTIMATELY UNSUCCESSFUL) TAKEOVER BY CERTAIN POWERS THAT WANTED TO TURN THE STATION INTO AN NPR CLONE OR MAYBE EVEN SELL THE STA-TION — IT WAS NEVER REALLY CLEAR — IT WAS CLEAR HOWEVER THAT MANY OF THE MOST OUTSPOKEN & BADASS REPORTERS & PRODUCERS WERE GETTING KICKED OFF THE AIR — BILL WAS VERY OUTSPOKEN ABOUT THE SITUATION — AS IS HIS NATURE BUT SURPRISINGLY & THANKFULLY HE WAS NEVER KICKED OFF THE AIR — WWW.WW3REPORT.COM

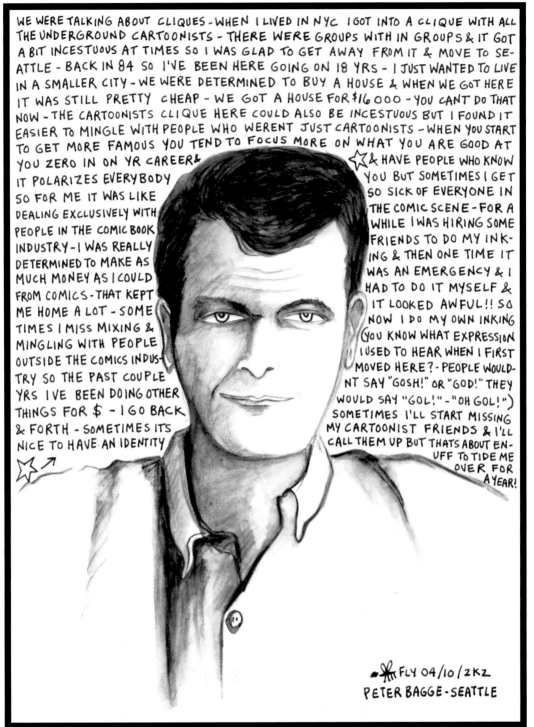

WE WERE TALKING ABOUT CLIQUES - WHEN I LIVED IN NYC I GOT INTO A CLIQUE WITH ALL THE UNDERGROUND CARTOONISTS - THERE WERE GROUPS WITH IN GROUPS & IT GOT A BIT INCESTUOUS AT TIMES SO I WAS GLAD TO GET AWAY FROM IT & MOVE TO SEATTLE - BACK IN 84 SO I'VE BEEN HERE GOING ON 18 YRS - I JUST WANTED TO LIVE IN A SMALLER CITY - WE WERE DETERMINED TO BUY A HOUSE & WHEN WE GOT HERE IT WAS STILL PRETTY CHEAP - WE GOT A HOUSE FOR $16 000 - YOU CANT DO THAT NOW - THE CARTOONISTS CLIQUE HERE COULD ALSO BE INCESTUOUS BUT I FOUND IT EASIER TO MINGLE WITH PEOPLE WHO WERENT JUST CARTOONISTS - WHEN YOU START TO GET MORE FAMOUS YOU TEND TO FOCUS MORE ON WHAT YOU ARE GOOD AT YOU ZERO IN ON YR CAREER & IT POLARIZES EVERYBODY SO FOR ME IT WAS LIKE DEALING EXCLUSIVELY WITH PEOPLE IN THE COMIC BOOK INDUSTRY - I WAS REALLY DETERMINED TO MAKE AS MUCH MONEY AS I COULD FROM COMICS - THAT KEPT ME HOME A LOT - SOMETIMES I MISS MIXING & MINGLING WITH PEOPLE OUTSIDE THE COMICS INDUSTRY SO THE PAST COUPLE YRS IVE BEEN DOING OTHER THINGS FOR $ - I GO BACK & FORTH - SOMETIMES ITS NICE TO HAVE AN IDENTITY

& HAVE PEOPLE WHO KNOW YOU BUT SOMETIMES I GET SO SICK OF EVERYONE IN THE COMIC SCENE - FOR A WHILE I WAS HIRING SOME FRIENDS TO DO MY INKING & THEN ONE TIME IT WAS AN EMERGENCY & I HAD TO DO IT MYSELF & IT LOOKED AWFUL!! SO NOW I DO MY OWN INKING (YOU KNOW WHAT EXPRESSION I USED TO HEAR WHEN I FIRST MOVED HERE? - PEOPLE WOULDNT SAY "GOSH!" OR "GOD!" THEY WOULD SAY "GOL!" - "OH GOL!") SOMETIMES I'LL START MISSING MY CARTOONIST FRIENDS & I'LL CALL THEM UP BUT THATS ABOUT ENUFF TO TIDE ME OVER FOR A YEAR!

FLY 04/10/2K2
PETER BAGGE - SEATTLE

PETER BAGGE – 04/10/2K2 – SEATTLE

I FIRST MET PETER BAGGE IN 1999 – I WAS PASSING THROUGH SEATTLE ON TOUR WITH AUS ROTTEN & MY FRIEND QUEEN ITCHIE HAD GIVEN ME PETERS PHONE # SO I JUST CALLED HIM UP & SAID – "HEY – LETS GO DRINK BEER!" – & HE SAID – "WELL OK!" – I HAVE BEEN A HUGE FAN OF P. BAGGE S COMICS FOR MANY YEARS – NEAT STUFF – HATE – THE BRADLEYS – PETERS COMICS HAVE BEEN A VISUAL ACCOMPANIMENT TO SEATTLES PUNK SCENE, GRUNGE MOVEMENT & SLACKER REVOLUTION – IT WAS TONS OF FUN DRINKING BEER WITH PETER & HIS LIMEY PAL EVERETT TRUE – WE ENDED UP AT A BAR WHERE A DRAG QUEEN WAS LIP SYNCING TO CHERS "BELIEVE" – WWW.PETERBAGGE.COM

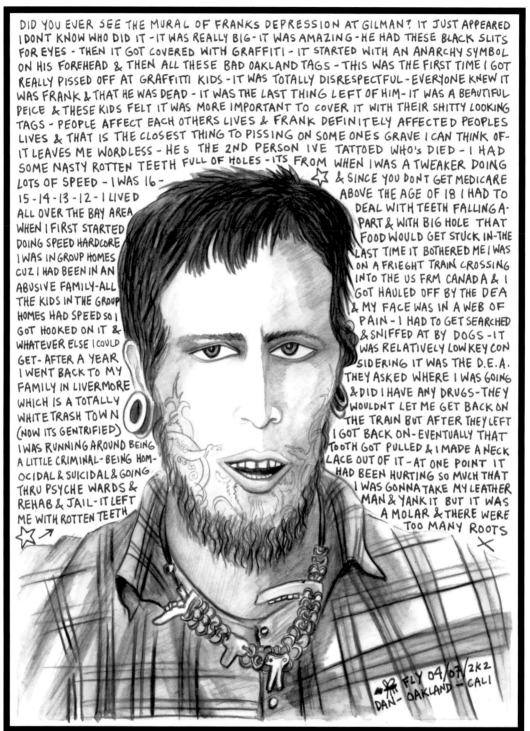

DID YOU EVER SEE THE MURAL OF FRANKS DEPRESSION AT GILMAN? IT JUST APPEARED I DONT KNOW WHO DID IT - IT WAS REALLY BIG - IT WAS AMAZING - HE HAD THESE BLACK SLITS FOR EYES - THEN IT GOT COVERED WITH GRAFFITI - IT STARTED WITH AN ANARCHY SYMBOL ON HIS FOREHEAD & THEN ALL THESE BAD OAKLAND TAGS - THIS WAS THE FIRST TIME I GOT REALLY PISSED OFF AT GRAFFITI KIDS - IT WAS TOTALLY DISRESPECTFUL - EVERYONE KNEW IT WAS FRANK & THAT HE WAS DEAD - IT WAS THE LAST THING LEFT OF HIM - IT WAS A BEAUTIFUL PEICE & THESE KIDS FELT IT WAS MORE IMPORTANT TO COVER IT WITH THEIR SHITTY LOOKING TAGS - PEOPLE AFFECT EACH OTHERS LIVES & FRANK DEFINITELY AFFECTED PEOPLES LIVES & THAT IS THE CLOSEST THING TO PISSING ON SOME ONES GRAVE I CAN THINK OF - IT LEAVES ME WORDLESS - HE S THE 2ND PERSON IVE TATTOED WHO'S DIED - I HAD SOME NASTY ROTTEN TEETH FULL OF HOLES - ITS FROM WHEN I WAS A TWEAKER DOING LOTS OF SPEED - I WAS 16 - 15 - 14 - 13 - 12 - I LIVED ALL OVER THE BAY AREA WHEN I FIRST STARTED DOING SPEED HARDCORE I WAS IN GROUP HOMES CUZ I HAD BEEN IN AN ABUSIVE FAMILY - ALL THE KIDS IN THE GROUP HOMES HAD SPEED SO I GOT HOOKED ON IT & WHATEVER ELSE I COULD GET - AFTER A YEAR I WENT BACK TO MY FAMILY IN LIVERMORE WHICH IS A TOTALLY WHITE TRASH TOWN (NOW ITS GENTRIFIED) I WAS RUNNING AROUND BEING A LITTLE CRIMINAL - BEING HOM-OCIDAL & SUICIDAL & GOING THRU PSYCHE WARDS & REHAB & JAIL - IT LEFT ME WITH ROTTEN TEETH

& SINCE YOU DON'T GET MEDICARE ABOVE THE AGE OF 18 I HAD TO DEAL WITH TEETH FALLING A-PART & WITH BIG HOLE THAT FOOD WOULD GET STUCK IN - THE LAST TIME IT BOTHERED ME I WAS ON A FRIEGHT TRAIN CROSSING INTO THE US FRM CANADA & I GOT HAULED OFF BY THE DEA & MY FACE WAS IN A WEB OF PAIN - I HAD TO GET SEARCHED & SNIFFED AT BY DOGS - IT WAS RELATIVELY LOW KEY CON SIDERING IT WAS THE D.E.A. THEY ASKED WHERE I WAS GOING & DID I HAVE ANY DRUGS - THEY WOULDNT LET ME GET BACK ON THE TRAIN BUT AFTER THEY LEFT I GOT BACK ON - EVENTUALLY THAT TOOTH GOT PULLED & I MADE A NECK LACE OUT OF IT - AT ONE POINT IT HAD BEEN HURTING SO MUCH THAT I WAS GONNA TAKE MY LEATHER MAN & YANK IT BUT IT WAS A MOLAR & THERE WERE TOO MANY ROOTS

FLY 04/07/2K2
DAN - OAKLAND - CALI

DAN AKA BOX CAR BEN – 04/07/2K2 – OAKLAND CA
I MET DAN WHEN HE WROTE ME A LETTER AFTER HE HAD READ A MEMORIAL COLUMN I HAD WRITTEN IN SLUG & LETTUCE ABOUT FRANKS DEPRESSION IN 96 – HE HAD BEEN A FRIEND OF FRANKS & THAT WAS THE FIRST HE HAD HEARD OF HIS DEATH – HE WROTE TO ME & DREW SOME PICTURES IN THE LETTER & MENTIONED THAT HE HAD DONE SOME OF FRANKS TATTOOS – I RECOGNIZED THE DRAWING STYLE – A FEW YEARS LATER I FINALLY MET DAN IN PERSON WHEN HE SHOWED UP AT MY HOUSE ALL STINKY & NEWLY RELEASED FRM JAIL – SINCE THEN I RUN INTO HIM EVERY FEW YEARS IN VARIOUS LOCATIONS – HE S ALWAYS TRAVELING & WORKING HARD ON THE ART OF EXPERIENCING LIFE INTENSELY

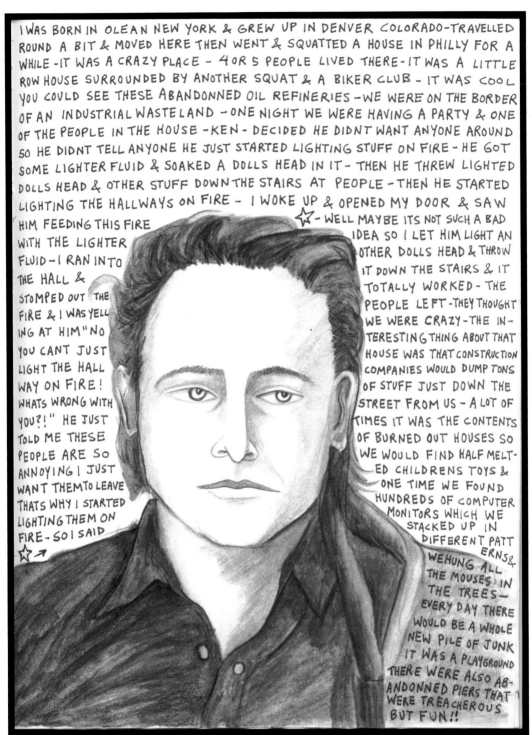

I WAS BORN IN OLEAN NEW YORK & GREW UP IN DENVER COLORADO-TRAVELLED ROUND A BIT & MOVED HERE THEN WENT & SQUATTED A HOUSE IN PHILLY FOR A WHILE -IT WAS A CRAZY PLACE - 4 OR 5 PEOPLE LIVED THERE - IT WAS A LITTLE ROW HOUSE SURROUNDED BY ANOTHER SQUAT & A BIKER CLUB - IT WAS COOL YOU COULD SEE THESE ABANDONNED OIL REFINERIES -WE WERE ON THE BORDER OF AN INDUSTRIAL WASTELAND - ONE NIGHT WE WERE HAVING A PARTY & ONE OF THE PEOPLE IN THE HOUSE -KEN- DECIDED HE DIDNT WANT ANYONE AROUND SO HE DIDNT TELL ANYONE HE JUST STARTED LIGHTING STUFF ON FIRE - HE GOT SOME LIGHTER FLUID & SOAKED A DOLLS HEAD IN IT - THEN HE THREW LIGHTED DOLLS HEAD & OTHER STUFF DOWN THE STAIRS AT PEOPLE - THEN HE STARTED LIGHTING THE HALLWAYS ON FIRE - I WOKE UP & OPENED MY DOOR & SAW HIM FEEDING THIS FIRE WITH THE LIGHTER FLUID -I RAN INTO THE HALL & STOMPED OUT THE FIRE & I WAS YELLING AT HIM "NO YOU CANT JUST LIGHT THE HALL WAY ON FIRE! WHATS WRONG WITH YOU?!" HE JUST TOLD ME THESE PEOPLE ARE SO ANNOYING I JUST WANT THEM TO LEAVE THATS WHY I STARTED LIGHTING THEM ON FIRE - SO I SAID ☆→

☆ - WELL MAYBE ITS NOT SUCH A BAD IDEA SO I LET HIM LIGHT ANOTHER DOLLS HEAD & THROW IT DOWN THE STAIRS & IT TOTALLY WORKED - THE PEOPLE LEFT -THEY THOUGHT WE WERE CRAZY -THE INTERESTING THING ABOUT THAT HOUSE WAS THAT CONSTRUCTION COMPANIES WOULD DUMP TONS OF STUFF JUST DOWN THE STREET FROM US - A LOT OF TIMES IT WAS THE CONTENTS OF BURNED OUT HOUSES SO WE WOULD FIND HALF MELTED CHILDRENS TOYS & ONE TIME WE FOUND HUNDREDS OF COMPUTER MONITORS WHICH WE STACKED UP IN DIFFERENT PATTERNS & WE HUNG ALL THE MOUSES IN THE TREES — EVERY DAY THERE WOULD BE A WHOLE NEW PILE OF JUNK IT WAS A PLAYGROUND THERE WERE ALSO ABANDONNED PIERS THAT WERE TREACHEROUS BUT FUN !!

JOHNNY COAST – SEPT. 2K2 – LOWER EAST SIDE – NYC
I MUST HAVE MET JOHNNY SOMETIME AROUND 1999 OR Y2K – HE STARTED HANGIN OUT WITH FAMOUS (PG. 31) & WAS LIVING IN THE BUILDING FOR A WHILE SORT OF ON & OFF – I DON'T KNOW MISTER COAST TOO WELL SO I DON'T HAVE ANY SECRETS TO TELL ABOUT HIM BUT WHEN HE WAS HERE HE WAS ALWAYS HAPPY TO HELP OUT AROUND THE BUILDING – I'M NOT SURE WHERE HE'S AT NOW – I THINK HE BECAME A TRUCKER – LAST I HEARD HE WAS DRIVING A BIG RIG SOUTH DOWN THE EAST COAST WITH JAY & PIERRE PRE$$URE DOIN A "CUSTOM JOB" – I THINK THEY GOT "STUCK" FOR A WHILE IN MIAMI.

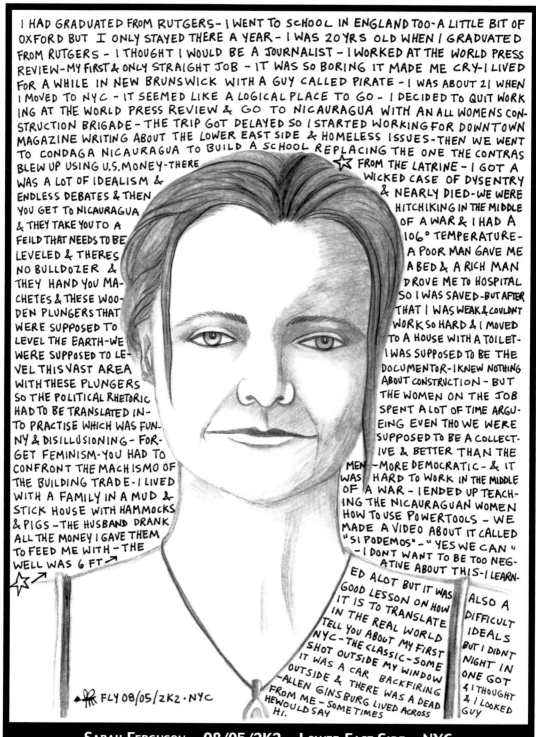

I HAD GRADUATED FROM RUTGERS- I WENT TO SCHOOL IN ENGLAND TOO- A LITTLE BIT OF OXFORD BUT I ONLY STAYED THERE A YEAR - I WAS 20YRS OLD WHEN I GRADUATED FROM RUTGERS - I THOUGHT I WOULD BE A JOURNALIST - I WORKED AT THE WORLD PRESS REVIEW- MY FIRST & ONLY STRAIGHT JOB - IT WAS SO BORING IT MADE ME CRY- I LIVED FOR A WHILE IN NEW BRUNSWICK WITH A GUY CALLED PIRATE - I WAS ABOUT 21 WHEN I MOVED TO NYC - IT SEEMED LIKE A LOGICAL PLACE TO GO - I DECIDED TO QUIT WORKING AT THE WORLD PRESS REVIEW & GO TO NICAURAGUA WITH AN ALL WOMENS CONSTRUCTION BRIGADE - THE TRIP GOT DELAYED SO I STARTED WORKING FOR DOWNTOWN MAGAZINE WRITING ABOUT THE LOWER EAST SIDE & HOMELESS ISSUES- THEN WE WENT TO CONDAGA NICAURAGUA TO BUILD A SCHOOL REPLACING THE ONE THE CONTRAS BLEW UP USING U.S.MONEY- THERE ☆ FROM THE LATRINE - I GOT A WAS A LOT OF IDEALISM & WICKED CASE OF DYSENTRY ENDLESS DEBATES & THEN & NEARLY DIED- WE WERE YOU GET TO NICAURAGUA HITCHIKING IN THE MIDDLE & THEY TAKE YOU TO A OF A WAR & I HAD A FEILD THAT NEEDS TO BE 106° TEMPERATURE- LEVELED & THERES A POOR MAN GAVE ME NO BULLDOZER & A BED & A RICH MAN THEY HAND YOU MACHETES & THESE WOODEN PLUNGERS THAT WERE SUPPOSED TO LEVEL THE EARTH- WE WERE SUPPOSED TO LEVEL THIS VAST AREA WITH THESE PLUNGERS SO THE POLITICAL RHETORIC HAD TO BE TRANSLATED INTO PRACTISE WHICH WAS FUNNY & DISILLUSIONING - FORGET FEMINISM- YOU HAD TO CONFRONT THE MACHISMO OF THE BUILDING TRADE- I LIVED WITH A FAMILY IN A MUD & STICK HOUSE WITH HAMMOCKS & PIGS - THE HUSBAND DRANK ALL THE MONEY I GAVE THEM TO FEED ME WITH - THE WELL WAS 6 FT→ DROVE ME TO HOSPITAL SO I WAS SAVED- BUT AFTER THAT I WAS WEAK & COULDNT WORK SO HARD & I MOVED TO A HOUSE WITH A TOILET- I WAS SUPPOSED TO BE THE DOCUMENTOR- I KNEW NOTHING ABOUT CONSTRUCTION - BUT THE WOMEN ON THE JOB SPENT A LOT OF TIME ARGUEING EVEN THO WE WERE SUPPOSED TO BE A COLLECTIVE & BETTER THAN THE MEN - MORE DEMOCRATIC - & IT WAS HARD TO WORK IN THE MIDDLE OF A WAR - I ENDED UP TEACHING THE NICAURAGUAN WOMEN HOW TO USE POWERTOOLS - WE MADE A VIDEO ABOUT IT CALLED "SI PODEMOS" - "YES WE CAN" - I DONT WANT TO BE TOO NEGATIVE ABOUT THIS- I LEARNED ALOT BUT IT WAS A GOOD LESSON ON HOW IT IS TO TRANSLATE IN THE REAL WORLD TELL YOU ABOUT MY FIRST NYC - THE CLASSIC- SOME SHOT OUTSIDE MY WINDOW IT WAS A CAR BACKFIRING OUTSIDE & THERE WAS A DEAD - ALLEN GINSBURG LIVED ACROSS FROM ME - SOMETIMES HE WOULD SAY HI. ALSO A DIFFICULT IDEALS BUT I DIDNT NIGHT IN ONE GOT & I THOUGHT & I LOOKED GUY

⚡FLY 08/05/2K2·NYC

SARAH FERGUSON – 08/05/2K2 – LOWER EAST SIDE – NYC
SARAH IS A JOURNALIST & A GARDENER – SHE HAS BEEN AROUND THE LOWER EAST SIDE FOR A LONG TIME – SHE S WRITTEN A LOT OF PIECES ABOUT THE SQUATS & ABOUT THE CREEPING & NOW GALLOPING ONSLAUGHT OF GENTRIFICATION – ITS REALLY HARD TO LIVE SOMEWHERE & BE REPORTING ABOUT IT – WHEN YOU HAVE TO LIVE WITH THE PEOPLE YOU ARE WRITING ABOUT ITS HARD TO BE OBJECTIVE & NOT GET AT LEAST A LITTLE NEGATIVE FEEDBACK ESP WHEN YOU HAVE TO ANSWER TO HARD—ASS EDITORS – BUT ON THE OTHER HAND SHE HAS BEEN ABLE TO GET THE REAL STORY & HAS SUPPORTED THE SQUATTERS & THE GARDENS MORE THAN ANY OTHER NYC REPORTER – SFERG@INTERPORT

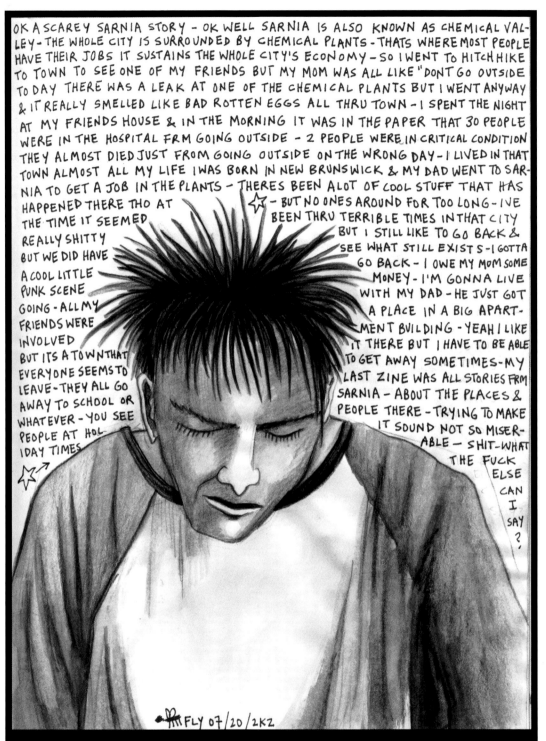

OK A SCAREY SARNIA STORY - OK WELL SARNIA IS ALSO KNOWN AS CHEMICAL VALLEY - THE WHOLE CITY IS SURROUNDED BY CHEMICAL PLANTS - THATS WHERE MOST PEOPLE HAVE THEIR JOBS IT SUSTAINS THE WHOLE CITY'S ECONOMY - SO I WENT TO HITCH HIKE TO TOWN TO SEE ONE OF MY FRIENDS BUT MY MOM WAS ALL LIKE "DONT GO OUTSIDE TODAY THERE WAS A LEAK AT ONE OF THE CHEMICAL PLANTS BUT I WENT ANYWAY & IT REALLY SMELLED LIKE BAD ROTTEN EGGS ALL THRU TOWN - I SPENT THE NIGHT AT MY FRIENDS HOUSE & IN THE MORNING IT WAS IN THE PAPER THAT 30 PEOPLE WERE IN THE HOSPITAL FRM GOING OUTSIDE - 2 PEOPLE WERE IN CRITICAL CONDITION THEY ALMOST DIED JUST FROM GOING OUTSIDE ON THE WRONG DAY - I LIVED IN THAT TOWN ALMOST ALL MY LIFE I WAS BORN IN NEW BRUNSWICK & MY DAD WENT TO SARNIA TO GET A JOB IN THE PLANTS - THERES BEEN A LOT OF COOL STUFF THAT HAS HAPPENED THERE THO AT THE TIME IT SEEMED REALLY SHITTY BUT WE DID HAVE A COOL LITTLE PUNK SCENE GOING - ALL MY FRIENDS WERE INVOLVED BUT ITS A TOWN THAT EVERYONE SEEMS TO LEAVE - THEY ALL GO AWAY TO SCHOOL OR WHATEVER - YOU SEE PEOPLE AT HOLIDAY TIMES ☆→ - BUT NO ONES AROUND FOR TOO LONG - IVE BEEN THRU TERRIBLE TIMES IN THAT CITY BUT I STILL LIKE TO GO BACK & SEE WHAT STILL EXISTS - I GOTTA GO BACK - I OWE MY MOM SOME MONEY - I'M GONNA LIVE WITH MY DAD - HE JUST GOT A PLACE IN A BIG APARTMENT BUILDING - YEAH I LIKE IT THERE BUT I HAVE TO BE ABLE TO GET AWAY SOMETIMES - MY LAST ZINE WAS ALL STORIES FRM SARNIA - ABOUT THE PLACES & PEOPLE THERE - TRYING TO MAKE IT SOUND NOT SO MISERABLE - SHIT - WHAT THE FUCK ELSE CAN I SAY ?

☆↗

FLY 07/20/2K2

NATHAN FRM SARNIA – 07/20/2K2 – LOWER EAST SIDE – NYC
NATHAN IS A PUNK KID FROM SARNIA WHICH IS IN CANADA – HE HAD CONTACTED ME THROUGH EMAIL TO DO AN INTERVIEW FOR HIS ZINE & THEN ONE DAY HE SHOWED UP IN NYC SO WE GOT TO DO THE INTERVIEW IN PERSON IN REAL TIME WHICH IS A RARE THING THESE DAYS – HE DIDNT HAVE A TAPE RECORDER SO HE WAS HAVING TO WRITE REALLY FAST & I COULD RELATE TO THAT BECAUSE I HAVE HAD TO DO THAT FOR EVERY SINGLE ONE OF THESE GODDAM PORTRAIT THINGS – AFTER THE INTERVIEW I SENT HIM ON OVER TO A PUNK SHOW HAPPENING AROUND THE CORNER AT C SQUAT – CHECK OUT NATHANS ZINE – CONCRETE SHOES: NATHAN, PO BOX 1986, CORUNNA, ONTARIO, CANADA N0N 1G0

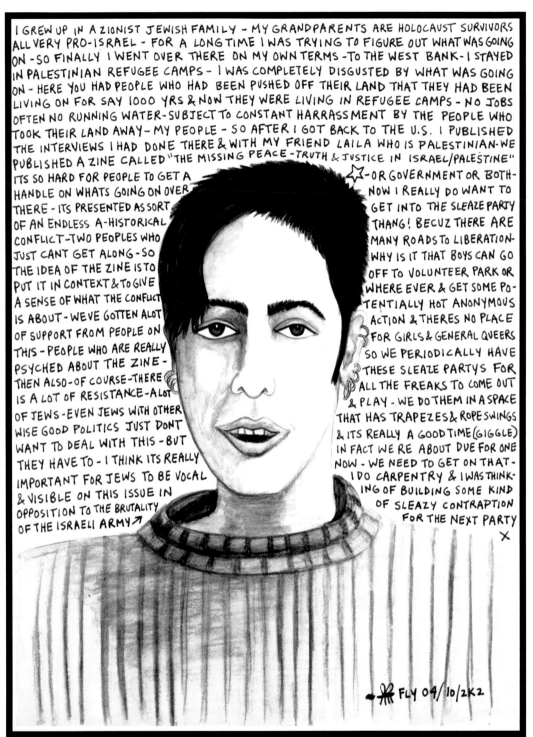

I GREW UP IN A ZIONIST JEWISH FAMILY - MY GRANDPARENTS ARE HOLOCAUST SURVIVORS ALL VERY PRO-ISRAEL - FOR A LONG TIME I WAS TRYING TO FIGURE OUT WHAT WAS GOING ON - SO FINALLY I WENT OVER THERE ON MY OWN TERMS - TO THE WEST BANK - I STAYED IN PALESTINIAN REFUGEE CAMPS - I WAS COMPLETELY DISGUSTED BY WHAT WAS GOING ON - HERE YOU HAD PEOPLE WHO HAD BEEN PUSHED OFF THEIR LAND THAT THEY HAD BEEN LIVING ON FOR SAY 1000 YRS & NOW THEY WERE LIVING IN REFUGEE CAMPS - NO JOBS OFTEN NO RUNNING WATER - SUBJECT TO CONSTANT HARRASSMENT BY THE PEOPLE WHO TOOK THEIR LAND AWAY - MY PEOPLE - SO AFTER I GOT BACK TO THE U.S. I PUBLISHED THE INTERVIEWS I HAD DONE THERE & WITH MY FRIEND LAILA WHO IS PALESTINIAN - WE PUBLISHED A ZINE CALLED "THE MISSING PEACE - TRUTH & JUSTICE IN ISRAEL/PALESTINE"

ITS SO HARD FOR PEOPLE TO GET A HANDLE ON WHATS GOING ON OVER THERE - ITS PRESENTED AS SORT OF AN ENDLESS A-HISTORICAL CONFLICT - TWO PEOPLES WHO JUST CANT GET ALONG - SO THE IDEA OF THE ZINE IS TO PUT IT IN CONTEXT & TO GIVE A SENSE OF WHAT THE CONFLICT IS ABOUT - WE'VE GOTTEN A LOT OF SUPPORT FROM PEOPLE ON THIS - PEOPLE WHO ARE REALLY PSYCHED ABOUT THE ZINE - THEN ALSO - OF COURSE - THERE IS A LOT OF RESISTANCE - A LOT OF JEWS - EVEN JEWS WITH OTHER WISE GOOD POLITICS JUST DONT WANT TO DEAL WITH THIS - BUT THEY HAVE TO - I THINK ITS REALLY IMPORTANT FOR JEWS TO BE VOCAL & VISIBLE ON THIS ISSUE IN OPPOSITION TO THE BRUTALITY OF THE ISRAELI ARMY↗

☆ - OR GOVERNMENT OR BOTH - NOW I REALLY DO WANT TO GET INTO THE SLEAZE PARTY THANG! BECUZ THERE ARE MANY ROADS TO LIBERATION - WHY IS IT THAT BOYS CAN GO OFF TO VOLUNTEER PARK OR WHERE EVER & GET SOME PO- TENTIALLY HOT ANONYMOUS ACTION & THERES NO PLACE FOR GIRLS & GENERAL QUEERS SO WE PERIODICALLY HAVE THESE SLEAZE PARTYS FOR ALL THE FREAKS TO COME OUT & PLAY - WE DO THEM IN A SPACE THAT HAS TRAPEZES & ROPE SWINGS & ITS REALLY A GOOD TIME (GIGGLE) IN FACT WE'RE ABOUT DUE FOR ONE NOW - WE NEED TO GET ON THAT - I DO CARPENTRY & I WAS THINK- ING OF BUILDING SOME KIND OF SLEAZY CONTRAPTION FOR THE NEXT PARTY
✗

↤ ✗ FLY 04/10/2K2

RONNI TARTLET – 04/10/2K2 – SEATTLE

I MET RONNI IN 1999 WHEN I WAS ON TOUR WITH AUS ROTTEN & MY BOOK HAD JUST COME OUT – I WAS IN SEATTLE FOR A FEW DAYS & I GOT HOOKED UP WITH RONNI & RONICA WHO WERE DOING A BENEFIT FOR THE PIRATE RADIO STATION – LATER IN Y2K I WAS TOURING AGAIN WITH THE PRIMATE FREEDOM TOUR & I STAYED AT RONNI & RONICAS COLLECTIVE HOUSE FOR A FEW DAYS – THATS WHERE I DREW THIS PORTRAIT – (THE GREAT THING ABOUT THAT HOUSE IS THAT IT HAS BOOKSHELVES ON EVERY WALL THAT ARE FULL OF INCREDIBLE BOOKS THAT YOU WANT TO READ) – RONNI HAS PUT TOGETHER A COUPLE OF REALLY GREAT ZINES OF INTERVIEWS WITH MIDDLE EASTERN ACTIVISTS – RTARTLET@YAHOO.COM

PEOPs Index

PEOPs Index

Eden

bio

FLY

Felix

Fly was born in Halifax, Nova Scotia (that's in Canada) - she came flying out of the womb on skates with a half-full sketchbook in her hands screaming that she had too much work to get done & complaining about the cold - she lived in a whole bunch of different places & lived a whole bunch of different lives until she landed in New York City in the late 80s & finally felt at home - she has been squatting in the Lower East Side of Manhattan since 1990 where she paints & draws comics & illustrations - her work has been published by New York Press, Juxtapoz, the Comics Journal, the Village Voice, San Francisco Bay Guardian, Raygun, The Bradleys (Fantagraphics), World War 3 Illustrated, Punk, Maximumrocknroll, Slug & Lettuce, & many more - Fly has self-published numerous comics & zines in the past 2 decades & a collection of some of these - entitled CHRON!IC!RIOTS!PA!SM! - was published in 1998 by Brooklyn-based Autonomedia - for several years she toured the world with the God Is My Co-Pilot band pretending to be a rock star & hypnotizing audiences with her dazzling technique on the bass guitar - she also co-founded & fronts the infamous Lower East Side punk rock band Zero Content - although the band has not existed for years they continue to write songs, produce CDs & tour & are more popular than ever - Fly likes to spend her spare time either working on her building, dodging NYC traffic on her inline skates, painting murals, or - best of all - PEOPing her PEOPs!! Her goal is to PEOP everyone she meets & that includes you!

Portraits of Fly frm left to right by Eden Orr & Felix Ashra Chrome